CW01175724

**HIDDEN TREASURES OF LONDON**

*Richard

A welcome to London from

Alistair & Wayne*

# Hidden Treasures
## *of*
# LONDON

### MICHAEL McNAY

*With photographs by Stephanie Wolff*

rh
BOOKS

1 3 5 7 9 10 8 6 4 2

Random House Books
20 Vauxhall Bridge Road
London SW1V 2SA

Random House Books is part of the Penguin Random House
group of companies whose addresses can be found at
global.penguinrandomhouse.com.

Penguin
Random House
UK

Copyright © Michael McNay 2015

All photographs copyright © Stephanie Wolff

Michael McNay has asserted his right to be identified as the
author of this Work in accordance with the Copyright, Designs
and Patents Act 1988.

Some articles in this book previously appeared in
*Hidden Treasures of England* by Michael McNay

First published by Random House Books in 2015

www.randomhouse.co.uk

A CIP catalogue record for this book is available from the British Library.

ISBN 9781847946171

Typeset by Palimpsest Book Production Ltd, Falkirk, Stirlingshire

Text design by Lindsay Nash

Printed and bound in China by C&C Offset Printing Co., Ltd

# CONTENTS

*Introduction* vii

The City 1

The West End 85

West London 213

South-West London 275

South-East London 327

East London 425

North London 491

*Index* 564

# INTRODUCTION

In 1777, the year that Samuel Johnson threw into a conversation with Boswell his now slightly foxed remark, 'when a man is tired of London, he is tired of life,' the capital had an estimated population of 543,520. Today's computed total is 8,615,246, a tiddler on the global scale but enormous in terms of infrastructure; and surely big enough to ease even Dr Johnson into second thoughts. Of course, the difference between living and working in the same place and commuting to work is vital: enough to guess that should he shamble blinking out of number 17 into Gough Square today, Dr Johnson might stand a chance of maintaining his love of the capital. Indeed, many of my former work colleagues lived in London and loved it, while I – and others like me – commuted into London and found it dirty, noisy, generally tiresome and good to get away from in the evenings.

So why write a book about the wonders of London? Easy. I stopped going to work there and returned to its bustle as a privileged sightseer. I set about discovering the places I'd heard of but never visited and other places in the outer tundra I had never come across at all: Southside House in Wimbledon, anybody? Or Manze's eel, pie and mash shop in Walthamstow, which I came across in a little down-page news item one day reporting that it had received an English Heritage listing?

The same rules applied to this book as to the last one I did (*Hidden Treasures of England*) with the same editor, Nigel Wilcockson, who at the outset said he didn't care that there were hidden treasures in the British Museum, he would sooner I didn't visit it; nor the National Gallery, nor either of the Tates (Tate Britain's restaurant murals stand apart from the collection). Of course, the rules for inclusion are ad hoc but easy enough to work out: statues in the street that people pass by daily for years without noticing, let alone knowing who or what they represent; or famous buildings which are closed to the public apart from on special

days (notably Open House London), such as the inside-out Lloyd's building, the halls of the City of London livery companies and the lawyers' Inns of Court. The choice I have made is personal and just as haphazard as the pieces written for the London pages of *Hidden Treasures of England*, most of which appear here again: some tweaked, some totally rewritten.

Whenever the name Pevsner crops up it signifies, of course, Nikolaus Pevsner (and later a growing team of writers and researchers) whose indispensable series of *Buildings of England* include the six volumes on London. Another authority is Howard Colvin, whose *Biographical Dictionary of British Architects, 1600–1840* was Pevsner's Pevsner. Many articles in the *Burlington Magazine* also aided my research, particularly John Larson's 'The Cleaning of Michelangelo's Taddei Tondo' (vol. 133, no. 1065, Dec 1991). An honourable mention goes to www.british-history.ac.uk (and we don't mention Wikipedia, but we should).

Apart from Nigel Wilcockson, whose patience and general support have been crucial, thanks to his assistant editor Fred Baty, full of insights and a brilliant organiser, and to the eagle-eyed copy-editor, Lynn Curtis. I found London exhausting but the photographer, Stephanie Wolff, covered the same ground on her push bike to put up with the slings and arrows of British officialdom and officiousness (as every photographer except David Bailey must in this country). Friends and strangers who helped include Penny Fussell, Gina Geeps, François Gordon, Richard Hollis, Murray Hunt, the Rev. Karlene Kerr, Tina Milne, Angela Nye, John Porter, the Rev. Marie Segal, Libby Shearon, the Rev. Nicola Stanley and Richard Surman. I thank Mike Rushton, my GP for forty years, for taking one look at me and getting a blood wagon around in a blur of sirens and flashing blue lights; and Scott Takeda with his team of cardiologists and nurses for saving my life. Just another case in the history of the NHS. Thanks to James Ritchie for putting me on my feet with a new ankle. My daughter Lois, my granddaughter Maisie, my son Ross and my younger daughter Anna all weighed in with visits, love and ideas.

And Sue, ongoingly and always.

Overleaf: the Monument to the Great Fire pushes its copper urn of flame (sculpted by Francis Bird) above the buildings around it: a major attraction to visitors fit enough to tackle the 311 steps to the iron basket near the top.

*The City*

# City

**ISLINGTON**

- The Quality Chop House
- Finsbury Health Centre
- Mural by Jack Hastings, Marx Memorial Library
- Norman Crypt, Priory Church of Saint John
- Old Sessions House
- St Peter's Italian Church

**CAMDEN**

- St Alban the Martyr, Holborn
- St Etheldreda's Church
- The Priory Church of St Bartholomew the Great
- Murals by Hogarth, St Bartholomew's Hospital
- The Golden Boy of Pye Corner
- St Andrew Holborn
- Bust of Charles Lamb, Giltspur Street
- Postman's Park
- Dr Johnson's House
- Statue of John Donne, St Paul's Cathedral
- St Dunstan-in-the-West
- Daily Express building
- Temple Bar
- Sculpture by Georg Ehrlich, Festival Gardens
- Ye Olde Cheshire Cheese
- Punch Tavern
- St Bride's Church
- Apothecaries' Hall
- St Lawrence Jewry Fountain
- Temple Church
- Zodiacal clock, Bracken House
- Middle Temple Hall
- *Temple Gardens*
- The Black Friar
- Guild Church of St Benet

*Thames*

| 0 | 0.1 | 0.2 | 0.3 mi |
| 0 | 0.1 | 0.2 | 0.3 | 0.4 km |

**SOUTHWARK**

## HACKNEY

Wesley's Chapel and House

Bunhill Fields

## TOWER HAMLETS

Murals by Dorothy Annan, Barbican

Sculpture by Jacques Lipchitz, Broadgate Circle

Sculpture by Fernando Botero, Broadgate

Sculpture by Richard Serra, Broadgate Circle

St Botolph without Bishopsgate

## CITY

Drapers' Hall

St Margaret Lothbury

Bank of England Museum

Bevis Marks

The Hoop and Grapes

Memorial to John Stow, St Andrew Undershaft

Mansion House

Sculpture by Aimé-Jules Dalou, Royal Exchange

St Katharine Cree

Statue of Sir John Cass, Jewry Street

St Mary Aldermary

Lloyd's of London

St Stephen Walbrook

St Mary Woolnoth

Leadenhall Market

St Olave, Hart Street

Prudential Assurance Building

St Mary-at-Hill

Font cover by Grinling Gibbons, All Hallows by the Tower

Monument

Watermen's Hall

St Magnus the Martyr

Old Billingsgate Fish Market

TOWER OF LONDON

## • FLEET STREET, HOLBORN, CLERKENWELL •

### MIDDLE TEMPLE HALL

*Where Shakespeare invited heckling*

John Manningham was a young Cambridge graduate studying law at Middle Temple before being called to the bar in 1605. At the beginning of 1602 he began keeping a journal of miscellaneous recipes, epitaphs, jokes, gossip, summaries of sermons (very long, most of them), and first-hand reportage of events. Abidingly the most valuable of these was his account, within a month of starting the journal, of the celebration in Middle Temple Hall on 2 February (the Christian Feast of Candlemas), when an itinerant theatre company took over what is normally the dining hall to perform a new comedy called *Twelfth Night, or What You Will* by a playwright of growing reputation, one William Shakespeare. (There have been arguments about whether the first night was here or in royal Whitehall, but a textual analysis in a back number of *Shakespeare Quarterly* highlights dialogue between the Fool and Malvolio in which the Fool describes the topography of the hall, and the verbal sparring between them amounts to a humorous assault directed by Shakespeare at his audience of lawyers, a profession he knew well and loved less. It was intended to prompt hoots and jeers from them, as might be done in pantomime today, and surely proves the case for Middle Temple Hall as first-night venue beyond reasonable doubt.)

It had been completed only 30 years before, with space for 500 (the number of law students annually today), standing room only. In 1562 Edmund Plowden, treasurer of Middle Temple whose bust stands before the screen in the hall, summoned John Lewis, chief carpenter at Longleat, to help build the hall. It was finished by 1570 (the date set in the west window) with one of the great double hammerbeam roofs in England and the finest in the City, with standing urns on the beams in counterpoint to the abundant hanging pendants. Oak panelled to clerestory level on three sides, the wall is inset with the arms and inscriptions of Readers (lecturers) from 1597 to 1899. Before the fourth, east, wall is an elaborate and wonderfully closely carved screen. Royal portraits adorn the west wall, including a decent copy of the best equestrian portrait in England, *Charles I with M. de St Antoine* by Van Dyck, in the Royal Collection. Elizabeth I is supposed to have given the three 29-foot-long oak planks that were floated downriver from Windsor Forest to be assembled as the hall's high table.

Members or guests at high table included the famous sailors Drake, Frobisher, and Raleigh; the diarist John Evelyn and poet William Cowper; the Duke of Monmouth, bastard son of Charles II executed for leading an insurrection against his uncle James II; the novelists Henry Fielding, Charles Dickens and John Mortimer (whose chambers were in Inner Temple; his creation, Horace Rumpole, practised from the fictional Outer Temple). The high table is not merely the heartbeat of Middle Temple Inn, but its stomach as well.

MIDDLE TEMPLE LANE, EC4Y 9AT

# TEMPLE CHURCH

*The Templars, holy usurers of the medieval world*

The Knights Templar was an international organisation founded in 1118 to protect Christian pilgrims travelling in the Holy Land. The knights took over a mosque as their headquarters in Jerusalem; in London they built the New Temple on the banks of the Thames. There were two halls, living quarters and the round church, based on the Temple of the Holy Sepulchre in Jerusalem. It is a romantic tale only a little tainted by their most significant wealth-creating activity: they set themselves up as usurers, or bankers as we would know them today, dispensing loans from an exchequer rich enough to grant loans to the King of England among other clients. Money lending was an activity forbidden by papal edict but increasingly essential to grease the wheels of fast-growing economies which needed exchanges in cash where service and barter arrangements were no longer sufficient to the task. The Temple Church, though now dedicated to the essential task of watching over the spiritual well-being of the lawyers who took over the Temple after the Reformation, is the outward and visible symbol not just of God but of Mammon and the green shoots of capitalism.

In 1185 the New Temple became an important depository for the king's treasure. Its church was consecrated in the same year, which may be a coincidence; or not. The round building had one appendage, a single-bay porch, and was pure Norman in parts, fully fledged Gothic in others. Most obviously, the porch has pointed Gothic arches but the portal it shelters is round-arched Norman. The round building became a nave when the Templars added a fully Gothic chancel, Early English, in 1220–40. There are slender Purbeck marble piers throughout, and the bright, airy, beautifully proportioned church survives in good order from those days with some noticeable nineteenth-century restoration, especially the recladding in Bath stone.

In 1941 the nave was hit by an incendiary bomb and the burning wooden vault fell on to the round nave's greatest treasure, the nine effigies of knights that had lain beneath for 700 years. They were comprehensively repaired and remain an impressive sight, but one effigy, especially, retains the skilful medieval carving of hair, chain mail and cloak, poised between the stylised and the natural. This is the effigy thought to represent Robert de Ros (*c.*1182–1226/7), one of the 25 barons chosen to compel King John to observe the provisions of Magna Carta. He is shown with clean-cut, youthful features and long aristocratic nose, as near a true portrait as we get from the thirteenth century. Ros was a turbulent northern magnate who retired in his last months to a monastery, left houses and land in Yorkshire to the Knights Templar and was buried in the Temple.

TEMPLE, EC4Y 7BB

## ST DUNSTAN-IN-THE-WEST

*A Romanian chapel under the protection of Queen Elizabeth I*

Squeezed in beside the London home of those last remaining illustrious journals in Fleet Street, the *Dundee Courier*, the *Sunday Post*, the *People's Friend*, and the *Beano*, rises a stone tower capped by a slender octagonal stone lantern with a lacy coronet. It is an echo of the fifteenth-century lantern of All Saints Pavement, York, and a pre-echo of the main church building behind. This is St Dunstan-in-the-West, built in 1830–3 by John Shaw and his son John on the site of a church of 1170. The octagonal form of the body of Shaw's design may have been imposed by the widening of Fleet Street after demolition of the original church.

Its most remarkable interior feature is the richly structured Romanian Orthodox iconostasis; the altar screen with about three dozen painted panels, not Byzantine but nineteenth-century, individually uninspiring but vivid as an ensemble. It was shipped in 1966 from the Antim Monastery in Bucharest after the Anglicans agreed to share St Dunstan with the Romanian community in London. The church is home to some indifferent stained glass and good memorial sculpture, though the most arresting sculpture is outside in a recess between the porch and the Scottish newspaper building. It is a statue of Queen Elizabeth I, crowned, gowned, and bejewelled, moved in 1760 to St Dunstan-in-the-West from the façade of the Ludgate, halfway up Ludgate Hill, when the gate was demolished for the same reason as Temple Bar at the other end of Fleet Street and, of course, the shunting back from the street line of St Dunstan-in-the-West itself.

Most authorities tended to place the sculpture in 1586 and assign it to a mason called William Kerwin, who had worked on introducing classical elements to the structure of Ludgate in that year (but is known for no other sculpture). This may be because the diarist John Evelyn recorded seeing the statue in good shape after the Great Fire of London in 1666, when the Ludgate was restored. Evelyn's witness is, however, equivocal and art historians increasingly propose that the relaxed naturalism of the sculpture, for all the weight of royal accoutrements, sits well neither with what we know of Tudor sculpture nor with how the queen preferred to be shown, which was in the rigid hieratic splendour displayed in so many well-known painted portraits of her. The statue looks every inch late Jacobean and stands in a handsomely proportioned niche in a fine post-Fire aedicule with pilasters and broken pediment, also removed from Ludgate. It is as uplifting a sight as any monarch could wish.

It quite dominates the good bronze head of Lord Northcliffe on a nearby plinth, made by Kathleen Scott, widow of Scott of the Antarctic (see Waterloo Place, page 148). Northcliffe, aka Alfred Harmsworth, was founder of the *Mirror* and the *Daily Mail*, newspaper genius, mad as a hatter, and the first and least meddlesome of millionaires to have owned *The Times*, which he did from 1908 until his death in 1922.

FLEET STREET, EC4A 2HR

## YE OLDE CHESHIRE CHEESE

*A tippling house*

Ye Olde Cheshire Cheese settles for grim authenticity, and that goes for the food as well. The pub sign firmly claims that it was rebuilt in 1667 (i.e. after the Great Fire), though Pevsner, not one to succumb to romantic myth, points out that it originated as two houses. The usual fancy folk memories that dress pubs up in faux-history may be founded in fact with the story that Dr Johnson and his circle, from Boswell to Garrick, Goldsmith and Reynolds, were Cheese regulars. There is a dim old portrait in oils of Sam in the chop room to the left of the entrance passageway, and eBay fans may sometimes find on its china and glass pages a Doulton dish depicting Dr Johnson beside the fire in the bar to the right of the passage. Certainly the great man lived around the corner at 17 Gough Square (see page 13) from 1748 until 1759 while he compiled his *Dictionary*, and he did not entertain at home; on the other hand, during those years he was compiling his Dictionary and mostly abstained from drink. The two activities do not, in his view, cohabit:

ALEHOUSE. A house where ale is publickly sold; a tippling house.
LEXICOGRAPHER. A writer of dictionaries, a harmless drudge.

The Cheese, as its habitués know it, has certainly never had a true Victorian makeover, no brilliant cut glass, no shining copper and mahogany, none of the music hall curlicues of the repro advertisements for brandy, port and stout. What isn't actually authentic here passes for authentic, and what is authentic is so real it can hurt: where most pubs of a certain age have health warnings, the Cheese doubles up with signs warning both 'Watch your feet' and 'Mind your head' on a single staircase descending to a basement, so close to another one above that customers have to bow their heads during the whole descent. The seventeenth-century frontage, stairs, steps, dark corners, wooden benches, deal tables, light filtering in as best it can from the dimly lit Wine Office Court where it stands, are part of the highly atmospheric effect.

There are building alterations from the eighteenth century and furnishings from the early to mid nineteenth century. The vaulted cellars, from which I have blurred memories of emerging after extended Christmas revelries with the bunch of journalists with whom I worked most closely many years ago, were probably part of the medieval cellars of the old Whitefriars monastery: genuinely old, unlike the house's name, Ye Olde Cheshire Cheese. *Sacré bleu*! Even Voltaire, another great man dubiously claimed as an authentic tourist to Wine Office Court (*'Un verre de Sam Smith's, s'il vous plaît'*), would have scorned that counterfeit olde Englishe.

145 FLEET STREET, EC4A 2BU

## DAILY EXPRESS BUILDING

*The glory days of newspapers*

Before the newspapers packed their tents and decamped from the Street of Shame

(© *Private Eye*), the *Daily Telegraph* was here in its monumentally oppressive Greco-Egyptian headquarters, Reuters and the Press Association were here, the *Evening Standard* was along Shoe Lane, the *Daily Mail* was in Tudor Street, and at 120 Fleet Street, outrageously, completely off the wall architecturally, was Lord Beaverbrook's *Daily Express*. The architect Owen Williams (1890–1969) built it for Beaverbrook in 1930–2, and followed up with a near replica for the *Express*'s Manchester office in 1939. It is a curved sheath of black Vitrolite and glass, the first glass curtain wall in England, rising four floors as a sheer cliff face and then stepped back a further three, and it encompassed the machine room, composing room, editorial floors, the business offices and what *Express* hacks called the bank in the sky – the accounts office where they picked up their expenses after weaving an unsteady route back from the nearest pub. By the end of the century only real banks could afford to remain in Fleet Street.

Most of all what caught the eye of any passer-by was the entrance hall, more exotic than any other art deco office or factory, cinema or theatre interior, in England. This is what Evelyn Waugh had in his mind's eye when he wrote his classic Fleet Street novel *Scoop* (1938), when his timid hero William Boot attends for an interview with Lord Copper, proprietor of the *Daily Beast* (based by Waugh on Lord Beaverbrook and the *Express*), and is 'rudely shocked by the Byzantine vestibule and Sassanian lounge of Copper House'.

This golden hall is the decorative masterpiece of the architect Robert Atkinson (1883–1952). Everything shines or reflects or glitters: the floor in wavy bands of blue, green and black reflects the central hanging pendant lamp with roots that spread like a sunburst across the ceiling, and a studded metallic arch spans the width of the hall, giving on to the smaller archway entrance to the staircase that spirals upwards like the cream topping on a sundae. One wall is filled by a climactic moulded-plaster mural, gilded and silvered, showing a great goddess of plenty surrounded by industrious troglodytes, natives and settlers of many climes and cultures – one charming cobras, a couple drilling roads, another shearing sheep, others bearing baskets of fruit from the palms – a vision of empire to glorify the proprietor's politics, sculpted by Eric Aumonier (1899–1974). Aumonier was a native himself, of north-west London, creator of the sculptures of the great dead on the escalator to heaven in the Powell and Pressburger film *A Matter of Life and Death* (1946) and of the stylised archer on East Finchley underground station (see page 532), the invisible arrow doubtless symbolising the speed and dispatch of Northern Line services.

Bankers, unlike newspapermen, are shy creatures, and curtains now hanging at 120 Fleet Street draw a veil over their activities. It's possible to enter and take a peek while claiming an appointment with Lord Copper or to wait for the annual London open day when Goldman Sachs

Ye Olde Cheshire Cheese is a tippling house, in Dr Johnson's definition of a pub in his dictionary. As he lived a few yards round the corner from the Cheese, there is a chance that he actually did drink here, as myth has it. Inside hangs a portrait of the old oracle.

throws wide the doors to this splendidly restored Xanadu.

120 FLEET STREET, EC4A 2BB

## ST BRIDE'S CHURCH

*The church of the print industry*

Fleet Street was the street of ink from 1500 until 1986, when it died 'of strikes and new technology', as an old colleague of mine put it. In the beginning was Wynkyn de Worde, who opened his printworks at the Sign of the Sun in Fleet Street in 1500 or 1501, probably the premises where the Old Bell pub stands now, backing on to St Bride's churchyard. Wynkyn worked for Caxton, and took over the business when his master died in 1492, rising to fame and riches in his own right. As death approached he asked to be buried in St Bride's, and lies here somewhere under the floor.

This is the church of the print industry and particularly of journalists. Here plaques honour Bert Hardy, the brilliant *Picture Post* photographer, and the other Bert Hardy, a key fixer between management and labour in a strife-ridden trade; Allen Hutt, communist chief sub-editor of the *Daily Worker* and newspaper designer; and a clutch of Harmsworths, the right-wing newspaper-owning family dynasty. There are plaques as well to institutions, like the *Sun* and the celebrity magazine *OK!*, presumably because they dropped something into the collection plate. What would the Poet Laureate of Fleet Street, John Davidson, have made of this love-in? Already in 1893, with the publication of his *Fleet Street Eclogues*, he saw through the daily hypocrisies and lies of the business in a few purgative lines:

> *This trade we ply with the pen,*
> *Unworthy of heroes or men,*
> *Assorts ever less with my humour:*
> *Mere tongues in the raiment of rumour,*
> *We review and report and invent:*
> *In drivel our virtue is spent.*

But in one corner of St Bride's the bitter cynicism is put to rest by a board commemorating the journalists who died in the 2003 Iraq War, and a display of photographs of those who died in other conflicts, like the thorn in the side of the Russian regime, Anna Politkovskaya, who was assassinated in 2006 in Moscow. The cull continues.

If there was a crisis at St Bride's when the newspapers folded their tents and departed, it was minor compared to other problems it has faced in its history: burned down in 1666, rebuilt by Wren with his most-loved spire, left with only that tower and spire and the outer walls after the bombs of 1941. In the restoration following the war, though, the crypt was rediscovered and found to contain sections of a Roman pavement built of small coloured tesserae, and fragments of stone walls from the Saxon period. The church itself has risen again more or less as Wren intended, and improved on the state it reached after his death when galleries were added. There is a fine new reredos based on a Wren original, pierced by a mandorla of brutally coloured glass and with a painting by the Slade-trained artist Glyn Jones (1906–84): a turbulent scene of the Crucifixion, psychologically intense, a collision in sources between the war photographer Robert

Capa and El Greco, as though this is the report of the very moment of Christ's death.
FLEET STREET, EC4Y 8AU

## PUNCH TAVERN

*Discord and anarchy*

The great funereally ornate façade of the former *Daily Telegraph* building in Fleet Street, colloquially described as Classical Egyptian, was most memorably categorised by Michael Frayn as the Tomb of the Unknown Leader Writer. In the foreword to the latest edition of his novel about Fleet Street, *Towards the End of the Morning*, Frayn recalls an incident involving the pub next door to the *Telegraph*: 'I was passing the King and Keys one day when I was almost killed by a projectile emerging from it like a shell from a howitzer. It was a man being ejected by unseen hands, in a high trajectory that took him clear above the pavement and into the gutter beyond; whoever it was, somebody evidently felt quite strongly that it was time for him to be on his way back to the office.'

When the *Telegraph* joined the press scuttle from Fleet Street in 1987, the King and Keys swiftly became obsolete. The tomb of the unknown leader writer fell into the hands of the multinational investment bank Goldman Sachs, which lacked the drinking culture that had sustained so many pubs and newspapers locally. The *Daily Mirror* pub, the Printer's Devil, has also gone the way of compositors, stonehands and copytakers. From the lanes south of Fleet Street the *Mirror* moved to Holborn Circus and adopted as its watering hole the White Hart in New Fetter Lane, soon known as the Stab in the Back or, in its edited version, the Stab. That remains, but as a shadow. The Printer's Pie, a *Sun* pub, was simply demolished.

The Punch Tavern is a special case. Its premises are said, as often happens, to have housed a pub since at least the eighteenth century. We are sure that in 1894 it was known as the Crown and Sugar Loaf, and was refurbished and renamed the Punch Tavern as a salute to the staff of *Punch* magazine founded in 1841 (in another pub, the Edinburgh Castle in the Strand, now defunct). The magazine lingered until 2002. The pub survives it, gloriously eclectic. On the fascia the tendrils of the letter forms picking out 'Punch Tavern' are too anarchic to find their way into any graphic designer's sourcebook. The effulgently tiled entrance passage has painted depictions on either side of Punch and Judy, and the bar room has hammerbeams beneath the overhead glass canopy, with a painted bust of Punch in a roseate plaster cartouche supported by two plaster putti.

But the glory is attenuated. The pub was originally put together from two separate freeholds, each owned by a different brewer. All was well until Bass and Samuel Smith's fell out in the 1990s. Smith's bricked off its one-third share of the premises and called the longest closing time known to drinking man, starting in the twentieth century (1997) and reopening in the twenty-first (2004), with the entrance to its severed portion on Bride's Lane. They called it, of course, the Crown and Sugar Loaf. A very pretty fake it is too, though lacking the joie de vivre of Punch; excuse the French – *Punch* magazine's subtitle, the *London*

The Punch Tavern

*Charivari*, freely acknowledged its French ancestry, embracing discordant but celebratory noise.

99 FLEET STREET, EC4Y 1DE

## DR JOHNSON'S HOUSE

*The fat man is gone, his song remains*

For anyone who goes to Johnson's *Dictionary* for a definition of garret, he will find 'a room on the highest floor of the house'. Considering that some of his definitions are among the great entertainments of the English language, this is surprisingly matter of fact. Even the sober Oxford English Dictionary adds a little colour: '... a top floor or attic room, especially a small dismal one'. At any rate, it was the garret at 17 Gough Square, off Fleet Street, that caused Samuel Johnson to rent the house. Because here he could install desks and bookcases for himself and the six copyists he hired to help him in compiling the first great English dictionary.

The enterprise had been in the back of his mind when a group of publishers commissioned him to produce a work to replace Nathan Bailey's *Dictionarium Britannicum* of 1730, which they thought inadequate. They paid Johnson 1500 guineas, a great sum in his time (1 guinea = 21 shillings), from which he would be responsible for paying his team. He was given a three-year deadline but took nine years, which even in the age of word processors is regarded as a miraculous feat.

As national newspapers deserted Fleet Street the journalists favourite watering holes dried up. But the Punch Tavern is a special case: an ancient pub renamed in 1894 in honour of its *Punch* clientele, it has survived the magazine's death.

Johnson rented number 17 in 1748 and remained there until 1759. By the beginning of the twentieth century it was derelict, but in 1911 Cecil Harmsworth, Liberal politician and younger brother of the newspaper magnate Alfred Harmsworth (Lord Northcliffe), bought it, restored it, built the cute little curator's house beside it, and turned it into the Johnson Museum. It is one of the few seventeenth- or eighteenth-century properties left after war and the relentless march of new office blocks opened up empty space where before there were tiny squares and little alleys. It is four storeys tall, red brick, with white sash windows and handsome doorcases facing east, which was the original main entrance, and south, which is now the way in for paying visitors.

Within are pieces of period furniture, some of which belonged to the great man. There are copies of portraits (Johnson by Joshua Reynolds) and actual portraits (his servant Francis Barber, released from slavery, brought up by Johnson as a son, painted possibly by Reynolds's pupil James Northcote), prints of friends, enemies and acquaintances, and a small library (books mostly not Johnson's). It is worth visiting as surviving houses of the period are, and because of its association with the exemplary English man of letters; but there is no real sense of his presence. Of his abundant eccentricities, voluble speech, affliction by violent spasms, his scorn and generosity, nothing remains. But in the garret there is, with a little willing suspension of disbelief and a replica of the massive two-volume *Dictionary* on a table, an immanent sense of the oversize character who sent the

most scornful letter in the language to Lord Chesterfield, his patron (*Dictionary* definition: 'commonly a wretch who supports with insolence, and is paid with flattery'), and signed it: 'My Lord, Your Lordship's most humble, most obedient servant, Sam. Johnson.'

17 GOUGH SQUARE, EC4A 3DE

## ST ANDREW HOLBORN

*A twentieth-century rescue for a church that survived the Fire of 1666*

On 4 September 1666, with St Paul's Cathedral, 87 City churches and 13,200 houses already destroyed, the apparently unstoppable fire leaped the River Fleet. Yet by the next day the east wind had dropped and the westward advance of the Great Fire of London was halted. St Andrew Holborn was spared, so one might have thought that Wren had enough to do without adding it to his reconstruction plans, which already included a proposal for great public squares and wide boulevards to replace the lost medieval maze of narrow lanes and streets overtopped by jettied timber buildings. But there was a bleak prospect of ownership disputes and compensation claims dragging through the courts ever unto eternity, so the grand design was discarded and the restored city adapted to the old medieval hotchpotch. Wren and his team settled for erecting the Monument and rebuilding the cathedral and 50 parish churches. And as St Andrew's had been long neglected, Wren added that to the list. If not his most beautiful church, it was the biggest.

He retained the fifteenth-century

west tower and clad the rest of the church in Portland stone. In 1703 he returned to add Portland stone to the tower too. The combination of its noble medieval proportions with Wren's balustrade and pinnacles in place of battlements, and the bewitchingly subtle window surrounds above the string course – 'the hand of Hawksmoor may be suspected', says Pevsner – makes St Andrew a fine prospect from whatever happens to be the latest glass block on the Fetter Lane corner of Holborn Circus or from the pavement outside Waterhouse's beef-red Prudential office block along Holborn (see page 44).

The church escaped the Great Fire but not the Blitz. The giveaway that most of the church is Seely & Paget 1961, not Wren 1684, is that the nave is bereft of monuments and the gay plasterwork of the ceiling is coarser than anything conceivably by one of Wren's craftsmen. The Venetian east window was a gift for the stained-glass designer Brian Thomas (also 1961): a theatrical framing for a sombre *Last Supper* below and *Ascension* above, Christ triumphant soaring over the comatose guards at his tomb. In the north-west antechapel Thomas produced a dramatic sky as a backdrop for the crucified Christ rescued from a reredos in the former St Luke Old Street (now a London Symphony Orchestra music centre) and in the vestibule is the tomb chest of the old sea dog Thomas Coram, founder of the Foundling Hospital (see page 116), with a statue of a weeping infant

The library in Gough Square with bookcases installed by Samuel Johnson. Here he and six copiers put together the first great dictionary in the English language.

boy, robustly carved and as much street urchin (or foundling) as putto. In the same vein two bluecoat children rescued from the façade of a vanished parish school decorate the wall below the tower, the boy's coat unbuttoned from the waist up to display his handsome white stock, the girl in a mob cap and a cross-laced tunic and big white collar, two more of London's collection of these remarkable little figures which, if all gathered together, would certainly fill a classroom.
ST ANDREW STREET, EC4A 3AF

## ST ETHELDREDA'S CHURCH

*The piece of London that was part of the Soke of Peterbrough*

Improbably, as it seems today, Shakespeare's King Richard III says to the Bishop of Ely:

> When I was last in Holborn,
> I saw good strawberries in your garden there:
> I do beseech you send for some of them.

The strawberries were attested by Thomas More in his biography of Richard, and there Holinshed picked up the story to include in his *Chronicles*, Shakespeare's prime source for the history plays. Richard would have seen the fruit in the bishop's country garden surrounding his palace, now lost under the diamond dealers' utilitarian street Hatton Garden and the gated enclave known as Ely Place. The church of St Etheldreda was the private chapel to the bishop (Etheldreda was a seventh-century princess and Abbess of Ely), built 1250–90 and alone in

the area in surviving the events of the Reformation and beyond.

Both garden and palace are a long time gone. Queen Elizabeth persuaded Richard Cox, Bishop of Ely, on peril of being defrocked, to disgorge the palace to her favourite, Sir Christopher Hatton. Hatton overspent on embellishing the house and couldn't repay the sum he had borrowed from the queen: a bad debt that doomed the house. It fell into ruin and by the eighteenth century all that remained was the chapel, set in Ely Place, a street built over the old orchard. Today, as though the Reformation had never happened, the Roman Catholic church again owns St Etheldreda's, having purchased it in 1873. The chapel survives, much damaged, much restored, but still trailing clouds of glory. Following the precedent set for private chapels by the unparalleled Sainte-Chapelle in Paris, it is two-storeyed: the main chapel sits above another, lesser, one in the ancient crypt.

Restoration for several years from 1874 stripped plaster away from the interior and revealed delicate medieval carved decoration, as well as big and impressive east and west windows, each with five tall lights and elegant tracery bridging the short gap between Early English (late twelfth/thirteenth centuries) and Decorated (late thirteenth/fourteenth). Second World War bombing saw off the last of the glass. Eddy Nuttgens replaced the east window in 1952 with a Christ the King: confidently used colour, adequate design, feeble draughtsmanship showing Christ surrounded by saints and evangelists, including, of course, St Etheldreda and also the Irish saint Bridget of Kildare, in benign communication with the Irishmen who laboured on the nineteenth-century restoration. Nuttgens's pupil Charles Blakeman followed with an execrable west window dedicated to the Catholic martyrs (English martyrs, the church calls them, as though Catholic Queen Mary hadn't taken her own grim toll). Much better is Blakeman's glass in the five windows of the south wall (Old Testament) and five in the north wall (New Testament). Mary Blakeman, his wife, sculpted the life-size coloured figure of St Etheldreda (resin and glass fibre) beside the east window and the coloured figures of the Catholic martyrs on the fine ancient carved corbels between windows, underperforming their role, as described by Thomas More in a letter from his prison cell to his wife, of 'cheerfully going to their deaths as bridegrooms to their marriage'.

14 ELY PLACE, EC1N 6RY

## ST ALBAN THE MARTYR, HOLBORN

*The masterpiece of a 'tired old Jew'*

Sunday. Mass has finished maybe half an hour before. St Alban's Holborn is locked and silent.

Thursday. I am in the area once more and want to see the mural filling the east wall, so try again on the off chance. As I walk along Gray's Inn Road, the air is rent by an exultant chorus of male voices raised in song. It can only be coming from St Alban's, by the sound of it an impossibly large congregation for any day of the week. It turns out to be a chorus of maybe 150, overwhelmingly priests in clerical

black, the gathering growing as others arrive and sign in at a table by the entrance. Only one woman that I can see. The event is the opening service for the London and Southern regional synod. It is sponsored by the Society of the Holy Cross, the principal organisation promoting Anglo-Catholic ritual. The officiating priest wears a green vestment, the colour that the first vicar of St Alban's, Fr Alexander Mackonochie, wore to proclaim his faith in Catholic ritual – a faith which would lead to Mackonochie's relentless persecution by Low Church (anti-ritualist) Anglicans, who eventually forced him to resign, whereupon he retired to Scotland, died in a snowstorm and was celebrated by history's most plonking rhymester, William McGonagall:

> *So a bier of sticks was most willingly*
> *and quickly made,*
> *Then the body was most tenderly upon*
> *it laid;*
> *And they bore the corpse and laid*
> *inside the Bishop's private chapel,*
> *Then the party took one sorrowful look*
> *and bade the corpse, farewell.*

A martyr to literature.

William Butterfield built the church in 1862–3 in the face of rioting against the Oxford Movement's promotion of Anglo-Catholic ritual. It was bombed in the Second World War and Adrian Scott – younger brother of Giles Gilbert Scott, grandson of George Gilbert Scott – rebuilt it in a clean white modernist take on Gothic. Butterfield's tower and clerical buildings survive but his trademark polychromy was eliminated by Scott's work. The crisp definition of the double lancets in the chancel, like modern slit windows as much as Old English, throw natural light on to the startlingly confident mural of 1966, 50 foot high by 29 foot wide: *The Holy Trinity*, by Hans Feibusch, a refugee from Hitler's regime.

In England Feibusch converted to Anglicanism and most of his work until his death in 1998 aged 99 was for the Church of England. This is a modernism based in a seemingly clapped-out late Renaissance figurative style, but realised with triumphant conviction in oils giving the effect of broad sweeps of pastel: colourful, vigorous, conjuring a sense of movement in critical balance among clusters of figures twice life-size, from the Trinity to the group of St Alban's priests over the years, with Fr Mackonochie in his green. In 1937 Germany contemptuously included Feibusch's work in the Munich exhibition of 'degenerate art'; in 1998 the West German state awarded him its Grand Cross of Merit. Soon after, Feibusch slipped off the mantle of Anglicanism. 'I am just a very tired old Jew,' he said.

BROOKE STREET, EC1N 7RD

## ST PETER'S ITALIAN CHURCH

*Rome in London*

Enter a Clerkenwell shop as a stranger and the chances are that the bloke behind the counter chatting to a customer will click like a light-switch from Italian to born-again Cockney: 'Allo, mate, wot can I do for yer?' The cake-shaped slice of Finsbury between Rosebery Avenue and Clerkenwell Road was Little Italy, and

still is in Holy Week and on one Sunday in mid-July, the day of the *processione della Madonna del Carmine* (the procession of Our Lady of Mount Carmel).

By 1895 there were 12,000 Italians in London, most of them packed into the slums of Saffron Hill and Clerkenwell, working as clockmakers, organ grinders, ice-cream manufacturers and vendors, café and restaurant owners, shopkeepers. Off Farringdon Road in Exmouth Market is the grand Italianate edifice of the Church of the Holy Redeemer, firmly planted in the life of the narrow street. But it is an Anglo-Catholic decoy.

The real Italian church, a quarter of a mile away, is St Peter's: Chiesa Italiana di San Pietro. Here it is the heart of the community, inaugurated in 1863 and still drawing a big congregation from all over London on Easter Sunday and the Sunday of the July procession, when the police close down the streets to traffic to free them for a crowd numbered in thousands. The church entrance is through a double arch in the brick façade, looking like an attenuated arcade. Through the entrance the space opens out into a grand Baroque basilica, beautiful against the odds. It was designed by an Irish architect, John Miller Bryson, using plans based on San Crisogono, a basilica in Trastevere dating from 1123. St Peter's has large yellow and red Ionic columns carrying a big entablature beneath the clerestory and a black *baldacchino* with a gilded canopy. The church is proud of the big organ to the west (actual east), filling the space where a ceremonial entrance from Herbal Hill was being prepared before the new Clerkenwell Road linking Old Street with Theobald's Road and Oxford Street was blasted through the ghetto past the south façade in 1878. The murals are by a couple of Piedmontese journeymen, but they are fresh and bright and everywhere, on the ceiling and the chancel arch in the apse, in clerestory niches; statues of saints too, and of these the biggest cheer on the day of the procession is, naturally, for Our Lady of Mount Carmel.

136 CLERKENWELL ROAD, EC1R 5EN

## OLD SESSIONS HOUSE

*The figure of Justice*

Joseph Nollekens was noted as the finest portrait sculptor of his day, and his day was the end of the eighteenth century and first couple of decades of the nineteenth. His father and grandfather were Flemish painters but Joseph (1737–1823) was a Londoner: born in Dean Street, Soho, baptised in a Catholic chapel in Lincoln's Inn Fields, married to a Londoner, his workshop established in Vine Street, off Piccadilly, died in his home of forty years in Mortimer Street, Marylebone. At the age of 25 he travelled to Italy and stayed for eight years, making his reputation as a portraitist but also learning what he later called his antique manner.

It was this that he adopted when he was employed to decorate the façade of the new Middlesex Sessions House of 1782 by Thomas Rogers on a green that is under tarmac today and given over to parking, though the fine space and some good old buildings hint at its past as a

pre-urban village. A glance at photographs of Roman and Greek sculpture shows that Nollekens's 'antique' was a development as sophisticated as the Palladian building it decorated, filtered through the sculpture of the exuberant later Renaissance.

Above the heavily rusticated ground floor of the sessions house the five Nollekens panels (three rectangular, two oval) are evenly spaced over the windows and between Ionic columns and colonnettes attached to a double-height storey of finely dressed Portland stone. The figure of Justice is lifted out of the ordinary by his treatment of it: a lovely seated woman, beautifully draped and lucidly articulated, derived from the Roman goddess Justitia. She holds the scales in her right hand and sword in her left (instead of the usual vice versa) and fills the oval medallion containing her with studied ease. The figure of Mercy in the other oval, holding a sheathed sword and a staff with a flaming lamp on top, is marginally but clearly less successful. In the centre is a portrait of George III on a medallion surrounded by garlands of oak leaves and acorns, a conventional obeisance nicely turned; the flanking rectangles each bear, beneath a lion's head, a bundle of rods wrapped around an axe crossed with a drawn sword, symbolising power.

This grand domed edifice, now the home of a private club, served in its early years as the court of rough justice for Middlesex: drunkenness would fetch some poor wretch the sentence of being placed in stocks on the green outside the courthouse to be reviled by the public; small thefts of food or clothing, which today would be deemed to merit a probation order or a few hours' community work, might have brought years in Newgate prison, transportation to Australia or worse.

22 CLERKENWELL GREEN, EC1R 0NA

## MURAL BY JACK HASTINGS, MARX MEMORIAL LIBRARY

*The period charm of an inflammatory mural*

The chaste lines of the former charity school for Welsh children look much as they did when the school opened in 1738, though after being divided for multiple uses in the nineteenth century, it assumed its former appearance only after careful restoration by the Marx Memorial Library which took over the building as its home in 1933, an elegant façade for its history and contents. Here, in an office preserved and shown off to visitors, Lenin worked in 1902–3, editing *Iskra* (Spark), the magazine for exiled Russian socialists. In the library is the Klugmann collection of Chartist posters, polemics and ceramics; the complete run of the *Daily Worker* from its first issue in 1930 and its modern avatar, the *Morning Star*; volumes rescued from Hitler's book burning (1933, not by coincidence the year of the library's foundation); the Spanish Civil War archive of the International Brigade; and a huge collection of print union documents from the time of John Wilkes to Rupert Murdoch's Wapping démarche.

Here too, in the first-floor reading

room, is what may well have been the most inflammatory mural in Britain (if one of the least seen), though with its claws drawn now by time and Thatcherite neo-liberal economics it is seen as possessing period charm. It measures 10 foot by 20 foot and has the uncompromising title *The Worker of the Future Clearing Away the Chaos of Capitalism*. The painter was Jack Hastings (1901–90), known in passing as John Francis Clarence Westenra Plantagenet Hastings, 16th Earl of Huntingdon. He was a collateral descendant of Edward IV's brother, the Duke of Clarence, was educated at Eton and Oxford, played polo in the Varsity Match, and came away with third-class honours in history, the unshowy degree expected of an aristocrat. At some point he did the eccentric lord bit, went to the Slade to train as a painter, lived in out-of-the-way places with his wife Cristina, daughter of the Marchese Casati, and in Mexico met the muralist of the Mexican Revolution Diego Rivera and worked as his assistant. With Rivera guiding him, his incipient socialism flowered as outright communism.

There's a comic-strip element to Hastings's mural, which could never be said of Rivera's work: a square-jawed worker, Gulliver in Lilliput, his head haloed by the sun, tears down a great church bare-handed; government buildings and a triumphal arch crumble too as panic-stricken prelates, policemen, top-hatted capitalists and their bejewelled wives flee. Workers and intellectuals populate other areas of the fresco, and flanking the great wrecker are further images, only relatively smaller, of Marx and Lenin. Today the painting has the power of a style that avoids the clichés of socialist realism, and the intrinsic interest of having been accomplished in fresco – painting fast on to freshly laid plaster as it dries – a medium that defeated even Michelangelo in the Sistine Chapel until he called in help from an expert. The library is proud of *The Worker of the Future* and its guidebook insistently calls the artist Viscount Hastings. Even a Marxist, it seems, loves a lord.

37A CLERKENWELL GREEN, EC1R 0DU

## NORMAN CRYPT, PRIORY CHURCH OF ST JOHN

*A Spanish tomb effigy worthy of Westminster Abbey*

Straddling St John's Lane a little north of Smithfield market is a much restored sixteenth-century gatehouse, now a good museum to the old Priory of the Order of St John in Jerusalem, home from the twelfth-century of the Knights Hospitaller, once crusaders dealing death and ministering to the sick, now home and headquarters to St John's Ambulance, the beneficent successors of the warriors. It has not had a trouble-free history. In 1381 Wat Tyler and his insurgents attacked the priory, 'causing it to burn by the space of seven days together, not suffering any to quench it', as the sixteenth-century historian John Stow relates. During the reign of the boy king Edward VI, the Lord

This magnificently realistic alabaster carving is of a Spanish knight of the order of St John who died in a sea battle against the Turks in the 1570s. It came from Valladolid to a London dealer, and is almost certainly by King Philip II's sculptor Esteban Jordán.

Protector, Somerset, carted away the priory's stone to build the first incarnation of Somerset House on the Strand. In 1710 a mob sacked the rebuilt priory once more, protesting against the impeachment of the churchman Dr Sacheverell for having preached against the ruling Whigs. In the Second World War the Luftwaffe bombed it. But the worst of all the affronts offered was to have Clerkenwell Road driven through its heart in the nineteenth century.

One thing survived intact through all the cycles of destruction above ground: the twelfth-century crypt beneath the 1950s church north of Clerkenwell Road. Handsome itself, it contains within it the sixteenth-century alabaster effigy of a recumbent figure with the eight-pointed star of the Knights Hospitallers blazoned on his breastplate. The sculpture arrived at the priory a few days before the outbreak of the First World War, donated by the illustrious first keeper of the London Museum (now the Museum of London), Sir Guy Francis Laking. He had bought it from a Conduit Street dealer, who in turn had acquired it in Valladolid where it lay in the cathedral. It was obviously a remarkable piece of Spanish High Renaissance sculpture, but who had carved it and who it represented were unknown.

Over the years, research proved that the subject of the piece was Juan Ruiz de Vergara of Valladolid, a knight of the Order of St John who took part in the siege of Malta in 1565. In 1571 he fought in the Battle of Lepanto, when the allies of Mediterranean Europe defeated the Ottoman battle fleet. He died some time in the 1570s while commanding a ship in a skirmish with the Turks off Marseille. Further research and stylistic evidence

established the sculptor as almost certainly Esteban Jordán (*c.* 1529–98), also of Valladolid, sculptor to Philip II and an incomparably finer artist than any English sculptor of the period. The knight is shown with a pageboy mourner and a lion at his feet, both modelled to a much smaller scale. He wears plate armour, magnificently rendered, and rests his head on two finely embroidered pillows; his curly hair is cropped close and he wears a full beard. On grounds of quality, if this were an English knight, the effigy would find its place in Westminster Abbey.

ST JOHN'S SQUARE, EC1M

## THE QUALITY CHOP HOUSE

*An historic working-class survival from the nineteenth century*

In the long-ago days before John Major's government denationalised the railways, newspaper journalists based on or near Farringdon Road used to try to beat the commuter traffic jams that accompanied the frequent strikes of railwaymen by driving to work when it was still dark. While the cleaning ladies were still busy, several journos would breakfast at the Quality Chop House in Farringdon Road. It was known too as the Progressive Working Man's Caterer, and the legend 'London's Noted Cup of Tea', engraved on the window to either side of the front door, had survived ever since it opened in 1869; the good deed of an architect called Rowland Plumbe. Inside, an aisle ran directly to the back of the dining room between two rows of hard upright oak benches and tables, and walls clad with linenfold panelling beneath mirrors. The old East Londoner whose gaff it was served liver and bacon with bubble and squeak, or eggs, sausages and bacon (of course), or Smith's kippers, which he swore were the best in Britain. The midday meal too was the kind of thing a works canteen would serve, but the Working Man's Caterer's was better and there was more of it.

The old man retired many years ago. A succeeding management cleverly doubled the size of the establishment in the same style and now maintains the old spirit, it claims, while discreetly tweaking the cuisine: chicory with Roquefort, say, and quince almond tart with crème fraiche; and the noted cup of tea might instead be a pewter mug of champagne. Unsurprisingly, there seem to be rather more media food critics' bums on newly cushioned benches than working men's. And there has been one sad loss. In the old man's time the walls were lined with a series of eighteenth-century engravings, *The Cries of London* by the Academician Francis Wheatley (1747–1801). There were 13 of them, a baker's dozen as that irregular number was known in those pre-decimal days. They illustrated the street cries of costermongers from flower girls ('Two bunches a penny, primroses, two bunches a penny!') to match girls, fishmongers and cherry sellers ('Round and sound, five pence a pound!'). When the original guv'nor walked off into the sunset, the engravings disappeared. I like to think the sage of Smith's kippers knew what he'd got and took them with him.

88–94 FARRINGDON ROAD, EC1R 3EA

## FINSBURY HEALTH CENTRE

*Berthold Lubetkin, an artist of the red dawn*

Berthold Lubetkin's London Zoo penguin pool of 1934 (see page 495) is much loved for its wit and elegance; adjectives not often tacked on to Soviet art and architecture, but Lubetkin had grown up in the heady Moscow days of immediately post-Revolutionary Russia among the Constructivist generation of artist and master-builder visionaries including that other émigré to the west, Naum Gabo (see page 336), with his fellow Constructivist Tatlin and other red stars of the new era. Unlike some of his former compatriots, Lubetkin came West and decided to stay. When he had finished rehousing London's population of penguins and gorillas – for which the inhabitants seem as grateful as the visiting public – he moved on to Finsbury's project for a health centre. The commission was a mutual attraction: socialist borough to socialist architect, and Lubetkin's pleasure in his work in the Nash-created beauty of Regent's Park carried over with his idealism into the slums of Finsbury.

In a sense this was the beginning of his life, but it was also the end. The clinic opened in 1938 but opportunities closed down in the war. Afterwards he was given charge of overseeing the building of Peterlee, a new town for miners in uplands County Durham near the sea and above working pits. It should have been the greatest challenge of his professional life but bureaucracy and shortage of funds strangled ambition and Lubetkin walked away after two years, having built nothing. There were more blocks of flats at Finsbury, but they too were utilitarian and Lubetkin faded away in fact and memory until his death aged 88 in 1990.

The health centre, designed as ever with Lubetkin's pretty well synonymous firm Tecton, opened in 1938 but suffered years of neglect in the shadow of Nye Bevan's National Health Service, created ten years later, and with dwindling local government funds under Labour austerity and Conservative ideology. Even the fine thick glass-brick front of the centre began to look fusty, and anyone stepping into the entrance hall from at least the 1970s onwards confronted a drab confusion of temporary partitions, utilitarian furniture, scruffy noticeboards and institutional paint, obscuring the bright poster-like murals Gordon Cullen had created as propaganda for living a healthy life. On top of all this, modernist critics abandoned it for much the same reason as they attacked the post-war Royal Festival Hall for its adoption of decoration and non-purist curves: this reaction looks now as absurdly prescriptive as it was all along.

Meanwhile new clinics and surgeries have taken over in the centre and, although the murals may never be reconstituted, we see the beginnings of a recovery: the glass wall cleaned up between the two wings projecting forcefully on either side, interior spaces de-cluttered, fresh paintwork, internal columns painted deep blue, columns on the first-floor terrace red. The curving concrete walls and the straight ones on the first floor define offices and clinics, while balanced as elegantly as a piece of Constructivist sculpture, textured

smooth as ice cream; there is a first-floor terrace that has the sense of a wonderful seaside pavilion, although the view, far from marine, has not been enhanced by the little row of new social housing that was a job lot as a condition for building the adjoining big, unbeautiful multi-storey car park. The shrubs and trees planted outside the health centre were never the architect's intention and need cutting back. Let there be light.

PINE STREET, EC1R OLP

## • BLACKFRIARS, ST PAUL'S, SMITHFIELD, BARBICAN •

### THE BLACK FRIAR

*A gallery of grotesques*

The Black Friar is a one-off. Not only is there no pub like it, there is no other building in any category like it. Strangers hardly need to see the huge golden figures 174 of its address against a green mosaic fascia. They can't miss the place. Which is not to say that it is a great pub; that is, a pub with the air of a local. It is popular with office workers, though even when *The Times* and the *Observer* were just around the corner it was never, I think, a journalists' watering hole. But it is a place where anyone who knows a pint of real ale from a bottle of tap water should drink before the Grim Reaper calls 'Time, gentlemen, please.'

The Black Friar is a wedge-shaped property inserted on the corner of Queen Victoria Street and New Bridge Street, squeezed into a ridiculously narrow space by the railway bridge passing over Queen Victoria Street into Blackfriars Station; indeed, the grotto-like saloon bar, which was added as late as 1917, is tucked in, appropriately tunnel-vaulted, beneath the railway line. Soane did it much better in Lincoln's Inn Fields with his monk's cell beneath an alarmingly vertiginous drop from the picture gallery, but that was his home (now the Sir John Soane's Museum, page 113), not a boozer; and he was a genius. Still, the position inspired some extraordinary sculpture on the façade, on the capitals beneath the jettied upper floors: the sculptor was Henry Poole, who worked on buildings in places from Pudsey to Shanghai and whose reputation has dwindled as the buildings have been demolished. Here the reliefs of the dubiously religious life of friars crowd on to the surface like a manic recreation of an artist-cross between Michelangelo and the *Alice in Wonderland* illustrator, John Tenniel.

The Black Friar was built in 1873, a pub tucked into an office block, but took on its current appearance only in 1905, when a singular guv'nor, Alfred Pettitt, commissioned an architect called H. Fuller-Clark, an academician who became master of the Art Workers Guild the following year. Fuller-Clark brought with him a group of four artists and craftsmen who shared his Arts and Crafts antipathy to industrially produced work – Frederick Callcott, Nathaniel Hitch, and the father and son

Between Michelangelo and *Alice in Wonderland*, this astonishing crypt-like bar is in the most bizarre pub in London, the Black Friar.

SEIZE OCCASION

A GOOD THING IS SOON SNATCHED UP

INDUSTRY IS ALL

team, E. J. and A. T. Bradford (see also Walworth Health Centre, page 346) – and let them off the leash. A French genre called cardinal painting had been adapted to the taste of the lower middle classes in late Victorian England in the theme of churchmen as luxury-loving trenchermen; at the Blackfriar it was ripe for development, natural for a pub built adjacent to the site of the Dominican monastery which had given its name to the area (not to mention a railway terminus whose owners had ideas above their station, so to speak: the stone pilasters were incised with the names of dream destinations, from Antwerp, Basel and Berlin to Vienna, St Petersburg and Wiesbaden – not omitting Ashford, Bickley and Walmer. In the new-build station with the platforms splendidly spanning the Thames, these old nineteenth-century destinations have been gilded and relegated ignominiously to a public concourse).

The artists at the Black Friar pub worked in polychrome, and how: alabaster and onyx, veined marble, mother of pearl, oak and copper, a stained-glass window of a monk, bold and bright if weak in detail and, outside and in, mosaic, designed and laid on walls and ceilings by specialist firms. Hitch did the sculptures of grotesques on the exterior and the Bradfords did the capitals and keystones on the west front, showing nursery figures like Humpty Dumpty. Calcott produced the copper panels showing the friars guzzling or preparing to guzzle, fishing, wheeling a trussed pig in a wheelbarrow, singing carols. Work resumed towards the end of the First World War. Callcott died in 1922 and into his place stepped Poole, to complete the saloon bar saturnalia.

174 QUEEN VICTORIA STREET, EC4V 4EG

## APOTHECARIES' HALL

*Royal medicine*

In the sunlit courtyard of the Society of Apothecaries, on special days, the Master may be found as he greets visitors wearing his golden chain of office over a dark blue gown with gold facings and trimmed with musquash. The Learned Society of Apothecaries is only one of the City livery companies granted it his royal warrant, but it owns the oldest livery company hall in town. It is substantially the post-Great Fire building of the 1670s, and is entered through a charming Doric arch off Blackfriars Lane, beneath the countervailing gaudiness of the Apothecaries' red, blue and gold coat of arms clutched within a broken pediment.

The Apothecaries split away from the Grocers' Company but grew swiftly in esteem under the patronage of James I, who, according to the playwright John Mottley in his eighteenth-century edition of Stow's sixteenth-century *Survey of London*, named it his favourite company (it cannot have done any harm that the king was a sickly man who needed close medical attention). The royally awarded arms were, in Mottley's words:

> *Azure,* Apollo *in his Glory, holding in his Left Hand a Bow, in his Right an Arrow, bestriding* Python *the Serpent.* Supporters, *two Unicorns.* Crest, *a Rhinoceros.* Motto, *Opiferque per Orbem dicor.*

And there it is in 3D above the portico: a golden Apollo astride a serpent with beaked head, arrow tail and two webbed feet, all in a blue circular shield draped in red with the motto beneath. On a silver helm above is a blue rhino (whose powdered horn was said to contain all manner of healing properties); all flanked by two gilded unicorns. The motto, from Ovid, means, 'And throughout the world I am called the bringer of help'. The unicorns are on long loan from James's arms. His portrait hangs in the parlour.

The Apothecaries' first and finest creation was the Chelsea Physic Garden (see page 220), which still displays the escutcheon of Apollo overcoming the dragon of disease. The Apothecaries were both hawkers of medicine and curers of disease: it was only in 2008 that they gave up training and awarding doctor's qualifications. Until 1922, when the pharmaceutical trade was fully established, the Apothecaries sold medicines over the counter in Blackfriars Lane.

The Apothecaries' Hall is small but friendly-feeling. The Alice in Wonderland portal opens on to a tiny, intimate paved courtyard in the style of the older Oxbridge colleges or of great houses like Knole: here is stucco on all four sides and a fanciful early nineteenth-century lamp marking the site of a friary well. Facing the entrance, four circular windows above four deep Georgian sash windows denote the Great Hall where livery dinners are held and lectures delivered; above that are a clock and a pediment. In fact the building stands on part of the site of the former Dominican friary, the Blackfriars. Lord Cobham acquired this from Henry VIII after the Dissolution and converted the guest house into his town house. The Apothecaries bought Cobham House in 1632 and a Mr Locke, assumed to be the master carpenter Thomas Locke, produced the designs for the new building after the destruction of the Great Fire. It was completed in 1670. Traces of the medieval monastery remain in the building today, and virtually all of Locke's work survives. North and south are ranges of buildings, formerly apothecary warehouses, workshops and offices.

Visitors approach the great hall from the ground floor and climb a seventeenth-century staircase to the parlour, where the displays are not of silver and gold; instead, practically wall-to-wall in a glass-fronted cabinet, is a collection of charming English-made blue and white china apothecaries' jars, dozens of different sorts. This room opens into the Court Room, where a portrait of James I presides. A grander portrait of Elizabeth II in the smallish oak-panelled Great Hall through the door barely passes muster. The big success here is an elaborate reredos at the opposite end of the room, with before it a marble bust by the master builder and sculptor Nicholas Young of Gideon Delaune, the Huguenot asylum-seeker hardened to persecution abroad and rebuff in England, who helped to establish the Apothecaries. Not drowning, but saving.

BLACK FRIARS LANE, EC4V 6EJ

## GUILD CHURCH OF ST BENET

*A Wren church not built by Wren*

Swaggering brick-built St Benet, standing above a steep slope to the south, a major traffic artery to the north (Queen Victoria Street), a flyover and a flyunder for the Gadarene motorists escaping west, is externally the prettiest church in London. It is a small square preaching box with festoons of fruit and leaves above the round-headed windows, and stone dressings gleaming crisply white against the red and blue brick. There is a tall west tower with a circular window in the second stage and white-shuttered rectangular windows on all sides of the third stage; all this capped by an entablature bearing a lead cupola with bull's-eye windows and an open lantern with a weathervane. The hipped roof looks cosily domestic. Even the conventional device of a cornice beneath the eaves moulded with little white brackets (modillions) looks exceptionally pert and pretty in this context.

It all reads as practically a prescription for a Wren church, and to Wren it has always been assigned, but research, that enemy of myth, has thrown up architectural drawings by Robert Hooke (1635–1703), which are powerful if not conclusive evidence that he designed St Benet. Never mind. Apart from his principal claim to fame as Hooke the natural philosopher and member, like his friend Wren, of the Royal Society, he was an unsung hero of the speedy rebuilding in brick of the houses destroyed by the Great Fire of 1666, and also designed the Monument with Wren (see page 62). He had become involved because immediately after the fire he drew up a plan for rebuilding which was rejected but resulted in his being invited to become one of the project's three surveyors.

St Benet was one of the 16 City churches that escaped heavy damage from Second World War bombing, and internally, regilded and repainted, it is in excellent order as well, with its clear glass in round-headed windows, intentionally or not, in step with the Age of Enlightenment (the Commandment boards, the Creed, and the Lord's Prayer behind the altar table, decorated with angels, constitute an admonition against proceeding too far in the direction of reason), neat, early nineteenth-century organ, north and west galleries, carved with fruit, and eighteenth-century slate monuments in the floor. The old church destroyed by the fire was the burial place of the great precursor of the Wren generation, Inigo Jones, whose tomb vanished in the flames, though the inscription on it has been replicated and set into the floor to mark the position of the vault.

St Benet is the place to hear services in Welsh: since an Act of Parliament of 1879 it has been the City's Welsh church.

PAUL'S WHARF, QUEEN VICTORIA STREET, EC4V 4ER

## ZODIACAL CLOCK, BRACKEN HOUSE

*Brendan and the sun god*

Bracken House was built in the mid-1950s as a new headquarters for the *Financial Times* (which has since moved to

Southwark Bridge). It is named after Brendan Bracken, the extrovert fixer and close friend to Winston Churchill, so close that the rumour ran widely in political and press circles that he was Churchill's illegitimate son. He was all manner of insufferable things to all men: capricious, a bully, an intriguer, a liar, a huckster, a thick-skinned loudmouth and boaster; yet also a highly successful manager of a stable of financial newspapers, a benefactor, a brilliant wartime minister of information and the man who could chase away the black dog of Churchill's depressions. He was a connoisseur of architecture, up to a point; and the point was marked by the arch-conservative architect Albert Richardson, the man he hired to build the new *FT* headquarters on Cannon Street in 1955, the year Richardson succeeded to the presidency of the Royal Academy.

Richardson's *FT* is not built in his normal faux-Georgian. It is sui generis, a four-storey building of deep red-brick columns interspersed by vertical rows of windows (though the original building now bookends Michael Hopkins's splendid central glass and steel riff on the same theme). So though it is a modern building, it was never modernist, and Richardson stood up against the modernist rejection of ornament by incorporating a bronze and blue, gold and red, enamel zodiacal clock, at the centre of which appears the sun god himself, Winston Churchill.

What's not clear is whether Bracken produced the idea of Churchill personifying Apollo, or whether Richardson did. He deeply admired the old man, who, sitting beside him at an RA dinner, had growled that art had stopped in 1800. Churchill surely knew that 1800 was when Richardson's clock stopped too, and since his own lively daubs reached back no further than post-impressionism, surely he was flattering (or winding up) the architect. Bracken was very much the impresario, rarely the artist, in all he did, and deeply committed to Churchill. So although Richardson is a possible instigator, the concept of Churchill as sun god would have been wholly characteristic of Bracken in its elision of wit with sycophancy.

Speculation aside, the clock enlivens the City scene with its pagan spirit, a small gesture against the great pile of St Paul's a spit away. It is a pity we don't know the name of the craftsman who did the beautiful lettering of Bracken House and the months. The Churchill portrait head, in dark bronze radiating the rays of the golden sun, is feebly modelled by a friend of Richardson's, the sculptor Philip Bentham, but just about recognisable. The signs of the zodiac, gold on blue, are by Frank Dobson, on holiday from his usual style of earthy English modernism and slaloming joyfully in something like the freer deco style of his Hay's Wharf river front decoration (see page 353). Virgo especially cavorts with dangerous, lovely levity.

CANNON STREET, EC4M 9JA

## ST LAWRENCE JEWRY FOUNTAIN

*A Blitz survival revived*

Late in 2010 an almost 30-foot-high buffed-up yellow stone Gothic fountain

appeared at the top of Carter Lane opposite St Paul's Cathedral, several tons of rock constituting an event as surprising as the arrival on the pavement of a miraculous draft of fishes. The obscure architect John Robinson designed and erected it in 1866 in Guildhall Yard outside the church of St Lawrence Jewry, where it is shown in a contemporary print. The polished red and black granite columns, the gabled niches with Joseph Durham's sculptures of St Lawrence and Mary Magdalene, and the apt bronze relief of Moses striking the rock are present and correct. Yet the structure as re-erected opposite St Paul's is clearly a few spirelet and crocket loads short of the full exuberant Victorian pastiche and is shortened by the apparent loss of some of its midriff.

Durham was once the darling of the establishment but is remembered now only for his statue of the Prince Consort on a high plinth on the opposite side of the road from the Albert Hall. His busts of Prince Albert and the architect to the City, James Bunning, perished with a large part of the Guildhall in the Blitz of September 1941, but the fountain survived, only to fall victim to post-war plans to enlarge Guildhall Yard. Giles Gilbert Scott, Gothicist son of Gothicist antecedents, dismantled this Gothic edifice and the City corporation parked its remains in the Guildhall bombsite for 15 years and then had it stored in an Essex barn. When the City decided to embark on a wide programme of refurbishing old drinking fountains and installing new ones in the optimistic expectation that tourists would refill their plastic bottles from them, it was time to make good its promise to re-erect the St Lawrence Jewry fountain. But some stones were missing and the most cursory glance shows that bereft of its detailed ornament the fountain looks bald. Durham's small-scale blandly naturalistic sculptures are the best thing about it, but cleaned up and reassembled in its abbreviated state, it happily perks up an uninspired passage of cityscape to the south of St Paul's.

CARTER LANE GARDENS, EC4

## SCULPTURE BY GEORG EHRLICH, FESTIVAL GARDENS

*Ehrlich's dream of young love*

We remember the Festival of Britain as an event that united the nation, but that is not how it seemed in 1951. In retrospect, Michael Frayn divided the population into herbivores and carnivores: the herbivores were the mass of the population who flocked to the South Bank; the carnivores were those, led by Winston Churchill and his shadow cabinet, who hated it and who, with the show over and the Tories voted back into power, could hardly wait to tear it down: the Skylon, the Dome of Discovery, almost all of it but for the Royal Festival Hall. On the Cannon Street side of St Paul's Cathedral, though, is the City of London's contribution to the celebrations of 1951, its own Festival Gardens. The architect chosen to create it was Sir Albert Richardson, PRA, KCVO, not a man known for his popular touch, but who for that reason created a classic-

ally graceful garden with a fountain and formal stone pavements, steps, low walls and parapets, built to last, a noble armature for temporal plants to cling to. Sculpture came later, in 1956, when the City committee responsible for gardens heard of Georg Ehrlich's bronze *The Young Lovers*, visited his studio, thought of their own younger days, and voted the cash to buy it.

Ehrlich was Viennese and had fought for Austria in the First World War but, as a Jew, even non-practising, he knew on the morning after *Kristallnacht* in 1938 that his number was up and fled to England with his wife, the children's illustrator Bettina Ehrlich. He was naturalised ten years later. English critics never particularly took to him, possibly finding his sculpture a touch anaemic, but just as likely finding it chimed with neither the pastoral glow of wartime and post-war English art nor vanguard modernism. The melancholy of his English sculpture has often been ascribed to his experience of two wars, but in fact he reached back for his main influences to the expressionism of the late nineteenth and early twentieth centuries, particularly to the exotic debauchery of the Viennese Klimt and Schiele, which he took and shaped through the refracting mirror of his own temperament. He treats his melting forms more warmly than Auguste Rodin does in that other favourite London piece, the well-muscled giants in *The Kiss*, but in comparison, say, with the eroticism of the naked couple in a small aquatint by Edward Munch, also called *The Kiss*, *The Young Lovers* lacks fire. Perhaps literally, because while Munch's couple have fallen into a clinch alone in a room, Ehrlich's lovers look as though their dream of young love has fallen victim to a wet English day. And on a wet English day they make a fine garden sculpture.

CANNON STREET, EC4

## STATUE OF JOHN DONNE, ST PAUL'S CATHEDRAL

*Death be not proud*

John Donne, lawyer, poet, dean of St Paul's Cathedral, preached his last sermon on 25 February 1631. He already knew he was dying, and this sermon was printed under the title *Death's Duell*. He spent the few weeks before his death on 31 March preparing himself. Among the practical items he sorted out was the matter of his own memorial in the cathedral. He had previously commissioned Nicholas Stone, the finest English sculptor of the period, to memorialise his wife, Anne Donne, when she died of puerperal fever in 1617, and now he needed a monument to himself. The monument to Anne disappeared in the rebuilding of St Clement Danes in 1680–2 though the epitaph remains: 'Her husband John Donne made speechless by grief, sets up this stone to speak…' In his own case, St Paul's Cathedral burned in 1666 but Stone still speaks in his likeness of Donne which survives, now in the south aisle of Wren's enormous crypt.

We can be sure of the likeness because it is the same face as in the portrait of 1516 by the miniaturist Isaac Oliver (in the Royal Collection), but older, the pointed

beard less kempt, eyes closed, not open and alert as in the miniature, lips still curved in a slight smile but the face in repose. The fashionable ruff around his neck in the miniature becomes in the effigy a coronet where the material of the shroud in which Donne posed for the artist has been gathered and tied at the top of his head. Stone worked from a drawing he made of Donne in this session, and the sculpture was ready the following year. It stands in a black niche upon a funerary urn, an extraordinary image both of death foretold and death fulfilled, an essential part of the duel with death.

So the purely decorative bust of Donne which a lay canon of St Paul's and the sculptor, Nigel Boonham, unveiled in 2012 in the garden south-east of the cathedral is otiose. If it serves any purpose it is purely as advertisement. It's in the style of Epstein's bronze portraiture, but Epstein's portrait elsewhere in the cathedral crypt of Stafford Cripps, a post-war Labour chancellor of the exchequer, could have shown how to do it. Until now, Donne was well served by portrait painters (Shakespeare should have been so lucky). Apart from Oliver and the several engravers who made portraits after Stone's sculpture, or his studies for it (which seem no longer to exist), there is the unusually expressive portrait for its date (1594–5) by an anonymous artist showing the bony, beardless Donne as a young man yearning in love. Donne bequeathed the painting to the 1st Marquess of Lothian, describing it in his will as 'that picture of myne wh[ic]h is taken in the shaddowes'. (The current marquess has sold it to the National Portrait Gallery.) At this point only destiny was on Donne's mind:

*I run to death, and death meets me as*
  *fast,*
*And all my pleasures are like yesterday.*

ST PAUL'S CHURCHYARD, EC4M 8AD

## TEMPLE BAR

*Entrances and exits*

Temple Bar, the elaborate stone arch at the point where Fleet Street meets the Strand, once marked the spot where the king's authority ended and he needed the permission of the Lord Mayor of London to enter the City. Or so the polite charade went, though, of course, the king's need to keep the City onside was never a fiction. Never mind the monarch, in 1878, whether or not the original design was Christopher Wren's, Temple Bar was deemed to be a traffic hazard and was taken down stone by stone. The brewer Sir Henry Meux bought the stones and re-erected the arch as the entrance to his estate of Theobald's Park, Hertfordshire. There it quietly mouldered away, like Sir Henry himself and even 'Meux's Celebrated Ales'.

The modern Temple Bar replaced a sixteenth-century arch in 1672 (and an earlier one is known to have been there in the fourteenth century). In 1984 a City organisation called the Temple Bar Trust acquired it from the Meux family, spruced

Temple Bar, the gate deemed a traffic obstruction in Fleet Street in 1878 and taken away, but now back in the City, beautifully refurbished. Erected in 1672, it is said without proof to be by Christopher Wren; the sculptures are by John Bushnell.

it up and placed it on the pavement to the north-west of St Paul's Cathedral at the entrance to (the pallidly redeveloped) Paternoster Square. It is a grand structure of one large arch flanked by two narrow pedestrian gates (though, of course, all three are now for walkers). Above the main arch is a second pedimented storey with central windows on the north and south façades flanked by niches to each side with statues by John Bushnell, also refurbished, of James I, his queen, Anne of Denmark, Charles I, and Charles II. Bushnell (d. 1701) was a celebrated sculptor, Italian trained, who, the connoisseur William Vertue reported, thought 'that this nation was not worthy of him, nor his works'. Nevertheless, the City paid him for his work, and the statues look good restored to their niches. Perhaps one day Fleet Street will become a pedestrian way and Temple Bar will be restored to its rightful place. Meanwhile, this is just fine.
PATERNOSTER SQUARE, EC4M 7DX

### POSTMAN'S PARK

*G. F. Watts's memorial to the people's heroes*

While most of the 23 City churches bombed during the war were skilfully restored, some were preserved as picturesque ruins at the centre of small gardens, to act as a gentle and civilising influence on the financial centre at work. The ruin of St Dunstan's-in-the-East on St Dunstan's Hill is an integral part of a sweet garden with a fountain; but on Newgate Street and King Edward Street the sites of two former religious foundations and the churchyard of the still-functioning St Botolph without

Aldersgate form a whole series of oases in one of the busiest parts of the City. Wren's ingenious tower for Christ Church, one of the former churches, remains; rose pergolas mark where the aisle arcades stood and the nave's pavement is neatly edged by dwarf box hedges.

This is on the corner of Newgate Street and King Edward Street, named for the boy king Edward VI, and thought to be an improvement on some of its previous names, like Blow Bladder Street and Stinking Lane. A few yards down the street is St Botolph without Aldersgate in a former churchyard, known as Postman's Park for its popularity with the men who worked in St Martin's Le Grand in certainly the grandest of all post offices, now sold off to other businesses. St Botolph itself is a delight. The current building is basically of 1789–91 by a City district surveyor, Nathaniel Wright, a dry occupation for a man who demonstrated such poetry as the glorious coffered and coved ceilings in west and east apses. The west has a big organ; the east a window in nineteenth-century Renaissance-style darkly painted glass depicting *The Agony in the Garden*, framed within an arch and carved crimson curtains held back by old gold ropes with tassels.

The sight to see in Postman's Park is the loggia planned by George Frederic Watts (1817–1904) with the full-hearted intention of paying tribute to the unknown everyday heroes: men, women and children who gave their lives trying to save others. Watts himself with his second wife Mary (1849–1938) designed the folksy little inscribed ceramic tiles, one tile per hero, until his death; but they

continue still. Here's one example of the Watts years, more egregiously sentimental than most – 'Soloman Galaman/aged 11/died of injuries/Sept 6 1901 after saving his little brother from being run over in Commercial Street/"Mother I saved him but I could not save myself"' – that unfortunately but irresistibly calls to mind Oscar Wilde's witticism about *The Old Curiosity Shop*: 'One must have a heart of stone to read the death of Little Nell without laughing.'

LITTLE BRITAIN, EC1A

## BUST OF CHARLES LAMB, GILTSPUR STREET

*The reputation dogging Charles Lamb*

Charles Lamb and Samuel Taylor Coleridge were friends from schooldays until they died, both of them in 1834. But when Coleridge described him in verse as 'my gentle-hearted child', Lamb had had enough. 'Gentle' and 'loved' pursued him throughout his life. In a letter to Coleridge he protested that gentle almost always meant poor-spirited; '... substitute drunken dog, ragged-head, seld-shaven, odd-ey'd, stuttering, or any other epithet which truly and properly belongs to the Gentleman in question', he begged. Even today Lamb is pursued by the encomium set in bronze below the memorial to him with portrait bust by William Reynolds-Stephens which proclaims: 'Perhaps the most loved name in English literature, who was a Bluecoats boy here for 7 years.'

'Here' was Christ's Hospital, the blue-

Tributes to everyday heroes at Postmans Park.

coat school in Newgate Street where Lamb and Coleridge were charity boys because their parents had fallen on hard times. Reynolds-Stephens carried out the commission in 1935 and the memorial was unveiled on the west wall of Christ Church (see page 34), which acted as the Christ's Hospital chapel before the school, long ago, moved to Horsham. After the Second World War, when Christ Church was bombed, the memorial was moved to Giltspur Street, on to the façade of a building copied from the bombed watch house of St Sepulchre (a watch house, that is, from which keepers could watch for grave robbers). How much more sympathetic a setting Christ Church would be once more, now that it has become a garden.

Reynolds-Stephens (1862–1943) was prolific and versatile in the Arts and Crafts movement. His chief monument is the exuberant interior he designed for the church at Great Warley, Essex, but he was also a brilliant sculptor who joined Alfred Gilbert (*Eros* in Piccadilly Circus) and George Frampton (*Peter Pan* in Kensington Gardens) in trying to raise late nineteenth-century English sculpture from the dead. In 1935 Reynolds-Stephens was an old man and his creative fires had died down; all the same, his Lamb is a warmly sensitive portrait from the top of the head to the second waistcoat button, where it ends. In such a small compass it shows a slight smile on a deeply intelligent face, and a faintly bohemian ease in the softly waved hair and disposition of the cravat. Above the bust is embossed the one word, Elia. This was not just Lamb's *nom de plume* for the essays he wrote in the *Spectator*, but also on occasion his alter

ego. Composing, as Charles Lamb, a short memoir in 1818 of the Christ's Hospital he had known from 1782 to 1789, he wrote of the 'numberless comforts and even magnificences that surround the bluecoat boy'; but Elia, a couple of years later, condemned this eulogy by 'Mr Lamb' and spoke instead and in detail of the 'execrable tyranny' of the institution. Perhaps in the interim Coleridge, who remembered the school as not much better than the notorious Newgate prison nearby, had jogged his old friend's memory.

10 GILTSPUR STREET, EC1A 9DE

## THE GOLDEN BOY OF PYE CORNER

*A memory of the Great Fire*

The golden boy high above the street at Pye Corner marks the spot where the Great Fire of London expired on 5 September 1666, just short of Smithfield market. It had started on 2 September and burned everything in its path: 13,200 houses including the houses and shops on London Bridge, 87 parish churches, St Paul's Cathedral, the Royal Exchange and 44 Company Halls. It had made 70,000 out of a City population of 80,000 homeless. Since the fire had started at a baker's shop in Pudding Lane 202 foot east of Wren's Monument (which is 202 foot high) and ended at Pye Corner at the junction of Giltspur Street and Cock Lane, it was held that some idiot divine had concluded the fire was holy retribution for the sin of gluttony, and a credulous population swallowed the notion. Beneath the boy is a plaque beautifully carved with the legend, 'This Boy is in Memmory Put up for the late Fire of London Occasion'd by the Sin of Gluttony 1666'.

In support of the theory, the boy, naked as he was born, is usually said to be fat, thus displaying the shortcoming especially manifested by art critics of not actually looking at the work in question. He is no fatter than the average tubby babe and has similar characteristics to the bronze tourist favourite *Manneken Pis*, of the same century in Brussels, though the boy of Pye Corner is broader in execution and lacking the *manneken*'s levity. He was carved from oak and gilded. He may have been made originally as a trade sign – to a clothes shop, for instance, as the lad hugs himself against the cold. At any rate, according to a newer plaque at ground level (which cautiously substitutes 'ascribed to the sin of gluttony' for 'Occasion'd by...'), the figurine adorned the wall of a pub called the Fortunes of War, which was demolished in 1910.

CORNER OF GILTSPUR STREET AND COCK LANE, EC1A

## MURALS BY HOGARTH, ST BARTHOLOMEW'S HOSPITAL

*The man who would be Michelangelo*

William Hogarth left his heart in St Bartholomew's when he moved to Leicester Fields (Leicester Square) and later bought a country house at Chiswick,

William Hogarth steps out of character and out of genre in his murals (actually on canvas), decorating the staircase. This one illustrates the biblical story of the good Samaritan.

which he loved unto death (see page 260). He had been born in Bartholomew' Close in 1697 and was baptised in St Bartholomew the Great beside the great meat market and execution place of Smithfield. He grew up with the stinking filth, sounds and sights of St Bartholomew's Fair, which shaped the social vision and art that made him famous. There was one thing missing from his life: his kind of populist art was not the sort that would win him riches and status. It nagged at him that the aristocracy hired second-rate foreigners to decorate their houses with murals. So when the news arrived – probably at the coffee house popular among artists, Slaughter's in St Martin's Lane – that the governors of St Bartholomew's Hospital in Hogarth's heartland were in discussion with the Venetian mercenary, Jacopo Amigoni, about a scheme of mural decorations, he jumped in and offered to forgo a fee for the privilege of painting murals on the grand staircase leading up to the Great Hall newly built to James Gibbs's designs, also gratis.

At the top of his form Hogarth's father-in-law, James Thornhill, had outdone all the country-house foreigners, like Verrio and Pellegrini and Ricci, with his magnificent scheme of murals and ceiling decoration at Greenwich, and Thornhill had the edge over other English pretenders too because he was well born; maybe at the back of Hogarth's mind was the thought that he, the young pretender from the rough northern extremity of London, could outdo his father-in-law's achievement. He painted two huge works in oils on canvas in 1735–7 on religious themes relevant to the hospital: *The Pool*

of *Bethesda* (where Christ cured a stricken man who was unable to climb into the curative waters of the pool) and *The Good Samaritan,* in which, of course, a rich man did not pass by a beaten-up wreck of a man on the other side of the road and thus earned eternal glory.

The governors were happy with the paintings and they received a good press, but no commissions followed for Hogarth. In fact, he was uncomfortable with 'history painting', and sweated so much over the compositions that he farmed out the landscape backgrounds to the chief scene painter at Covent Garden, George Lambert. The figures which work in *Bethesda* are the halt and the lame gathered behind Jesus: the sort of human flotsam of the streets and stews of London Hogarth had drawn and painted all his career. The central stricken figures are both heroic nudes, and the man who fell among thieves and was left half dead, in Christ's Parable of the Good Samaritan told in Luke's Gospel (10: 25–37 v 30), is recognisably inspired, in Hogarth's brave failure, by the Adam in Michelangelo's Sistine ceiling. It was not the work Hogarth was born to do, but visit it for Gibbs's magnificent setting.

WEST SMITHFIELD, EC1A 7BE

# THE PRIORY CHURCH OF ST BARTHOLOMEW THE GREAT

*A rare Norman chapel*

On a pilgrimage to Rome in about 1120 the Augustinian monk Rahere fell ill with malarial fever picked up at a holy but insanitary fountain. He took an oath that if he lived he would build a hospital for the poor. He recovered, and in 1123 Henry I granted him land in Smithfield. Rahere dedicated the hospital to St Bartholomew and went on to build the Priory of St Bartholomew hard by. Along with the grandly elemental and slightly earlier Romanesque chapel of St John in the Tower of London and the slightly later Temple Church (see pages 446 and 5), it is the finest church of its age in the capital, though battered and more or less eccentrically restored in the early twentieth century by Aston Webb (he of the Mall-facing front of Buckingham Palace). The nave was almost wholly lost in the Reformation but the east end was left as a parish church. It stands to the east of Smithfield, with the great meat market to the north, pubs and shops opposite, and Bart's Hospital and the fifteenth-century Church of St Bartholomew the Less to the south. The Luftwaffe bombed the warren of alleys that hugs St Bartholomew the Great, but the maze would still be recognisable to William Hogarth as the place where he played marbles in the church precincts.

The entry from Smithfield is through a gatehouse beneath a sixteenth-century half-timbered house, where Rahere's original west front stood. So nine bays of the ten-bay nave went from this point across what is now simply the churchyard and path. All nine bays were destroyed in 1543. What one Henry gave, another took away. Reform and simple

The Norman interior of St Bartholomew the Great: the oriel window (top right) looks down upon the tomb of the Augustinian monk Rahere, who founded the priory church (below left, just within the chancel rail).

neglect laid ruination all about, including, to the south, the cloister and the totally destroyed chapter house to the south. At the end of the path is a very odd porch (Webb) and the undistinguished brick tower of 1628 offset and aligned on the south aisle of the church.

Inside the church, the view is superb. Despite restoration in the late nineteenth and early twentieth centuries, choir and ambulatory with part of the remaining section of the cloisters are still basically Rahere's. The choir is four bays with massive piers curving into an apse, beyond which is the Lady chapel behind fine iron railings by Webb. Above the choir the arcade has arches delicately subdivided into four smaller arches with slender columns, and above that is the clerestory, also with an ambulatory. Moving towards the high altar and looking west shows that the one remaining bay of the nave houses the organ, nineteenth-century, not beautiful but strongly sympathetic to its setting.

Rahere died in 1144, and his remains were translated to this tomb on the northern side of the sanctuary (between choir and apse) in 1405. It is a classic of the period and stands opposite a sixteenth-century classic, Prior Bolton's window, a lovely oriel for a famous churchman oddly inserted into the arcade

from which the prior might observe the monks at prayer. Rahere's effigy on a tomb chest shows him in the black habit of the Augustinian canons, his head on a tasselled cushion. A crowned angel kneels at his feet holding a shield bearing the arms of the priory: two lions, gilded, on a scarlet background with two ducal coronets. There are two tiny monks at each foot reading from Bibles. It's all contained in a tabernacle with a vaulted ceiling within an elaborate arched and crocketed canopy with quatrefoil windows cut into the rear wall overlooking the ambulatory, a fine and private place across the square from the bustle of Smithfield meat market.

WEST SMITHFIELD, EC1A 9DS

## MURALS BY DOROTHY ANNAN, BARBICAN

*Earth and electricity*

Goldman Sachs spent a fortune restoring the glossy black glass exterior and exotic art deco lobby of the former *Daily Express* headquarters and a small fortune refurbishing the old *Daily Telegraph* façade. That's the extra cost that goes with acquiring listed buildings. Possibly the kindest thing ever said about the unlisted Fleet Building is that unlike later telephone exchanges it was not built of pre-cast concrete. Tough luck then on Goldman's that following its acquisition, English Heritage listed, not the building, but the nine big ceramic murals of 1960 by Dorothy Annan sunk into nine bays of the Farringdon Street façade just above pavement level. Goldman's fought

to avert the listing by hiring an authority on these matters to pronounce that Annan's murals were boring and attached to a boring building, that they lacked historical interest, and that there were 'many examples of public murals by artists who are more widely known and renowned than Dorothy Annan'. Goldman Sachs lost the case and the mosaics now repose in some style in a corridor walkway in the Barbican, quite close to the art gallery.

English Heritage was surely right in dismissing this expert opinion. Fame, especially in a turbulent period in art, is not the best indicator. Imagination, ingenuity and technical brilliance are. She took as her subject the leading edge of telecommunications technology and composed her panels with imagery suggested by details of the hardware and by diagrams of circuitry in the ether and beneath the earth and ocean. She was a painter of charming but 'unimportant' Post-Impressionist scenes, and a potter. In 1939 she was 31 and a prominent member of the left-wing AIA (Artists International Association) when Picasso's *Guernica* made its fleeting appearance in London and Manchester, and would surely have striven to see its rich texture of pigment brushed and dribbled, practically invisible in reproduction. It is this influence or something similar rather than immersion in the warm pool of English art that stands out in her murals now.

Dorothy Annan, a little-known artist and potter, produced these murals for the Farringdon Street walls of a telephone exchange. The building was knocked down but the murals were listed and reinstalled in a warm dry walkway in the Barbican.

She contracted Hathernware of Leamington to make the biscuitware tiles and went there to draw into the wet clay. (It was a town she knew, possibly well, and where she had painted a townscape of the Parade in 1944, inalienably English yet as delicate as a Raoul Dufy picture of the Mediterranean.) Back in her own studio she built the glaze up into low relief, dragged it across the rough surface of the biscuit, allowed viscous dribbles of glaze to ooze across the earthy palette of blacks, browns, blues, greys and greens, blurred the edges of her blocks of colour into misty skyscapes, and jolted the compositions into life with the high tensile strength of her linear overlay suggestive of aerials, keyboards and pylons. Then she fired the tiles, forty to a panel, in her own studio kiln.

These lovely murals belong to the 1960s but their pictorial strengths mean they will not date, and they survive Harold Wilson's febrile boast about the 'white heat of technology' that helped to win him the 1964 election. I hope Goldman Sachs look upon them now that they have been reinstalled as a bonus.

HIGHWALK BETWEEN SPEED HOUSE AND THE BARBICAN CENTRE, EC2Y

# Roman London

The glorious bronze statue of the Emperor Trajan on Tower Hill is bogus. The London wall is getting on for 2,000 years old; the statue has been here since 1980. It was a bequest from the Rev. P. B. (Tubby) Clayton, founder of Toc H and vicar of All Hallows by the Tower from 1922 to 1962 (see page 68), who found it in a junk yard in Southampton and on his death asked the Tower Hill Improvement Trust to place it here in Wakefield Gardens before the most publicly visibly stretch of the wall remaining. The Trajan bears the imprimatur of the twentieth-century Chiurazzi family foundry, which has a branch in Naples where the marble original of this sculpture resides in the Museo Nazionale.

Why a homage to Trajan? After all, he personally never played away in this chilly shard of the Roman Empire. He left that to his successor, Hadrian. Trajan (AD 53–117) himself concentrated mostly on pushing the bounds of empire in eastern Europe and the Middle East (the Dacian Wars celebrated on Trajan's Column in Rome), though from distant places he did lay down an expansionist policy for his British territory. So the Rev. Tubby's Trajan statue perhaps represents the general Roman presence in a city which has been put to fire and sword many times, from the sacking by Boudicca in AD 60 to the Second World War bombing, has been virtually submerged beneath glass, steel and concrete, but has never mislaid its original town plan, a square mile within a wall punctuated by round bastion towers and six gates (from east to west, Aldgate, Bishopsgate, Cripplegate, Aldersgate, Newgate and Ludgate: Moorgate is a sixteenth-century interloper), whose ruin runs alongside and beneath the modern city, a palimpsest and a full-scale 3D model in one.

The accessible stretches of wall run from Tower Hill to the garden beside the Museum of London. The Tower Hill stretch by the Trajan statue has courses of tiles between rows of ragstone, signifying Roman construction. It climbs to a height of 20 foot and the medieval reinforcement takes it to 35. Down an alley and into a courtyard beside the Grange City Hotel in Vine Street there is another high stretch of the wall, yet more interesting visually because it includes the base of a fourth-century bastion and a row of medieval archers' loopholes, the dressed facing stone stripped away to expose the rough rubble core structure: like a growling captive bear against the surroundings of glossy glass and terrazzo paving. There are more wall fragments in buildings between Tower Hill and the Museum of London. St Alphege's garden near London Wall leads through to a good stretch by St Giles Cripplegate (the church where Milton is buried), which avoided destruction because it was annexed as part of the church wall. Still in the garden by the Museum of London is a well-preserved Roman bastion off Queen Victoria Street, best viewed from a height in the museum.

Bomb damage around Queen Victoria Street revealed a temple to the sun god Mithras (that might usefully be rededicated). It was moved during bouts of post-war rebuilding and at the time of writing is being moved back to its original position north of the street; in the basement of the Guildhall Art Gallery are the ruins of the entrance to an amphitheatre; and remnants have been

discovered on the northern bank of the Thames of a wooden bridge a little downriver from modern London Bridge, with warehouses, staithes, wharves, public baths, another temple and a palace.

Roman corruption and contempt for the natives, besetting sins of empire, triggered Boudicca's revolt, which also levelled Camulodunum and Verulamium (Colchester and St Albans), but, admittedly in the realm of speculation, the great battle following the sack of London was at Battlebridge (Battlebridge canal basin, a little north of King's Cross Station), and Boudicca lies buried unquiet somewhere beneath the tracks from which Edinburgh trains arrive and depart around a hundred times a day.

Put into the shade by all this, not to say the ersatz emperor, is another reproduction set into the Tower Hill stretch of wall, this time of the original fragmented gravestone, now in the British Museum, of a true honorary Cockney, the procurator fiscal Julius Alpinus Classicianus, who restored peace and brought prosperity to London after the suppression of Boudicca.

One of the taller surviving stretches of the Roman wall, off Cooper's Row.

# • WALBROOK, CORNHILL, BISHOPSGATE, OLD STREET •

## PRUDENTIAL ASSURANCE BUILDING

*The Gothic way of commemorating sacrifice*

The roll call of the dead embossed in bronze on the First World War memorial at Prudential Assurance's old headquarters in Holborn runs into hundreds of names, columns of them lined up together like crosses in a military cemetery. One of them, Pte Christopher Elphick from Dulwich, a member of 2nd Battalion Honourable Artillery Company and a clerk at the Pru, was killed near Arras on 15 May 1917, within weeks of enlisting. His body was, in the church's phrase, known to God; one of 1,800 unrecovered after the battle. Then, in 2012, the mortal remains of several men were discovered buried in a field in the hamlet of Bullecourt; one of them, identified by a signet ring, was Christopher Elphick. In 2013 to the sounding of the Last Post in the presence of Elphick's two grandsons, their families, Prudential staff, Prince Michael and relatives of the other men, he and his comrades were reburied in the Ecoust-St-Mein cemetery.

As a tale, this has neither the drama nor the Hollywood ending of *Saving Private Ryan*, but it illustrates the story behind one more name among the hundreds displayed in a courtyard in the Pru with enduring poignancy.

In recent years the Prudential judged its headquarters out of date and departed, apart from leaving behind a rump office. But it still owns the building and still holds its Poppy Day ceremony at the base of the war memorial every year. The Swiss-born sculptor F. V. (Ferdinand) Blundstone (1882–1951) built the memorial in pink marble with spectacular art nouveau bronze female attendant figures – with their gowns slipping from their shoulders they could hardly be called mourners – and two female angels, also half-naked, supporting the fallen body of a soldier. Nothing could be further from the realism of Charles Sargent Jagger's memorial figures at Hyde Park Corner and Paddington Station (see pages 210 and 247). Blundstone must have seen these, or maybe he reacted to the antagonism of some Pru staff towards the memorial's sexuality; anyway, when he came to add a Second World War memorial its symbolism was reticent, even sombre.

The courtyard where the memorials stand is named after Alfred Waterhouse, the architect who designed the Pru's headquarters in 1879 and chose the fiercely red brick from which it is built. It's very like one of his Gothic town halls, though none was quite as big or quite as red as this. When Prudential decided to move out, it had already made a mistake worse than Blundstone's beautiful but egregiously misjudged war memorial: it had ripped out the interiors of conference rooms to make them more modern, leaving a legacy of bare halls littered with institutional tubular chairs, but fortunately also the opulently carved wooden interiors of the boardroom and library for comparison. A door in the boardroom leads to a tiny space where a woman

secretary could sit unseen and take a note of meetings: hardly a triumph for feminism, but then the Prudential was the first major company in Britain to employ female clerks.

5 LAURENCE POUNTNEY HILL, EC4R 0HH

## ST MARY ALDERMARY

*Wren's gothic metamorphosis*

St Mary Aldermary sits at the southern end of Bow Lane, a busy, believably medieval passageway of shops and pubs jostling together (although it was flattened in the war) that crosses Watling Street, another historic highway as narrow now as it was 2,000 years ago. The church, off the true line of west-east maybe because of medieval property rights, had its veil of modesty torn aside and its south and east walls exposed to the passing traffic by the building of Queen Victoria Street. Umbilically linked at the north of Bow Lane, no more than a couple of hundred yards away, is St Mary-le-Bow with the greatest of all Wren steeples, incorporating the noblest of his towers and the most famous peal of bells in Cockney heaven. Unluckily the post-war rebuilding of the gutted church is obtrusively clumsy, but beneath is a fine Romanesque crypt dating from the Conquest.

St Mary Aldermary, on the contrary, suffered very little from bombing and raises prettiness to the level of rapture. Actually, there is no documentary proof that this was Wren's church; in fact, he expressed disobliging views about Gothic architecture in general. But St Mary Aldermary certainly comes from his office, and as a good deal of sixteenth-century Perpendicular Gothic remained in the walls after the Great Fire, Perpendicular presented itself as the pragmatic choice for the new design, whose quality also strongly suggests Wren himself. At any rate, it is the only surviving 'Wren' Gothic revival church and it anticipates Horace Walpole's Strawberry Hill Gothic (see page 302) by, roughly speaking, seventy years (Wren 1679–82; Walpole 1749–76). Up with the times, Walpole disapproved of Wren, yet both St Mary Aldermary and Strawberry Hill show the artist's pleasure in playing about with medieval prototypes and turning them into something wholly different; something that – had they visited the two buildings – would have made Pugin and Ruskin, those tormented Gothicists of a later day, feel nothing but contempt for their supposed frivolity. The feature that instantly strikes any visitor to St Mary Aldermary is the shallow flying-saucer domes, the focus of an infinitely delicate system of fan vaulting in plaster, six domes running the length of the nave ceiling with a smaller one in the chancel, the shorter aisle ceilings with five each.

It did lose all its (Victorian) stained glass to a nearby bomb, but Lawrence Lee (1909–2011) made new glass in the early 1950s for the south aisle window, with a kneeling figure of Wren, and the big east window Crucifixion, where the figure of Christ is unexciting but the design is taut and lucid. The panel at the bottom commemorating the defence of the City in the war has a sweet Cityscape – St Paul's, the Monument, St Mary

Aldermary itself with its four commanding pinnacles, softly rolling clouds overhead – as pristine as in a medieval book of hours, the colour pastorally fresh, nicely fitting the mood of Wren's lyric treatment of the plaster ceiling. There is nothing here of Milton's 'storied Windows richly dight [coloured], / Casting a Dim religious light.'
WATLING STREET, EC4M 9BW

## ST STEPHEN WALBROOK

*Henry Moore meets Sir Christopher Wren*

Wren's finest church of all, including St Paul's, hides (the apt word) behind the Mansion House and hugger-mugger office buildings by the old Walbrook stream, now underground but beside which the Romans of the first Londinium built at least one villa terrace from which to take the air and watch kingfishers hunting over the waters. St Stephen Walbrook (built 1672–80) has an unassuming exterior, though its tower (post-Wren) has an attractive dome, cupola and lantern of which some viewpoints give glimpses. It is Wren's interior that is so spectacular – a mathematician's solution to the problem of worshipping God in a curious and confined space. That may sound forbidding, but the result is simply astonishing in its complex clarity.

The floor space is rectangular west to east with a notional nave, chancel and north and south transepts: notional because the separate spaces of the church are defined, not by walls, but by groups of Corinthian columns. These carry a continuous entablature that follows the shape of a cross, so in effect the church's interior plan is drawn in the air, an idea of immensely subtle yet lucid ingenuity. The entablature itself carries a series of round arches, and resting on those is a coffered dome of Roman grandeur. In other words, this big dome rests ultimately on the slender Corinthian columns. You don't have to understand the engineering (I don't) to recognise that this is abstract art in a high stage of evolution.

So where does that leave Henry Moore's famous altar? The then rector, Chad Varah, had founded the Samaritans in 1953, operating a hotline from the vestry under the tower to offer aid and comfort to potential suicides. By the 1970s he and the congregation wanted a church to reflect a ministry that took into account the City's secular activities – in short, a people's church. The property developer, art collector and former chairman of the Arts Council, Peter Palumbo, who had already put huge amounts of money into restoring the church, commissioned Henry Moore (1893–1986) to fashion an altar to stand centrally under the dome and fit in with the new liturgy, which drew the congregation around the priest. Every Tom, Dick and Harriet attacked it, at first on the grounds that it looked, allegedly, like a large Camembert, then because it was liturgically unsound. Finally, an ecclesiastical court ruled in favour of the altar. Moore carved it from a block of rough-textured travertine marble eight foot across and many tons in weight. It is a noble piece, informally accenting the circle of the dome above, but there's no question

St Mary Aldermary escaped the worst of the Blitz: Wren's ceiling raises prettiness to the level of rapture.

that it runs counter to Wren's obvious aim of stressing the basic rectangle in which the people enter through a carved wooden screen at the west and look towards a reredos at the east, behind an altar and a priest. The reredos is now isolated, and instead the altar and the circular benches around it, devised by Varah, are the focus beneath the sublime dome.

39 WALBROOK, EC4N 8BN

## MANSION HOUSE

*From Mayor's home to palace of high capital*

The Mansion House is nothing short of a palace built upon the ruins of St Mary Woolchurch Haw, a church burned down in the Great Fire, with a transitional phase as the stocks market (there's a blue plaque). Wren declined to choose it as one of the churches for rebuilding and so in a sense sealed the deal which transformed the square mile of merchants and crafts guildsmen into a centre of world finance, once upon a time *the* centre. Lord Mayors of this uniquely governed and powerful community had always worked at home and thrown civic banquets there or at Guildhall, but post-Fire the idea was floated of building a mayoral mansion, though it was 1737 before the corporation settled on an architect and a site.

It would be at the City centre, facing the Bank of England at the convergence of Poultry, Prince's Street, Threadneedle Street, Cornhill, Lombard Street and King William Street. George Dance the Elder (1695–1768) was the chosen architect, but almost as important to the impression of Mayoral magnificence was the donation (as late as 1987) of the Harold Samuel art collection: 84 Old Master Dutch paintings encapsulating English elitist taste of the late seventeenth and early eighteenth centuries.

The grand exterior has a giant six-column portico raised on a rusticated base. The clamorous Corinthian scheme is carried through to the interior, touched up with 23-carat gold, in rooms like the spectacular double-height Egyptian banqueting hall (not authentic Egyptian but Dance's idea of Vitruvius's idea of how the Romans built in Egypt). Dance's cortile thrust up high and roofless into the sky behind the exterior pediment, but this was England, wet and windy, so when the old man was off the scene his son, George Dance the Younger, reduced the height by half and roofed it in as a saloon, shimmering with chandeliers. The more intimate state rooms continue the opulent theme of creamily carved plaster, and windows are swathed in rich red taffeta curtains or hung with crimson silk tabaret lined with gold silk (this in a room painted eau de Nil to set off the grand suite of 24 chairs upholstered in scarlet and gold by John Phillips in 1803 and decorated with naval motifs to recall Nelson's victory in the Battle of the Nile).

The mythical and triumphal sculptures everywhere do nothing to harm the decor, but the Dutch paintings are the thing. There are small-scale, lovely landscapes by Salomon Ruysdael and his greater nephew Jacob Ruisdael (sic), who was to influence Gainsborough, Constable, and the French pre-Impressionists, the Barbizon Group. The

master of seascapes, Jan van Goyen, is here, and a small panorama, infinite in effect, by Aelbert Cuyp with shepherds, sheep and a distant town bathed in the soft yellowish evening light of which only he had the secret (a masterpiece casually hung on a staircase, as people do); also the shadowed, contemplative *A Young Woman Sewing* by a Rembrandt pupil, Nicholaes Maes, and *The Merry Lute Player* – terrible title – by the incomparable Frans Hals.

WALBROOK, EC4N 8BH

## ST MARY WOOLNOTH

*The Hawksmoor church with an Underground station*

The palimpsest of City of London streets, temples, churches, brothels, inns, counting houses, and burials reaches its most fantastic at the triangular site where Lombard Street and Cornhill converge and Nicholas Hawksmoor built St Mary Woolnoth with a crypt beneath for the dead. Here architecture, archaeology, engineering and subterranean transport converge. The view from Mansion House is of a pile of massively rusticated masonry containing the west porch and bearing above it a phantasmagoric structure of entablature, Corinthian colonnade and two balustraded turrets, a malproportioned edifice uncertainly performing as steeple or palace or triumphal arch.

St Mary Woolnoth had been only partly rebuilt after the Great Fire and Hawksmoor's new building (1716–27) sneaked in under the Fifty Churches Act of Queen Anne's Tory administration; opium for the masses. The new churches were supposed to be in outlying areas but the case for yet another City church was accepted. In the late nineteenth century the City and South London (C&SL) Railway (now the Northern Line) sought permission to demolish St Mary Woolnoth and build an Underground station instead. After protests, the railway received permission simply to get rid of the cadavers and convert the crypt into the booking hall, with an entrance from Lombard Street, unused now that Bank station concourse is beneath the meeting of the streets (London has never been good at creating a circus, and this accident in particular doesn't even have a name). As it happens, lifts still operate well beneath the church.

Since 1991, an underground pedestrian passage has run between Bank and Monument stations along the length of King William Street and links the Northern, Central, Waterloo and City, District and Circle lines, and the Docklands Light Railway; during excavations for this feat, the workforce discovered one of the famous tunnelling shields invented by I. K. Brunel for digging the London tunnel under the Thames (which now takes a tube-train line) and perfected by James Greathead for excavating the C&SL line. It forms part of the passageway as a monument to the enterprise.

The interior of St Mary Woolnoth is a masterpiece of a different order. Here behind the bizarre façade is a controlled display of grandeur. Tall, doubled-up Corinthian columns define a square and carry a strongly articulated entablature, which in turn supports four huge semi-circular windows beneath a

double-bordered plaster ceiling, white as snow, by Chrysostom Wilkins (one of the master craftsmen among others like his fellow plasterer Henry Doogood to the great metalworker Jean Tijou and the carver Grinling Gibbons), with concave scoops at the corner of the inner border allowing for lilting palm-like decorations and a chandelier suspended from a great floriated gold boss. The wonderfully pompous pulpit below has a sounding board which echoes the shape of the ceiling, and the woodwork (Thomas Darby, John Meard, Gervase Smith) takes in a baldachin (Meard with the carver Gabriel Appleby) with barley-sugar columns, and an organ case of 1681. Two centuries later William Butterfield laid polychrome tiles in the chancel, took down the galleries and reused the fronts as wall decoration: mild stuff given his record.

KING WILLIAM STREET, EC3V 9AN

## SCULPTURE BY AIMÉ-JULES DALOU, ROYAL EXCHANGE

*A proletarian madonna in Royal Court*

The bronze sculpture *Charity* adorning a drinking fountain in the shady little square behind the Royal Exchange bears the embossed signature Dalou, and the year 1879. It is the only public work in England by one of the finest sculptors of the century because this was the year the French state declared an amnesty on all communards, and Aimé-Jules Dalou was free to return to his friendly rivalry with Rodin in Paris, which he did in 1880. Once home, Dalou (1838–1902) took up the commission for the dazzling *Triumph of the Republic*, a figure ensemble celebrating glory which, in the way of these things, was commissioned to efface the recent memory of inglorious defeat in the war against Prussia and set up in the Place de la Nation, the heart of a working-class area of the city.

Everywhere in the world except in the newer dictatorships this sort of bravura triumphalism is out of favour, and despite the brio of the *Triumph*, the piece that survives better is the Royal Exchange *Charity*, a woman sitting on a rock, suckling a child held to her breast with her left arm while she leans to her right to embrace a small naked boy; a group quite close to familiar Renaissance studies of the Madonna and child with St John, except that no Renaissance sculpture of a Madonna is ever shown as a proletarian. Dalou shows his Madonna's sleeves rolled up to reveal muscular forearms, and her blouse, open at the throat, is a basic working garment. Pragmatically, she has tied her hair into a knot behind her head.

The commission would have appealed to Dalou after the private commissions he had been working on. It was triggered in 1878 when the Metropolitan Drinking Fountain and Cattle Trough Association of glorious memory proposed to erect a new drinking fountain, but the plans were so unappealing that a couple of aldermen moved in, provided most of the finance, and bought the figure group

Aimé-Jules Dalou became used to tackling massive sculptural commissions like *The Triumph of the Republic* in the Place de la Nation in Paris, but in 1879, after ten influential years in England as a Communard refugee, he produced this earthy mother and child for a drinking fountain in a small City space.

Dalou had been carving for his own reasons. It was in marble, but within a very few years of the unveiling, the marble began to break up and was replaced with this bronze cast on a granite base. This quiet study is a very great piece. Incidentally, there is an appealing terracotta version of 1873 in the V&A, but the City *Charity* gains from the shadows and dappled light falling on the bronze. Nearly 40 years later Renoir produced a bronze *Mother and Child*. No one remarks on the resemblance, yet it is very close.

Back in Paris Dalou, a supporter of the Jewish army officer Alfred Dreyfus, infamously accused of treachery, was moved to model another woman sitting on a rock, her arms folded across her knees, her face buried in her arms. It is called *Truth Denied* and exists in the Petit Palais as a small plaster model; but it looks monumental, as though cut from a square block of stone. The relationship with Rodin was now one of pure rivalry, but whatever might be thought about the merits of the two sculptors Dalou was closest to sensing the future of art with this near-prototype for Brancusi's square block of stone with a wavy line incised down the middle and a title, *The Kiss*.
ROYAL EXCHANGE AVENUE, EC3V

## BANK OF ENGLAND MUSEUM

*The Bank of England's stock of memories*

James Gillray, a satirist of parts, published a 1797 cartoon called *Political Ravishment* or *The Old Lady of Threadneedle Street in Danger*. It shows the prime minister, William Pitt the Younger, forcing himself on the old lady who screams rape as he thrusts one hand into her purse of gold coins and with the other seizes a handful of her dress of banknotes. Neither the old hag, as Gillray portrays her, nor the prime minister attracts sympathy (so not much change there today), though the cartoon appeared as poverty deepened through the first three decades of the nineteenth century, brought an increase in forged banknotes, and the Bank directors became popularly known as 'grand purveyors to the gibbet' by relentlessly pursuing the death penalty for counterfeiters.

The Gillray cartoon is among a batch of eighteenth-century lampoons in the Bank of England Museum and, incidentally, was probably the first use of the soubriquet 'the Old Lady of Threadneedle Street'. By this time she was around 103 years old, having been founded in 1694. 'What remedy is there if we have too little money?' Samuel Pepys's friend, the ever-inventive Sir William Petty, had asked rhetorically, late in the seventeenth century. 'We must erect a bank.' Had there been such a thing already Pepys himself would never have needed to bury his gold in his garden or carry some of it in a money belt that was more money than belt: there were goldsmiths who acted as bankers but Pepys could not trust them not to die on him.

The new Bank of England was founded as banker to the government, managing its debts and funding its wars, a status recognised when the Labour government nationalised it in 1946. Long before this date the Bank had also become banker to the banks. Tucked away in St

Bartholomew's Lane is the only public entrance, and that leads not into the bank proper, but into the museum opened in 1988. The first stop is the stock office reconstructed from John Soane's drawings. It is a small recompense for the fate of Soane's bank, built slowly between 1788 and 1833, and demolished by Sir Herbert Baker in short order between the two world wars to make way for his own grandiose replacement: the difference between talented professionalism and imaginative genius, Nikolaus Pevsner wrote.

A sense of Soane's building survives in the massive windowless stretches of rusticated perimeter wall but only this one stock office, rebuilt where it stood originally, remains to show his 'imaginative genius', with a typical Soanian flattened dome, light filtering in from the sides and discreet arches beneath leading out of the hall to either side. The tour continues through displays of banknotes, gold bars, and silver plate, into Herbert Baker's rotunda, with a neat tribute in an alcove to the Bank's Secretary and dreamer of *The Wind in the Willows*, Kenneth Grahame, and where ten rescued Coade stone caryatids stand in a circle in the hall, one last Soane legacy.

BARTHOLOMEW LANE, EC2R 8AH

## ST MARGARET LOTHBURY

*Wren, measuring space against profusion*

Even some of the loveliest post-Fire 'Wren' churches are from the commissioner's office, not Wren himself (though his was the overarching plan). But the mild and beautiful St Margaret Lothbury looks all-Wren and pretty well is. It survived the Second World War effectively unscathed. It bears all the signs of a masterpiece but is flanked by business premises along the line of the narrow lane where it stands, its tower like a guardsman on parade, one pace forward, and the narrowest passageways east and west separating the church from the buildings to either side. Its smooth stone facing throws into relief the three crisply carved arched windows beneath a balustrade (a fourth, circular, window marks the vestry). The fine south door at the base of the tower has Corinthian capitals flanking a very pretty and profusely carved lintel, and supporting a pediment so sharply carved that the Worshipful Company of Cutlers could sharpen its knives upon it. On the tower's second stage, a clock and a round-headed window beneath a nifty floral swag; the third stage allusively blank, arguing less is more; the fourth, a dominating shuttered bell opening; at the top a lead-covered spire fitting the tower as sweetly as a cork in a wine bottle.

The cunning that made St Stephen Walbrook (see page 47) shows in one detail particularly of the design of St Margaret Lothbury. For the three external tall arched windows are seen from within to light the south aisle, but at a level above these three big windows, unexpectedly, are three small circular windows that throw light into the nave. Where have they appeared from? Like all the best sleights of hand it's elegantly simple: outside, the circular nave lights are recessed and hidden behind the balustrade.

City companies have replaced the

nave windows destroyed in the war with neat but effective armorial stained glass. One of them is from the Worshipful Company of Glovers (motto, True Hearts and Warm Hands), another from the Worshipful Company of Armourers and Brasiers (Put on the Whole Armour of God); a third, the Tinmakers, is unusually firm and noble for the genre. Large iconic (in the original sense of the word) late seventeenth-/early eighteenth-century paintings of Moses and Aaron flank a very proper reredos. Standing before that, and fitting across the width of the church as though it were bespoke, is the better one of only two remaining chancel screens in Wren churches; it came from All Hallows the Great, Upper Thames Street, demolished in 1895. A carved royal coat of arms (Charles II) is displayed above its entrance, embraced by a broken pediment; below the pediment an eagle, apparently hung out to dry. Intertwining pairs of very slender balusters link the low screen to either side of the entrance with the crossbeams at the top. The pulpit has a greatly ornate sounding board (also from All Hallows the Great). Spare a minute's silence for the unknown craftsman who wrought the lyrical and summery engraved memorial plaque for 'Mr Thomas Cooper, Died 31 Aug 1771 In the 59th Year of his Age.'

LOTHBURY, EC2R 7HH

## DRAPERS' HALL

*Roman splendour in place of Tudor discord*

Within the main entrance of Drapers' Hall is a dull copy of Holbein's famous portrait of Thomas Cromwell, Henry VIII's hit man. It hangs here because Cromwell's house once stood on this site and the residue lingers. After decades of keeping the lid on his bitterness, John Stow published a denunciation of Cromwell in his history of 1598, *A Survey of London*. Stow described Cromwell as: 'master of the king's jewel house, after that Master of the Rolls, then Lord Cromwell, knight, lord privy seal, vicar-general, Earl of Essex, High Chamberlain of England, &c.' In short, untouchable. With this leverage Cromwell obtained the land of the dissolved abbey of Austin Friars on the edge of Stow's father's house and, with neither permission nor compensation, ordered his men to dig the house up, place it on rollers, and shift it 22 foot backwards to release land for an extension to Cromwell's new garden.

I report this result of my bedtime reading to Penny Fussell, archivist to the Drapers. 'Ah, but we have the deeds,' she says, 'and they tell a different story from Stow's.' No doubt; anyway, Cromwell fell from grace and Henry VIII summarily disposed of him in the usual way in 1540. The Drapers' Company acquired the land in 1543 and built its hall following the lineaments of the mansion Cromwell had created for himself, including the open courtyard behind the entrance. Tudor justice had been roughly served.

The Drapers' official story begins in 1364, when Edward III bestowed its first royal charter incorporating it as a livery company, though the building now is grandiloquently Victorian with, interspersed between the brown marble

pillars with gilded Corinthian capitals in the great livery hall, the full-length portraits of nine and a half monarchs (William III but not Mary, Anne, Georges I to IV, William IV, Edward VIII all artfully arranged as a foil for Queen Victoria at the focal point of the apse-like end of the hall). Georges V and VI are in a corridor and Elizabeth II, by Sergei Pavlenko, a Soviet-period artist trained in Leningrad, in full-on Romanoff majesty, hangs over the fireplace in the court dining room. HM is 'said' to like it. The pillars support a great Roman arcade with blazoning arms and enormous urns decorated with sunbursts on the balustrade. Above all this Herbert Draper (the name a coincidence) painted the ceiling in 1903 with at the centre a scene from Shakespeare's *The Tempest*, featuring Prospero, Puck, and several naked ladies not readily recalled from the play. The court room's glory is two Gobelins tapestries on the legend of the Golden Fleece – two more from the same set are in the court dining room – but a full-length portrait by William Beechey (1753–1805) of Horatio Nelson is closer to the heart of the company, which commissioned it to mark the election of the admiral to the freedom of the Drapers' after his victory in the Battle of the Nile in 1797. There are other versions, possibly also by Beechey himself, but it is odds on that the Drapers got in first and their Nelson, given its quality as well as its unchallenged authenticity, is about as good as it gets among the portraits.

Apart from the courtyard there is one more relic of Cromwell's time: his garden has been mostly voraciously swallowed by big business but the pretty fragment by Throgmorton Avenue is what remains of the cause of John Stow's anguish and anger.

THROGMORTON AVENUE, EC2N 2DQ

## ST BOTOLPH WITHOUT BISHOPSGATE

### *A church marked by war*

Someone with a website devoted to St Botolph (because he lives in a house converted from a church dedicated to the saint) has counted 84 churches in England dedicated to the saint. Some of these are redundant, like his own desirable family des. res. with well-kept graveyard, some destroyed, but most are going concerns. Details of Botolph's life are scarce, and though he is hardly the only obscure saint in what can scarcely be called history, few of the others have been so popular (think merely of those dim Cornish saints, Ia and Kea, or Just, Meriasek, Morwenna, Padarn, Brioc and Blaise), but who else with so few available facts about his life and, doubtless, good works, is as popular as Botolph?

An excavation in 1977 established his principal fame as abbot of a monastery at Iken, a small village on the Suffolk coast. His *Oxford Dictionary of Biography* entry runs to a mere three paragraphs, setting out the insubstantial facts and factlets, and even speculating that there may have been two of him, so various are the sites with Botolph relics. Anyway, it is clear that his (or their) hold on the medieval imagination was powerful. In the square mile alone we have three churches

dedicated to St Botolph: Aldersgate, Aldgate and Bishopsgate, all just outside or on the verge of the City (maybe because he was patron saint of travellers). There was a fourth, the fisherman's church St Botolph Billingsgate, destroyed in the Great Fire and never rebuilt.

St Botolph Bishopsgate was a Saxon foundation rebuilt early in the sixteenth century. It escaped the Great Fire but became ruinous and was demolished and rebuilt in 1725–8 by George Dance, his father Giles Dance, and his father-in-law James Gould. It's a small miracle that so much of the design survives nineteenth-century alterations, the Blitz, and not one but two bombings by the IRA; the first of which demolished St Mary Axe in 1992. It retains the tower and its Venetian window over the altar in the east, its galleries, the barrel-vaulted ceiling and glass dome carried on giant Corinthian columns. Willy-nilly, war has become the theme of this church. It has two memorials to the local regiment, the Honourable Artillery Company. One especially attractive memorial recalls the men of the HAC who died in the Boer War, an elegiac golden plaque with a border of oak leaves and acorns in the style of William Morris, with the company's enamelled coat of arms composed in scarlet, blue, grey and gold. Other memorials are for the HAC's near neighbour in Bunhill Fields, the London Rifle Brigade, which also fought in South Africa and the two world wars. The latest memorial is a window by the glass painter Nicola Kantorowicz presented by the Worshipful Company of Bowyers to mark the post-IRA bombings restoration, thus the mildly anachronistic reference to the glorious medieval victories of Crécy, Poitiers, and Agincourt.

BISHOPSGATE, EC2M 3TL

## SCULPTURE BY RICHARD SERRA, BROADGATE CIRCLE

*Che sera, Serra*

Stopping strangers in their tracks as they step out of Liverpool Street station is *Fulcrum* by the American minimalist sculptor Richard Serra (b. 1939). Never was the word minimal so abused. *Fulcrum* is a freestanding monster of rusted Cor-Ten steel 55 foot high. Its five slabs tower from a sunken plaza called Broadgate Circle at the nexus of Liverpool Street and Eldon Street. Honeycomb-fronted office buildings about it emphasise its impermeability and the red splash of a telephone box throws into relief its massive dignity. Paradoxically, the form is of large sheets folded back at the edges like paper aeroplanes half made, the folds wider at the top than at the bottom; but the effect is not of potential flight but of harsh immovability. *Fulcrum* has been here since 1987 and looks as though it could be here still when the waters rise to close over London. *Che sera*, Serra.

It is nothing like the biggest piece Serra has made. His installation in the Bilbao Guggenheim is another horizontal work. *Tilted Arc*, all 120 foot of it, made 'stopping people in their tracks'

This installation sculpture of Cor-Ten steel is, at 55 foot high, one of Richard Serra's smaller pieces, facing up to the challenge of the surrounding buildings.

more than a figure of speech. Commuters used to the direct route from bus or subway to office fought through the courts to have it removed, backed by the usual claque of philistines, and Serra, backed by the usual solemn oafs in the art business, fought for the immutable right of the artist to have his site-specific art left in immovable majesty. The commuters and philistines won, surely rightly this once, and Serra's piece was dismantled and put into storage. Outside the law courts the voice of criticism is stilled. He is, indisputably it seems, one of the great artists of the twentieth and twenty-first centuries, achieving equipoise with *Fulcrum* just as that other masterpiece, Jacques Lipchitz's *Bellerophon Taming Pegasus*, inside the Broadgate Centre, achieves its own miraculous equipoise, but by a wholly different route; Serra ploughs his furrow as unwaveringly as the abstract expressionists of last mid-century, but unlike them he does not run out of steam.

*Fulcrum* holds not just itself but the buildings around it in the balance of a spinning vista of the railway station, the Swiss Re building, Tower 42 (once the NatWest Tower), and the financial, mercantile and commercial architecture of Bishopsgate and Finsbury Circus. It is Serra's force of mind over matter, not only the matter of vast slabs of steel to be mastered, but of the challenge of all those massive neighbouring buildings; and the simplicity of this object, no function, no useful purpose, simply unarguable building, wins. If the language suggests a fight, maybe that is the way it looks.

BROADGATE CIRCLE, EC2M

## SCULPTURE BY JACQUES LIPCHITZ, BROADGATE CIRCLE

*Violence in startling equipoise*

Intensely imaginative and sculpturally inventive, *Bellerophon Taming Pegasus*, by one of the grand old men of twentieth-century art, Jacques Lipchitz (1891–1973), is surely the finest monumental sculpture in London by an artist formed with the Cubist generation, and it stands in Broadgate, the City's Xanadu where few venture except on business. The sculpture is about 12 foot high, a barely controlled explosion of violence, with the two wrestling figures symbolising man's struggle with unbridled nature. Pegasus is all flying hooves and tail with a wing raised like a huge open hand about to smash down his adversary, the wooer of Zeus's daughter, setting out to perform the impossible task the god has set him as the price of winning her hand. Bellerophon, a barrel of stocky strength, feet solidly planted on earth, has a rope around the neck of Pegasus. The winged animal bares its teeth and rolls its eyes like the horse in Guernica. The resemblance to Picasso is unsurprising; in a less obvious way than Picasso and Braque or Matisse and Picasso, because Lipchitz was never a painter, Lipchitz and Picasso shadowed each other intermittently through the century.

Lipchitz was Lithuanian and came to Paris at the age of 18. He returned home briefly to sort out a passport problem, and the interlocking forms of the pre-Christian art of Near Eastern nomads he then saw in the Hermitage planted a seed that germinated when he discovered the

Cubist collages of Picasso and Braque in 1913–14. Lipchitz's early work in sculpture was influenced by Cubism's cohesively organised pictorial space, and after the First World War his work in turn fed back into Picasso's and Braque's. As Picasso moved on to other ways of painting, Lipchitz too developed a curvilinear approach, which came to full fruition when the United States offered him shelter after the Nazis invaded France.

The Broadgate Lipchitz is a version of an even bigger piece commissioned in 1964 for the University of Columbia law school, but though Lipchitz had burst the bounds of Cubism the essential dynamic is still Cubist, the ferociously battling figures controlled by taut spatial control. Other sculptors in the sixties were bringing sculpture democratically down to earth from its plinth, but Lipchitz places this lurid struggle on a slender column and holds it there in startling equipoise.
BROADGATE CIRCLE, EC2M

## SCULPTURE BY FERNANDO BOTERO, BROADGATE

*The five-ton fat lady of Broadgate*

Liverpool Street was always the prettiest of the London railway stations, when its interior could be seen through the smoke and stygian gloom. Today the station is better than ever before. In 1995–2001, under the guidance of Nick Derbyshire, the now defunct Network Rail architecture and design department refurbished the great iron and glass naves and installed a new paved concourse, which sweeps broadside across the platforms and has brought clarity and easy access to the underground in place of labyrinthine confusion. The ironwork pillars and arches shine in blue and red livery, and Derbyshire returned the iron acanthus leaves that had, for obscure reasons, been stripped off to the capitals between pillars and arches.

All this happened as part of the Broadgate development, and absolutely the best thing to come out of it is at the unknown northern end off Primrose Street. A raft floated across the railway tracks bears the whole of Exchange Square with its massive office towers, lunchtime City workers with their packets of sandwiches lazing on the great steps to the north of the square, and a five-ton fat bronze female nude of awesome aspect by the Colombian sculptor Fernando Botero lying as though she has just fallen there above a wide cascade. With a shiny new office block by the ubiquitous American architects of skyscrapers, Skidmore, Owings & Merrill, it would all be more Chicago than City of London except that at the southern edge of the platform, past the naked lady and cascade, is an old railway carriage converted to dispense food and drink, and beyond that is a magical view towards what railwaymen charmingly call the country end of the station, with a pretty decorative wooden valance at the end of the train shed as would be seen in any rural station, and beneath, the tracks emerging from between the platforms – a wave of the wand to rescue a great square from a hint of megalomania.
LIVERPOOL STREET, EC2M 7QH

## BUNHILL FIELDS

*The burial place of the dissenting great: Daniel Defoe, William Blake and John Bunyan*

The unconsecrated ground of Bunhill Fields sandwiched between City Road and Bunhill Row became the graveyard of choice from the late seventeenth century for dissenters seeking an eternal resting place, but banned from hallowed Church of England land in the shorter term for their refusal to toe the Anglican line. Eternity, though, can be a flexible concept in these matters: in the sixteenth century St Paul's Cathedral had already found it a useful site for a mass grave for the disposal of old bones from its overcrowded charnel house. But after 1685 it became a designated graveyard, and John Bunyan, who died in 1688, became the first great man to be buried there, beneath a tomb chest with a well-worn effigy and a relief sculpture of Christian from *Pilgrim's Progress* on one side. Daniel Defoe (died 1731) lies here too, honoured by an obelisk raised in the nineteenth century. In due course a couple of descendants of Oliver Cromwell followed. Here, too, are Susanna Wesley, mother of John Wesley (he is buried over the road behind his chapel, see page 61), and that great businesswoman Eleanor Coade (1733–1821), manufacturer of Coade stone, a composite of ceramic and ground stone which lasts, it seems, for ever. Her factory lay where County Hall now stands, and the great lion at the nearest end of Westminster Bridge balustrade is of Coade stone.

William Blake became the one undisputed genius of the deathly ensemble in 1827 when he squeezed in beneath a plain

headstone in memory of him and his wife Catherine who outlasted him by four years. Admirers frequently place roses before the headstone, possibly in honour of his lines, 'O Rose thou art sick. / The invisible worm,/ That flies in the night/ In the howling storm:/ Has found out thy bed/ Of crimson joy:/ And his dark secret love/ Does thy life destroy.' Blake's great dissenter hero Milton had his last home in Bunhill Row, where it and everything else was Blitzed in the last war, and wrote *Paradise Regained* there; but he is buried beside his father in St Giles Cripplegate.

By 1853, 123,000 or so other cadavers were crowded into this green space of about ten acres, most of them having in life been persecuted in one way or another by governments to whom they must have appeared as part of a Cromwellian fifth column. Along with so many London cemeteries, Bunhill Fields became overcrowded and a noxious threat to health, so the authorities closed it. Today the government has declared it a grade 1 park, with many of its tombstones given the separate listings of grade 2 or grade 2*. The main path between City Road and Bunhill Road is flanked by great London planes, there are oaks and limes among the graves, and a great lime too in Quaker Gardens at Quaker Court behind Bunhill Street, where the Friends had their own graveyard around the grave of their founder, George Fox (1624-91). The north-eastern corner of Bunhill Fields has been cleared as a place for City workers to relax

Bunhill Fields, burial place of Dissenters. William Blake lies here and Milton lived in Bunhill Row (in the background), but is buried in St Giles Cripplegate.

and picnic in the lunch hour; not a mark of disrespect, but a healthy acceptance of life in the midst of death.

CITY ROAD, EC1

## WESLEY'S CHAPEL AND HOUSE

*The home and chapel where the reluctant reformer settled*

Outside the Wesley Chapel in City Road stands a bronze statue of Wesley himself, apparently preaching to the passing world. It is an apt image for the man who built Methodism from his pulpit in the open air. He travelled the country on horseback and is said to have preached three times a day and delivered more than 40,000 sermons. He came to see open-air preaching as an absolute necessity. John Adams-Acton (1830-1910) made this statue and also carved the wall monument in Westminster Abbey with a double portrait in relief of John and Charles Wesley, underneath which is a scene of Wesley preaching, sure enough, in the open air. Nathaniel Hone's sparkling contemporary portrait of Wesley in the National Portrait Gallery shows him thus as well; and the most appealing thing in the Museum of Methodism adjoining the Wesley Chapel is the large canvas of Wesley preaching in Ireland, standing on a sawn-off trunk under a tree.

And yet despite Wesley's disagreements with Anglicanism, he could never contemplate breaking from the Church of England, and the chapel remained his rock. His first base was a short distance away, off Moorgate. The lease

was running out so he called in obligations from Wesleyans he and Charles had helped all over the country and built the new chapel in 1778. Not all authorities accept that this big plain five-bay building, utilitarian inside, is by George Dance the Younger, though the portico does have the sawn-off Greekish look suggestive of Dance (and his pupil John Soane). The opening service was held in the same year and Wesley moved into his house on City Road next to the chapel in 1779. Today his followers call the chapel the mother church of Methodism. The tall narrow brick house of four floors became a museum separate from the Museum of Methodism in 1898, more than a hundred years after Wesley's death. Most of the furniture is simply of the period but one room on the first floor has Wesley's own possessions: the bookcase with his books, the library chair, a longcase clock, a bureau. He died in 1791 and is buried behind the chapel. Charles hedged his bets and for his own grave insisted on consecrated ground in Marylebone. Like John himself, tub-thumping Charles was uneasy about breaking away from the Church of England. Like John, he saw the Methodist approach as getting rid of the trumpery and returning closer to early Christianity, but he maintained his belief in the sacraments. Today it is no particular surprise that the two churches are considering a rapprochement, 'for the sake of the mission'.

As for the appealing canvas in the Museum of Methodism, it is by Maria Spilsbury (1776–1820), now for no good reason almost forgotten. Her father was a Moravian and both parents became friends of the Wesleys. They moved to Ireland in 1791, just after John Wesley's death. Maria was 14, so the painting of Wesley preaching in Ireland must have been from memory, with plenty of extant portraits of the great man for reference. It renders what she did best: a crowd scene with a sense of intimacy and informality, of real life, movement, and colour and light in pastoral surroundings; the sort of setting where, one suspects, Wesley was happiest.

49 CITY ROAD, EC1Y 1AU

## • BILLINGSGATE, FENCHURCH STREET, ALDGATE •

### MONUMENT

*King Charles II succouring the City*

When Dr Johnson was asked in 1749 how he felt about the failure of his tragedy *Irene*, he said, 'Like the Monument.' There are single-column monuments around the world, from Trajan's column in Rome of 113 AD, the prototype, to the Melville Monument in Edinburgh, the spectacularly hubristic Siegessäule in Berlin and a clutch of Nelson's Monuments, in London, on Calton Hill in Edinburgh, in Dublin (blown up, the locals like to kid visitors, by carousing students in 1966), in Hereford and Great Yarmouth. In Canada there's one in Montreal, and British Columbia saved itself the trouble by annexing a mountain to the cause. But were Sam Johnson

alive today, he would still refer to Wren's work singularly as 'the Monument'. It is the only column in the world that needs no qualification.

The Fire of London destroyed well over 13,200 houses, 52 livery company halls, St Paul's and 87 parish churches. There was plenty of work in the years following for architects, builders, and sculptors, among whom Wren and his collaborator Robert Hooke took the lead. Between them they designed the Monument which stands in Fish Street Hill close to the point where the Fire started at Thomas Farynor's bakery in Pudding Lane. The Monument is merely a fluted Doric column with a gilded fire in an urn as its crown, but that 'merely' is a modest mouthful for a work more beautiful than the Emperor Trajan's victory memorial, if not as awesome.

The plinth is inscribed on three sides with improving Latin texts; the fourth carries a huge bas-relief by the sculptor Caius Gabriel Cibber. Cibber was born in Denmark, came to London after a visit to Rome, and was made a freeman in 1668 – although at the age of 44 in 1674 he was still working as an assistant in the workshop of John Stone (not to be confused with the great Nicholas Stone). But in that year Stone died and Cibber won the commission to decorate the Fish Street Hill façade of the Monument and, in the fashion of the time, carved a Baroque allegorical scene showing Charles II in the garb of a Roman warrior succouring the tastefully underdressed female figure of the City, urging the figures of Architecture and Science to the rescue. Another woman waves a lighted brand, dangerously in the circumstances it might be thought, but it is merely an unconvincing pictorial device for linking the earthbound figures to the bountiful envoys of Architecture and Science in the clouds. On the right, the new City rises behind scaffolding even as the stones burn in the old City on the left; this is not one of Cibber's fancies, for on the morning of 2 September when the fire was at its height Samuel Pepys took a boat at the Tower and was rowed upriver under London Bridge where, he observed, 'everything, after so long a drought, [was] proving combustible, even the very stones of the churches'.

The later commission for the two figures of lunacy, as the condition was cheerfully known then, on the gateposts of Bedlam hospital in Bishopsgate (now Bethlem Hospital: see page 403) constitute Cibber's most powerful masterpiece. The Monument's unease with the complications of scale and perspective doesn't show him at his best, but it launches Wren's 202-foot monument into space with some élan.

FISH STREET HILL, EC3

## ST MAGNUS THE MARTYR

*Wren's repertory theatre at its height*

In the eighteenth century the City decided to widen the walkway to the east of London Bridge. Wren's post-Fire rebuild of St Magnus the Martyr was already pressed up hard against the bridge, so the workmen lopped two bays off the west end of the nine-bay length, built arches through the tower and drove the walkway through

the arches. A close shave, but St Magnus is used to close shaves: two in the seventeenth century, one in the eighteenth, and one plus a bombing in the twentieth. Its post-war heritage has landed it with unfriendly neighbours, bigger and bulkier, hemming it in east, west, and south, with dual carriageway traffic in Lower Thames Street pouring by day and night. But St Magnus has a better trick than any of them: its great spire sublimely commands the view from the Monument and all the way down Fish Street Hill.

The church stands on the site of the Roman approach to their, possibly, wooden London Bridge and the triumphal arch set up on the north bank, though the flowing stone drapery adorning the torso in the little churchyard looks more medieval than Roman, and the great carved stones are relics of the medieval bridge of 1209. This lasted until John Rennie's new bridge of 1831, in turn succeeded by the latest model.

Enough of mundane practicalities. This is the church to which T. S. Eliot glancingly refers in *The Wasteland* for its 'inexplicable splendour of Ionian white and gold'. The phrase resonates down the years, tying the passing show of rectors into sticking with the architectural and decorative scheme, on the alternative threat of the eternal stigma of philistinism. So it is that the piers of the church remain Ionian, the scrolling capitals gold, the columns white. Though the interior has been altered in the years since 1684, St Magnus still bears the signature of Wren and of the craftsmen with whom he moved around the city like a repertory theatre workshop. Here the star was William Grey who, with a craftsman called Massey about whom nothing else is known, was responsible for the pulpit and sounding board beautifully poised on a slender stem; also the magnificent reredos, which the twentieth-century Baroque revivalist Martin Travers combined with the original altarpiece so that gold on red Commandment boards are punctuated by two fine, plain paintings of Moses and Aaron (by Anon). Spectacular eighteenth-century Baroque golden angels perch to either side of the reredos, and a golden pelican, symbol of Christian sacrifice, spreads its wings at the centre of the ensemble beneath a circular painted glory with a dove signifying the presence of God.
LOWER THAMES STREET, EC3R 6DN

## OLD BILLINGSGATE FISH MARKET

*A fine and ancient riverside site in search of a new identity*

The oppressed-looking classicism of Old Billingsgate fish market looks wonderful since Richard Rogers pulled it together with glass screen doors all along the arches of the façade and created a potential City Utopia within. But it is soulless. The conversion was a long shot anyway, from market in 1985 to commercial property: whatever that is, it never took. Today it's promoted as an events space, so from time to time it springs to spurious nite life. The market had to move, of course (to the Isle of Dogs). It was already congested when William III put his name to a parliamentary act in 1698 naming market forces as destructive to a fair economy and

observing in the preamble that Billingsgate had 'time out of mind been a Free Market for all manner of Floating and Salt Fish as alsoe for all manner of Lobsters and Shell Fish'.

The problem was not just price fixing but that horses and carts crowded into Lower Thames Street, a highway much narrower than today's. When William Hogarth and four boozing friends took a boat after midnight of 26 May 1732 from Billingsgate to Gravesend and then on to the Isle of Sheppey, the market looked like a prototype for a Second World War bomb site, open from street to river. The merry friends published a journal of their adventure, *The Five Days' Peregrination*, for which Hogarth produced illustrations; Samuel Scott, 'England's Canaletto', then more highly rated than Hogarth, added riverscapes; and Ebenezer Forrest, a lawyer with some success as a librettist, produced a text. There must have been other Hogarth sketches made along the journey that didn't survive, among them the caricature he scribbled of a Billingsgate porter (dubbed by himself the Duke of Puddledock) at the start of the journey, which the ruffian immediately pasted to a door; although there's an amusing nineteenth-century engraving of Hogarth himself affixing the portrait.

The wide stretch of stone quay at Billingsgate supported on concrete piles driven into the river bed is a relatively late development. As late as 1859 another artist, James McNeill Whistler, produced an etching of a clutch of tall-masted fishing boats moored one to the other, close to the building, on a stretch of tidal river that would have left a muddy foreshore at the ebb tide. The market building is James Bunstone Bunning's of 1853, with a pavilion at either end and a campanile in the middle. (The etching, incidentally, is poetry and realism in an acute balance which eludes Whistler's paintings, though the realism is modified because the etching process has flipped the view and placed Billingsgate to the south of the river. The British Library has a copy.) The current building with its Rogers adaptation dates from 1877 and is by Horace Jones, architect also of Leadenhall (see page 71) and Smithfield markets. He retained Bunning's pavilions but dispensed with the campanile and went Frenchified rather than Italianate. All it needs is to be put to good use. Maybe a museum about the peregrination of the River Thames by Hogarth and his friends.
1 OLD BILLINGSGATE WALK, EC3R 6DX

## ST MARY-AT-HILL

*Where the old men of Billingsgate bring their annual tribute of fish*

In the words of the Gospel, Flora Winfield is a fisher of men. In full fig, she is the Rev. Canon Flora Winfield, and at the service described here Rector of St Mary-at-Hill. The church shares its name with the street to the east of the church, though the entrance is to the west from the narrow cobbled alley of Lovat Lane. At the foot of the hill on the far side of Lower Thames Street is the building where Billingsgate fish market stood certainly from 1327, when Edward III licensed it. St Mary too dates from about this time, so there's a natural symbiosis; not that fish porters

are best known for piety. Yet when the Rector presides over the Harvest Festival service each autumn, St Mary's sweet perfume is not of flowers and vegetables but of haddock and sole, cod, herring, sardines, dab, mackerel, sprats, whiting, mussels and clams, shrimps and crab and squid – trophies displayed in the lobby as though on a fishmonger's slab, arranged before dawn by fish porters from Billingsgate, in their uniform of white coat and leather hats, the so-called bobbins, tough enough to protect heads against piled up cargoes of kipper boxes. The market moved to Canary Wharf in 1982 but the gnarled old porters return year after year for the harvest of the sea.

Although the church is only a couple of streets away from the seat of the Great Fire of London, Pudding Lane, Wren was able to reuse large parts of the medieval structure in recreating it within a basically Byzantine plan, a cross within a square – a quincunx, five points centred on the dome: Pevsner suggests that Wren might have conjured up the notion from two short transepts in the old church contained within the boundary walls of the aisles. Whatever the post-Wren alterations this remains one of the calmest of his interiors, with four beautiful freestanding pillars supporting a coffered dome that anchors, to the east, a barrel vault above the altar, and another to the west harbouring the organ gallery.

The ceiling was successfully restored after a fire in 1988, and this century the splendidly designed and carved west gallery has been restored along with the royal arms of Charles II and the William Hill organ of 1848. What has not yet been brought back is a large part of the most complete set of Wren fittings in existence which just about survived the fire, but terribly damaged. This includes the reredos, the communion rail, the box pews and the font cover. Meanwhile, the harvest festival has come around again with the anthem 'They that go down to the sea in ships', and that most rousing of weather forecasts, 'For those in peril on the sea'. So the brilliant young people in the gallery, organists, flautist and choir, continue a high tradition of music already existing when the immortal Thomas Tallis was registered here in 1537–8 simply as a 'singing-man'.

LOVAT LANE, EASTCHEAP, EC3R 8EE

## WATERMEN'S HALL

*A tiny giant among livery companies*

Every year, for rather longer than the Oxford–Cambridge affair which started as late as 1829 and took some time to gear up to annual encounters, the watermen of the Thames have competed in the race called the Doggett's Coat and Badge Wager. Each peacetime summer since 1715 single-sculled wherries, the heavy gondolas of the Thames, have competed over the 4 miles 5 furlongs stretch between London Bridge and Cadogan pier in Chelsea for the scarlet jacket and silver arm badge given by the popular actor Thomas Doggett (*c.* 1670–1721), a regular client of the Thames watermen. A rough

Dolphins, oars, a Thames wherry and, on the keystone, Triton the sea god, looking like a very tired old wherryman: this is the entrance to the City's only remaining eighteenth-century livery hall, the Watermen's.

bunch, the wherrymen (water taxis) and lightermen (goods transport) had become a nuisance until an Act of Parliament in 1555 established the Worshipful Company of Watermen and Lightermen, which thrives in the only surviving eighteenth-century domestic hall in the City. Although roguery, too, survived, in the matter of negotiating fares in midstream, deep-dyed villainy vanished. Just over fifty years into the new, regulated watermen's world John Stow guessed that, not counting big ships and 'other vessels of burthen... there purtaineth to the cities of London, Westminster, and borough of Southwark, above the number, as is supposed, of 2,000 wherries and other small boats, whereby 3,000 poor men, at least, be set on work and maintained'.

Yet the Watermen's Hall is a Lilliputian among the livery companies; in fact, despite its antique splendour, it harbours a working guild, not a livery company. Among a number of charities the company still runs the 'Company's Poor Fund' established by Act of Parliament in 1700, with a 'Christmas box' annually given to deprived watermen or their widows. In truth, not many members of the company would qualify today: the modern waterman could be a lawyer with a yacht moored in St Katherine's Dock, or he might run a tourist cruiser; the stellar Olympic oarsman Steve Redgrave is a member, the writer and riverman A. P. Herbert was. Harry Gosling, Labour minister of transport in 1924, served a seven-year apprenticeship to the Watermen's Company. The ebulliently crazy 'Water Poet', John Taylor (1578–1653), was clerk to the Watermen's Company, though he was one of the royalist old guard swept aside in 1642 by reformers demanding more openness in the election of officers.

The company first had a hall on the Billingsgate side of Lower Thames Street. It acquired a new site for the current hall, which William Blackburn built in 1778–80, sweeping aside misgivings about its smallness with giant Doric columns, pediment and heavily rusticated and grooved stone façade, well ornamented: dolphins supporting a roundel with crossed oars, a keystone with the head of a sea god, ichthyocentaurs blowing on conch shells and built like watermen, with swishing fishtails instead of legs. Inside is a waiting room beautifully panelled in 1983 with wood from nineteenth-century warehouses and inscribed with company luminaries' names. The circular staircase spirals up through a well of daylight from the dome above to the court room with, seemingly, a Wedgwood-patterned ceiling, exceedingly fine in pale blue, pink, gold and white, adorned with a period chandelier found wrapped up in a Tate & Lyle warehouse; there is a bravura window over the street, and a red leather and gilded wooden throne with an extravagantly spreading royal coat of arms (*plus ça change*).

16–18 ST-MARY-AT-HILL, EC3R 8EF

## FONT COVER BY GRINLING GIBBONS, ALL HALLOWS BY THE TOWER

*A Grinling Gibbons masterpiece*

On 5 September 1666, as Samuel Pepys recorded in his diary entry for the day: 'I up to the top of Barkeing Steeple, and there saw the saddest sight of desolation that I ever saw. Everywhere great fires. Oyle-cellars and brimstone and other things burning. I became afeard to stay there long; and therefore down again as fast as I could…'

Pepys's neighbour in nearby Seething Lane, Sir William Penn, ordered houses round about the church to be torn down to provide a firebreak, so despite Pepys's fears, the tower survived the Great Fire of London with the rest of the church. It survived again in 1940, but this time the body of All Hallows was reduced to smouldering walls and a scatter of monuments, damage so bad that restoration took until 1957. When All Hallows was at last reconsecrated the congregation discovered, courtesy of the Luftwaffe, the newly exposed Anglo-Saxon crypt of 675, now the church museum, and an even earlier floor, from the Roman occupation. But the greatest survival was the unparalleled limewood font cover that Grinling Gibbons carved in 1682, originally for a wooden font later taken to Philadelphia, now as the crown for an elegantly simple stone font carved after the war by an Italian prisoner-of-war known only by his surname, Tulipani.

Grinling Gibbons has become in effect a generic name for any fine English seventeenth-century wood carving, but despite all that has been lost, the real thing constitutes a supreme national legacy. If his finest remaining ensemble is the carved room at Petworth of 1692, then surely the All Hallows font cover vies for supreme honour among his smaller-scale work. In the well-known story another great diarist, John Evelyn, discovered Gibbons

Grinling Gibbons's exuberant font cover is the highlight of All Hallows by the Tower.

eking out a humble living in rural Deptford and introduced him to the king (Charles II), after which fame followed. There's something a trifle fishy about this. Although both Gibbons's parents were English, he was born in Rotterdam and trained in the home of the finest limewood carving, northern Europe. For the rest of his life this all-English boy spoke the language with a Dutch accent, and it may be that he struggled initially when he came to London in about 1667, but hardly more than any of the great or merely good immigrant sculptors who came to England without the accreditation of a City guild. At any rate, by the time he carved the All Hallows font cover, he was the best-known sculptor of the time in England and has remained so.

The cover is a rich spectacle of cupids reaching into massed flowers, foliage, berries, and ears of wheat with a bird on top which, if it is a dove, holds itself like a warlike eagle; wings spread, head thrown back. It has been placed in the baptistery created from the vestry by the south-west door and is protected by padlocked glass doors, so it's not altogether surprising that most visitors come and go without a second glance at All Hallows's greatest treasure.

BYWARD STREET, EC3R 5BJ

## ST OLAVE, HART STREET

*Where Pepys sat eyeball to eyeball with his dead wife's portrait bust*

After years of Samuel Pepys's infidelity to his unsuspecting young wife Elizabeth, on 25 October 1668 she caught him at it with her new maid Deb. As he recorded in his diary, 'I was at a wonderful loss upon it, and the girl also…' Elizabeth sacked Deb and there followed months of deep and sometimes violent unhappiness in the household until in 1669 the couple and her favourite brother Balty took a holiday on the continent, partly because Elizabeth wanted to revisit Paris, where she had spent some of her childhood (although she was born in Devon her father was French) and maybe partly to heal the wounds. All went well until on the return trip she fell into a fever. Three weeks later she was dead, probably of typhoid. Pepys had her buried under the chancel floor of their parish church, St Olave Hart Street, and commissioned a portrait bust of her by the fashionable sculptor of the day, John Bushnell (*c.* 1630–1701), to be mounted on the chancel wall.

St Olave stands at the junction of Hart Street with Seething Lane, where Pepys lived close to the Navy Office, and is the smallest surviving medieval church in the City, with a north door that opens into a tiny secret churchyard. Until it was ripped out in the nineteenth century St Olave had a navy office gallery, positioned so that when Pepys attended on Sundays he sat eyeball to eyeball with Bushnell's lively portrait bust of Elizabeth, in which her head turns as though searching for him. As a young journeyman sculptor Bushnell had visited the Netherlands, France, and Italy. In Venice he helped to shape the massive monument to the Doge Alvise Mocenigo and in Rome he saw the carvings of Bernini, so when he returned to England he was the only sculptor who

understood the Baroque and for a while, until society realised that his work could be unpredictable and delivery unreliable, his order books were full. He had returned to London in the year of Elizabeth Pepys's death, and his portrait of her, quick with life and animated by a mocking gaze, is one of his finest; *the* finest I know by Bushnell of a female sitter.

When Pepys died in 1703, he had arranged to be buried alongside Elizabeth. There was no memorial to him until 1883, when the editor of the first complete (but bowdlerised) edition of the diaries, Henry Wheatley, organised a public subscription for an inscribed tablet with a relief portrait to be placed on the north aisle wall. But Pepys's true monument is the indispensable 11-volume edition by R. C. Latham and W. Matthews, a late twentieth-century publishing triumph.

8 HART STREET, EC3R 7NB

## LEADENHALL MARKET

*Designed by the architect of Tower Bridge*

Leadenhall Market is London just as 'Oranges and lemons say the bells of St Clement's' is London, or the pearly kings and queens, or Bethnal Green's boxing arena, York Hall. It crouches as pugnaciously as the bare-knuckle champion and Panton Street publican, Tom Cribb, gaudy in its glass casing and the red, cream and gold livery of the cast-iron structure, toe to toe with Richard Rogers's glossy Lloyd's showpiece (see page 74) among ever larger and shinier neighbours. The Falstaffian designer, Horace Jones (1819–87), had built two other markets, Smithfield and Billingsgate (see page 64), by the time he built Leadenhall (1880–1).

As a young man Jones had visited Italy to further his education in architecture, and although the Galleria Vittorio Emanuele II of Milan was not built then, it was the talk of Europe by the time Jones began drawing up his blueprints. There are similarities that show up particularly in photographs: the glass tunnels in the form of a cross, the profuse decoration. But in fact the galleria is much bigger and classier than the market, with even the streets encrusted with mosaic. It was an upmarket shopping mall, unlike Leadenhall; *Vogue* compared to *Loaded*. Milan's entrance is a grand Roman triumphal arch; Leadenhall's entrances are cheeky fascias straddling the passages leading into the market, the hall's identity announced in music-hall capital letters carved in relief. At Leadenhall, the concourse at the crossing of the two main lanes clad with solid stone setts, not mosaic, is a circus covered with an octagonal glass dome. It may have been authenticated by Milan, but it was the effective solution to the problem of an enclosed space hemmed in on all sides and with multiple entries.

Everywhere are jauntily decorative metal grilles above the pub, restaurant and shop windows, and coarsely moulded castings of the City of London arms or, as it were, quotes from the arms; firebreathing dragons gone walkabout. Big lamps hang from the wooden trusses of the tunnel-vaulted, louvred glass roofs of the lanes, and the gorgeous restoration

# Pepys's London

Even by the standards of the twentieth century, Pepys's London years were apocalyptic. While the Blitz did not entirely rip the heart out of the City, the Great Fire of 1666 did. So too did the Great Plague, which had visited its horrors the previous year. It was one of three outbreaks of plague in Pepys's century, and far the worst. A spate of rumours about the plague striking Holland in 1664 heralded it. Pepys wrote: 'The talk upon the 'Change is, that [Admiral] De Ruyter is dead, with fifty men of his own of the plague…' (he wasn't). As the plague spread in London, Pepys recorded the general terror and on 15 August 1665 he inscribed in his diary: 'It was dark before I could get home; and so land at Church-yard stairs, where, to my great trouble, I met a dead Corps, of the plague, in the narrow ally… I shall beware of being late abroad again.' The death toll reached more than 100,000.

The last of the Great Plague overlapped with the Great Fire and the indefatigable Pepys walked down to the river '… and there saw a lamentable fire… Everybody endeavouring to remove their goods, and flinging in or bringing into lighters that lay off; poor people staying in their houses as long as till the very fire touched them, and then running into boats… and among other things, the poor pigeons, I perceive, were loth to leave their houses, but hovered about the windows and balconies, till they some of them burned their wings and fell down.'

It was a century, too, that saw civil war, a King of England led to his execution from the middle window of his own Banqueting House in Whitehall, a Republic declared and the dead King Charles I's son restored to the throne. As a boy, Pepys witnessed the execution. As a rising civil servant he went with his patron, Lord Sandwich, to The Hague to welcome Charles II before his embarkation for England: 'The gun over against my Cabbin I fired myself to the King, which was the first time he hath been saluted by his own ships since this change. But holding my head too much over the gun, I have almost spoiled my right eye.' Every possible entertainment was available after the Restoration, music, theatre, sermons great and poor (whereat Pepys might nod off), and on 13 October 1660, having called on Sandwich and found him not yet out of bed, 'I went out to Charing-cross to see Major-Generall Harrison hanged, drawn and quartered; which was done there, he looking as cheerfully as any man could in that condition.' Harrison was the first of the regicides to meet retribution.

Pepys was the ultimate Londoner. He was born in Salisbury Court and baptised opposite in St Bride's; in retirement he chose to live in Clapham, less than five miles away, even though he had inherited a big house in Huntingdonshire.

It cannot be definitively stated that he loved womanising above all else, but Pepys clearly enjoyed it immoderately, and when he didn't actually have the woman of his choice he imagined he did, every class of woman from the wife of a Deptford ship's carpenter to the Queen, and set it all out in impeccable shorthand in the six vellum-bound volumes of his diary. Almost inevitably his wife walked in one day and found him in flagrante delicto with their young maid Deb Willet perched on his knee and his hand up her skirt. 'I was at a wonderful loss upon it, and the girl also…' Never a detail out of place, he added, 'my wife was struck mute'.

Sam Pepys's put-upon wife Elizabeth died in 1669, probably of typhoid. John Bushnell created this very human portrait bust of her for the chancel wall of St Olave, Hart Street.

of 1990 has coloured the interior in the dusky reds, pinks and greens of Pompeii, with details picked out in gold and little painted friezes of terracotta Greek urns. And among all the iron grilles and heavy embossed ornament, stylised floral patterns have been painted not quite as delicately as an Adam interior.

Leadenhall was a new tune on the same old fiddle. The market had existed since 1321, maybe earlier, and long before that it was a corner of the site of the great complex of Roman basilica and forum. So the market lies at the heart of the matter, that part of the City which then, as now, was at the crux of Roman power and finance. Jones had a shrewd idea of what would hit the nail on the head (even his gross Tower Bridge of 1886–94 is a hugely popular symbol of London) and despite the ageless routine of the freely adapted cross design, its various arms wind easily into the neighbourhood, along Central Avenue (the entry from Gracechurch Street), Whittington Avenue (an 'avenue' no wider than a back alley), Leadenhall Place, Beehive Passage, Bull's Head Passage and Lime Street Passage. You can eat French, Spanish, Italian, Mexican, even English, food. The Lamb Tavern remains from 1780, though of course restructured by Sir Horace, the Knight of Cheapside. And you can buy a frock from Hobbs or a Barbour from Barbour; this is very Barbour country, here today, Twickers tomorrow.

GRACECHURCH STREET, EC3

## LLOYD'S OF LONDON

*The boy who made it big:*
*Richard Rogers at Lloyd's*

You would have to be Richard Rogers to believe that the City of London is one of the most creative and exciting skylines in the world, with older, high-quality architecture sitting alongside the best of the new (his statement, word for word). If, as he spoke, he'd had a reproduction of Canaletto's view of Lord Mayor's Day in 1746 open on-screen in front of him, he might have paused in embarrassment before that glorious, unrecoverable view of dozens of Wren steeples punctuating the space from Ludgate Hill to the Monument.

Yet London is lucky that Wren's post-Fire plan for a *beaux arts* city of long avenues and broad boulevards was never adopted, for what does work wonderfully well today is the close texture of narrow streets, narrower alleys and tiny squares and the vivid conjunction of old buildings with new towers, among them of course St Helen Bishopsgate and Leadenhall Market tucked in with one of the most dizzily imaginative buildings in the world, Rogers's headquarters for Lloyd's of London.

He was part of a younger generation gripped by the raw energy of British Pop Art and by its 1960s architectural equivalent, Archigram, a splinter group within the Architectural Association which embraced technology and the mass arts with lunatic concepts like the spray plastic house, sin city, the city walking on

Out of lunatic concepts like the spray plastic house, sin city, the city walking on its own legs, and the plug-in city came Richard Rogers's magnificent hive of finance.

its own legs, and the plug-in city. None of them were built but, like Antonio Sant'Elia's blueprints of 1912–14 for the Futurist Città Nuova, they acted as mind fodder. Had Rogers built Lloyd's in New York he would have supplied King Kong with the building.

He launched himself with a bang: his hastily sketched last-minute submission, with his partner Renzo Piano, for a competition to design a gigantic arts centre on the site of the old Les Halles market was posted to Paris with no real hope of success, competing as it was with entries from some of the most famous architects in the world. Yet just as it was to grip *le tout* Paris later, it caught the imagination of President Pompidou (with a little help from an adviser) and the unknown ad-hoc partnership landed the job of building the unprecedented Pompidou Centre (1977).

Nevertheless Rogers was jobless and broke when the ultra-distinguished Lloyd's of London, founded in a coffee house in 1689 and unmatched for marine insurance, outgrew its most recent building and chose him as the only architect in the field to grasp that what Lloyd's needed was not another building but an expandable and flexible space. So despite some nervousness that they might finish up with a Pompidou-themed pleasure drome, Lloyd's backed Rogers and received a flexible glass and steel-clad shell with lifts and service ducts plugged into the exterior, and within a mind-blowing Gothic vastness traversed by multiple criss-crossing escalators, like Piranesi's dark prisons of the imagination crossed with Sant'Elia's finned futurism.

The plangent Lutine Bell from a captured eighteenth-century French frigate hangs from its pillared wood rostrum at the still centre, tolling for those in peril on the sea. And, at the quaint request of the directors, the Robert Adam Committee Room, originally an eighteenth-century dining room, was painstakingly transferred to the top of the building from the previous headquarters in Lime Street.

1 LIME STREET, EC3M 7HA

## MEMORIAL TO JOHN STOW, ST ANDREW UNDERSHAFT

*A monument to London's pioneering Tudor historian*

The story of the City's churches is interwoven with the history of the Great Fire and the Blitz. St Andrew Undershaft survived both complete with a west window of 1642 composed of figures of monarchs of England; but where the Germans failed the IRA succeeded in 1992 with the bomb that killed three people and destroyed the Baltic Exchange at St Mary Axe, where St Andrew stands on the Leadenhall Street corner. The monarchs went and the church replaced them with heraldic shields, but the glass of the tracery survives with saints, angels, signs of the evangelists, and the rose of England in brilliant hues of blue, purple, red, green and gold as a vestigial reminder of what was destroyed.

The church itself is given over to students studying Christianity with laptops and Bibles. The light, as it were, has been let in, but the atmosphere has been destroyed and fittings like Tijou's

communion rails removed. Visitors (access obtainable by ringing St Helen Bishopsgate, 020 7283 2231) have to pick their way through the rubble that would normally be confined to the vestry, but for London fanciers it's worth it for the wall memorial to John Stow (c. 1525–1605), author principally of *A Survey of London*, published in 1598, revised in 1603 and never, it is claimed, out of print since, and father of all those other historians and travellers and topographers who have described London, Mayhew, Mee and Morton, Peter Ackroyd and Roy Porter, Michelin and Michael Leapman and dozens more, maybe hundreds, brilliant and obscure. His contemporaries, John Leland and the two Williams, Camden and Lambarde, had more formal education and better literary credentials, but none approached the vividness, breadth and depth of Stow's account of London's violence and beauty through the centuries into his own times.

He was born in the parish of St Michael Cornhill, all of a quarter of a mile away from Lime Street, where he died, and from 'the fair and beautiful parish church of St Andrew the Apostle' (the name Undershaft is a reference to a huge maypole outside St Andrew that is said to have been burned as a pagan symbol). The monument is a curiosity. It shows the writer sitting at a desk, facing straight into the church but with eyes cast down at a document he holds in both hands, a foursquare, totally unimaginative composition at which Tudor craftsmen excelled; in this case possibly Nicholas Johnson, an associate of the far greater sculptor, Nicholas Stone. Stow sits in a recess between flat pilasters and beneath an exotically formed headpiece that can scarcely be called a pediment. The decorative paraphernalia include books, lions' heads, and memento mori. Bald, bearded and thick-set, stranded in his study in a full gown and quilted tunic, he looks like a secular St Jerome in Queen Elizabeth's Protestant England.
ST MARY AXE, EC3A 8BN

## ST KATHARINE CREE

*A visual coup*

St Katharine Cree is an enchanting medley, inside and out. It is a survivor of the Great Fire, but was built only a few years before in place of an older church. The main body of the church was built in 1628–31, squared blocks of masonry on top of the old ragstone foundations. According to John Stow, 'the steeple, or bell-tower thereof, hath been lately built, to wit, about the year 1504'. It sits at the south-west of the church on the corner of Leadenhall Street and Creechurch Lane, surmounted by a charming cupola and weathervane of 1776. The entrance is off Leadenhall Street, through a doorcase in the tower with pediment supported on Corinthian columns of the same date as the cupola. The rest of the building stretches east along Leadenhall Street and to the north nuzzles up to small shops in Creechurch Lane (Cree is a colloquialism for Christ, though this seems not to have been so in the century of Stow, who calls the church St Katharine Christ Church).

Inside, too, the church is of 1628–31, built with the patronage of Charles I's favourite churchman, the dangerous Bishop Laud, later leader from the See of

Canterbury of the English Counter-Reformation. So this isn't Gothic revival, it's Gothic hanging on tenuously, even prettily, with more classical columns and Corinthian capitals supporting the arches of the six-bay interior. The insides of the arches (soffits) are coffered, Renaissance out of Ancient Rome. One particularly commanding monument of 1570 survives from the previous church, a tomb chest with a minatory effigy of Sir Nicholas Throckmorton, a rare Protestant in a family who remain Catholic after 600 years at Coughton Court in Warwickshire; as a Protestant, Sir Nicholas thrived as 'chief butler of England' (Stow again). His surroundings too are not Gothic, but the new Classicism of the age of Inigo Jones, six bays each side of the nave with arches carried on Corinthian columns, all white but the capitals gilded.

The east window is, literally, the highlight. It remains Gothic of a singular nature: a tall rectangle top to bottom of the wall between reredos and pretend rib vault, and divided into two, the top section a square – it has to be because it contains a rose window – the bottom, slightly wider than tall, divided into five lights. The thrill is the circle within the square, radical because its sixteen lights are circumscribed by a stone rim and outside that, instead of masonry spandrels filling the square, is more glass, more light, more freshness; a visual coup that smites you hip and thigh as you step in through the church entrance. Apparently the pre-Great Fire St Paul's had a similar window and there are others on the continent that I haven't seen. The glass in the rose is abstract, very pretty, and contemporary with the rest of the interior. The glass in the five lights below is Victorian and does the job where clear glass would not.

86 LEADENHALL STREET, EC3A 3BP

## BEVIS MARKS

*England's oldest synagogue*

Edward I expelled the Jews from England in 1290. Oliver Cromwell welcomed them back in 1656 after negotiations with Rabbi Menasseh ben Israel and his community of Spanish and Portuguese Sephardic Jews conducting international trade in Amsterdam. Cromwell wanted them in the country with their lucrative links to the Spanish Main, but without a public display of their religion, so he allowed them to build synagogues, but not on high streets. This is why the oldest synagogue in England, Bevis Marks, stands in a little court off Heneage Lane. (An earlier synagogue off Creechurch Street became an eighteenth-century doss house and was later demolished.)

A Quaker carpenter, Joseph Avis, was contracted in February 1699 to deliver the Spanish and Portuguese Synagogue, to use its official name, 'in a good and workmanlike manner... one large building with a gallery round the same'. He delivered just such a building in time for the dedication on 12 September 1701. It remains effectively unchanged today. There is more than a touch of a typical Wren City church about it, which is hardly surprising since in the building bonanza that followed the Great Fire of 1666, Avis and his carpenters and joiners had been involved in many of the new churches

built by Wren or to his commission. Bevis Marks is a plain rectangle, 50 foot by 80 foot, and top to bottom red brick with white stone dressings. The three-bay west façade has round-headed windows and its sole display is a handsome doorcase with moulded hood and long brackets from either side of the door clasping an iron-bound glass lamp (there is a nice nineteenth-century street lamp at the north-west corner of the church).

The interior is divided into a nave with two aisles by columns carrying galleries to north, south and west. The furniture is a mixture of stern Cromwellian and mildly relaxed Queen Anne. Avis's handsome marbled green ark at the east, which contains the Torah, the holy writings delivered by God to Moses, looks a lot like the screen in the Merchant Taylor's' Hall where Avis was a member and had been working when the architect craftsman Robert Hooke (see St Benet, City of London, page 28) was building the screen. The ark has attached Corinthian columns framing the three doors, and there are urns either side of the gilded entablature and great, gilded Baroque scrolls supporting tablets inscribed with the Hebrew text of the Ten Commandments. In the body of the synagogue there are ten big candlesticks, standing for the Ten Commandments, and seven joyously spectacular chandeliers, one for each day of the week, hanging low and used for candlelit services.

Benjamin Disraeli was born into the congregation of Bevis Marks, and on the 350th anniversary of the Jewish resettlement Disraeli's prime ministerial successor, Tony Blair, spoke in the synagogue of the benefits the Jewish community had brought to England since 1656 in 'arts, sciences, commerce, politics, the world of learning and thought, philanthropy and many more areas'. To Cromwell and Menasseh ben Israel go the credit and, in this little City courtyard, the Quaker carpenter who refused to take a profit out of the building of Bevis Marks.
4 HENEAGE LANE, EC3A 5DQ

## STATUE OF SIR JOHN CASS, JEWRY STREET

*A seventeenth-century Rumpole*

High up on the wall of the Sir John Cass's Foundation building, Louis-François Roubiliac's statue of Cass is not just his only outdoor work in London, but one of his best anywhere, inside or out of doors. Cass, Master of both the Carpenters' Company and the Skinners' Company, Sheriff, Tory Alderman and MP for the City, strides out from a niche looking pleased with himself, every inch like Rumpole of the Bailey homing in on a well-earned bottle of Pomerol after playing a trump card in court. The toe of Sir John's right shoe protrudes over the ledge, his cloak is thrown open and sliding off one shoulder, his jacket bulging, his cravat askew, his stockings wrinkled at the knees.

Across the centuries, the statue it most resembles in posture is Epstein's horseless portrait in Parliament Square of General Smuts, also striding off his plinth (see page 172); but Smuts is smartly disciplined, shoulders back, belly in, uniform jacket buttoned, pocket flaps ironed, leather leggings tightly fastened. The Roubiliac sculpture is all movement, no

SIR JOHN CASS

graceful loops of drapery but jagged folds, abrupt light-catching facets of cloth, buttons barely restraining the bulky physique beneath the costume.

Cass survives in the City's historical memory as the founder of the John Cass School in Aldgate, the parish where he was born: the institute and the primary school are later developments. He was pugnacious in his opposition to the ruling Whig interests, and precisely the kind of portrait subject to appeal to Roubiliac. The sculptor was closer in spirit to Hogarth than any other artist of the century, even though he was born in Lyon and trained in Dresden and Paris before coming to London in preference to Rome. Indeed he portrayed Hogarth in a speaking likeness now in the National Portrait Gallery, as well as, separately, a terracotta portrait of Hogarth's pet dog, Trump – the pug that the painter had included in his own self-portrait (in Tate Britain). Roubiliac's nearest rivals came out of the Classical and Baroque traditions, but his manner, like Hogarth's, is a sparkling version of Rococo as stand-up. As a matter of fact, the statue on the face of the Cass Foundation building is a replica, but we must learn to accept that as we do the four replica horses of San Marco in Venice and the equestrian statue of Marcus Aurelius in Rome. A pity, though, that the original Roubiliac (cast, by the way, in lead), which was taken on long-term loan by the Guildhall, has been confined to a private room.

SIR JOHN CASS'S FOUNDATION, 31 JEWRY STREET, EC3N 2EY

Sir John Cass, entrepreneur and benefactor, with all the flamboyance of his own success, steps out on the façade of the John Cass Institute. The bronze is one of the finest works of the finest sculptor in England in the eighteenth century, Louis-François Roubiliac.

## THE HOOP AND GRAPES, ALDGATE

*An antique boozer standing up against modern giants*

Aldgate High Street is the short stretch of the parish of St Botolph's Without where the City peters out beyond the now-vanished gate in the eastern defensive wall. Beyond this is Whitechapel. The first noticeable thing about number 47 Aldgate High Street is the sign of the Hoop and Grapes, which is not a painting but a sculpted bunch of golden grapes in a cascade suspended inside a hoop like one of the rings of Saturn. It is modern, so is the taste behind the restoration of this ancient inn, so too the steel frame that rescued the building's gnarled timber frame from collapse into the street. The steel is hidden, the timber remains self-consciously on show like a model on a catwalk. The plaster has been stripped from the walls of the bars to expose courses of English bond brickwork; bricks, that is, laid in alternate courses of stretchers (the long side) and headers, though the end wall is Flemish bond: for the full length of each course bricks are laid header, stretcher, header, stretcher. Apart from the beauty of the two styles of brickwork, they suggest the possibility that this part of the structure dates from the sixteenth and seventeenth centuries: English brick had become beautiful to the sixteenth-century eye; the seventeenth century was when Flemish bond became popular in this country. But dating vernacular buildings from their structure is notoriously iffy. Nor is there any help from the two sturdy

old oak posts flanking the front door, painted black with vine leaves picked out in gold, kitsch rendered venerable by indeterminate age. And then there is the cellar, to which a date in the thirteenth century has been attributed.

Standing among some of the worst twentieth- and twenty-first-century buildings in London, built and still being built, the Hoop and Grapes and its next-door neighbour, number 46, are rare and precious survivals. On each, boxed rectangular bays climb through first and second floors to the attic (at a different height for each building, so brothers, not twins). The ground-floor windows of the pub are permanently squeezed into the hunched shape the subsiding timber frame imposed on them. Behind the windows, the successive rooms of the Hoop and Grapes reach back into the depths, the divisions indicated by schematic remains of the wall divisions of public bars, saloon bars, and snugs, amalgamated now into a handsome form of the dubious modern comfort of the open-plan office floor.

47 ALDGATE HIGH STREET, EC3N 1AL

Number 47 Aldgate High Street, the Hoop and Grapes with its medieval cellar, and its neighbour, 46: rare survivals as the modern City encroaches.

Overleaf: the lovely, complex vestibule of Somerset House, William Chambers's building intended to rival the Louvre.

# The West End

# West End

Regent's Park

MARYLEBONE

CAMDEN

ST PANCRAS

Russell Square Gardens

BLOOMSBURY

HOLBO

SOHO

COVENT GARDEN

MAYFAIR

Hyde Park

CHARING CROSS

ST JAMES'S

Green Park

St James's Park

Palace Gardens

CITY OF WESTMINSTER

WESTMINSTER

VICTORIA

BELGRAVIA

PIMLICO

1. 2 Temple Place
2. Twinings, 216 Strand
3. St Mary le Strand
4. Somerset House
5. Courtauld Gallery
6. The Queen's Chapel of the Savoy
7. Joe Allen
8. Rules
9. Zimbabwe House
10. Memorials in Victoria Embankment Gardens
11. Memorial to Sir W. S. Gilbert, Victoria Embankment
12. Murals by Robyn Denny, Embankment Underground Station
13. York Watergate and the New Adelphi
14. Gordon's Wine Bar
15. Benjamin Franklin House
16. London Transport Museum
17. St Paul's, Covent Garden
18. Red phone boxes opposite the Royal Opera House
19. Seven Dials
20. Sculpture by Barry Flanagan, Lincoln's Inn Fields
21. Hunterian Museum
22. Sir John Soane's Museum
23. The Duke of York, Roger Street
24. Charles Dickens Museum
25. Foundling Museum
26. St George's, Bloomsbury
27. Statue of Charles James Fox, Bloomsbury Square
28. James Smith & Sons
29. Congress House
30. Mosaics by Eduardo Paolozzi, Tottenham Court Road Station
31. Statue of Mohandas Gandhi, Tavistock Square
32. Petrie Museum of Egyptian Archaeology
33. Relief sculptures by John Flaxman, UCL
34. Government Art Collection
35. Pollock's Toy Museum
36. All Saints, Margaret Street
37. Pilar Corrias Gallery
38. St Martin-in-the-Fields
39. Statue of Charles I, Trafalgar Square
40. Statue of King James II, Trafalgar Square
41. National Portrait Gallery
42. Notre Dame de France
43. The Gay Hussar
44. Statue of Charles II, Soho Square
45. St Anne's, Dean Street
46. Statue of George II, Golden Square
47. Statue of Robert Falcon Scott, Waterloo Place
48. Royal Opera Arcade
49. Statue of King William III, St James's Square
50. London Library
51. The Red Lion, Duke of York Street
52. St James's, Piccadilly
53. Quaglino's
54. Economist building
55. Schomberg House
56. Oxford and Cambridge Club
57. Queen Alexandra Memorial
58. Chapel Royal
59. The Queen's Chapel
60. Clarence House
61. Spencer House
62. Artemisia Gentileschi's self-portrait, Buckingham Palace
63. Banqueting House
64. Horse Guards
65. National Police Memorial
66. Foreign and Commonwealth Office
67. Statue of General Smuts, Parliament Square
68. Supreme Court
69. Palace of Westminster
70. Statue of Oliver Cromwell outside Westminster Hall
71. Jewel Tower, Old Palace Yard
72. St Margaret's, Westminster Abbey
73. Tombs of Henry VII and Elizabeth of York, Westminster Abbey
74. 28 Queen Anne's Gate
75. London Underground Head Office
76. Sculptures outside Tate Britain
77. Murals in the Rex Whistler Restaurant, Tate Britain
78. Sculpture by Henry Moore, Chelsea College of Arts
79. St James the Less, Pimlico
80. Westminster Cathedral
81. St Barnabas, Pimlico
82. Belgrave Square
83. All Souls, Langham Place
84. BBC Broadcasting House
85. Relief carvings at 219 Oxford Street
86. Sculpture by Barbara Hepworth, 300 Oxford Street
87. Sculpture by Gilbert Bayes, 400 Oxford Street
88. Wallace Collection
89. St George's, Hanover Square
90. Sotheby's
91. Handel House Museum
92. Relief carving by Michelangelo, Royal Academy of Arts
93. Fleming Collection
94. Devonshire Gates, Green Park
95. Curzon Mayfair
96. Farm Street Church
97. Grosvenor Chapel
98. Hyde Park Corner
99. Apsley House
100. Royal Artillery Memorial

• **STRAND, EMBANKMENT, COVENT GARDEN** •

### 2 TEMPLE PLACE

*The zillionaire Astor who owned Anne Boleyn's Tudor fortress and built another*

William Waldorf Astor was the fabulously rich son of a fabulously rich American father. Despite having served as US Minister to Italy, he fell out with his native country, moved to London, was naturalised in 1899, built the London Waldorf Hotel as a sister to the one he had built in New York, acquired the *Pall Mall Gazette* then bought the *Observer* so that he could induce its editor, J. L. Garvin, to edit the *Gazette* as well, and distributed money liberally to good causes. He shipped the whole garden balustrade of 1619 from the English garden of the Villa Borghese and reassembled it at Cliveden, which he had bought from the Duke of Westminster. He purchased Anne Boleyn's girlhood home, Hever Castle, and constructed on this Tudor estate an Italian Renaissance garden embellished with Italian classical sculpture delivered by the shipload.

There wasn't a Tudor mansion to buy in London to serve as estate office, so in 1893 he had the notable Gothicist J. L. Pearson build one brand new, at 2 Temple Place. Finally, after discreet help to the Allied cause in the First World War, he attained the aristocracy – some say bought his way in, but that may have been because he bought everything else that took his fancy. Until 2011 Astor House, as it was known, remained inaccessible to the public, but after a series of corporate owners following the Astors it was acquired as its headquarters by the Bulldog Trust, a super charity set up by the ancient banking family of Hoare that helps other charities to function with cash handouts and expert advice on administration. What would a super charity do with the leftover space other than dedicate it as a super gallery to show the best from regional art collections? Which is how the building comes to be open to the public.

The prime exhibit is the mansion itself. The exterior is very fine – Portland stone with a rich cornice, big multi-light windows and lavishly carved bays – but the interior is magnificent, from the oak and mahogany staircase with carved figures as finials, rising from a floor set with jasper, marble, onyx and porphyry, all the doors with elaborate relief patterns, the atrium roof light filled with patterned glass, and then, the utterly splendid great hall on the first floor. Oak-panelled, with hammerbeams in mahogany, and deeply recessed windows at either end of the hall complete with bright stained-glass pictures of Swiss landscapes (Clayton and Bell, one of the best of Victorian firms), it looks out serenely across the Thames.

At his death in 1919 old man Astor, by then 1st Viscount Astor, of Hever Castle in the County of Kent, was a recluse rejected by English high society. Probate was declared at £421,963 4s 10d, but that was

The grand staircase in the medieval house at 2 Temple Place – brand new in 1893, built as home from home for the fabulously rich William Waldorf Astor – the country home was Hever Castle.

the small change. The other zillions in cash and real estate had already been shared out between his two sons, Waldorf and John Jacob Astor.
WESTMINSTER, WC2R 3BD

## TWININGS, 216 STRAND

*The beverage that floated the British Empire*

That great grumpy sage and confabulator William Cobbett had few doubts about anything and about tea drinking none at all. Here he is in *Cottage Economy*, his address on home economy to country labourers first published in 1821 and scarcely out of print since: 'I view the [sic] tea drinking as a destroyer of health, an enfeebler of the frame, an engenderer of effeminacy and laziness, a debaucher of youth, and a maker of misery for old age.'

The teabag would have left him speechless. This was only one of many vituperative asides from his main theme of how to brew healthy and sustaining beer for all the family, but it was already a lost cause. Thomas Twining, a former apprentice with an East India Company merchant, had bought Tom's Coffee House at Devereux Court, off the Strand, in 1706, and introduced a sideline in tea; eventually he dealt only in tea and so helped to establish a taste for the beverage which floated the British Empire. Twining heirs were born and grew up in Devereux Court and manned the business. It became so prosperous that in the nineteenth century it started Twinings Bank which, now merged with Lloyds, still occupies the same building next door.

Visitors enter Twinings at 216 Strand opposite the law courts through a white portico adorned with two charming figurines of Chinese men, one in a blue tunic figured in white, the other in a yellow tunic with red spots, reclining against a plinth beneath a pediment. On top of the plinth is the firm's sign, a golden lion couchant: the royal coat of arms and the announcement of royal patronage, first bestowed by Queen Victoria. Inside there is only a corridor, the same width as the front door, which means narrow, lined by wooden shelves, drawers, cases, and pigeon holes containing hundreds upon hundreds of tea samples – green teas, fruit teas, herb teas, *digestif* teas, English breakfast tea, Chinese white tea, Assam and Darjeeling teas, Ceylon, and chai – all interspersed by dim portraits in oils of the founding Twining and his successors, Daniel, Richard, and a number of others who did not engage in the business. Twinings's claim to have invented Earl Grey tea is disputed by Jacksons of Piccadilly, but since Jacksons is now owned by Twinings, the disagreement is no more than a storm in a teacup.
STRAND, WC2R 1AP

## ST MARY LE STRAND

*A cheerful ship at anchor in the middle of the Strand*

Even though he had more plans drawn than buildings built, by 1714 the young James Gibbs (1682–1754) was riding high. The Act of Union had been passed seven years earlier and he had arrived in

London the following year from his native Scotland via Rome, where he had been studying architecture. In London he put together a string of powerful Tory friends. Backed by Robert Harley, Earl of Oxford and lord high treasurer to Queen Anne, John Erskine, Earl of Mar, Tory secretary of state and Gibbs's compatriot, and Christopher Wren, Gibbs secured the post, shared with Hawksmoor, of commissioner for the building of 50 new churches. From this privileged position he chose for himself the commission for the church of St Mary le Strand, his first, to be built opposite Somerset House. But by 1715 his prospects had darkened. Queen Anne was dead, the Hanoverian George I was on the throne, Harley, Erskine and Wren were out of favour and out of office, and the Whigs were in. Gibbs lost his role as commissioner but was graciously allowed to complete St Mary le Strand, without pay.

It is an elaborate building and was not ready for consecration until 1724; two years before that, the foundation stone was laid for St Martin-in-the-Fields, which is generally held to be Gibbs's masterpiece. That may be so, but it is a difficult distinction to make. St Mary stands, a cheerful sight, in the middle of the Strand, like a tall ship at anchor, with St Clement Danes in a reach further east. The semi-circular portico with Ionic columns and west window above the string course, a big pediment breaking through the balustrade beneath a four-stage steeple, are a more effortless unity of London (the steeple) and Rome (the façade) than St Martin's conjunction of grand classical portico with the steeple set awkwardly further back. On the Strand sides to north and south only the clerestory has glazed windows; traffic was intense even at the beginning of the Hanoverian era as evidenced here by the ground floor having blind windows as a sound baffle. North and south, Ionic columns flank the ground-floor bays with Corinthian above. A lovely balustrade with urns the length and breadth of the building, and the unexpected continental round apse, bring an added frisson of lightness and movement.

The interior has no aisles, but the lack of them only enhances the theatricality of the apse and the dramatic, heavily patterned coffered ceiling, its packed squares and lozenges in white picked out with maroon and pale green accents. The visitor immediately confronts a Roman Catholic exoticism, though salted with Scottish rectitude. The same might be said of Gibbs himself, a Catholic though a discreet one for professional and social reasons. (This is the man of whom the architectural historian John Summerson observed: 'He was very distinctly the Tory architect in the great age of Whig ascendancy and his personal style is correspondingly out of the swim. Like all good Tories he stole radical ideas promptly and unblushingly and presented them as his inimitable own.')

STRAND, WC2R 1ES

## SOMERSET HOUSE

*William Chambers's barely known masterpiece*

Here's a funny thing. Somerset House, stretching between the Strand and the Thames, was built with the blessing of George III in the late eighteenth century to rival great national showpiece buildings known the world over, the Louvre Palace, say, or royal El Escorial, or St Peter's Basilica and its Bernini piazza. It is their equal with its grand courtyard, its rich sculptural decoration, its terrace supported by great arches rising from the riverbed (before six lanes of traffic displaced the river). Yet while the fame of other buildings endured, Somerset House would become a byword only as the place where an office dispensed copies of birth and death certificates or guarded mouldering files of family history.

In 1989 the Strand range became the home of the Courtauld Institute (see page 93), and as government departments moved out, other artistic institutions moved in, including the Hermitage, which in millennium year opened an exhibition space in the east wing to display selected items from its fabled collections. Nobody came, and in 2007 the Hermitage slipped quietly back into the St Petersburg night, with its treasures.

The Somerset House project was blighted from the start. William Chambers was born in 1723 when his father, a Scottish merchant, was stationed with his family in Gothenburg. Chambers's education in architecture was French-influenced, but English aristocratic taste, founded on the prevailing system of classical education,

was Roman and favoured Robert Adam. Luckily, Chambers did visit Rome and there impressed Lord Bute, who recommended him on his return to England to Frederick, Prince of Wales (later George III). Princess Augusta, one of Frederick's daughters, commissioned Chambers to lay out Kew Gardens and Frederick took lessons in architecture from him. Royal patronage saved his career. Chambers was not daunted by wide spaces, but although he had built an occasional stable block, a temple here, a pagoda there, and a few country houses, had otherwise hardly built anything bigger than the king's state coach for the coronation, before he was given the Somerset House commission.

The site was once occupied by the house of the Duke of Somerset, lord protector and effectively ruler of England during Edward VI's minority. The Strand façade of Chambers's building has only nine bays, but it opens through a lovely, complex vestibule (Courtauld galleries to the right, bookshop to the left) with a decorated plaster ceiling supported on paired Doric columns. On emerging into the courtyard beyond the effect is spectacular: four huge wings are visible, clad in Portland stone with deeply cut rustication, and in the four central bays a giant classical order in the east, west, and south ranges rising from halfway. There is elegant sculptural decoration everywhere. Yet still few people love it; perhaps it is too cold, too intellectual, too French in its pursuit of *la gloire*. Under the millennium dispensation the Dixon Jones partnership designed the neat ranges of courtyard fountains which, in winter when a skating rink takes over, discreetly disappear beneath the surface.

STRAND, WC2R 1LA

## COURTAULD GALLERY

*Charity begins at Home House*

In the 1950s and sixties, the cheap way to pretend you were wearing a silk tie was to buy one in rayon instead, a synthetic first produced by Courtaulds Fibres. The trouble was that after being worn a couple of times a rayon tie looked like a greasy rat's tail. It seemed odd that Samuel Courtauld, a man of such impeccable taste, could get by in life by selling such ratty tie tat. But presumably he didn't wear the things himself and those of us poor enough or sufficiently deficient in taste to do so could draw comfort from the good deeds of Samuel Courtauld in setting up the Courtauld Institute.

In fact, the actual initiator of the project, in 1929, was Lord Lee, soldier, diplomat and lifelong collector, and Lady Lee, who wanted to found a London University institute of art to rival the Fogg Art Museum at Harvard. Courtauld had been buying art only since 1922 but with his vast wealth had also bought the beautiful Home House in Mayfair, designed by Robert Adam, which he donated to be the headquarters of the Courtauld Institute, and by 1930 this was up and running and attached to the university. Lee's collection gave the Courtauld Institute gravitas: he had been buying pre-Renaissance Italian art from early in his career, and northern

William Chambers had hardly built anything bigger than the state coach for King George III's coronation before he was given the Somerset House commission.

Renaissance paintings, of which his prime bequest is the magnificent Rubens study for the finest (I think) of all his paintings, *The Descent from the Cross* altarpiece in Antwerp Cathedral. With further bequests, the collection moved after the war into premises in Woburn Square, Bloomsbury, famous for its rickety lift and paucity of visitors. In 1989 the teaching institute and library moved into the north block of Somerset House and a year later the museum moved into the Fine Rooms, home to the Royal Academy in the eighteenth century.

For the public the most joyous element of these combined collections must be the late eighteenth- and nineteenth-century holdings, by Goya, Tiepolo, Gainsborough, moving on to one of the greatest of Manets, *A Bar at the Folies-Bergère*, Renoir's *La Loge*, a clutch of Cézanne works, impeccable, monumental, oils, drawings and a sumptuous watercolour still life, Toulouse-Lautrec, Van Gogh, Gauguin, Degas. Courtauld learned from Roger Fry, which may account for the wealth of Cézannes, and certainly the Fry bequest of underwhelming English Post-Impressionism.

But now, please give a big hand to Count Antoine Seilern, the very figure of a bon vivant, who provided the bequest to the Courtauld that all pukka art historians would approve most warmly. Born in London in 1901, brought up in New York and Vienna, returning to London with an art history doctorate in the summer of 1939 as well as his library and art collection, he was engineer, horseman, pilot, and, when war broke out, private in the Pioneer Corps (known to comrades in more conventional military occupations as the shit shovellers). His donation to the Institute included works from Giovanni Bellini to Picasso, a sublime Virgin and Child of about 1522–4 by Parmigianino, and studies for the two wings of the Rubens *Descent*, of which a study for the main panel was already in the Courtauld (see above). The bequest comprised 127 paintings and hundreds of drawings.
STRAND, WC2R 1LA

## THE QUEEN'S CHAPEL OF THE SAVOY

*The elegant ghost of an ancient royal chapel*

Early this century the Queen insouciantly mentioned to her biographer, Sarah Bradford, that she wouldn't mind retiring to the Forest of Bowland. The remark wasn't completely off the cuff. In her role as Duke of Lancaster (sic) she personally, not the crown, owns a vast swathe of north-west England and more modest tracts elsewhere, so she could if she so wished ordain a retirement home for herself in the ancient northern royal hunting forest. Yet commercially speaking, the most important Duchy of Lancaster land is a holding of under two and a half acres, sandwiched between the Thames and the Strand, known as the Precinct of the Savoy after Peter of Savoy, uncle of Eleanor of Provence, wife of Henry III, to whom this royal manor was granted by the king in 1246. The greater part of Elizabeth II's income from the Precinct of the Savoy is yielded by rents from the shops and offices on this blessed plot; quite enough to sustain the non-commercial Queen's

Chapel of the Savoy, tucked away on Savoy Hill in the shadow of the Savoy Hotel (which is not part of the precinct).

The palace built by a minor royal in the fourteenth century was soon destroyed by the revolting peasants of 1381. After more than a hundred years of dereliction the first Tudor king, Henry VII, built a hospital on the ruins, which itself succumbed to time, misfortune, and inadequate capital investment. All that remains is the former chapel of St John, now the Queen's Chapel of the Savoy. This in turn was gutted in a fire of 1874 that left only the walls standing. So today's light and airy aisle-less chapel is largely a work of architectural fiction confected by Sidney Smirke. There are the remains of a Tudor piscina, and on the west wall (the chapel is aligned north and south) a lovely female mourner from a destroyed monument. The gorgeous ceiling is based on the original, with painted Tudor shields interspersed with azure quatrefoils outlined in white and gold. A small army of Victorian glaziers produced the anodyne fittings and stained glass (one window, prettier than the others, is dedicated to Richard D'Oyly Carte, purveyor of English light opera).

Since George VI turned the chapel over to the Royal Victorian Order in 1937, the order's members (people deemed to have rendered important service to the sovereign) have their own armorial bearings on what look suspiciously like tin plates fastened to the panelling. Best of all is Smirke's delicate Perpendicular wall-to-wall reredos that partly obscures the east window (east liturgically, that is; actually it faces north. God and monarchs may dispose as they please). Set into it above the gold crucifix on the altar is a painted panel of the Madonna and child surrounded by saints from a fourteenth-century Florentine polyptych: elegant, humane, with a red, blue and gold purity that pre-dates the great dawning of the fifteenth century with Masaccio and Donatello. It is quite hard to see this little treasure behind its security glass, but the friendly chapel officials aren't stuffy about allowing the public to enter the sanctuary area.

SAVOY HILL, WC2R ODA

## JOE ALLEN

*Joe's diner*

Joe Allen behind its raffish basement entrance in Covent Garden is often enough called an American brasserie. In New York the term is more likely to be hash house. They mean much the same thing: an eatery with a democratic range of food, smarter than a diner, cheaper than a restaurant. In either case, it's a London institution. (In Paris and Miami too.) The London cellar has remained much the same since its opening day in 1977, acting as a canteen for theatre workers and a refuge for Americans far from home. It is a take on its New York brother but without the wall of posters for shows that flopped inside a week of opening. There are other posters, though, and lots of them, Broadway and Shaftesbury Avenue both, and pap shots of famous names from cast lists, mostly Hollywood: Groucho, Ava Gardner, Marilyn, Liza, Gregory Peck, Elizabeth Taylor, plus the *éminence grise*,

Joe Allen himself, eighty-something American summers old, a veteran of his New York launch in 1965, a launch in his own lunchtime.

Allen still drops in on London from time to time to say hello even though he and his partner in crime, Richard Polo, sold out to a group of restaurateurs in 2012 when Polo retired, having been in London since he arrived way back when to organise the opening. One of the new men, Tim Healy, had been coming here since he was a little boy, brought along by his father who was, of course, an actor. The boy has had many years since to commit the menu to memory: crispy squid with chipotle mayo, black bean soup, chopped liver with pickles, the daddy of Caesar salads, sirloin steak, spiced back ribs, rib-eye steak, grilled chicken, fillet steak, catch of the day, chopped chilli beef, cheesecake, to quote a few stayers. His customers wouldn't have allowed him to forget it anyway.

It was not hard to find a London theatreland basement entrance that would match the archetype at 326 West 46th Street; fixing the basement was harder. The public area, the eaterie, was two large rooms. Fine, but the dividing wall had to be more or less rebuilt incorporating a couple of arched openings to allow people to clock the scene and the who's who on either side, though at some hours of the day tourists at one set of tables are quite likely to find themselves gazing into the eyes not of renowned thespians but of more tourists at the other tables.

The tables themselves are impeccable, the chairs an assortment, the wood-block floor slightly scuffed, the lighting just right. The bar has a brass speed rail, there are rows of those bistro-style French hat and coat stands. Come early and find the pianist, woolly-hatted Gilly Spencer, famous in the streets of London and the fields of Glastonbury, eating her breakfast before launching into her repertoire of 10,000 tunes. It is as well she's good because she follows Jimmy Hardwick, who started here on launch day. He knew everyone and everyone knew him, but he died in January 2014.

13 EXETER STREET, WC2E 7DT

## RULES

*A personalised survival of Edwardian England*

Seating, red plush; patterned red carpet, red and cream walls, *Vanity Fair* cartoons of stage and screen celebrities crowding the walls; sets of antlers; Neo-classical marble busts in black and gold shell alcoves (borrowed perhaps from the estate in Upper Teesdale where Rules rears its own beef and game); coloured glass above the main dining room, more skylight than dome; portraits in oils of the founder's aunt and uncle; the frames of giant mirrors festooned with hop bines, like any old Kentish pub, though the county itself has all but given up on hops these days. Upstairs there is a famous cocktail bar, with a sweet frieze above the picture rail of a country race meeting, horses streaming along against a scene of wooded hills, and a Spy cartoon of Edward VII, an allusion to his illicit trysts here with Lily Langtry. The bill of fare,

too, is deeply Edwardian: oysters, steak and kidney pudding, great sides of sirloin, hare and rabbit, turbot, ptarmigan and teal, golden syrup sponge with custard. Alas, tripe and onions no longer.

For the architect, Alfred Cross, Rules was a deviant development: almshouses and especially public baths were his *métier*. But Maiden Lane, an ancient track skirting the convent garden (Covent is a corruption) between Drury Lane and St Martin's Lane, remains a back alley to properties in the Strand and maintains its claustrophobic narrowness. Rules's own vintage Rolls-Royce of 1935 (Bubbles, it's called, presumably in celebration of the fizzy drink rather than the late socialite Lady Rothermere) parks at the kerb outside the restaurant when it isn't commuting to the restaurant's game estate on the County Durham border with Cumbria: the visible sign that some things have changed (some time ago).

The restaurant as it is now was built in 1873. That puts it alongside the Criterion on Piccadilly Circus, and a little behind Kettner's in Romilly Street, which opened in 1867. But Rules was already in Maiden Lane in 1798, when Thomas Rule founded the business as a fish shop and oyster bar just along from old William Turner, the barber and wigmaker whose son, Turner the painter, was born there and maintained quarters in Maiden Lane to which he returned whenever he had completed another of his extensive travels with sketchbook.

All this was enough history for the GLC to threaten in the 1970s to knock Rules down, along with a lot of the rest of Covent Garden, taking advantage of the removal of the fruit and vegetable market to Nine Elms by rebuilding the area for big business. The residents erupted and in his own effective way John Betjeman chipped in on behalf of Rules: '... its interior on the ground floor is unique and irreplaceable,' he wrote to the authorities, 'and part of literary and theatrical London. As at present furnished, its interior is historic.' At any rate, London has nothing comparable, Paris has nothing to offer more fair (well, maybe the bar at the Folies Bergère).

34–35 MAIDEN LANE, WC2E 7LB

## ZIMBABWE HOUSE

*A big day for vigilantes, all in a day's insults for Epstein*

Nothing much has changed since Jacob Epstein wrote in his autobiography in 1955: 'Anyone passing along the Strand can now see, as on some antique building, the few mutilated fragments of my decoration.' These fragments are the remains of Epstein's first big commission, from the architect Charles Holden in 1907, for 18 figures to flank the windows of his new British Medical Association building on the corner of the Strand and Agar Street. Although Epstein says 'decoration', he surmises that the uproar that followed their unveiling in 1908 was precisely because they were not decoration in the normal sense but eight-foot-high freestanding sculptures which, as bizarre coincidence arranged it, faced the National Vigilance Society's offices across Agar Street. The scaffolding came down, the vigilantes were exposed to the full

horror of naked human figures and immediately called in the *Evening Standard*. The *Standard*, not the enlightened organ it has since become, invoked the wrath of Heaven.

Crowds gathered on the pavements to gaze upon the spectacle, the BMA stoutly defended Epstein's work, and the matter simmered away until the mid-1930s, when the Southern Rhodesian government bought the building as its High Commission and decided that the sculptures were not a suitable match for the Commission's dignity. In the public uproar the voices of Epstein's defenders caused the Commission to hold off. But in 1937 the sculptures made useful mooring points for tethering decorations celebrating the coronation of George VI, and when the bunting was taken down a piece of stone detached itself from one of the sculptures and fell to the pavement below. Without further consultation, and refusing to allow Epstein to examine their condition, the High Commission ordered them to be mutilated.

There is no particular moral to the story since white colonial Southern Rhodesia is now black independent Zimbabwe and the post-war heritage laws that prevented the Time-Life organisation from removing the Henry Moore sculptures it had commissioned for the balustrade of its Bond Street building when it moved headquarters, had they been in place before the war, would likewise have prevented the destruction of Epstein's work. Judging by photographs, the sculptures were not his finest (he was only 26); but destroying them was not an exercise in art criticism, just bureaucratic barbarism. His early career, until the public and popular press fell for his vividly modelled portraits cast in bronze, was marked by abuse piled upon abuse. Henry Moore shipped some abuse of his own, but mostly just a gentle riff by cartoonists, each thinking he was the first, on the hole in his sculptures: Epstein had drawn the sting, though his own late works, like the *Madonna and Child* in Cavendish Square and the (posthumously unveiled) *St Michael* at Coventry Cathedral were popular triumphs. The stunted ruins in their niches on Zimbabwe House remain as a reminder that the beast only slumbers, waking at intervals to write letters that begin: 'Sir, Am I alone in thinking that my five-year-old child could do better ...'

429 STRAND, WC2R 0JR

## MEMORIALS IN VICTORIA EMBANKMENT GARDENS

*A hero of court martials and a Belgian tribute to Britain, back to back*

In the middle of Embankment Gardens there is a little stone-built circular pond popular on sunny days with mothers of small children, until the little sweethearts fall in. Behind it is a wide stone screen wall, its subtly modulated planes and masses as powerful as Edwin Lutyens (1869–1944) could make it, with a central inscription decked around with tasselled swags and a finely carved free-standing

A token of thanks to the British for aid rendered to beleaguered Belgium in the First World War: the architect of the exedra was British, Reginald Blomfield, and the sculptor, Victor Rousseau, was Belgian. It was unveiled on the Embankment opposite Cleopatra's Needle in 1920.

coat of arms on top; yet it is tranquil, with shaded stone benches built into recesses in either wing where old men may sit and recall better days. It is as fine a piece of work, one might think, as the Cenotaph or the Thiepval Memorial to the fallen.

What great statesman or hero has earned this tribute from a grateful nation? Why, none other than Herbert Francis Eaton, styled 3rd Baron Cheylesmore, who, euphoniously, was educated at Eton, rowed for Eton House four in 1866, and in the same year shot for Eton in the Ashburton Shield. A military man, he had the misfortune never to experience the battlefield but taught others to shoot straight and rose to the rank of major-general, headed a series of court martials in the First World War, afterwards served on endless important committees, and rose from CVO in 1905, to KCVO, then KCMG and GBE in 1925, when death cut him off from further honours. He was what we would call a safe pair of hands.

Lutyens's monument tells us less about the man himself and more about the ruling class of a nation that could raise such a tribute to a sterling servant of king and country, one of no lasting glory, no especially shining merit but the possession of money, rank, and the gift of knocking along with people; one, in fact, who is dimmed in popular memory and recalled mostly in the dustier pages of the *Oxford Dictionary of National Biography*.

By a happy stroke of judgement, Lutyens's memorial, which was unveiled in 1930, was raised precisely behind the Belgian Monument to the British Nation, an exedra of much the same dimensions as the Cheylesmore Monument but on the Victoria Embankment facing Cleopatra's

Needle. Reginald Blomfield (1856–1942) was the architect of the scheme, which might be called Lutyens-esque except that Blomfield got in first, ten years earlier (in 1922 he gained greater celebrity with his Menin Gate in Ypres). In each wing of the concave wall is a stone sculpture, one of *Honour*, one of *Justice*, both over the years symbolically eroded. At the centre is the huge éclat of a vivid bronze group by the Belgian sculptor Victor Rousseau (1865–1954), a proudly naked young man (no wonder so many were killed) and a young girl carrying spectacular garlands of roses. A beautiful woman follows behind, her mourning veil thrown back and flowing in the wind, like her long gown, as she leans forward in mid-stride, arms held wide shaping a protective embrace. It's unreal, it's magnificent, it's *la gloire*.
WESTMINSTER, WC2N

## MEMORIAL TO SIR W. S. GILBERT, VICTORIA EMBANKMENT

*'His foe was folly & his weapon wit'*

Oscar Wilde, James McNeill Whistler, Aubrey Beardsley... each had a way of standing out against the Teutonic backwoodsmen of Victorian art; the light operatic W. S. Gilbert had another. The meeting between the two trends in George Frampton's memorial to Gilbert forms a curious hybrid. Gilbert disguised his roguish element behind a solidly bourgeois front, and Frampton himself (1860–1928) was a straightforward if gifted professional artist who happened to have started professional life when the so-called new sculpture had become the option of choice for artists wishing to escape the dead hand of mid-century classicism. A perusal of the interview with Frampton in *Studio* magazine of January 1896 yields only accounts of the commissions he had undertaken and the media he had used; but then, faced with questions like 'Do you find mother-of-pearl difficult to obtain?' that isn't altogether surprising. But if the new sculpture lacks the ring of names such as are found in Impressionism or Pre-Raphaelitism, that is because neither its achievement nor its role in helping to liberate English art from moralising sentimentality has yet to be appreciated by media or public.

The Gilbert memorial itself is full of juice, even Gilbert's moustachioed and mutton-chop-whiskered profile bust in relief on the bronze tablet memorial, scowling as though he had freshly disposed of a new fool's pretensions (the alliterative epigraph beneath the portrait reads: 'His foe was folly & his weapon wit'). This is deftly handled, but the real interest lies in the figure of *Tragedy* seated to one side and *Comedy* to the other. They could be two little maids from school, grown up but chaste, each with her hair set in a modern bob. *Tragedy* writes in an open book on her lap and with her left hand offers a spray of laurel to the playwright. *Comedy* has a bunch of doll-like figures from light theatre suspended from one sleeve and has selected one of them, from *The Mikado*, to hold up in admiring appraisal. Both figures, not much more than miniatures themselves, are fluid in movement, their gestures and drapery in harmony. It's anyone's guess what *Tragedy*

is doing on this memorial. It was hardly Gilbert's occupation, and maybe the closest he came to it was to die of heart failure as he disported himself with a couple of young women in the lake at his home, Grim's Dyke, in Harrow Weald (see page 557).

VICTORIA EMBANKMENT, WC2N

## MURALS BY ROBYN DENNY, EMBANKMENT UNDERGROUND STATION

*The colours and forms of the Underground livery remade as decoration*

A train arrives in an Underground station. The doors open, passengers emerge. They look for directions to a connecting line or for the Way Out sign. Do they also take in the array of artist-crafted murals adorning some stations? In Embankment station, perhaps not.

Transport for London in its various manifestations has hired a range of artists to make tube travel a better experience: from the temporary, ill-treated junior draughtsman and visionary Harry Beck (1902–74), who invented the schematic London Underground map, to Edward Johnston (1872–1944), whose typography is the face of London Transport. Add to these the sculptors Epstein, Gill, Moore, Eric Aumonier, Samuel Rabinovitch (Sam Rabin) and others, whose work is the added extra on transport headquarters in St James's; Eduardo Paolozzi (see page 125); and Robyn Denny, whose murals for Embankment are so discreet that they hardly seem to be there at all. He left a couple of signatures below his work on the Bakerloo line platforms, possibly as a nudge to passengers to help them realise that as they shove their way on to a packed train they are in the middle of an artwork.

Denny (b. 1930) was in the first generation of British artists to whom making abstract art was as easy as falling off a bus. The generation that was just about adult as the war broke out had struggled to reconcile itself to abstraction, to feel that it was no more artificial than the imitation of appearances. Finally they fitted into an abstraction that was more or less landscape-based; the young group (and it was a group, defined by participation in a London exhibition in 1960 called Situation) claimed to be total abstractionists; that is, as detached from the 'real' world of appearances as a Persian rug. That just about disqualifies the observation in the Westminster volume of *The Buildings of England* that Denny's mural is 'arranged to echo the curve of the river', since that would place it in the despised landscape-inspired branch of abstraction. Still, Situation was situated in the real world and Denny's work relates to it. It is composed of narrow ribbons of colour against the white tiles of the tunnels. The curves, if anything, reflect the curve of the tunnel vault. The colours pick up the Underground livery: there are reds and blues, like the red and blue of the wheel logo bearing the station name, there's a brown for the Bakerloo line and a green for the District line, both of which run through Embankment, though no yellow for the Circle line; that's reserved for the line behind which passengers must please stand.

So what? Well, the lines dance, they

set up a happy rhythm as they climb into the tunnel roof, they are beautiful and not all that remote, and it takes only a few moments of any passenger's time for that to be recognised.

VILLIERS STREET, WC2N 6NS

## YORK WATERGATE AND THE NEW ADELPHI

*The tragedy of York Gate and the Adelphi*

Noble in itself, York Watergate is a beached relic of a grander age when it stood precisely where it is now, but on the edge of the Thames as the entrance to the river terrace of York House. The house itself is long gone together with its owner, the over-mighty 1st Duke of Buckingham, its past summoned to memory along with the other houses of great seventeenth-century magnates by the names of newer streets nearby: York Buildings, Villiers Street, Buckingham Street, Durham House Street, Northumberland Street.

Then came the Adam brothers, John, Robert and James, with the Adelphi, a splendid riverside terrace of 11 houses built above barrel-vaulted warehouses and buttressed by the forward projection of the house at each end. The concept was Robert's, based on his visit to the palace of the Emperor Diocletian on the Dalmatian coast. Adelphi Terrace, Robert Street, John Adam Street and Adam Street recall the Adelphi, whose destruction was enabled last century by an Act of Parliament between the wars, permitting one Stanley Hinge Hamp, architect, to raise the elephantine office block that stands on the site now, called, with no obvious sense of irony, the New Adelphi.

'The demolition, which occurred in 1936, was one of the twentieth century's most notorious of an historic building,' English Heritage judges, '... the loss of the Adelphi is regarded as one of the watersheds of early conservation history.'

The watergate, built in 1626, may have been by Inigo Jones, but has also been ascribed to his contemporaries, the mason and sculptor Nicholas Stone and the brilliant Balthazar Gerbier, artist of a sort, architect, diplomat, adviser to the Duke of Buckingham and to King Charles I on the purchase of works of art and conman to the court at large, probably not by appointment. The gate is similar in style to Stone's gateway to the Oxford Botanic Garden, but Gerbier was living in York House at the time the gate was built. It has the arms of the Villiers (Buckingham family name) embowered in a wreath smudged by erosion, and four columns with heavy bands of rustication support the three rusticated arches. It is set on a stone platform adorned with potted palms on a little gravelled court at the back of Victoria Embankment Gardens. To see this and then to Google the Museum of London painting of as recently as 1872 by John O'Connor, a theatre scene painter turned fine artist, showing a full tide lapping against the watergate in the foreground, the Adelphi terrace behind, Waterloo Bridge and Somerset House stretching downriver – a city waterscape as fine as any in Venice or Naples or Benares – is enough to make a gondolier weep.

With a stiff upper lip, English Heritage has listed the New Adelphi

Cut off from the Thames: the watergate to the former York House.

grade II, observing that alongside Shell Mex House (the one with the squat clock tower known in the business as Big Benzene) it is 'part of a group of riverside buildings of considerable monumentality... with which the Adelphi has group value'. It can say that again.

WATERGATE WALK, WC2N 6DU; 1–11 JOHN ADAM STREET, WC2N 6HT

## GORDON'S WINE BAR

*The wine bar where customers pioneered sitting on their butts*

Gordon's wine bar claims to be the oldest in England. It certainly looks it. At the foot of a staircase descending vertiginously from Villiers Street is the bar, the colour of congealed mustard, as one reporter winningly noted; and that was many years ago. The point is that though the wine bar has been going only since the last years of the nineteenth century, the cellars date from the fourteenth. Off the bar is a cage which used to be the storage cellar but now seats up to a dozen people around a table, and a long, low brick tunnel vault lit by candles but so dark it would be hard to find your own granny there.

Where the tables in the tunnel bar are not rickety they are empty wine butts, almost impossible for customers to park their own butts on in comfort. Vintage sepia photographs and framed newspaper pages adorn the walls, there is a small board with wines of the day chalked up, a faded ad for OK Sauce, on the mantelpiece stands a fat-bellied wine flask, and above the grate a cartouche bears the slogan 'Luis Gordon / Sole

Concessionaires / Pedro Domecq / Jerez / Frontera'. The Luis Gordon who founded the sole concessionaires was unrelated to the Luis Gordon who opened the wine bar in 1890, but the latter Luis's descendant Andrew Gordon sold the wine bar in 1972 to another Luis, who was a descendant of the founder of the concessionaires. Thus, happily (if only for the sake of clarity), the different businesses continue under a Gordon umbrella. The import trade lives on in the oak casks of sherry and port behind the bar.

A few feet away is York Watergate (see page 102), stranded 150 yards from the Thames where it was once the river entrance to the gardens of York House. This was the London home of the 1st Duke of Buckingham where now stands the building with the much older cellar that contains Gordon's: in the last century the room above the cellar provided living and writing space for Rudyard Kipling and the east of the building, opening on to Buckingham Street, is where Sam Pepys lived with his manservant, business partner, friend and executor Will Hewer from 1679 to 1788, after the diary years.

Although Gordon's is louche, scruffy and said to attract rakish custom, I was introduced to it in 1957 by a young but very proper civil servant clearly destined for high success, and now duly knighted and retired with a clutch of directorships. On a recent visit the dark-suited clientele had such extended lunch hours that I assumed they were civil servants too, though not as committed as my old friend. Gordon's was much the same then and doubtless was much the same in 1857; although possibly not in 1364, when Edward III bestowed a royal patent upon the group of vintners who first set up here; so far as is known, not one of them a Gordon.
47 VILLIERS STREET, WC2N 6NE

## BENJAMIN FRANKLIN HOUSE

*'The first American Embassy'*

When Benjamin Franklin was in France cementing an alliance between the two countries, after the American Declaration of Independence and before the French Revolution, he would from time to time play chess with the old Duchess of Bourbon. During one game he put her king in check and removed it from the board. As Thomas Jefferson describes the outcome: *'"Ah," says she, "we do not take kings so." "We do in America," says the Doctor.'*

And so they did. Franklin had failed in his last task on a long posting from the American colonies to England to persuade king and Parliament not to impose direct taxes on the American colonies without either their consent or their representation in Parliament. George III and his prime minister, George Grenville, were unconvinced, and besides, they needed the money.

Franklin, born in Boston, first visited England aged 19 in 1725. He stayed a year, long enough to fall in love with the country and to learn the trade of printing in a print shop at 54 Bartholomew Close. It was 1757 before he came to London again, this time as agent for the Pennsylvania Assembly. He landed at Falmouth and, as all tourists do, 'stopt a little by the way to view Stonehenge on Salisbury Plain, and Lord Pembroke's

house and gardens, with his very curious antiquities at Wilton'. In London he found lodgings at 36 Craven Street, between the Strand and the Thames, with the widow Elizabeth Stevenson and her daughter Polly. Home again in 1763 for a brief year with the wife and daughter he had left behind, in 1764 he returned to Craven Street and the two women who had become a second family to him.

Number 36 is one of a terrace of four-storey houses planned by Henry Flitcroft, architect also of St Giles-in-the-Fields, and is claimed now as de facto first American Embassy in England. Like many a home of a famous Londoner where there was no family to keep the house going, Craven Street has nothing to recall this key founding father of the United States except its own authenticity, but that goes a long way.

The house's Georgian middle-class sobriety is enough: restored but essentially unaltered grey-panelled rooms down to original floorboards, shuttered sash windows, dog-leg staircase with nicely turned balusters leading to the grand, front-to-back reception area on the first floor (later split into two rooms) where Franklin pursued his scientific interests, original stoves and fireplaces. Everything just so.

This tour of duty stretched out for a further 11 years before Franklin grasped the failure of his mission. For a diplomat, though only notionally, he suffered an unconventional farewell, fleeing Craven Street in 1775 as the authorities closed in with a warrant for his arrest. The memory lingers of a staged debate in the house in which an interlocutor asked what would happen if England sent troops to enforce tax collection. Franklin presciently replied: 'They may not find a rebellion. They may indeed make one.' When his ship arrived back in America, the revolution had already begun.

36 CRAVEN STREET, WC2N 5NF

## LONDON TRANSPORT MUSEUM

*The history of Underground travel in posters*

The directors of the Victorian and Edwardian London Underground railways, divided until the 1930s between different companies, swiftly realised that the company's best chance of hitting the jackpot was to exploit the downtrodden middle-class city worker's need to work in the metropolis but to live the rural idyll, with all mod cons. The slogan blazoned across an Underground poster of 1912 read, 'Right into the heart of the country. Book to Harrow, Sudbury or Perivale'. The fields and hedgerows interspersed by trees in the picture didn't long survive the onrush of Gadarene swine and the bricks and mortar constituting the Metropolitan Railway's vision, Metroland.

This primal image survives in the London Transport collection of posters, and flourished when Frank Pick joined the Underground Electric Railways Company of London, also in 1912. It was Pick who commissioned the distinctive typeface for use on everything from trains to stations and posters and added Harry Beck's brilliantly functional abstraction, the London Underground map; Pick who

appointed the house architect, Charles Holden. The posters too became subject to Pick's micro-management. He built up an astonishing array of contributors, from starry young graphic designers like Paul Nash, Edward Bawden and Enid Marx, to the Bauhaus teacher László Moholy-Nagy, who was passing through to America from Hitler's Germany. The impetus carried beyond Pick to the post-war years, with the new generation of artists including Howard Hodgkin and R. B. Kitaj. Among them was the designer of a single poster of 1956, still illustrating village life 'in London's country': he was a recent Royal College of Art graduate, Leonard Cecil Deighton, and his career in illustration was to stop short in 1962, the year that, as Len Deighton, he published *The Ipcress File*.

The London Transport Museum holds its collection of more than 5,000 posters for both buses and underground trains in a wonderfully apt split-level conversion by the transport architects' department of the old fruit market in the south-west corner of Covent Garden piazza, a building with cast-iron girders and tongue-and-groove planking ceilings from 1862 that neatly blend with the architecture of the railway age, not to mention the century of the Great Exhibition and the nascent Underground. The building is stuffed with antique buses and underground trains including the earliest with nothing but tiny glass slits for windows, because there was nothing to see but smoke from the coal-powered engines.

The posters come and go to be replaced by others, but through the changing seasons it is clear that the most brilliant designer of them all, if only for his versatility, was the British-domiciled American, Edward McKnight Kauffer (1890–1954). His CV embraces an eclectic range of Kauffer-adapted Post-Impressionism, Fauvism, Futurism, Vorticism, and Cubism, extolling the gentle pleasures of Watford and Reigate, of Uxbridge (by tram) and Chingford, the necessity to shop early for Christmas and the advisability of buying a season ticket for the buses and underground. He produced artwork in gouache with simplifications of form and economy of tone which translated brilliantly into commercial lithography. He pushed the art forward from the French chic of Jules Chéret and Toulouse-Lautrec to a popular modernist medium combining immediately accessible messages with subtle appeal. In 1939, the US Embassy said it was time to go home. Our loss wasn't America's gain. In New York he couldn't resurrect his career.

COVENT GARDEN PIAZZA, WC2E 7BB

## ST PAUL'S, COVENT GARDEN

*Eliza Doolittle's church, where the great and good of showbiz are commemorated*

'The handsomest barn in England' Inigo Jones is said to have promised the Duke of Bedford when admonished to accomplish his church of St Paul's, Covent Garden, at minimal cost. In fact, the challenge suited Jones down to the ground. He was not in love with the Baroque interpretation of ancient Roman architecture prevalent in sixteenth-century Europe and wanted something big, plain and emphatic, like

the Etruscan architecture of the seventh and eighth centuries BC. So he built St Paul's as an Etruscan temple, with a monumental Tuscan portico at the east and massive overhanging eaves carried through to the no-nonsense pediments to the east and west of the church. Jones loved the idea of having the eastern portico as the entrance, for the sake of the grand Roman approach across the piazza, but the powerful cleric Archbishop Laud insisted that the east was where the altar belonged, and Jones had to comply.

If there were a secular saint for Covent Garden, it would be Liza Doolittle, the flower girl selling her wares from the portico ('I've a right to be here if I like, same as you'), or her interpreters, the enchantresses Wendy Hiller, Liza in the film of G. B. Shaw's *Pygmalion*, and Audrey Hepburn in the filmed Lerner and Loewe musical version, *My Fair Lady*. For throughout its history, the real driving force behind the role of St Paul's was neither duke nor archbishop but the proximity of the fruit and vegetable market, long since fled to Nine Elms, and the developing neighbourhood of theatres. Inside, the church is about as plain as outside, but the walls hold not just monuments but layer upon layer of plaques recording the theatre's glorious dead: Noel Coward, Ivor Novello, the impresario Emile Littler, Charlie Chaplin (or Sir Charles as the plaque has it), Terence Rattigan, the dancers Anton Dolin and Robert Helpmann, and the film star Boris Karloff (William Henry Pratt), the Forest Hill Road lad whose name is so inseparable from Frankenstein's monster that his plaque's inscription, from Andrew Marvell, comes as a surprise: 'He nothing common did or mean, / Upon that memorable scene'.

Here as well are a scribbler or two, one of them Philip Hope-Wallace (1911–79), opera and drama critic first for *The Times* then the *Guardian*, famed for his wit and concision. His memorial service was held here with music from the luminous Romanian soprano Ileana Cotrubas, who hurried across the piazza from the Royal Opera House with a scarf wrapped tight around her neck, and the pianist Clifford Curzon, playing a Fauré quintet with the Medici String Quartet. Daily, Hope-Wallace used to hold court at El Vino's in Fleet Street, where journalists from all publications came to pay tribute. El Vino's thought to honour him with an engraved brass plaque on his chair. The guv'nor rang the *Guardian* to check whether Philip Hope-Wallace had one l or two in his name. Two, of course, said the *Guardian*. And so Philip appears in El Vino's to this day with two l's. It's good then that St Paul's sent him on his way spelled correctly.

BEDFORD STREET, WC2E 9ED

## RED PHONE BOXES OPPOSITE THE ROYAL OPERA HOUSE

*Protected, up to a point*

Giles Gilbert Scott, the twentieth-century Scott (1880–1960) of the architectural dynasty, is more widely known than either his famous Gothicising grandfather or his father in the same line, first, for the stupendous and stupendously late-Gothic Anglican Liverpool Cathedral

(completed in 1978), then for the power station that now houses Tate Modern, and lastly for what's popularly known as the red telephone box, even though almost all types of telephone boxes were red except in Hull, where they were privately owned and grey. Scott's red telephone box is the thatched cottage of modern design, even more popular, if possible, than the old half-timbered Morris Minor, still to be spotted by keen watchers of the street scene and not totally dissimilar from Scott's sturdily mullioned and transomed phone boxes.

Since the introduction of mobiles they are living on their listing as protected grade-II buildings. At their best they stand smartly to attention in their guardsman-fresh red livery, like the five in Broad Court on sentry duty opposite the Royal Opera House. The other 2,000 or so listed booths linger on, some dilapidated, some ankle-deep in urine, some vandalised – because, of course, their protected status didn't deter vandals, with whom the phone box was even more popular than it was with the general public.

The finest moment in art for the red box (all right, its proper name is K2) must be the few moments of total anarchy in Alexander Mackendrick's film comedy *The Ladykillers* (1955) when Alec Guinness, Peter Sellers, Herbert Lom and Danny Green all struggle to pile into a phone box somewhere near King's Cross, a reprise of the Marx Brothers's mad moment in *A Night at the Opera*, though of course Groucho, Chico and Harpo had to make do with some inferior American call box.

CORNER OF BROAD COURT AND BOW STREET, WC2B

## SEVEN DIALS

*Gin Lane rehabilitated*

Thomas Neale, Member of Parliament, controller of the Royal Mint, 'Lord of the Lotteries' (for his lucrative role in regulating gambling), fellow of the Royal Society, and groom of the bedchamber, made his name for posterity as the speculator who developed the parish of St Giles-in-the-Fields. In 1693, at the point where seven roads met to create a traffic hub called Seven Dials – circus would be too grand a description for such a small space – Neale commissioned the master mason and gifted sculptor Edward Pierce (1635–95; also known as Pearce) to design a column as an ornament to his new development of grand houses. Alas, the area swiftly became a focus for derelicts, the scene of Hogarth's Gin Lane, and was still a slum in 1882 when Gilbert and Sullivan launched *Iolanthe* at the nearby Savoy Theatre, with a libretto that included a peer's lament:

> *Hearts just as pure and fair*
> *May beat in Belgrave Square*
> *As in the lowly air*
> *Of Seven Dials!*

Queen Matilda had founded a hospital here on the road between the City and Tyburn in 1101; the church of St Giles-in-the-Fields began as the hospital chapel. As John Stow puts it in *The Survey of London* of 1598: 'At this hospital the prisoners conveyed from the city of London towards

The column at Seven Dials was created to try to help the area shed its reputation as the *Gin Lane* engraved by Hogarth. The ploy didn't work and the column now stands on Chiswick green: this one is a copy.

Tyburn, there to be executed for treasons, felonies, or other trespasses, were presented with a great bowl of ale, thereof to drink at their pleasure, as to be their last refreshing in this life.' Neale's counter-intuitive intention was to transform this stinking slum into a smart urban setting for the upper crust of London society, and Pierce gave him a 40-foot column crowned with an entablature carrying a hexagonal spire with a ball finial and each face bearing an oval sundial.

In 1773 the London paving commissioners ordered the removal of the Seven Dials column. Today it stands on the altogether more salubrious green at Weybridge as a monument to Frederica, Duchess of York, who graced the town by dying there in 1820. In the 1980s, when Seven Dials was being restored as part of the plan embracing Covent Garden, Weybridge quite reasonably refused to part with the column, so the newly formed Seven Dials monument charity set about commissioning a replica.

Their choice fell on the architect Red Mason, who worked from Pierce's original drawing, now in the British Museum, with a team of student masons to carve the Portland stone, and the letter designer and cutter Charlotte Webb to replicate the six faces, coloured blue with the elegant characters in gold. The column itself is said to double as a gnomon standing in for the notional seventh face: the original six roads converging on the hub had become

seven at a stage when Pierce's work was already done. Now, rather than houses, fashion shops, boutiques, eateries, and the Cambridge Theatre draw the well-heeled crowds.

COVENT GARDEN, WC2H

## • LINCOLN'S INN FIELDS, BLOOMSBURY, FITZROVIA •

### SCULPTURE BY BARRY FLANAGAN, LINCOLN'S INN FIELDS

*A sculptor more interested in process than result, but leaping with joy*

Barry Flanagan was the man who modelled hares, hundreds of them, cast in bronze. Troops of them appeared in Park Avenue, New York, the Champs-Elysées, O'Connell Street, Dublin. Every corporation wanted one for their headquarters, and so from 1982 when he made the first hare until his death in 2009 Flanagan turned them out, on a production line you might say, except that they were all different. People accused him of selling out: figurative sculpture! Animals!! Cast in bronze!!! And they were confirmed in their opinion when Tate Britain mounted an exhibition of his early work, made of piles of sand, sacks of beans, or folded blankets, felt, hessian, trails of rope like meandering brush strokes, and cut-out sheet metal. But he hadn't sold out. A return to bronze was just another way of doing it. His sales gave him the means to afford bronze and he gave away the surplus cash in barrowloads.

Flanagan was in his sheet-metal period when Camden Council came calling in 1980, asking for a piece of sculpture for the corner of Lincoln's Inn Fields, the big square where Pepys would defy his puritan conscience by attending the theatre, and where Nell Gwyn once lived, and great lords and prime ministers; lawyers too, 'like maggots in nuts', in Charles Dickens's phrase. Flanagan named his sculpture *Camdonian* and it stands at the north-eastern corner where Great Turnstile enters from Holborn with the park in the middle of the square behind it. He could almost have taken a giant old-fashioned tin-opener to the metal and carved it open, forming a ragged shape with a surface as raw as a can of beans with the label washed off, a half rhyme to the trees behind. It supports itself on a section of metal cut away on three sides and bent backwards like the support for a photo frame; above that, the whole piece curves forward as though caught in a gale.

It was not just that he was proving that art could be made of anything. That really was old hat in the second half of the twentieth century. What drove Flanagan was sheer joie de vivre, the joy of taking a line for a walk, of watching it enclose a surface and create a shape. He was, it has often been observed, more interested in the process of making art than in the result, but this piece, like the drawings he constantly made, leaps into life.

LINCOLN'S INN FIELDS, WC2A

Barry Flanagan, master of sculpture in many media from bronze to bags of sand, created this ebullient piece, *Camdonian* (don't ask), in bronze-sprayed steel for a corner of Lincoln's Inn Fields.

## HUNTERIAN MUSEUM

*The exotic Indian rhino, in Lincoln's Inn Fields*

John Hunter was one of those eighteenth-century Scotsmen, like Boswell and the architect James Gibbs, who came to London and made a great name for himself, in Hunter's case as a surgeon. He arrived from East Kilbride in 1748 at the age of 20 to stay with his brother William and work with him at his anatomy school in Covent Garden. In 1761 he became an army surgeon and worked on treatment for venereal disease and gunshot wounds, the biggest threat, probably in that order, to the health of the rude soldiery. Empirical research became the basis of his approach to surgery and by the time of his death in 1793 he was famous for his teaching, his salon where artists and scientists met to exchange ideas, and his breadth of interest. His medical collection was interspersed with works of art and after his death the government bought it and gave it to the Royal College of Surgeons. As the Hunterian Collection, it is open free to the public in the grandiose home of the college directly opposite the Sir John Soane's Museum across Lincoln's Inn Fields. From the birds and tiny mammals bottled in formaldehyde to the human nervous system displayed flat against a board and nearly as complex-looking as the circuitry of a computer, this museum is the ultimate natural scientist's playroom.

The art interspersed with Hunter's medical exhibits is always chosen for its interest to scientists, mostly portrait busts of eminent surgeons including one of Hunter himself by the eighteenth-century sculptor John Flaxman, but even the pictures in the small gallery devoted to them are there for reasons other than their quality as paintings: dwarfs, Siamese twins, the nation's fattest man. The Indian rhino (*Rhinoceros unicornis*) painted by George Stubbs (1724–1806) was only the third sighting of one of these beasts in England; the previous one had been almost 60 years before. It arrived from the subcontinent aboard an East Indiaman in 1790 and went on exhibition at the Lyceum in the Strand where, the *Morning Herald* reported, 'a greater living curiosity has never appeared in this country'. One visitor remarked that its temperament was similar to 'a tolerably tractable pig', and despite the fierce samurai-style armour plating of its hide, Stubbs shows it manifesting every sign of boredom with its mild brown eyes and downturned mouth. After three years of touring the country the poor creature lay down and died.

Hunter probably commissioned Stubbs to paint the rhinoceros, since it was in his collection before he died, in the same year as the rhino. Nobody could have been better qualified for the commission. Stubbs had spent years making impeccable anatomical studies of men and beasts and was easily the best painter of horses this country has ever seen. He shows the rhinoceros on a stony plateau with a louring sky behind, stage set for a close portrait of an animal the artist regards with utter objectivity. Hunter, certainly, was pleased: in 1791 he bought at a sale a painting by Stubbs of a yak (Tartar ox), an animal which the first Governor General of India, Warren

Hastings, brought back to Daylesford, his ancestral home in Gloucestershire. Like pendant portraits the two exotic rarities hang, still curious to us where they hadn't been to Stubbs.

ROYAL COLLEGE OF SURGEONS, 35–43 LINCOLN'S INN FIELDS, WC2A 3PE

## SIR JOHN SOANE'S MUSEUM

*Soane, the star of his own show*

Hogarth is everywhere in London; in his time he *was* London. But though number 13 Lincoln's Inn Fields contains two of his great series of paintings, *The Rake's Progress* and *The Election*, it is primarily the house and museum that Sir John Soane (1753–1837) built in 1792–4 for himself and his huge, eccentric, eclectic jumble of collections: his pictures, sculptures, plaster casts, an Ancient Egyptian royal sarcophagus, and an invaluable cache of extraordinary drawings and plans by many of the great architects of the century and earlier. They inundated the house to such a degree that he bought and rebuilt numbers 12 and 14 to either side; in the main house, unchanged except that it is now known precisely as the Sir John Soane's Museum, Soane himself is the star to navigate by through the shifting spaces of his genius. When he died in 1837 Soane left his house to the nation. It is, as the museum's one-time curator Margaret Richardson writes, 'a museum piece among museums'.

The brick-built house announces itself from the outside as quirkily quasi-classical, with a Portland stone projection of three bays (the full width of number 13) narrowing to one bay at the second floor. At the first-floor angles of the projection stand two caryatids freely adapted from originals at the Erechtheion in Athens (there's a large fragment of the real thing inside, if you can find it), but on the face of the projection are four Gothic brackets lifted from Westminster Hall.

Like all Soane's buildings, it is subliminally disturbing, as though the architect had come by the design in a dream. But if the outside is disconcerting, that's nothing compared to the interior. Although it is stuffed with classical artefacts, the spaces themselves are mysteriously Gothic, reaching a climax in the lurid Monk's Parlour in the basement, where the main feature is the sepulchral chamber, a rectangular space as deep as the house. And then there are the apparently solid walls of the picture gallery, which fold back once to reveal more pictures and fold back again on to a vertiginous view of the floors below.

From the ground floor the visitor looks down on an area lit by a large dome in the roof. Here is the translucent sarcophagus of Pharaoh Seti I, who reigned from 1294 BC until 1279 BC and whose tomb was uncovered during the excavations of the necropolis at Thebes. In 1824 the British Museum refused to pay £2,000 for it, so Soane stepped smartly in. It is wonderfully, though now very faintly, incised with tiny tomb figures, inside and out, which well repay a close look from a wooden step at each end of the sarcophagus. Soane, of course, showed this prize acquisition to visitors by lamplight.

Off the entrance hall are two rooms merging into one, the dining room and

library, and they make a perfectly usable living space, even homely with its deep red walls and little canopies composed of semi-circular arches (another feature throughout the house). Soane's portrait by Thomas Lawrence hangs in the dining room and shows him apparently sane and civilised. Always bear in mind that the answer he supplied to questions about the Monk's Parlour was a quotation from Horace: *Dulce est desipere in loco* ('It is pleasant to be nonsensical in due place').
13 LINCOLN'S INN FIELDS, WC2A 3BP

## THE DUKE OF YORK, ROGER STREET

*A pub that travels incognito*

The Duke of York is a perpetual contender for understated pub of the year. Its hanging inn sign could hardly be more discreet: no picture, just blue lettering shadowed grey on an off-white ground; 'The Duke (of York)' (including the parentheses), then a little joke, 'Inn Business'; and across the top, on a separate shallow panel, the address, 7 Roger Street. The impression that the landlord is appealing to a select band of loyal customers is heightened by the front door: two slabs of solid wood which give the impression that the place is boarded up.

The immediate impression on entering is underwhelming too. Denis Edmund Harrington, who had trained in the offices of the exotic firm of architects Mewès and Davis (Ritz Hotel, Polesden Lacey), though evidently nothing rubbed off, designed this pub in 1937–8 as an integral part of Mytre House, a spec-built office block inhabited at first by Linotype when the age of hot metal seemed to stretch into the future in perpetuity. In 1936 the then Duke of York, Albert Frederick Arthur George Windsor, had become King George VI in succession to his abdicating brother Edward. Bertie, as he was known to his intimates, remained duke as well until the title perished with him, not to be recreated until it was felt appropriate for a second second son, Andrew, very much a royal in parenthesis. So it is difficult to guess the derivation of this ducal boozer. Maybe simply the grand old Duke of York.

Most of the fittings are, like the door, polished hard brown wood – the cubicles with crenelated glass backs to them, the dumb waiter, the dresser for bottles and glasses, the fire surround, the bar curving between the two main rooms and dented in both by many drunken heads, the red, black and white lino scuffed by 10,000 pairs of feet. The windows have the harsh metal glazing bars of the 1930s, the street door to the lounge bar (now a restaurant serving fish, chips, mushy peas, recommended by this customer) has a small frosted-glass window lettered in a squeezed sans face, reading inside out as E G N U O L, restorers have re-covered the chairs in what might be 1930s retro but they could possibly have reached further into the ragbag for an Omega Workshops pattern or thereabouts. Is there something a bit self-conscious here? But this is not the sort of Art Deco to which you would bring an American cousin or a French friend in search of the art of

Comfortable middle-class life at Charles Dickens's house in Doughty Street.

England. The Deco styling has travelled incognito through the years; it flew under Pevsner's radar and was not tracked down by English Heritage until 2010.
7 ROGER STREET, WC1N 2PB

## CHARLES DICKENS MUSEUM

*What very extraordinary things*

When Charles Dickens moved to 48 Doughty Street from rooms in Furnival's Inn in 1837 it was a step up the ladder. Dickens was a newly married writer who was experiencing his first success with the running serial of *The Pickwick Papers*. He and his growing family would stay only three years before moving on to a grand house in Devonshire Terrace, but the Doughty Street house at the heart of Georgian Bloomsbury is the single survivor of the several London houses where Dickens lived.

Here Dickens settled down to married life with his wife Catherine, and also, in the back bedroom, her sister Mary Hogarth (with whom Dickens seems to have been more in love than with his wife). Here too he completed *Pickwick Papers* and wrote *Oliver Twist* and *Nicholas Nickleby*, with only a slight pause in the weekly serialisation of the first two after Mary's shockingly sudden death at the age of 17 after the threesome had returned from a happy visit to the theatre. Here he began his professional association with Phiz (Hablot Knight Browne), who picked up the task of illustrating *Pickwick* after the first artist, Robert Seymour, killed himself seven illustrations into the task. Phiz did the remaining 37 etchings and worked on nine more books afterwards,

from *Nicholas Nickleby* (1838–9) to *A Tale of Two Cities* (1859). It was the perfect partnership; not, however, especially reflected in the contents at Doughty Street, any more than is the daily life of the Dickenses. This is simply a museum of objects with some attempt to provide context, but it's the best collection of Dickensiana in the world. There are portraits of Catherine and Charles by his friends Daniel Maclise, W. P. Frith and Augustus Egg. There's a bust of George Cruikshank, who illustrated *Sketches by Boz* and *Oliver Twist*, and eight monthly parts of the thirty-two in the *Nicholas Nickleby* serialisation (with the Phiz illustrations). There is Dickens's inkpot and the red leather chair in which Cruikshank portrayed the great man in Doughty Street. There are theatre memorabilia, best of all a vivid fin-de-siècle poster by Charles Buchel, the house artist hired by the actor manager Herbert Beerbohm Tree for His Majesty's Theatre, of Constance Collier as Nancy in Tree's production in 1905.

And, at the point where life meets art, here is a wooden carving of 'the little midshipman', which stood outside the premises of the real-life Messrs Norie & Wilson, nautical instrument makers, in Leadenhall Street, turned up as the sign of Sol Gills's shop in *Dombey and Son*, and now manifests itself in real life again on permanent loan to the museum. But there's nothing to beat the grandfather clock that stood in the Bath offices of the stagecoach operator Moses Pickwick, who was known to Dickens from his many coach visits to Bath, and acknowledged in chapter 35 of *The Pickwick Papers*, in which the ineffable Sam Weller draws Mr Pickwick's attention to the name in gilt on the coach door, Moses Pickwick. '"Dear me," exclaimed Mr Pickwick, quite staggered by the coincidence; "what a very extraordinary thing!"'
48 DOUGHTY STREET, WC1N 2LX

## FOUNDLING MUSEUM

*Hogarth's tribute to a kindly benefactor to foundlings*

Captain Thomas Coram RN, born in Lyme Regis in 1668, sent to sea at the age of 11, now retired and shocked by the sight of babies abandoned in the streets of London, sets out to create an asylum for foundlings. It takes him 17 years, tramping the streets of London collecting signatures to a petition, soliciting contributions, at the age of 70 covering 15 to 20 miles a day. The money is raised, land in the countryside north of Gray's Inn bought, the Foundling Hospital built, the children flood in. The new board of governors finds the blunt sea dog an embarrassment and casts him off. For the rest of his life he is the ghost at the feast, visiting daily, sitting in the colonnade (which is still there in Coram Fields north of Guilford Street in Bloomsbury), distributing gingerbread to the foundlings.

William Hogarth (1697–1764) paints him seated with a globe at his feet, a bluff white-haired old man, and donates the painting to the hospital. George Frederick Handel 'Generously and Charitably offered a Performance of Vocal and Instrumental Musick' to raise funds to complete the chapel, and he composes the Foundling Hospital Anthem for the occa-

sion. Hogarth and Handel each become governors and Hogarth encourages other artists to contribute paintings. They do, Reynolds and Ramsay, Francis Hayman, Joseph Highmore, Richard Wilson, Thomas Gainsborough, the marine painter Samuel Scott – Hogarth's roistering companion on a well-recorded weekend's boozing voyage up the Thames to Rochester, and others. But Hogarth is the top of the bill in his own show.

He was a popular though uneven painter, often thought of as the first truly English artist. He was born in the shadow of St Bartholomew's Priory, studied with the history painter Sir James Thornhill, but his own history painting is a rite of passage and doesn't suit his rough nature. London in the here and now was his project. Its abject down and outs, its hopeless drunks, its dissolute rich, its licentious soldiery, crowd his canvases. In the Foundling Museum too is his famous response, painted in 1749–50, to the government reaction to the Jacobite rebellion of '45, *The March of the Guards to Finchley* (which might better be called *The March of the Guards and Their Whores*). He was attracted by Coram's plans and what they built together lasted until 1954, though after the Blitz it moved out to Berkhamstead. Here in Bloomsbury, in interiors rescued from the bombing, hangs Hogarth's portrait of the hospital's founder. It is one of his best. Alan Ramsay painted the hospital's physician, Dr Richard Mead, as a pendant portrait. It hangs alongside, and the two paintings take up a whole wall. Hogarth's painting wipes Ramsay's out. Everything about it – the strong heavily veined hands, the big red coat with huge cuffs and collar, the big red face under a wild white thatch – is utterly vital, unpolished, unacademic, a living presence.

Outside the Foundling Hospital a woolly white mitten, apparently lost, is inverted on to the spike of the black iron railings, as if placed there by a thoughtful passer-by. Actually, it is a tiny sculpture in bronze by Tracy Emin, created for her exhibition at the museum a few years ago and acquired for the collection. Emin based it on the hospital's collection of foundling tokens assembled through the practice of inviting every poverty-stricken mother who abandoned her baby at the door of the hospital to leave with them a token by which to reclaim the child, should she be able to in future years. Many did, more never could. There were thimbles, coins, a child's ring, lockets, pieces of fabric embroidered or merely chosen for the pretty printed pattern: tokens of love, tokens of hope.

40 BRUNSWICK SQUARE, WC1N 1AZ

## ST GEORGE'S, BLOOMSBURY

*A seventh wonder by Hawksmoor*

In *Gin Lane*, Hogarth's etching of the dissolute, the dying and the dead of the notorious parish of St Giles, beyond the pawnbroker's sign stands the curious spire of St George's, Bloomsbury in the background, which the Bishop of London had consecrated in 1730. Its architect, Nicholas Hawksmoor, based the spire on one of the seven wonders of the ancient world, the vanished mausoleum of Halicarnassus in Turkey, as described by

# Dickens's London

Dickens's London is all the world's London, with its social inequality, humiliation of the poor, dismal jobs, thieves' dens, violence, pubs, prisons, disease and death. Charles Dickens was born in 1812 (d. 1870), but whether his fiction is set in the nineteenth century or late in the eighteenth, the time of the French Revolution (*A Tale of Two Cities*) and the Gordon Riots (*Barnaby Rudge*), it feels like solid Victorian currency. The rough comedy of Mr Pickwick's Cockney factotum, Sam Weller, or Fagin's right-hand boy, the Artful Dodger, made his readers laugh, and the heart-tugging tragedy of Nancy's murder in *Oliver Twist* made them cry. To a Soviet public possibly not much prone either to laughing or crying, this was Socialist Realism with a human face and Marxist critics slipped him in under the Iron Curtain as a critical realist, the Red equivalent of the virtuous pagans who escaped damnation because they never had the chance to embrace Christianity. In China too Dickens was not only the most-read foreign author from his first translation in 1890 until the Cultural Revolution, he was also considered safely within the canon of Socialist Realism.

Dickens's first publication was *Sketches by Boz* (Boz was his pseudonym for one book only), serialised throughout 1836 before publication in two volumes. He was only 24 and the writing shows it; but its plotless observation of anonymous characters whom he trawled the London streets to find, using his notebook the way Cartier-Bresson would later use a camera, harvested the catch which he drew on for his subsequent novels, pouring out as serials and then collected as hardback novels (today's equivalents to TV series and their subsequent box sets). He picked up the idea of the Artful Dodger from a boy he had seen in court cheeking the magistrate and first sketched in *Boz*; Sam Weller from a street Cockney: and here's the Beadle in *Boz*, 'one of the most, perhaps the most, important members of the local administration... and the dignity of his office is never impaired by the absence of efforts on his part to maintain it'; then fully realised in *Oliver Twist*: 'He was in the full bloom and pride of beadlehood; his cocked hat and coat were dazzling in the morning sun; he clutched his cane with the vigorous tenacity of pride and power.'

The Dickens tours prolifically available today tend to emphasise the London that still belongs to Dickens. But it doesn't. Maybe it never did but rather was deflected through the prism of Dickens's vision, but education and mass media, modern communications and job mobility, immigration and the greater spread of wealth at least until about ten years into this century, have left Dickens's London as an emptied container. So, of course, did the conquest of hygiene over the filth, stink and disease of the streets and river, a triumph which largely belonged to a local government civil engineer called Joseph Bazalgette, whose status now is hardly trumpeted compared to the builders of railways, steam ships, bridges and tunnels. The only tunnels Bazalgette built were for sewage, plus pumping stations like Crossness on Erith Marshes or Abbey Mills in the Lea Valley and, later, when it became clear that the tides simply moved the sewage from the open sea back upriver, the treatment works.

So we have the tarted-up Old Curiosity Shop; the Bloomsbury house in Doughty Street (the Dickens Museum) where Mary,

the sister-in-law Dickens loved more than his wife, died; the site of the Marshalsea Prison (destroyed) in Borough, where John Dickens, Charles's father, was incarcerated for debt; Saffron Hill in Holborn, where Fagin harboured his den of thieves; Seven Dials, a notorious rookery: all now outwardly blameless and in many cases commercial or happily domestic husks of what they were in Dickens's fiction, so closely drawn from fact.

*Pickwick* was the first novel, originally serialised in monthly instalments as *The Posthumous Papers of the Pickwick Club: Containing a Faithful Record of the Perambulations, Perils, Adventures and Sporting Transactions of the Corresponding Members*, and in book form late in 1837. The author was 25 and assured of a fortune for life had he wanted to leave it at that. Princess Victoria came to the throne in June 1837, shortly before *Pickwick* was published in book form: *Boz* and *Pickwick* set the pattern that Dickens and his publishers would follow until he died in 1870 at the halfway point of *Edwin Drood*. Even that, with several episodes to go, was published as a novel, Dickens's unfinished symphony. Nowadays they'd get William Boyd or John Banville to complete it.

The one of Dickens's many former abodes to survive: 48 Doughty Street.

Pliny the Elder who, after enumerating the four sculptors who each worked on one of the four sides of the mausoleum, continued: 'There was also a fifth sculptor. For above the colonnade rises a pyramid as high again as its substructure, tapering in twenty-four stages to its apex. Here there stands a four-horse chariot in marble made by Pythius, which brings the overall height to about 150 feet.'

Hawksmoor obviously looked upon Pliny's first-century text as a work to set alongside Vitruvius (died about 15 BC) rather than the sixteenth-century texts of Palladio and Serlio commonly used by his contemporaries. He cut Pythius's prescribed 24 stages to 18, and clearly could not visualise a four-horse chariot on top of a spire, so the Bloomsbury parish had instead to put up with a statue of (the recently dead) King George I, albeit togged out as an ancient Roman standing on a Roman altar.

As a commissioner for Parliament's Fifty New Churches Act of 1711, Hawksmoor was well placed to award himself the contract to build half the 12 churches completed. St George's was the last and best; now that it has been magnificently renovated it looks like the most imaginative building of his life. *Gin Lane* shows it crowded in by houses, yet Hawksmoor himself negotiated the purchase of the plot of land for the church, so circumscribed that he could only place the impressive main portico with its huge Corinthian columns to the south instead of the normal west, so that it could be observed from Bloomsbury Way.

By the last decades of the twentieth century the interior was in miserable shape. Then a £9 million restoration in the new century brought the church back to its full glory. In 2006 the lions and unicorns which G. E. Street had removed in 1870 were repositioned at the base of the spire, having been resculpted by Tim Crawley. The restoration team reordered or stripped out Street's internal 'improvements', and in the apses and square nave replaced the north and south galleries. They returned the liturgical east of the church where it belonged, at the geographical east with, naturally, the altar and noble Caribbean mahogany reredos, and placed the font in which the infant Anthony Trollope had been baptised in the south of the church. They spruced up Isaac Mansfield's gorgeous plasterwork in the ceiling and from the plaster rose suspended the rare and lovely seventeenth-century Dutch chandelier on loan from the V&A, an inspiration that would have made Hawksmoor clap his gouty old hands together for joy.

BLOOMSBURY WAY, WC1A 2SA

## STATUE OF CHARLES JAMES FOX, BLOOMSBURY SQUARE

*The man beneath the Whig*

Bloomsbury is Russell territory. The Earl of Southampton laid out Bloomsbury Square in the late seventeenth century, but when he died his property passed through a daughter to the Russell family, Earls of Bedford, Dukes of Bedford and their heirs, Marquesses of Tavistock, whereupon Russell Square sprang up, and Tavistock Square, Bedford Square, Woburn Square, and a grid of Georgian

streets and courts and places to link them, now eaten into by war and the visual atrophy of London University. Lord Southampton's own house was at the north end of what later became Bloomsbury Square, but in 1642 the Civil War broke out. He resumed building in 1660, at the Restoration, and chose to sell leases with the injunction that each lessee should build a substantial house. He saw to it that the street grid also contained shops and cheaper houses and constituted a quarter that John Evelyn described in his diary as a 'littel town': this was to prove the pattern of development throughout the West End.

Lord Southampton died in 1667 and the Russells completed Bloomsbury. Today the square remains surprisingly atmospheric, though the original fabric is mostly gone, just a terrace along the west side remaining. Bloomsbury Way, a continuation of New Oxford Street, forms the south of the square and carries the full weight of London bus services from the West End to points further east; the square has a large paved area instead of grass. Yet it retains a sense of the semi-rural idyll it once was.

The Russells were long-term Whig supporters, and Francis Russell, 5th Duke of Bedford, was a Foxite Whig and member of the Fox Club: what survives of this in Bloomsbury Square is Richard Westmacott's bronze statue of Charles James Fox, possessor of Whig England's greatest mind and unruliest character. Club members followed Fox in being ferociously anti-Pitt and deeply suspicious of the monarch, George III, whom they suspected of conspiring to curtail the freedom of the subject. The duke had a Nollekens bust of Fox at Woburn (still there), and other originals and at least 30 copies existed in great Whig houses. Today even the Royal Collection has one of its scallywag enemy. Westmacott's statue, isolated by handsome protective railings to the north of Bloomsbury Square, was erected in 1816, ten years after Fox's death, in homage to a man whose political career ran into the sands of scandal but whose libidinous, drunken, gambling ways remained legendary in a hard-drinking and whoring Whig society (the post-mortem autopsy showed Fox had a grossly hardened liver). The statue shows him seated, erect and dignified in a toga, shod in sandals, his right hand balancing on his knee a rolled document sealed with the figure of Justice. This is Fox, the bringer of law. It's the customary, and to us customarily boring, accolade accorded to great men of the period, but the sculpture bears close examination for the human corpulence of Fox's waist and the balding head, the easy plumpness of cheek and jowl, the sensuously curved lips, showing that the man's a man for a' that.

The statue looks north towards Russell Square, which sports the same sculptor's statue of the 5th Duke.
BLOOMSBURY SQUARE, WC1A

## JAMES SMITH & SONS

*Never a rainy day in the top-end brolly business*

New Oxford Street is Oxford Street's much smaller and even less attractive brother, running westward from the

7
JANUARY

Large Handles

AB

CDEF

GHIJ

junction with Charing Cross Road and Tottenham Court Road and soon petering out at High Holborn. There's one good-looking late-Victorian pub, the Bloomsbury Tavern, where the top of Shaftesbury Avenue meets New Oxford Street, and at number 53, Hazelwood House, it has an outstanding sight: James Smith & Sons' umbrella shop, established 1830 to manufacture and sell ladies' and gentlemen's umbrellas, tropical sunshades, garden and golf umbrellas, Irish blackthorns, malacca canes, riding crops and whips, shooting sticks ('the celebrated Tunliffe sports seat'), and, when the map of the world was largely coloured British Empire pink, a big business in military swagger sticks. Swagger sticks aside, business still flourishes.

All this is profusely advertised in Victorian decorative lettering painted on glass framed in a shopfront of mahogany beneath glass fascia boards bearing the name of the proprietors, not once but many times (the same family today as always), the initial capitals coloured red and interwoven with green foliage. For most of the nineteenth century book and newspaper typography was dismal, but from early in the century the burgeoning marketing and entertainment industries brought with them innovatory typefaces long before Art Nouveau decoration turned kitsch into art.

The Smith shop is a rare if glorious survivor of mid-Victorian display: it dates

Same family from way back, same shop from 1857: James Smith, purveyor of umbrellas and sticks to ladies and gentlemen. Only sword sticks and swagger sticks have fallen from fashion.

from 1857, when James Smith, son of the founding James Smith, moved there from the original West End premises, where they boasted two prime ministers, Gladstone and Bonar Law, and a Viceroy of India, Lord Curzon, as customers. Today at number 53 the display is, naturally, all sticks and umbrellas. Sticks range from simple chestnut at around £25 or maplewood inlaid with mother of pearl at £75 to silver-topped canes or buffalo-horn sticks for which you must coax the shop assistant to whisper a price into your ear. There are hollow sticks containing dice or maybe a phial of whisky, though nowadays never a sword. Umbrellas might be striped or plaid with a malacca handle, or lacy, theoretically for women only (ladies, as they are known in the trade). Style and content mesh seamlessly, a brave survival in a humdrum world.

53 NEW OXFORD STREET, WC1A 1BL

## CONGRESS HOUSE

*Epstein's sombre tribute to the war dead of the trade union movement*

There's the British Museum, of course, but another excellent reason for visiting Great Russell Street is to see the astonishing and little-known Congress House, the TUC headquarters and beacon of 1950s design with its curved glass stair drum. The plans came off David du Rieu Aberdeen's drawing board in 1948, even before the Royal Festival Hall was built, though the building wasn't ready until 1956 and for all sorts of reasons except quality has never matched the Festival of Britain showpiece for fame. Congress House prefigures late

twentieth-century work from the likes of Richard Rogers and Norman Foster, David Chippendale and Zaha Hadid, but at its opening was not much liked by purists: so no one better to create the building's stark Second World War memorial to unionists killed in the conflict than Jacob Epstein, who had been not much liked by anyone at all.

Aberdeen won the commission for the building on the corner of Great Russell Street and Dyott Street in competition; the chosen sculptor was to have been subject to a competition as well, but Epstein refused to compete. The TUC gave him the job anyway, and Bernard Meadows, who did compete and win, in effect made a second-prize winning figure group for the entrance canopy: a unionist Good Samaritan helping a fallen comrade.

Epstein chose a Pietà as his theme, a Mother Courage figure with a dead soldier, in the spectacular lightwell of the courtyard at the centre of the building, visible from the café through the huge sheet of glass forming the courtyard wall and in fact visible from Dyott Street outside, beyond the exterior glass wall. Aberdeen provided the tremendous backdrop of a mountain of marble, shown in early photographs of Epstein balancing on the narrow plank which would be home to him as he carved, sizing up the ten-foot-high, ten-ton block of Roman stone he had chosen. The green marble looks marvellous in the photographs but it rotted faster than a green banana and the TUC not surprisingly felt obliged to replace it with a serviceable but dull pyramid shape of green mosaic.

Epstein's Pietà, similar to *Night*, a mother and child he had carved in the winter of 1928–9 on the face of the London Underground headquarters at St James's

Park station, is quite unlike the bronzes that were more acceptable to most clients. He carved directly into the unyielding stone as his tools shattered and the building rose around him, and for the first time in his life he brought in an assistant. The woman's hands, as big as shovels, clamp the lifeless body of the soldier to her bosom, her sledgehammer feet are planted apart on the tall plinth, the cowl around her head drops in shallow curves around throat and shoulders but barely softens the unrelentingly harsh geometry of the verticals and horizontals articulating the two figures.

GREAT RUSSELL STREET, WC1B 3LS

## MOSAICS BY EDUARDO PAOLOZZI, TOTTENHAM COURT ROAD STATION

*An enemy alien who became a great British artist*

Some commentators like to claim the mosaics by Eduardo Paolozzi in Tottenham Court Road Underground station as one of the greatest works of Pop art. They aren't, partly because Paolozzi (1924–2005) was not a Pop artist, though he has some claim to being an initiator, but mainly because despite the powerfully concentrated colour and imagery of the mosaics, their effect is too dissipated along platforms, around corners and among moving groups of travellers. Yet

Jacob Epstein carved this harsh Pietà as the Trades Union Congress Second World War memorial from a ten-ton block of Roman marble. It is displayed at Congress House against a mountain of Aberdeen green marble.

they are astonishing and, though a few have already been lost, Transport for London must be held to its promise to preserve those which remain, through the massive rebuilding of the station (continuing at the time of writing).

Paolozzi became one of the most innovative and influential of post-war British artists, though his childhood when he was banged up in Saughton Jail in 1940 as an enemy alien hardly promised that. His Italian father had routinely sent him from their home above their ice-cream shop at Leith Walk in Edinburgh to young fascist camps in Italy, as though to the boy scouts; but then Paolozzi was only 16 at the time of his arrest. After his release he was called up into the Pioneer Corps, and in 1945 he went to the Slade School of Art in Gower Street, which seemed much the same to him. He quit the Slade and went to Paris. There, he met all the bricolagistes, collagistes, assemblers of nuts, cogs and any old iron, Cubists, Realists, Léger, Picasso, Dubuffet, Braque, the old Dadaist Tristan Tzara, and Giacometti. Back in England he gave a lecture consisting not so much of words as of images from comics, advertising, magazines, tabloids, and sci-fi publications. His audience was a like-minded group of artists, academics and critics, including Peter Reyner Banham, the architects Alison and Peter Smithson, Richard Hamilton, and many others. Together they blew the cobwebs off British art and Paolozzi became a prime mover.

In one of Scottish National Galleries' two museums of modern art, the Dean Gallery, is Paolozzi's reconstructed studio full of a clutter of unfinished sculpture,

heaps of magazines and papers, an aeroplane propeller and machine parts: one look at this cornucopia of rubbish says what's behind the Tottenham Court Road murals. Many artists of his generation revered the thunderous thoughts of Nietzsche; more to Paolozzi's taste was Wittgenstein, a philosopher so profound that only about half a dozen people in the world ever understood him. Maybe Paolozzi was one of them, but maybe he simply took from Wittgenstein what he needed, a few random sayings (not necessarily from the *Tractatus Logico-Philosophicus*) like, 'A picture is a fact', and, 'If a lion could talk, we could not understand him', and, of course, 'Don't think, but look'. All of these say something about the genesis of Paolozzi's brilliant mosaics, part Pioneer Corps, part figurative, part abstract, those bits of any old iron, those cogwheels, a man running, a saxophone, as tightly knit as a Mondrian abstract but jumping, jumping. In the brilliant new white-tiled twenty-first-century Tottenham Court Road Underground they will be wonderful, but see them now before work is complete, on the Central Line or the Northern Line or whatever is open to the public.

TOTTENHAM COURT ROAD, W1D

## STATUE OF MOHANDAS GANDHI, TAVISTOCK SQUARE

*The sage of independent India commemorated in the capital where he was derided*

While other statesmen gaze farseeingly from horseback at the horizon, or stride imperiously across their plinths,

Mohandas Gandhi squats cross-legged on his hollowed out pedestal in Tavistock Square as though before his loom. It must have been from news photographs that the sculptor, Fredda Brilliant (1903–99), worked, since Gandhi was assassinated by an extremist Hindu in 1948 for perceived treachery in reaching out in friendship to the Muslim community. It is entirely apt that he should appear clad only in a dhoti in the city where Winston Churchill derided him in 1930 as a half-naked fakir stirring up sedition. Apt too that the bronze statue should be unveiled in 1965 by another prime minister, Harold Wilson, rounding off the traditional colonial ritual: decry, imprison, consult, consent, acclaim.

Fredda Brilliant was born in Łódź, Poland, of Jewish parents, and married the English film director Herbert Marshall in Moscow in 1935. She met him when he was studying with Sergei Eisenstein, and made a bronze statue of the great Russian film maker and, later, a portrait bust of the poet Mayakovsky. The notoriously uncommunicative Stalin apparatchik Vyacheslav Molotov refused her request for sittings. On her move to England with Marshall she played opposite Michael Redgrave in her husband's production of the anti-fascist play by Robert Ardrey, *Thunder Rock*, at the Globe Theatre in Shaftesbury Avenue in 1947. She took lessons in opera singing, was a novelist, short story writer and essayist, and a social and artistic success in India in the early years of Independence.

Part figurative, part abstract: a detail from one of Paolozzi's brilliant mosaics at Tottenham Court Road Underground Station.

She was less than a Renaissance woman, but more than a dilettante. Her Rodinesque figure of the Mahatma (the honorific meaning 'holy man', or 'sage', by which Gandhi was known) brightens a London scene in which there are too many undistinguished, dutiful statues of famous men of the last couple of centuries. The bone and tough sinew of the almost emaciated Gandhi catch the light and create a vivid impression of the willpower of the old ascetic who pretty well single-handed kept forcing the British Raj back into negotiations and finally into conceding Independence, but with that fatal flaw, the division between Hindu and Muslim.

TAVISTOCK SQUARE, WC1H

## PETRIE MUSEUM OF EGYPTIAN ARCHAEOLOGY

*How Cleopatra must have looked*

Through a door like the entrance to student rooms off the northern rump of Malet Street that acts as a pedestrian entrance to UCL, and up an old staircase, another door gives on to three fusty rooms lined with bookcases and vitrines that stand stacked to the ceiling. There are broken stelae, thousands of shards of pottery and even whole pots, carvings, paintings, papyruses, examples of the famous painted Fayum funeral portraits, mummy masks, the oldest piece of linen in the world, a bead dress for a dancer of 2,400 BC: 80,000 pieces, all meticulously labelled in crabbed handwriting or in a typewriter face almost as ancient as this rescued detritus of the Nile valley. Some

of it is well above eye level and impossible to see without steps. Welcome to the Petrie Museum of Egyptian Archaeology, the premier teaching museum in the subject in the Western world.

Flinders Petrie (1853–1942), too feeble as a boy to be sent to school, grew up to be the most tenacious, prolific, yet painstakingly accurate of archaeologists, spending whole winters in solitary labour. Other archaeologists working in Egypt in the 1880s were like Atlantic fishermen, picking up what they wanted and dumping the rest. Everywhere dealers from the back streets of Cairo hung around, buying finds from the labour force. The general belief was that the major pieces, many of which were Petrie's discoveries, constituted the available history of Ancient Egypt, and that the rest could be disposed of. Petrie knew that his job was to rescue what he could before it was dispersed or destroyed, and it is the rest, or that part of it which he kept for his own collection, which eventually he sold to University College, where he was Professor of Egyptology for more than 40 years. He devised a system of cards to enable statistical analysis of the results to compile a picture of a vanished civilisation reaching from pre-history to the Roman period; it was a system not taken up again until the advent of computers in the 1970s.

Impossible, of course, for a layman to make sense of any of this, but there are some wonderful fragments. To pick one superlative limestone carving from the Ptolemaic period, which lasted from 305 BC until Cleopatra yielded to the Romans (or at least two of them) in 30 BC: it shows two goddesses in the familiar stylised pose – body shown frontally, head in profile. One in particular wears a finely articulated necklace of five strands, covering her from the base of the throat to the shoulders; her hair hangs down to her breasts, beaded as formally as the necklace, and she wears an elaborate and sculptural viper headdress. Her face, modelled with striking subtlety, is marked by intelligence, sensuality and willpower. Here, one feels, we get as close to how Cleopatra must have looked as we ever will.

There is a photograph of Professor Petrie taken in the 1920s or thirties, peering into one of his showcases in the museum. Except for the absence of the man himself, the scene has not changed. Long may it stay so.

MALET PLACE, WC1E 6BT

## RELIEF SCULPTURES BY JOHN FLAXMAN, UCL

*John Flaxman's greatness revealed*

William Wilkins has faced enduring scorn for his National Gallery with its unimposing façade and starveling dome. But his dome behind the gigantic Corinthian portico of University College London not only salvaged the reputation of its architect, it also kept a light burning for Wilkins's contemporary, the sculptor John Flaxman (1755–1826). For in the walls of the rotunda is set a collection of the working models in plaster which are the closest Flaxman came to greatness.

He was regarded in his time as the best of his generation of British sculptors – unaccountably, it may seem to us. He

laboured under the disabling general view that the baroque sculpture of the preceding generations was beneath contempt (which dismissed the like of Bernini and Roubiliac); he seems to have bought into Joshua Reynolds's theory of the superiority of classical art as a model for all subsequent art; and his works were carved by assistants working from smaller models and using an improved version of the pointing machine, a system of callipers which allowed swift copying and production of marbles with a fine mass-produced academic sheen. Add to all those limitations his natural inclination towards a non-sculptural linear art rather than an art of mass and space, and you have the Eric Gill of his era. This is why both Flaxman and Gill are at their best with relief sculpture, which in a sense is drawing in 3D.

In fact, on the continent it was not his sculpture but Flaxman's illustrations of Homer that were regarded as a model for Neo-classical artists; even the great Ingres kept examples pasted into a notebook. Yet while many of Flaxman's smaller relief sculptures, like the memorial in Bath Abbey to an Oxford professor of botany, are blessed with charm and gaiety, a great set-piece sculptural group like *St Michael Overcoming Satan* seems only yawn-inducing. Presumably it was meant to rival the great set-pieces of ancient classicism, the *Laocoön* and the *Apollo Belvedere*, but although Flaxman's riposte is beautifully conceived it makes only a desultory centrepiece to Lord Egremont's sculpture gallery at Petworth. The full-size plaster model for it, however, stands at the centre of the display under the dome at UCL, where it pulls the whole ensemble together, architecture and sculpture.

More to the point, looked at piece by piece, the white relief sculptures set into terracotta-painted walls show a different Flaxman, an artist stripped of his habitual mechanical finish with instead an instinct for soaring movement and spectacular ensemble. Here they are in all their original rawness, fresh and vital as they were when Flaxman shaped them with quick sensitive fingers a couple of hundred years ago.

Incidentally, in the passage to the rotunda is the figure of Jeremy Bentham, philosopher of 'the greatest happiness of the greatest number' and founder of the college. At his request, his skeleton sits in his everyday clothes complete with a tall straw hat. Only the painted mask of his mild face with benign blue eyes is artificial.
GOWER STREET, WC1E 6BT

## GOVERNMENT ART COLLECTION

*Pictures as pawns in the great game*

Four lanes of traffic press relentlessly north along Tottenham Court Road. It's noisy and it's smelly, but here you can buy a newspaper and sample the ultimate burger or pause a little longer in a Lebanese eaterie. There are as always multiple electronics shops and computer stores. Heal's adds tone but the grand house of Maple's, furniture suppliers to the British Empire, is, like the empire itself, consigned to history. Just off the main drag in an alley called Queen's Yard is a six-storey white-painted anonymous

brick block. It seems a likely setting for the seedy spy Harry Palmer of *The Ipcress File*, not for what actually is there, the Government Art Collection.

It's not a state secret. At present it allows pre-booked parties to visit and there are plans to show individual visitors around. It contains art, but it's a working department, not a gallery, receiving, checking condition, restoring, reframing, dispatching. The art is preponderantly British, 13,500 works acquired since 1898 and growing, augmented from a hopeless annual budget of £200,000, and ranging from work by Gheeraerts the Younger (1561/2–1636, *Elizabeth I*) to the curiously switched-off, minimalist figurative painting by Julian Opie (b. 1958, *Aniela, Singer*). It supplies government offices, ministries, Downing Street, embassies and high commissions around the world, 400 buildings in all. Among the resting paintings, Ruskin Spear's portrait of Harold Wilson stands in a corner, not much in demand with politicians these days, though another portrait, full-length, of George II from the studio of Charles Jervas, is here only on rota, because there are a couple of other George IIs as well. One or other, it is felt, should always hang in 10 Downing Street since this was the monarch who first gave the house to the British Prime Minister, then Robert Walpole.

Abroad, the Paris and Washington Embassies get the pick of the collection. Washington has George III, which seems a mite masochistic given that he let a perfectly good colony slip its collar. The Athens Embassy usually sports the emblematic portrait of Lord Byron by Thomas Phillips (1770–1845). These are not just classy pictures, they are pawns in the great game, designed to celebrate an entente, discreetly alluding to shared cultural values and reminding guests of England's helpful involvement with their country. An ambassador might remark on a painting behind his desk as he welcomes a high official of his host country, though it's difficult to imagine what conversational gambit he might rise to if the place were the British Ambassador's residence in Paris, the painting the full-length portrait by the humiliated acolyte of Napoleon, Baron Gérard, of the victorious Wellington, and the visitor, let's say, the President of France.

In other words, what's hung and how can prove tricky and, possibly, fun for subtle minds. In 2004, for instance, at the centennial anniversary of the entente cordiale, the portraits usually in situ in the splendid ante-room in the rue Faubourg-St Honoré were of Wellington alongside Princess Pauline Borghese, sister of Napoleon – provocative, it might have been thought. So they were replaced for the occasion with an oil by Anon. after Philip de László of Lord Lansdowne, who as foreign secretary in 1904 fixed the entente cordiale with England's ancient enemy France, and a drawing of the Parisian society favourite and partner in the entente, King Edward VII, by Vilma Lwoff-Parlaghy, a German aristocrat who specialised in portraying aristocracy, nationality no barrier.

QUEENS YARD, 179A TOTTENHAM COURT ROAD, W1T 7PA

## POLLOCK'S TOY MUSEUM

*Eric, the oldest bear in the world and a truly ancient mouse*

Hamley, checked in the stalwart *Oxford Dictionary of National Biography*, yields:

> Hamley, Edward (bap. 1764, d. 1834), poet
> Hamley, Sir Edward Bruce (1824–1893), army officer and military writer

And that's it. Not a whisper of Hamley, William, which seems a little stuffy since he's the man who invented childhood in 1760, or at least commercialised it, by founding the biggest toy shop in the world. Today's glossy new Hamley's toys could be tomorrow's exhibits at Pollock's Toy Museum; but whether Hamley's customers today could adjust to Pollock's Toy Museum – probably the smallest museum in the world, three tiny floors of a couple of rooms each linked by steep and rickety stairs – is less certain. The museum looks as though it has been at its raffish urban cottage premises at 1 Scala Street forever, but when a printer, bookbinder and tobacconist called John Redington added toy theatre sales to his business in 1851 it was at 73 Hoxton Street. His daughter Eliza and son-in-law, Benjamin Pollock, inherited the business in 1873. Pollock lived until 1937. Under new management, it was bombed in 1944, relaunched in Monmouth Street in 1955 and switched to Scala Street a year later as a toy museum, now run by a trust.

It is a vivid but erratic collection: Matchbox toys, say, but no Dinky fleets of replica Austin 7s, Rollers, RAC motorbikes each with mounted patrolman, plus military hardware, primarily Spitfires, Hurricanes, Blenheim bombers and the enemy Junkers Ju 89. That's what you'd call a boyhood (the sex argument is water off a duck's back in Pollock's). Up the creaking staircases is a showcase full of teddy bears. Here's sad Eric, blind in one eye, one ear missing, gungey brown, and billed as the oldest teddy bear in the world which, since he was made in 1904 and the teddy bear was invented in 1902, makes the claim more feasible than all the others made for all the well-groomed bears elsewhere that have clearly never shared a child's life. There are toy acrobats and clowns, circuses, board games, a zoetrope of 1834 (don't ask; stick to your TV), Action Men and space toys, rocking horses, Hungarian moulds for gingerbread men, prams and baby dolls, down-the-rabbit-hole dolls' houses, an American ventriloquist doll, rag dolls, Japanese acrobats, Ukrainian and Russian peasant dolls side by chummy side, an Egyptian toy mouse in better nick than Eric the bear even though 2,000 years older than Shakespeare's serpent of old Nile, Cleopatra.

Which brings us to the theatre prints: all those Benjamin Pollock lithographs arranged like theatrical flats, 'penny plain and twopence coloured', in the phrase minted by Robert Louis Stevenson, a childhood buff. Best of all is an exquisite, almost Claude-like view of a harbour with sailing ships viewed through a curtained and tasselled proscenium arch and down broad steps to the waterside; it is the product of Imagerie d'Épinal, a business set up by the woodcut artist Jean-Charles Pellerin in 1795 and into the fourth

generation of Pellerins in 1890, when it produced this theatre print. Minus any Pellerins, the firm continues in Épinal (I've visited it in my role as an ex-child), and as a regular eBay feature.

1 SCALA STREET, W1T 2HL

## ALL SAINTS, MARGARET STREET

*Butterfield's masterpiece*

An Open City fact sheet about All Saints, Margaret Street asserts: 'On entering the church, one is met by a reverential gloom, invariably infused by drifting clouds of incense.' Maybe the church had mislaid the incense censer for one particular Tuesday lunchtime mass, when the only cloud about was in the vicar's Bible reading from *St Luke* (9.35): 'And there came a voice out of the cloud, saying, "This is my beloved Son: hear him."' Still, it is true that All Saints is High Church, founded as such by Tractarians and designed in 1850-59 by William Butterfield (1814-1900), no stranger himself to clouds of incense.

This church is often acclaimed as Butterfield's masterpiece. Keble College, also from the master of striped brick, would run it close. The bricks of All Saints are dark red with close-set stripes and patterns in black, a pale green slate roof and a slender broach spire, grey slate with pale green stripes, soaring above the street's roofline. The interior is covered in the glad panoply of Butterfield's undimmed relish for polychromy, not garish exactly, partly because the interior lighting is dim, but discordant certainly.

'The thought and care over detail in this building are best appreciated after long familiarity,' was the advice of John Betjeman, the twentieth-century champion of protecting and restoring Victorian buildings. Well, the detail includes the architect's lumpen patterning and in the north aisle the tile paintings designed by Butterfield and painted by Alexander Gibbs: a frieze illustrating the nativity. It is the rock bottom of high Victorian figurative art, epicene, languid and pallidly sentimental. Brief familiarity with these is already too long.

Yet Betjeman is sensible and sensitive in his overall assessment: 'For the smallness and confined nature of the site the effect of space, richness, mystery and size is amazing,' he wrote, and it is surely true that Butterfield possessed the prime requirement in architecture, the ability to create space and enclosure. His patron, Alexander James Beresford Beresford Hope, known familiarly as Beresford Hope, supplied the funding and therefore had to be obeyed. He demanded a choral school and a clergy house on the same constricted site as the church. Butterfield solved this problem by pushing the church well back from the east-west street line and building school to the west, house to the east, church to the north, creating a welcoming courtyard between (now enhanced by plants in tubs). The main entrance to the church is tucked into the north-west corner of the courtyard, mysterious and inviting as the garden door encountered by Alice in Wonderland.

The interior, so constricted that there

Reverential gloom at William Butterfield's masterly All Saints, Margaret Street.

are only three bays to the nave, makes the most of its height instead, accentuated by shortish piers with polished Aberdeen granite shafts and Derbyshire alabaster foliage capitals, solidly carved. The chancel and lady chapel are decorated more splendidly than any other part of the building, because the reredos in each case was richly recreated after Butterfield's death by the ecclesiastical specialist Ninian Comper.

7 MARGARET STREET, W1W 8JG

## PILAR CORRIAS GALLERY

*A rock'n'roll architect plays it cool*

Rem Koolhaas (born Rotterdam 1944) is known all over the world as a rock 'n' roll architect – inventive, provocative, often outrageous. Everywhere, that is, except Britain, where he has built very little even though he trained and taught here at the Architectural Association. Definitely not a man to be recommended to Prince Charles. In fact, he has a way of shedding even well-disposed potential clients fast. In the late 1990s the Museum of Modern Art in New York asked him to produce a proposal for an extension. MoMA had undoubtedly seen the manifesto in which Koolhaas wrote: 'Manhattan has generated a shameless architecture that has been loved in direct proportion to its defiant lack of self-hatred, has been respected exactly to the degree that it went too far.' Koolhaas's subsequent 'impertinent proposal', as the sensitive American architect and critic Witold Rybczynski termed it, involved sinking MoMA's much-loved sculpture garden with its heavyweight Maillol water nymphs disporting by a pool to basement level, and adding on top of the current building a seven-storey addition emblazoned with a neon sign spelling out MoMA Inc. Farewell Koolhaas. A few years later Los Angeles County Museum of Art needed refocusing, so he proposed trashing it and starting again. It became a pattern.

Between New York and the private Pilar Corrias Gallery in Fitzrovia (2008), he wrote a huge book called *S,M,L,XL*, sorting out his architecture in T-shirt sizes (though the stores he has designed run more to Prada than Gap). The only XL that the generality of British public might have taken on board would have been on changing high-speed trains in Lille, where the views from Koolhaas's light fantastical railway station give on to views over the rest of his Euralille project, the encircling shopping city like an update to Kubrick's movie *2001*. On the other hand, the Pilar Corrias Gallery is so S it doesn't even appear in the list of projects by Koolhaas/OMA (Office for Metropolitan Architecture, his outfit). It's easy to see why. Given the ground and basement floors of a former leather goods shop in a building not to be knocked down, what could a self-respecting outrageous architect do? What Koolhaas did was to paint it dazzling white, all through, with silvered electrics and water conduits on the ceiling, two partitions on the ground floor, one to hive off a conference-sized space, the other to demarcate the main gallery behind the reception area with a glassed-in façade that invites the street inside. Nothing less than a beautiful setting for art, some of it even

paintings. Steel-mesh fences in the stairs leading to a film area, and there is another small display space plus storage and conventional rooms off it, with conventional doors and doorknobs.

So even with Rem Koolhaas it's horses for courses. Nor are the horses frightened by his slightly earlier London building, Rothschild's (L), off St Swithin's Lane in the City, but there the buildings are as mad as he (*Hamlet*, XL).

54 EASTCASTLE STREET, W1W 8EF

## • TRAFALGAR SQUARE, SOHO, ST JAMES'S •

### ST MARTIN-IN-THE-FIELDS

*An eastern enhancement to Gibbs's finest church*

David Piper loved the church of St Martin-in-the-Fields, and in his spell as director of the National Portrait Gallery in the 1960s he saw it at most times of day and in all weathers. In his *Companion Guide to London*, apart from the obligatory complaint about the Gothic spire stuck on behind a gigantic Corinthian portico (the first in what became an eighteenth-century fashion), he had only one quibble: the interior lacked a suitable climax. That was then. The shortcoming was removed in April 2008, and with some effrontery: a new east window of glass as clear as crystal.

But first things first. St Martin's is all things to all men. It is the parish church for Buckingham Palace; the reigning monarch when it was consecrated in 1726 was George I, so he became a church warden. It has English and Chinese language congregations. It is a port of call for the oppressed and the derelict, a mission laid down during the First World War by Dick Sheppard, a saint disguised as vicar of St Martin's. It welcomes all comers, the followers of other faiths and the unbelievers, wealthy sinners as well as the poor; and the mission to the poor has survived the grand makeover (£34 million worth) of the church and remarkable groin-vaulted crypt in 2008, its first refurbishment since the Italian-trained Catholic architect James Gibbs built it. Since he had studied in Rome, Gibbs fashioned his glorious St Martin's interior as Roman Baroque, which is now returned to splendour in declamatory white and gold. Curiously, the new clear glass in the Venetian east window is baroque too.

It is the work of Shirazeh Houshiary (b. 1955), an Iranian who arrived in London from Shiraz at the age of 18 to study at Chelsea School of Art and has remained, working as sculptor and painter. Critics tend to disapprove of her tranquil paintings, some because they are too busy, others because they are not busy enough. The stillness of her work hints at her immersion in Iranian culture, but the rectangular steel grid of the St Martin's window, engineered by her husband, the architect Pip Horne, forms a large ellipse above centre and the grid is pulled out of true horizontally and vertically, so the powerful initial effect is of a pebble thrown into water forming a cross, with the ellipse tilted to the right; it might be the sun or it

could represent the head of Christ, though Reverend Nick Holtham, the former vicar, suggested it need be neither. That seems to fit with Houshiary's own approach. And as for easing this minimalist modern conception into Gibbs's Baroque, her unclassical lurch out of true creates a perfect symbiosis. It is hardly a surprise to find that she followed Gibbs in studying Bernini before embarking on the project.
TRAFALGAR SQUARE, WC2N 4JJ

## STATUE OF CHARLES I, TRAFALGAR SQUARE

*Praxiteles le Sueur was here*

How often do we say 'we don't do these things as well as the French'? Well, it is true that they would have made a better job of Trafalgar Square than we have, though perhaps they wouldn't have included Nelson's Column. Their Places, des Vosges, de la République, de la Concorde, de l'Étoile, are object lessons in how to do triumph. And yet Trafalgar Square was purpose-built by Act of Parliament after 600 years as home to the royal mews. It was initially named Charing Cross until Parliament intervened again, permitting the raising of the admiral's column and the naming of the square for his greatest victory. (The address was Charing Cross and remains so, although actually the postman never calls: the real Charing Cross has moved to the Strand.)

Charles Barry, who had taken over as architect for the National Gallery after William Wilkins had died, protested against Nelson's Column, and added a rider that all art of any sort except in the gallery should be kept at bargepole's

length. That started the rot that has since galloped through the whole of London scattering incompetence. Now Trafalgar Square is shared beween monarchs and Prince Albert, admirals and tinpot generals including General Havelock of the Indian Mutiny, a work that Ken Livingstone, as Mayor of London, wanted to remove on the grounds that he'd never heard of the man. Well, that might be a starting point for a clear-out of all the names better left in dusty tomes.

The equestrian statue of Charles I, where Whitehall debouches into Trafalgar Square, has been there since 1675. Richard Weston, lord treasurer to Charles I, commissioned it for his garden at Mortlake Park, as great courtiers did. He died before he could take delivery and it lay in store in the crypt of St Paul's, Covent Garden. But in 1650, acting on orders from the Cromwellian Parliament, agents tracked it down and sold it as scrap metal to a brazier in Holborn, one John Rivet, ordering him to break it up and melt it. Instead, he hid it. When Cromwell fell, Weston's family reclaimed it and his widow sold it to King Charles II for £1,600. For precisely the reasons Cromwell had wished it destroyed, Charles erected it upon a pedestal by Christopher Wren on the spot where the last of Edward I's Eleanor crosses had stood until Cromwell destroyed that. Ostensibly it was an act of homage to his father; it was at least as much of a covert indication that normal service had been resumed.

This sculpture of King Charles I by Hubert le Sueur was the first bronze equestrian statue made in England. It was placed at this point between Whitehall and what is now Trafalgar Square on the orders of Charles II.

The sculptor was Hubert le Sueur (c. 1580–1658). He was king's sculptor in Paris at the court of Louis XIII but in 1626 he came to London, at the instigation, it seems, of the Duke of Buckingham, Charles I's principal lieutenant in artistic as well as most other matters, including his marriage to Louis XIII's sister Henrietta Maria. The sculptor was a man of supreme vanity who submitted invoices to the king signed 'Praxiteles le Sueur' as though he were brother to the great sculptor of dim history and bright myth. He got away with it until Charles received the bust of himself by Bernini (from the triple-view template in oils by Van Dyck now at Windsor Castle) and realised that Le Sueur was a comparative duffer; worse, a duffer who overcharged. Critics have pointed out that his work looks as though it has been pumped up rather than modelled.

But approaching Trafalgar Square along Whitehall on the top deck of a number 11 bus the equestrian statue might look majestic if it weren't overwhelmed by Nelson. Close to, it is high in artificial decorative content but formulaic, as though Le Sueur had designed it as a small tablepiece. Indeed, though this was the hub of London and is still the point from which distances to the capital are measured, Charles and his horse, the first equestrian bronze in England, are stranded on a traffic island. Could it be that the look on that bronze face expresses wistfulness as it gazes towards the spot of the actual Charles I's execution? No such luck; it's a blank.

TRAFALGAR SQUARE, WC2N

## STATUE OF KING JAMES II, TRAFALGAR SQUARE

*The sculptor who covered up for Grinling Gibbons's royal incompetence*

The statues on the grass in front of the National Gallery portray two who got away. In the right corner, a bronze cast from Jean-Antoine Houdon's marble statue in Virginia is of George Washington, renegade British colonial and first President of the United States; in the left corner, King James II, Roman Catholic schismatic. The king's statue, which was originally placed in the privy garden in Whitehall Palace, is freely attributed to Grinling Gibbons, which as always means pretty well any passer-by with pretensions, preferably a Dutchman (Gibbons had a Dutch mother and was born and brought up in the Netherlands) or a Fleming. Whoever they were they became known as 'studio of Grinling Gibbons'. This was because Gibbons himself, though a genius when carving in limewood and boxwood or, on a small scale, marble, was hopeless at statuary from life size upwards. His usual facilitator was Arnold Quellin, a more than competent and sometimes inspired modeller and carver.

Horace Walpole, who believed that Gibbons himself had modelled the statue of King James, added that George Vertue's notes on which he based his own book, *Anecdotes of Painting*, said the actual sculptors were Laurens van der Meulen and Pierre van Dievoet of Brussels; 'if either of them modelled it and not Gibbons himself', he wrote, 'then the true artist deserves to be known.' History is on Vertue's side: it is suggested today that van Dievoet modelled the piece and van der Meulen cast it. The evidence lies partly in Gibbons's widely touted incompetence and partly on five sketches in ink and wash in the British Museum (accessible on the database) of various versions of the statue listed as by Gibbons, but with a curatorial suggestion that they may actually be by van Dievoet (1661–1729).

The bronze statue itself is a heroic figure, though sinuously graceful with an almost androgynous swelling of the belly– 'great ease in the attitude, and a classic simplicity', says Walpole. It shows the king in the armour of a Roman warrior, though the general's baton, previously smashed, has disappeared from his right hand within the last few years. The piece was cast in 1686 and two years later the more or less bloodless revolution removed James from the throne and dispatched him into exile. Possibly expecting the worst from the unruly Londoners, van Dievoet and van der Meulen swiftly returned home, van Dievoet to greatly beautify the façades of the main square (Grand Place, or Grote Markt) of Brussels with sculptural decoration.

TRAFALGAR SQUARE, WC2N

## NATIONAL PORTRAIT GALLERY

*The coffee house virtuosi*

The National Portrait Gallery has always been as much historical archive of the nation's great and good as art collection, though its possession of works with the weight of Holbein's defining life-size

image of Henry VIII, feet spread, arms akimbo, makes it unmissable for art buffs too. The Tudor gallery is its greatest strength, but there are good unsung areas, such as the collection of eighteenth-century portraits, adding another dimension to the picture of the period given in the letters, diaries and memoirs of the time by figures such as Horace Walpole, Elizabeth Montagu ('Queen of the Bluestockings'), James Boswell, Edward Gibbon and all. Among these were the virtuosi, clubbable men of accomplishment and taste, in their own eyes certainly, gentlemen like the sober, not to say pompous-looking, group in the team picture by Gawen Hamilton (*c.* 1698–1737), *A Gathering of Virtuosi*. This is untypical in that all but one of them are celebrated artists of their day. Hamilton portrays them in 1735 at their regular meeting place, the King's Head in New Bond Street. It was the age of coffee-house assemblies and the nascent clubs of St James's, some devoted to politics, some claiming to be devoted to cultural pursuits but actually to debauchery. Hamilton's conversation piece hangs in an area of the second floor of the NPG where, small and under-regarded, the *Virtuosi* is nevertheless the document that pulls it all together, a portrait of men too involved in the vulgar reality of making a living to take up the higher debauchery.

The odd-man-out is the elegant fellow on the scarlet chair in the centre posing with a pencil between his fingers. This is Matthew Robinson, coffee-house wit and father of an even greater wit, the acknowledged 'Queen of the Bluestockings', Mrs Montagu (her name surfaces in dictionary definitions of the word). He is the sole amateur artist among the virtuosi, rich and fawned upon. Robinson and the dozing dog are the only ones here who have it made. He looks particularly contented because he is in town instead of at his normal residence on his daughter's country estate – living in the country, he told her, was like being asleep with one's eyes open.

Those hanging on his words here include the busy portrait painter Michael Dahl, sitting opposite him, and the architect of St Martin-in-the-Fields, James Gibbs, standing behind the centre of the table. Then there are two artists who were soon to be overtaken by other talents: the sculptor Michael Rysbrack showing off an antique bust, and, leaning chummily over Rysbrack's shoulder, the painter of sporting pictures, John Wootton, who suffered later when the great horse painter George Stubbs usurped him. On the right, putting his best foot forward, is William Kent, interior designer of genius and Lord Burlington's architect at Chiswick and Burlington House, who went on to build Thomas Coke's Holkham Hall with its grand Roman sculpture gallery. Hamilton himself is at work behind him, remembered today for this picture. He is the only one with his painting hat on rather than a wig (a self-portrait of Hogarth at work wearing similar headgear is in the same room). At the far left is George Vertue, well known as an engraver but remembered today as the forefather of English art history. Horace Walpole bought Vertue's bulging notebooks about the artists of his time and based his own *Anecdotes of Painting* upon them.

Like other clubs, the Virtuosi contributed towards good causes, and to help raise funds Hamilton agreed to raffle the painting on 15 April 1735. Joseph Goupy, a miniaturist and portrait painter, who stands behind Robinson in the picture, won it with the highest throw of the dice. He died in 1747, and at the auction of his goods Robinson (who else?) bought *A Gathering of Virtuosi*.

ST MARTIN'S PLACE, WC2H 0HE

## NOTRE DAME DE FRANCE

*A mural by the gadfly who dreamed he created Picasso*

'Meeting Picasso changed my life,' remarked the poet, painter, playwright and cineaste Jean Cocteau (1889–1963). It's true that Picasso has left his mark on the mural Cocteau completed in 1960 for the church of Notre Dame de France just off Leicester Square. It had been entirely rebuilt in 1951–5 after wartime bomb damage, repeating the rotunda shape of the first French church on the site, of 1865–8. That in turn was inherited from a previous building there, a cyclorama built by the painter and showman Robert Barker in 1792–3. In it Barker presented huge paintings pasted to a cylinder so that punters paying a shilling a time could view 360-degree panoramas of St Petersburg or Constantinople, Malta, Paris, and London itself; or the Battle of the Nile and – the longest-running popular success – the Battle of Waterloo. The idea caught on and panoramas in England and abroad became the biggest thing in popular entertainment before the invention of the cinema.

After the death of a later proprietor, a Marist priest raised funds in France for a Catholic church on the site. The first church was a cruciform within Barker's rotunda; the post-war rebuilding by Hector Corfiato reverted to a pure rotunda behind a concave façade of narrow bricks with a big stylised Virgin of Mercy by the prolific Beaux Arts cum modernist sculptor and professor Georges Saupique, above the triple front doorway. Inside is an Aubusson tapestry of the Blessed Virgin, a Vosges sandstone font carved in the Strasbourg Cathedral workshops, a feeble nativity scene on a side altar by the Bloomsbury Group's favourite Russian émigré mosaicist, Boris Anrep, and behind that in the lady chapel, Cocteau's *Annunciation*, *Crucifixion*, and *Resurrection* murals.

Cocteau was the gadfly of French culture from early in the century until his death, half admired, half despised. He was always at the centre of things: poet, novelist, critic, actor, cineaste, playwright, artist; but in everything he did, he claimed to be a poet. In his painting, he remained Picasso's epicene follower, with big ideas. He devised the storyline for the Diaghilev ballet *Parade*, but had to play second fiddle to the top desk of Erik Satie, the choreographer Leonid Massine, and Picasso. 'He knows that the sets and costumes are by Picasso, that the music is by Satie,' Gide recorded in his journal entry for 1 January 1921, 'but he wonders if Picasso and Satie are not by him.'

Still, the power of Picasso's example

Mary, the mother of Christ, weeps at the foot of his cross in this mural in Notre Dame de France by Picasso's follower Jean Cocteau.

# Soho

A sign on the door of a house in Meard Street (above the knocker, as it happens) advises: 'This is not a brothel.' Soho's longest-running service industry has flourished at least since the eighteenth century within the swarming rectangle defined by Oxford Street to the north, Shaftesbury Avenue to the south, Charing Cross Road and Regent Street east and west. Casanova, fleeing troublesome connections on the continent, took lodgings at 47 Greek Street in 1764 but retreated to the continent again after falling in love with a prostitute who rooked him.

Strip clubs and peep shows added to the variety over the years, although it was initially the home of nobility. Kings and courtiers slummed it in Soho; gangsters, artists, models made a living or cadged an existence. Ronnie Scott had his jazz club here (he's dead, it is not) and the itinerant jazz singer and art fancier George Melly was a Soho regular who doubled up for a couple of years as film critic of the *Observer* (at one post-prandial press view he snored through Tarkovsky's stupendous *Andrei Rublev* but had the grace not to review it).

A blue plaque in Frith Street boasts of the boy Mozart composing there in 1764–5; on the same street was Hazlitt, who died in a room on the top floor murmuring the unlikely last words, 'Well, I've had a happy life', though his love life was disastrous and he serially backed failing political causes. In Greek Street Peter Cook ran his satire club the Establishment at number 18 from 1961 until it went bust in 1964; *Private Eye* is still there, still lunching fortnightly at the Coach and Horses. At number 11 was Britain's best under-read poet Ian Hamilton, nurturing both his rigorous *New Review* (of the arts) and various unknown talents like Ian McEwan and Julian Barnes, next door to his watering hole the Pillars of Hercules, though he would chat up potential contributors at Bianchi in Frith Street (a tribute volume of essays to Hamilton, an academic *festschrift* edited by his fellow poet David Harsent, was called *Another Round at the Pillars*, and a regular contributor, Clive James, named a book of his own essays *At the Pillars of Hercules*). The Pillars is still there but Bianchi has gone, though its famous maîtresse d', Elena Salvoni, friend of the stars and honorary mother to the abidingly impoverished Hamilton, is in well-deserved retirement: no plaque, but she is the Elena of Elena's L'Etoile, the starry restaurant where she worked until she was 90.

Mozart, Melly, Dylan Thomas, Karl Marx and William Blake are among the in-crowd on the OK-ish mural in Cornaby Street. The Hearst–Emin generation of artists were too young to make it; they did hang out at the Colony Room in Dean Street before it crept into the shades, but too late: its glory days had died with Muriel Belcher, another formidable Soho boss who tolerated Francis Bacon, Michael Andrews, Lucian Freud, Frank Auerbach, Robert Colquhoun and Melly among her habitués.

The gods of mirth know the secret of the survival thus far of this congeries, its dark alleys, little covered passages, its 'French pub' (the York Minster) and its Patisserie Française Maison Bertaux Creating Daily on the Premises Est. 1871, Meard Street, of the best George I period, intact and flower-decked and no prostitutes please we're

English… Now they are protected in perpetuity, despite the Rogers Stirk Harbour (Richard Rogers), Broadwick House, a plug-in, space-age, spec-built buttress of offices at one corner of Broadwick Street; and the costermongers in Berwick Street below didn't turn a hair.

Eighteenth-century survivals in Soho.

and his own confidence sustained Cocteau in producing in London, directly on to the plaster, a stylised drama in blues, reds, yellows and greens of the beginnings of Christianity, a cool grotto in a refuge from the glitz of the theatres, cinemas, restaurants and bars of Leicester Square and Chinatown. But to the generation of the decade in which Cocteau died, his real achievement was in the cinema, and for Truffaut and Godard in particular that meant one thing above all, *Orphée*, a movie about one poet feeding off the work of another.

5 LEICESTER PLACE, WC2H 7BX

## THE GAY HUSSAR

*An irreplaceable piece of Hungary in Soho*

In the days when Eastern Europe was the Soviet playground, I went with a correspondent for *The Times* to a discreet privately run restaurant in the hills of Budapest. We were the last customers at the end of the evening, and when we stood up to leave, the pianist stopped playing and went to fetch our coats. That's the kind of place the Gay Hussar has always been, not intimate exactly and minus pianist, but relaxed as no foodie paradise will ever be, perfect for the dissident lefties from the Parliamentary Labour Party and the press who were its bedrock clientele (with incursions, it was occasionally rumoured, from the *Daily Telegraph*).

The proprietor and founder of the Gay Hussar, Victor Sassie, was not, as widely believed, Hungarian but the son of a Welshwoman and a shipwright from landlocked Switzerland; Victor was born in Barrow-in-Furness in 1915 and trained in cuisine in Budapest in the 1930s before returning to London. His obituaries in 1999 reported that he worked for British Intelligence during the war. If so, that must have been after the photographs in Philip Ziegler's book *London at War* showing an uncaptioned maitre d', unquestionably Sassie, stout and smiling and ministering to customers during the Blitz in a small Soho hotel called the Hungaria. Unless, of course, he didn't have to move from Soho to provide intelligence to the spymasters. He founded the Gay Hussar at 2 Greek Street in 1953, still stout and still smiling though not on the occasion he ejected the fulminating foreign secretary George Brown, drunk as always, for groping a woman at a neighbouring table. Sassie was there day after day, but when he sold up and quit in 1987 he never showed his face again.

Greek Street had grown piecemeal from the late seventeenth century; number 2, which has not changed much, was built as a pair with number 3 around 1744, abutting on Soho Square. It has four storeys, brick-built, but with the ground floor faced now in big planks painted bright red, with 'Gay Hussar' cut into the brown-varnished fascia board and spelled out in lilting customised and gilded capital letters. The main restaurant downstairs is larded with caricatures of politicians and media folk and there's a rack of famous customers' books. The food and drink, like aspic in jelly, is unchanged: beef goulash, roast duck with red cabbage and apple sauce, sweet cheese pancake, unctuous Tokai, the grand classics. There is private dining on

the floors above reached by the original dogleg staircase. After the 2010 election the whole Tory whips' office, stomping in triumph at the eviction of Labour, occupied the first-floor room with its table for two dozen. John Wrobel, the Pole who has managed the Gay Hussar since Victor Sassie quit, thought the floor would fall in. In 2010 it did: the owners, Corus Hotels, put the restaurant up for sale. Regulars formed a consortium to buy what is in truth a part of British social history. Corus rejected the bid but gave the Gay Hussar a period of grace. For now, goulash remains on the menu.

2 GREEK STREET, W1D 4NB

## STATUE OF CHARLES II, SOHO SQUARE

*London's would-be Piazza Navona with a king looking like a dosser*

Covent Garden piazza, built to the plan of Inigo Jones in 1630, is the oldest city square in England. On its heels came Leicester Square, Bloomsbury Square (now chaotic), Soho Square, Red Lion Square, St James's Square, and Grosvenor Square. In Soho Square Caius Gabriel Cibber (1630–1700) carved a splendid monument of Charles II on a high pediment surrounded by figures representing the great rivers, Thames, Severn, Humber and Tyne, almost certainly modelled on the example of Bernini's Roman Ganges, Nile, Danube and Río de la Plata in the Piazza Navona. Its unveiling in 1681 marks as good a date as any for the square's completion. Not too much of the traffic of Oxford Street, Charing Cross Road and Shaftesbury Avenue impinges. But if many of the buildings have been swept away to make space for the coarser commercial architecture of the nineteenth and twentieth centuries, the worst treatment has been saved for Cibber. All that remains is the figure of King Charles, stripped of his surrounding river gods, stranded on a stunted pediment on a paved path through the square, hidden from the southern side by a kitsch Swiss chalet that is now more famous than either the statue of the king or Cibber.

It has been Cibber's fate to be remembered not so much for his work as a sculptor as for being the Danish father of Colley Cibber, England's first actor-manager, poet laureate without an ounce of poetry in him, and chief dunce of Alexander Pope's *Dunciad*. Caius Gabriel Cibber's rudely realist masterworks, the *Raving Madness* and *Melancholy Madness* statues originally placed on the gateposts of Bedlam in the City, are confined to a tiny museum in the reconstituted Bedlam, now Bethlem Hospital, in far-flung Beckenham (see page 403). His other works, smoothly professional and widely disseminated, have been destroyed or are mostly hidden in a cloak of anonymity, like the phoenix in relief in the south pediment of St Paul's Cathedral, just about visible from the Millennium Bridge, or the decorative carvings and pediments at Hampton Court.

Cibber, the son of a cabinet maker to the Danish royal family, arrived in England at the age of about 30 after a period of sustained study in Italy. Application more than any other virtue recommended him to the restored King

Charles, to whom he became sculptor in ordinary, and to Wren. He became rich, gambled it away, and died poor. His panels on the plinth of Wren's Monument to the Great Fire, showing the king as saviour of London, are noble but inanimate. Soho's King Charles is an eroded ruin, his armour limp as a dosser's suit of cast offs. The whole edifice was already a ruin when it was removed from the square in the late nineteenth century, acquired by Sir W. S. Gilbert, and returned to the square by his widow in 1938. There it must be allowed to remain until it crumbles. RIP.

SOHO SQUARE, W1D

## ST ANNE'S, DEAN STREET

*Here lies William Hazlitt, who cocked a snook at death*

Theodor Stefan von Neuhoff, Baron von Neuhoff, rogue and adventurer, promised to deliver Corsica from the overlordship of Genoa if the inhabitants would make him king. He drummed up a dubious but ultimately successful expeditionary force and was duly crowned on 14 April 1736 Theodore I, King of Corsica. In 1749 he arrived in London, took digs in Soho, was a brilliant success in society, but, flat broke, ended up in the King's Bench debtors' prison in Southwark. Seven years later, upon registering the Kingdom of Corsica as his only asset and assigning it to his creditors, he was released but died a few days afterwards and was buried in the churchyard of Soho's parish church, St Anne's. The grave was unmarked but his new friend Horace Walpole paid for a memorial slab to be inserted in the church's west wall, nowadays accessible from Gerrard Street. Surmounted by what looks uncommonly like a pantomime crown, is Walpole's neat epitaph:

> *The grave, great teacher, to a level brings*
> *Heroes and beggars, galley slaves and kings.*
> *But Theodore this moral learn'd ere dead:*
> *Fate poured its lessons on his living head,*
> *Bestowed a kingdom, and denied him bread.*

Alongside this tablet is one dimly inscribed to another pauper, the essayist and art critic, theatre critic, journalist and revolutionary, William Hazlitt (1778–1830). He died nearby at a lowly lodging house, 6 Frith Street, now the upmarket Hazlitt's Hotel. The gravestone itself, by the north wall of the cemetery, was hopelessly eroded until in 2003 the journalist Ian Mayes, prompted by a book on Hazlitt he had just read, found it, was outraged, and used his *Guardian* column and influential friends to drum up donations. He commissioned Lida Cardozo Kindersley, the widow of Eric Gill's one-time apprentice, David Kindersley, to recut the inscription with members of her Cambridge workshop upon a new tomb slab of hard-wearing Lake District slate. The lines they had to recut were composed 'by one whose heart is with him in his grave' – romantics believe this indicates Hazlitt's rejected first wife, Sarah Stoddart; sceptics think it was the lawyer and devoted follower, Charles Wells. In

any case, the Cardozo Kindersley Workshop was up against it: the inscription runs to more than 40 lines and practically constitutes a biography, shorter than Hazlitt's own unreadable four-volume life of his hero Napoleon, but more than enough for a gravestone. Yet the newly cut lines on a tomb with just the one name, Hazlitt, carved on the side in masthead capitals, add a wonderful concision to the beauty of the living Gill tradition.

At the end, Hazlitt had his way. In his essay *On the Fear of Death*, he wrote: 'My public and private hopes have been left a ruin, or remain only to mock me.' But soon before he died he wrote, 'I confess I should like to live to see the downfall of the Bourbons.' Charles X, the last Bourbon king of France, abdicated after the July revolution of 1830. Hazlitt died on 18 September that year.

55 DEAN STREET, W1D 6AF

## STATUE OF GEORGE II, GOLDEN SQUARE

*A king's statue imported from a famous doomed house*

Golden Square, hemmed about with ghastly twentieth-century buildings, which were until the last years of the century home to the woollen industry (with close connections to the tailors of Jermyn Street and Savile Row), was laid out originally in 1675, maybe by Wren. It is built around a formal garden above incongruously rural retaining walls (not Wren's), and at its heart is a statue of George II. This was long thought to be by John Nost, but as its probable date is 1627, 16 years after Nost's newly discovered date of death, it has lately been attributed to the Nost workshop and specifically to Andrew Carpenter (aka Andries Carpentière, *c.* 1677–1737). The other controversies over whether it is actually a statue of the king and whether it has always been here or actually came from the Duke of Chandos's mansion Cannons near Stanmore, rumble on in the distance. It can be said in answer to the first point that the figure is, as usual with representations of royalty, shown in Roman dress, crowned with a laurel wreath, and that the stocky figure depicted tallies with descriptions of the king. In answer to the second, originally Golden Square housed many of the most illustrious in society, including the 1st Duke of Chandos while he was in London, and it seems likely that this statue, though erected as that of the king in March 1753, may indeed originally have been one of the allegorical figures from the roof balustrade of Cannons.

George II himself has never ranked high in the pantheon of English kings, partly because his grasp of the language was tenuous, partly because he preferred Hanover and spent as much time as he could there, and largely because, as Thackeray cruelly but entertainingly described him, he was 'A dull little man of low tastes'. More, 'Here was one who had neither dignity, learning, morals, nor wit – who tainted a great society by a bad example; who in youth, manhood, old age, was gross, low, and sensual...' A crushing indictment of the (possible) subject, but what is there to be said for the statue?

It is a good piece of work, as good as

Carpenter's master Nost could have made it if not as spectacularly good as the sculpture of their predecessors Rysbrack and Roubiliac. It is pitted and eroded and, shamefully, has the fingers broken off one hand, but it is in a much better state than Cibber's Charles II in Soho Square (see page 145), is rescuable, and ought to be restored. The choleric little king faces frontally, without baroque braggadocio, cloak thrown about his bare torso, sandalled feet planted firmly on the edge of the plinth, left hand gripping a sword hilt carved with an eagle emblem, his face beneath the wreath set like Jimmy Cagney's in *White Heat*: 'top of the world, Ma'. The lack of a horse seems fitting because (Thackeray again), at the Battle of Dettingen in 1743, when the king's horse ran off with him almost into the enemy lines and he had to abandon it, he planted himself on foot at the front of the English infantry, drew his sword, and declared, 'Now I know I cannot run away.'

GOLDEN SQUARE, W1R 3AD

## STATUE OF ROBERT FALCON SCOTT, WATERLOO PLACE

*Kathleen Scott's send off to Valhalla for her husband*

Captain Robert Falcon Scott, celebrated in a heroic bronze statue tucked in amongst royalty and military top brass against the garden railings of Waterloo Place, was the son of a brewer who sent the boy at the age of 11 to a crammer's to prepare him to be a naval cadet. Scott proved an average cadet and an average midshipman. Yet by application and keenness, this middling mariner would come to represent the gilded youth of late-Victorian and Edwardian England, celebrated in popular legend, in books, plays, and on screen (in a portrayal by John Mills, inevitably), as the courageous amateur who failed to plant the Union Jack at the South Pole in 1910 before the icily professional Roald Amundsen placed the flag of Norway there; the leader who died with his five companions on the return journey – on the spur of the moment he had taken one companion too many for available rations, and there were no dogs to pull the sledges or to serve as a reserve menu when food ran out.

Two years before, Scott had married Kathleen Bruce (1878–1947), the daughter of a Norfolk rector and descendant through her father of Scottish royalty and through her mother of Greek Phanariot aristocracy, a heady mix for a romantic young woman. An established artist trained at the Slade and in Paris, she was a friend to the artistic elite, from Henry James and G. B. Shaw to Rodin and Gertrude Stein. She met Scott, who was ten years older, in 1906. She needed a man of the right mettle to father her sons, but wasn't sure about Scott. She married in doubt but fell in love with him when their son Peter (the ornithologist) was born. When she heard of her husband's death she set out to create a monument fit for Scott of the Antarctic.

She was a talented portraitist, particularly good with figures of supple young men, but for Scott she needed the image of a Siegfried. This was difficult because Scott didn't look Wagnerian, though he had the John Mills stiff upper

lip. He was not tall and not strong (though endowed with great stamina). Kathleen Scott made light of this. Her husband had gone to Valhalla, and, following Rodin, she modelled her clay swiftly; she shows the explorer immobile, clutching a ski pole as though it were a spear, and gazing steadily at the ice-packed horizon, but the light plays on the folds of his tunic and baggy trousers, modelled as a sort of Antarctic equivalent of the toga, and creates a sense both of movement and of monumental bulk.

The statue was in place in 1915. Affixed to its plinth is a plaque bearing words from his last diary entry: 'Had we lived I should have had a tale to tell of the hardihood, endurance, and courage of my companions which would have stirred the heart of every Englishman. These rough notes and our dead bodies must tell the tale'.
WATERLOO PLACE, SW1Y

## ROYAL OPERA ARCADE

*London's best shopping arcade*

The English original of all those egregious modern shopping malls is the Royal Opera Arcade, nowhere near the Royal Opera House but running between Charles II Street and Pall Mall. It is the earliest and best of the group of four West End arcades: Burlington, Princes, the Royal Arcade and the Royal Opera Arcade. Everyone knows the Burlington Arcade (1819), the toffs' Woolworth's, with its beadles in top hats and tailcoats. It is full of little jewellery shops, art dealers and boutiques for the fashion-conscious hunting set leaving the summer show at Burlington House next door. The Royal Arcade of 1879–80, off Old Bond Street, has an entrance that wouldn't disgrace an East End music-hall and an interior that is a cross between the Burlington Arcade and a miniaturised Leadenhall Market. The Edwardian and passably soigné Piccadilly Arcade and the 1930s Princes Arcade both link Piccadilly to Jermyn Street, so shirt-makers join the lists. The Royal Opera Arcade, though the shops are nothing like as flash, is the gem, its window casings, hanging lamps and flowerpots painted dark as sapphire against the cream of the walls and vault.

John Nash (1752–1835) and his chief assistant, G. R. Repton (1786–1858), the son of Humphry Repton, the landscape gardener and former partner of Nash, built the Royal Opera Arcade in 1816–18 as part of their revamping of the Haymarket Opera House. This was then rebuilt in 1896 as Her Majesty's Theatre, whose superior back alley the arcade now is, with a back door too into the fifteen-storey New Zealand House. North and south, the entrances are crisply carved stone archways. The arcade has Doric pilasters and is groin-vaulted with small glass domes. There are nineteenth-century iron-cased lanterns suspended in the centre from brackets curving out from the walls between every second bow-fronted shop, and lunettes set into arches above the display windows. It is effortlessly elegant Regency architecture, a parting kiss bestowed by the eighteenth century on the early years of the brasher nineteenth.
ROYAL OPERA ARCADE, SW1Y 4UY

## STATUE OF KING WILLIAM III, ST JAMES'S SQUARE

*Bacon brings King William home*

The 1st Earl of St Albans (not to be confused with the grander 1st Duke, who was Nell Gwyn's son by Charles II) built St James's Square, the only square in St James's and the finest of all the London squares except for Inigo Jones's Covent Garden piazza, though Inigo Jones would scarcely recognise what stands there today. It was ready in 1675–6 and from the beginning lacked only one thing: a statue of the reigning king. By 1697, when the first reference was made to the need for 'the king's statue in brass [bronze]', the king was William III, who always looked becoming on horseback. Nothing happened except for further proposals in 1710 and 1721 (the last one for a statue of the then monarch, George II). A plinth-in-waiting was erected and later removed before at last, towards the end of the eighteenth century, John Bacon (1740–99) received the commission for the statue at the centre of the garden in the square. (At one end of the garden is a little shelter by Nash masquerading as a classical temple.)

Bacon showed his design for the monument to the trustees of the square in 1795. It was unveiled in 1808 with the bold inscription on the plinth 'I. BACON, IUNR. SCULPTR. 1807'. John Bacon Senior had died in 1799 and Junior, helped by his elder brother Thomas, modelled the statue from the father's design and cast it in 'brass'. It has never received its due praise. To start with, it was hard to place in Bacon's canon, which comprised mostly marble church monuments, some good, some almost mechanically produced – not altogether surprisingly since Bacon had invented a pointing tool that made it simple for his assistants to carry out quite complex modelling very quickly; mechanically in fact. Secondly, it was a stylistic throwback to the Baroque in the face of the modern fashion, Neo-classicism. And thirdly... well, who knows? Because this is a fine ensemble, a warhorse with flowing mane and tail as wild as the king's own hair. The horse is palpably poised for action, alert to its rider's light touch on the reins. The rider himself, in Roman armour with a short cloak thrown over his shoulder, clutches the obligatory marshal's baton in his out-thrust right hand.

True, the horse's musculature is not as well articulated as Rysbrack's heavy-cavalry horse in the statue of William III in Bristol, nor Scheemakers's in Hull, but it is a friskier version, like the smaller, quicker steeds the Romans rode into battle and harnessed to their war chariots, and which the anonymous sculptor of the predecessor of all later equestrian statues showed in his Marcus Aurelius at the Roman Capitol. All three English versions borrow the notion of the rider without stirrups, but only Bacon's king rides, like Marcus, with his ankles and open-sandalled feet thrust well below the level of the horse's flanks. Set among the London planes and the cropped grass of the square, it is a majestic sight.

ST JAMES'S SQUARE, SW1Y

Elegant Regency shop fronts in the Royal Opera Arcade.

## LONDON LIBRARY

### *An unlisted gem*

The worst house in St James's Square, said the Victorian scholar Sir George Dasent, was number 14. And that was before it became the London Library. Robert Adam, who built the splendid number 11 with its four statues of muses above the balustrade, produced plans for number 14 which were never implemented. The one Adam item, imported from the demolished Lansdowne House nearby, is an elegant chimney piece with a little carved relief panel of a Bacchanalian dance. The library installed this in a 1930s committee room (now at the disposal of laptop-toting readers), designed in faux-Adam style by Mewès and Davis, architects of the Ritz, in memory of Henry Yates Thompson, library member and illustrious collector of medieval manuscripts, including the glorious St Omer Psalter, a collection reposing now in the British Library.

The London Library's first home was in Pall Mall but in 1845, as the collection grew above the 10,000 mark, it moved to the north-west corner of St James's Square. It certainly has the narrowest frontage in this illustrious quarter, presaging the crowded book stacks within. Devotees describe the architecture as eclectic. The front door is flanked by Ionic pilasters but the windows here and on the second floor are Jacobethan, stone-mullioned and transomed. The classical allusions on the library façade might have been intended by its nineteenth-century builder, James Osborne Smith, as a witty allusion to number 15's gigantic Ionic order and full-width pediment; but it succeeds only in looking eccentric.

The loss of Adam's plan has actually been to the benefit of bookworms since, as the building is unlisted, the London Library has been allowed to expand physically: upwards, with a new readers' room to come at the top of the building, sideways into Mason's Yard with the new T. S. Eliot Building, and, westwards, stretching out a tentacle into Duke Street. The nineteenth century brought storey after storey of vertiginous and indispensable steel book stacks: clangorous, says Pevsner, though readers creep about between them like the bookworms they are.

Thomas Carlyle founded the library in 1841 after he had moved to the capital and found no lending libraries at all. The Poet Laureate Tennyson served as president for seven years until his death in 1892. The other great poet-president, T. S. Eliot, served following the period of depression after the loss of 16,000 volumes to a bomb in 1944. Just before the First World War there were nearly 300,000 volumes, now there are more than a million. And still it grows. The young firm Haworth Tompkins, with the Turner Prize-winning artist Martin Creed co-opted for design advice, is steering developments: a supplementary basement reading room open to the sky, a swish art room replacing the former car crash of crowded shelves, a reorganised main reading room, an elegant *Times* room (for bound volumes); still to come, a members' room on top of the building. The library is in sore peril of becoming known for qualities other than the smell of old leather and yellowing pages.

14 ST JAMES'S SQUARE, SW1Y 4LG

## THE RED LION, DUKE OF YORK STREET

*The rise of the Red Lion in a time of destruction*

A Red Lion has been at 2 Duke of York Street since the eighteenth century, first mentioned in 1788, and possibly longer established than that. But the Red Lion where we lift our elbows today is a survivor of the transformation of the late nineteenth century: the heyday of the English town pub, direct descendant of the medieval hostelry but, unlike Chaucer's Tabard Inn, about as rural as the Palace of Versailles. Its close relations are showbiz: gin palace, pub, music hall, opera house; same difference, as they'd say down the Red Lion. The Parliamentary Act of 1869, which gave full licensing powers to magistrates (who then snuffed out thousands of beerhouses and decimated pubs), also provided the impetus for breweries to create chains of tied houses refurbished by a small group of specialist architects (some of these, including the celebrated Frank Matcham, created pubs before moving on to the music hall and theatre).

The Red Lion, now a Fuller's house, is a pub inserted into the ground floor of an early nineteenth-century three-storey yellow stock brick house within a couple of years of the passage of the 1869 Act; it is by an architect called J. H. Rawlings, whose other work is totally forgotten. He introduced the round-headed doorway with skylight and with black and gold fluted colonettes at either end, a central double door between two windows, and a cast-iron scrolly railing above the fascia (a rarity today after the twentieth century has taken its own toll of pubs), though that is usually seven-eighths invisible behind hanging plants. This exterior is attractive and typical of the period, but the interior is exceptional, all glowing mahogany, prettily embossed ceiling patterns, gleaming copper, mirrors and glass deeply and lavishly engraved by the firm of Walter Gibbs of Blackfriars Road in 1893 or soon after, as we can guess because that was when Gibbs first advertised the amber staining that is a feature of the Red Lion's 'brilliant cut glass' (a trade description of a technique rather than praise, although it deserves that too). It is customary to say that mirrors make a small interior look bigger; in fact it is said of the Red Lion itself, but here it's not true. The close-worked opulence of the mirror glass crowds in on the pub's two bars, not claustrophobically, but with an effect of glittering luxury.

Duke of York Street, named for the future James II, is a short stretch of three or four houses on each side, west and east, which links Jermyn Street to St James's Square. Boozers were not for the toffs, who, if they did go slumming, didn't do it on their own doorsteps, so it must have been established to cater for the staff of the town mansions, though today there is an injection of those tourists who care to brave what is clearly the daytime local for closely knit groups of office and shop workers from nearby in St James's, who take their liquid lunches here.

2 DUKE OF YORK STREET, SW1Y 6JP

## ST JAMES'S, PICCADILLY

*Lutyens's homage to Wren's parish church for Westminster*

Edwin Lutyens once observed: 'Architecture is building with wit.' Nicely put, and close to the mark, because if Lutyens had a problem in his own career it was his proclivity for mistaking buffoonery for wit. Even the biggest project of his life, the majesty of Viceroy's House in New Delhi (now the president's residence, the Rashtrapati Bhavan) is slightly marred once you suspect that the building's domes have been formed to resemble the white man's solar topees; a suspicion confirmed when you've seen the bronze portrait bust of Lutyens showing him in a topee and presented to the architect by the building's contractors as an admiring joke on his visual pun (the bust is now in the RIBA collection). But the former Midland Bank in Piccadilly where the vestry of St James's, Piccadilly once stood is in the style that Lutyens called, somewhat wittily, Wrenaissance, and is a salute to the church in the adjacent churchyard that is now a daily market place. As a young man Lutyens invented Wrenaissance for some of the country houses that made his name, though Wren himself designed very few; but the Midland Bank (1925) is held to be Lutyens's best exercise in the style, a charming homage in orange brick dressed in crisply rusticated white Portland stone and excellently carved festoons of fruit and flowers. A dominating sash window in the centre of three bays on the Piccadilly façade has the front door to the left and a false door to the right, cheekily Baroque. Nevertheless, it's a pastiche.

Wren's brick and stone basilica of 1685, on the contrary, was absolutely serious. It was to be the parish church for St James's, and was to make possible the strictures of the Book of Common Prayer of 1662 which stipulated that all in the church should both see and hear the minister preaching: he designed it, squarish, with galleries all round (or rather, one gallery sinuously serving south, west and north). It seated 2,000. As Wren himself wrote:

> *The Romanists, indeed, may build larger Churches, it is enough if they hear the Murmer of the Mass, and see the Elevation of the Host, but ours are to be fitted for Auditories. I can hardly think it practicable to make a single Room so capacious, with Pews and Galleries, as to hold above 2,000 Persons [yet] I endeavoured to effect this, in building the Parish Church of St. James's, Westminster, which, I presume, is the most capacious, with these Qualifications, that hath yet been built; and yet at a solemn Time, when the Church was much crowded, I could not discern from a Gallery that 2,000 were present.*

Albert Richardson restored the fine coffered ceiling stretching the length of nave and chancel after a fire bomb left the church a smoking ruin in 1940. With uncommon foresight the church elders had sent its three great artefacts for safekeeping: the unrestorably magnificent cedar reredos with Grinling Gibbons's profusion of fruit, flowers and foliage rendered in limewood; the great organ case presented by Queen Mary in 1691 (from the chapel of Whitehall

Palace, destroyed by fire), with triumphant musical angels, also by Gibbons; and Gibbons's font at which William Blake, visionary poet and painter, was baptised in 1757 (he was born nearby in Broadwick Street, Soho). Perhaps the angels stayed with him and inspired the youthful vision in Peckham that so upset his mother (see page 389).

97 PICCADILLY, W1J 9LL

## QUAGLINO'S

*Conran's new Quaglino's from the ashes of the old*

Quaglino's came at a point in Terence Conran's life when he had done it all, was knighted to prove it and was thinking of retiring to a potter's wheel in the country. But then he found the site of the restaurant launched in 1929 by Giovanni Quaglino in St James's and something stirred: it was his memory of La Coupole, a classic Paris brasserie of the 1930s. If the youthful Conran was indulging himself in that kind of place, obviously he hadn't been born without a silver spoon or two, and by the time he was considering Quaglino's, it was more like three or four. Even after he left Storehouse, the company he had created and which included his special baby, Habitat, he seemed up for another spin of the wheel, but a roulette wheel, not a potter's.

What he re-fashioned on the site of the old Quaglino's was the new Quaglino's. For those of us who never made it to La Coupole in its heyday, the first impression is not so much of Paris as the Hollywood of *The Broadway Melody*, Busby Berkeley without the faintly ominous militaristic choreography of the thirties. The white marble stairway with its brass handrail supported on elegantly intertwined bicycle wheel-sized Qs sweeps down into the restaurant from the cantilevered mezzanine bar. There are mirrors everywhere, photographs of boy, girl and androgynous pop and rock stars, murals in the bar: a Cocteau-esque cocktail waiter outlined in white on a red pillar and, on a wall by the entrance, a big yellow flower, with a hint of a metamorphosis into the Quaglino Q or the wheel of a yacht. Smart, light-as-air Pop.

It is modernism made as easy to swallow as a Bellini, and in that sense it's what Conran has been the master of. Like William Morris a hundred years earlier, Conran wanted to make good-looking workable things available cheaply to a wide public; unlike Morris, he succeeded, achieving a prominence in the design world Morris might have envied, and despised. Conran embraced modern production methods and modern materials and transformed the taste of a whole generation of young professionals home-making in the 1960s. And then he did for eating out in England what Elizabeth David had done for cooking at home. He stole the young generation's attention away from politics, and the professionals stole off with politics. Michael Caine, Sandie Shaw, Twiggy, George Harrison, were the sort of names in the headlines pictured by the paparazzi emerging from his stores in the early days of Habitat. Both Chelsea furnishing store and flash St James's restaurant were created to be affordable. It was a good deal.

16 BURY STREET, SW1Y 6AJ

## ECONOMIST BUILDING

*Lord Drogheda's refined taste for English elegance celebrated*

'New brutalist' was what Alison Smithson called the architecture created by herself and her husband Peter. It was not good spin, particularly as critics began to apply it to every concrete monster rising in former slums, and it certainly didn't apply to the Portland stone-clad unbrutal *Economist* building in St James's Street. In 1964 this replaced the old *Economist* office block with three towers of different heights, accommodating the magazine, a bank, flats, a restaurant, and an art gallery. It opened up space and introduced a miniature plaza between St James's Street and Ryder Street.

Now, in a small enclave to the north of the plaza, is *Eclipse*, a water-driven mobile sculpture by Angela Conner (b. 1935), in which two seven-foot discs rotate, one dark slate, the other white marble, slightly out of kilter, so that at each revolution there is a point at which the dark disc eclipses the white. They are set before a slate-block wall washed by a constant fall of water.

The sculpture is in memory of Lord Drogheda, chairman of the *Financial Times*, the Royal Opera House, the Newspaper Proprietors' Association and, as the *Guardian* put it in his obituary in December 1989, 'Lord High Everything Else in British financial and cultural life', among which was an executive position on the *Economist*.

Drogheda was known for bombarding editors and writers with memoranda, especially, perhaps, those not working for him. One day I received one of these Droghedagrams, as they were known. I had reviewed an exhibition in the *Economist* plaza of paintings from the *Financial Times* collection and remarked on its post-war pastoral English good taste – work by romantics like Edward Middleditch and John Craxton. It seemed that the collection had been assembled by the good lord himself. Summoned to Bracken House, headquarters of the *FT*, I presented myself to the headmaster's study. Instead of reproving me, he took me on a tour of the building and the collection. In its way, the Conner waterpiece is a latter-day example of the same sort of preference, refined, nice in its taste and its placing in the plaza; but just lacking the raw vitality of the origins of the species, the rotating discs of Marcel Duchamp and the rudely vital kinetic art from France and Latin America that was popular in West End galleries in the 1960s.

25 ST JAMES'S STREET, SW1A 1HG

## SCHOMBERG HOUSE

*Pall Mall's old Dutch*

Pall Mall's name derives from a game similar to croquet that was played by the gentry from 1630 where the street is now. Today's incarnations of those players sit and doze gently with *The Times* in their laps in the leather armchairs of the great clubs: the Athenaeum (with its gilded

The waterpiece in the Economist plaza by Angela Conner, in memoriam Lord Drogheda, Lord High Everything..., including the chairmanship of the *Financial Times*. The sculpture is just the sort of refined art he might have chosen himself.

Pallas Athene over the front entrance in Waterloo Place), the Travellers, the Reform (from which Phileas Fogg emerged to circle the world in 80 days), the gigantic Royal Automobile Club, the Oxford and Cambridge Club. Greek Classical, Italian palazzi, French grand hotel Baroque. Between them is sandwiched 100 Pall Mall, post-war classicism by Donald McMorran, its angles sharp as parading guardsmen's trouser creases, the windows regimented, and, climbing above the roofline of the street, corner pavilions possibly inspired by those at Wilton House; odd, maybe, for a plan of 1957.

Number 100 was where the Lloyd's underwriter John Julius Angerstein's townhouse stood at the beginning of the nineteenth century and became the first home of the National Gallery when Angerstein died and Lord Liverpool's administration bought 38 of his paintings (acquired using profits from the slave trade), including Sebastiano del Piombo's *The Raising of Lazarus*, Rembrandt's *The Woman Taken in Adultery* and Hogarth's wonderfully popular, utterly in character selfie, *The Painter and his Pug*, and launched the smallest national gallery in the world.

Amid Pall Mall's grandeur stands Schomberg House (numbers 80-2), classical certainly, but with a sort of Dutch bourgeois gaiety, though Schomberg was a Duke and his Huguenot father came to England from Holland with the royal party at the Restoration. Schomberg the Younger had the house refronted in 1698 and today a front is all it is, with twentieth-century offices behind (you can see the neon strips glowing). Brown brick, white keystones on all 33 windows and white window frames, white porch with a lovely carving on the balustrade of a reclining female with an easel and a quiver of brushes in one hand, an allegory of painting; and two Atlantes (male caryatids) holding up the porch entablature. Fine carving by Anon., and if it's in Coade stone it is nineteenth-century, when there was much restoration to the building in Mrs Coade's ceramic-based patent. The central three bays with white pediment above push forward, so do each of the end bays once constituting separate houses (number 82 totally rebuilt last century after being demolished in the general alterations). So there is lots of movement and colour. It's like a light going on in the street.

On number 80 a blue plaque informs us that here Thomas Gainsborough lived and had his studio for a number of years until his death in 1788. Next door there's another for Nell Gwyn, the king's Protestant whore, as she carefully distinguished herself from the Duchess of Portsmouth. It's also the street frequented by one of Defoe's fictional whores on the make, Roxana, and in fact Schomberg House itself once served as a brothel. Lucky nothing like that goes on nowadays, it might wake up the clubbable old boys.

80–82 PALL MALL, SW1Y 5ES

## OXFORD AND CAMBRIDGE CLUB

*Oxbridge comes to town*

It was the hour of the morning snifter, to quote P. G. Wodehouse, when I arrived at the Oxford and Cambridge Club. I was

responding to an invitation to lunch from an old friend and contemporary, an American alumnus of Oxford. Part of the attire the club requires is a tie, so I hit them with my current funeral favourite, a splashy expressionist number in scarlet, orange, black, blue and emerald by the late-lamented English abstractionist John Hoyland. All the members in the dining room seemed to be of my generation and were apparently smitten, to resume the Wodehouse passage about his fictional Drones Club, into 'a general disposition... towards a restful and somewhat glassy-eyed silence.'

In 1830, the year that Lord Palmerston began his 20 or so almost uninterrupted years of running Britain's gunboat diplomacy, he chaired the meeting that founded the club, and Robert Smirke, not the best architect of the period but possibly the most famous and successful (he built the British Museum), produced a design in 1835 which was replicated in the building of 1838 with scarcely an alteration. It was a family show: his younger brother Sidney helped and his father, also Robert, designed the sculpted panels above the first-floor windows, showing scenes involving, left to right, Homer, Bacon, Shakespeare, Milton, Newton and Virgil. In the middle are Apollo and Athene, gods possessed of all the civilised virtues which universities exist to bestow on their members.

The building is the last of the Greek Revival clubs on Pall Mall. The dining room is where the members take lunch and dinner, which must be why it is called the coffee room. Like the other grand public rooms (bedrooms were added in a dormer attic in the twentieth century) it is huge,

and contains an array of portraits, including one of William IV, who was too thick to have been a member even in those days but he won a place for his likeness when he mounted to the throne from the foredeck of his ship in the year the club was founded *and* he lived practically next door in Marlborough House, which combined seem to have been qualification enough. The portrait is said to be by the Irish artist Martin Archer Shee, but it looks like a good copy of the one he did for the king himself, full-length, right royally robed, Windsor Castle in the distance beyond a classical arch. Its attribution recalls country house practice in those days, when the name Shee (or Lawrence, or Van Dyck) would be used as a blanket term, loosely covering anything vaguely gesturing towards the style of the actual old master.

The room is 66 foot deep and 33 foot wide and the smoking room across the landing (members only) not much smaller, given that even then more people tended to eat than to smoke. In fact, it's evident that in those pre-Victorian days smoking was controversial: the proposal to furnish members with a smoking room aroused opposition, and in a vote of hundreds of members smoking was allowed by a majority of six.

71 PALL MALL, SW1Y 5HD

## QUEEN ALEXANDRA MEMORIAL

*The memorial that saved Alfred's bacon*

Bankrupt, dismissed from the Royal Academy, living in exile in German-occupied Bruges in the First World War,

Alfred Gilbert (1854–1934) was remembered only for *Eros*, as the public has chosen to call it (officially the Shaftesbury Memorial). Even *Eros* (1892) had been bitter fruit for Gilbert. He had gone bust making it and after the unveiling the critics weighed in: indecent, irrelevant, too small, too louche for Piccadilly, encouraging prowling streetwalkers night and day. The royal family already despised Gilbert for having failed to complete commissions for them. Edward VII stripped him of the Royal Victorian Order in 1908 and in the same year the Royal Academy forced him to resign. Ruritanian punishments indeed in terms of his artistic abilities, but socially for the sculptor who had been considered England's finest in the eighties and nineties (and probably was), it was a heavy burden of failure to bear.

Yet after the war Edward's son George V allowed himself to be persuaded, reluctantly, to commission Gilbert to create the bronze memorial to his mother, Queen Alexandra, who had been the only steadfast royal friend to Gilbert and who had died in 1925. The king's officials paid for the broken old man's passage to England, and saw to it that he was fed and watered and had somewhere to lay his head.

Somehow Gilbert summoned up the strength to work and by 1932 the huge bronze was finished. On 8 June Sir Edward Elgar conducted the band of the Welsh Guards, the Westminster Abbey choir and the child choristers of the Chapels Royal in the 'Queen Alexandra Memorial Ode' which he had composed for the occasion; next, the king unveiled the memorial set into the wall of Marlborough House opposite St James's Palace, and the following day *The Times* pronounced itself satisfied and the king knighted Gilbert. The RA had already re-enrolled him.

Yet today the Queen Alexandra Memorial is forgotten again. Maybe that was inevitable. It has neither the exposed site circled by red double-deckers nor the exciting poise and economy of *Eros* on its slender base, wings spread, bow drawn. Nevertheless the Alexandra Memorial is a far richer piece, symbolically and as a sculpture, ultimate Art Nouveau with the swirling gown of the female figure of Love framing the half-naked pre-pubescent girl child. The child stands between the legs of Love, who holds the girl's arms so that the whole figure suggests a cross while the figures of Faith and Hope kneel at the child's feet to support her as she traverses a stream (this piece is designed as a fountain, though I have never seen water running). The symbolism, of love, birth, death and perhaps rebirth, poised between royalty and divinity, is very much of its time as well.

MARLBOROUGH ROAD, SW1A 1BG

## CHAPEL ROYAL

*A family chapel for the royals*

Only one of the two Chapels Royal in St James's Palace is known as the Chapel Royal. The other Chapel Royal was designed (by Inigo Jones) for the Spanish infanta, the intended bride of the future Charles I, and then used by the eventual queen Henrietta Maria and is known as

the Queen's Chapel (see below). Since Marlborough Road was built in 1856 over the ruins of destroyed royal apartments the chapel has been severed from the palace, although no one involved seems to have noticed: the scarlet-cassocked Queen's chaplain wanders to and fro across Marlborough Road as though it were the monarch's back garden.

St James's Palace today is the London residence of the Prince of Wales and assorted other royals, together with their retinues and retainers. The acknowledged Chapel Royal has been held close to the bosom of the royal family since it was built in 1540. When Henry Purcell was composer and organist here he lived in rooms in the gatehouse tower, which is the only part of the Tudor palace apart from the chapel still standing, albeit extensively remodelled in 1826 by the Classical Revival architect Robert Smirke. In the chancel the heart and gut of Mary Tudor, Henry VIII's sister, are buried, and in an attached chamber Charles I received communion on the night before he was executed. Queen Victoria chose to be married to Prince Albert here, and here the future George V married Mary of Teck. William and Kate, Duke and Duchess of Cambridge, chose the Chapel Royal for the baptism of their infant; Prince William's mother, Princess Diana, had lain there for several nights before her funeral. Sheltering such scenes since 1537 is the ceiling with its painting created to celebrate Henry VIII's marriage to Anne of Cleves. Short wooing, shorter marriage, but the beautiful ceiling remains, painted with Anne's heraldic ciphers and other devices locked into compartments by a structure of octagons, crosses and stretched hexagons from a highly influential manual by the Renaissance architect Sebastiano Serlio. The royal website claims Holbein as the artist, and none can blame it; but Pevsner suggests the royal employees Antonio Toto del Nunziato (obscure) or Andrew Wright (obscure to vanishing), and is likely to be correct. Holbein too was a decorative artist, but Henry had a team of them at his disposal and at this moment Holbein seems to have had work enough, such as travelling the continent to portray prospective consorts.

This feels like a family chapel, from Smirke's royal closet theatrically curtained in red damask to the bland oak panelling and even the sunburst 'east' window (actually north-westish). This is by the reformed society portraitist John Napper celebrating the Queen's Golden Jubilee in 2003 with a kind of Jesse Tree, based on Queen and Commonwealth and bearing the mystic prognosis of Julian of Norwich, 'All shall be well, and all shall be well, and all manner of thing shall be well'.

ST JAMES'S PALACE, MARLBOROUGH ROAD, SW1A 1BS

## THE QUEEN'S CHAPEL

*Inigo Jones's unprecedented classicism*

Not for a minute is anybody suggesting that the Queen's Chapel in Marlborough Road is fomenting rebellion against the established royal and ecclesiastical order. But it is bound by the distinctly un-English rules of the Anglo-

Portuguese Treaty of 1661, which has never been revoked, and the part pertaining to the marriage of Charles II and Catherine of Braganza still theoretically applies: 'It is also agreed, that Her Majesty and whole Family shall enjoy the free exercise of the Roman Catholic religion, and to that end shall have a Chapel, or some other place, set apart for the exercise thereof.'

In fact, Inigo Jones designed the chapel in 1623 (built by 1625) at the command of James I for the Spanish infanta, the bride intended for his son Charles (later Charles I), to use as her Roman Catholic chapel. The planned marriage fell through, but Charles seamlessly took to wife Henrietta Maria of France who used the chapel constantly until 1642 when the Civil War brought hell and confusion to the royal family. So at the Restoration of the monarchy, the Portuguese Treaty simply reiterated the provisions that had lapsed during Oliver Cromwell's rule. Today, the English church might be seen as keeping the chapel warm for the Romans, with some hymns sung in Latin even though the Papal millions have turned to their vernacular tongues. Here, at Ascensiontide, is a setting of the mass by Spain's prime Counter-Reformation composer, Tomás Luis de Victoria, and Stanford's soaring Communion Motet:

> *Coelos ascendit hodie*
> *Jesus Christus Re Gloriae:*
> *Sedet ad Patris dexteram,*
> *Gubernat coelum et terram.*

(Jesus Christ, King of Glory, has ascended to heaven today, governor of heaven and earth, he is seated at God's right hand).

So as always the English church is keeping a foot in each camp. Simultaneously Stanford asserts the Protestant ascendancy and the Victoria mass perpetuates a tradition of Catholic music that stretches back to Elizabeth I's time, when she called off the Parliamentary dogs hunting down her favoured composer William Byrd, accused of recusancy. Today, whether or not Elizabeth II especially enjoys music, her domestic chaplain, the Reverend Prebendary William Scott (Father Bill to his familiars), does and so the choir of ten boy choristers in the scarlet, black and gold state coats specified in 1661 and six gentlemen in ordinary, professional tenors and baritones, produces a descant to the grand simplicity of Jones's chapel.

The classicism of this little church was unprecedented in any other in England, and it stands among the greatest buildings in these islands, difficult to access but not to be missed. It is brick-built (but rendered to look like stone) and pale yellow-washed, and has Portland stone quoins and dressings to windows, doors and pediment. Within as without the building is a simple rectangle, pews parallel to the walls beneath a magnificent white and gold coffered tunnel vault. The interior is dominated by a sensational Venetian east window, filling the space beneath the cartouche with two elegant angels supporting the royal arms added by Grinling Gibbons. The blue and gold reredos under a classical pediment is also Gibbons: pediment and the inset Renaissance altarpiece of *The Holy Family*

are attributed to one of the two Carracci brothers, Annibale or Agostino.
MARLBOROUGH ROAD, SW1A 1BG

## CLARENCE HOUSE

*A palace loved for its domesticity*

'Billy Clarence is rigging up in a small way in the Stable Yard,' the MP, diarist and gossip Thomas Creevey wrote in 1826. Billy was the Duke of Clarence, later William IV. Curiously, what he and his architect John Nash were rigging up, the stuccoed Neo-classical Clarence House, appears scruffily out of kilter beside the long regular range of redbrick Tudor state rooms of St James's Palace, to which it is joined at the navel. When Billy became the Sailor King (1830), the transformation of Buckingham House into a palace was incomplete but Clarence House was better than shipboard, so he remained there until his death (1837). After that, first Queen Victoria's mother and then the Duke and Duchess of Edinburgh (nineteenth-century incarnation) commanded changes, including the off-centre porticoed main entrance in the southern front (instead of the west) and the addition of a fourth storey. So the mish-mash of classicism was Nash as rehashed by a humble builder, and it still clashes with the Tudor range, which is actually Wren Tudor of 1702.

Yet generations of royals have loved it for its atmosphere of domesticity. Queen Elizabeth the Queen Mother lived there for 50 years, from the death of King George VI in 1952 until her own death in 2002, and it is her taste that sets the tone of those downstairs rooms that are open to the public in summer, courtesy of the Prince of Wales, the current resident (Charles himself uses the garden room as an office, where he can look out upon his beds of lavender). It is definitely masculine in style, with a wall-sized Gobelins tapestry from a design by Delacroix's contemporary Horace Vernet called *Mohammed Ali's Massacre of the Mamelukes at Cairo*. Charles Baudelaire excoriated Vernet ('he is the absolute antithesis of the artist: he substitutes chic for drawing, cacophony for colour and episodes for unity'), but he was a favourite of Napoleon III, who presented the tapestry to Victoria. Perhaps Charles looks forward to exercising Mohammed Ali's power: the tapestry brought no such luck to Napoleon.

Charles's grandmother ordered things differently. The mass of John Piper watercolours, mostly of Windsor, were ostensibly a war commission by Kenneth Clark, but somehow accorded perfectly with her taste. She bought late W. R. Sickert, the best of which is a painting of George V with his stud manager, based on a newspaper photograph (1930s critics decried Sickert for often working in this way). She bought a Monet: the only Impressionist painting in the massive Royal Collection. And instead of throwing a surprisingly tentative and unfinished but fresh and expansive portrait of her by Augustus John into the dustbin, she had the chutzpah to flaunt it over the dining-room fireplace. There is a corridor of horse paintings, books about the last war and about friends and relations, like Kaiser Wilhelm II, and the posh comfort-

able bric-a-brac of a well-to-do upper-middle-class family. But royal? Well, only in the sense that Marie Antoinette's little hamlet in a corner of the vast Versailles estate was royal.

THE MALL, SW1A 1BA

## SPENCER HOUSE

*Athenian splendour*

The 1st Earl Spencer was a member of the Society of Dilettanti, which in the eighteenth century might have been described as a drinking club with discrimination and which lived by the motto, 'Roman Taste and Greek Gusto'. When he built Spencer House in St James's he opted for Rome downstairs and Greece upstairs. The Spencer family departed this palace overlooking Green Park in 1927, since when wartime bombing and several years spent serving as offices left Spencer House not remotely resembling a stately home. In 1985 Lord Rothschild bought the lease on behalf of RIT Capital Partners plc and set afoot the training of a group of craftsmen to replicate what had been lost and carry through a total restoration, with a few offices remaining out of sight. Today, open to the public on Sundays, the state rooms are once again in good order, just as they were when the house was first completed in 1766.

Earl Spencer's first hiring was John Vardy (1718–65), a friend and associate of William Kent, who had seen through the completion of the Horse Guards in Whitehall after Kent's death. In 1758 he built the exterior of Spencer House with its majestic eight-column first-floor pediment overlooking Green Park – at the time there was only grass and fresh air between Spencer House and Buckingham House (the predecessor to the palace). Vardy had completed the designs for the ground-floor rooms celebrating the themes of love, hospitality and the arts, drawing richly on the apses, coffered ceilings and friezes of the ruined temples of Rome, when Spencer fired him in favour of the new architectural darling, James Stuart. Stuart had just returned from Athens with notebooks stuffed with drawings and measurements of the Erechtheion and a head full of winning enthusiasm. Very soon he would be known as 'Athenian' Stuart, a nickname that has stuck, although when Earl Spencer commissioned him to design the state rooms on the first floor he slyly filled in the gaps in his Greek invention with Roman details.

Between them, Vardy and Stuart created two magnificent suites of rooms, Vardy's Palladian (Rome), Stuart's Neo-classical (Athens). Each has one climactic room. Vardy's much photographed Palm Room is his show-stopper, built in the belief that ancient architecture had its origins in organic growth. It has carved columns wreathed in gilded palm leaves spreading wide into fronds across the spandrels of arches leading into a glorious alcove with a coffered dome. Stuart's masterpiece is the Painted Room, a celebration of the loving marriage of the Spencers, completed in 1765 and thus the earliest room of the Neo-classical Revival in the world. This is near perfection in the delicacy and discrimination of the decor, the friezes, the painted roundels, the flower-decked pilasters, the grandeur of

the fireplace carved by Scheemakers (the original; many of the others have been faithfully copied from the originals now at Althorp) and the chimneypiece painted with a copy of the famous ancient Roman Aldobrandini Wedding, the candelabra on the chimneypiece, and the small forest of gilded Corinthian columns articulating the bowed apse-like alcove to the south. The splendour is undimmed from the day when the eighteenth-century travel writer (and agriculturist) Arthur Young wrote: 'All is richness, elegance, and taste, superior to any house I have seen.'

27 ST JAMES'S PLACE, SW1A 1NR

## ARTEMISIA GENTILESCHI'S SELF-PORTRAIT, BUCKINGHAM PALACE

### *The Renaissance feminist*

In August and September the Queen opens the state rooms of Buckingham Palace to the paying public. The best of them are those John Nash created when George IV came to the throne in 1820. Nash (1752–1835) built and decorated the throne room, drawing rooms and state dining room, ballroom, picture gallery and music room, borrowing whatever he fancied, ancient or modern, inventing from scratch. Neither George IV nor William IV, nor for that matter Nash, lived to see it completed, but within it finally Victoria disposed hundreds of thousands of old master prints, Sèvres porcelain ordered especially to match the decor of each room, tapestries, red hangings, gilt trim, glorious chandeliers, and part of her collection of 7,000 paintings.

So although the best way of gaining an overview of the collections is to visit the shows at the Queen's Gallery on Buckingham Palace Road, nothing can take the place of seeing in opulent context whatever happens to be displayed in Nash's rooms in any one year. ('They move around a bit,' as an attendant remarked to me.) The heart of the collection is the royal portraits, and no later painter has matched Van Dyck's depictions of Charles I and his family. But Charles in person, his representatives and his successors, scoured the continent for works of art other than portraiture, like the Mantegna *Triumphs of Caesar* at Hampton Court (see page 311) and the Raphael cartoons for tapestries on permanent loan to the Victoria & Albert Museum. Among smaller easel paintings, he acquired surpassing work by Vermeer, Rembrandt and Rubens. Orazio Gentileschi was already in England, working for the court, when the king invited the painter's daughter Artemesia Gentileschi (1593–1651/3) to join him. From this working visit of about three years he acquired her great self-portrait. Its distinction lies in its graphic power and intensity, the female as dynamic mistress of her art.

Artemesia learned to paint in her father's studio and at the age of 18 or 19 was raped by a collaborating artist of Orazio's, Agostino Tassi. Orazio pursued him through the courts and secured a conviction. There seems no reason to doubt that the horror of Artemesia's three gory depictions (in Rome, Florence and Naples) of the Jewish Judith's slaughter of the enemy

Assyrian general Holofernes resulted from personal trauma. Her handling is incomparably more expressive than the contemporary treatment of the subject by Caravaggio. But then, Gentileschi was a woman of powerful emotions. Her self-portrait is of an uncourtly, uncourted working woman with tousled blue-black hair, as muckily unkempt as a fishwife, the locket suspended from a golden chain around her neck hanging into space as she leans out towards the viewer and forwards to work pigment on to the primed canvas, very like a 'snapshot' portrait by Degas, but three centuries earlier. She could have produced this unusual and dynamic viewpoint only by deploying a carefully positioned combination of mirrors. It serves as an allegory of painting as well as a portrait: the locket hanging from her neck, among other attributes, was specified in a text of the time as symbolic of the figure of Painting. But primarily this is a freely brushed work of breathtaking immediacy that surpasses the history of its making.

BUCKINGHAM PALACE, SW1A 1AA

• WESTMINSTER, PIMLICO, BELGRAVIA •

## BANQUETING HOUSE

*The Apotheosis of King James I – and of Rubens*

The placing of Peter Paul Rubens's ceiling paintings in Inigo Jones's Whitehall Banqueting House amounted to the collaboration of the most celebrated painter of his time with the reigning genius of English architecture: 'the immortal Jones', as a later Palladian, Colen Campbell, dubbed the earlier architect in a passage he wrote about this building. Rubens (1577–1640), a diplomat as well as artist, was esteemed in the most glittering courts in Europe. Jones (1573–1652), the contemporary of Shakespeare and Marlowe, and also of Ben Jonson, with whom he devised masques for the entertainment of the court of James I and Anne of Denmark, adapted Italian classicism to the banks of the Thames and matched in this cool vein the extravagantly baroque achievement of Bernini beside the Tiber.

The ceiling Rubens painted for the Banqueting House must be among the least-visited indisputably great works of art in Britain. It was the first of two collaborations by Inigo Jones with a major Flemish artist: the second was the double-cube room at Wilton House, albeit created by surrogate (the building was supervised by another architect), which is really a glorious frame for Van Dyck's portraits of the Pembrokes and their royal master, Charles I. In modern terms, it would be like Mies van der Rohe collaborating with Picasso on a wonderful pavilion.

Although the Banqueting House was complete by 1619, during the reign of James I, Charles only succeeded in

King James I (bottom) on the wings of an eagle, preparing to be crowned with laurel by a half-naked angel in this main panel of nine by the immortal Rubens in Whitehall Banqueting House.

pinning Rubens down to work on the decorations in 1630. The canvases, which Rubens painted in his Antwerp studio with help from his assistants were put in place in 1636. His glorious monochrome oil sketch for the commission was in private hands until early this century when Tate rescued it from being exported.

The Banqueting House ceiling consists of nine panels separated by enriched surrounds of gold. No contract for the commission exists and no one knows whether Jones and Rubens discussed the project, yet both had visited Venice and both were probably influenced by the ceiling of the Sala del Consiglio dei Dieci of the Doge's Palace. Jones visited Italy in the second decade of the century to study architecture, and the structure of his Banqueting House ceiling is quite similar to that of the Venetian council chamber. Rubens certainly studied this ceiling, because the Doge's Palace and the church of San Sebastiano were prime sites for the work of Paolo Veronese, which Rubens revered and studied closely. The fluent brushwork, thunderous light and colour and dramatic movement were all qualities Rubens went on to emulate.

Since all correspondence relating to the ceiling is lost, nobody knows why it is dedicated to the reign of James I and not Charles I. Charles presumably saw his own kingship reinforced by his father's glory. What is certain is that the ceiling is a political statement. The central panel shows the apotheosis of King James, the main panel to the south shows him as peacemaker, and to the north he is depicted as the unifier of Scotland and England. But history was saving up one of its great ironies: within seven years of Rubens's paean to peace, Charles I was engaged in civil war; and on 30 January 1649 he walked directly from the Banqueting House on to the scaffold erected outside for his execution.

WHITEHALL, SW1A 2ER

## HORSE GUARDS

*Where horse soldiers are part of William Kent's scenery*

When the V&A held a big show recently of the work of William Kent all the dogs came out to bark. And why not? He was the spoiled brat of eighteenth-century art, promoted far above his worth by his patron, Lord Burlington, to a gullible nobility; depriving a better man, James Thornhill, of the key commission of decorating Kensington Palace. As a painter, which was the skill in which Kent first won acclaim, he was incompetent going on terrible. Hogarth, who hated everything Kent stood for, lost it altogether over the matter of Thornhill (whose daughter was his wife), and whenever he mentioned Kent in writing took to leaving the 'e' out of his name, with malign intent. And yet Horace Walpole, whose observations drew laughter and blood in equal proportions without worrying unduly about justice, in the case of Kent judiciously observed:

> *He was a painter, an architect, and the father of modern gardening. In the first character, he was below mediocrity; in the second, he was a restorer of the*

*science; in the last, an original, and the inventor of an art that realises painting, and improves nature.*

Walpole overlooks the furniture, the interior designs, the theatre work, the glorious 63-foot state barge built for Prince Frederick and replete with roaring lions, sea monsters, the fleur-de-lis, the insignia of the garter, and a royal crown, enhanced by more 24-carat gold leaf, possibly, than all the chairs, console tables, mirrors and picture frames, and the ceilings and the semi-domes of apses of his interiors put together. It seems possible that Kent, who was no fool, knew he did not possess the skill to be a painter, but that he had the painterly eye to map out great schemes of interior decoration, and to wash in impressions of his projected landscape gardens with a vision that would inspire successors like Capability Brown and Humphry Repton.

Kent's architectural reputation in London is rooted in his building of Horse Guards which, when he died in 1748, was finished by John Vardy. In any case, draughtsmanship too eluded Kent, dead or alive, so Vardy was happy to sign the drawings instead. Yet here Kent moved confidently away from the classicism of his patron Burlington to the baroque of Horse Guards. Seen either from Whitehall or Horse Guards Parade, its restless projection and recession within the central seven bays and in the flanking wings and, with the vivid skyline of balustrade, clock tower and pyramid roofs, combine to suggest that this is Kent's St Pancras. *Georgian London*, John Summerson's great summary, observes that it is 'grotesquely out of harmony' with the building's function. Horse Guards was intended to be the army's general staff HQ but better fits its secondary role as one of Kent's stage settings, with a cast of mounted Life Guards in gleaming breastplates and red-plumed helmets while the public in holiday mood drifts in and out of the arch at will.

WHITEHALL, SW1A 2AX

## NATIONAL POLICE MEMORIAL

*The book of courageous bobbies*

How do we get away from it, all those clay models and plaster casts, built up and broken down, all that expensive bronze given over to sterile servility offered up in tribute from the third-rate to the first-rate: a vacuous copy from a film clip (Charlie Chaplin with bendy legs and bendy stick), a television comedy act (Morecambe and Wise), or, much the same, pally politicians playing to the crowd (Churchill and Roosevelt side by side on a wooden public bench in Bond Street; Frankie and Winnie)? One answer is the National Police Memorial by Norman Foster (b. 1935) with the Danish artist Per Arnoldi (b. 1941) in St James's Park up hard by the old Admiralty building on the Mall, a tall aquamarine glass stele rising from a rectangular pool let into a terrace paved with Purbeck stone that links with a rectangular block, clad in black marble with a vitrine let into one side: behind the glass a book bears

the names of every policeman listed since record began who has died in the line of duty or been slaughtered off duty.

There are the names of PC John Egerton of Manchester, stabbed to death while arresting a thief; DC James Brian Porter of Durham, shot dead when chasing two men he knew to be armed; PC David Ian Haigh of North Yorkshire, shot by a suspect he was questioning, and Sergeant David Thomas Winter, shot by a suspect in the shooting of Haigh; Kenneth Robert Howorth, Metropolitan Police explosives expert killed trying to defuse a terrorist bomb... hundreds and hundreds of names plus dozens upon dozens of Ulster policemen shot down on and off duty, outside church, walking with their wives. And WPC Yvonne Fletcher, assassinated in St James's Square in 1984 by a hero of the Libyan Republic firing from a window of its embassy. It was this killing that stirred the film maker Michael Winner to found a trust to raise money for the memorial, and then persist with his plan for over ten years before the project was accepted.

ST JAMES'S PARK, SW1P

## FOREIGN AND COMMONWEALTH OFFICE

*Engineers of Empire – and the entente cordiale*

George Gilbert Scott's huge edifice on King Charles Street, backing on to Downing Street, flanked by Whitehall and St James's Park, is of course the Foreign Office. It is the home of hubris, of high ambitions biting the dust, of empire rising and falling and treaties no sooner signed than shredded. Yet nemesis, the destiny of hubris, has not stricken the Foreign Office itself. Not yet.

Scott himself expected to create a great Gothic building. A dispute about this ensued on the floor of the Commons, memorable enough to be known as the Style Wars, until Palmerston, embarking on his second spell as prime minister in 1859, intervened and insisted on Renaissance. What he got was Italianate Victorian classical.

Scott did introduce some medieval detailing, but the discipline of classicism produced more impressive results than unfettered Gothicism would have done (think of the extravaganza of St Pancras and compare that with the majesty of the Foreign Office and its fine tower seen from St James's Park). The building incorporated the India Office, for which Scott had to accept the collaboration of Matthew Digby Wyatt, a nonentity who produced a masterpiece, the India Office courtyard. For two years it was open to the sky but then, facing facts, it was glassed over; a lesson in Realpolitik. In 1903 it was renamed more romantically the Durbar Court when the coronation of Edward VII was marked by the Delhi Durbar, and parts of the celebration were held in the India Office. This too, despite the Minton majolica friezes and the sculpted reliefs of East India Company nabobs patronising their new subjects, is more Victorian than Indian.

The lush Locarno Suite in George Gilbert Scott's Foreign Office, where the European nations signed the Locarno non-aggression pact of 1925. Hitler destroyed that when he marched into the Rhineland 11 years later.

By another of those quirks of history, the hero of the enterprise of India, judging by the statuary in the courtyard, is the administrator and soldier Warren Hastings, Governor-General of Bengal, although he ended his days in the shadows in 1818, besmirched by his impeachment in Parliament for corruption despite fighting off a vitriolic prosecution by Edmund Burke. Elsewhere, in Wyatt's classy India Office council chamber, which looks down upon the Durbar Court, hangs Romney's full-length portrait of Hastings. It shows him standing on a natural eminence (not too many of those around Calcutta) in or soon after 1795, the year of his acquittal. It is not Romney's finest effort except for the passage to the right of a burning Indian sunset at Hastings's feet, a reminder of what a fine colourist the artist was; the chamber also contains a fireplace and overmantel commissioned from Michael Rysbrack, who carved a languid Britannia receiving tribute in cash and kind from what we once termed the natives. Today this chamber is known as the Entente Cordiale room, since it is where the famous treaty of 1904 between Britain and France was sealed. Curiously, it also contains a portrait (some distance after J. L. David) of Bonaparte as emperor, a friend neither of entente nor of cordiality.

Moving on from Indian affairs to Foreign Office (via yet another sculpture of Hastings, by Flaxman, very good), brings the visitor to the Locarno Suite by Scott: lush coffered ceilings, walls dripping in red and gold. It was named this because here the European nations signed the non-aggression Locarno Pact of 1925, the first of those pieces of paper that Hitler tore up, this time when the Nazis marched into the Rhineland in 1936: an early rehearsal for 1939, when nemesis was visited, not on the Foreign Office, but on Prime Minister Neville Chamberlain.
KING CHARLES STREET, SW1A 2AH

## STATUE OF GENERAL SMUTS, PARLIAMENT SQUARE

*An enemy turned friend, by Epstein*

Parliament Square is the biggest gallery of outdoor sculpture in the capital, which is not necessarily a cause for pride. Abraham Lincoln stands with his back to Middlesex Guildhall in a copy of the original in Chicago by the Irish-American sculptor Augustus Saint-Gaudens; nicely placed since the Guildhall became home to the new Supreme Court of the United Kingdom. Winston Churchill (lumpen) and David Lloyd George (vacuously populist) stand to the north of the square, backs to the Treasury, and a range of nineteenth-century statesmen line the west side along with the figure of Nelson Mandela: Westminster City Council turned this down for Trafalgar Square on the grounds that it was not good enough, so instead it has found its place in Parliament Square. Among all this mediocrity and semi-mediocrity stands Field Marshal Jan Smuts, who fought against the British in the Boer War but also sat in the British war cabinets of both world wars, and so is fittingly placed alongside his former comrades in armchairs, Lloyd

George and Churchill. This statue is by Jacob Epstein (1880–1959), the last sculptor in Britain to understand and be able to cope with the demands of large-scale outdoor portrait sculpture.

Epstein had borne the brunt of press and public obloquy for the remarkable power of his sculpture, which translated in the popular mind as primitive and obscene. Public commissions dried up but Epstein had a brilliant and sensitive talent for a naturalism that translated well into portraiture in bronze. Critics now professed boredom, though he kept them on their toes with sculpture like the great *Lazarus* in the chapel of New College, Oxford. The Smuts statue was unveiled in 1956, well after the age of equestrian statues, though Epstein's Smuts, in military uniform with boots and gaiters, looks almost ready to offer his kingdom for a horse. Epstein never met Smuts, but studied photographs and film clips and settled on the taut, forward-leaning posture, head thrown back, trimly bearded chin thrust out, to capture the essence of him. He creates brilliantly the wiriness of the figure, the tangible sense of contained energy of the man. But what kind of man? Smuts was both courageous and philosophical; he was born in 1870 and never shook off his belief in white supremacy; but he hated the politics of apartheid and mourned the National Party's victory in 1948 which kept it in power until the coming of Mandela in 1994. For that too, his statue belongs in Parliament Square.

PARLIAMENT SQUARE, SW1P

## SUPREME COURT

*The court that reigns supreme, up to a point*

The Supreme Court of the United States and the Supreme Court of the United Kingdom do exactly what the titles suggest: they are each the highest court in the land. The clear differences are: the American court was created in 1789 by decree of the newly drawn Constitution, but the UK's lusty infant arrived with healthy lungs as late as 2009; the UK court yields precedence to the European Court, the American court to no other party; the US court acts in the name of the people, the UK court in the name of the monarch. And the British court is still waiting for a Constitution. Gladstone observed in his orotund way: '… the American Constitution is, so far as I can see, the most wonderful work ever struck off at a given time by the brain and purpose of man'. As for Britain's unwritten Constitution: it was 'a constitutional settlement', as the late senior law lord Tom Bingham termed it with an advocate's subtlety; and one, he wrote, that could in these turbulent times become a serious problem.

Still, the new UK Supreme Court removed the law lords from government and placed them at the far side of Parliament Square, a jury, as I write, of 11 good men and one true woman. The building had been Middlesex Crown Court and before that from the time of its opening in 1913, Middlesex Guildhall. As it was sited to the north of Westminster Abbey and to the west of Pugin's Gothicised Palace of Westminster, the Scottish architect James Gibson adopted

Gothic dress, but here it takes a softer form. Done up for its exalted role, all is quiet, orderly, light and friendly, but with quotations that resonate like the Judgment of Solomon engraved on glass doors, actually admonitions from the judicial oath. There are three courtrooms up the curving Portland stone staircase; the biggest, court number one, alone on the second floor, has a hammerbeam roof and heavily mullioned windows. On the first floor, court number two has lots of old oils of serious men in wigs and gowns; and court number three is modern, clean and practical. The fine library has books only lawyers would want to consult and a carpet with neat bright patterning by the pop artist Peter Blake using the Supreme Court symbol of a rose, a leek, a thistle and a blue flax flower, sweeter in Blake's rendering than elsewhere in the building.

In this setting the law lords examine what can seem to be small cases, but these are defining because they raise important points of law, occasionally with lethal thrusts of the legal paper knife. 'The Secretary of State', they write of the blessed Theresa May in one judgment on an immigration issue, 'has failed to exercise her judgement on this imbalance… On any view, the measure was a sledgehammer but the Secretary of State has not attempted to identify the size of the nut.'
PARLIAMENT SQUARE, SW1P 3BD

## PALACE OF WESTMINSTER

*Pomp, tragedy and sleaze*

The two fires that consumed the Houses of Parliament, on 16 October 1834, after an overloaded and overheated stove burst

apart, and 10 and 11 May 1941, after incendiary bombing, had one thing in common: while practically everything else perished, Westminster Hall, the greatest vaulted medieval interior in Europe, survived. On the night of 10 May 1941, the Scottish MP Walter Elliot was in the house as the bombs dropped (coincidentally, it was the first anniversary of Churchill replacing Chamberlain as prime minister and evicting Elliot from the cabinet). The firefighters told him they couldn't save both the Commons chamber and Westminster Hall. Elliot opted for the hall and himself seized an axe to smash the door open and admit the firemen and their hoses. So it remains recognisably the hall that William II built in 1099, remodelled 300 years later by the master mason Henry Yevele with the great angel hammerbeam roof by Hugh Herland. Here the nation's highest courts of law were based; here the Roundheads sentenced to death Charles I, with the message that a king was as much subject to the law as a commoner; and here, James Somerset, who had been confined in chains after attempting to escape from his master, was declared in 1772 just as entitled to the protection of the law as a king in the famous judgment by Lord Mansfield stating that no man in England could be a slave. The rest of Westminster Palace (as it is still often known) is the rebuilt and restored masterpiece of Charles Barry (1795–1860) with lifeblood from Augustus Pugin (1812–52), who devoted his last years to devising the intricacy of Gothic detail no one else could have managed.

Visitors pass from Westminster Hall into St Stephen's Hall above the crypt chapel. Together, they were once a church modelled, a little hopefully, on the glorious Sainte-Chapelle in Paris, though soon the upper chapel became the House of Commons and remained so for 300 years until Barry made it the main approach to both houses, Commons and Lords, its walls decorated since 1927 with murals telling the story of Britain, politely sober in comparison to the death of Nelson and the victory of Wellington and Blücher in Daniel Maclise's celebrated paintings of 1859 and 1861. This pair is in the royal gallery, which lies on a north-south axis parallel to the Thames with the new Houses of Lords and Commons, the Lords in full high Victorian splendour, the post-war Commons muted, a green Gothic chamber by Giles Gilbert Scott (1880–1960), fatally without Gothic detail. Yet despite the disfiguring sleaze associated with the Commons now, it is strangely moving to tread the empty chamber where the shades of historic men and women in their pomp or their tragedy haunt the dispatch box and the back benches: Nancy Astor, the first woman to take her seat, Churchill in his quirky majesty, Attlee in his humility; Gladstone and Disraeli, Lloyd George and Asquith; the broken Eden.

PALACE OF WESTMINSTER, SW1A 0AA

Westminster Hall basically as it looked in 1355 after the master mason Henry Yevele had remodelled it and the carpenter Hugh Herland had installed the spectacular angel hammerbeam roof.

## STATUE OF OLIVER CROMWELL OUTSIDE WESTMINSTER HALL

*Hero and villain*

Hamo Thornycroft is not a name that springs readily to people's lips, though anybody who has ever stood in a queue for the Houses of Parliament knows his life-size sculpture of Oliver Cromwell set on a high plinth outside Westminster Hall. It is a wonder that the statue has survived since it was unveiled in November 1899. Lord Rosebery's Liberal government of 1894–5 sponsored it, but Cromwell's reputation had survived both as the butcher of Wexford and Drogheda and as the chief regicide of Charles I, and ensured that a large majority of Tory royalists voted with the whole block of Irish MPs against the sculpture.

The government only narrowly won the vote and withdrew its plan to fund the placing of the sculpture. Rosebery himself donated the money and so ensured that at least one of the measures put forward in his term as prime minister went ahead. It was unveiled, not at the dead of night, but quietly, and dissent rumbles on.

The statue is a prime piece of what is known as the new sculpture, if only inside the covers of esoteric art magazines. The phrase was coined by Edmund Gosse, a man of letters (at a guess, an extinct species today) and close friend of Thornycroft. It denotes a time after English sculpture woke from a period sunk in the torpor of carving marble as though it were luxury toilet soap and took on board the achievements of sculptors over the Channel such as Rodin. This was largely through the agency of Jules Dalou who, as a member of the revolutionary Commune formed in Paris after the French defeat to Prussia in 1871, had fled for his life to London where he peacefully propagated the values of the French way of art (see page 50). Thornycroft learned from him and became his assistant.

The *Spectator* gave a subdued welcome to Thornycroft's Cromwell:

> Though the statue is not in any sense a great one, we are most heartily glad to see a memorial of Cromwell placed in so conspicuous and honourable a position in London. England cannot be too often reminded of her heroic son, one who was at once the first and greatest of Unionists and of sane Imperialists, and the representative of all that is strongest and best both on the spiritual and the political side of the national character.

The dismissal of the quality of the statue is harmless: the *Spectator* is clearly in the political game. Thornycroft was not, though he had clearly read up on his subject. Cromwell carries a Bible in his left hand, hat crushed beneath his arm, and in his right his sword, point to the ground. The sculpture is the man, pragmatic, dressed for war, gazing downwards as though at a regiment passing by. There was no problem getting a likeness. Most painted portraits of Cromwell tell the same story, warts and all as ordered, and Thornycroft certainly used a portrait sketch in his possession as reference material, the work of the seventeenth-century master miniaturist Samuel Cooper.

Hard by, outside the House of Lords, is the bravura statue of Richard Coeur de

Lion by another immigrant, the exotic Carlo Marochetti, Baron Marochetti in the nobility of Sardinia. Prince Albert proposed the positioning of the statue, and the Queen later commissioned Marochetti to sculpt the seated prince at the heart of the Albert Memorial in Kensington Gardens, though the artist died before it was finished. His Richard I is a kind of folly, licensed perhaps by the age of chivalry, not a portrait of a soldier who could say, like Cromwell after his massacres: 'I am persuaded that this is a righteous judgment of God upon these barbarous wretches, who have imbrued their hands in so much innocent blood.' God's Englishman, as the historian Christopher Hill called Cromwell, with a tinge of irony.
HOUSE OF COMMONS, SW1A 0AA

## JEWEL TOWER, OLD PALACE YARD

*Yevele's weekday masterpiece*

Through the vicissitudes of 650 years Edward III's Jewel Tower of 1365-6, built at a little remove from Westminster Hall, has survived. Like much of London it is built of Kentish ragstone floated by barge down the Medway from Maidstone and up the Thames. The hall is recognised as one of the greatest of medieval buildings; the Jewel Tower is scarcely known. It sat in a quiet, almost secret, corner of the king's privy chambers and gardens. Even today, approaching from Parliament Square, the tower is largely obscured by 6-7 Old Palace Yard, a big Palladian government building.

Just as at Westminster Hall and in the nave of the abbey, the master mason was Henry Yevele (*c.* 1320/30–1400), as we know from a surviving list of payments to him for work and expenses. Compared to the nave of Westminster Abbey this is Yevele's journeyman work. He built the tower L-shaped because it formed the south-west corner of the palace, actually invading the abbey's grounds. The monks were enraged and much good it did them: to this day the abbey garden walls take a detour around the tower. To one side is the old moat once fed directly from the Thames and excavated in the 1960s, and the ancient quay. Both have been absorbed into the little garden.

In the tower King Edward and his successors until Edward VI in 1551 kept their personal treasures of jewel and plate and possibly livery and robes too. After this date it became variously a Parliament office, a near ruin, and, after restoration, the office of the controllers of weights and measures. Some part of all this is reflected in the contents of the little museum it has become, but most interesting of all is the ground-floor box office where Yevele's rib-vault survives with its big bosses well carved with grotesques and intertwined birds. Here too are displayed the eight carved Norman capitals from William Rufus's original Westminster Hall of 1097-9, later used as infill for the walls remodelled by Yevele and discovered during early nineteenth-century restoration. Most of the capitals are ruined, but there are fine survivals of animal carvings and of a soldier attacking a tower, uprooted, crude, but charged with the energy of the Vikings for whom the Dukedom of

Normandy and Kingdom of England were only small parts of an enterprise extending across the Mediterranean.

ABINGDON STREET, SW1P 3JX

## ST MARGARET'S, WESTMINSTER

*Once a society church, now the church of the House of Commons*

St Margaret's, the pretty church in the lee of Westminster Abbey, was the venue of choice for the bright young things between the two world wars, 'those vile bodies' in Evelyn Waugh's phrase. Since the 1930s it has come down in the world: it is now merely the church of the House of Commons. Its Portland stone apparel, white as a society bride's, was ordained in the eighteenth century. The west tower, offset to the north, is Gothick of the period of Horace Walpole's Strawberry Hill. George Gilbert Scott intervened in the nave. The Victorian Gothicist J. L. Pearson created the filigree porch. Somewhere beneath all this, just possibly, are the mouldering remains of the eleventh-century church dedicated to St Margaret of Antioch.

Other remains are commemorated in a glut of memorials, but it is the glass that lifts St Margaret's above the norm for parish churches, among them the good west window (1883) which commemorates the voyages of Sir Walter Raleigh, who was buried here after having his head chopped off in New Palace Yard. Admiral Robert Blake, hero of the Anglo-Dutch Wars and the obliteration of a Mediterranean pirate fleet, died in 1657 and was first buried next door, but he had fought for Cromwell, so when royalty was restored his remains were abruptly decanted from the abbey to St Margaret's; the window in his memory in the north aisle is by Edward Frampton (1845–1928), a forgotten artist who should be remembered for his productive adherence to the advanced art of the French Symbolists, well suited to glass. But the big one is the east window, which is filled with sixteenth-century Netherlandish glass installed to celebrate the marriage of Henry VIII and the first of his six wives, Catherine of Aragon. Though the alliance swiftly became a political hot potato, it is the single best window of stained glass in Westminster, not counting the six small thirteenth-century windows in the abbey museum.

Its subject is the crucifixion and the glass designer was the Leiden artist Cornelis Engebrechtsz (*c*. 1462–1527) or someone in his circle. It looks convincingly as though it had been designed for this window of five lights, with the crucified figures set against a brilliant blue sky, and a crowd of mourners in red and blue in the foreground at the foot of Christ's cross uniting the composition. But it had actually been designed as one large light, possibly for Waltham Abbey. In 1758 the church wardens bought it from Copt Hall in Essex where it had been adapted to five lights which, near enough, fitted St Margaret's showpiece window. No work by any Leiden painter before Engebrechtsz survives. Later the city was to be a famous training ground for artists, among them Rembrandt. But that's another story.

ST MARGARET STREET, SW1P 3JX

## TOMBS OF HENRY VII AND ELIZABETH OF YORK, WESTMINSTER ABBEY

*The sculptor who fell out with Michelangelo*

One of the early frames of the world's biggest comic strip, the Bayeux Tapestry, shows Harold being crowned King of the English in 1066 in Westminster Abbey, the event which precipitated the invasion by William of Normandy. Today the Abbey's appearance is dominated by Henry III's rebuilding of it in pointed Gothic but its function hasn't changed: ever since Harold, the Abbey has been the place of coronation of English monarchs. For centuries it was their burial place as well with its glorious culmination the lady chapel, now named for Henry VII, first of the Tudors, who further rebuilt it and is buried there with his queen, Elizabeth of York, under an astonishingly intricate fan vault with hanging pendants, a last fling for Perpendicular Gothic before the Reformation.

The chapel was finished in 1510, a year after the king's death, and work on the tomb started in 1512. Henry had chosen the Florentine Pietro Torrigiano (1472–1528) as sculptor and designer of the effigies of Elizabeth and himself and the plinth-like sarcophagus with medallions containing lovely relief sculptures. There is no labelling in the chapel to identify the Florentine master Torrigiano as the author of this tomb, medieval England's first fully Renaissance work of art, even though the format, effigies lying side by side, pays respect to the Gothic tradition. Torrigiano had studied side by side with Michelangelo, learning painting and drawing in the workshop of Ghirlandaio and sculpture under the patronage of Lorenzo the Magnificent. In the first decade of the sixteenth century, nothing in this turbulent offshore island had previously been seen to compare with such sculpture and nothing like Torrigiano's work would be seen again before Hans Holbein arrived at the riverside home of Thomas More 14 years later (and even so England never fully took to the Renaissance until Inigo Jones, Peter Paul Rubens and Anthony van Dyck began work for the first Stuart kings a century later)

Torrigiano is infamous as the fellow apprentice who broke Michelangelo's nose in an argument in the Brancacci Chapel, Florence, where both were making studies of the Masaccio fresco cycle. He was, in the words of the sixteenth-century art historian Vasari, motivated by envy, and Condivi, Michelangelo's other biographer, simply wrote him off as bestial. Does any of this matter 500 years later? Well yes, because Michelangelo's bad break was England's good fortune.

Henry VII's mother, Lady Margaret Beaufort, died, like her son, in 1509 and Torrigiano began her separate tomb in the south aisle of the chapel in 1511. The gilt-bronze figure of Lady Margaret lies on a lower sarcophagus than those of her son and daughter-in-law so it is easier to see the moving humanity of the portrait. The lines of age and suffering marking her exquisitely modelled face and the long easy curves of the gown cloaking her body are from a new world of

Renaissance art compared to the severe angularity of the Gothic memorials, which were all England knew until this point. The gilded sculptures of Henry VII and his queen lie side by side above eye level upon a sumptuous marble tomb like a great sculptural plinth contained within a Gothic open screen of brass. Torrigiano has treated their heads like the emblematic royal portraits on coins, though they may have been actual portraits made on the basis of death masks. All the warmth here is lavished on the winning angels at the corners of the tombs, and the lions at the couple's feet combine an architectural formality with a flowing line of contained energy. The enterprise suggests quite a different Torrigiano from the one described by the friends of Michelangelo.

WESTMINSTER ABBEY, SW1P 3PA

## 28 QUEEN ANNE'S GATE

*A fine Queen Anne doorway*

The terraces of dark redbrick houses of 1704–5 with sumptuous doorcases make Queen Anne's Gate one of the grandest streets of its kind anywhere. It was once divided into two: Queen Square, where the best houses are, and, after a sudden narrowing, Old Queen Street. At the join halfway down, where the narrowing provides a corner, stands a weathered statue of Anna Regina, as the plinth is inscribed, installed by 1708, six years after her accession to the throne. Opposite it is number 28 Queen Anne's Gate, which has the best doorcase and history.

Between the two world wars the owner of the house was Ronald Tree, a bisexual Conservative MP who also owned Ditchley Park, near Charlbury

in Oxfordshire, which he lent to Winston Churchill as a wartime hideaway. At number 28, following the resignation of Anthony Eden in the run-up to the Munich Agreement, Tree entertained the members of a supposedly secret grouping of MPs opposing Prime Minister Neville Chamberlain, including Harold Macmillan, the socialist and diarist Harold Nicolson, Duff Cooper, who resigned as minister of war after Munich, Eden himself and Leo Amery, who would later make the key speech from the floor of the Commons demanding Chamberlain's resignation ('in the name of God, go!'). The group had no name until it was contemptuously dubbed 'the glamour boys' by a former MI5 operative and Chamberlain groupie who succeeded in bugging number 28. It probably wasn't worth doing, because the group seems to have been merely a glamour boys' talking shop.

As with other houses in the old Queen's Square, grotesque heads are carved on the keystones above the windows. But what's so good about this door is that, where the detail of the others in the street (apart from number 1, which is a grandiose modern invention) is clogged by white paint, number 28's has been left, or brought back, to natural wood, possibly anti-historically, with lacy pilasters as doorposts and on the door hood a double arch with opulent foliage and a beautiful hermaphrodite head in the centre. Actually, in the necessary modern way, the original doorway is

The weathered statue of Queen Anne that presides over Queen Anne's gate.

preserved in the Victoria & Albert Museum and an exact replica is installed on the house.

QUEEN ANNE'S GATE, SW1H 9AB

## LONDON UNDERGROUND HEAD OFFICE

*Epstein's modernist challenge*

Charles Holden was an austere architect and an austere man, but he loved the sculpture of Jacob Epstein with a passion, so in the late 1920s, when it came to commissioning sculpture for his new London Underground headquarters, Epstein was top of his shopping list. He was to carve sculptures of *Day* and *Night*, and six other sculptors Holden commissioned together with Frank Pick, London Transport's enlightened man for all seasons (see pages 234-5), divided eight representations of the winds between them. Eric Gill took a North Wind, a South Wind and an East Wind, Eric Aumonier a second South Wind; Alfred Gerrard took a second North Wind and Allan Wyon a second East Wind, the young Henry Moore one West Wind and Samuel Rabinovitch another. The six artists apart from Epstein fitted neatly into a modern reinterpretation of pre-Renaissance frieze sculpture, Gill's wind gods' horizontal slipstreams represented freezing into architectural elements, as they do at the Tower of Winds in Athens; Rabinovitch's articulated as toughly as working machinery; Moore's archaic female figure throws her massive limbs horizontally across the face of the building like a runaway Tube train, though the

format is clearly based on a Romanesque angel.

Unconfined by a frieze, Epstein marched to a different drumbeat. His two elemental pieces are vertical, the figures inspired by pre-Columbian Mexico. *Day* is a god assembled with tree-trunk limbs, a naked boy protected between his legs, dawn stretching aspiringly upwards (the boy's genitals provoked another of the outraged reactions from press and public that characterised Epstein's career). *Night* is the massively sombre mother figure of a primitive pietà, the mate of *Day*, and the body stretched across her lap is the same boy, their son and personification of the done day. Epstein carved *Night* from scaffolding in situ, hitting a note of raw vitality that he would achieve only rarely in his long life.

Holden's building itself is a stepped pile suggesting a ziggurat, much admired but by some (me anyway) unloved for its massive inertia. It certainly was not designed for the display of sculpture. Epstein's apart, the other sculptures can only be dimly discerned. While the press inveighed against Epstein, as it always did in his early career, a public-spirited Underground company director whose sentiments echoed the hullabaloo kindly offered to pay the costs of having the two carvings removed, and Pick submitted his resignation (it was refused). With an action strangely premonitory of how Gill settled the predictable public outcry a few years later over his naked *Ariel* on the BBC building in Portland Place (see page 192), Epstein chopped an inch and a half off the *Day* boy's penis.

The real problem was always about placing sculpture on a building that was not designed for it and some of it is pretty well invisible anyway: an intimation of the fate awaiting the artists as sculptors. Aumonier prospered, like Epstein, Moore and Gill: his free-standing (or strictly, kneeling) archer on top of Finchley East Underground station barely alters the relief technique to three dimensions and works equally well (see page 532). Gerrard taught (among others) Eduardo Paolozzi. Wyon made church memorial sculpture and in late life embraced holy orders. Samuel Rabinovitch, unjustly, could not make a living from sculpting, so called himself Sam Rabin and became a boxer and a painter, working as a realist: so real that his pictures are scenes from the square ring where now he fought for life.

55 BROADWAY, SW1H OBD

## SCULPTURES OUTSIDE TATE BRITAIN

*Out of season, out of place, ancient myth cast in bronze*

Henry Tate left two monuments by the Thames: the first was the huge sugar refinery in Silvertown (1879, heavily blitzed and rebuilt in the 1950s); the second, the gallery on Millbank. It opened in 1897 on the site of Millbank Penitentiary, the biggest jail in London and probably the gloomiest, which opened in 1816 and died of misery in 1890. The large collection of Pre-Raphaelites with which Tate launched his gallery were thought to be an improvement on the prison, and continue to serve as another way of satisfying the nation's

sweet tooth. At the opening of Tate Modern on Bankside in 2000 the Millbank institution reverted to being the gallery for British art, and is now a good deal more bracing than at any time in its history. A wide flight of steps leads to the entrance, framed by a portico with Neo-classical columns, a large entrance hall beneath a dome. A new big entrance opens at basement level off Atterbury Street, and to the other side of the core Tate is the cheekily radical Post-Modernist Clore Gallery by James Stirling (1987), basically in red and yellow brick with windows and a brashly welcoming entrance framed in bright green opening on to the great Turner collection.

As for the Pre-Raphaelites, they remain as a staple of the permanent collection, and as the basis of temporary 'major' shows, treats incorporating loans from elsewhere. But the gallery's opening coincided with the end of the Victorian era and the impending end of the Queen herself. When the Prince Consort died, George Gilbert Scott set to producing his 174-foot-high paean in granite, the Albert Memorial. The eminent Edwardian Lytton Strachey later came to describe it, having gazed in fascinated horror and not a little glee at the cladding of mosaics and, at the point where authorities seemed to be losing count, 175 life-size or larger sculptures in stone and bronze with, at the base of this immense gilded ciborium a seated ten-foot-high gilded Albert. Strachey concluded: 'It was rightly supposed that the simple word "Albert", cast on the base, would be a sufficient means of identification.'

This was the consummation of a vein of British sculpture that had turned rancid. The Queen unveiled the Albert Memorial in 1872. Two years before the Franco-Prussian War had driven a number of French Impressionists to escape across the Channel. In 1872 as the revolutionary Commune collapsed other artists followed, bringing an injection of new ideas to enliven British painting and sculpture. Two of the fruits of this movement, which flank Tate Britain's portico, were created by Henry Fehr (1867–1940) and the exotically named Sir Charles Bennett Lawes-Wittewronge (1843–1911), lord of the manor of Rothamsted in Hertfordshire. One piece, *Perseus Rescuing Andromeda*, nine foot high, shows Fehr at his best even if, at a guess, it is rarely seen although prominently displayed with its equally invisible partner, Sir Charles's *The Death of Dirce*, at eight foot four inches high. Both are packed with energy, but both are out of season and out of place, and I for one didn't spare them a glance in something over 60 years until one day my idle eyes fell on *Dirce* and stayed there.

In his day Lawes-Wittewronge was celebrated, not as an artist, because he exhibited only a dozen pieces of sculpture at the Royal Academy, but as the finest athlete and oarsman anybody at Eton or Cambridge could remember. He took the eccentric decision for a man of his class and long lineage to be a sculptor, but as he studied in London and Berlin he clearly paid attention. The almost languid elegance of Fehr's *Perseus* makes it the more immediately attractive piece, but also the less ambitious: Lawes-Wittewronge's Dirce, the cruel queen of Thebes, has mistreated her husband's niece Antiope, whose two sons catch up with Dirce and rope her to a bull

as a slightly outré way of killing her. Anguished Antiope, who travels naked like her sons and Dirce, makes a fifth member of the group counting the bull. It is bulging with more classical myth than any one piece should be able to stand, but *Dirce* deserves an audience.

MILLBANK, SW1P 4RG

## MURALS IN THE REX WHISTLER RESTAURANT, TATE BRITAIN

*Rex Whistler's Epicurania*

In 1925 the art dealer Joseph Duveen (later Lord Duveen of Millbank) suggested a refreshment room for the Tate Gallery and added an inducement: £500 to pay for a mural. A committee was formed to sort out the practicalities, and one member was Henry Tonks, Professor of Fine Art at the Slade. He was a severe old cove and a hard taskmaster, but he had taken a shine to a student, Rex Whistler, wet behind the ears at 20, endowed with a lightweight talent, witty and with a streak of melancholy; in all, an unlikely-seeming recipient for the professor's approval. But Tonks believed that Whistler was one of only a handful of artists he had ever met who were naturally endowed with drawing skills. He may, too, have sensed the core of steel Whistler would draw upon to complete the commission (and, at the age of 38, to become a tank commander; he was killed in the Normandy landings).

The committee handed the commission to Whistler, and he took on as assistant to mix colours and square up the design for enlargement on the canvas another Slade student, Nan West. His pay was £5 a week, hers £3 (and, when Whistler delivered, Duveen added a bonus of £100). The refreshment room, later the restaurant, is in the basement and was a mess of heating apparatus, water pipes and iron pillars. Whistler deployed colour to throw light into the gloomy room in a narrative written for him by his lifelong friend, Edith Olivier, called *An Expedition In Pursuit of Rare Meats*. In it a light-hearted party departs gaily on foot, bicycle and in a chariot from the gigantic portico of the palace in the Duchy of Epicurania in search of sturgeon, truffles and game. Into a landscape of distant mists and mountains they go, past streams and rushing torrents, parks modulating into China and Peru and scattered with architectural follies researched on visits into the English countryside, including the famous bridge in Wilton Park, a pavilion and an arch from Stowe, a Chinese pagoda (from Richmond?) and grottos (Stourhead?), with a bust of Professor Tonks looking out benignly from a niche in one. Onward through green vistas mostly unknown to nature and trees from paintings by Claude to a rapturous reception on their return to the palace through a Roman triumphal arch.

Whistler completed the painting in 1927. In 1928, the Thames flooded the room to a depth of eight feet, but he had worked in a mixture of oils and wax to make the murals easy to clean. Inadvertently, he had discovered the recipe to save them from the results of inundation. Recently the Tate restored the restaurant, wiped the residue of cigar

smoke from the murals and introduced beautiful top lighting. These murals bought Whistler to the attention of the beau monde, to whom he became a favourite illustrator and muralist, painting's equivalent to the song writer, entertainer and actor Ivor Novello, another boy who rose from humble beginnings to make the miserable rich a little happier.
MILLBANK, SW1P 4RG

## SCULPTURE BY HENRY MOORE, CHELSEA COLLEGE OF ARTS

*Moore's two into one piece*

As Tate Britain prepared to mount an exhibition in 2010 of the work of Henry Moore (1896–1986) which, it told the press, would 'reassert his position at the forefront of progressive twentieth-century sculpture', Chelsea College of Arts, across Atterbury Street from the Tate, mounted its own show. Its rather narrower focus was to document the peripatetic history of its own Moore sculpture. The show was lit up with a filmed recital by the actor Dudley Sutton of his own verse entitled *Don't do any more Henry Moore (You are becoming a monumental bore)*. The public might have seen it as a riposte to the Tate, and so it was, but it was dressed up as a lament written from the point of view of the removal men saddled with shunting Moore's *Two Piece Reclining Figure No.1* (1959) from place to place during its 50-year history.

In the 1930s Moore was Professor of Sculpture at Chelsea, so in 1963, when the school was preparing to move to Manresa Road and felt it needed a piece of sculpture as a focus, it seemed a good idea to approach the grand old man. Although Moore had made sculpture in separate parts previously, *Two Piece Reclining Figure* was No. 1 because it was the first time he had divided a single figure. 'I did the first one in pieces almost without intending to,' he said. 'But after I had done it... I realised what an advantage a separated two-piece composition could have in relating figures to landscape. Knees and breasts are mountains. Once these two parts become separated, you don't expect a naturalistic figure; therefore you can justifiably make it like a landscape or rock.'

In 1964 this severed woman/landscape arrived at Manresa Road. In the years following it was sent for exhibition to Tate, the Royal Academy, and the Jeu de Paume. While the school prepared to move from Manresa Road to the Victorian headquarters of the Royal Army Medical Corps in Atterbury Street, the Moore reclined in Yorkshire Sculpture Park. On its arrival (at its final resting place?) in 2010, students satirically arranged to have it displayed on the wooden transport pallets with straps and blankets, just as it had arrived.

When Moore sold the piece to Chelsea Art School, he was becoming vocal about his place in history. There was little by him in London, and even Tate's collection was wanting. He presented 28 major pieces to the gallery (the swelling total including drawings now reaches 634 pieces), and today, hard by, his *Locking Piece* stands in Riverwalk Gardens, *Knife-Edge Two Piece* is close to the Jewel Tower, and *King and Queen* sometimes appears

outside Tate Britain. Meanwhile, when *Two Piece Reclining Figure No.1* returned from Yorkshire to Chelsea, it displaced a statue of Sir James McGrigor, surgeon general to the Duke of Wellington's army in the Peninsular Wars and founder of the Medical Corps; a salutary warning of what a hundred years or so can do to a place in history.

16 JOHN ISLIP STREET, SW1P 4JU

## ST JAMES THE LESS, PIMLICO

*Street's sketching trip that produced a fine church*

... the Less what? G. E. Street's Pimlico church is packed with all the effects he could summon, which is a lot. The modernist slogan 'less is more' was hardly ever less true than here. Street, born in 1824, a short generation after Augustus Pugin and his followers, rejected the new Pugin orthodoxy proclaiming fourteenth-century English Gothic the one true architecture. Instead he returned from his first visit to France exhilarated by what he had seen there. He followed this up in 1853 with a visit to northern Italy, sketching all the way. Back home, he sat down and wrote and illustrated a book about its buildings, grand and humble. He called the book *Brick and Marble in the Middle Ages* ('copiously illustrated'), and though it has the title of a boring manual it shapes up as a holiday guide with the sort of eyes-wide-open detail of R. L. Stevenson's *Travels with a Donkey in the Cévennes*, but in this case by steam train and the Channel link from Folkestone. What's gripping is Street's vision of a fresh way to building a Gothic New Jerusalem in England, of brick (how suitable for London!) and marble and semi-precious stones (how beautiful compared to ragstone!). He is bowled over by brick campaniles – unbuttressed yet so powerful – and by the time he reaches Mantua he is besotted with brick windows: one after another he draws, captioned merely 'brick window', with the place name often an afterthought.

When he came to design St James the Less, his first London church, instead of a conventional tower he built a campanile, unbuttressed, standing just apart from the church, straddling the porch before the main entrance, and in the campanile is a bell opening, deeply exotic, an emotional expression of all that Street had felt in Italy. Strictly speaking it is composed of two windows, separated by a slender white shaft, repeated on each of the four faces, brick-built of course, finely moulded, the framing brick not quite forming an ogee at the top but curving indicatively; above, large semi-precious stones set in white plates. The whole of Street's Italian trip is here in embryo with the sole intrusion of large louvres of slate in the bell openings, an item borrowed from France.

Calmly, Street imposed a French apse too, the roundness picked out by diapered red and black brick, the lancets punched through solid stone, the earliest blunt Gothic window form (plate tracery) introduced about 1200, and a steeply pitched French roof of grey slate, the chancel and slightly taller nave massed like a bulwark

Work in progress: while the lower part of Westminster Cathedral is richly adorned, much of the upper part still awaits its intended mosaics.

against the huge vertical thrust of the campanile, pointed up by slit windows (not that different from Goldfinger's Trellick Tower, picture page 249). Inside the main entrance is a spectacular font and canopy, clear, attractively coloured stained glass by one of the bigger and better Victorian manufacturers, Clayton and Bell, red and black brick, the vaulted chancel with lots of marble.

No organ, but a Yamaha keyboard.
MORETON STREET, SW1V 2PS

## WESTMINSTER CATHEDRAL

*Ancient and modern*

When the architect of Westminster Cathedral, John Francis Bentley, proposed a Neo-Byzantine design to Cardinal Vaughan, his clinching argument was this: whereas with a Gothic building, structure and adornment had to be integrated time-consumingly, with his favoured Byzantine the Cardinal could have a functioning building fairly quickly, to which adornment could be added later. And so it proved. Building started in 1895; today only the appearance of the eastern apse and high altar, and its flanking chapels of the Blessed Virgin Mary and Anrep's Blessed Sacrament, show how the cathedral could look with a complete programme of mosaics in place, which, judging by current progress, would be in 3-400 years. Not that the delay matters: the consuming darkness within the three great domes over the nave has its own sombre magnificence. And then, beyond the marble and alabaster, and Eric Gill's 14 *Stations of the Cross* and Giacomo Manzù's bronze plaque of St Thérèse of

Lisieux, are the mosaics, not to be compared with Ravenna's, but including among them the work of Boris Vasilyevich Anrep (1883–1969), which makes its way in the world on its own terms.

Anrep grew up fascinated by Orthodox icons. He was a First World War warrior, a wit, a Boris-the-lad loved by many women, one of them the poet Anna Akhmatova, revered by her readers but not by Stalin, who forthwith banned publication of her poetry. She dedicated poems to Anrep, often reproachfully ('Oh, in dreams you don't confuse my name,/ Or sigh, as you do here'); and in 1917 she chewed him up and spat him out over his move to England:

> *You are an apostate: for a green island*
> *You betrayed, betrayed your native*
>     *land*

She was not far off the mark. In England Anrep became a close friend of Roger Fry and the Bloomsbury Group, until Fry stole his second wife, though he picked up a third from the queue. Augustus John promoted him and he worked for high society, creating domestic mosaics for John himself, Diana Cooper, Lytton Strachey (who fancied him), and Lord and Lady Jowitt. In the same spirit he decorated the floors of the National Gallery vestibule, incorporating portraits of the famous: Bertrand Russell as *Lucidity*, Churchill as *Defiance*. And his lost Akhmatova as *Compassion*.

His triumph was to bring this spirit of levity to the cathedral. His mosaic of St Oliver Plunkett, executed at Tyburn, glitters with Byzantine gold outside the chapel for the Irish Martyrs, while the Chapel of the Blessed Sacrament, all Anrep's work, makes sense of his help to Fry with the famous Post-Impressionist exhibition of 1912 in London: angels and prophets in pastel colours, pale pinks and yellows, cool blues, lawn greens from that green and pleasant island he had come to, escaping Akhmatova's biblical wrath, the earth taking on the hues of heaven at dawn (*Impression, Sunrise*). Brave art from Boris the rogue, brave and lovable.

From the mosaics to Eric Gill's *14 Stations of the Cross*, every artwork in the cathedral is, it might be felt, presided over by *Our Lady of Westminster*, lately so called because it is a medieval Virgin and Child presented to the cathedral only in 1955. It is probably of the late fourteenth or the fifteenth century, since that's when the Nottingham workshops were geared up to full production and export mode. Some of the output was the work of monks responding to market demand; most was produced by professional masons. These small sculptures, from stone quarried in the north Midlands, were sold all over Europe; those that stayed in England suffered destruction like most other religious imagery when Henry VIII sent his unsparing commissioners into the regions to root out papist idolatry.

The Westminster piece was saved because it was one of the exports. It is a stock Virgin and Child of the period, she crowned and the child rendered as a little manikin standing on her knee. It's not that sculptors of the time were incapable of carving a realistic child – the figure of the mother gives the lie to that in its tenderness of face and pose. It is

more likely that the sculptor was encapsulating the adult Christ in the child, foreshadowing his fate as saviour of mankind. The Virgin's crown and mantle are brown, tinged gold, her face is glowing cream alabaster, her eyes downcast in love and sorrow. It is a Christian image like many other Christian images, alike in iconography, idealisation and pose, and yet it is uniquely beautiful. Whatever the harsh realities of life in Nottingham in the Middle Ages, the artists who made these objects knew a peace that passes the understanding of our own age.

42 FRANCIS STREET, SW1P 1QW

## ST BARNABAS, PIMLICO

*The new church that raised a riot*

Thomas Cubitt's grand project of five decades, building Pimlico, was half complete in 1850 when the church of St Barnabas on the corner of St Barnabas Street and Pimlico Road was consecrated. The founder was the Reverend W. J. E. Bennett, who had been drawn in to the Oxford Movement which advocated a return to the ritualism lost in England since the Reformation. (The architect chosen for this notable Early English building was Thomas Cundy.)

The enterprise came at a point where half the population was non-conformist, and the other half who professed Anglicanism closer to non-conformism than to the developing High Church of Anglo-Catholicism. The savage Gordon Riots of 1780 against Catholicism were still vivid enough in public memory for Dickens to put them at the centre of *Barnaby Rudge* as late as 1841. In 1845 the leader of the Anglo-Catholic Oxford Movement, John Henry Newman, converted to Roman Catholicism. Bennett's choice of early preachers for the church he'd founded included a string of High Churchmen, notable among them John Keble and Archdeacon Manning, later a cardinal of the Roman Catholic church.

To the people of Pimlico, it seemed that Rome was controlling the ritual, and the opening on the saint's day, 11 June, of St Barnabas, complete with rood screen and a choir trained in Gregorian chant, was seen as a direct incitement. Riots broke out, 100 policemen were sent to disperse the disaffected parishioners, and the Bishop of London, Charles James Blomfield, forced Bennett to resign. The riots continued and the affair simmered in and out of the law courts for five years until it became clear that the pope's legions were not on the march.

In calmer times by the end of the century the notable ecclesiastical architect G. F. Bodley (1827–1907), his pupils Ninian Comper (1864–1960) and the stained-glass artist Charles Eamer Kempe (1837–1907), set about transforming St Barnabas into one of the finest churches in London; and still in the scholarly High Church faux-medieval mode rather than the rather more contemporary Arts and Crafts style. Bodley built a screen with a highly stylised cross on Christ's rood. His, too, is the convincing take on a Decorated fourteenth-century reredos of multiple carved figures. Comper designed a freestanding 'medieval' sculpture of the

*Madonna and Child* for the south wall, painted a 'primitive' altarpiece for the lady chapel of the *Lamentation* over the dead Christ and above it placed a window that is better than the nine Kempe windows in the north and south walls: the Kempe workshop can be brilliant, but here it isn't, probably because most of the windows were made by his weaker successor and nephew, Walter Tower.

In the streets around the church today, homes designed for the poor fetch up to £4 million and St Barnabas Street itself sports a starred Michelin restaurant. But at another High Anglican church in Tunbridge Wells (another St Barnabas too), the dispute rumbles on: in 2011 the priest and 54 parishioners out of 72 voted to leave and join the Roman Catholics and their opposition to women priests. *Plus ça change, plus c'est la même chose*, as they say down Pimlico way.

ST BARNABAS STREET, SW1W 8PF

## BELGRAVE SQUARE

### *A Yank in Belgravia*

Belgrave Square, though big, is not as big as Tiananmen Square in Beijing, nor as grand as Grande Place in Brussels, as old as the Place des Vosges in Paris, as gaudy as Times Square in New York. Neither in its own terms is it wholly satisfactory: the terraces on each side of Belgrave Square are tantalisingly different but all big, four storeys, the fourth above the main cornice and, typically, beneath a balustrade punctuated by urns. In 1826 Belgravia had been open land belonging to Robert Grosvenor (born Viscount Belgrave, succeeding as 2nd Earl of Westminster, ancestor of the Dukes of the same style). He brought in the London master builder William Cubitt to build the streets and squares of Belgravia, though the designer of the terraces of Belgrave Square was Soane's brilliant pupil George Basevi. On three of the square's corners are freestanding mansions, but not the fourth. The three, incidentally, were each fine houses in their own right, by Robert Smirke, in the north corner, Henry Kendall, in the south and Philip Hardwick in the east. The problem with the square as a whole (which covers more than ten acres) is that it's impossible now to see any one side from the others across the mature gardens. But there is no doubting its splendour, and well into the twentieth century it was one of the most sought-after addresses for rich socialites, the kind of people who, like Henry ('Chips') Channon, were keen on the Nazis and quite bowled over by the charms of Hitler's ambassador to London (1936–8), Joachim von Ribbentrop.

Chips was an astute American popinjay and diarist, infatuated with English high society, naturalised British, knighted but never m'lorded. He bought the lease of 5 Belgrave Square, dubbed it Schloss Chips, and brought in Stéphane Boudin, 'the greatest decorator in the world' (who later did interiors for Jackie in the Kennedy White House). Boudin set out to make the rooms rival the Amalienburg Palace, something he came close to, judging by the reaction of Chips's fellow diarist Harold Nicolson: 'Oh my God, how rich and powerful Lord Channon has

become! ['Lord' is below the belt]... The house is all Regency upstairs with very carefully draped curtains and Madame Récamier sofas and wall-paintings. Then the dining-room is entered through an orange lobby and discloses itself suddenly as a copy of the Amalienburg near Munich – baroque and rococo and what-ho and oh-no-no and all that.'

Extant photographs show Channon's interiors, but his was only one among many such houses in Belgrave Square, though singular in the scale of Channon's ambitions for it. Belgravia remains a cornerstone of the vast fortune of the Grosvenor family and multinational conglomerate Grosvenor Group. Number 5 has once again been privately occupied, by Oleg Deripaska, a Russian businessman also richer than either Croesus or Chips, but in general the square is the heart of envoy country: Austria, Spain, Romania, Trinidad and Tobago, Serbia and sad Syria, Portugal, Ghana, Brunei, Norway, Bahrain, Malaysia, all have embassies or high commissions here. The biggest is Germany's, three houses run together with two extensions along Chesham Place. In 1977 a new West German Ambassador, Hans Helmuth Ruete, had just settled into his role when the Queen remarked that the first extension, of German brown brick, was an eyesore. Without fear, the rest of us may approve the tall winged bronze by Fritz Koenig on the pavement outside, likened to a seed but which might just be a discreet abstract reference to the mighty Victory Column, the *Berliner Siegessäulle*.

BELGRAVIA, SW1X

## • MARYLEBONE, OXFORD STREET, MAYFAIR •

### ALL SOULS, LANGHAM PLACE

*The 'intelligence and judgment' of a misplaced zealot*

The climax of the view of John Nash's great processional progress from Carlton House Terrace to Regent's Park is All Souls Church. Its circular portico suggests the Temple of Vesta on top of its cliff at Tivoli, but Nash's church has traffic-clogged Langham Place at its foot instead. The plan of the route is still there, on the ground, much honoured but hopelessly abused as well. All the Nash buildings along Regent Street and Langham Place except for the church fell to the wrecking ball in favour of developments in the commercial grandiose style that succeeded them. Still, there is that fine view of All Souls, with a balustrade around the top of the portico and a second peristyle and needle spire rising above that. Purists sniff as purists will: who has heard of a Gothic spire above a classical building except in London? John Summerson points out that the church is at an angle of 45 degrees to the street but that the portico is at a 45-degree angle: an application of his principle in town planning of using a circus to spin off a change of direction when it is necessary.

There is no denying the drama of the

scene, but it is hardly compulsory to enter the church itself, always a box and a plainer box since the Blitz. The interior is flat-ceilinged but supported theatrically by large columns with Corinthian capitals. During the post-Blitz refurbishment a crypt was devised for a BBC sound recording studio. There is but one sizeable marble monument, placed on the south wall in 1857. The firm of Edward and Thomas Gaffin (father and son) carved it, one of the later works of a production line that ran into hundreds of memorials in this country and in the empire from Australia and India to the Caribbean, and is usually judged indifferent. Certainly this one is old-fashioned for its period, a Neo-classical image of a woman kneeling and bowing her head on to a large urn, but it is totally competent.

The memorial is to William Richard Moore, deputy collector of Mirzapur near Benares and joint magistrate, whose body was buried there. 'His zeal, intelligence, and judgment had won for him the marked approbation and just confidence of his superiors', the inscription in All Souls reads. It adds that on 4 July 1857 he 'was barbarously and treacherously murdered'. It is true that mutiny was in the air and in May Moore had two Indians whom he judged to be instigators arrested and executed. The widow of one of them put a bounty on his head of 300 rupees. In July Moore had arrived at another British depot with a group of prisoners when he and his men were attacked. He counter-attacked and was killed. Within a day or two the victors delivered his head to his widow. Between the lines of the memorial inscription, it might be deduced that, for a civil servant, he was brave but precipitate in each action he took. He was 24 when he died, and Mirzapur was scarcely touched by what we call the Indian Mutiny, which today India calls the First War of Independence.
2 ALL SOULS' PLACE, W1B 3DA

## BBC BROADCASTING HOUSE

*'I' the air or the earth?', Gill's Ariel*

In its early days Broadcasting House aroused angry opposition. Viewed from Oxford Circus, its huge curving prow overwhelms John Nash's All Souls church standing just before it, and destroys the unity of his Georgian houses sweeping round the bend into Portland Place. Maybe the BBC hoped that sculptural decoration on the façade and flanks of the building would calm the controversy. At any rate, it commissioned Eric Gill to create carvings on the face of the building when it opened in 1932. In fact a series of sculptures based on the theme of Ariel, Shakespeare's sprite in *The Tempest* who appears as a flash of light in the storm he has summoned, or flies invisible, singing sweet airs ('Full fathom five thy father lies; / of his bones are coral made'), to which Ferdinand, the son of the presumed drowned man, responds: 'Where should this music be? I' the air or the earth?... / Sitting on a bank, / Weeping again the king my father's wreck,/ This music crept by me upon the waters'; which could almost be a premonitory reference to Radio 3.

On the right, All Souls, Langham Place; on the left, BBC Broadcasting House, with Gill's *Ariel* over the doorway.

Anyway, Ariel was the BBC's preferred symbol to announce its presence in Langham Place, and Gill shows him in a couple of panels on the west side of Broadcasting House, flanked by *Wisdom* and *Gaiety* as they offer him flute and book (he chooses the flute and plays to children in a third panel, on the east side). But the chef d'oeuvre is the larger than life Ariel with long-bearded *Prospero* above the main entrance, standing upon a globe.

David Kindersley, the celebrated letter carver who began as an apprentice to Gill, tells of attending a lecture with his master delivered by the sculptor Frank Dobson. Dobson announced that undoubtedly man first created art in the round, modelling with a piece of mud. Gill stood up and disputed this. Man indubitably drew with a stick in the dirt first of all, he asserted. Another audience member pointed out that each theory was unprovable, and each man was arguing from his own predilection. Gill, the supreme letter carver and decorative artist, thought in line, Dobson in mass. It's the shortcoming of Gill the sculptor, though in these sweetly decorative very English works for the BBC it matters hardly at all.

The wider public was interested in none of this, but raised hell in another of those peculiarly pre-Second World War rows, of which Epstein was usually on the receiving end. This time it was about the notably uninvisible *Ariel*, naked and with allegedly over-large genitals. The BBC maintains that the report that it suggested to Gill that he might do something about it, so he recarved them smaller, is unsubstantiated. 'It's all balls,' as he shouted to a passer-by in the street below.

PORTLAND PLACE, W1A 1AA

## RELIEF CARVINGS AT 219 OXFORD STREET

*The Festival of Britain lives*

It's a fair bet that anyone too young to remember George VI won't have a clue what the reliefs on the façade of 219 Oxford Street in the West End of London signify, and, since the whole world shops in this crowded and unlovely thoroughfare, no foreigners at all. The corner building itself has a tall, narrow frontage on Oxford Street east of Oxford Circus, but its four storeys of alternate bands of stone facing and windows wrap round in an elegant curve into a longer façade on Hills Place. The curve and the metal fenestration suggest the 1930s, but actually this was one of the first buildings of the Festival of Britain year, 1951. And the reliefs alongside the window strips on the top three storeys above Oxford Street represent the Dome of Discovery and the Skylon, the festival logo designed by Abram Games, and the Royal Festival Hall.

In 1951 London was still a bombed ruin, full of rank weeds and gaily decorated if fading wallpaper peeling from indecently exposed inside partition walls. The festival was a nationwide celebration aimed at suggesting a bright new dawn after a bruising night, but the focus was on the South Bank near Waterloo. Because the Labour government was underwriting it, Lord Beaverbrook's *Daily Express* attacked it. But, as Michael Frayn commented later: 'It quickly became clear that the South Bank, conceived in austerity and shaped by expediency, was a knockout.' The crowds flocked in. Domestic design took off into a decade of funny furniture with knobs wherever they could be screwed on, but at least it didn't look like wartime utility style. The elegant cigar-shaped Skylon has gone, as well as the Dome of Discovery (grandad to the Millennium Dome) and the Lion and Unicorn Pavilion; so have all the murals and mosaics and sculptures. Just the Festival Hall remains, some curling pages of Women's Institute scrapbooks, fragments in the Festival Pleasure Gardens in Battersea Park, maybe a few park benches around the country, and the Oxford Street shop that in its small way set a benchmark for commercial architecture to follow.

OXFORD STREET, W1D 2LG

## SCULPTURE BY BARBARA HEPWORTH, 300 OXFORD STREET

*With one leap, she was free*

John Lewis started by asking Epstein for a new sculpture to embellish its store in Oxford Street, freshly rebuilt after bombing in the war and opened in 1960. He was preoccupied at the time, working on his *St Michael* – not, as might be supposed, for the John Lewis rival Marks & Spencer, but for the new Coventry Cathedral. So John Lewis set up a competition for young sculptors, but that produced nothing it liked either. Finally, its chairman, O. B. Miller, approached Barbara Hepworth. What happened next was a classic misunderstanding between a corporate client delivering a deadly dull brief and yet another artist thrown into dismayed disbelief at the

rejection of her work. The story has a happy ending, just about.

The front of the store is a good but unlisted modernist eleven-bay façade with a grid of windows and mullions on Oxford Street above the wraparound display window and fascia. The façade along the side road, Holles Street, begins with a large blank stretch of Portland stone; this is where the proposed sculpture was to be placed. Miller wanted something that symbolised the company's benevolent relationship with its customers and staff. Hepworth tackled this by producing a maquette called *Three Forms in Echelon* with a complex of three irregular forms one above the other, each with a large irregular hole and strung together; 'radiating strings rising upwards is my interpretation of the John Lewis Partnership, its Members and the Public', as she wrote to Miller in explanation.

The commission was a woolly notion more suited to the nineteenth century with its plethora of well-meant but inept symbolic works of public statuary. What we see on the store now, *Winged Figure*, is Hepworth's response to Miller's rejection of *Three Forms*, a piece worked up from a small sculpture totally unrelated to the John Lewis project but accepted by them and fixed to the Holles Street façade in 1963. It's 19 foot 3 inches tall, aluminium, with stainless-steel cables strung tautly between the wings, commanding and visible at least as far away as Oxford Circus. No shopper there would have known what it meant nor could they; none of us now knows what the abstract *Winged Figure* stands for and, if anyone had asked Hepworth, she would probably have asked why it should stand for anything, which was almost certainly what she thought all along. The inspiration for *Three Forms in Echelon* was what Alfred Hitchcock would have called a McGuffin, a plot device that seemed important but was there merely to drive the action forward. In this case the McGuffin was a tripartite notion, company, public, workers, that could never exist as an entity in a work of art but which, planted in Hepworth's mind as a challenge, produced a brilliant visual solution. Those three forms would have been at least as dynamic a presence as *Winged Form*, but less tidy, less safe, more challenging. Now all anybody can do is to look at the maquette of the project in Tate Britain, and wonder.

OXFORD STREET, W1C 1DX

## SCULPTURE BY GILBERT BAYES, 400 OXFORD STREET

*The Queen of Time who presides over Selfridges*

Selfridges, with an apostrophe or, as the store itself insists, without, was not the first department store in London but it very soon became the biggest. In the twentieth century an international congress of shopkeepers garlanded it as the world's best department store, beauty, accessories, home and leisure, food and wine and all. Whatever Miss Selfridge adds to the mix by way of party dresses, playsuits, jumpsuits, petites and denim, there is nothing missy or prissy about Harry Gordon Selfridge's mammoth building. He brought with him the man

he considered the best architect dollars could buy in his home city of Chicago, Daniel Burnham, added a clutch of American and English architects to help, and received in return a palace Babylonian in aspiration and Greek in its massive articulation, swallowing a whole block, 398 to 494 Oxford Street. The first part opened in 1909 and it was complete by 1928. To top it off, Selfridge picked the sculptor Gilbert Bayes (1872–1953) to design an angel called *The Queen of Time*, poised over the canopy of the entrance with a big gilded clock above her. This was inserted in the building's grand frontispiece in 1930, and since that day time has not stopped still at Selfridges.

The sculptor George (Peter Pan) Frampton helped Bayes along in his career, but more importantly Bayes was influenced by the Frenchman Aimé-Jules Dalou (see page 50). Dalou was de facto head of the South Kensington School sculpture class and though he had not much more English than 'You do this', that phrase delivered the *coup de grâce* to the Neo-classicism that had turned rancid after its own period of being young and fresh. As Dalou uttered the words, he modelled the clay before him with such speed, skill and dexterity, such improvisation yet accuracy, that the students saw instantly what sculpture could be, as art and life became one before their eyes.

To this inheritance Bayes added the belief that arts and crafts should be indivisible. He made medals, seals and statuettes as well as sculpture, and worked with the ceramics firm Doulton. *The Queen of Time* is an 11-foot-tall gilt figure clad in azure, the wings bronze; the richly wrought clock gilt and bronze with blue hands and numerals. The angel stands at the prow of the ship of commerce, a sailing ship crowns the clock, and bronze mermaids kneel at the angel's feet, their tails green, white and blue ceramic. Corny, but it adds to what Gordon Selfridge sold as the pleasure of shopping.

Inside the store is a memorial Selfridge ordered from Bayes to commemorate himself and his achievement. The sculptor delivered in 1940 and Selfridge stuck around to admire it until his death seven years later.

OXFORD STREET, W1A 1AB

## WALLACE COLLECTION

*Laughing all the way to the revolution*

*The Laughing Cavalier* is not just the most famous work by Frans Hals, but conceivably one of the ten best-known old masters in the world. It is the poster painting that would be most likely to draw the public into Hertford House in this quiet north London square, even though the Wallace Collection also contains Poussin's consummate *A Dance to the Music of Time*, Titian's spectacular *Perseus and Andromeda*, Rembrandt's portrait of his son *Titus*, and the great late Velázquez portrait *Lady with a Fan*. Oh, and a portrait on loan from the National Gallery of Art in Washington by Thomas Lawrence of Francis Charles Seymour-Conway, 3rd Marquess of Hertford

Harry Gordon Selfridge chose Gilbert Bayes to make this flamboyant timepiece above the entrance to his new store. Bayes believed that arts and crafts should be inseparable.

(1777–1842), the bad Lord Steyne of *Vanity Fair*; bad but cultivated: he it was who bought the house (built 1776, much altered since) from Lord Manchester, added the Titian, the Rembrandt and crates full of Sèvres porcelain. While others in the wake of the French Revolution sought out stained glass for English churches, the marquess preyed on the art collections of aristocrats who had their necks to worry about and skimmmed off the best for himself.

His son, Richard Seymour-Conway, brought up in France, acquired most of the highlights of the collection, died in 1870 as the Prussians advanced into France and left the lot to his illegitimate son, Richard Wallace, who promptly decamped to London with the cream of the collection for display in Hertford House. He died in 1890, leaving everything to the nation, and by 1900 it had opened as a museum.

Wallace inherited the taste of his father and grandfather, so although the masterpieces make it a great collection, its character is defined by rooms full of the art of the Ancien Régime's twilight years, the glittering Versailles court art of Louis XV and his mistress Madame de Pompdour, of Louis XVI and Marie Antoinette: the French Rococo dominated by the work of François Boucher, over-pink and over here, and Jean-Honoré Fragonard, enslaved to the higher frivolity, Jean-Antoine Houdon's portrait sculpture, the furniture of Marie Antoinette intended for the ante-rooms of love, rooms full of glorious armour celebrating war though never, surely, meant for the battlefield.

One or two rooms in the house are arranged as they were when Wallace was

alive, but it's all best summed up in the back state room on the ground floor where the outdoor still lifes of game by Jean-Baptiste Oudry (1686–1755), favourite of Louis XV and his court, hang on the walls above the gilded walnut and beech armchairs carved by Georges Jacob with tapestries designed by Oudry stretched on the frames. The dyspeptic Denis Diderot, reviewing a Paris Salon, remarked on the good sense of Oudry's still lifes of game: in art of this sort, he wrote, the first necessity was common sense, 'which is about all that's needed to be a good father, a good husband, a good merchant, a good man, a bad speaker, a bad poet, a bad musician, a bad painter, a bad sculptor, and an indifferent lover'. Oudry also had the common sense to survive the king by less than a year. Next up was Louis XVI, and the Revolution.

HERTFORD HOUSE, MANCHESTER SQUARE, W1U 3BN

## ST GEORGE'S, HANOVER SQUARE

### *Kent's Last Supper*

The horses have departed, but the large number of mews that stabled them is the giveaway to Mayfair. This was aristocratic London, and despite the incursions of commerce and new money, the aristocrats are still with us. The high tide was the eighteenth century, when Burlington's houses and Grosvenor's sober streets were laid down and churches like St George's, Hanover Square (actually it's in St George's Street) and the Grosvenor Chapel were built. St George's (1725), one of the 50 churches built under the Act of 1711, is by John James, who trained with the king's master carpenter but then worked with both Wren and Hawksmoor; some of their knowledge rubbed off on him, but not much of their talent. Still, with its big six-column Corinthian portico with a steeple behind (the first arrangement of this sort) it makes a vivid impression on the street scene. Internally it is decorated in white with gold, strikingly effective in the barrel-vaulted coffered ceiling and in the fine Venetian east window with an entablature supported on Corinthian columns. There is a complete set of galleries with a liltingly carved royal coat of arms (George I) on the baluster of the west gallery. But the real curiosity is the painting in the reredos.

The subject is *The Last Supper*, and the artist was William Kent, architect of genius, great originator of landscape gardens as art, furniture designer extraordinary, but a painter 'below mediocrity', as his shrewd contemporary Horace Walpole put it. Yet somehow the age's arbiter of taste and Kent's sponsor, Lord Burlington, failed to see this, or saw it very late when Kent had already made a fool of himself with an altarpiece in St Clement Danes (destroyed in the Second World War), and been humiliated as an incompetent in a lampoon by Hogarth. His *Last Supper*, though, gets by perfectly well. It is a large canvas and it is recognisably based on Poussin (Kent is thought to have seen an engraving of a Poussin *Last Supper*, otherwise known as *The Eucharist*, now in the Louvre), but the chip of ice in

Sekhmet, the Egyptian lion-headed god of 1320 BC reduced to a mascot, a symbol of art for money's sake.

Poussin's soul that produced such unearthly beauty of colour and composition is entirely missing from Kent's work. Kent's Christ is Hollywood branded: blond skin, golden hair and beard; but there is an energy in the other heads, the well-observed drapery and the flickering light that suggests that with a decent training he might not have diverted his career to become Burlington's and England's favourite builder and gardener.

Take a look as well at the stained glass in the Venetian window above. It is of about 1525, attributed to Arnold van Nijmegen (1470–*c*. 1530), was liberated before Napoleon reached the gates of the Carmelite monastery in Antwerp, languished in an English nobleman's storeroom, and found its way to St George's. It shows Christ's ancestors arranged in a glowing family tree.

ST GEORGE'S STREET, W1S 1FX

## SOTHEBY'S

*Sekhmet, the fearsome destroyer-goddess*

Poor Sekhmet, the Egyptian lion-headed goddess with power over war, fire and pestilence, is quite denatured outside in New Bond Street. This black basalt half-figure reclines on the gable of a quaint porch forming the entrance to Sotheby's in one of the older buildings in New Bond Street ('early eighteenth-century'). Sekhmet has become a symbol of art for money's sake, poised above the Sotheby's doorway partly obscured by the auctioneer's blue flag, disregarded by the clientele passing under the arched entrance, blackness soaking up the light and giving nothing out, an alien object of about 1320 BC, somewhat pre-dating Sotheby's itself; reduced to the status of saleroom mascot and looking, I regret to report, a little like a somnolent Egyptian teddy bear.

Sekhmet was made at the end of the eighteenth dynasty, the era of the female pharaoh Hatshepsut, of Akhnaten and his consort Nefertiti, and of Tutenkhamen. Sekhmet's consort Ptah was the creator, Sekhmet the destroyer, the 'powerful one' portrayed in many versions with a sun disc above her head (the Sotheby's sun is broken in half). It was an age when the rigid formality of ancient Egyptian art softened into elegance, movement, and even tender portraiture, especially of lovely women, notably Hatshepsut and Nefertiti. Sekhmet would have none of this. In the representation of her in the half-light of the ancient temple of Ptah in Memphis this grim goddess's best trick used to be to scare the pants off twentieth-century AD visitors.

Sotheby's acquired its Sekhmet in the nineteenth century when it was selling off a collection of Egyptian art and the punter who bid £40 for the goddess failed to collect it. The statue stayed in the company offices in Wellington Street, Covent Garden, until Sotheby's installed it above the doorway to the New Bond Street premises when it moved there in 1917. From 1937, when the firm sold the contents of a Rothschild house in Piccadilly, it didn't have to look for publicity; publicity came knocking at Sotheby's door. In 1983 A. Alfred Taubman emerged on the scene. He was an American grown very rich indeed by building shopping malls and he bought a controlling share in Sotheby's and changed the name of the game to hardball. In 2002 Taubman was convicted on the evidence of his chief executive officer of price fixing with Christie's, sentenced to ten months in jail and fined $7.5 million. A gentle warning, perhaps, from Sekhmet, who is said to be subject to episodes of bloodlust; but the Taubman family has divested itself of a controlling interest in Sotheby's which may have propitiated the god: anyway, things have been quiet on that front since 2002.

34–35 NEW BOND STREET, W1A 2AA

## HANDEL HOUSE MUSEUM

*Where Handel composed his* Messiah

The date of the first official public performance of Handel's *Messiah* was 13 April 1742, in Dublin; but the very first performance, to an invited audience of friends, was in the moderately large first-floor front room of Handel's house at 25 Brook Street, Mayfair. For Handel, the room had two uses: a place for entertaining friends and a rehearsal space, and here, some time in October or November 1741, with around a dozen performers and four soloists, he conducted from the harpsichord the first run through of *Messiah*. At any rate, that's the story they tell today in 25 Brook Street, and there is no reason why it should not be true. Today the house is the Handel House Museum.

George Frideric Handel (1685–1759) first visited London in 1710 and returned for good in 1712. He leased 25 Brook Street in 1723, on the security of a pension from George I, when it was newly built, one of a terrace of four, and he lived here, worked here, and in 1759 died here in his bedroom on the second floor. He worked hard at being a Londoner. He had already learned English, he was naturalised in 1727, and he joined Hogarth as a governor of the

Foundling Hospital (public performances there of *Messiah* with its libretto by Handel's closest collaborator as librettist, Charles Jennens, established it as the great national musical favourite, an institution). The first-floor back room at Brook Street was where Handel did his composing. Here, often with Jennens, he created his greatest music. It was a not a big house, but he had no wife and family so it was sufficient.

After many occupancies and a deal of rebuilding and redecoration in the early 1990s with Edwardian alterations stripped out, the musicologist Stanley Sadie with his wife Julie Anne Sadie set up the Handel House Trust which opened 25 Brook Street as a museum in 2001; but not before conservators had crawled over the structure, taking 250-year-old paint samples, painting the panelling of the rooms 'lead' (grey) and doors chocolate brown, building in the correct period fireplaces (removed from Tom's, a nineteenth-century coffee house at 17 Russell Street, Covent Garden), refurbishing the beautifully carved stair-tread ends, supplying a harpsichord, a period bed and bed linen for Handel's second-floor bedroom, finding autograph scores to display and hanging portraits of Handel's friends and accomplices, some bought, some on loan from the National Portrait Gallery, Tate, Compton Verney and other sources: a fraction of the collection that Handel himself owned, but indicative.

The museum has expanded for exhibition space through the walls into number 23 where, by a fluke, the rock musician Jimi Hendrix shared a flat with his lover Kathy Etchingham. She recalls that he was tickled by the blue plaque to Handel on the front of 25. Today some Hendrix memorabilia is on show, but it's the blue plaque on the front of 23 that he would have loved. It reads: 'Jimi Hendrix / 1942–1970 / guitarist and songwriter lived here / 1968–1969'.

25 BROOK STREET, W1K 4HB

## RELIEF CARVING BY MICHELANGELO, ROYAL ACADEMY OF ARTS

*A memory of his lost mother*

Sir George Beaumont embarked on the grand tour with Lady Beaumont in 1782–3 more as an amateur water colourist and sketcher than as a rich dilettante in search of ancient treasure, but his real gift lay in putting together the collection of paintings with such notable highlights as Rubens's greatest landscape, *A View of Het Steen in the Early Morning*, and Rembrandt's *The Lamentation over the Dead Christ* which became, with John Julius Angerstein's collection, the core of the new National Gallery founded by Lord Liverpool's administration in 1824.

In a much smaller collection of sculpture, Beaumont owned one supreme piece, Michelangelo's relief carving in Carrara marble of the serene *Madonna and Child with St John*, dating from around 1504. Lady Beaumont donated it to the Royal Academy after her husband's death in 1827 as an example to students in the academy schools of Renaissance genius. It remains one of only four major Michelangelo sculptures outside Italy,

along with the *Madonna and Child* in Bruges cathedral, probably carved just before the RA's piece, the *Crouching Boy* of the 1530s in St Petersburg, and the two slave figures of 1515 now in the Louvre. It was 1989 before the academy put its Michelangelo on discreet daily show to the public. It is mounted now on a wall at the end of the landing outside Norman Foster's Sackler Galleries.

Michelangelo clearly didn't finish it in any conventional sense, and so provided one of those puzzles art scholars love: did the sculptor leave it unfinished because he was dissatisfied with its progress, or did he set out to make a sketch in marble? He left many of his projects incomplete, some because he moved on, some because the project proved too grandiose (the slaves were to have been part of a much bigger tomb for Pope Julius II), some, maybe, because he became dissatisfied with his work. The RA's tondo (from the Italian *rotondo*, round; a favourite Florentine format from the 1430s) is 106.8 centimetres (marginally over 3 foot six inches) in diameter and into this Michelangelo has fitted the Madonna, the child Jesus leaning into his mother's lap and looking with apparent apprehension over his shoulder at St John, who has in his hands a goldfinch, a symbol of the crucifixion – some scholars argue that no theology supports the view of a fearful Christ child, but neither does theology support a young Madonna holding the dead Christ in the Rome Pietà; that was Michelangelo's expression of her incorruptibility.

Michelangelo used a small claw chisel to carve Jesus smoothly and almost in the round; the Madonna is rendered more like a coin relief; St John is vigorously carved with a large claw chisel and roughly finished so that he fades into the background like an out-of-focus figure in a photograph. At its shallowest the block is only three inches deep: had Michelangelo carved it any shallower it would have shattered. But if this is an exercise, it becomes a masterwork because of the sublime treatment of the Madonna's head and close-wrapped turban emphasising the sweetness and sadness of her expression as she gently restrains St John. This was a period of magnificent Michelangelo Madonnas, and it is difficult to doubt that he was recreating in marble the memory of the mother who died when he was six, leaving him to a harsh upbringing.

BURLINGTON HOUSE, W1J OBD

## FLEMING COLLECTION

*A painter who imported the South of France to Hawick*

Back in 1968, when all was right with the world and bankers' hands were clean, Peter Donald, a director of Flemings, the venerable bank that Robert Fleming had set up in Dundee in 1873 on the basis of rich pickings in the Indian jute industry, began to buy paintings to cheer up the bank's London offices. Donald bought, not as an investment, but for pleasure. He even purchased art he liked by Fleming employees. They had to work for their bonuses in those days.

We march forward to 2000, when Chase Manhattan paid out $7.7 billion to

buy Robert Fleming Holdings, as it was by then known. Chase Manhattan took a look at these Scottish paintings, unlisted on Dow Jones, and generously handed the collection over to a specially created charitable foundation, which exhibits it on the first floor of the Fleming Collection gallery in Mayfair (the ground floor is devoted to temporary exhibitions of the new movers and shakers).

The collection's signature canvas, displayed on the publicity, is a gloomy old narrative painting called *The Last of the Clan* about the Highland clearances (by Thomas Faed, 1865), showing a brokendown old horse carrying a brokendown plaid-wearing clansman. But, and despite the preponderance in the collection of the Scottish Colourists, who were much in advance of English painters at the beginning of the twentieth century, the star of the show is a little group of interiors by Anne Redpath (1895–1965). Born in Galashiels, in 1920 she married a young architect about to assume a job with the Imperial War Graves Commission in the Pas-de-Calais. There she had two sons and her art went into hibernation, but she channelled her orthodox Edinburgh College of Art training into decorative skills, painting brilliant-hued birds, animals and flowers on to furniture. In the late 1920s a new job took the family to the area of St Raphael in the South of France, and she saw the colours she had been using turn into daily reality.

Back in the Scottish borders in the 1940s she put two and two together and produced a significantly more vibrant update on the Colourists. Her masterpiece in the Fleming Collection is *Still Life – the Orange Chair* of 1944. The front legs of the chair are planted on a blue carpet, the rear legs on a greenish-yellow rug. A yellowish-green cloth is spread on a low table behind the chair, with a white pot of big white daisies on it. The wallpaper has a splodgy red pattern, which might be poppies. That's it. It really does not matter that Abstract Expressionism was taking over in America, and that a fresh clutch of -isms had breathed new life into old Europe; a painterly approach that was still good enough for Pierre Bonnard, who was living in Cagnes-sur-Mer and painting his aged wife as a young woman in a bath, was good enough too for Redpath in her new home in the grey old wool town of Hawick.

13 BERKELEY STREET, W1J 8DU

## DEVONSHIRE GATES, GREEN PARK

*Ducal gates that never open*

The Devonshire Gates at the Piccadilly end of the broad walk through Green Park never open and shut, as gates are supposed to do. This seventeenth-century gold and blue wrought-iron portal between nineteenth-century piers as stately as a cenotaph, each with a sphinx on top, remains shut, apparently, for ever. That may be why the gates are taken for granted as simply another part of the urban scene, street furniture like the tall lamp post on the other side of the pavement obscuring a clear view of the gates. The hanging flower basket only compounds the offence. Commuters and tourists hurry by, heads down, antici-

pating the steps a few feet away into the depths of Green Park underground station, and on Sundays the hawkers of bright pictures along the railings of Green Park tie their screens to the gates and obscure the bottom two-thirds.

It's a shame because these gates are the very lovely sole survival of a lost gem: Devonshire House, which was built by William Kent (c. 1685–1748) in 1734 as the London mansion of the Cavendishes of Chatsworth, Dukes of Devonshire, destroyed in 1924 to make way for a motorcar showroom and a block of flats above. The gates are probably by the skilled Huguenot craftsman in ironwork, Jean Montigny, who had certainly worked at the Duke of Chandos's famous and short-lived country seat in Edgware, Cannons (glass and paintings from Cannons in the same pretty rococo taste beautify the Church of St Michael's at Great Witley). Although the Devonshire Gates were made in 1735, the commission was meant for a house in Turnham Green, and the gates didn't arrive at Devonshire House until 1897, when the Devonshire arms supported by two deer with golden antlers were added to adorn the centre of the arch above the double gates. There is a fine view through the gates along Broad Walk to the Queen Victoria Memorial in front of Buckingham Palace.

GREEN PARK, W1J

## CURZON MAYFAIR

*The most comfortable picture house in town*

The Curzon cinema Mayfair is that rare thing, an art house that doesn't just cling on, it flourishes and produces progeny all

over town. There are Curzons in Soho, Bloomsbury (called the Renoir), Chelsea, Richmond, and a 56-seater at the Mondrian Hotel on South Bank. Out of town there are Knutsford, Ripon and Canterbury, and many more in the planning stage. Within London, Curzon Victoria is the most recent; it has five screens, which surely takes it beyond the definition of art house, and was put together by the clever young rising star of interior design, the London-born Greek Afroditi Krassa. She describes it as more of a cultural hub, whatever that may be, than a cinema. She should know; but it does look strangely like a cinema.

Design has been important from the first, when the Marques de Casa Maury opened the original Curzon Mayfair in 1934. He employed the fashionable 1930s architect Francis Lorne of Sir John Burnet, Tait and Lorne to build the cinema on the corner of Curzon and Hertford Streets (also to build a home in north London for him and his new wife, Freda Dudley Ward, the Prince of Wales's favourite love of the pre-Mrs Simpson harem). In 1964, the businessman and theatre magnate Harold Wingate had taken over the Curzon leasehold: he bulldozed the cinema and employed H. G. Hammond of the original firm to rebuild it with a restaurant and garage below and a couple of storeys of offices and flats above. The Curzon resumed its place as the most comfortable picture house in town.

The elaborate gates separating Piccadilly from Green Park came from Devonshire House, the demolished London home of the Cavendish family, Dukes of Devonshire. This detail shows the Devonshire coat of arms.

The foyer warmly embraces visitors like the lounge of a smart boutique hotel: marble-lined, warm orange and tan decor with leather-covered bucket chairs and capacious sofas, matching blond-wood tables and bar, the bar doubling up as box office. There's a real box office too, manned only on a desultory basis. The auditorium has the two essential items: a huge screen (43 foot by 20 foot) and deep comfortable seats. The decor, as well, falls neatly into two: the walls are imitation rockface that contrive to look plush (of nickel silver-faced glass-reinforced plastic by the sculptor William Mitchell). Victor Vasarely constructed the deeply coffered ceiling with the wells holding the lighting and each well coloured in muted tones of brown or a vanilla-ish white, and a sort of sage green affected by which of the two colours it shares in its well. It is a subtle and satisfying harmony. Vasarely (1906–97) was a Paris-based Hungarian, a Bauhaus abstractionist, op artist, kinetic artist, what you will, whose reputation was high in London in the 1960s. In France his reputation burgeoned beyond his death where his Fondation Vasarely on Cézanne's old estate, the Jas de Bouffan above Aix, was not, he reckoned, a museum but a place 'where the future takes shape in this new geometric polychromatic and solar city'. In fact this solar city is a museum, and a small one, but the idea may grow into a mighty oak. Which makes the Curzon ceiling an acorn.

38 CURZON STREET, W1J 7TY

## FARM STREET CHURCH

*Where the Catholics came in from the Cold*

In 1828 the Catholic agitator Daniel O'Connell won the Parliamentary by election for County Clare. Catholics at that time, even the loyal and mild English variety, still put the fear of God into the Church of England. So the government applied the full rigour of the old law and banned O'Connell from taking up his seat in Westminster. At this point the fear of effectively disenfranchised Catholics voting their co-religionists into every available Parliamentary seat and plunging Ireland into civil war edged the British government into passing the Roman Catholic Relief Act; besides, George III was dead and so implacable royal opposition to Catholic emancipation was gone. Roman Catholics in the British Isles came in from the cold and the pope's legions did not invade. Within a few years even the proselytising Jesuits were building their own lavishly decorated church, the Immaculate Conception, ever since known as Farm Street from its location in a Mayfair of diminishing rustic charm. It was consecrated in 1849 without a stone thrown or a stained-glass window broken.

As an internationally celebrated centre of Catholic life in London, the Immaculate Conception is regarded as a masterpiece of the sacred arts; but it isn't quite. 'Smart' was the word applied by David Piper, the director of the National Portrait Gallery in the mid-1960s, and that seems about right. The Jesuits chose J. J. Scoles as their architect. He was the son of Roman Catholics and trained with a Catholic architect, so unsurprisingly he mostly worked for Catholics. He could supply whatever was required: Norman, Early English, Decorated, Perpendicular. Farm Street is fourteenth-century, i.e. Decorated. Scoles's liturgical west front (geographically south) is in imitation of Beauvais Cathedral, a tall order, quite literally, that falls short, and the 'east' window is after Carlisle Cathedral.

The view from the entrance is spectacular: no rood screen, so the revelation is of refulgent stained glass and the ethereal white arched ceiling whose panels are painted with grey decorative figures and delicate pale pink and blue circlets carrying the Christogram IHS. Set into the wall beneath the window are Venetian mosaics of *The Annunciation* and *The Coronation of the Virgin*, figured in red, blue, white and green against gold. The window had to be moved upwards in the wall to accommodate the mosaics set above and behind Augustus Pugin's elaborate high altar, the most celebrated single item in the church.

Doubts about all this splendour are twofold. First, the glass in the east window is by the renowned firm of John Hardman, but although the colours are wonderful, the figures are not. Secondly, unlike Morris and Burne-Jones and the best Arts and Crafts practices, which were innovatory within the ancient tradition, Pugin's skills, like Scoles's, were based on close imitation of medieval Gothic. Skill and faith are insufficient to produce great art, and the lack of originality was a severe limitation, even in the church furnishings which were his forte.

114 MOUNT STREET, W1K 3AH

## GROSVENOR CHAPEL

*A pretty church where the 'Friend of Liberty' is honoured*

The eighteenth-century character of Grosvenor Square had already been destroyed by the time the United States practically annexed the place after the war with Eero Saarinen's fortress embassy occupying the whole of the west side. The US's tributary, the British government, joined in by reshaping the north of the garden around a sculpture on a tall plinth of Franklin Delano Roosevelt, the saviour of the Western world whose memory, notwithstanding, is spat upon by many right-wing Republicans to this day. The sculpture is by William Reid Dick, a committee choice as a safe pair of hands.

A little way off along South Audley Street lies the Grosvenor Chapel, which American servicemen in London chose during the war as their parish church over the ocean. No doubt proximity to the embassy was the principal reason, but the chapel does bear more than a passing resemblance to the seventeenth- and eighteenth-century colonial churches of New England, and the contrast between the overweening twentieth-century power implicit in the embassy with its faux-battlements and giant eagle and the neat, sweet humility of the simple chapel, appears to embody a short history in stone of America from George Washington to the men on the moon.

Sir Richard Grosvenor, 4th Baronet, commissioned it to a design of 1730 by Benjamin Timbrell, who was a builder, not an architect, but had worked with the architect of St Martin-in-the-Fields, James Gibbs, and paid attention. It has an organ of 1734 in the west gallery, and only in Ninian Comper's work in the chancel does the building begin to get above itself, in the disproportionately big rood screen and two massive Ionic columns, part of his scheme for an unfinished baldachin, more Rome than home. Yet the prettiness survives, and in the north gallery is a memorial tablet to John Wilkes (1725-97), a radical journalist and politician who fought for freedom for Americans and British alike and was a hero of the campaign for a free press. 'Friend of liberty', the tablet is inscribed. It can say that again. And again.

24 SOUTH AUDLEY STREET, W1K 2PA

## HYDE PARK CORNER

*Wellington and all that*

The triumphal Wellington Arch and the elegant Neo-classical screen at Hyde Park Corner should have been the climax of Decimus Burton's career as architect even though, born in 1800, he was only in his twenties; instead, it became a fiasco. It is hardly possible to see the elegant Greek Revival screen at the south-eastern edge of Hyde Park through a moving wall of double-decker buses, the arch is stuck on a traffic island among a litter of war memorials, some good, some bad, and their purpose has been lost, a super fudge among English fudges.

It began as a sop to George IV, a royal figure much like our own Prince Charles, with ideas about architecture. He wanted a proper royal approach to Buckingham

Palace. Burton designed the screen with its triple arches separated by columns and proposed that the triumphal arch celebrating Wellington's victory should be based on the first-century Arch of Titus in Rome, the font of all such things. A second arch was proposed for the courtyard before Buckingham Palace; that was moved away when a new front range was needed for the palace and is now known as Marble Arch, though because it too is isolated on an inhospitable traffic island, the name is better known as the identity of a tube station. Meanwhile, Burton's screen and arch were almost complete in 1826 and, in alignment, formed the entrance from Hyde Park. But George IV had overspent, the government refused to open the purse strings, and the arch was unveiled bereft of decoration.

In 1838 the Duke of Rutland won the royal assent for a wildly disproportionate 28-foot-high equestrian statue of Wellington to be placed on top of the arch. It became an instant public laughing stock and was soon removed to Aldershot. In 1880, with the success of Victoria Station, the road from Piccadilly to Grosvenor Place needed widening. This arch too had to be moved away from the top of Constitution Hill to its present position. Yet it has gained a worthy enough crowning sculpture, *Peace Descending on the Quadriga of War*, completed by Adrian Jones in 1912, a phlegmatic army man having it both ways, decently proportioned, wildly bombastic, un-English even, in feeling more like the victory column in Berlin, the *Siegessäule*; but the Germans know how to display these things.

Close by Burton's screen and the Wellington Arch, in Green Park a memorial has appeared as late as this century to the 55,373 men of RAF Bomber Command who died in the war and paid the second price of our shame for the exchange Baedeker raids. The size is a shot at brazening it out, the memorial is a lumpen parody of Burton, the larger than life figures of a bomber crew aspire to Charles Sargeant Jagger's realism (see pages 210 and 247) but manage only the falsehood of Soviet socialist realism.

MAYFAIR, W1J

## APSLEY HOUSE

*A king's bounty at the Wellington Museum*

Many other honours danced alongside Arthur Wellesley's achievements in Spain on the battlefield against the forces of Napoleon under the command of his brother, Joseph Bonaparte, de facto King of Spain. From Talavera in 1809 when he became viscount it was a case of another battle, another honour until England created him marquess after the brilliant action at Salamanca (and Portugal Marquês *de Torres Vedras*, and Spain bestowed on him the Order of the Golden Fleece). But from the point of view of posterity his greatest reward came at the decisive Battle of Vitoria in 1813, when he came away with the 165 paintings from Joseph Bonaparte's train of loot.

In 1817 the Duke of Wellington, man of

Apsley House, Wellington's London home after the end of the Napoleonic wars. In it are the 176 paintings he seized from Joseph Bonaparte's loot.

peace, returned to buy Apsley House from his brother for himself and the wife he can scarcely have seen in the 11 years of their marriage. In the late 1820s Wellington commissioned the fashionable architect of the day, Benjamin Wyatt, to add extra rooms to the Robert Adam original, including the glamorous Waterloo Gallery, where he would hold banquets and display the pick of the collection. Those from the Spanish Royal Collection might have been regarded as spoils of war, but when Wellington proposed returning the trove to Ferdinand VII, the king-in-waiting munificently waived his rights in a letter from the Spanish Minister in England, Count Fernan Nunez, who wrote, '... His Majesty, touched by your delicacy, does not wish to deprive you of that which has come into your possession by means as just as they are honourable.'

It is said that Wellington often showed his delight in his favourite acquisition, Correggio's luminous little night scene, *The Agony in the Garden*, depicting an angel appearing to Christ. Here too is the equestrian portrait of the duke by Goya, knocked off in a few days after the fall of Joseph Bonaparte, which may explain why the horse is on the small side and also too heavy, decidedly unfit for the purpose of pawing the air with its front hooves, as horses in equestrian portraits must do. X-rays disclosed another portrait beneath, and it has been extensively argued that the subject was Joseph Bonaparte, just completed as he was driven from Madrid. A patch of dark cloud detached from the main cumulus sits behind Wellington's head to ensure that the putative Bonaparte's big hat doesn't show through.

Apart from a Rubens portrait of an

old man, there is nothing to touch the four *Velázquez* paintings: two portraits, one a small study for the painting of Pope Innocent X in the Doria-Pamphilj Gallery in Rome, and two early genre scenes: in particular *The Water Seller of Seville*, not as fantastic as his later work yet sublime, a sombre symphony in browns and a subtle deployment of harmonious space. Many arguments about the symbolism have been put forward by eminent scholars, but in this case one can say flatly, it doesn't matter a damn in the light of the palpable sense of reality and the triumph of pictorial values in this wonderful work.

149 PICCADILLY, HYDE PARK CORNER, W1J 7NT

# ROYAL ARTILLERY MEMORIAL

*The quick and the dead in Jagger's memorial*

Peace, a suspiciously warlike rider in a chariot hauled by four turbulent horses upon the triumphal Wellington Arch, dominates the garden at Hyde Park Corner, where all the other monuments observed in passing by the celebrated man on the Clapham omnibus are war memorials. One shows Wellington in person on horseback, the Machine Gun Corps is represented wildly elliptically by a naked youth with a sword, many big steel girders dug into the earth like a gun emplacement are New Zealand's memorial, the Commonwealth in general has a proud memorial entrance leading into a bog standard subway to Constitution Hill

and Grosvenor Place. But the most despised, most lauded, and certainly the best of the war memorials is Charles Sargeant Jagger's for the Royal Artillery designed at the end of the First World War in which he himself had been an infantryman.

A war memorial, Jagger observed, 'ought not to make war attractive', but with the Royal Artillery commission he had to satisfy their desire for a work that glorified their heroism. The architect of the podium, Lionel Pearson, built a podium like a fortress devoid of classical allusions and capped by Jagger's massive stone sculpture of a 9.2-inch howitzer. Jagger (1885–1934) placed three bronze soldiers in full kit on three sides of the memorial. On the fourth lies a dead soldier with his greatcoat thrown over him, carved like the other figures with harsh realism, yet the spread coat lends a formal grace and quietude. No shattered limbs or body parts here, but in the friezes in relief on the bottom level of the podium showing horses and men dragging gun carriers through the mud, artillerymen hoisting wounded comrades on to their shoulders, and gunners in action, the harsh smashed limbs of trees stand in as a metaphor for men.

Jagger was a Yorkshireman, the son of a colliery manager. As a brilliant student he had learned most from the end-of-century new sculpture movement, and his experience in the trenches moulded Jagger the mature artist. Who could wish it different? No one quibbles that the verse of Sassoon and Owen is not like Eliot's or Pound's or that Graves's *Goodbye to All That* doesn't read like Proust or Joyce. But in the visual arts, conformity to the current norms is essential to a respectable CV. Thankfully this is at last being perceived as nonsense and the best of Jagger's monuments – notably the wonderful Great Western Railway figure at Paddington station (see page 247) of a single soldier reading a letter from home – are increasingly recognised as masterpieces. Jagger's fellow feeling for the working-class Tommy is palpable: on the massive pile of the Artillery Memorial, he chose to carve his name an inch high below the figure of his comrade, the dead soldier.

HYDE PARK CORNER, W1J

Evening shadows draw in over Charles Sargeant Jagger's Royal Artillery Memorial at Hyde Park Corner, in which the sculptor's fellow feeling for the Tommies is palpable.

Overleaf: in the eighteenth century the grand tour became the essential item in a gentleman's education and Chiswick House was Lord Burlington's response: based on Palladio's Veneto villas, it changed the direction of English architecture.

*West London*

# West London

*Pinner Park*

**HARROW**

*Nort[h]*
*P[ark]*

❖ Swakeleys House

**HILLINGDON**

❖ St Mary's, Northolt

The Hoo[ver] building

**EALIN[G]**

St Michael and All Angels ❖
❖ Pissarro's house
❖ The Tabard Inn

**HOUNSLOW**

❖ Emery Walker's House

❖ Hogarth's House

❖ Hogarth's tomb

*Osterley Park*

❖ Osterley Park

Bos[ton]
Ma[nor]

❖ Harmondsworth Great Barn

❖ Chiswick House

**HOUNSLOW**

HEATHROW AIRPORT

*Hounslow Heath*

| 0 | 0.5 | 1 | 1.5 | 2 mi |
| 0 | 1 | 2 | 3 km |

## BARNET

### KENSINGTON & CHELSEA

- Kensington Palace
- Memorial to W. H. Hudson
- Hyde Park
- Barkers Building
- Statue of Ernest Shackleton, Exhibition Road
- 18 Stafford Terrace
- Leighton House Museum
- Michelin House
- Holy Trinity Sloane Square
- St Cuthbert's, Earls Court
- St Luke's, Chelsea
- Chelsea Royal Hospital
- St Mary the Boltons
- Thomas Carlyle's House
- Roper's Garden
- Chelsea Physic Garden

*Hampstead Heath*

## CAMDEN

*Regents Park*

## CITY OF WESTMINSTER

- Kensal Green Cemetery
- Trellick Tower
- GWR War Memorial, Paddington Station
- Hyde Park
- St Mary Abbots
- Brompton Oratory
- The Ismaili Centre
- The Troubadour
- National Army Museum
- The More chapel, Chelsea Old Church

## HAMMERSMITH & FULHAM

- Russian Orthodox Cathedral, Chiswick
- Lyric Theatre, Hammersmith
- Craven Cottage
- Fulham Palace

*Kew Gardens*

*Deer Park*

*Battersea Park*

## RICHMOND UPON THAMES

*Richmond Park*

## WANDSWORTH

*Clapham Common*

*Wandsworth Common*

# • CHELSEA, KNIGHTSBRIDGE, EARLS COURT •

## HOLY TRINITY SLOANE SQUARE

*Grand Arts and Crafts elegance but the spark of genius is missing*

On the west side of Sloane Street stretching as far as Knightsbridge are Tiffany, Cartier, Pringle, Vidal Sassoon, Gucci, Prada, Armani. On the east is Holy Trinity. God and Mammon stand face-to-face, but step through the Late Gothic portico set in John Dando Sedding's triumphal Gothic west façade of 1880 and the differences are not immediately striking. For here the Arts and Crafts Movement's team of all the talents has laid out its finest wares. Sloanes, give or take the Christian faith, can be quite as much at home in Holy Trinity as they are in the streets and bars of Chelsea.

Here are a font of onyx and marble by the sculptor Edward Onslow Ford, a pulpit of white and green marble supported on a great red-veined central shaft surrounded by slender salmon pink columns with Ionic capitals, stained glass in the south aisle and clerestory by the most inventive of the Arts and Crafts glass designers, Christopher Whall, and a First World War chapel (at the east of the south aisle) by the versatile F. C. Eden in measured baroque. F. W. Pomeroy designed the beautiful chancel stalls and the altar railing with its aerial angels, and Harry Bates carved the big marble altarpiece of the Crucifixion that wants nothing of luxury but everything of energy. Sedding (1838—91) orchestrated his team perfectly; everything is beautiful, nothing obtrudes within the soaring vault, nothing is out of place. But the single stroke of genius needed to bring the enterprise to life is missing.

The nearest to this is the 48-light east window, which Sedding designed in French-style Flamboyant tracery rather than English Perpendicular (ditto the west window) and filled with Morris & Co. stained glass: the biggest window it ever undertook. Like the other artists, William Morris and his designer Edward Burne-Jones slotted into the team. The very pretty tracery shows snapshot episodes from the Bible, from Adam and Eve to the Crucifixion. Beneath are Burne-Jones figures of saints, each fitting into an identical rectangular light in four rows of twelve, eschewing Burne-Jones's usual languid grace but clad in Morris's brilliant greens, blues, reds and gold with an occasional sumptuous brown, and standing against a Morris foliage pattern. This is mature Burne-Jones of 1894—5, when he had only three or four years to live, and it gives Holy Trinity its one work of restrained eloquence in a setting of grand elegance.

SLOANE STREET, SW1X 9BZ

Like a detail from a painting by Vermeer: an intimate sunlit detail of a corridor in Chelsea Royal Hospital.

## CHELSEA ROYAL HOSPITAL

*The Wren masterpiece where
old soldiers fade away*

In late May the green grass of the grounds laid out between the embankment and the Chelsea Royal Hospital is covered with marquees, instant gardens and people politely celebrating spring at the annual Chelsea Flower Show. In the darkest time of year, between Christmas and Twelfth Night, the people have vanished and Christopher Wren's Great Hall and hospital chapel is left to the stray visitor celebrating, in a sense, war and peace, encapsulated in the presence of the 300 or so pensioners, the 'Men in Scarlet' (blue in winter): old soldiers fading away here as generations have since the hospital opened in 1689.

The scale of building is grand, the style reticent, unlike the Gallic glory of the slightly earlier Hôtel des Invalides in Paris, which was Wren's inspiration. Before it is Grinling Gibbons's equestrian statue of King Charles II, who laid the foundation stone in 1682. The statue is fine in outline, feeble in modelling, and gains from its recent regilding. Wren's portico is splendid, and inside a vestibule gives on to the chapel to the east and the hall to the west, each gained by a wide flight of steps. The chapel apse has a sparingly decorated but magnificent reredos with wings following the curve of the walls and crowned by tall urns, carved, like the rest of the work, by Grinling Gibbons's predecessor, William Emmett. In the half dome of the apse there is that unusual animal for England, a brilliant mural. It is a *Resurrection* by Sebastiano Ricci (1659–1734), a Venetian whose so-called peripatetic career was the direct result of his secondary career, seduction. He spent his life having to get out of town. He lasted in England four or five years, longer than usual, and on the evidence of his work in this chapel it is a shame he didn't stay longer.

At the far end of the great hall, putti apparently hold back theatre curtains to reveal Verrio's inert rendering of angels ushering Charles II towards centre stage. They needn't bother. Down either side of the hall are gleaming rows of stout dining tables and on the walls paintings from stock of past monarchs and the battle honours of 400 years listed in gold on oak panels: battles won, battles lost, wars in good causes, wars in bad causes right down to Iraq 2003. Here is inglorious Pennsylvania in 1808, and glorious Waterloo, 18 June 1815, given a panel of its own, the first Afghan War and the second, the first and second Sikh Wars, Crimea, Egypt, Flanders, Singapore, Tobruk and Sidi Barrani, then Alamein and the advance on Tripoli. And after that, all the other wars, from Korea and Malaya and Suez to the Falklands and the third Afghan. If you visit after two o'clock, when lunch hour is over, you can smell the good canteen food and wonder how those mild, bright-eyed old soldiers react to all this. Another helping of the roast beef of old England, if I might?

ROYAL HOSPITAL ROAD, SW3 4SR

## NATIONAL ARMY MUSEUM

*Making a small fortune from paint jobs*

The museum lies between Chelsea Royal Hospital and the Physic Garden. Unlike the hospital, there is not much Wren-ish about this brick-faced and concrete three-storey bunker with a monster protected mobility vehicle parked outside the front entrance: that's a training version of the Mastiff, a Trojan horse fast on its 6x6-wheel drive, bomb-proof, grenade-proof, used for plucking soldiers safely from one danger zone in Helmand and dumping them in another. But 'army' and 'museum' makes a paradox, or should, and the problem about this history of Britain's fighting men is that the closer to our time it gets, the harder it is to feel close to it. The First World War machine gunner is as cold as clay, nor do I recognise the National Service experience laid out over two floors as my own: yes, that's the infantryman's .303 Lee-Enfield, as old as the Boer War and forever jamming; the Sten sub-machine gun, exciting, hopelessly inaccurate beyond about two foot but cheap to produce; the boot-cleaning gear; the kit laid out for inspection; the placard quotes from ex-NS guys, nicely balanced pro and anti, but the army in actuality was saltier. 'The Black Watch are braw, The Argylls are naw, but a cocky wee Gordon's the pride o' them a" – the war cry down Leith Walk on Thursday, pay night. And the Highland Light Infantry, hastily dispatched to Edinburgh from Cyprus after bombing their own officers' mess. The Cameronians, known to civilians in occupied Germany, as the poison dwarfs. Big Bill Speakman, shambling in from Korea, wreathed in clouds of glory with his VC and unquenchable insubordination.

So where the museum works best is in its art gallery, a big hall at the top of the building. Here is a full-length portrait of the foppish-looking HRH 1st Duke of Gloucester (1743–1805); he couldn't make it in the army because his physique was weak, neither was he too bright. So they made him a field marshal. The painting is by Gainsborough and it is the best in the place, audacious late-manner, landscape background swiftly brushed in like watercolour. Unfinished? Beautiful anyway.

Yet it is not as art that the paintings are most interesting, despite the Reynoldses, the Raeburn, the truly awful Benjamin West, but as social history. Here we have Tilly Kettle, excellent in his own right but remembered as the first British painter into the East India Company subcontinent. Born 1734, arrived India 1769, made a small fortune from portraits of Warren Hastings and the Nawabs of Arcot and Oudh, though the unidentified officer of the Regiment of Foot in the museum may be pre-India. A regiment could have been formed of later artists, some long-stay, some, like Zoffany, brief but successful. But the market shrivelled and in 1831 reports from Calcutta said that there was only one British painter with a practice, a Miss Jane Drummond, who found it hard going. Her work is not in this collection, but what is there constitutes a slice of pre-imperial life in what was to become the jewel in the crown.

ROYAL HOSPITAL ROAD, SW3 4HT

# CHELSEA PHYSIC GARDEN

*Apothecaries' heaven*

The real Chelsea flower show, not the annual six-day jamboree, has run all the year round since 1686, a little further along Royal Hospital Road. In 1673 the Society of Apothecaries of London decided to make a garden of useful plants and set up in the grounds of Danvers House, which was where Danvers Street is now, and several years passed before the society found suitable land for the large physic garden of its desires.

At the heart of the garden is a statue, not of one of the older makers of the garden but, inevitably, of Hans Sloane, the presiding genius in the creation of modern Chelsea, who bought the physic garden in 1712 as a job lot along with the Manor of Chelsea; as a student of medicine, later to succeed Isaac Newton as President of the Royal Society, he covenanted the garden to the apothecaries. It's not really possible to guess that the statue in its doleful state is by the great John Michael Rysbrack (1694–1770), because this (good) glass-fibre replica on the original stone plinth reproduces faithfully the erosion of the original before it retreated into well-earned retirement in the British Museum. Yet this evident ruin hints at more than ordinary skill in the sculptor's rendering of Sloane's pose, which suggests a great gentleman languidly taking his ease in the nearby Vauxhall Pleasure Garden.

He stands at the main crossing of paths. Around him is a pool, a rock garden (the oldest in Europe), and among the trees a rectilinear arrangement of narrow beds laid out in the spirit of the

original design, tended by a squad of keen young gardeners. Sloane Rangers, I suppose. The Physic Garden has been open to the public only since 1983, when it had fallen on hard times. Despite the undoubted gains there has been a loss: a rare silence. On my only other visit, in the early seventies' with a friend who was a member with a key of her own, I went in like Alice in Wonderland through the little door in Swan Walk; inside, it was as private as the grave Sloane now inhabits. The benefits of public access in the summer months include free public lectures, a good café, and well-informed friendly guides at frequent intervals (paying attention not compulsory).

'God almighty first planted a garden,' wrote Francis Bacon, and if the Almighty lent a hand in laying out this beautiful healing garden, it might have been to compensate for the lost Eden. After visiting it, I showed my younger daughter a photo of Chelsea's lovely *Catharansus roseus*, Madagascan periwinkle, source of the anti-cancer drugs Vinblastine and Vincristine. She remembered them well. 'Funny they should come from such a pretty little pink flower,' she mused. 'Vinblastine was the nasty one which was in my first regime, which caused the chest pain from the radiotherapy to all reignite. Vincristine was in the second regime, probably the one responsible for the hair loss.' God moves in mysterious ways.

66 ROYAL HOSPITAL ROAD, SW3 4HS

Sir Hans Sloane covenanted Chelsea Physic Garden to the apothecaries in 1722. They responded by commissioning a statue of him: the original is in the British Museum and this replica, erosion and all, stands at the heart of the garden.

## THOMAS CARLYLE'S HOUSE

*Where Thomas and Jane Carlyle learned to adapt to Cockneycalities*

Early in his marriage Thomas Carlyle felt that he and his wife Jane must leave their native Scotland for London if he was to achieve his ambitions as a writer. It meant abandoning their past in Dumfries, where they had been born and got married. He tramped around London looking at houses, and on 21 May 1834 he wrote to tell Jane about 5 Cheyne Row (now number 24), built in 1708. 'On the whole a most massive, roomy, sufficient old house; with places, for example, to hang say three dozen hats or cloaks on.'

One of his big felt hats is still there, hanging in the hall; a lot of the furniture remains, some of it bought back, some never having left. So does the cast-iron range the Carlyles installed in the basement kitchen, the auxiliary cooker that looks like a piece of medieval armour but was the height of new technology, the pump which fed water from a well beneath the flagged floor into the stone sink, the table on which the maid slept at night. Pictures hang in Victorian profusion, one or two by Walter Greaves, the insufficiently talented amanuensis of James Abbott McNeill Whistler; and there's a small bronze version of Edgar Boehm's statue on the Embankment of Carlyle seated, just as he liked to be on a kitchen chair in the town garden behind the house, with its Tudor wall at the end still basking in past glories.

It was a sometimes wretched marriage, but the Carlyles dressed up their house like any respectable couple,

and loved and hated each other according to their individual manner, and clung together throughout. When they had both died, she in 1866, he in 1881, the owner of the house let it out once more, then 14 years later a trust bought it and made it a Carlyle Museum. Working from the watercolours of the interior by the Carlyles's friend Helen Allingham, the trust restored pictures and furniture to their accustomed positions. In 1937 the National Trust took over.

If the kitchen was the stomach of the house, the first-floor drawing room was the heart. Here Carlyle wrote *The French Revolution*, working with essentially the same type of Romantic imagination as Coleridge (whom he knew), recreating history as a darkly gleaming dream. Like the person from Porlock, who terminally interrupted the composition of *Kubla Khan* by arriving untimely on Coleridge's doorstep, Carlyle suffered the irruption of a white-faced John Stuart Mill into this drawing room, with the news that a large part of the first draft which Carlyle had entrusted to him had been accidentally burned by a housemaid. Unlike Coleridge, Carlyle managed to rewrite his work.

Later he had the attic soundproofed, inefficiently, and converted into his study. In it today are bundles of letters (in facsimile) by both Carlyles. The house lives on in Jane's words: 'Well! is it not very strange that I am here? sitting in my own hired house by the side of the Thames, as if nothing had happened, with fragments of Haddington, of Comley Bank, of Craigenputtoch interweaved with *Coc[k]neycalities* into a very habitable whole?'

24 CHEYNE ROW, SW3 5HL

# THE MORE CHAPEL, CHELSEA OLD CHURCH

*The small miracle of the More chapel's survival*

Thomas More was a man with death on his mind – the death of heretics. Six were executed while he was Lord Chancellor and others died in the cells to which he had committed them. All this has to be weighed in the balance against his courage in the face of his own execution decreed by his temporal master Henry VIII for preferring the authority of his spiritual master, Pope Clement VII. So More's sainthood has proved contentious. Pope Pius XI canonised him in 1935, 400 years after his death, a suitable pause for reflection, and the Church of England too recognises him in its own oddly equivocal calendar of saints (in which none of the successful candidates is actually prefixed by the word 'saint'); but no doubt those Anglicans who care feel a certain satisfaction in the small miracle of the survival of the More chapel when the Blitz of 1941 reduced most of Chelsea Old Church to a smoking ruin.

The church is a twelfth-century foundation largely rebuilt in redbrick in the sixteenth century and again in brick after the Second World War. It had been the heart of old Chelsea and the post-war work succeeded against the odds in restoring its country parish church feel. Many monuments survive, including a bizarre triumphal arch under the chancel arch in the north aisle in memory of Richard Jervoise, a sixteenth-century local landowner. The More chapel is separated from the chancel by a single arch of

the south aisle arcade, the principal survival of the bombing, with the two octagonal capitals from which the arch springs decorated with legible but badly eroded Renaissance motifs, though the captivating charm of the little angel on each of the faces of the octagon survives.

The most effective More memorial, memorable for its unforced simplicity, stands outside the church on Cheyne Walk: a statue of him by Leslie Cubitt Bevis (1892–1984), a competent, little-known practitioner in portrait busts whose name will live as long as the More statue survives. In previous portraits, by Holbein and his copyists, More is shown seated, black-robed, his chancellor's chain fastened around his shoulders with its Tudor rose lying on his chest, his hands folded in his lap or, in the wonderful Holbein painting in New York, holding a document. Bevis's statue borrows the black gown and hat, but his head and his hands are gold. He wears a gold cross around his neck and the discarded chancellor's chain of office hangs from his knees, forming an M shape. The implications are clear, and More's austere expression anticipates his fate on Tower Hill.

OLD CHURCH STREET, SW3 5LT

## ROPER'S GARDEN

*A green space for people and sculpture where the Luftwaffe flattened some houses*

In one of the worst nights of the Blitz in London, 16/17 April 1941, not only did a parachute mine all but destroy Chelsea Old Church on Cheyne Walk, but another flattened an adjacent group of houses. In 1965 the space where the houses once stood reopened as a little sunken garden of lawn, shrubs and trees. The local authority called it Roper's Garden, to commemorate its sixteenth-century existence as an orchard on Thomas More's estate, which he had given as a wedding present to William Roper and his new wife, More's daughter Margaret.

The sculptor Gilbert Ledward, born and brought up in Chelsea, lived close to the devastated stretch of Cheyne Walk, and Jacob Epstein lived and worked from 1909–14 in a studio destroyed by the parachute bomb. Both have commemorative sculptures in the garden. Ledward (1888–1960) was in full maturity when sculptors were required in busloads to create First World War memorials. He was a gifted but academic artist so all his work, though skilfully realised, is not very interesting because the primary characteristic of academic art is that it looks like too much other art being produced at the same time based on worn-out models. Still, as garden ornament his life-size bronze, *Awakening*, of a nude female stretching the sleep out of her limbs, is charming. He has another and better nude, a crouching *Venus*, at the centre of the fountain in Sloane Square. Epstein's relief sculpture, unveiled in 1972 by Augustus John's son, Admiral Sir Caspar John, is also a nude. It looks as though it is an early work in his 'primitive' style, more rampantly naked than Ledward's tasteful nude could ever have countenanced, and is certainly unfinished, perhaps because Epstein realised it wasn't going to make it: the head, hidden behind an upflung arm, is

awkwardly crammed into the space of the stone slab. But the garden is a sweet green bulwark between the unceasing growl of armies of traffic along the Embankment and the streets of the oldest part of Chelsea, reaching northwards to the King's Road.

CHELSEA EMBANKMENT, SW3

## ST LUKE'S, CHELSEA

*James Savage, a failure who rose to the top of the class*

Chelsea Old Church became old by popular assent at the end of the Napoleonic Wars when the parishioners realised the village was growing so fast that the intimate parish church at the side of the Thames would become inadequate. A public meeting in 1818 voted for a new church. The architect chosen was James Savage (1779–1852), best known for having bright ideas but coming second in competitions. History does not record who put in a good word for him at Chelsea but he landed the job.

Savage repaid the vote of confidence by breaking free from the prevalent St-Martin-in-the-Fields-style churches (classical pediment, bastard spire of one sort or another mounted behind). He built a Neo-Perpendicular church sporting a tower 142 foot high and a nave 60 foot high. Many of Savage's successors despised it, probably because the style was late-medieval, whereas Pugin and his followers later decided that the Gothic of choice was thirteenth-century. But Savage had another trick to play: he built a glorious vaulted roof, not of wood or plaster but of stone. Could the others have achieved that? Not likely. Hardly surprisingly, Savage also built a battalion of flying buttresses to hold the edifice up. It was the first thoroughgoing Gothic Revival church; he was the 11-plus failure who finished top of the year.

It is true that St Luke's is a touch undernourished as well as tall. Nor does it have the wonderful decoration that Sedding was to coax out of his Arts and Craftsmen at Holy Trinity. But it has incidents, not least the huge east window of 1959 replacing the bombed-out original: it is by Hugh Easton (1906–65) and although its iconography is uninteresting the fanfare of colour is just right. As it happens, the original window was from an unrecorded design by James Northcote, Joshua Reynolds's pupil (or drudge, as Northcote put it), who also painted the reredos, *The Entombment of Christ*, which survives in Savage's fine stone frame. In his late years when Northcote (1746–1831) painted the reredos, he was, as his younger contemporaries Richard and Samuel Redgrave put it, 'the depository of the art-lore of nearly two generations', and is remembered now largely for his long conversation about that recorded by William Hazlitt. But the *Entombment* is better than any 'history painting' Reynolds ever accomplished: more human, more dramatic in the baroque torque of Christ's body and winding sheet as a disciple and a soldier take either side to ease him down the steps into the tomb.

This charming nude by the academic sculptor Gilbert Ledward is called *Awakening* because Roper's Garden, where it stands, was created after a parachute bomb opened up the space during the Blitz.

The colour is undistinguished and the touch mundane; and, of course, we know both that Northcote was at the fag-end of a burned-out tradition, and also what miracles Delacroix and Géricault were performing over the Channel at this time.

The Bishop of London consecrated the new church on 18 October 1824, St Luke's Day, in the period when the Commissioners' Waterloo churches were rising all over London. Ironically, although St Luke's was not a Waterloo church, its first rector, Gerald Valerian Wellesley, was a younger brother of the Duke of Wellington.

SYDNEY STREET, SW3 6NH

## MICHELIN HOUSE

*How a bonkers showroom and tyre-fitting workshop became a chic restaurant and shop*

When the Danish Royal Family wanted to see the back of Hamlet, they sent him to England. As the first gravedigger said, he was mad, but "twill not be seen in him there; There the men are as mad as he'. With much the same principle in mind, the flourishing young Michelin company, manufacturers of the new-fangled pneumatic tyres in Clermont-Ferrand, dumped on a certain François Espinasse (1880–1925), employed as an engineer but wholly untrained in architecture, the instruction to design a building for them in London, which was to be a showroom, tyre-fitting workshop and office block. It was to be on one of the main highways from the west, Fulham Road, and would fill the wedge-shaped plot betweeen Sloane Avenue and Lucan Place. The building was to function additionally as a kind of three-dimensional billboard for Michelin and its products as it fought to gain a foothold in a British market dominated by Dunlop. The hapless M. Espinasse did as he was told, and the building was opened in 1911.

It is plain bonkers, but the locals took it in their stride, and perhaps even came to love it with its rubber-tyre Michelin man, Bibendum, represented in big stained-glass windows based on advertising posters, chewing a cigar as he jauntily cycles without hands on handle-bars (look *Maman*, no hands), practises kick boxing, or raises a glass in a front window emblazoned with a line from Horace, '*Nunc est bibendum*' ('Now is the time to drink'): naturally, behind the window is a restaurant. Piled tyres compose turrets on the front corners of the building and Bibendum's monogram, drawn in steel on the fascia, is not quite as elegant but quite as eloquent as the celebrated Art Nouveau lettering at the pavement entrances to the Paris Metro.

Espinasse's building is made of concrete, but concealed beneath it are Burmantofts tiles and friezes of ceramic panels, mostly depicting motor racing triumphs of the turn of the century. One shows Charles Terront pedalling to victory in the Paris-Brest cycle race of 1891 through the Breton countryside, the very year that Gauguin was there and just the kind of scene he was painting, though his work and the Michelin ceramic are barely on nodding acquaintance.

This alarming stained-glass figure of the Michelin man, Bibendum, is in the restaurant of the finely restored Michelin House. The name comes from the Latin '*Nunc est bibendum*' ('Now for a drink'). Cheers.

After the war the Fulham Road building had served its purpose for Michelin. The designer and shopkeeper Terence Conran bought it with his friend the publisher Paul Hamlyn, and in 1987 reopened it after a refurbishment by Conran Roche (now Conran & Partners) and YRM, which introduced the Bibendum Restaurant on the first floor, the highly elegant glass-fronted Conran Shop in the former loading bay on Sloane Avenue, and offices for the publisher. The tyre bay on the Fulham Road converted seamlessly into an open loggia with an oyster and seafood bar to one side and a stall flaunting a mountain of flowers to the other. This organisation knows how to run a whelk stall.

81 FULHAM ROAD, SW3 6RD

## THE ISMAILI CENTRE

*Classic Islam at the heart of Kensington*

A group of people hoping to transform a notional theatre into a national theatre gathered on a parcel of land opposite the Victoria and Albert Museum in 1938 to see a performance of the ancient land conveyancing custom known as the livery of seisin; or, to non-lawyers, the ceremony of the sod and the twig. They watched as Sir Robert Vansittart, a diplomat with a taste for theatre, handed the deeds of the land, with a square sod of Kensington grass and a leafy Kensington twig, to George Bernard Shaw. 'I suppose,' said Shaw to the cameras, studying the mud and greenery distractedly for a moment, 'that I am here as the next best thing to Shakespeare.' Next best was not good enough, because the war intervened, the project died and so did GBS. It was 1963 before the National Theatre at last opened on the South Bank.

The parcel of land stood vacant until the late 1970s before the deeds passed to the Ismailis, a growing sect of Shi'a seeking a place in London for a Muslim cultural and social centre, a place for lectures and political debate, and a prayer hall. They got it in 1984 from Neville Conder of Casson Conder. Hugh Casson got the glory of the zoo's elephant house, Neville Conder drew the short straw: different culture, multiple use, difficult position, polished and rough-grooved grey granite up against the massed red brick of the V&A. He resolved to build a hunched fortress that would not advertise itself too boldly. But my, how he must have worked at the interiors, grasping the key that Islamic arts are not just based on geometry but exist within it, squares within circles, and polygrams and triangles, and intersecting figures that in a heartbeat can throw up a pattern of flowers. So the interior grew, closely planned and beautifully crafted. There is immense subtlety of shape and symbol and number, and low-key colours of granite, black modulating to grey, as the stairs climb towards the prayer hall.

But the music is missing. The architect has grasped the solution yet has not heard the song. Cross the road to the V&A's rooms of Islamic ceramics and see the bowls that could be held in the palm of a hand or the long-necked vases, or the celestial blues of dishes; all the elements of the Taj Mahal are here. Then look at a little sixteenth-century polygonal Turkish

table, a gorgeous ceramic top of 12 sides standing on six legs inlaid with ebony and mother of pearl and separated by multi-cusped arches: forms common in Mughal public buildings in India of the same period. The nearest thing in the Ismaili Centre is the fretted screen (some movement, at last) across the long west window made by Karl Schlamminger, a German – and a Muslim. Stout pillars take the weight of the Islamic garden of paradise on the floor above, banks of camellia and roses, open to heaven but wonderfully sheltered from the street noise below.

1–7 CROMWELL GARDENS, SW7 2SL

## BROMPTON ORATORY

*A baroque corner of Kensington where papal writ runs*

Brompton Oratory is a large chunk of baroque Rome plugged into Kensington; Roman in religion too. Properly though infrequently known as the Oratory of St Philip Neri and the Church of the Immaculate Heart of Mary, its grandeur withstands the heat of the massive sculpture-littered main façade of the next-door neighbour, the Victoria and Albert Museum. If the V&A declaims the liberality of the late Hanoverian monarchy, the Oratory pronounces the supremacy of the pope. At any rate, its construction followed close on the heels of Pope Pius IX's restoration in 1850 of the Catholic hierarchy of England, though for lack of funds it was initially built in plain brick. By 1878 money was available to allow a second shot. The church fathers held a competition and selected the little-known 29-year-old Catholic architect Herbert Gribble. Cardinal Manning consecrated the church in 1885, though building and the decoration of the interior continued long after Gribble died in 1893 at the age of 43.

The interior almost impels visitors to bend the knee and bow the head in supplication, and that of course is the intention. The dome and crossing dominate the composition; the entrance to the marble-lined sanctuary is flanked by two seven-branched candle holders looking like treasure from Byzantium but designed in nineteenth-century London by the ever-interesting medievalist William Burges. Dramatically over-life-size statues of the apostles of 1680–5 by Giuseppe Mazzuoli, accomplice of Bernini, once stood in the Cathedral at Siena but now line the Oratory's nave. Instead of aisles, between the apostles are side chapels of great splendour with moulded stucco angels. Venetian mosaics (run of the mill), pink Italian marble, splendid moulded stucco saints in the spandrels of the chapel arches (these by C. T. G. Formili, who had worked in London for many years and took charge of the nave decoration). The paintings are journeyman stuff except for the triptych behind the English martyrs' altar in St Wilfrid's chapel; a gilded and curved white marble reredos frames three canvases by Rex Whistler (1905–44), almost wholly removed from his country house and Tate restaurant mode and mood. In the central panel of a languidly Whistlerian pastoral landscape something burns fiercely in the distance, a house, or a pyre, sending an ominous

column of dark smoke into the early morning sky; in the foreground two insouciant putti support a carved cartouche inscribed to the martyrs; in the middle ground several corpses hang from a huge gallows and men climb the ladder either with another victim or to fetch a body down. An appreciative crowd gathers around. It's not overstated but casts the sombre shadow of cruelty and death over the land. The right-hand panel shows St John Fisher; the left hand has Thomas More, in this context a saint, as a portrait heavily depending on Holbein. The church commissioned the triptych to celebrate More and Fisher's canonisation in 1935. It is the work of a minor artist rising to great sensitivity, judgement, and emotional power.

BROMPTON ROAD, SW7 2RP

## ST MARY THE BOLTONS

### *The Bedlington terrier that takes his place in a Crucifixion*

George Godwin built St Mary the Boltons in 1849–50, and the roads around it in 1850–51. The two roads known as The Boltons, each a crescent, describe an almond shape that hold church and churchyard, a garden, close. In medieval Christianity this would have been called a mandorla (Italian for almond), and was the shape in which Christ was depicted on his ascent to heaven. Godwin was intensely interested in art and architectural history, so although the mandorla passed out of favour when art embraced Renaissance naturalism, it must have seemed to him a still-living symbol for the unity of luxurious villas and the church in this growing new London suburb. At the least, he must have enjoyed indulging an archaeological caprice that worked as a planning solution.

The exterior of the church itself is ugly, with a misshapen west porch under a tacky bellcote. The interior is good, seeming spacious, partly because there are no aisles but a clearly defined crossing beneath the tower, and partly because most of the Victorian fittings have gone. In the south wall is a new window that manifests itself sensationally by the red-orange glow it throws across the floor of the nave even when the sun has moved on. This is *Crucifixion* by Craigie Aitchison.

He had painted the subject almost throughout a career beginning in the 1950s. The simplicity of his treatment came from his love of Piero della Francesca's murals. Aitchison's typical components settled down into the crucified Christ, Goat Fell (a pyramid-shaped mountain on the Isle of Aran, close to Aitchison's heart from childhood), a cypress tree, a star. And a dog. A Bedlington terrier. Aitchison bought his first Bedlington terrier, called Wayney, from the 1971 Crufts Show. After it died in 1985 he made a painting called *Wayney Going to Heaven*, showing the animal floating Chagall-like in a lucent blue sky. Wayney's successors each took their place in the Crucifixions, standing in for the mourners traditionally present. Veronese had risked condign punish-

A left-over of the coffee bar revolution of the 1950s where, later, Bob Dylan and Jimi Hendrix strummed, the Troubador still swings, retro decor and all.

ment when he placed a dog centrally in the foreground of *The Last Supper*; the Inquisition was not amused and ordered him to paint the dog out. With some panache, Veronese left the picture alone, but renamed it *The Feast in the House of Levi*. But the Inquisition has gone the way of the mandorla and dogs have risen in the social scale. This painting shows one of Wayney's successors in the bottom left-hand panel, alone; Christ, face bright white like the star, body washed lime green, the tree, the star, the mountain pink against a red sky and above earth of burning red.

Aitchison died in 2009, but the glass painting specialist Neil Phillips saw the job through, at the German glass manufacturers who make glass not needing traditional leading so that there are clear uninterrupted passages of colour. On Ascension Day, May 2012, the Bishop of London dedicated *Crucifixion* as the Craigie Aitchison Memorial Window. By June, through the glass with the burning red earth, you could see the roses blooming outside.

THE BOLTONS, SW10 9TB

## THE TROUBADOUR

*The 1950s haunt of Lonnie Donegan, Dylan, and Hendrix that still thrives*

The Troubador's decor looks like the detritus of a raid on a 1950s junk shop. An array of vintage enamelled and coloured tin coffee pots stands in a window on the street front, and inside on walls rough-plastered and matchboarded there is a random collection of agricultural instruments, and metal

tractor seats, and a penny farthing bicycle. Fiddles and mandolins hang from the ceilings, left, no doubt, by a passing troubadour. Enamel signs cover the walls: Rinso – Save Coal Every Washday; Colman's Starch; the *West London Observer* and the *Western Daily News*; Organs and Street Cries Prohibited; The Chislehurst Company Mineral Water, Stephens Ink. A wooden carving of some stately ecclesiastical figure nests among this glorious tat in a complex of hefty blackened beams rescued, no doubt, from some fifteenth- or sixteenth-century structure and pretending to be holding up this nineteenth-century building although more likely it is weighing it down. A dismal painting of a troubadour hangs in a corner, but Troubadour, a poet composing to music, maybe a wandering minstrel and maybe sleeping rough, is an apt enough name for a coffee bar founded in boho 1954. It has chairs and tables with ornate cast-iron legs as found in the night-time cafés in Van Gogh's Arles. Beyond the back door is the hint of a broad-leaved Douanier Rousseau jungle.

The Troubadour came in on the spring tide of a new generation, prompted by the sudden availability of the Gaggia espresso machine in a country where coffee had previously been instant and one level up from dishwater. Gaggia had cachet, and the Troubador was Mediterranean, young, as classless as the Morris Mini of 1959, it shed the chains of convention, it had the red, white and blue Routier imprimatur (and still displays it like a Croix d'honneur). The coffee-bar revolution, pure teen hyperbole, swept London. There was even a seriously un-chic intellectual wing in Soho where following the Suez invasion of 1956 the charismatic left-wing historian Raphael Samuel and a few Oxford comrades launched the Partisan Coffee House, a scrubbed deal institution where customers in cords and polo-neck pullovers played chess, despised Colin Wilson and rated Albert Camus, read the news and discussed Hungary over a lunchtime bowl of borscht. It lasted four years.

The Troubadour, on a programme of folk music floated with Lonnie Donegan's skiffle, is still going, still fun, coffee bar/restaurant on the ground floor, serving breakfasts, brunches, salads of peppers, mushrooms, artichoke hearts and aubergines, grub all day, club till past midnight in the cellar where Bob Dylan performed under the name Blind Boy Grunt. Jimi Hendrix, who had gigs all around the way the future Charles II hid in trees, played here too, and here Richard Harris, then a drama student, auditioned and rehearsed the Clifford Odets play *Winter Journey* for his own production of it at the Irving Theatre. The tradition continues and by tomorrow we'll have heard of today's performers.

263–267 OLD BROMPTON ROAD, SW5 9JA

## ST CUTHBERT'S, EARLS COURT

*The ultimate in parishioners' churches*

St Cuthbert's, Earls Court is a sort of elevated DIY church, Arts and Crafts: that is, with a huge input from parish-

ioners. It is set in Philbeach Gardens, a big crescent embracing impressive parkland, one of those many communal green spaces set among and behind and between the enveloping high, terraced mansions off Earl's Court Road and Warwick Road (for Warwick, read warren). For decades this was home ground to artists and recent ex-students; now the rooms and flatlets house the nations of the world in a surprisingly successful environment of old four-storey red-, black- and yellow-brick terraces with ornate gables and tall chimneys. Work started on Philbeach Gardens in open fields in 1876 and the church followed in 1884 (completed 1887).

It may be that a romantic decision to quarry the foundation stone for the east wall on Holy Island came before the decision to dedicate the church to its most famous abbot, since dedications to Cuthbert are rare in the south. Either way, the stone came with its own new legend, having apparently fallen from its cart into the sands and been rescued just in time before high tide engulfed it. The episode seems to have been inspirational. The architect was Hugh Roumieu Gough. Roumieu was the name of his father's partner in an architectural firm, so it seems that young Hugh was always intended for the same profession. He remained obscure, yet his St Cuthbert's is a convincing take on medieval piety, Early English but soaring like a French church, red and black brick gathered into a culminating flèche, in this case a better word than our own dismissive spirelet since it means arrow.

For anyone who isn't averse to a superfluity of Victorian extravagance, the interior is splendidly rich (High Anglican). The piers supporting the five-arched nave are Devonshire marble and the chancel is paved with marble from Connemara and Tinos in the Cyclades. The walls are clad in small square stones slotted together diagonally after being individually carved by the parishioners, organised like their English Christian forebears into guilds. They may have enjoyed the work, but it took many years and one begins to see the argument in favour of industrial production. There is no chancel arch but a huge rood; no east window but a massive reredos yet more heavily carved than the rood and with a confusion of detail. The balustraded pulpit is by Gough, richly Italian in feeling, with a curving staircase and an intricately carved sounding board; Italianate too the small, canopied lady's chapel, gleaming darkly golden.

The mood lightens with the work of the metalworker William Bainbridge Reynolds, a parishioner of St Cuthbert's. There's a hiccup with his extraordinarily ugly lectern of iron and beaten copper. But the noble silver-bound high altar is his (women of the parish made the green and gold frontal), and the communion rails, the altar rails in the lady's chapel, the metalwork screen to the organ and the intricate but compact royal arms, a constant admonition to the reredos.

50 PHILBEACH GARDENS, SW5 9EB

# The Underground

There is a beautiful book available from V&A Publishing called *Frank Pick's London*. It celebrates the 150th anniversary of the London Underground (in 2013) through the personality of an administrator so colourless that he was invisible to the public, or even to many of the staff, until they realised that, disguised as commercial manager, he had risen by 1933 to become prime mover and shaker, the chief executive officer of the company he had joined over a quarter of a century earlier. By this time Pick and his boss, Lord Ashfield, the diplomat and conciliator of the two, had already modernised the Underground, and Pick, with no background in art or design, had put together an unbeatable team: the architect Charles Holden; the typographer Edward Johnston, disapproving of commercialism but who designed a typeface anyway, still modern and still used on all London transport after a hundred years; the graphic designer Harry Beck, who devised the inimitable Underground map (though attempts at imitations exist all over the world); and a group of poster artists: in a memorial catalogue in 1955 for the best of these, the American-born Edward McKnight Kauffer, the V&A described him as 'the son of a hundred kings', which suggests that it rated him royally (see page 106).

Holden built the St James's Underground headquarters but his real achievement was the stations on the Piccadilly line, clean-limbed, brick, concrete and glass, maybe with a tall drum encasing the ticket hall (Arnos Grove, Chiswick Park) or a tower (Boston Manor), tall, its silhouette broken by a vertical strip of glass bricks that light up at night, together with the glazed roundel below superimposed with the station name in Johnston's typeface. If anything the post-war addition of safety railings around the flat roof increased the design's edginess.

The idea of an underground railway had first been propagated in the 1830s by Charles Pearson, Solicitor to the City of London, and somehow it survived his less than inspired idea of calling it 'trains in drains'. He lived until 1862, long enough to know that the world's first underground railway was being built. It started rolling in 1863 with the launch of a line from Paddington to Farringdon: semi-underground actually, just as today, with passages in deep uncovered trenches. Contrary to prediction, it was an immediate popular success, despite smoke-filled windowless carriages and a Fenian bombing campaign in the 1880s. (On 1 March 1884 Camille Pissarro wrote from Éragny to his son Lucien, also an artist, in London: 'I am at the moment reading about the terrible explosion in Victoria Station, and I am beginning to think that there is no security for anyone in London now, it would be wiser, my boy, to come home and work with me. Don't you think so?') No one was killed and Stanley and Pick were left to stitch the system together.

It was not easy. Nothing much was planned. Even what is now the Circle Line came about more by accident than design. It started as two separate services between Kensington and the City, run by competing lines – the District and Metropolitan (to use today's names) – the former providing the anti-clockwise trains, and the latter the clockwise. A difficult relationship became a fractious one when, during the night of 5 July 1870, the District secretly went ahead with a plan to improve its share of revenues by building a short section of track, parallel to the Metropolitan's own, between Gloucester

Road and High Street Kensington stations. Done without parliamentary say-so (necessary in those early days), this led to a lasting enmity between the owners, and a long-running court case.

If Pick's was the golden age, the Jubilee Line extension of the 1990s was the platinum. Starting at Westminster, swinging south over the river to Waterloo and around to Canary Wharf and North Greenwich beside the O2 Arena then back over the Thames to Stratford East: 11 magnificent new stations (including Southwark, see page 343), 11 architects including the leader of the team, almost unknown beyond the profession, Roland Paoletti, who ensured that the architects and not the civil engineers were in charge: not, in other words (Norman Foster's), simply 'putting lipstick on the face of a gorilla'.

The familiar oxblood red tiles of Leslie Green's Underground designs, here of 1906 at Gloucester Road, originally opened in 1868.

# • HYDE PARK, KENSINGTON, PADDINGTON, LADBROKE GROVE •

## MEMORIAL TO W. H. HUDSON, HYDE PARK

*Where Epstein demonstrated his ability to enrage reactionary opinion*

John Galsworthy wrote of W. H. Hudson that 'of all living authors – now that Tolstoi has gone I could least dispense with W. H. Hudson'. Tolstoy's majesty remains, but Hudson's light flickers fitfully, although after his death in 1922 the Royal Society for the Protection of Birds commissioned a memorial to him from Jacob Epstein (1880–1959) for the bird sanctuary in Hyde Park. It remains there today like a terrace wall against a stand of trees, with a little fountain playing in front of it and, behind, a trough of green water and a small stretch of grass.

Epstein began by making sketches for a portrait head of Hudson, but learned that the Office of Works forbade portraits of real people in the Royal Parks; so he turned instead, and fortunately, to carving a relief sculpture of *Rima*, the heroine of Hudson's idyllic novel of 1904, *Green Mansions*, set in a South American jungle; part human, part pure spirit, part teasing echo. Epstein's naked figure is less Hudson than British Museum: he had made a long study of 'primitive' non-European sculptures. His statue might be thought too earthy to be a spirit except that she seems almost to fly among the birds that crowd in around her and her hair streams as though galvanised by nature's electricity. It fills the central, rectangular, panel of three and the space behind the figures (what painters would call the picture plane) works too as part of the interlocking decorative scheme. In the other square panels flanking the relief Eric Gill carved Hudson's dates, MDCCCXLI and MCMXXII (1841–1922).

The Prime Minister, Stanley Baldwin, unveiled the monument in May 1925, and immediately the reactionary sections of the establishment and press poured out a stream of abuse. The target was not, of course, Hudson, but the sculptor, Jacob Epstein, and the nudity so inevitably resented in his work. The *Daily Mail* ('Take this horror out of the park') and the *Morning Post*, companions in arms against vileness wherever it could be found, denounced it. An MP stood up in the chamber to decry *Rima*, imaginatively, as a 'bad dream of Bolshevism', and a group of VIPs signed a letter to the *Morning Post* demanding the instant removal of Epstein's work. The signatory dignitaries included Hilaire Belloc, Conan Doyle, the president of the Royal Academy, one Sir Frank Dicksee, and the racehorse painter and future PRA, Alfred Munnings, who was to make a career of denouncing artists whose dirty working smocks he was not fit to kiss. Soon after this very English incitement a band of bravos under cover of darkness daubed *Rima* with paint.

Since then the memorial has survived, gazed upon by the occasional off-course and out-of-breath jogger. It remains a glory of English Modernism of the twen-

tieth century, though it should be noted that part of the objection raised against Epstein was that he was an American-born Jew.

HYDE PARK, W2

## STATUE OF ERNEST SHACKLETON, EXHIBITION ROAD

*A statue to a down-to-earth transatlantic hero*

Ernest Shackleton died of a heart attack on South Georgia Island on his way to lead another Antarctic expedition. It was 1922 and he was a month short of his 48th birthday and an undisputed hero of the great age of exploration. As Apsley Cherry-Gerrard, one of his comrades on the fatal Scott Antarctic expedition, wrote: 'For a joint scientific and geographical piece of organisation, give me Scott; for a Winter Journey, Wilson; for a dash to the Pole and nothing else, Amundsen; and if I am in the devil of a hole and want to get out of it, give me Shackleton every time.'

Just the kind of down-to-earth hero, then, to touch a nerve with the public after the trauma of war; and like Scott's, his major expedition was a heroic disaster, just the sort of thing the British warm to. On that basis the Royal Geographical Society, which had been behind so much exploration of untrodden lands, went ahead with an appeal for funds to educate Shackleton's children and pay for a memorial. A committee hired Charles Sargeant Jagger to create a statue of the explorer to be cast in bronze for Lowther Lodge, the society's headquarters at Kensington Gore. In the nature of committees, this one took several years over decision-making, involving the precise site, the nature of the statue (with an added scene of polar sledging or without? Without, it eventually decided), even whether the sculptor should pick up the bill for the scaffolding (he didn't). At last, in January 1932, the society unveiled the statue in a niche in the new lecture theatre's blank brick wall overlooking Exhibition Road.

Although polar exploration was untainted by the imperialism that post-colonial history lays to the discredit of African exploration (though the hunt for oil will change that), the lustre of Shackleton's achievements faded. But Jagger, himself a decorated war veteran, responded to Shackleton's heroism in the best way he knew: modelling his subject with intense realism. Faced with the decision that the niche for the sculpture would only be deep enough for the figure of Shackleton, Jagger resorted to the closely observed detail that had made his front-line Tommy in the Great Western Railways war memorial at Paddington Station (see page 247) so powerfully emblematic. His Shackleton is a strong-willed pragmatist, swathed in bulky clothing, his face peering grimly from an enveloping balaclava at an icy waste, gloves suspended from a line slung around his neck and hanging at knee-level (modelled, typically, from a pair used on a polar expedition, which Jagger borrowed for verisimilitude). The ledge on which the sculpture stands is labelled simply: Shackleton. Straightforward

SHACKLETON

enough, but carried through with a native genius close, it seems, to Shackleton's own.

There is one problem. Although the teeming traffic in Exhibition Road has recently been tamed, it is not quite the handsome boulevard that was intended, and the view of Shackleton would be helped by a pair of polar binoculars.

CORNER OF EXHIBITION ROAD AND KENSINGTON GORE, SW7

## KENSINGTON PALACE

*A palace destined to be the people's*

Just as on her death Lady Di became the people's princess (© Tony Blair), so her royal home, Kensington Palace, is the people's palace. It has been so almost by definition since the demotic monarchs, William and Mary, arrived in 1689 to public acclaim and ordered Christopher Wren to adapt the existing Jacobean house to their use. (Asthmatic as well as demotic in William's case: his reason for moving away from Whitehall's allegedly unhealthy air.) Wren took a good look at William's Dutch house, Het Loo, added pavilions to each of the four corners of the putative palace, and had it ready for occupation the same year. Later additions destroyed his simple symmetry.

Mary II's brief joint rule ended when she died aged 32, even younger than Diana, in 1694. There were no forests of flowers laid for her before Kensington Palace as there were to be during the fever of grief at the death of Di, yet even today, in a sense, the newly refurbished palace is a paean to William of Orange and our Princess of Wales: William, because his quarters in the palace are an object lesson in how to do it; Diana, because the royals have learned to tread carefully around her memory and their publicity people know a good thing when they see it. The biggest thing in Kensington Palace as I write is a huge portrait of Lady Di (Lah Deedee as French waiters disconcertingly pronounced it) in diamond coronet and embonpoint only slightly less effulgent than had been fashionable in Mary's Stuart court.

The king's rooms are different. William Kent was much loved by all who knew him, but although the stories of his inadequacies as an artist are much told (see Horse Guards, page 168), in his own time men who knew his ineptitude kept silent in the presence of the comparatively new king of the early 1720s, George I. He insisted that the amusing little Englishman should be his decorator. What Kent produced was a sequence of well-meant but ill-drawn, badly proportioned, billiard ball-headed courtiers behind an awkwardly angled balustrade on the King's Staircase walls and ceiling. Yet there follows a sequence of state rooms that revolutionised interior decoration, though it's Versailles squeezed into a country cottage: the Presence Chamber, with Grinling Gibbons's sensational carved limewood decorations of putti, birds and foliage surrounding a landscape set into the overmantel and a ceiling painted in

'If I am in the devil of a hole and want to get out ... give me Shackleton every time,' a fellow explorer said of Ernest Shackleton. This statue of him at the Royal Geographical Society is by the great war memorialist Charles Sargeant Jagger.

imitation of the ancient Roman decor excavated beneath the Palatine Hill; the Privy Chamber, with four excellent Mortlake tapestries; the Cupola Room with a deeply coved oval in the ceiling with the star of the Garter at the centre; Wren's splendid King's Gallery, Kent's red damask on the walls with a couple of Tintoretto canvases and a dull copy of the Van Dyck equestrian portrait of Charles I with his groom.

The Queen's wood-panelled quarters are warm, relaxing and sober, with fine deep windows giving on to garden views, an antidote to the King's glittering drama. What a shame that this magnificent suite of rooms has been mucked about with silly little gimmicks.

KENSINGTON GARDENS, W8 4PX

## BARKERS BUILDING

*A department store that maintains its thirties shock effect*

Kensington High Street maintains an aloofness that hints at power and money, an impression only enhanced by the occasional policeman prowling by armed with a sub-machine gun. Better not to ask, but he is probably an overspill from the police presence in the vicinity of the Israeli Embassy in Kensington Gardens. This has been one of the great shopping streets of London; maybe it still is, but on different terms from the days of the big London department stores, when Barkers, Derry & Toms and Pontings competed (until Barkers took the others over and House of Fraser swallowed them all). Close up it is clear that the store has become a bazaar of shops entered from pavement level, some units slotted in cleverly, others not. From Derry Street to its west is the entrance to the *Daily Mail* with offices wrapped around a seven-storey atrium, impenetrable without a friend with a switch card. So stand back on the other side of the street to enjoy the building, designed in the 1930s by Barkers' little-known in-house architect Bernard George, and thanks to the Second World War not completed until 1958.

In 1956 Kenneth Tynan had written about the effect on theatre of Bertolt Brecht's Berliner Ensemble's first appearance in London: 'It is as shocking and revolutionary as a cold shower.' Barkers belongs to the period of Brecht's *Threepenny Opera* and *Happy End* and to this day the building maintains something of the Brechtian shock effect, a long curving façade with its tall Portland stone-clad steel frame and its bronze-bound windows dramatically reaching from canopy to the massive triple cornice that pulls the design together, with two glass- and stone-clad staircases busting through the cornice and soaring like lighthouses above the flat roof. Piers on the towers and horizontal bronze panels dividing the windows and marking floor levels bear low-relief decoration composed of teddy bears, solar topees, ladies' shoes and gloves, crossed cricket pads and wirelesses, with airliners, ships and trains as symbols of the store's intrepid ventures on behalf of customers. Lousy art but amusing.

63–97 KENSINGTON HIGH STREET, W8 5SE

## ST MARY ABBOTS

*A church where a tomb is greater than its setting*

North of Kensington High Street the spire of St Mary Abbots rises to 278 foot, the tallest spire in London. The most direct approach to George Gilbert Scott's church of 1872 is across a little set-back in the pavement with a pretty flower stall beneath green canopies, a stretch of the market square that maybe never was, through a roofed-in, winding arcade, or cloister, to the entrance in the south door. The church is as big as the steeple suggests, with a tall nave of six bays separated from wide aisles by slender piers carrying pointed arches. The ceiling was rib-vaulted until the wartime bombers visited; now it is a barrel vault. The chancel glitters with gold mosaic, the big east and west windows are full of passably good, dark glass, the tower is hung with ten bells, handmaidens bring armfuls of flowers to fill the numerous great vases. Everything that scholarship can order and money can buy this church has. What it lacks is inspiration.

Scott held a low opinion of Clayton and Bell, the high-production, highly commercial stained-glass firm (300 employees in the Regent Street factory, working night shifts to cope with orders), yet he employed them. No doubt he would have preferred to commission William Morris, but Morris detested Scott for his crass work in restoring medieval Gothic (after Scott's death Morris referred to him as 'the happily dead dog'). At any rate, while the colour of the St Mary Abbots east window gives a good impression looked at through half-closed eyes, the design is insipid.

In the ancient churchyard (there have been at least two earlier churches on this site) is the parish primary school with charming Bluecoat figures of a boy and girl. And north of the church's west door is a sarcophagus for a parishioner called Elizabeth Johnstone, who died in 1784. It is by John Soane, Etruscan in feeling, something like the rock that rolled from Christ's tomb but, speaking of finality, packing in more meaning than all Scott's careful great edifice.

KENSINGTON CHURCH STREET, W8 4LA

## 18 STAFFORD TERRACE

*The nineteenth-century house that preserves the memory of* Punch *in all its unfunniness*

(Edward) Linley Sambourne was not a rich man. To help set up Sambourne and his new wife Marion, her parents gave them half the price of the house they desired in Stafford Terrace, £1,000; Sambourne fixed a mortgage for the other half. It was a solidly respectable street. Neighbours included civil servants, retired army officers and lawyers. It was everything Marion wanted from life: William Morris and Japanese wallpapers, stained glass to keep the sun at bay, Chinese and Japanese porcelain (albeit slightly cracked and chipped), tasselled desk lamps, household items bought from Harrods ('dirty place though cheap', she judged), her menus for dinner parties handwritten in French. Yet there was another side hinted at in her diaries, another society. 'Rather slow

dinner. O. Wilde sat next me and & spilt all his claret all over my dress,' she notes on one occasion, but she forgave him for the sake of his plays. She pampered her son Roy, a scapegrace and ladies' man, and put up with her husband's mildly louche ways and tastes, even the string of favourite female models he hired to photograph (for purely professional purposes, he would have assured her).

Linley Sambourne, born in 1844 the son of a furrier, was a cartoonist. No training, bluff Dickensian sense of humour, stumbled into the job when a friend showed some of his drawings to the editor of *Punch*, and at *Punch* he stayed for ever and succeeded the *Alice in Wonderland* illustrator, John Tenniel, in 1900 as the quaintly termed 'chief cartoon'. He died in 1910 of too many cigars. He had never drawn a funny cartoon in his life. Nobody seems to have noticed, perhaps because at the time cartoonists were not held to be funny.

The first Sambourne child, pretty Maud, inherited her father's talent for drawing but, being well brought up, made less of it. She herself produced a son, Oliver Messel, a designer whose sets and costumes for the 1946 Royal Ballet production of *Sleeping Beauty* are still in use at Covent Garden, and a daughter, Anne Messel, later Countess of Rosse, who in 1958 held a meeting of friends in 18 Stafford Terrace and founded the Victorian Society to preserve the national heritage, just as her family had preserved the family home in every unfashionable Victorian detail. John Betjeman became the first secretary. In 1980, Anne sold the house as a museum to Kensington and Chelsea, lock, stock and drawing room, dining room, hall, the bedrooms and the servants' quarters, all survived. The staircase too survived with Morris paper where it can be glimpsed between Sambourne's nudes and his cartoons and those of colleagues Tenniel and George du Maurier. And there is the morning room, Marion's own most-loved space, where she could display a few passable oil paintings, *objets d'art* and *objets de vertu* to suit her taste and to dispose according to her wishes, not Linley's.

One further bequest Anne bestowed upon the nation: from her first marriage a son, Anthony Armstrong-Jones, often said to be a more promising photographer even than his great-grandfather Linley.

KENSINGTON, W8 7BH

## LEIGHTON HOUSE MUSEUM

*A necessary reconstruction
of Leighton's brilliant Arab farrago*

The dome at one end of the big Victorian house at 12 Holland Park Road suggests that the smoked salmon red-brick exterior might conceal something unexpected. It does. Frederick Leighton had commissioned the house from the architect George Aitchison for himself in 1864. He was in his mid-thirties and nearly ten years on from his painting *Cimabue Finding Giotto in the Fields of Florence*, his first huge hit at the Royal

The bewitching interior of the Arab Hall created as an extension at Leighton House. A magnet to nineteenth-century high society, it was rescued from ruin after the Second World War.

# Bluecoat Hospital Schools

A little like the hare mascot Alvis Owner Club drivers wear as a badge of distinction, some of the remaining scatter of Bluecoat Hospital schools advertise their identity by displaying the painted statues of a little boy and girl, usually seventeenth- or eighteenth-century, somewhere on their building. There is no known cause for the spread through many charity schools of the Bluecoat uniform, or the statues. Maybe the notion was propagated by the Society for Promoting Christian Knowledge (SPCK), which an Anglican vicar founded in 1698 with the by-product of charity schools: the basis of today's system of primary and secondary education.

The Bluecoat figures are merely ornamental, but charming. Rarely is a school still attached. The figure carvers varied costume and pose, but the dominant colour remained blue, although there have been Greycoat schools and even Greencoat schools. In Westminster, a step or two from the Bluecoat boy in a niche above the doorway of the fine National Trust shop adapted from an old school in Caxton Street, is Grey Coat Hospital, now a flourishing community school just for girls. It was founded for 70 poor boarders after an initial whip-round among parishioners in 1698 and opened in 1702, redbrick Queen Anne, two wings sandwiching the hall and cupola, with the boy and girl figures in niches above the front door. This central block was blitzed in 1941 but rebuilt in the same style.

Its appearance is too smart to recall the eighteenth-century state of affairs in the slums of Westminster, but that doesn't hold true downriver at the heart of the old Surrey Docks where Elephant Lane runs out of King Stair Close and into Marychurch Street: here, opposite St Mary's Church itself (see page 358), is the old Bluecoat school founded as early as 1604 by a transatlantic mariner called Peter Hills (who is buried in the church with his two wives) and another parishioner called Robert Bell. At the end of the following century it moved into the Marychurch Street house, built a hundred years before, tall and narrow, dark brick with striking white stone quoins up the edges, and the Bluecoat boy and girl (Portland stone) displayed on corbels either side of a sash window and above a plaque recalling the founders' largesse.

There's a new Hilton nearby on the river and the surrounding warehouses are converted into expensive flats, but the names and places round here cling as densely as lichens to the Mayflower pub's wharf, making history an almost tangible entity, from the watch house adjoining the school (overlooking corpse snatchers in the churchyard) to the pub, the swing bridges, the air tunnel turned Brunel Museum (see page 359) and the tunnel entrance, the winding streets, stretches of cobbles and Sufferance Wharf, one of a group south of the river given temporary legal rights to relieve the shipping queues for the legal wharves, so-called, on the north bank.

Over in cosmopolitan Kensington Place, a shady square behind the High Street, the charity school of the church of St Mary Abbots became especially well cared for after its royal patrons Queen Anne and her consort Prince George of Denmark each donated £50 a year to help it on its way. The Bluecoat school has moved but the Bluecoat children stand preserved on corbels high on a sturdy tower, and the real children here, of

many nations and religions, are no longer sent out into the world with a Holy Bible, a little like Becky Sharp in *Vanity Fair*, receiving as an enlightened leaving present from the principal of her young ladies' academy a copy of Dr Johnson's *Dictionary* (and immediately hurling it from her carriage).

Quite the outstanding worldly success among Bluecoat schools is Christ's Hospital. It moved from Newgate Street in 1902 to its palace in the Sussex market town of Horsham, but even early in the nineteenth century, it was achieving rather more than the basic literacy and numeracy that most charity schools aimed for. The poet Leigh Hunt, for example, wrote in his memoirs: 'I am grateful to Christ-Hospital for its having bred me up in old cloisters, [and] for its making me acquainted with the languages of Homer and Ovid...' Today, the pupils of Christ's Hospital alone among all these charity foundations still wear the uniform of blue coats (long skirts for the girls), yellow stockings and white stocks at the throat. And a recent leaver called Joe Launchbury, poet in motion, plays spectacular rugby for England.

Mind the gap … a bluecoat boy and girl adorn the wall of St Mary Abbots primary school, one of the many such twins across London dating from as far back as the mid-sixteenth century.

Academy; but it preceded a lull of several years. Academicians tended to remain suspicious of him. As a young artist he had travelled the Continent and come back spouting the latest theory of Baudelaire, *l'art pour l'art*, art for art's sake. Stuff and nonsense, the RAs said. But in the 1860s Leighton's new house attracted a coterie of artists, stuff and nonsense became the latest thing and his work prospered. In 1877 he recalled Aitchison to build him a domed Arab Hall as an extension to the house, based on a real one in Palermo. It was lined with rich blue tiles from Damascus and had exquisite grilles of *musharabiye* screens in the windows. The dome was figured in gold and the columns around the fountain were of alabaster set in a mosaic floor.

Leighton wasn't much of a painter in his RA backwater, but he was a terrific interior designer, and collector, and showman. Two years after the Arab Hall coup he was knighted, following a line of succession initiated when Charles I knighted Rubens for his ceiling paintings in the Whitehall Banqueting House (see page 166). He became President of the Royal Academy and honorary member of the academies of a gauntlet of European cities, Commander of the Legion of Honour, Commander of the Order of Leopold, knight of a Prussian order, knight of a Coburg order, and in 1896 he became the first artist to be raised to the peerage, as Baron Leighton of Stretton. The next day he died, murmuring, 'My love to the Academy'. To the end he got his priorities right.

After his death there were no takers for his house with its Arab Hall and its contents were sold off and spread to the corners of the earth, every last piece. Leighton House mouldered, and after the Second World War became part of a public library, its Islamic-tiled walls and the gilded dome institutionally (i.e. barbarically) whitewashed. From the 1970s Kensington and Chelsea council funded a piecemeal restoration. The council closed the house for 18 months until April 2010 and dug £1.6 million deep to finance the architects Purcell Miller Tritton and the senior curator Daniel Robbins to go back to basics, examine photographs, eyewitness accounts, fragments of painted floorboards and fabric threads, to pull Leighton's house together again. The red dining room with red floorboards, the blue drawing room with peacock blue boards, the splendid studio occupying most of the second floor, are as close as can be to Leighton's astonishing original except for the missing ceramics and the paintings by his friends (with a few by himself).

For the reopening to the public some pictures were borrowed, some brought back (a Tintoretto portrait head from the Ashmolean), a precious few bought back (notably another Tintoretto half-length portrait of a Venetian nobleman). Four Corots of the day are in the National Gallery and wouldn't be lent, so in 2010 Charlie Cobb painted copies, a nice way of turning an honest penny by fakery. There was no chance of a budget to replace the Islamic vases and dishes, so they too have been acceptably mocked up.

As for *Cimabue Finding Giotto in the Fields of Florence*, the Maharajah of Baroda bought it and it still hangs in Baroda Museum and Picture Gallery where, doubtless, it looks as exotic to the natives there as the Arab Hall does to the natives here.

12 HOLLAND PARK ROAD, W14 8LZ

## GWR WAR MEMORIAL, PADDINGTON STATION

*A war memorial shaped from memory*

Having a body scarred with shrapnel, having suffered the hell of gas burning the lungs, having lain in no-man's-land among the dead, listening for the enemy: these things mark a man and they are what made the war memorials by Charles Sargeant Jagger (1885–1934) different. His Tommy on the Great Western Railway war memorial tucked away up the side of platform 1 at Paddington isn't a muted, neutered soldier remembered from some corner of a foreign field, standing with head solemnly lowered and rifle upended, bayonet point to the ground; Jagger's soldier is off duty, obviously tired, his helmet shoved back clear of his forehead, his greatcoat slung over his shoulders, his long heavy-knit scarf knotted loosely and hanging below waist-level, gaitered legs and boots wide apart and planted firmly on the earth. His head is lowered, certainly, but that's because he is reading a letter from home.

Jagger had read that letter, worn this half-inch thick greatcoat and turned its collar up against the biting wind. He had been due to take up the Royal College of Art's Prix de Rome in 1914 as war broke out; instead he enlisted. Four years later he had served with the Worcesters in Gallipoli and on the Western Front, been wounded, gassed, and won the Military Cross. When he came back to civvy street and a South Kensington studio financed by the British School in Rome with a year's funding in lieu of the Rome scholarship, and a recommendation from a member of the British School in Rome to a war memorial committee in the Wirral, he was interested only in creating something out of his savage experience. Many memorials followed and the GWR bronze soldier is among the two or three best he created. Close up, you can see that Jagger modelled it in clay; his thumb and finger marks are there where he pressed lumps of clay to the armature, sticking to the earth he knew best: 'Was it for this the clay grew tall?'

By this time sculpture had moved towards abstraction, or the semi-abstraction of Epstein and Gill, and Jagger was ignored, a craftsman among journeymen turning out soldiers for monuments, his evident superiority overlooked. Yet the figure of the dead soldier covered by his cape and helmet on one side of Jagger's famous Royal Artillery memorial at Hyde Park Corner (though few know who created it) shows he could harness the sublime to the reality of violent death. And the soldier on platform 1 is a man first; as he lingers for eternity over his letter, he makes the connection with hearth and home. This was the first war that affected everyone in the country, and Jagger's monument says so.

PRAED STREET, W2

## TRELLICK TOWER

*The architect with a champagne touch*

Ernö Goldfinger was the most significant twentieth-century import to Britain from the Continent. That was always easy to tell from the weight of abuse he shipped for his Modernist architecture, especially those two sisters in crime, Balfron Tower in Poplar and Trellick Tower at the gritty end of Kensington. He was born in Budapest but trained in Paris under Auguste Perret, the pioneer of building in reinforced concrete, and while others scuttled away, he never betrayed Perret's principles. The worsening reception for Goldfinger's work wasn't helped by the collapse of the Ronan Point flats (not his) in Newham in 1968, a year after the opening of Balfron Tower. He had built all round London, but it began to seem at times as though his work was being demolished almost as fast: a newspaper office here (the *Daily Worker*), a cinema there (the Odeon Elephant and Castle), housing here and there. Goldfinger died aged 85 in 1987; the press forgot about him.

It hadn't always been like this. When Balfron opened, Goldfinger took a flat for a couple of months at the skyscraping end of the building so that he could tap the new residents for their views on the high life. Naturally, he launched his quest with a champagne party. The findings came fast and the consequence was improved space in the Trellick Tower, cedarwood finishes to the balconies and better fittings generally, plus better amenities including shops in the low-rise B-block running along Golbourne Road from the base of the tower. The one-bedroomed flats are good for starters; the three-bedroomed maisonettes are as good as a house in the sky. Trellick Tower (31 storeys) and Balfron Tower (27) are both dramatic sculptural statements, each of them a main block umbilically linked at every third floor to its slender separate services block like a huge transporter jet being refuelled in mid-flight, the rows of flats strongly articulated by the concrete lines of 'streets in the sky'.

Trellick Tower was first to recover its reputation when the residents tired of broken-down lifts, vandalism, rape and robbery, and formed an association to persuade Kensington and Chelsea council to introduce secure voice entry to the block backed up by a concierge. It turned out that the problem wasn't bad architecture, it was bad management. Then the council took advantage of the right to buy clause in the Housing Act to introduce a mixed economy of private ownership and social housing, and called in James Dunnett, an architect who had worked in Goldfinger's office in Trellick's low-rise B-block, to help with refurbishment, including some caused by the council's own vandalism on the principle that what yobs can do bureaucratic insensitivity can do even better: ripping the great slabby jewel-like glass from a wall of the lift shaft, for one thing. Today the man in the street (generically speaking) joins long queues on London Open House weekends to view the wonders of Modernism. Champagne socialism, it seems, sometimes works.

GOLBORNE ROAD, W10 5PL

Trellick Tower: a modern masterpiece by Ernö Goldfinger.

## KENSAL GREEN CEMETERY

*The Victorian way of death*

Napoleon established the Père Lachaise Cemetery in Paris in 1805, although he himself is entombed in lonely splendour under a pile of red porphyry in Les Invalides. Père Lachaise inspired the creation of Kensal Green, London's oldest and classiest city of the dead, 72 acres of mournful vistas, sombre draped urns, symbolically broken columns, crucified Christs, grand tombs as big as modest houses, crumbling walls and fallen headstones, all sandwiched between the halal groceries of Harrow Road and two rusting gasholders on the Grand Union Canal. There's an Orthodox Christian sector, another for Catholics, and an Anglican church, All Souls, got up as a Greek temple with colonnades either side and enclosing an open square behind.

The General Cemetery Company opened Kensal Green Cemetery of All Souls for trading in January 1833 in a bull market for death as a cholera epidemic took hold in London. Business remains healthy today, and the very same company retains control. The early boom years peaked with the burials on the central avenue of two royals, HRH the Duke of Sussex (d. 1843), sixth son of George III, buried under a massive stone slab, and Princess Sophia, the king's fifth daughter (d. 1848), interred in an elaborate Carrara marble sarcophagus on a high, dignified pedestal. There followed scores of writers, Thackeray and Trollope among them; engineers, including Rennie and Brunel; an Archbishop of York; the first man to cross Niagara Falls on a tightrope, Emile Blondin; lawyers, architects and artists, including Frith and Bonington. There are no doubt fornicators, thieves, drunks, wife-beaters, journalists and worshippers before foreign idols as well. The modern world has edged in, too. Feet away from the princess's tomb a modern black marble headstone commemorates 'Kevin and Ted – Together in peace'.

There are, too, an alarming number of bellicose tomb carvings representing military ordnance; soldiers to the left of us, soldiers to the right of us, many of them old Indian Army wallahs, the grandest of them being the Hon. Sir William Casement (1780–1844), Knight Companion of the Bath, Major-general in the Bengal Army and Member of the Supreme Council of India. His ordnance is real enough: old cannon have been adapted as bollards around the tomb. His death from cholera came 13 years before the Indian 'Mutiny' caused the British government to withdraw its commission to the East India Company and itself assume power. So the young Casement's battles in 1803 and 1804 against the Marathas and, incidentally, Napoleon's French lieutenants, was a fight for company and lucre rather than king and country, fine drawn though the distinction was. He died neither vilified for corruption nor celebrated for singular military prowess; but he was buried with full military honours in Calcutta, so his tomb in Kensal Green is presumably a memorial only. On a plinth four caryatids, proud Bengal warriors, stand wrapped against the English weather, arms crossed over their chests, light turbans (known as *pugrees*) tied on their

heads. These stoics bear the weight of a big coffered entablature sheltering a draped tomb chest on which is placed the plumed pith helmet of Casement Sahib, a last symbol of the Raj in a West London sepulchre.

HARROW ROAD, W10 4RA

## • FULHAM, HAMMERSMITH, CHISWICK •

### FULHAM PALACE

*From home to the Bishops of London to a people's palace*

The parish churches of Putney and Fulham look at each other along the length of Putney Bridge. At the south-east corner of the bridge St Mary's (see page 284) stands barely clear of the busy commerce of Putney High Street, with its new church hall-cum-coffee bar advertising its role in the community. On the Fulham bank All Saints Church to the north-west of the bridge is stand-offish, sheltering quietly behind a screen of trees in its churchyard. Once the church was separated from the 33-acre Fulham Palace Park by a moat, long-since filled in. Now the church is, willy-nilly, the gatehouse to the park in which the palace was the country home of the Bishops of London for something over 800 years. In 1975 the church rendered their palace unto the Caesar of Hammersmith and Fulham borough council, and for years afterwards the building mouldered and suffered miserable depredations and alterations. Now it is being transformed into a people's palace, a patchwork, admittedly, of passing centuries and fashions and utilitarian imperatives, but opening up its finest rooms to the public: Bishop Howley's drawing room, where the most utilitarian imperative was the big crystal chandelier, is now an excellent café with views from the huge sash windows across the park; and his dining room and the Bishop Porteus library is the Palace museum.

The entrance to the palace is through an arch into the oldest and much the most interesting part of the building, the basically fifteenth- and sixteenth-century west court, a quadrangle of red brick with a sweet little fountain and purple brick diaper patterning (painted on the wall opposite the arch), though in 1853 Bishop Charles Blomfield rebuilt the south range of the quadrangle and had the diaper patterning rendered in paint there, too. On the far side of the quadrangle a door gives on to a wide corridor clad with splendidly formal Baroque panelling. Between west court and the much smaller east court are the hall and a linking corridor clad in majestic dark Baroque panelling.

All Saints and the Palace became practically a Blomfield fiefdom when the bishop's son, Arthur Blomfield, who was born in 1829 in Fulham Palace, grew up a scholarly architect specialising in the restoration and rebuilding of churches. In 1880 he signed the contract to rebuild All Saints. The best thing about the church today is the fifteenth-century tower,

which escaped rebuilding, if one may express it so. There is nothing wrong with Blomfield's work, but the most interesting thing inside is a fine collection of tombs, fifteenth-century to nineteenth-century.
BISHOP'S AVENUE, SW6 6EA

## CRAVEN COTTAGE

*The quirkiest (and the only listed) football ground in England*

It is the morning after the night before at Craven Cottage. The cleaners are still bagging the previous day's litter left in the team dugouts as Fulham played a 1–1 draw with Wigan. This is my first trip since January 1949 to the stadium caught like a sandwich tackle between Stevenage Road and the Thames. Then my father's First World War comrade Charles Pritchard brought me to watch his beloved Fulham of the First Division (the Premier League of those days) lose 1–0 in the FA Cup to fustian Walsall from the third. The result was typical: Fulham's historically predictable trait is its upredictability.

A year later I won two tickets for England v. Scotland schoolboys in a *Daily Express* football competition and this time took 'Uncle' Charlie to Wembley. England won 8–2 and a 14-year-old called John Haynes scored twice and coolly masterminded the rout. Soon, he signed for Fulham and spent his career there; as the ineffable sports journalist Frank Keating wrote in 1975: 'Haynes suffered 18 glorious, exasperated years for Fulham, carpeting out the world's most sumptuous passes to a motley crew of single-jointed unappreciative nuts.'

By the time of my tour with a motley collection of football nuts in 2013, the Stevenage Road stand had been renamed the Johnny Haynes stand, and a bronze statue of Johnny had been erected outside. The stand is the core of Fulham zaniness. The Scottish engineer Archibald Leitch completed it in 1905. The redbrick gabled frontage along Stevenage Road fits in quietly with the suburban houses opposite. The residents don't necessarily recognise the charm, but it has been there longer than they have, long enough to become the only listed football stand in the country. It has a corrugated-iron roof, decorative iron scrolls at the tops of pillars holding the roof up, tiny doorways to the turnstiles built for the average-sized Edwardian male (by 1914 the mean was 5 foot 4 inches tall) and century-old wooden seats which, in the press box, must be the most cramped in the business. In a corner of the ground is a quaint pavilion built on the diagonal with banked seats for WAGS (Leitch had in mind a cottage orné that stood where the centre circle is now). The cottage is listed too and cannot be substantially altered, so the changing rooms are too small to measure up to the Premier League's minimum. As a sop, the bigger room goes to the visitors. The tunnel for the players to run through and emerge on to the pitch to be greeted by a roar is a canvas job on wheels.

For a long spell after the war the chairman was Tommy Trinder, music hall and film comedian. Until recently it was

It's an engineering gem, but the seats are cramped, the press box prehistoric, the turnstiles fit for children in this stand at Craven Cottage. Fulham FC built it in 1905 and now nothing can be updated because it is heritage listed (along with the house that gave the ground its name).

Mohamed Al Fayed: short of chuckles, but his pockets were deeper. In a corner of the ground in 2011 he caused a statue to be erected of a glitzy guitar-toting Michael Jackson, no footballer but Fayed's sad, dead friend. But in 2013 Fayed sold the club and the new owners removed the statue. Fulham were relegated from the Premiership. Fayed said that this ill fortune was Jacko's revenge.

STEVENAGE ROAD, SW6 6HH

## LYRIC THEATRE, HAMMERSMITH

*A heaven-sent combination of a Matcham auditorium inside a skin by Mather*

There's no need to ask on emerging, blinking, from the Underground on to Hammersmith Broadway where the Lyric Theatre is. It stands 100 yards or so down King Street, glowing through areas of semi-opaque glass walls defending one of Frank Matcham's prettiest auditoriums, of 1895, cocooned in rococo splendour high above street level, the Lyric's name spelled out vertically at auditorium level. It is a lucky survival: it was condemned to demolition in 1966, one more to add to the list of 20 of Matcham's London theatres destroyed by bomb or demolition ball, but this time the public protested and the government insisted that the old Lyric could be razed only on condition that the auditorium was saved. Saved it was and rebuilt in 1979 inside a new theatre complex included in a shopping centre called Kings Mall; but the new mall was a distinctly unlyrical concrete obtrusion by R. Seifert & Partners and the Lyric was

given a dim shopfront entrance in King Street and a utilitarian setting.

But come the new century, come Rick Mather (1937–2013). As the architecture critic Hugh Pearman wrote in 2004, 'Mather is one of the first names on anyone's list when it comes to stitching damaged bits of urban fabric together.' It is no surprise then that when Mather came as a student from Oregon to London in the 1960s, he should have opted to study at the Architectural Association, that body addressing the problems of architecture in a swiftly growing urban environment. He took UK citizenship and to his project credits added the extensions to Soane's Dulwich Art Gallery, to the Ashmolean, to the Wallace Collection in Manchester Square. In Hammersmith Mather stitched together the Lyric and its 'damaged urban fabric' with a café on the ground floor and an inviting entrance off the newly created pedestrian precinct, Lyric Square; a floor above there's a large white lobby with tables and big black comfortable sofas and chairs, and red wheel lampshades suspended from the concrete ceiling with its exposed service ducts; there's a sister to the downstairs café, a studio theatre through one door and the main Matcham auditorium up an open staircase, crimson and gold in equal measure, arcaded boxes and cantilevered circle and gallery all under a sunburst central light. It sits within Mather's imaginative Modernism, a perfect marriage of opposites, like a naughty François Boucher painting on the white wall of a Corbusier villa.

LYRIC SQUARE, KING STREET, W6 0QL

## EMERY WALKER'S HOUSE

*Where the decor of his friend William Morris survives almost intact*

The story of 7 Hammersmith Terrace embraces the history of two men and two women. The men are Sir Emery Walker, who owned the house, and William Morris, a fellow Socialist; the women are Walker's daughter Dorothy and her companion and nurse in later days, Elizabeth de Haas. Morris lives on in fame; Walker is almost forgotten although his work with typography left a lasting imprint; Dorothy and Elizabeth dedicated themselves to saving the house, one of a terrace of 17 built in the 1750s, just as Walker had left it, not simply as a time capsule but also a faithful representation of what it was like to live there, with some letters stuffed in drawers, others, maybe from Kipling or Walter Crane, acting as bookmarks. There are Walker's photographs of Morris and G. B. Shaw on the mantelpiece in the dining room, with Burne-Jones's pencil portrait of William and Jane's daughter May Morris (Walker's next-door neighbour) hanging on the wall. Then, of course, Morris wallpapers in every room of the house, Morris hangings, chair covers, tablecloths, Morris furniture and, of all unlikely things, a piece of Morris lino, the pattern faded but visible when the hall rug is pulled back; the only Morris lino in situ anywhere, Helen Elletson, the custo-

Emery Walker died, his house lived on. Walker was a typographer and colleague of William Morris and furnished the house throughout with Morris products, even the lino in the kitchen. This is the first-floor living room.

dian for the Emery Walker Trust, believes.

There is furniture by their Arts and Crafts Movement friend in the Cotswolds, Ernest Barnsley, bookcases, cabinets and a whole raft of stuff left to Walker by another companion in arts, Philip Webb (including a charming little wall-hung bookshelf he designed for himself), a small conservatory stuffed with the pots Walker picked up on continental holidays, and a vine grown from a cutting taken in 1890 from the garden of Hogarth's house (see page 260). By the river is a tumbled, pretty little back garden. The kitchen is a Walker Trust shop. From the narrow hall, stairs lead to the front drawing room directly above the dining room. At the back of the house is another drawing room and Mrs Walker's bedroom with a bedspread embroidered for her by May Morris. The other bedrooms, including the one at the back preferred by Emery Walker for its river view, are on the second floor.

Morris visited Walker daily from his house nearby in Upper Mall, and with Walker devised the project of printing the Kelmscott Chaucer with Burne-Jones illustrations. Walker himself joined Thomas Cobden-Sanderson, a neighbour of Morris in Upper Mall and a bookbinder, with the notion of producing England's greatest literature in hand-tooled vellum covers. Walker, looking for something to replace the debased text faces of the nineteenth century, founded a type modelled on an orginal by the fifteenth-century French printer based in Venice, Nicholas Jenson, and his books, unillustrated but relying simply on the beauty of type and purity of page design, initiated the twentieth-century renaissance in typography and book

production. For Walker, the story ended disastrously when he fell out with the ageing and eccentric Cobden-Sanderson, who ditched the cases of type from Hammersmith Bridge into the Thames, to make sure his partner would never have them for himself.

When Walker died in 1933 at the age of 82 (his own act of betrayal was to accept a knighthood) Dorothy was left trying vainly to attract funds to keep the house and its contents together in perpetuity. When she died in 1966 she left the problem to the friend she had attracted from Holland by advertising in the pages of the *The Lady*. Elizabeth de Haas finally felt compelled to sell Walker's complete sets of the production of Kelmscott and Doves Presses. The books went to Cheltenham Art Gallery; the house is a hunting ground for scholars and a treasure in aspic for visitors.

7 HAMMERSMITH TERRACE, W6 9TS

## PISSARRO'S HOUSE, BEDFORD PARK

*A French Impressionist painter visits his son in suburbia*

Camille Pissarro paid his first visit to London in 1870 in flight from the Prussian army who were besieging Paris. He brought with him the mother of his children, Julie Vellay. She was tired of being an unmarried mother and felt especially vulnerable in the land of upright Anglo-Saxons, so Pissarro graciously surrendered and married her at Croydon Register Office, handy for Norwood where they had lodgings. The following year he and Julie returned to France where their son Lucien, by now eight years old, grew up to be an artist like his four brothers, Georges, Félix, Ludovic-Rodolphe and Paulémile, Lucien's daughter Orovida, and a couple of Paulémile's sons and his granddaughter. Lucien visited London as a young man before, attracted by the theories of William Morris and the work of the Arts and Crafts Movement, he made his permanent home in London's first garden suburb.

Suppose people lived in little communities among gardens and fields, Morris had written, so that they could be in the country in five minutes. Bedford Park was the word made brick and mortar by, mostly, Norman Shaw (see page 257). Shaw had bent the knee at Pugin's funeral and worked for the Gothic Revival architect G. E. Street, but by 1877, when he came to Bedford Park, he was a convert to the soft southern English vernacular of houses in redbrick, terracotta tiles and white-painted wood, spacious and varied, with acres of glass in big bay windows. Artists and poets moved in, men like W. B. Yeats and the playwright Arthur Pinero. Lucien Pissarro too moved his family into 62 Bath Road, and this is where Camille came on his last visit to his son in 1897. When he alighted from the train at Hammersmith and Chiswick station (now Stamford Brook on the District Line) he took in a very ordinary semi-pastoral scene: some vegetable gardens, the level crossing keeper's wife hanging out washing, St Mary's Church and Stamford Brook Common beyond. Passengers still see this, but crowded in

by newer houses. Camille immediately took it for the subject of a painting; and had he arrived today, there's little question that he would have done the same. His eye was totally demotic, he was prone neither to the picturesque nor to melodrama: he painted as he saw. He had looked hard at Millet's peasants in fields, but his own women were working women, not grand symbols of labour.

The painting he made of 62 Bath Road on the far corner of Abinger Road opposite Lucien's house is in the collection organised by Orovida as a Pissarro family archive in the Ashmolean Museum in Oxford. It is incomplete but shows with utter objectivity a typical middle-class Bedford Park dwelling with conservatory, lofty chimneys, and white wooden balustrade, all of it still there today: this is the fidelity that both raised him to the level of the highest achievements of Impressionism yet also caused a comparative neglect of his work by critics and the public; it was exactly the quality that prompted Cézanne to speak at his old friend's death in 1903 describing him as 'the humble yet colossal Pissarro'.

62 BATH ROAD, W4 1LH

## ST MICHAEL AND ALL ANGELS, BEDFORD PARK

*A homely church for Shaw's Bedford Park estate*

Norman Shaw's first employer, G. E. Street, a foremost Gothic Revivalist (see St James the Less, Moreton Street, page 186), remarked when he saw his chief assistant's church, St Michael and All Angels, that 'it is very novel and not very ecclesiastical'. Yet Shaw was a deep-dyed High Anglican when half of the Church of England held anything smacking too much of pomp and glamour to be next to papism. The controversy ran deep, the wounds were raw and Shaw stood accused of rubbing in salt. Even so Street surely hit the mark, and, at the sight of the holiday levity of St Michael, the religiously unaligned, who must be the majority after an intervening century, would agree. It is too open-heartedly joyous to be made for controversy. Everything about it says so: the eclectic mixture of styles, from a Strawberry Hill Gothick in the pretty dormers to Dutch and East Anglian domestic influences and would-be Perpendicular in the ground floor, to the five-light clear-glass window in the west gable with a clock above it suspended from a long arm, like the White Rabbit's watch in *Alice*, 'Oh my ears and whiskers, how late it's getting!'; the arms-open happy-clappy south porch; the lantern over the crossing with a touch of Chinese pagoda about it; the white balustrade running the length of the nave – balustrades echoed internally fencing the clerestory windows and at the top of the tall, open rood screen beneath the figure of a golden-robed Christ flooded in light. Almost everywhere daylight streams in to enhance the green and terracotta colour scheme: terracotta walls with green wooden panelling, green rood screen, green panelled wooden plinths to the stone piers of the arcade, Shaw's green bench pews in the aisles set at a diagonal to those in the nave, like rows of oars in a racing eight.

Shaw's assistant on the project, Maurice Adams, added the north aisle to Shaw's design in 1887, when more money became available. Adams's own innovation, in 1909, was the Chapel of All Souls. This, with a vaulted brick roof instead of the big open roof of the nave and chancel, brings the church its only Gothic darkness; it is dimly lit by excellently coloured and figured Arts and Crafts stained glass in the south and east walls, particularly J. H. Bonnor's red, green, blue and purple window above the reredos with scenes of the *Ascension* and the *Noli me tangere*, with the risen Christ appearing to Thomas in an orchard laden with fruit.

But Shaw's own influence on the church to the new parish of Bedford Park is dominant, and there is no secret about all the light: the windows, with their suggestions of Gothic, are wide and full, like the windows of his houses in Bedford Park. As he wrote to J. D. Sedding, like himself a former pupil in Street's practice: 'You know I am not a Church man, I am a house man' (he was joking solely about his architectural practice). Then he added, with a smile like the smile on the face of his architecture, 'and soil pipes are my speciality'.

BATH ROAD, W4 1TT

## THE TABARD INN, BEDFORD PARK

*The Tabard Inn revived*

The church on one corner, the pub opposite. God and Mammon separated by a zebra crossing; the perfect solution to community planning it might be thought. In fact, St Michael and All Angels and the Tabard Inn were the hub of the architect Norman Shaw's plan for Bedford Park. The Tabard opened its doors to a thirsty public in 1880 and needed an instant and expedient touch of the antique to bestow credibility. Shaw provided it with the tile-hung double gable above leaded bow windows, the name and signboard evoking the *Canterbury Tales* pub in Borough High Street, which had been destroyed by commercial imperatives, though Shaw's Tabard would have looked as strange to Chaucer as the muezzins' minarets of the East End.

The row along Bath Road with a private house next door to the inn and the village stores between that and the corner of Flanders Road, seven jolly gables in all, is the perfect Christmas card scene: nicely proportioned, beautifully detailed despite some wear and tear, and comforting to behold. But it lacks the rough edge of vulgarity that make the gin palaces of the same period so much fun, to which the Tabard was intended as a counter thrust on behalf of a class that liked a drink but preferred to choose its company more carefully.

Yet, contrarily, the William de Morgan tiles that are so much a feature of the Tabard's interior stand up sturdily to the flashing lights and gaudy colours of the rather more recently installed gaming machines. De Morgan (1839—1917) had worked as a craftsman with the first William Morris firm, Morris, Marshall, Faulkner & Co., designing stained glass, and his experience of the brilliant iridescence caused by certain processes of glass firing led him to his

experiments with glazed tiles at a kiln he set up at 40 Fitzroy Square. Despite the unfortunate experience of having to depart hurriedly after burning the roof off the house, he deemed the experiments successful. He decorated his tiles in the Morris manner, but under his brushes and in his kiln they became entirely his own sturdy creation: climbing vines with red and green grapes hanging from the same bunches, profuse growth of blue and purple trumpeted petunias and lilies bending under the weight of bluebirds, or, at any rate, blue birds.

The Tabard was a townsman's idea of old England just as the houses of Bedford Park were a make-believe rural idyll; but inevitably the trains that took commuters into London from Turnham Green station over the road from pub and church brought speculators in the opposite direction to gaze on the fine prospect of more countryside to bury under suburban housing.

2 BATH ROAD, W4 1LW

### HOGARTH'S TOMB

*A grand tomb for 'her Billy',*
*raised by his wife Jenny Hogarth*

William Hogarth retired in 1749 to his country house in Chiswick, but his wife Jane (or Jenny, as he always called her) could not keep him from his easel and engraving tools, nor from the bustle of the London streets. He returned often to his house and studio in Leicester Fields (now Leicester Square), and there he died on the night of 25–6 October 1764 at the age of 67. His wife had his body brought home to Chiswick for burial in St Nicholas's parish churchyard, and seven years later found the money to raise a classical monument to the memory of Billy (as she called him), with a garlanded urn as finial and relief decoration of the tools of his art. Hogarth's friend David Garrick wrote the verses inscribed at the base of the tomb:

> *Farewell, great painter of mankind,*
> *Who reached the noblest point of art;*
> *Whose pictur'd morals charm the mind,*
> *And through the eye correct the heart...*

and so on. These stately octosyllables might have been suitably adjusted as tribute to Hogarth's artistic enemies buried in the church, Lord Burlington and his architect William Kent, but they barely hint at the burlesque vividness of Hogarth's work and personality; '... the heart of art here torpid lies', as Dr Johnson responded to Garrick's verse. It was a curious failure by Garrick because, as another poet, Christopher Smart, had observed, 'Hogarth is the Garrick of his art.' Each received acclaim for his everyday realism, each recognised the other's genius, and one of Hogarth's most striking portraits is of Garrick in character as Shakespeare's Richard III, a flawed man, albeit a king, not a classical hero.

Hogarth was bound to the city by his birth and upbringing in Smithfield, but his private joy was the Thames, the arena of his 'five days' peregrination around the Isle of Sheppey in 1731, by way of Billingsgate, the Isle of Grain, Gravesend, Chatham and Rochester, accompanied by four friends including the marine painter

Samuel Scott, playacting, boozing, flirting, throwing animal dung at each other, alarming the natives and generally having a high old time. The house at Chiswick, which Hogarth called the 'little country box by the Thames', was the outward sign of an altogether more sedate way of life in the bosom of his family (see Hogarth's House, below).

Landscape was a genre Hogarth never tackled, but it cannot have been accident that led him to this stretch of Chiswick Mall a few minutes' stroll from his house, with the mist rising from Corney Reach upriver and tidal mud sliming the road surface of the Mall where grand houses were already built or building. Nor can Mrs Hogarth have been wrong in bringing his body back from London for burial. And when Jenny died, the family opened Hogarth's tomb and laid her there with her Billy.

ST NICHOLAS'S CHURCH, CHURCH STREET, W4 2PH

## HOGARTH'S HOUSE

*William Hogarth's country retreat, caught between streams of traffic*

The critic Richard Dorment has written of taking 'a sentimental spin out to Hogarth's house in Chiswick' as one of the essential stop-offs on a Hogarth pilgrimage. In the house itself is a mock Hogarth print by the cartoonist Martin Rowson showing the Hogarth roundabout on the A4 where the Great West Road goes one way and the road to Kew goes another, the scissor shape slicing off a piece of old Chiswick where the only dwelling was Hogarth's; beneath Rowson's turbulent clouds an airliner jets into Heathrow, the traffic-jammed Chiswick flyover disappears behind a gross tower block, a cast of Hogarthian characters circle the roundabout in beaten-up jalopies, someone takes a leak in the right foreground and a dosser slumps on the pavement at the left. Dorment and Rowson each have part of the picture right, though Rowson edges the contest: Hogarth House hangs on just about unsubmerged by the last racking cough of the motorised industrial age.

William Hogarth bought the house in 1749 when the latest in a run of heatwaves nudged him into acquiring a summer house in the country with, as his biographer Jenny Uglow says, 'its back to London'. Walpole had called Strawberry Hill a box; just so Hogarth with his house, and with more justice. An odd-looking box at that. What Georgian grandeur it possesses resides in the oriel he constructed above the front door: offering a grandstand view of the garden and its mulberry tree. The tree is about all that has remained unscathed in the house's recent history, bombed in the 1939—45 war, then fire-damaged while it was under restoration in the early years of this century. Still it emerges with credit. There is a hall, a parlour, the quirkily shaped dining room and Hogarth's bedroom above, with other bedrooms, and the servants' quarters on the attic floor. There is a longish ground-floor gallery exten-

Hogarth's wife may have preferred the Chiswick house; he couldn't wait to get back to London. The display inside is mostly of his prints, but then those are what kept the Hogarths and the Hogarth pug alive.

sion where once there might have been outhouses. Nothing much but that and a few Hogarth items on loan from other museums, which include, touchingly, the Latin Primer his father used to teach boys when he lay in a debtor's cell in Fleet Prison. That said, the house is hung with Hogarth's prints, which, after all, became the heart of his enterprise.

The best of his paintings were those closest to people and furthest from the grand manner he sometimes aspired to, perhaps in vain competition with the shade of his grander father-in-law, Sir James Thornhill. But he wasn't in enough demand as a portraitist to make a living from them. Prints became the mainstay. People of fine sensibilities are not loud in praise of this storytelling part of Hogarth's output, *Marriage à la Mode*, *The Four Stages of Cruelty*, *Gin Lane*, *A Harlot's Progress*, though David Hockney's readable adaptation of Hogarth prints on a theatrical scale with his designs for Stravinsky's opera, *The Rake's Progress*, may have brought Hogarth back into currency. He was a genius. He must have been: even the French appreciate him now.

HOGARTH LANE, GREAT WEST ROAD, W4 2QN

## CHISWICK HOUSE

*The birth of the English villa and informal garden*

When English Baroque fell from grace, and even within his own lifetime, the disgruntled old Christopher Wren had to bear the whips and scorns of a new generation. The retro revolution looked no further for its beau ideal than back to Inigo Jones's Queen's House at Greenwich. A century after Jones, on the banks of the soft-running Thames from Chiswick House to Marble Hill and Ham House, Georgian grandees set about creating their revolution.

The most celebrated of the new buildings was Chiswick House of 1727—9, 'too small to live in and too big to hang to a watch', as the foppish wit Lord Hervey quipped, but the Anglo-Irish Richard Boyle, 3rd Earl of Burlington, designed it for his own family and preferred it to any of his other homes, including Burlington House. Boyle inherited large estates all over England at the age of ten. There was an even bigger one in Ireland, of 42,000 acres, and though he never visited, Ireland financed his visits to Italy (and most other things): and in Italy he came into his intellectual estate. He went the first time an art fancier; he returned from the second visit with architecture as his 'passionate avocation', as an elegant entry by Pamela Denman Kingsbury in the *Oxford Dictionary of National Biography* has it. She remarks also that Chiswick, his domed house on a podium, based on Palladio's Villa Rotunda in the Veneto, has a 'didactic, lucid character', and that remains true: viewed today from in front it doesn't have the easy confidence of Mereworth Castle, that earlier villa in Kent by Colen Campbell, Burlington's first mentor in architecture, also based on the Villa Rotunda. Perhaps it's something to do with the deadening precision of Chiswick's octagonal dome above and behind the splendid portico supported on Corinthian columns.

The villa decor is by Burlington's acolyte William Kent (1685–1748), who was not much of an artist when he took to canvas but possessed a sense of colour and form that served him well in the blue and gold brackets, picture frames, doorways and porticoes in Burlington's study, the white and gold coffered ceiling of the Red Velvet Room, the richly coffered apses in the gallery, and the gilded furniture. These rooms in a suite are contained within strict mathematical parameters but each one is different... square, octagonal, circular... the first marker of the style of Burlington and Kent throughout their collaborations. The wheel of chambers on the first floor, with an octagonal saloon beneath the dome as the hub, are the mirror of the chambers on the ground floor, saloon above octagonal hall. In truth, Hervey's jest hit the mark: the house proved too small for the family (it's a strange thing that rich people always need more space than poor people do) and Burlington used it as his study, for receiving guests and for hanging his art collection. The art is not up to much despite the Italian visits and has been absorbed into the collections of his collateral descendants, the Cavendishes at Chatsworth.

As well as the decor, Kent created the garden. He concluded that smaller Palladian villas like Chiswick did not need to dominate the landscape like a Chatsworth and that the natural setting for Chiswick should be within a park of artfully distributed groves of trees, long vistas towards tiny classical follies, and an exedra lined with sculpture, a composition with echoes of paintings by Claude or Poussin. It was at Chiswick that the Palladian villa within an informal garden was born, and although it needs restoration it can still be seen as the prototype of those artfully natural gardens, the *jardin anglais* and the *Englishcher Garten*, which became popular all over Europe.

BURLINGTON LANE, W4 2RP

## RUSSIAN ORTHODOX CATHEDRAL, CHISWICK

*Where hard necessity made a Byzantine vision real*

Among the winter lime trees and birches of Chiswick, the Russian Orthodox Cathedral appears just as the M4 overpass mutates into the A4, gleaming sharply white beneath a blue onion dome fretted with golden stars and set on a white drum. To commuters who don't usually enter London along this motorway, the Byzantine vision is an apparition, an invasion of unorthodoxy where no church was before, yards from the A4, feet from the District Line in a deep cutting beneath the open west tower with its nest of bells, thousands of miles and years from the fount and origin of the style, Constantinople. The Chiswick version takes its specific inspiration from Pskov, a little-known Russian city close to the border with Estonia with a heritage of dozens of small fifteenth-century onion-domed churches.

There has been an Orthodox church in London since 1713, founded by Greeks at the instigation of Peter the Great of Russia. Two more recent Russian Orthodox churches in London survive:

the Chiswick Cathedral, which is part of Russian Orthodox Churches Abroad (known as Roca), and one in Knightsbridge which held allegiance to the Stalinist Soviet as part of the Patriarchate of Moscow (not called Poms). Each of these tolerates the other, politely if glancingly, following years of schism when Roca alleged that the Patriarchate was riddled with KGB agents, and the Patriarchate asserted that Roca had cosied up to Hitler. But the Chiswick Cathedral announced an allegiance rather closer to its heart than Adolf when it canonised the Romanoff Royal Family slaughtered by the Bolsheviks and dedicated itself as the Cathedral of the Dormition of the Mother of God and the Holy Royal Martyrs.

The Chiswick vision materialised out of harsh necessity. The first post-war church was knocked down to make way for Victoria Coach Station; from 1959 the congregation leased a disused church building in Emperor's Gate but the lease ran out in 1989. The Russians cast about and a year later bought the Chiswick site from a couple of spinster sisters who lived there in a house with a big garden. Hounslow council granted planning permission in 1997, with appropriately Byzantine planning regulations. A Russian expert on the Byzantine medieval architecture of Pskov churches flew in to advise the English architectural consultant Douglas Norwood. In 1999 a crane on the back of a truck swung the drum and cupola into place. The crypt church was consecrated in 2005, the upper church with its grand new triple-layered iconostasis and huge circular chandelier like a corona, part electric, part candle-lit, in 2009.

The icons are a throwback, early-medieval in appearance though painted to commission this century in Moscow at the school of iconography, and with key images of the murdered Tsar Nicholas II. The new Chiswick panels of the Annunciation take part in a conversation that has very little to do with anything that happened in Western art after about 1500, but remains valid in Orthodox terms.
57 HARVARD ROAD, W4 4ED

## • EALING, BRENTFORD, HOUNSLOW, HILLINGDON •

### PITZHANGER MANOR

*Soane's shot at rural bliss*

Pitzhanger Manor, like Sir John Soane's town house at 12—14 Lincoln's Inn Fields, shows clearly that he was mad, as creatively mad in his own eclectic way as Gaudi was with his Sagrada Familia in Barcelona. Into this modest house Soane squeezes his favourite motifs from the Arch of Constantine in Rome, the Acropolis, and from Old Kingdom Egypt as well; like a staging of *Aida* in a village hall with Callas, the greatest diva in a hundred years, in the lead role. By the time he came to build a new façade in Lincoln's Inn Fields (1814), he had refined his style into a stripped-back Classicism, the classical orders indicated almost as ideograms, skittishly incised into stone.

As the son of John Soan (sic), a bricklayer in rural Oxfordshire, Soane (1753—1837) treated his earliest years as a shameful secret and added the 'e' to his surname as part of his programme of self-improvement. He came to Ealing in 1800 because the house he already occupied at 12 Lincoln's Inn Fields was too small for his collections and had no garden (he added number 13 in 1814 and number 14 in 1824). In 1800 he heard that Pitzhanger was on the market: the very house he had worked on in the previous century, assisting George Dance the Younger, his 'revered master', in adding a wing to the old mansion. So in 1800 he bought it and knocked it down, retaining Dance's south wing, while adding a new core with a frontispiece. It was finished in 1803 but Soane sold it in 1810 because his wife did not take to rural bliss.

Unlike Dance, Soane had little Latin and no Greek, as Ben Jonson said of Shakespeare. Though he burned with ardour for Classicism, his cast of mind was darkly Gothic, and it becomes the mood that tinges the classical allusions. When he came to rebuild Pitzhanger the frontispiece was a version of his triumphal arch for Lothbury Court at the Bank of England: three bays with four free-standing Ionic columns crowned by versions of Phidias's figures on the Erechtheion.

After Soane departed Pitzhanger mouldered, and in 1901 the gardens and house became a public park and Ealing public library. The library moved out in

Russian-designed, fresh icons from Russia, this tiny cathedral seemed to appear this century in Chiswick almost overnight, the first purpose-built Orthodox church in Britain.

1985, the house was reopened to the public, and it is now being slowly and beautifully restored. Soane's repertoire is on display – not the full bag of tricks but enough for the purpose – domes, clerestory lights, barrel vaults, mirrors, more classical statues rendered in Coade stone (and a bust of the assassinated prime minister Spencer Perceval, whose unmarried daughters lived here soon after the Soanes had decamped). The paintings have gone to Lincoln's Inn Fields, including the *Rake's Progress* series that Mrs Soane secured for 570 guineas at Christie's in 1802, but the wonderful Soaneian wall and ceiling colours at Pitzhanger, from verdigris to pale green, lemon yellows and greys with pale clouds in a blue sky painted inside the Breakfast Room dome, hint at the splendour of this family home pretending to be a palace.

WALPOLE PARK, MATTOCK LANE, W5 5EQ

## BOSTON MANOR

*A Jacobean house with a motorway attached*

If any Jacobean house has a finer room than the State Drawing Room of Boston Manor, I have not seen it; nor a more dramatic setting. The house has the misfortune to share its park with the Hammersmith flyover section of the M4. Beyond the flyover the blue glass GlaxoSmithKline slab soars; behind GSK, minute by minute, airliners disappear momentarily as they approach Heathrow. The house has been unlucky, though

A dream of a house: the architect John Soane's country retreat in Ealing, Pitzhanger Manor, freshly restored.

some sense of its rural past remains in its great cedars, and the attenuated park is pretty and popular with the residents of Brentford. The Clitherow family which had owned Boston since 1670 sold the pictures off the walls, the furniture for cash and carry, and then in 1924 the house to Brentford council. Desuetude followed, interspersed by periods as a school and as flats for working women.

Lady Mary Reade, a young widow, had knocked down an old house and built this one in 1622/3. In 1623 she remarried Sir Edward Spencer of Althorp; the date 1622 appears at the top of a drainpipe, and 1623 is moulded in plaster in the drawing-room ceiling together with the initials MR. After the Restoration James Clitherow, a City merchant, bought the house and extended it by adding a service wing on the west end under a matching third gable and cased the windows in classical style with big showy keystones and a key date on another drainpipe, 1671. After the last of the Clitherows, dry rot did more damage than bombing, and cash for restoration has come in slowly since the 1960s. Today, under the ownership of Hounslow borough council, the four main rooms, dining room and library downstairs, are not really ready for viewing. The good bedroom and superlative drawing room on the first floor are all that is in good enough condition to be seen, except for the staircase to the second floor: this is blocked above the landing, but has eighteenth-century wallpaper rediscovered beneath later coverings, imitating the balustrade in trompe l'oeil and with lovely capricci of elegant ruins on the landing.

The drawing room, with good period furniture from Gunnersbury Park Museum, is the pick of the bunch. The walls have been re-clad in golden damask and colour has lent the fireplace and ceiling the blush of their early days. The pale sage-green ceiling has intricate white strapwork and roundels in relief representing the elements, figures based on designs by Marcus Gheeraerts the Younger (1561–1636), a Flemish artist working in England whose popularity was wiped out with the arrival of Van Dyck; but the joy and vigour and sheer cheek of these figures cavorting in their niches are enough of a legacy to preserve his name. Next there are the five senses, the four elements, then Faith, Hope and Charity, War and Peace, and the odd uppity Eros. Can the relief in the middle of the overmantel be better? Well, it's different. Abraham, sword raised to slaughter his son Isaac in the name of the Lord, starts up pop-eyed as the angel stays his butchering hand. It is at once comical, dramatic and joyful, set into more splendid plaster decoration.

BOSTON MANOR ROAD, TW8 9JX

## OSTERLEY PARK

*Robert Adam's artifice of high originality*

For a country house now swallowed up in outer London directly under the incoming flight path to Heathrow, Osterley Park has the best of deals. It retains its full 357 acres with lakes, gardens and a big picnic area, free of access to the public, with meadow unploughed in 300 years so that today it harbours rare species of wild plants and butterflies. And it has the house, open to view for a handful of nickel by the National Trust; it is one of the four or five greatest houses by Robert Adam (1728–92), Adam at his most splendid, with the nobility of nearby Syon House (see page 286), the exquisite detail of Home House in Mayfair, and a roomful of tapestries designed by Madame de Pompadour's favourite, François Boucher, and woven by Gobelins, like Newby Hall's but better.

In common with many great houses in the seventeenth century, Osterley was owned by bankers, first by Sir Thomas Gresham, who bought the manor in the 1560s and completed the house in 1576, and then the Child family. As with many of Adam's projects, he had to work within the existing exterior, in this case a much-altered Tudor structure in brick, built around a courtyard with ogee-capped towers at each of the four corners. But here Adam was permitted to knock down the hall in the east wing to expose the courtyard behind a spectacular new Ionic portico. Beyond the courtyard he devised a new entrance hall, a Roman fantasy: at each end is an apse with a semi-domed coffered ceiling, the coffering shallow and adapted to a lilting sense of decoration quite untypical of the vast basilica of Maxentius in Rome, which inspired it; stucco panels have moulded decorative arrays of Roman arms; the pilasters designed from the drawings Adam made on his famous visit to Diocletian's palace at Split on the Dalmatian coast; antique statues in niches and urns on pedestals; a floor of white Portland stone and red sandstone, with a design echoing the great

central oval stucco of the ceiling. The room is painted in white and pale French grey, confirming that it was intended to be a more intimate space than the great clarion call of Syon's hall.

Beyond this the splendid Adam staircase leads to the great treat of the enfilade of first-floor rooms climaxing in the three rooms of the state suite, the sumptuous Tapestry Room, which is an ante-room to the State Bedchamber, and the Etruscan Dressing Room. The Gobelins tapestries were woven to order for Francis Child, *'un seigneur anglais'*, each embellished with swags of fruit, flowers and foliage with a big central medallion by Boucher on a classical theme. The room was closed throughout the nineteenth century and the tapestries protected behind curtains, so today they come up as fresh as in the years of their manufacture, 1775—6. Next is the bedroom, a theatrical statement in suave deep green with painted medallions in the walls and ceiling by Antonio Zucchi and a fabulous brown-and-gold-canopied Adam eight-poster. Finally the idiosyncratic Etruscan Room, an utterly elegant box with painted ornament based on Wedgwood's idea of Etruscan ware. The entire house is an artifice of high originality, demonstrating that in those days too, bankers thought they were worth it.

JERSEY ROAD, TW7 4RB

## THE HOOVER BUILDING

*Hoover's hymn to commerce*

Is it a bird? Is it a plane? No, it's the Hoover building. It's a factory of such joyous vulgarity, a hymn to trade, industry and the profit motive, that it was not until our own vulgar, commercial and nostalgic decades that it became generally appreciated. The contrast is best illustrated by the gulf that exists between the description given by Pevsner in the 1951 Middlesex volume of his *Buildings of England* series and that offered by his successors. The grand old man himself describes the Hoover factory as 'perhaps the most offensive of the modernistic atrocities along this road' (meaning that Art Deco is an abortion of true modernism). The new all-embracing north-west London volume of 1991, with the added by-line of Bridget Cherry, quotes the prophet of Modernism with measured respect but adds: 'Forty years on we can enjoy the brash confidence of the façade with more detachment.'

The American manufacturer of vacuum cleaners so popular that the trade name became generic commanded it, and an English firm, Wallis, Gilbert & Partners, designed it in 1931 with Stars and Stripes in their eyes, the kind of romantic attachment to an idea of America as land of the free 'n' easy that marked post-war British Pop Art and encompassed enjoyment of Bogart, Cagney and Mary Pickford, of Chrysler automobiles and the Chrysler skyscraper, Marvel comics, Joe Louis and the lights of Broadway. That's a big billing to live up to, and the Hoover building doesn't really attempt it. Apart from the US, it is, like all Art Deco buildings, a child of the Egyptian Revival of the 1920s – not always a thing of explicit Egyptian imagery, like the sphinx-like black cats outside the old Carreras Cigarette Factory in Camden Town (see page 505), but of flattened-out

architectural decoration, streamlined wrap-around windows, flowing lines, emphatic bands of colour and interchangeability. In Art Deco a building's decoration might translate to a scarab ring, and an ashtray could bulk up to a swimming pool. All these are characteristic of the Hoover building's astonishing totemic entrance, its zigzag paving, its astringent reds and greens and yellows, mirrored lift doors engraved with motifs that are picked up in window lights arranged like a hand of poker. Round the back is the former canteen of 1939. It might be an airport control tower or it might be a cinema, but today it's a Tesco supermarket. Hoover abandoned Perivale in 1982. English Heritage listed the factory to prevent it from being demolished like the lurid Firestone building nearby built by the same firm. Tesco picked it up, restored it with immense care, rented out the main building as offices, and built possibly the only Art Deco supermarket trolley park in existence.

WESTERN AVENUE, PERIVALE, UB6 8DW

### ST MARY'S, NORTHOLT

*The Welsh bard of Northolt,
passing through, but behind him
followed a memorial plaque*

On the inside of the north wall in the tiny church of St Mary's, Northolt, a nicely carved legend in elegant Roman capitals on a stone tablet celebrates the life of the wandering Welsh poet Goronwy Owen, born on New Year's Day 1723. It verges on the illegible now even though it dates from as recently as 1923, but dimly discerned is this tribute: 'Master poet and

prose writer in whose works the ancient dignity and beauty of the Welsh language shone forth anew'. St Mary, with its familial memorials to Northolt worthies, seems on the face of it an odd place to find an encomium to a Welsh-speaking bard.

The brief facts are that Owen was born in the Anglesey village of Llanfair Mathafarn Eithaf, the son of a labourer, and brought up in poverty, but with the help of a sponsor received a thorough education in Latin and Greek. He entered the priesthood and after a series of misadventures moved with his young family to Northolt as a curate on a tiny stipend. Here he wrote what are said to be his finest poems but stayed only the two years 1795–7 before sailing to America to become headmaster of a grammar school and later to obtain a living at a church in Williamsburg, Virginia. He died in 1769 and was buried on his own tobacco and cotton plantation. The tablet in St Mary was erected on the 200th anniversary of Owen's death by Cymmrodorion, the society for the preservation and propagation of the Welsh language, which Owen's friend Richard Morris founded in 1751, and which still flourishes today.

So too does Northolt with its military airport, abounding housing estates, and, in the southern part of the town severed by the A4, a park reclaimed from wasteland with four massive mounds like prehistoric burial sites designed by the German landscape architect Peter Fink and created with debris from demolished

Pevsner thought this Hoover headquarters at Perivale an atrocity. English Heritage saved it. Pevsner's successors coyly enjoy it. Tesco gave it the first-known Art Deco trolley park.

buildings, including the old Wembley Stadium. St Mary's own envelope of conservation area parkland is more modest but somewhat older, a throwback to Domesday, and enough to insulate it against the encroaching tides of the last two centuries. The present aisleless church, white with a steeply pitched roof, was raised in 1300 and the weather-boarded turret and splayed-foot spire are sixteenth-century. The windows are delicately crafted Early and Late Decorated. The two outsize seventeenth-century brick buttresses against the west wall were added when the church seemed in danger of sliding into the stream below. Internally there are good rough-hewn sixteenth-century tie beams and crown posts, an ancient piscina and water stoup, a wonderfully rickety musicians' gallery of 1703 supported on slender pillars seemingly insufficient for the job, and a fine Byzantine-style rood fashioned by an unknown hand for, of all things, the Festival of Britain in 1951. There is not much in this place on its green island that would seem changed to Goronwy Owen, so long as he had earplugs.

EALING ROAD, UB5 6AA

## SWAKELEYS HOUSE

*London's own Michelangelo, or not*

Destiny never did intend Swakeleys to have a settled history; the first step towards calamity was in 1485, when a member of the family which owned the estate had the lack of vision to fight on the losing side at the Battle of Bosworth, which spun the dynastic coin in favour of

the red rose instead of the white. The seventeenth-century lord of the manor who rebuilt Swakeleys as we know it was Sir Edmund Wright, also Lord Mayor of London. It is thought that the bust that appears in the gable on the south front of this H-shaped redbrick building represents him. Splendid though it is, as a Jacobean edifice Swakeleys had already, by 1638, outrun time and fashion as England was waking up to Palladianism. As Samuel Pepys would describe it in the 1660s, it was 'a place not very moderne in the garden nor house'. Wright's son-in-law revived the Swakeleys tradition of backing the wrong horse, signed the death warrant for King Charles I, and upon the Restoration fled to France; Sir Robert Vyner bought the house from him and by bankrolling Charles II bankrupted himself. It was after an unsuccessful scrounging trip on behalf of the Navy Office that Pepys made his mildly disobliging remarks, though he was taken by the sight of Charles I's bust on the screen in the great hall, where it remains.

In the centuries since, Swakeleys has hosted the All England croquet championship, been home to the Foreign and Commonwealth Office sports association and the London postal sports club, been used by police dog trainers, and narrowly escaped demolition. So its prime is long past, but it now has well-restored rooms, a buffer of parkland against the 1920s and 30s suburbs, and one intriguing mystery: the wall and ceiling paintings of the grand staircase, opulent scenes of the Death of Dido, Aeneas founding Lavinium, a classical landscape, and, on the ceiling, baroque goddesses in a baroque sky. No contemporary document indicates its artist, and nobody now seems much interested, though a long and perhaps long-forgotten editorial in the *Burlington Magazine* of January 1944 argued the case for Robert Streater (1621—79), master painter to Charles II and decorator of the ceiling paintings of the Sheldonian Theatre: 'The drawing of the figures is on the whole, quite in the manner which we know from the Oxford ceiling .. Also the masses of piled-up drapery are immediately reminiscent of the ceiling.' In his own time no less than the Sheldonian's architect, Christopher Wren, was proud to praise Streater, with the complicity of Robert Whitehall, clergyman and poet, who wrote:

> *… future ages must confess they owe*
> *To Streater more than Michael Angelo.*

To which Horace Walpole, as an early representative of future ages, loftily demurred, 'from the few works I have seen of his hand, I can by no means subscribe to these encomiums'.

MILTON ROAD, UB10 8NQ

## HARMONDSWORTH GREAT BARN

*Betjeman's 'Cathedral of Middlesex'*

The parish of Harmondsworth always reached beyond the Bath Road to the south and included Heathrow, though Heathrow village itself has vanished beneath some of the busiest flight paths in the world. Penguin Books too, whose

imprint made Harmondsworth famous around the world, has packed its tents and departed. The Bath Road, where its offices and warehouses for tens of millions of paperbacks stood, is infamous now for the bleak UK Border Agency warehouses 'processing' immigrants and asylum seekers before their involuntary departure. The housing for the (legal) foreigners making up a high proportion of the airport's labour force is scarcely less dreary.

In short, Heathrow's embrace is throttling Harmondsworth. The village centre clings on, a pretty but beleaguered enclave around the tiny green: the twelfth-century church of St Mary's inside a populous graveyard behind a tall, good-looking iron gate; a shop and post office with a red pillar box on the pavement outside; the Five Bells pub with a sixteenth-century (probably) red-tiled gable showing above the white-stuccoed façade, pretty hanging baskets of flowers and boards boasting traditional ales, fine wines, hot and cold home-cooked food – but a prominent estate agent's To Let board punctures the idyll.

William of Wykeham bought Harmondsworth in the late fourteenth century as a mylch cow for his grammar school foundation, Winchester College. The barn was part of that enterprise – it was built by the school in 1426 for the collection of tithes (to help ease the pain of William's building expenses). It is not quite as big as its parish neighbour, terminal 5 at Heathrow, but at 190 foot long, 37 foot 6 inches wide and not far short of its 600th anniversary, it is impressive in its own fashion. How the villagers must have hated this load placed on their shoulders by God. It could be that local labour constructed this mighty oak building, but it is just as likely that an outsider took charge, not as eminent as the master of the Westminster Hall hammer-beam roof, Hugh Herland, but nonetheless mightily gifted. Herland himself had worked in William of Wykeham's service, and though he died in 1411 he could conceivably have had a hand in training the Harmondsworth master carpenter. Not that Harmondsworth was unique. There are known to have been at least a dozen bigger timber barns in England at this time, but this alone survives, with some replacement of its exterior cladding but with the original oak of its complex joinery in almost perfect condition through 12 bays of nave and two aisles. Shamefully for a poet, John Betjeman was moved to enunciate a cliché as old as the barn in calling it the 'Cathedral of Middlesex': nevertheless, in the middle of the nineteenth century George Gilbert Scott had made a study of the barn's interior, intending at that stage to borrow its structure for his Christchurch Cathedral project in New Zealand. Had Scott done so, maybe his cathedral would have withstood the 2011 earthquake.

MANOR COURT, HIGH STREET, UB7 0AQ

Overleaf: the suave brown hall of Horace Walpole's Strawberry Hill is the first swallow of the Gothic revival. It was loved by society of the day, despised by the solemn revivalists of the nineteenth century. Surely Walpole's generation was right.

# South-West London

# South-West London

**HOUNSLOW**

- St Anne's, Kew Green
- Syon House
- Old Deer Park
- Marianne North Gallery
- All Saints, Isleworth
- The London Apprentice
- St Mary Magdalen, Mortlake
- Richmond Palace
- All Hallows, Twickenham
- Sandycombe Lodge

**RICHMOND UPON THAMES**

- York House
- St Peter's, Petersham
- Ham House
- Richmond Park
- Alexander Pope's grotto
- Orleans House Gallery
- Pembroke Lodge
- Strawberry Hill
- Langham House Close

*Bushy Park*

- Statue of Queen Anne, Ancient Market Place
- Eadweard Muybridge Gallery, Kingston Museum
- Garrick's Temple to Shakespeare
- Hampton Court Palace
- Hampton Court Park

**KINGSTON UPON THAMES**

*SURREY*

0  0.5  1  1.5  2 mi
0  1  2  3 km

Thames

Sculpture by
Nicola Hicks

*Battersea
Park*

**HAMMERSMITH
& FULHAM**

St Mary's,
Battersea

575 Wandsworth Road

Soweto
Memorial,
Max Roach Park

St Mary's,
Putney

*Clapham
Common*

**WANDSWORTH**

*Wandsworth
Common*

**LAMBETH**

*Wimbledon
Park*

*Tooting
Bec
Common*

Wimbledon
Greyhound Stadium

thside
ouse

St Mary
the Virgin,
Merton

**MERTON**

*Morden
Park*

*Mitcham
Common*

**CROYDON**

**SUTTON**

Statue of
Anne Boleyn,
Carshalton

St Dunstan's,
Cheam

Little Holland
House

such
ark
Whitehall

## • BRIXTON, WANDSWORTH, BATTERSEA •

### SOWETO MEMORIAL, MAX ROACH PARK

*A photograph of a Soweto killing transmuted into a drawing in the air*

The opening in 1986 of a new park beside Brixton Road coincided with a Lambeth council plan to rename numbers of Brixton places and houses after eminent black people (27 of them, from Dr Johnson's servant Francis Barber to the 1984 Los Angeles Olympic gold javelin thrower Tessa Sanderson). Lambeth picked out the jazz drummer Max Roach for the park, and as the man himself was touring Europe at the time he turned up for the opening. It may be a coincidence that Max Roach Park was selected in 1998 as the site for a memorial to a child, one among 116, who was shot dead by police in the Soweto shootings of 16 June 1976, but it was appropriate. Roach (1924–2007) was a political radical, a founder of bebop with its complex rhythms intended initially to take the music beyond the understanding of a white audience. Roach was engaged in an assault on white supremacy and there can't be much doubt that he would have welcomed the Soweto memorial, which Happy Mahlangu, Deputy Commissioner for South Africa, unveiled on 16 June, ten years after the shootings.

The sculpture itself is a vivid transmutation of its source, the famous photograph of the body of the 12-year-old boy Hector Pieterson cradled in the arms of an older student, Mbuyisa Makhubo, with Hector's distraught sister, Antoinette Sithole, running alongside, into a flowing linear steel structure, a drawing in the air. The photographer, Sam Nzima of the *World* newspaper, Johannesburg, took many exposures, one showing Antoinette howling in distress, but the best one was chosen by picture editors around the world, a rough triangle created by the head of the older boy at the top and the girl's and her dead brother's heads lower down on either side. The girl runs with her right hand, palm to the front, fingers stretched out as far as they will go as though she's fending off the terrible truth. The sculptor, Raymond Watson, a Jamaican living in Brixton when the piece was commissioned, dispenses with the stability of the photo's triangle and switches the girl to the other side of the group so that she is in the lead, clutching her brother's dangling leg with her right hand and her left arm pointing; the student and his burden move heavily; the girl's motion is pure electrical energy through to the fingertip. And yet the memory of the original image is retained.

Lambeth refers to the piece by Watson's title, *First Child*, the first to be killed. But he wasn't. The belief took hold simply because of the raw power of that initial newspaper image. Watson himself was born in London in 1954 but spent many years in Jamaica and returned there after the unveiling. He remains little known and sells little. Some of his sculptured heads, typically in wood, look like the heads in Picasso's breakthrough modernist work of 1907, *Les Demoiselles d'Avignon*, but, judging solely from his website, nothing else he's done stands as tall as the image in Max Roach Park.

MAX ROACH PARK, SW9

## 575 WANDSWORTH ROAD

*A poet and Treasury official
touched by decorative genius*

The poet, novelist and Treasury official Khadambi Asalache, son of a Masai chief, given the name Nathaniel at the Holy Ghost Fathers' Mangu High School and known to close friends thereafter as Nat, chose his home at 575 Wandsworth Road when he spotted it was for sale from the 77 bus that took him to Whitehall each day. He saw how shabby it was and guessed that he would be able to afford it. It was early nineteenth-century, one of a terrace, two-up and two-down with a basement. Dossers had taken it over and damp was oozing through a basement wall. It was not a promising start to an enterprise that ended with his bequest of the house to the National Trust in 2006 when he died aged 71.

In the life left to him after moving in to 575, it transpired that his greatest talent was for decoration. What started as an absurd enterprise to cover up the damp became an obsession: to cover every wall and every ceiling and a lot more besides with fretwork. At least one female companion (they were always redheads) left him in exasperation at finding him each evening, back from his labours at the Treasury, immensely tall, hunched on the back step with his fretsaw, creating fresh patterns for walls and ceilings, window frames and fire surrounds. The floors he merely painted.

On his travels he collected Islamic and African objects to display on mantelpieces and ledges alongside English lustreware, and turned to Moorish and Indian patterning for surfaces: all surfaces. One of Asalache's novels has animal characters, and here they are carved on the walls too, from ducks to giraffes and elephants, embedded in freely scrolling designs, looping arches, filigree-screened windows, candles everywhere to take over at dusk from the flickering light of the sun through trees outside; and on a wall beside a window what looks like a delicate Chinese landscape, but is in fact oil on canvas with a passage of paint that looks like light from the window falling on the surface. The painting is by Asalache's friend Frank Bowling, the first black Royal Academician, a hot abstractionist, but this cool canvas looks as though it had been intended by nature and artifice for its context of teeming Moorish forms and peaceful figuration.

Asalache wrote an exquisite poem about the funeral of a chieftain, presumably his father; poetry and painting don't replicate each other but a small sampling from anywhere in 'Death of a Chief' catches the flavour too of 575 Wandsworth Road, the elegiac sense of an exile separated from his heritage:

> *the path is silent*
> *to this procession*
> *walking into a myth*
> *as he passes*
> *alone*
> *freed from praises...*

As for the National Trust, it was knocked out by the richness of Asalache's bequest and closed the house until 2013 to raise £4 million, not to restore the decor, but to ensure that the house didn't fall in on it.

WANDSWORTH, SW8 3JD

# Brixton

From Victoria Underground to the southern end of the line, Pimlico, Vauxhall, Stockwell, Brixton: ten minutes, but disembark in another country. Afro-Caribbean predominantly. You feel the buzz before you're off the escalator. On Brixton Road there's a hoarse-throated black woman preacher with a fistful of pamphlets offering everlasting salvation, a greybeard rastafarian beating hell out of expensive-looking steel drums, another preacher promising the return of Christ, more ageing rastas lounging around laughing and smoking up in Windrush Square, and more in the garden of the massive basilica (1827) of St Matthew's, its iron railings heavily locked, steel doors secured behind.

Thumb back the files to 22 June 1948; look out those yellowing Windrush cuttings: the MV *Empire Windrush* arriving from the Caribbean with 492 Jamaicans on board (plus a few stowaways). Many of them are wartime ex-servicemen; veterans or not, all of them have been invited to Britain to fill labour vacancies. Most of these first arrivals are placed initially in the hurriedly reopened air raid shelter deep beneath Clapham Common. The nearest labour exchange is in Coldharbour Lane in Brixton, and here the immigrants find lodgings. They become known as the Windrush generation.

Café life today congregates around the Ritzy cinema on the corner of Coldharbour Lane opposite, street life in the square itself. Windrush Square is big, not quite pulled together, though the bulk of the town hall and the height of its tower work at it. Brixton was prosperous in the nineteenth century when God and Mammon erected the church and town hall, and before either, the windmill at the top of Brixton Hill signalled a rural past.

Today in Britain as a whole the white majority is 83 per cent; in London the whites are a minority; in Brixton Hill (total population nearly 16,000) the white British population slipped from 51 per cent at the 2001 census to 41 per cent in 2011, Afro-Caribbean 24 per cent, 'other whites' 15 per cent, and a mixed collection of Pakistanis, Chinese, African Asian, Asian British and among religious affiliations, four Voodoo worshippers, no race given. Brixton has all the problems that London is heir to, magnified. When riots broke out in Bristol in 1980, posters here went up warning 'Brixton tomorrow'. The biblical tomorrow was a year later, 1981, when resentment over police stop and search boiled over. Next, 1985, 1995, 2005 and then, one of a dozen London boroughs, in 2011 after the police shooting of the unarmed Mark Duggan.

In 2015 someone took up the weapon of choice, a brick, and hurled it through the window of Foxton's estate agency: that might indicate that the next riot would be about gentrification. There is deep suspicion of the motives of Network Rail, which owns the arches in Atlantic Road and Station Road inhabited by a lot of shops and market stalls, where one fishmonger slung up a big banner painted: 'Triple the rents? You must be squidding'. There's suspicion, too, of the council's motives in investing in central Brixton. I asked half a dozen people the way to Pop Brixton, a new council-aided site for coffee shops, cafes, and more stalls. Each one of the locals looked at me blankly, and then helpfully directed me instead to the old market in Electric Avenue and the covered

passages around it. And it is wonderful, full of the things that make an English market good. It is a short, curving street which was once beautiful, with glass canopies either side; neglect saw to what wasn't blitzed and they were junked. It's Electric because it was the first shopping street in London lit by electricity and, by chance, for the lively street scene. Fruit and veg, halal butchers and straight-up butchers, fish, with one of the best fishmongers I've seen outside Billingsgate, cheap jewellery, tee shirts, party frocks, satin, denim, baggage.

But Pop Brixton? 'Don't you find that name a bit patronising?' said the North American ('other white') boss in Book Mongers, the second-hand dealer in Coldharbour Lane. Then he mentioned that there was a new blue plaque on the house above a shop at 163 Railton Road where the Trinidadian C. L. R. James had lived his last years as cricket writer, philosopher, revolutionary socialist, polymath, local saint, the usual things. He died there in 1989, on this long, dull street like most of the others in the area; and lately a young white couple moved in, discovered James's connection, campaigned for a blue plaque, got it and by doing so charmed all Brixton.

Granville Arcade, one of several in Brixton village off Electric Street and Atlantic Street, the area where the 'Windrush generation' set up shop.

## SCULPTURE BY NICOLA HICKS, BATTERSEA PARK

*The dog it was that died*

The maps placed at strategic points in Battersea Park are very useful, showing where to find the Battersea Millennium Arena (the old athletics track freshly spruced up), the lake, the cricket field and pavilion, the small English Garden. But one thing is missing from the pieces of sculpture listed: sure enough, the Barbara Hepworth is there, the Henry Moore, and the dismal Eric Kennington First World War memorial, three soldiers disposed like chorus girls in drag. What's left out is *Little Brown Dog*, a monument by the highly gifted sculptor Nicola Hicks (b. 1960).

The original *Little Brown Dog* was a commission from the National Anti-Vivisectionist Society in 1903 in response to a libel case brought against them and won by the physiologist William Bayliss, the joint discoverer of hormones, over an allegation by the society's secretary that he had behaved illegally in operating before an audience of University College London students on the fateful dog, which, after more operations, died. The police had to mount guard over the statue to prevent attempts by physiology students to destroy it and in 1907 Trafalgar Square erupted in violence between students and anti-vivisectionists – the brown dog riots, as they became known. The trouble dragged on until 1910 when Battersea council removed the statue and, apparently, destroyed it.

Seventy-five years later the anti-vivisectionists commissioned a replacement from Hicks and that same year, 1985, that jewel in the crown among actresses, Geraldine James, unveiled it. No police guards have proved necessary. On the other hand no one walking a dog seems to know where it might be found; the answer is to find the parks office first, then find the patch of woodland beside the Old English Garden (labelled No Dogs).

Some anti-vivisectionists today prefer, as far as they can judge from a photograph, what they see of the old bronze dog, a militant animal, upright and alert like a gun dog. The new dog is more like anyone's pooch, and it appears that Nicola Hicks modelled it on her own terrier. Like its predecessor, it sits, but its head is tilted to one side, snout raised hopefully, ears unevenly cocked. Its undocked tail curls round its haunches in what is clearly an uncertain wag. Walkies?

What matters isn't whether it is a barking likeness or not but Hicks's instinctive feel for the exact tension of materials held in balance between the bronzeness of bronze and the scruffiness of unbrushed animal hair, the inertia of the metal and the kinetic energy of the animal. It is a heart-lifting visual coup that has little to do with sentimentality. Nicola Hicks's default medium is straw and plaster, one which gives her creations an astonishingly feral appearance. These have always seemed preferable to her bronzes, but this little piece, at around eye height on its plinth in a clearing beside the

Right place, but out of time: St Mary's, Battersea. J. M. W. Turner had himself ferried across the river, from a very different Chelsea, to work from the church, and here William Blake married his life's helpmate Catherine Boucher.

footpath, only about 17 inches high and 22 inches nose to tail, lifts the spirits with its audacity.

BATTERSEA PARK, SW11

## ST MARY'S, BATTERSEA

*The church of J. M. W. Turner and an art-loving vicar who smashed all the windows*

In his old age during the 1840s J. M. W. Turner lived in Davis Place, Chelsea (now 119 Cheyne Row), with his former Margate landlady Mrs Booth. Word got around that this strange little dauber who loved the river was Admiral Booth, fallen on hard times. It was his habit of a morning to ask an old waterman called Charles Greaves how the day would turn out. If the prediction were for calm weather, Turner would employ Greaves to ferry him across the Thames to Battersea parish church a little upriver, just as Greaves's famous son, the painter and waterman Walter Greaves, would later row James Abbott McNeill Whistler about Chelsea Reach.

The eighteenth-century riverside church of St Mary's has a west steeple and classical pediment on Tuscan columns; in the wall at the back of this portico, unusually, is a pretty oriel window supported on a base tapering like a wine glass, contained within the space of a large round-arched window. Through the oriel, from a seat in the vestry, Turner would sketch the changing scene, looking up Battersea Reach. Today the church commemorates him with a competent stained-glass window by John Hayward of Edenbridge, one of four he created between 1976 and

1982 to replace windows smashed in the war – another commemorates the marriage in this church of William Blake (poet, not admiral) to Catherine Boucher.

St Mary's is an old foundation: twelfth-century at least, though it recently celebrated its 1,500th anniversary, imaginatively but feasibly, since the river mooring at the edge of the churchyard is the heart and oldest part of Battersea; it was in this stretch of river that the magnificent Iron Age Battersea shield (now in the British Museum) was found. Joseph Dixon designed the replacement church in 1775, the year of Turner's birth, at the end of Church Road, a charming survival of village Battersea with modern insertions. The church is of dark brick with white stone quoins, with a gallery inside, and outside a proper country churchyard enhanced by the houseboats moored to the stone-built embankment. The gravestone inscriptions are mostly unreadable now, but anyway the finest monuments are within the church, the best of them a subtle double-relief portrait of Alexander Pope's dedicatee for *An Essay on Man*, Henry St John, 1st Viscount Bolingbroke, whose ancestral home (now long gone) was in Battersea, with his wife Mary Clara des Champs de Marcilly: this memorial is by Louis François Roubiliac, surely the finest portraitist in any medium in eighteenth-century England.

As for the church windows supposedly wrecked by the German bombs, the wartime vicar, Stephan Hopkinson, later confessed that on the night in 1940 when German bombs fell hard by, he rushed from the vicarage expecting to see the Victorian glass lying scattered in shards on the ground; disappointed in his hopes, he took a stone and smashed the windows himself. Otherwise, the church entirely survived assaults from both Luftwaffe and art-loving vicar.

BATTERSEA CHURCH ROAD, SW11 3NA

## • PUTNEY, MORTLAKE, KEW, ISLEWORTH •

### ST MARY'S, PUTNEY

*Where tinkers and tailors and butchers and bakers changed the course of history*

King Charles I was under house arrest at Hampton Court and Parliament's New Model Army had set up winter quarters in Putney. In the parish church of St Mary on the Thames riverside, a group of army grandees including the three grandest, Oliver Cromwell, Henry Ireton and Thomas Fairfax, conducted the Putney Debates, as they are known to history, with representative officers and men from the regiments to decide the king's fate and the future of England, nothing less. The debates continued from 28 October 1647 until 9 November, and in that time, and against the wishes of Cromwell, the shoemakers and the tinkers, the tailors, the butchers, the bakers, the poor men and a handful of the rich, briefly turned the world upside down, in the biblical phrase popular in that year.

Colonel Thomas Rainsborough

encompassed the feelings of his men in a passionate declaration spoken at the debates, inlaid now on the face of a modern gallery above the church's south aisle: 'For really I think that the poorest he that is in England hath a life to live as the greatest he'.' The poorest she isn't mentioned, so what's changed? Not much, by one measure; a lot by another. Cromwell and Ireton, concerned about the threat of militant Christianity to property, shut down the debates (which survive in the shorthand record) and circumvented the army's block vote. Neither the Commonwealth nor the New Model Army long survived Charles I's beheading. Yet the tenor of history had changed and the issues of democratic accountability raised in 1647 are still current now.

Inside the entrance to St Mary's the events are related in an exhibition of wall placards and video talks. The curiosity is that if the debaters could resume today they would hardly recognise their surroundings, for in 1980–2, after fire had gutted St Mary's, the ecclesiastical architect Ronald Sims (1926–2007) was party to another revolution that moved the altar to the middle of the north aisle, with seats around it like theatre-in-the-round, and the brick walls exposed by the fire left unplastered.

In one form or another the church has been here since before the Conquest, but, before Sims, always aligned west to east. Edward Lapidge, once an assistant to Capability Brown in Hampton Court Palace gardens, rebuilt it in 1836–7 but in retaining the oldest part of the building, the fifteenth-century tower and the nave arcades, he dismantled the tiny and delicately fan-vaulted chantry chapel built by Bishop West of Ely, the son of a Putney baker, early in the sixteenth century, and reassembled it on the north side.

So there was an audacious precedent for Sims's re-ordering and he has seized it and made it good; but perhaps because he came from a conservative line of architecture, not as good as the work of a younger generation, which has fully grasped how excitingly steel and glass Modernism can sit with the old: St Pancras and Tate Modern, to name the obvious two, and St Mary Lambeth (the Garden Museum), to point to a church.

PUTNEY HIGH STREET, SW15 1SN

## ST MARY MAGDALEN, MORTLAKE

*Arabian nights in an English churchyard*

It was a lifelong and tortuous journey to his mausoleum in the western outskirts of London for Richard Burton. The famous writing and exploring Richard Burton, that is: soldier of the Raj, spy for General Napier, diplomat, more or less full-time maverick, master of 40 languages and dialects and translator of what is widely held to be the best English version of *The Book of the Thousand and One Nights*. Not least, he was the first and best fake sheikh, with deference to Mazher Mahmood, the journalist on the now defunct *News of the World,* who lays claim to the same nom de guerre; but Burton (1821–90) pre-empted him. He passed as the wholly fictional Sheikh Abdullah, a Sufi dervish, for several

weeks within the walls of the forbidden cities of Medina and of Mecca itself, where to be discovered as an impostor meant death.

Burton was born in Torquay and died in Trieste, had nothing to do with Mortlake and was an agnostic, but St Mary Magdalen, Mortlake, is where his wife, Isabel Arundell, a descendant of a noted Roman Catholic family, chose to inter him, because it was one of the few Catholic churches close to London. She followed his wishes in one crucial respect: 'I should like us to lie in a tent, side by side,' he had told her, and duly she designed a Bedouin tent for the two of them, in stone, to the east of the church in a churchyard tightly hemmed in on three sides by little nineteenth-century villas and on the fourth by a country railway line sporting a London service.

The architect of St Mary Magdalen itself, which was consecrated in 1850, was Gilbert Blount, who had a successful practice building churches for Roman Catholics in England. There is an attractive Gothic canopy above the south door containing a figure of Mary Magdalen, fluently carved and with none of the usual cloying sentimentality of the period. The church itself is in a style that might be called Gothic Peculiar, but nothing could be more peculiar than the tented mausoleum, with its stone folds like ripples in the desert sand and a crucifix above a rim of Islamic crescent moons and stars. A short steel ladder at the back of the tent gives access to a window with a view of the interior: two elaborate coffins, Arabian oil lamps hanging above or disposed in a group on the tiled floor and, in an inner chamber, a

dimly perceived figurine of what seems to be the Madonna. The effect is more gloomy than spiritual or noble, but it is unquestionably one of the great English funereal eccentricities.

61 NORTH WORPLE WAY, SW14 8PR

## ST ANNE'S, KEW GREEN

*The mixed history of two friends of one king*

The guidebook for St Anne's on Kew Green has an intriguing plan of the church composed of 11 blocks of colour, each representing a new period of development: that is, 11 significant changes to the appearance of the building between 1714 and 1988. Not bad going. According to biblical apocrypha, St Anne was the mother of Mary the mother of God, but as St Anne's on Kew Green was built in 1714 with a grant of land and cash from Queen Anne, it seems clear that the dedication was a vote of thanks to the monarch. It was never a royal church, but the family and the peripatetic court used St Anne's quite extensively and it became a favourite of Georges III and IV. Jeffry Wyatville, the showman architect who magicked the staid old medieval Windsor Castle into a vivid brand new medieval castle, while working for George IV in 1837, spruced up the classical west portico with its four Tuscan columns and added the little clock turret. St Anne's is a lovely focus to a wide space that, like Richmond Green but without the grandeur, is a cross between a village green and a great city square. The interior of the church is without much distinction, but it contrives to be pretty with its gold-starred blue dome holding things together.

Of an undistinguished collection of memorials the unworthiest of all is a plain stone plaque to Thomas Gainsborough, who had no connection with Kew except a close friendship with Joshua Kirby, architect of some of the changes to the church and a competent (though not distinguished) artist, who taught the great Gainsborough engraving. Kirby was a friend of George III but blundered in conversation with him by rejecting the notion of a Royal Academy, not realising that the king had given it his assent the day before. He was regally banished from the presence and lost all his influential London friends, except for Gainsborough, whose request to be buried at St Anne's was, surely, a last act of solidarity. Their gravestones lie side by side outside the church, and Gainsborough, who died in 1788, brought in train into his tomb his wife (died *c*.1798) and Gainsborough Dupont, his nephew (died 1797), most famous for working with his uncle all one night to complete the great companion portrait to George III in the Royal Collection of Queen Charlotte in a shimmering evening gown. By this time, 1781, the queen had already borne 14 of the king's 15 children and, as the old painter and windbag James Northcote slyly told William Hazlitt, this portrait was the 'essence of genius, the making beautiful things from unlikely subjects'.

KEW, TW9 3AA

A Bedouin tent eccentrically carved out of stone serves as the tomb of the nineteenth-century traveller Richard Burton in the small graveyard of a Roman Catholic church in Mortlake. He was not a Catholic but his wife was, and she had the last word.

# MARIANNE NORTH GALLERY

*A world traveller who built a museum and filled it with her plant paintings*

One day when Marianne North was in her twenties and visiting Kew Gardens with her father, they met Sir William Hooker, the director at Kew, who presented her with a spray of the spectacular hot pink *Amherstia nobilis*, the so-called Pride of Burma. The memory stayed with her, and in 1882, around a quarter of a century later, she returned the favour to Hooker, still in place as director: she gave Kew Gardens a museum.

North was born in 1830 in Hastings, the town for which her father was Member of Parliament. She had practically no schooling, but her parents educated her with a tour of Europe on which she encountered the Austrian version of the 1848 revolutions in Vienna and survived typhoid in Munich. Her younger sister Catherine married the poet and critic John Addington Symonds, so when their mother was dying in 1855 it was Marianne she asked to promise to stay with her father until his death. Marianne kept her promise and mourned him sincerely at his death in 1869, but, released from family obligations, like many women of the late eighteenth to the early twentieth centuries, from Hester Stanhope and Mary Kingsley to Freya Stark, she chose then to escape the stifling conventions of Victorian life by setting out by train and boat on extensive unaccompanied travels in exotic parts of the world.

This extraordinary woman packed her paints and easel and journeyed at the age of 40 to Ceylon and Sarawak, Australia and New Zealand, Borneo, Burma, India, Russia, China and Japan, the Caribbean, the Seychelles, South Africa and South America, to name a few destinations. She recorded the landscapes of places she visited but mainly the plant life, some of it as beautiful as the Pride of Burma, but some that looks as though it could eat you. She engaged her architect friend James Fergusson to build a museum to look like a house with verandah built for Europeans in India (the verandah is very like, the house not much). It is a showcase for her impeccably conserved work, views of some of the places she visited but principally studies of tropical plants: 833 paintings hung wall to wall, several deep, frame to frame, not a fraction of an inch between. She was an amateur, but the love of her subject shines through and if none of the paintings is wonderful, the impact of the display is a work of art in itself.

Everything at Kew is subservient to the landscape, even the seventeenth-century Kew Palace, a house built by a merchant and later the favourite retreat of George III and Queen Charlotte, the much more exuberantly palatial glasshouses designed by Decimus Burton, and William Chambers's soaring pagoda. Marianne North's museum is smaller than any of these, an incident in the garden landscape, but a showcase for the splendour of one woman's courage and determination laid out in oils on paper.

KEW GARDENS, TW9

## SYON HOUSE

*Dredged from the bed of the Tiber*

Syon House is where the Scottish architect Robert Adam (1728–92) proved himself the finest interior designer of his time. The first Duke of Northumberland would not allow him to rebuild the Tudor original, so the only bravura touch to a dull exterior is the Northumberland lion above the east range, which gives the old pile the cheery look of a riverside brewery and which was moved from the demolished Northumberland House in the Strand in the nineteenth century. Adam got on with the interior design. The eighteenth-century aristocracy liked to think of themselves as Romans, so he duly indulged the duke by creating a suite of state rooms with an elegant opulence that would have made Nero envious.

Adam's early experience had been working in the early 1750s with his father, William, and his brother, John, in their native Scotland. By the time he received the Percy commission in 1761 he had been on the grand tour. Grand tourists came in two kinds: the rich, who returned to Britain with shiploads of booty; and the artists, who returned with nothing but minds enriched and notebooks filled. At Syon the interests of client and designer dovetailed, for in the glorious setting of the ante room of the entrance hall with its polychrome scagliola floor (a composition stone with the effect of marble), its mahogany doors, its gilded statuary on the entablature and gilded military trophies on the walls, and sumptuous white and gold moulded plaster ceiling, the verde antique columns were, in the words of Sacheverell Sitwell, 'dredged, appropriately, from the bed of the Tiber, and ransomed by Sir Hugh Smithson, first Duke of Northumberland of the new creation, for a thousand pounds apiece'.

Except for William Kent's grand staircase entrance at Holkham, the fanfare of Syon's almost double-cube entrance hall is the finest in England, or at any rate, now that I think of Vanbrugh's Blenheim and Grimesthorpe, my favourite in England. It has an apsidal end, floor paved in black and white marble, walls and ceiling whitish with decorative details in grey (a new colour scheme since Sitwell's time), slender Roman Doric columns, antique busts, medallions painted with details from the Arch of Constantine, and apses with copies of the Apollo Belvedere in marble and the Dying Gaul in bronze. Horace Walpole waspishly disparaged Adam in comparison to Kent ('from Kent's mahogany we are dwindled to Adam's filigree') and it is true that Adam's decor has a feminine delicacy undreamt of in Rome or in Palladian England. But the evident excitement manifest in Adam's work at Syon shows that the heady mixture of the power and wealth of Harry Hotspur's Northumberland descendants, in combination with Adam's recent experience of the imperial and republican heart of ancient Rome, gave him the impetus to leave behind the severe Palladianism that had dominated English architecture since Lord Burlington had built Chiswick House a little upriver.

There follows the white and gold apsidal dining room with niches for sculpture, and a coved ceiling with arcadian figures painted in medallions by the

popular Italian painter, engraver and decorator Giovanni Battista Cipriani, who worked in England from 1755 to his death in 1785 and became a founder member of the Royal Academy. Adam's rival William Chambers (see page 92, Somerset House) likened the medallions to skied dinner plates. Well, every great man should be allowed his little envy. There follows the red drawing room of equivalent splendour hung with crimson Spitalfields silk and with an Adam carpet echoing the ceiling design; finally a mauve, green and gold long gallery exquisitely divided by the horizontal thrust of pilasters separating the book cases and with painted medallions above: one of them is Harry Hotspur as interpreted by the gilded nonchalance of the eighteenth century.

SYON PARK, TW8 8JF

## ALL SAINTS, ISLEWORTH

*New wine in a broken old bottle*

As a variation on a theme of Second World War destruction, Isleworth parish church was razed in 1943, not by the Luftwaffe, but by a couple of boys and a box of matches. What was left was the Kentish ragstone medieval tower and part of the walls of the nave that had been rebuilt in the early eighteenth century when a chancel was added. By the time the group that wanted a straightforwardly safe reconstruction and the group that wanted something more imaginative had reached an agreement (in favour of the twentieth century), 20 years had passed. Michael Blee was appointed architect to the project in 1963 and started work even before the parish had sold mind-boggling quantities of marmalade and Christmas cards to raise funds. He was born in 1931 and had worked for Basil Spence on replacing the bombed-out St Michael's Cathedral, Coventry. There, the cathedral ruins were left alone as consecrated ground and the new St Michael's rose beside it. Spence's design came in for sustained criticism, but perhaps having become an object of artistic pilgrimage, it made Blee's designs for Isleworth more readily accepted.

Both the cathedral and All Saints have dated a little: too mild and mid-century parochial (if that can be taken as criticism by a parish). One might, only slightly frivolously, make an argument that the elephant and rhino house in London Zoo, dating from the same period as Blee's brick All Saints, would have been a better template, its gutsier concrete more like Corbusier's unsurpassable, sculptural Ronchamp chapel in the Haute-Saône in eastern France. The old nave of All Saints forms part of the outer walls of a series of offices and the little Joshua chapel built in memory of a parishioner who died aged two. The unroofed nave is now a courtyard: beyond on the ground of the old chancel is the new church. The skylights on top of this with white hoods look ingeniously like the smoke vents of oasts but throw light into the worshipping space, supplemented by soft pools of electric light

The London Apprentice, named after the annual river jaunt of apprentices completing the period of their indentures and launching into life. Today, boatless, the main problem is finding a parking space.

thrown on to the bare brick walls. In the west gallery there's a fine monument by the Wren-era sculptor Francis Bird of Sir Orlando Gee of Syon Park, bewigged and holding a scroll, perhaps the will in which, when he died in 1705, he donated £500 for the rebuilding that started the following year, now incorporated into Blee's work. And there is a curious and elegant sundial of 1761, once on the nave wall, now fixed to the exterior of the Joshua chapel.

The best view is close up, through the barred gate in the arch of the fifteenth century tower at the sheer glass south wall of the new church; in the space between, the courtyard with its fountain has the potential to be as peaceful as an Islamic garden: a small stream running from the fountain over a little ledge, more flowering plants... It's nowhere near, but the space is there and what a coup that would be.

63 CHURCH STREET, TW7 6BE

## THE LONDON APPRENTICE

*Carry on up the river*

The eighteenth-century London Apprentice keeps very good company, standing in a street of fine houses and, a few feet away, All Saints, the parish church of Isleworth (see above). The Duke of Northumberland's London pad, Syon House (see page 289), is a neighbour too, allowing for a couple of hundred acres of park enfolding it, identifiable from the pub by the pink eighteenth-century pavilion on the green bank above the confluence of the River Thames and the Duke of Northumberland

River. This is a short stream borrowed from the little River Crane at a point south of England's rugby headquarters, Twickenham stadium, and culverted with military precision to take a smart right turn and run along the Syon estate's boundary, possibly to deter boozers from emerging at closing time to water the duke's shrubbery.

Heaven forbid that the clientele of today's London Apprentice should match the ebullient-going-on-loutish behaviour of those Hogarth-era apprentices who, it is said, would celebrate the end of their indentures by rowing barges up the Thames as they sang the ballad, 'The honour of an Apprentice of London', to stoke up a thirst for an unbridled night out in Middlesex (match up the brass-buttoned blazers at the customer side of the bar today with the blue-tunic clad apprentice, arms akimbo, on the pub sign). The Thames yields a romantic view of the pub, muffled and enhanced at twilight with its terrace lamps glowing, 'Yellow as honey,/ Red as wine', on the edge of the Thames, partly hidden by Isleworth Ait (ait: from the Old English of Alfred the Great for island; several of them in this stretch of the London river). The terrace is perfect in fine weather.

Some florid Victorian engraved glass survives within, if not a lot. Above a mantelpiece in the main bar downstairs a signboard celebrates in ornate gilded lettering the feat of five parishioners in 1848 who rang 'A true & Complete peal' on handbells in three hours and twenty minutes 'in this room'. The room is now a figment: it was one of the small separate bars knocked together into one big bar, the old intimacy glancingly suggested by the juxtaposition of a faded photograph of Charles Dickens, the smartened-up London boozer's ultimate seal of authenticity (cue here also Nell Gwynn, alleged to have been a customer accompanied or not by her royal paramour). Today the only problem facing Charles I and Charles II, Charles D., Oliver Cromwell, Lady Jane Grey (outsourced from visiting Syon House) and the Protestant whore, as Nell described herself to align with the goodies, would be the parking.

62 CHURCH STREET, TW7 6BG

• RICHMOND, TWICKENHAM, HAM •

## RICHMOND PALACE

*Where a king's triumph turned to ashes in his mouth*

Tucked into the south-west corner of Richmond Green is a modest gateway with an earlier date than any of its neighbours, an entrance to nowhere in particular with the arms of Henry VII over the centre of the main arch built of warm red English bond brick. For this was the entrance to Richmond Palace, which, originally Sheen Palace, burned down and was rebuilt by Henry in 1501 and renamed after the Yorkshire fortress town from which his earldom had been derived. It was an urgent task, to be completed for the wedding celebrations

of the heir to the throne, his son Prince Arthur, and Catherine of Aragon, both of them 15 years old. Like almost everything Henry did after seizing the crown from Richard III in 1485, the rebuilding, the wedding and the celebration were grimly political, part of the upstart king's resolution to appear wealthy and, most importantly, the head of a stable dynasty. Westminster festivities were succeeded by a week of revels in the new Richmond Palace, rising like a cliff by the side of the Thames, awesome in its height, with its multiple towers and gleaming copper-clad onion domes gay with flags. Within were dance floors, 'housis of pleasure to disporte inn, at chesse, tables, dise, cardes, bylys [billiards?]; bowlyng aleys, butts for archers, and goodly tenys playes',' as a contemporary account had it.

After these festivities, Prince Arthur and his bride departed for his castle in Ludlow. Two weeks later the boy prince was dead of a fever, and with the child Prince Henry now heir to the throne, and the queen, Elizabeth of York, soon to die, Henry's dynastic plans hung by a thread.

Yet Richmond Palace remained a royal favourite. Henry VIII would use it as he ruthlessly consolidated his father's work and Elizabeth I loved it. She was in residence there when she died a century after Arthur, in March 1603, as the lawyer John Manningham reported, 'easily like a ripe apple from the tree' (he was a Kentish man). The palace was bounded by the green and the Thames, roughly 20 acres of halls and chapels and houses with courtyards, an orchard, formal parterres and informal gardens. Oliver Cromwell set off the wrecking and by the end of the eighteenth century only the gateway and round-diapered gatehouse adjoining were left.

Within the gate is a pretty miniature of Richmond Green, Old Palace Yard. One row of houses had been the Wardrobe and is still so named but is a handsome terrace of residences dating from 1707. What was the middle gate giving on to a small courtyard is obliterated by a 1950s pastiche called Trumpeters' House. And the stretch of houses between the surviving gate and Friars Lane is now Maids of Honour Row, of 1724, built for the maids of Caroline of Ansbach, Princess of Wales. Such calm, such plenty, such a civilised space, all consequent on the upshot of a scruffy combat and a horseless king encircled by Henry Tudor's insurgents at Bosworth Field.
RICHMOND GREEN, TW9

## SANDYCOMBE LODGE

*The house that Turner built*

The question seemingly most asked, and probably most unnecessarily, about J. M. W. Turner's house in Twickenham is: where did he paint? The only room big enough to be a studio looks out to the east rather than the north, which painters prefer for the cooler, less variable light, but has huge French windows. But Turner liked to entertain, and this is the only space that could have made a drawing room. In fact, he carried his notebooks with him all the time and sketched everywhere: on coaches, in the mountains, on the sea, by rivers in

# London Bridges

The geography of London did not decide where London Bridge should be built. The bridge decided where London should be. Although London Bridge is said to have been sited at the lowest point of the Thames where a crossing was feasible, it seems likely that Roman technology might have stretched further but Roman practicality decided the issue ('let's get the thing built; never mind about half a league onwards'). Maybe the proximity of Ludgate Hill clinched it. So the occupation forces built the bridge, in about 52 AD and, like all wooden bridges, it soon fell down, perhaps encouraged by Boudicca. Succeeding bridges included one of mixed stone, brick and wood, which may have lasted until the Roman occupation ended in 410. The next references to it are in the late tenth century after King Alfred had rebuilt London, then of tolls being collected in the year 1000. Then, the big one: King Olaf of Norway attacks London in 1014 and pulls down the bridge. Hence

> London Bridge is broken down.
> Gold is won, and bright renown ...

Unluckily, the supposed Old English version is only a rumour and the *Anglo-Saxon Chronicle* does not cover the battle. Yet the old rhyme persists, in variations, even as nurseries fade away.

Starting from Hampton Court upstream to Tower Bridge there are at least 30 bridges (20 for road traffic, 10 for trains), but also several footbridges and many tunnels, mostly for road traffic and trains, some for pedestrians only. The bridges often replaced old horse ferries (see Horseferry Road off Lambeth Bridge, celebrating the previous ferry linking Lambeth and Westminster Palaces). Judging by the faces of commuters pouring out of London Bridge station, even without T. S. Eliot's brown fog of a winter dawn, people still take the bridges as a humdrum part of the workaday scene:

> A crowd flowed over London Bridge,
> so many, ... And each man fixed his
> eyes before his feet.

The bridge itself can never again be as pretty as when it was covered in shops and houses, as portrayed by Samuel Scott, London's Canaletto, a few years before the buildings were cleared away by 1763. Constable painted the opening of Waterloo Bridge on 18 June 1817, a crossing much fought for and mourned when it was knocked down, though the bridge that replaced it in the 1940s, built with the architectural overview of Sir Giles Gilbert Scott (of the K2 red phone boxes), is surely one of the finest in the world: white Portland stone (self-washing in rain), lithe in outline, five easily paced elliptical arches each with a span of nearly 240 foot, beautiful to look at and beautiful to look from at London. Anyway, I would sooner have kept the Constable painting of the animated scene at the opening than the original bridge itself, and to accompany it into my personal museum without walls, of André Derain's several paintings of the Thames, I'd help myself to the one of which the *Daily Telegraph* critic Richard Dorment wrote: 'In *Barges on the Thames*, for example, a dark green locomotive thunders across a purple bridge under a salmon-pink sky, while the river below ripples with touches of lime green, yellow, emerald green, and blue.'

A short list of favourites then: Hampton

Court (Lutyens's Wrenaissance to match the real Wren in the Palace); Richmond and Teddington locks with their footbridges; Albert Bridge, floodlit after dark… you expect the imminent appearance of pierrots; Waterloo; and, yes, the latest mistakenly abused London Bridge.

Bring on the pierrots: a twilight moment enhances the filigree delicacy of Albert Bridge.

England and abroad, inside houses and outside. He built Sandycombe Lodge in Twickenham in 1813 precisely to escape the pressures of London life and the canvas on the easel. So the short answer is that in this house he didn't want a studio.

It stands on the narrow plateau above a slope on a plot he had bought four years earlier. Turner was a dedicated angler. The son of H. S. Trimmer, an old friend, recalls fishing as a young boy on the Thames with Turner: 'He threw a fly in first-rate style, and it bespeaks the sportsman whenever the rod is introduced into his pictures.' And he adds that when Turner succeeded, 'he insisted on my taking the fish, which he strung on some grass through the gills'. That tallies with the story of Turner himself digging out a pond in the garden into which he could release his catch.

The bigger question about the house is the background whisper that he was helped in its design by John Soane. Turner and Soane had become friends at the Royal Academy, and allies in a democratic faction against a claque of royalists. In 1809, when Soane delivered his first lecture as Professor of Architecture, Turner helped him with the illustrations, and it could be that two years later Soane helped with the house. The impact on first looking through the front door is powerfully Soaneian: a short lobby culminating in four arches at right angles, one at the end of the lobby, another above the entrance to the drawing room straight ahead, and two at the beginning of corridors leading left and right. There it ends, just a gesture towards the richness of effect Soane strove for with mirrors and light, alcoves and domes; enough for the 'unpretending little lodge', as the younger Trimmer described it. It seems far more likely given the pages and pages of Turner's sketched plans that the painter's eye picked up enough from Soane's practice for his own needs.

In short, it is a small villa, in a lane that was unpaved at the time. The suburb came with the railway in 1845. Externally there never was any of the Greek grandeur of Soane's Pitzhanger, though around the back over the garden there are the remains of a course of triglyphs, flattened and more Soane than Doric. The house and garden both are dilapidated, but the *genius loci*, the sense of the painter indulging himself with rod, line and architect's drawing board, is strong and moving.

40 SANDYCOMBE ROAD, TW1 2LR

## ALL HALLOWS, TWICKENHAM

*A Lombard Street church that mislaid a congregation and found Twickenham*

On the face of it, November 1940 was not a promising time to consecrate a newly built church in London. The sermon by Geoffrey Fisher, Bishop of London, was delivered to the accompaniment of anti-aircraft fire. All Hallows, Twickenham had been swiftly built after the peacetime demolition (July 1939) of Wren's All Hallows Lombard Street, a much-loved church that had run out of congregation. When the other 30 or so City churches fell to bombs or the wrecker's ball their flocks were assigned to adjoining

parishes, but the church in its wisdom recreated All Hallows Lombard Street in the relative safety of this western suburb, separated from the Rugby Union stadium and headquarters by Chertsey Road. The architect, Robert Atkinson, faithfully rebuilt the Portland stone Wren tower and then added a big boring brick barn for the body of the church, vestigially similar to a pared-down Wren building, and linked to the tower by a cloister. The surprises are all inside.

Before the wrecking ball swung, the removal men shifted everything from reredos to lord mayor's ceremonial sword rests and church bells out of Lombard Street and in due course into Twickenham. The reredos is the most spectacular piece here and the congregation suggests Grinling Gibbons as the author, but the design has none of his spaciousness and the detail little of the abundance and freedom of his carving. But that is only to say that the All Hallows reredos is not by a genius; it is still a fine piece from one of the many woodcarvers who worked with Wren. The pulpit, though big, is fashioned in the goblet style, standing on a slender stem. Its main distinction is historical: John Wesley regularly preached from it in Lombard Street, and in it first extemporised a sermon at a time when extemporising in preaching and in prayer was frowned upon. There are fine carved doors to the west of the church, a baluster font from St Benet Gracechurch carved in stone with cherubs' heads and an even finer font cover, and an early eighteenth-century organ in the west gallery. Wren might have fretted at the ill-adjusted set of fittings to building, but the church people are unsurprisingly proud of their happy inheritance.
CHERTSEY ROAD, TW1 1EW

## YORK HOUSE

*Twickenham's take on Renaissance Rome*

It is sometimes said of a building, 'I've seen better urinals.' That would be unfair to York House, a perfectly good mid-seventeenth-century house, 'plain and dignified' as Pevsner says, but its plainness has been degraded by various extensions to west and east and by conversion for use as council offices. Yet as it happens, unsignposted among shrubbery in the lovely garden, there is a small iron urinal (takes three men side by side), painted green for camouflage, embellished with embossed surface decoration, that looks almost precisely like one of those popular *pissoirs*, ubiquitous in French streets from the 1850s until a presidential edict during General de Gaulle's incumbency in the 1960s got rid of them as unbefitting the dignity of the nation. The modest English touch is that York House's *pissoir* reaches to the ground, thus depriving passers-by of the popular spectator sport of the sight of legs, knees down, reaching below the level of the urinal's skirt, and also that it is embossed inside with the well-remembered slogan, 'Please adjust your dress before leaving.' Is this unusual feature French or English? And who can have commissioned it?

The last owner but one was Prince Philippe, Duke of Orléans, pretender to the throne of France from 1894–1926; but he seems an unlikely contender. A closer

guess might be its last male owner, Ratan Tata, given his practicality. He was one of the family of priestly Parsis who set up the Tata Group in the nineteenth century, to this day family-owned: it has interests in steel, automobiles, air transport, chemicals, Taj Hotels and hundreds of other companies, a gigantic Indo-international conglomerate. Ratan and his wife created the horseshoe-shaped sunken garden behind the house, and the Chinese stone bridge that crosses a narrow lane to an outer garden close to the Thames. Ratan and Navajbai gave away houses as if they were baubles, though after Ratan died in 1918 Navajbai, before returning to Bombay, sold York House to Richmond council, which uses it now as the town hall.

The gardens are open to the public, and the great attraction is another Tata innovation: the group of Carrara marble *Oceanides*, daughters of the sea, thought to have been carved on spec in the studio of the skilled but lightweight Roman sculptor Orazio Andreoni in the late nineteenth century. They are naked and larger than life size, and now frolic among the rocks of a fountain not much smaller than the Roman Trevi Fountain itself, though without Anita Ekberg to disport herself in its waters as in *La Dolce Vita*. They're of no distinction, and had been ordered from Italy by someone who died before taking delivery. The statues were still in crates, but Tata bought them and set up the fountain for them as the great set-piece of the garden. The ladies of Twickenham

The daughters of the sea: nineteenth-century Roman carvings bought on spec by Ratan Tata and installed in this rock pool at York House.

love them. Whatever your reason for being in the area, they will say, 'Ah, but have you seen the naked ladies?'
RICHMOND ROAD, TW1 3AA

## ORLEANS HOUSE GALLERY

*The chequered history of Orleans House, where the Duc d'Orléans went into hiding from Napoleon*

With not quite admirable insouciance, grubbers after quick profit demolished stately Orleans House on the banks of the Thames in 1927 and dug a gravel pit in its place. It had been built in 1710 for James Johnston, a retired secretary of state for Scotland. As the main part of this mansion fell, the next-door neighbour, Mrs Nellie Ionides, quickly moved to save the remaining part: the glorious Octagon Room, so redolent of a stirring chapter of Anglo-French history. It is a small free-standing banqueting hall fit for the entertainment of a king (George I) and a queen (Caroline of Ansbach, wife of George II), and designed by the Scottish Baroque master James Gibbs (1682–1754). Mrs Ionides bought it and the remaining garden landscape and, when she died in 1962, bequeathed it and the adjoining stable block and coach house to the people of Twickenham (these separate buildings are now art galleries and archives).

The Octagon, brick and stone with tall round-headed windows and brushed redbrick pilasters at each corner capped by urns on the parapet, gained its fame and lasting name when Louis Philippe, Duc d'Orléans, leased it for the two years 1815–17. Louis Philippe, although a

member of a cadet branch of the Bourbons, was a prince of the blood, the eldest son of the duke who had changed his name during the Revolution to Phillipe Égalité, but went to the guillotine anyway. His son, too, adopted the name Philipe Égalité, but when Napoleon returned to power in 1815 the prince prudently slipped out of France to Twickenham, which he already knew, and set up court in what would become known as Orleans House.

He returned to France in 1817, becoming its last king in between the revolutions of 1830, which installed him as the so-called Citizen King, and 1848, which deposed him. Louis Philippe's son, Henri, Duc d'Aumale, then bought Orleans House and remained there with his large family for nearly 20 years, living in splendour but making friends and, with his wife, becoming involved in local affairs. On his return in 1871 to the ancestral home in Chantilly, now the Musée Condé, he installed in the Tribune Room a painting of Orleans House among all the other family palaces as a permanent reminder.

Although he took with him most of the paintings and some of the fittings from the house, he fortunately left intact the Octagon, with its froth of plasterwork by Gibbs's favourite Italian *stuccadori* Giuseppe Artari and Pietro Martire Bagutti, its lively putti and relief busts, including one each of George II and Caroline attributed by the architectural historian Christopher Hussey to Michael Rysbrack, its Rococo domed ceiling gilded and painted in eau de nil and oxblood red, its marble fireplace with female nudes reclining on the pediment: altogether a jeu d'esprit marred slightly by the empty

frame from which a Panini fantasy landscape was stolen after the death of Nellie Ionides.
RIVERSIDE, TW1 3DJ

## ALEXANDER POPE'S GROTTO

*Where the gods and fate fix'd Pope*

The headmaster of Radnor House School welcomed his visitors cheerfully and said he hoped we would stay for the pedagogic part of the tour. He was, however, good enough to visit the grotto beneath the school first so that the faint-hearted among us could slip off before school time. As a welcome it was faultless, if not quite up to the original owner of the villa which the school has replaced:

> *Approach. Great NATURE studiously behold!*
> *And eye the Mine without a wish for Gold.*

This was Alexander Pope of course. 'The Gods and fate have fix'd me on the borders of the Thames, in the Districts of Richmond and Twickenham,' he wrote to his friend, the portrait painter Charles Jervas, when he moved to Twickenham in 1719 at the age of 30. He built himself a handsome villa with a garden on the far side of the road, and stayed there until his death in 1744. His overriding occupation for long stretches of the rest of his life was, first, to tunnel from beneath the villa under the road to the garden; next, to create a grotto at the entrance to the tunnel; and finally to transform the tunnel into an extension of the grotto, so that the Flemish bond brick structure became merely an armature for the fantastic cladding of Cornish 'diamonds' (quartz good enough for a lady's jewellery), petrified stone, chunks of rock from the Giant's' Causeway, snakestones, sea shells, Thames pebbles, shards of mirror, Egyptian verd-antique, amethysts, flints, and sculpture – herms on plinths, the bust of some kind of shaman sunk into a wall, Apollonian heads.

In 1725 Pope wrote: 'I have put the last hand to my works of this kind, in happily finishing the subterraneous Way and Grotto [a vain claim in the light of history]; I then found a spring of the clearest water, which falls in a perpetual Rill, that echoes thru' the Cavern day and night.' The spring, which shows at the garden end of the tunnel on an outline plan Pope drew, was an unheralded gift from the gods, and capped his pleasure in his achievement, which he could now claim, if he cared to, to be a nymphaeum, home of water nymphs. The society hostess Lady Montagu preferred to call it 'this palace plac'd beneath a muddy road'. Today, scholars shoot the breeze in arcane journals about whether Pope was a true Classicist big enough to indulge his deeper romantic instincts, or whether his Classicism was a sop to his patron Lord Burlington. Either way, the mildly grotty grotto is a fascinating relic, certainly more engrossing (I'm sorry, Headmaster) than the school that harbours it, but the 'perpetual Rill' has dried up and the grotto is no longer quite the place

This octagon room is the glorious fragment that remains of Orléans House, named after Phillipe, duc d'Orléans, who fled from Napoleon and lived here (1815–71) with a single interruption to be king.

*where Thames's translucent wave
Shines a broad Mirror through the
    shadowy cave;
Where ling'ring drops from min'ral
    Roofs distill,
And pointed Crystals break the
    sparkling Rill.*

RADNOR HOUSE SCHOOL, CROSS DEEP, TW1 4QG

## STRAWBERRY HILL

*Walpole's barefaced cheek, magic and invented Gothic*

To Strawberry Hill came Horace Walpole, man of letters (nine volumes of them), to turn a cottage into a Gothic dream: 'the prettiest bauble you ever did see', he wrote to a friend in 1747, when he took out a lease on the house that he was to buy outright two years later. 'Richmond Hill and Ham Walks bound my prospect;' he added, 'but thank God! the river Thames is between me and the Duchess of Queensberry' (the unfortunate lady who seems to have been popular with everyone but the king, with whom she had been over-strident, and Walpole).

Whatever he felt about the Thames as a defence against the duchess, Walpole's eye and mind's eye worked in harmony. The exterior is limewashed a brilliant ethereal white and among the thickets of spirelets on the roof are slender chimneys embossed with heraldic roses and fleur-de-lys. Walpole looked at a drawing of a rose window in old St Paul's Cathedral and translated it (harnessing the skills of Robert Adam) into a ceiling for the round room in the new tower at Strawberry Hill. He saw tombs in the Gothic churches of London and magicked them into fireplaces. He took Gothic tracery as a starting point for the faery filigree of windows. He had Gothic frames curving into ogee arches for the shelves in his library, but they swung outwards on hinges to reveal more shelves – pure design wizardry; and on the ceiling he commissioned the painting of a cod medieval ancestry for the Walpole family, rising from the same imagination that composed his Gothic novel *Otranto*. In the gallery he set portraits into webs of tracery beneath fabulous canopies. He invited friends to form what he called his Committee of Taste, and they were the forerunners in the archaeological correctness of Pugin, Ruskin and their followers; but Walpole's spirit was far from holy. His Gothic is utterly rococo in spirit, closer to the 'Hindoo' rococo of the Prince Regent's Brighton Pavilion of a few years later than it is to Pugin's sanctified solemnity. He topped it off with scarlet- and blue-damask-covered walls, and with an astonishing collection of genre scenes in stained glass from the Low Countries set into the windows. And he did it in the face of the prevailing orthodoxy of Palladian Classicism. Barefaced cheek was expected of Walpole and at Strawberry Hill he dished it out in full measure.

In 1923 the Catholic St Mary's College bought the house complete with the decently dull Gothic extension added half a century after Walpole's death in 1797. By

Pembroke Lodge, high in Richmond Park, home to the ex-Whig prime minister Lord John Russell and to his grandson Bertrand, mathematical genius and philosopher, who loved it.

the end of the twentieth century the site had become a campus with a state-of-the-art running track used by athletes in training for the 2012 Olympics, but the Walpole core had begun to crumble and it joined the English Heritage list of buildings in peril. It opened to the public in 2010 after £9 million worth of glorious restoration, a work in progress. Is it possible now on the evidence of Strawberry Hill, hemmed in by Twickers suburbia, to call the gifted amateur Walpole a genius? I should jolly well rococo.

268 WALDEGRAVE ROAD, TW1 4ST

## PEMBROKE LODGE

*The home and view where Bertrand Russell grew up*

It's a good place to drop by for a nice cup of tea and a bun. Outside, well hidden from the house, is parking for 500 cars, and beyond that the 3,000 acres comprising Richmond Park, royal hunting grounds made exclusive by Charles I's unpopular enclosure of the land in 1637 on the abiding principle that 'whosoever hath, to him shall be given… but whosoever hath not, from him shall be taken away even that he hath' (Matthew 13.12 et al). King Charles's brick walls are still there, and the park remains royal, but the masses come to take tea. The caff, as it has been under separate dispensations since the Second World War, is Pembroke Lodge, granted by Queen Victoria to the Whig Prime Minister, Lord John Russell. He described it as 'an asset that could scarcely be equalled, certainly not surpassed in England'. It became home as well to his grandson, the future 3rd Earl and, incidentally, philosopher, political agitator and mathematical genius,

Bertrand Russell (1872–1970). Little Bertie's parents died before his fourth birthday and so he spent his early years with his rather grander than usual grandfather and his grandmother, Lord John's second wife Lady Frances Anna-Maria Elliot-Murray-Kynynmound.

Pembroke Lodge is described on its website as 'a beautiful Georgian mansion in the heart of Richmond Park', which is not altogether wrong. But in his autobiography Bertrand Russell describes it as a rambling building, which is certainly true, with its addition of wings concertina-e'd into the north of the original six-bay main building with its attractive Tuscan portico and the two bays to each side projected forward. Russell remembers the beautiful garden studded with ancient oaks when it was falling into a wilderness around his antique grandparents as they spoke of times past, of Lord John's visit to Napoleon on Elba, or how his grandmother felt ill at Windsor Castle before Queen Victoria, who grandly relented: '"Lady Russell may sit down. Lady So-and-So shall stand in front of her."'

The first house on the site was a mole-catcher's cottage, then a gamekeeper's house, but after 1787 it was replaced by the core Georgian building commissioned for the Countess of Pembroke, a favourite of Mad King George. There remain elements of the early Georgian establishment, such as two elegant fireplaces in what is now the café's dining room, and plaster medallions in the hall and on the staircase, though it can never have been as splendid as the White Lodge, eastwards across the park and now devoted to training ballet dancers. But it had and has one inalienable asset, available to all visitors who choose to take their refreshments out on to the terrace: the view westwards across Epsom Downs to Windsor Castle, which, probably, was what made the house so important to Lord John and of which Bertrand Russell wrote: 'I grew accustomed to wide horizons and to an unimpeded view of the sunset. And I have never since been able to live happily without both.'

RICHMOND PARK, TW10 5HX

## ST PETER'S, PETERSHAM

*A church with a rare and wonderful Georgian interior*

Tucked along a lane leading to the Thames, St Peter's, Petersham masquerades very successfully as a remote country church. Yet a few feet away on Petersham Road, flanked by big handsome eighteenth-century houses, the traffic never ceases and pavements are so narrow that dodging the wing mirrors of passing double-decker buses is pretty well a necessity for harassed pedestrians. Externally, St Peter's is a charming dark redbrick church with a yellow rose climbing up the north wall and a crenellated tower hardly higher than the pitch of the church roof, sporting a naively oversized wooden cupola with weathervane. Inside, it's a church that escaped that favourite Victorian pastime of tearing out Georgian galleries and box pews.

The gaudy tomb of George Cole and his family in St Peter's, Petersham seems ancient now, and was old-fashioned even when it was sculpted in 1624.

## MEMORIAE SACRUM

GEORGIO COLE AVO NEPOTIQ HIC EODEM
TVMVLO CONDITIS GREGORIVS COLES
HVIVS PATER ILLIVS FILIVS
POSVIT

VNA LAPIDE HOC SVB VNO OSSA DVORVM SITA SVNT
GEORGII COLE AR AVI GEORGII NEPOTIS AVVS AOCIS
ETATIS MEDIO TEMPLI FVIT VXOREM FRANCISCAM PROLEM
VNICAM THOMAE PRESTON FAMVLI PRESTONORVM LIN-
COLNIENSIVM DVXIT QVE EVM DECVNDA SOBOLE CVI
FILIORVM ET FILIARVM QVINQ DEDAVIT SEPTEM PATRI
ADHVC VIVENTI MORS PRIVRIPVIT QVI IAM DISCIDEN
SVPERSTITES RELINQIT FILIOS TRES GREGORIVM QVI
IANAM GVILIELMI BLOIRE ABOYDIAN IN COM CORNAL
AR FILIAM VXOREM DVXIT GEORGIVM AVO CONSE-
PVLTVM GENVIT THOMAM ET ROBERTVM FILIAS ITIDEM
TRES QVE TRIBVS CIVIBVS LONDINENSIBVS NVPSERVNT
FRANCISCAM QVE RICHARDO HACKET IOHANNAM QVE
EDWARDO MOWSSE ET ELIZABETHAM QVE HENRICO
LEE NEPOS AVO PRAESENS IN IVNIIS QVADRIMVS AN EIVS
DEM MENSIS 23 SEPTVAGENVS OBIIT ANNO DNI
1624

SISTE GRADVM, FORTIS&Iacute; NEMEC MORTALIS SPECI
ILLVSTRIVM, EN FATO CORPORA BINA AVO
PENE SIMVL DEFVNCTO, NEPOS MODO IRIDA VIVO
CARA SENI, EXTNECTO NVNC COMES ILLE AVO
LVSTRA SENEX BIS SEPTEM AVI FELICIA ELVXIT:
QVARTA SED HVIC PVERVM BRVMA RENATA RVIT
HIC AEVVM EVASIT SENIO SATVR ILLE RECESSIT
NEC PLVS VIVERE FAS, NEC VELLE ILLE MANVS
NIL HABET INVIDA IPSA SENI QVO VELLET ANNVS
NIL SPES QVOD PARVO NON QVOQ BLANDA DEDIT
ERGO ITIS HAS LACHRIMAS AN ARTA ET FVNDE VIATOR
QVEM DVBIO MISERO TVRBINE FATA ROTANT

FRANCISCA VXOR PRAEDICTI GEORGII
COLE OBIIT 15 DIE IVLII IN ANNO
DOMINI 1633

Instead, when the south transept was enlarged in 1840, the gallery was actually extended and box pews added. All higgledy-piggledy, this is not art but it is heartwarmingly pretty.

All that remains of the thirteenth-century church is a chancel no bigger than the wardrobes in houses of the neighbourhood; in any case it looks like a hasty addition rather than the oldest part of the building. The main body of the church is sixteenth to seventeenth century, when the west tower and north and south transepts were added. The transepts are a real eccentricity because they constitute the biggest part of the church. Anyone entering through the west door under the tower is confronted by the improbable chancel no further than a decent nave's width away; the north transept looks like the beginning of the nave and one's automatic reaction is to turn to the right to look for altar and chancel; instead a ceiling-to-floor organ blocks most of the south wall. The font, an elegant little baluster number (that is, the base looks like a single unit from a classical balustrade), stands as normal by the west door, but in Petersham's case this means that it's at the centre of the church. In the north transept there is a vertiginous pulpit made by a local carpenter in 1796.

Against the north chancel wall is a gaudy Tudor monument in scarlet, black and gold with the rigidly reclining effigies of George Cole and his wife and grandson, but the surprising thing is that it is not Tudor at all: Cole died in 1624, a year before the accession of Charles I. And it might have been expected that any memorial to Elizabeth Murray, Duchess of Lauderdale and 2nd Countess of Dysart, grand chatelaine of Ham House (see below), would have mightily outmatched Cole's, but her remains were merely deposited in a vault below the chancel.

CHURCH LANE, TW10 7AB

## HAM HOUSE

*A paradigm among great Stuart houses*

The Duke of Lauderdale, Elizabeth, Lady Dysart's second husband, died in 1682, having spent a fortune on extending Ham House and introducing a sequence of state rooms on the first floor. The year after Lauderdale's death Elizabeth ordered an inventory of paintings. This *Estimate of Pictures* survives and the National Trust house guide indicates with an asterisk those paintings which still hang in the house. I haven't counted the asterisks, but there are a lot. And it is the same story with the contents in general.

Sir Thomas Vavasour built Ham in 1610 but by 1626 William Murray, later 1st Earl of Dysart, was the owner. His daughter Elizabeth succeeded to the house and the title of Countess. She married the bereaved Lord Lauderdale in scandalous circumstances ('That it should come to this! But two months dead: nay, not so much, not two'). He was ruthless, autocratic, unpleasant and a favoured councillor to Charles II; she was avaricious and lubricious, and the double portrait by Lely hanging in the great hall gallery says as much. Between them they set about creating a paradigm among

Stuart houses. The downstairs rooms remained relatively unadorned, but for the state rooms the Lauderdales brought in Verrio to paint ceiling panels, and William van de Velde the Younger was only the most accomplished of the Netherlands artists who painted panels inset into walls; the plasterer Henry Wells created moulded plaster ceilings you could practically eat, and the joiner Thomas Carter panelled the long gallery in dark wood and created the pilasters with gilded garlands woven into the Ionic capitals. This is a very beautiful long gallery, shorter than most but with better pictures than almost any, including a rarity, a portrait of King Charles I by Van Dyck not, as was usual, a copyist, and presented by the king to Elizabeth's father.

Most of this work, even many of the damask hangings, survives along with the furniture and porcelain; yet the greatest survival is the most arcane: the green closet. This chamber, devised to display small paintings and miniatures under a ceiling and coving painted by Francis Cleyn, is the only one of its kind in England, and contains the finest collection of miniatures in private hands (now National Trust). The prize is a miniature of Queen Elizabeth by the greatest master of miniatures, Nicholas Hilliard (1547–1619). The queen appointed him royal limner (artist-illustrator) in 1570 but, as Hilliard testified, the portraits had to be shadowless political icons. Yet in all his work for the sovereign, he managed to maintain a poetic distance from politics, with a view of Elizabeth akin to Spenser's *Faerie Queen*, of whom, the poet wrote, 'living Art may not [in the] least Part expresse,/ Nor life-resembling pencill it can paint'. Spenser published those lines in 1590, the year that Hilliard exposed Spenser's flattery with a more dangerous one: this actual image of the actual bejewelled queen, watercolour on vellum, showing a pale almost transparent face against an ultramine background, long delicate white fingers, silvery-white organza ruff, embroidered white bodice and stomacher seeded with jewels, jewels in the hair, a glimpse of a peacock-blue cape showing between arm bent at the elbow and bodice. It is one of the finest of all Hilliard's works, though of the naturalist-leaning kind the queen had expressly forbidden (there is, just about, a human being among the finery). And the painting's listing is marked with an asterisk.

HAM STREET, TW10 7RS

## LANGHAM HOUSE CLOSE

*The New Brutalist of Ham Common, and what it portended*

The S-bend on Petersham Road leading from Richmond holds a group of some of the finest Georgian houses anywhere in the capital. As it straightens out it opens into the green, neatly triangular Ham Common (ignoring, that is, the woodland to the left flanking Ham Gate Avenue), and here is a collection of more modest Georgian houses with an enlivening scatter of earlier cottages and groups of modern buildings added to the mix. On Upper Ham Road is a short stretch of six 1950s shops built by Eric Lyons to serve his early, slightly tame, houses on Parkleys,

lying behind. Opposite, in Langham House Close, is a terrace of houses: the first swallow in the glorious summer of former paratrooper James Stirling (1924–92) after he returned from war.

In fact, the Ham commission, which Stirling won in 1955, prompted him to set up in private practice with the first of his partners, James Gowan, and the houses they built (occupied in 1959) were instantly dubbed New Brutalist. It's difficult to see why, unless Le Corbusier, whose Marseille flats were the prime influence, is the Old Brutalist. Looked at now against Alison and Peter Smithson's shamefully neglected Robin Hood Gardens housing in Poplar (also 1972) or Ernö Goldfinger's 1930s flats in Willow Road, Hampstead, never mind his 1960s Balfron Tower, Langham House Close seems civilised and English, at least by naturalisation. Yes, thick concrete floors carry broad exposed battered concrete flanks through to the exterior; the U-shaped rainfall outlets are the visual equivalent of a whack behind the ear with a sand-filled sock; there are acres of glass, divided though into louvres, and with smaller glazed windows, square or slit as in a barbican, for bathrooms; but there is also the mediating influence of lots and lots of yellow-brick walls that at least offer a nod of the head to a neighbourhood first populated when men wore powdered perukes and women promenaded in stomachers, wide skirts and silk stockings.

Stirling and Gowan had met when they worked in Eric Lyons's architectural office. Lyons cannot have avoided noticing his pupil's progress over the road in a development so much less cosy than his own. But for Lyons the domestic was to remain his yardstick. He was an architect with a sense of fitness and context, a feeling for the textures of wood, tile and slate. Stirling was an artist-architect, and Langham House Close is palpably a passionate work, aspiring to the sculptural, a work in which, like all artists, he has had to hold the passion in check. Stirling was to become internationally famous as the architect of enterprises like the engineering building at Leicester University, the Neue Staatsgalerie in Stuttgart, the post-modern Clore Wing for the Turners at Tate Britain, and the highly idiosyncratic Number 1 Poultry. It was in his stars and the intimation of it is there in Langham House Close.

RICHMOND, TW10 7JE

## • HAMPTON, EAST MOLESEY, KINGSTON •

### GARRICK'S TEMPLE TO SHAKESPEARE

*A Shakespeare temple from a great Shakespearean*

To this day David Garrick is lauded as one of the greatest actors in the history of theatre. We have to take it on trust of course, since there isn't even the briefest YouTube clip of a performance. He is said

The Shakepearean actor David Garrick built this temple to Shakespeare in his garden by the Thames in Hampton. It contains paintings and a portrait bust of the playwright.

to have supplanted mannered acting with naturalism; the Brando of his day. Samuel Johnson said that the death of his young friend Garrick 'had eclipsed the gaiety of nations', then added: 'and impoverished the public stock of harmless pleasure'. Perhaps that notably cool qualifier seems especially so in our hyperbolic age. Anyway, Dr Johnson preferred his Shakespeare in print.

Garrick himself was in no doubt that it was Shakespeare who had underwritten his fame and fortune – his mansion at Hampton and the garden over the road by the river (© Capability Brown) – even though he himself played King Lear in Nahum Tate's version with a happy ending, something Shakespeare had by no means envisaged. Anyway, here by the Thames Garrick built his Neo-classical Temple to Shakespeare in 1755–6 and installed in an alcove opposite the Ionic-porticoed entrance a life-sized figure of the playwright which he commissioned from Louis François Roubiliac. He bequeathed this statue to the British Museum (now in the British Library) and later, when the temple was rescued from dilapidation (final restoration 1998–9), the BM repaid Garrick's thoughtfulness by supplying a good replica for the alcove.

Robert Adam might have designed the small octagonal temple, goes one theory, though it seems too simple and unadorned for him. Or Garrick himself, with the help of Capability Brown? Or Garrick's near neighbour Horace Walpole? But the young art historian Tessa Murdoch argued persuasively in 1980 that Roubiliac, though not trained as an architect, frequently executed the smaller settings for his own sculpture and trained

his students to do the same. At Hampton, Roubiliac and temple as a single assignment make perfect sense.

Garrick seems to have assumed that the temple would not long survive his death, and it was luck that spared it. Everything inside is fake: the replica Zoffany conversation pieces of the Garricks reclining outside the temple or entertaining friends, a big copy of the Hogarth *Richard III* painting (the original is at the Walker Art Gallery in Liverpool), and theatrical engravings, but the effect is totally charming. Roubiliac's Shakespeare is close to the earlier Scheemakers version in Westminster Abbey, but livelier, a figure catching a thought on the wing.

Outside, the garden is dominated by cypresses, replacements for the originals donated by Walpole in October 1756. To his friend George Montagu he wrote: 'John [Walpole's gardener] and I are just going to Garrick's with a grove of cypresses in our hands, like the Kentish men at the Conquest. He has built a temple to his master Shakespeare, and I am going to adorn the outside…' Walpole had wanted to decorate it inside with Latin mottoes, but Garrick turned him down. Quite right too: as Ben Jonson had said, Shakespeare had little Latin and no Greek.

GARRICK'S LAWN, HAMPTON COURT ROAD, TW12

## HAMPTON COURT PALACE

*A tale of two kings, a bishop and a palace*

Hampton Court is the nearest thing we have to Versailles (without the Hall of Mirrors or the great crowds). It's a thought that strikes every visitor who sees the Long Water (three-quarters of a mile long) at Hampton Court and has been to the Palace of Versailles with its Grand Canal in its back yard. There the comparison stops. Hampton Court Palace will never incite a revolution whereas, with its overweening ostentation, Versailles in its glory days was a glittering provocation to the capital city on its doorstep. Hampton Court Palace has always looked out mildly on what may be the largest village green in England (though owned by the palace, not the village). Versailles is the result of the high talents of the architects, gardeners and artists singing from the same *livre de cantiques*; Hampton Court is a botched English job, but a magnificent botch for which we must thank God, Wolsey, Henry VIII, William III (not necessarily in that order) and the law of unintended consequences: King William hired Wren to replace what he saw as the gaucheries of the Tudors but fell off his horse in 1702 and died untimely with building incomplete.

So we have the rich historical panoply of the separate periods, starting with the eight terracotta heads by the Florentine Giovanni da Maiano, commissioned by Cardinal Wolsey in 1521 and disposed between the gateways to the three courtyards (binoculars help in getting a sense of the power of the modelling). Then there is Wolsey's chapel royal completed by Henry VIII's blue and gold vaulted ceiling, and an oak reredos by Grinling Gibbons replacing the huge stained-glass window smashed during the Commonwealth.

Wren was always going to leave Henry's Great Hall intact (maybe having received privileged advice from the king),

but the rest was intended to be a mighty Baroque palace. What we have instead is Wren's long east façade, a shorter north wing, otherwise the original Tudor plan of accretions around the main courtyards. The third of these is now Wren's fountain court, no bigger than a medium-sized cathedral cloister, redbrick pretty as paint, an arcade, tall first-floor sash windows (among the earliest), small windows within circular garlanded frames on the second floor, one of the four sides blank to allow for paintings, now faded, of the Labours of Hercules (translate as William III), square windows on the third floor and a balustrade all round. The size is everything here, because the palace's east façade composed of the same elements stretches too wide and the composition loses coherency. But then Wren did have the saviour of the nation peering over his shoulder and poking his nose in.

An earlier candidate for the role of saviour of the nation, Oliver Cromwell, moved into the glorious palace of the Tudors and defeated Stuarts following Charles I's execution in 1649. Of all Charles's huge collection of paintings that Cromwell scattered to collectors abroad, the one he kept, presumably as fitting to to his own dignity, was *The Triumphs of Caesar* by the fifteenth-century master Andrea Mantegna. It consists of nine canvases each nine foot square (painted in 1492), gleaming in the half light of the Lower Orangery entered from the gardens of Hampton Court, separated by pilasters along the length of the building. Mantegna painted them for the Gonzagas, rulers of Mantua, over the course of nearly a decade towards the end of his life. Charles I bought them at the Gonzaga sale in 1629 when they were still the most famous paintings of the fifteenth century; they have remained in Hampton Court ever since, accelerating towards oblivion and their reputation fading along with the painted surfaces. Mantegna seems to have worked in distemper, but all the restorations from the seventeenth century until the most recent seem to have been done without knowing whether his preferred medium was egg-based or glue-based. That was disastrous enough, but early in the twentieth century the critic Roger Fry, though he had no very evident expertise in restoration, was let loose on the canvases. Finally John Brealey, the pre-eminent conservator of his day, worked on them from 1962 to 1974, saved them, reversed some of the damage, and revealed what remained of Mantegna's own brush-work which, especially in the passages like white tunics, looks like broadly applied pastel: even some twentieth-century artists used distemper precisely to recover that chalky finish. Anyway, the restoration is a triumph to add to the *Triumph*.

The nine canvases effectively form a frieze depicting a procession, preceded by trumpeters and followed by standard bearers holding up paintings of Julius Caesar's victories, bulls prepared for sacrificial slaughter, elephants, trophies of captured armour carried aloft on poles, prisoners (on the one canvas that cannot be restored because none of Mantegna's paintwork survives beneath the repainting, only the design), and, bringing up the rear, Caesar in his triumphal chariot, a vehicle that seems carved from stone and drawn by a sculptured horse from a stone plinth.

I like to think of Mantegna plotting the sequence, working on the balance between living art and ancient history, working out the continuity of design and colour like a magazine art editor shuffling small dummy pages. Who knows? But we do know that the Gonzaga who commissioned the sequence was himself a leader of mercenaries, a *condottiere*, so Mantegna's paintings were a tribute to a general of his own time in the form of a tribute to the noblest Roman of them all.

EAST MOLESEY, KT8 9AU

## STATUE OF QUEEN ANNE, ANCIENT MARKET PLACE

*A long-suffering queen, gleaming in gold by a town's command*

On a good day along the Portsmouth road entering Kingston, the glitter of sunshine, the sailing craft on the river and the holidaymakers on the towpaths remain strikingly similar to the upriver Thames that the Impressionist Alfred Sisley painted in 1874 on the first of his occasional brief visits from France, his birthplace, to the land of his fathers. Kingston itself, although it is irredeemably modern under the primary influence of its gargantuan department store Bentall's and the merely big John Lewis, retains some of the charm of a country town, with the picturesque Clattern Bridge of the twelfth century crossing the fast-running Hogsmill river and the little warren of short streets and tiny alleys leading from Market Place to Apple Market and from High Street to Bath Passage to Guildhall. The buildings, again mostly modern though the occasional first-floor overhang suggests a much older structure, retain the variety of width, height

and roof levels that enliven the multiple vistas of the town centre.

In short, it's a place with charters from the time of King John, a historic church and an ancient school, though history in this multifarious shopping town only occasionally manifests itself openly, for instance in the Coronation Stone near the Guildhall on which, it is just feasibly claimed, Saxon kings sat to be crowned, and certainly in the statue by Francis Bird (1667–1731) of Queen Anne on the Market Hall terrace overlooking Market Square.

Queen Anne was small-minded, ill-educated, jealous, obstinate, and immensely popular with her subjects. The statue of the queen outside St Paul's Cathedral (unveiled in 1713) is the best-known of the three Bird made of her, though actually what stands there now is an ignoble copy of the original, which decayed badly and was carted off by the popular Victorian writer Augustus Hare to Holmhurst, his house at St Leonards-on-Sea (where it remains). In 1719 a benefactor commissioned another Bird statue for Minehead on the Bristol Channel coast in which the queen looks older but no wiser. Kingston's is the oldest of the three. Bird made it to order for the borough in 1706 and was paid £47 18s 6d.

As might be expected she looks younger than in his later sculptures, although it must have posed a problem for Bird because Anne was already worn out and effectively crippled by a series of pregnancies. There were to be 17 in 17 years, all but five ending in miscarriage or still births, and none of those five surviving long. So if she looks plain and grumpy it's not altogether surprising. However, the Kingston statue is becomingly decked out in gold paint, Anne's dress is closely embroidered with big flowers, a long gold cord is tied at her waist and the tassels hang down to her feet, she has a string of pearls at her throat and carries the orb and sceptre, so perhaps it wasn't all bad.

KINGSTON, KT1 1JS

## EADWEARD MUYBRIDGE GALLERY, KINGSTON MUSEUM

*Photographs that changed the world*

By the late 1870s Edgar Degas had given up trying to paint racehorses in action. The best models he could find were by his predecessors, Théodore Géricault and the father and son team of sporting painters and print makers, the Alkens, but neither the French genius nor the English journeymen seemed to Degas to have it right and he himself, Degas felt, came no closer. In the end, his problem was solved by a photographer from Kingston upon Thames.

This was Edward Muggeridge, born in 1830, four years before Degas, to a father who was a corn chandler and a mother from a family who worked barges from wharves at Hampton Wick. Edward did not see a future for himself in these occupations. He envisioned his destiny in America, but first he needed to equip himself with a more romantic name,

Grumpy but popular, Queen Anne was the subject of three statues by Francis Bird, the main sculptor at St Paul's Cathedral. This one looking down into the ancient market place in Kingston is the oldest.

borrowed from the plinth under the small square boulder which the town elders had recently displayed in the town centre (see page 313) on the confident assumption that it was the Coronation Stone upon which seven Anglo-Saxon kings had sat to be crowned, including Edweard the Elder and Eadweard the Martyr. This regal spelling suited Edward exactly: he adopted it, edited his surname to the more acceptably exotic Muybridge and embarked for New York.

His colourful early years included joining the California gold rush (fool's gold for him, but he did well from a bookselling business in San Francisco) and shooting his wife's lover dead, but being acquitted of murder by a jury's sympathy vote. He took up landscape photography and, backed by Leland Stanford, president of Central Pacific Railroad, perfected a technique of rapid-fire photographic exposures of horses in motion on Stanford's stud farm at Palo Alto, California, which incidentally demonstrated that a galloping horse is airborne part of the time, though not with legs stretched out fore and aft as paintings had been showing. *Voilà*! Degas became the latest and greatest of horse painters.

Muybridge was living in Kingston again when he died in 1904, leaving £300 and a collection of his photographic prints and plates to the museum. There is always a residual selection of his bequest on display among big box cameras and his proudest invention, the Zoöpraxiscope, a solid construction of wood and brass for projecting the flickering images which anticipated cinematography. The bleak objectivity of these images attracted artists beyond Degas: the American Realist Thomas Eakins, the Futurists and, in our own time, Francis Bacon. Muybridge had extended his studies to other species, notably homo sapiens, stark naked, and Bacon assembled dozens of these in an image bank for his own paintings of corrupted man, Muybridge male wrestlers adapted to obscure sexual grapplings, a strange child on all fours pitilessly transmuted to a nameless horror. Arguably Muybridge's camera-eye vision, without the presumption of original sin, makes the point better, closer to King Lear's view of the human race: 'unaccommodated man is no more but such a poor, bare, forked animal as thou art'.

WHEATFIELD WAY, KT1 2PS

## • WIMBLEDON, CHEAM, CARSHALTON •

### WIMBLEDON GREYHOUND STADIUM

*Going to the dogs*

Hello, and welcome to the 1950s. We're at Wimbledon Stadium in Plough Lane, not the rural idyll the name might suggest but a shabby inner-town street that has mushroomed as a straggle of prefab warehouses, yards, paint shops and the stadium, built-in obsolescent going on obsolete. It comes to life on Greyhound Derby Day, but although today's is an ordinary weekday meeting the bookies

are there, the bars are open, the lights are on and the crowd, which starts in the low hundreds, grows to the low four figures during the evening. So Wimbledon dog track (like the one at Romford) survives tenuously. There are conflicting plans for its future, some of them involving football and dogs, but houses seem the safe bet since a house-building firm has a big share in the site. If that happens, Wimbledon will go the way of Catford Greyhound Stadium, now a Tesco, just as Hendon dog track has become Brent shopping centre, Walthamstow has given way to housing, White City too is under bricks and mortar, and West Ham, Hackney Wick, Clapton, Harringay, Wembley and others are all gone. Many of them looked in better nick than Wimbledon does.

Should the sport go, that would kiss goodnight to a major twentieth-century episode in popular culture. The first organised greyhound race meeting in England was in 1926 at Belle Vue Stadium in Manchester, so it is a new sport, but it grew out of hare coursing, with whippets released in pursuit of live hares in the northern out-of-town bleaklands. Though coursing attracted gamblers too, greyhound racing *is* gambling. Today banners blazon the name of William Hill, sponsors of the sport and of the dog Derby, and television beams afternoon meetings directly into betting shops. On course, the bookies hunch over the *Racing Post,* tightly folded open to the columns of dogs' form, and the gaudy lights of their trackside booths add visual zing. There are a bar (beer and burgers) and a restaurant (say, sirloin or sea bass, Lanson champagne). Boards with the names of Derby winners lettered in gold bestow a spurious solemnity on the enterprise.

For an evidently dying form of entertainment the surprise is that the fans are mostly young, mostly couples, and some of them with tiny babies in those groovy shopping basket-type carriers. Cheering and booing might ironically be said to be post-modern irony, becoming more ironic as the beer flows. They have come for a good evening out, and the dogs are almost incidental although to a newcomer their speed out of the traps is phenomenal: they are said to go from 0 to 40 m.p.h. in a second on an oval 380 metres in circumference (20 metres shorter than an athletics track), with tight bends that scarcely slow the hounds. The fans seem happily oblivious to the decay all around. Basic grandstands give protection from the weather on every side of the stadium and on the Plough Lane side bars and restaurants are behind glass. Nightfall and floodlights shining into the arena are the stadium's close friends.

Outside the ring of light a review of greyhound racing by Lord Donoughue in 2007 said that 10,000 dogs left the sport each year, a lot of them to be slaughtered. His report caused the creation of a reformed governing body, the Greyhound Board of Great Britain. Its headquarters is Wimbledon Stadium and you have to hope that the stadium's slogan, Love the Dogs, is more than just words. And that there's something left for those babies in baskets to look forward to when they grow up.

PLOUGH LANE, SW17 0BL

# Riverside Houses

The most popular house on the Thames was for many years Starlings, a large middle-class house and garden with a private landing stage and a motorboat. For this was Mrs Miniver's house, from which her husband Clem navigated the Channel to help in the Dunkirk evacuation. If the address is hard to locate, that is because it was 10202 W. Washington Boulevard, Culver City, California. MGM built the house on a movie lot there and *Mrs Miniver* went on to win one Oscar for its anglophile director William Wyler, another as hit balderdash of 1942, four more for cast and cinematography, and six nominations (Walter Pidgeon lost best actor to Jimmy Cagney in *Yankee Doodle Dandy*). Churchill may or may nor have said that as propaganda it was worth five battleships (or pick any number up to a hundred).

The river the studio gave Starlings looked nothing like the Medway and realistically could only have been an inlet off the Thames approach to Richmond. Clem Miniver (Pidgeon) was a successful architect, which would have made him comfortably rich. Today the river is probably only for the filthy rich, as it was in its great period for houses, the seventeenth and eighteenth centuries plus a handful from earlier centuries (Henry VII's Richmond Palace, now destroyed but leaving an interesting site, Ham House, Hampton Court Palace, Kew Palace and Syon House, the earliest of the lot but most notable for its Adam interiors). This riverscape was away from the hurly burly of Westminster and the City, and further away again from industry. It must have been the soft landscape that attracted Lord Burlington to Chiswick, Henrietta Howard to Marble Hill, and Horace Walpole to Strawberry Hill.

'The prospect is delightful, the house very small, and till I added two or three rooms scarce habitable,' Walpole wrote to a friend in 1748, soon after he had acquired it. He was, of course, already bubbling with Gothic ideas, not at all the sort of thing that Burlington could possibly have approved, though he himself professed admiration for the noble lord.

Probably Burlington's closest connection, though, was with Alexander Pope, a friendship based on mutual admiration. Pope's poetic genius was not in question and he may have regarded Burlington as an architect of genius. At any rate, he warned in his *Epistle to Richard Boyle, Earl of Burlington* of the danger of imitating Burlington's neo-Palladianism at Chiswick House:

> Yet shall (my lord) your just, your
>    noble rules,
> Fill half the land with imitating fools;
> Who random drawings from your
>    sheets shall take,
> And of one beauty many blunders
>    make.

Despite this, he himself took the chance by building a Palladian villa and a grotto linking the garden by the Thames to the villa north of the road. Nobody accused him of blundering, and James Gibbs embellished the villa, but it is long gone. The grotto survives.

When Burlington first visited Italy in 1714–15 he was not at all engaged by Palladio's villas. He caught the bug with the publication of the three volumes of Colen Campbell's *Vitruvius Britannicus* in 1715–25, in which his introduction included an attack on the

baroque introduced by the Wren generation; the third volume included his own Palladian plans for Mereworth Castle in Kent (1720–5). Campbell took Palladio's Villa Rotonda near Vicenza as, more or less, his template and so did Burlington in 1725–7 for Chiswick. Chiswick is much admired, held up as the English exemplar of Palladianism: it's a fine building but seems uneasily severe, designed as a weapon in Pope's style wars. Mereworth catches the ease of Palladio, and Campbell went on to help Burlington until William Kent joined the entourage as his protégé.

In all of this, the outstanding addition to a perfectly cultured English landscape (not the original garden) is Roger Morris's Marble Hill House for Henrietta Howard, mistress to George II and mistress of the robes to Queen Caroline; she used the house as an escape from these functions, the tittle-tattle of court, and from her grasping and abusive husband. It is a white stucco house in perfect harmony, elegantly balanced, looking back to Inigo Jones and the unfussed play of his buildings between mass and the perfectly placed space of doors and windows.

The batsman hits a boundary on the Great Field before Marble Hill House, just as a predecessor might have done in 1729 when Henrietta Howard's emblematic Palladian residence was ready for her.

## SOUTHSIDE HOUSE

*Real Van Dyck, fun 'rococo' interior*

During the restoration process after a fire in Southside House in 2010, workers uncovered a bricked-in space that contained a service revolver, a Sten gun and two sticks of dynamite. Major Malcolm Munthe, who had lived in the house until his death in 1995, was parachuted as a Special Operations Executive agent into Norway in 1940 to sabotage railway and other communications, was wounded and later, reverting to his role alongside the Gordon Highlanders, mortared in the Anzio landings. Meanwhile Southside had been bombed and by restoring it he found peace and put the events of the war behind him. Had the fire of 2010 reached the hiding place, Southside House would have ended up in fragments scattered over Wimbledon Common. Instead it survives divested of dynamite, an extraordinary living relic partly for the dissimulation involved in its appearance and realised by Munthe, partly for its contents representing a slice of English history from the reign of Charles I and the English Revolution.

The building first. The façade, built by the original owner, the royalist Robert Pennington, dates from 1687 (though the foundations are Jacobean) but the house is divided horizontally and the rear of the building is Georgian. There are two blocked-in doorways in the façade, entrances presumably to the original building designed as two grand semi-detached houses, now with (post-1945?) niches for antique statues of *Spring* and *Plenty*. There is a dodgy Doric doorway and behind this Munthe designed a double-height hall with a faux-rococo ceiling painting by his brother Peter and wooden piers and gallery leading off to rooms front and rear, one of them a 'tapestry' room hung with painted sacking, it is said from the eighteenth-century Vauxhall Pleasure Gardens; another room, intimate and cluttered, for the war-haunted hero himself.

Munthe was the son of Axel Munthe, the Swedish author of the century-long bestseller, *The Story of San Michele*, who had married Hilda Pennington, a descendant of the house's builder and first owner. To her wealth embracing many fine *objets* like a pearwood Pleyel piano, Waterford crystal chandeliers, and eighteenth-century French fireplaces, he brought his own magpie collection of articles from his mansions scattered about Europe. To top all this Malcolm Munthe's friend and wartime contemporary Lord Wharton, also a distant relative, added a bequest which included several Van Dyck portraits commissioned by a Wharton ancestor, a courtier of Charles I. They're well authenticated (something that needs to be said given the mass production from Van Dyck's studio plus Munthe's own mischievous gift for inventing pedigrees). These remains of Lord Wharton's collection are a lucky survival: after his death most of his collection went to Robert Walpole's collection at Houghton Hall and subsequently to the Empress Catherine's collection in St Petersburg (now the Hermitage Museum). In Southside there's also a splendid portrait by Hogarth of Charles Kemeys-Tynte, who was another Wharton, and a

Constable study unusually dramatically lit but also authenticated by Tate Britain.

A visit is a journey through time, real and fantastic; but one suspects that the favourite treasure for Malcolm Munthe was the garden his father and mother had started and upon which he lavished time and money. Much like the house.

3-4 WOODHAYES ROAD, SW19 4RJ

## ST MARY THE VIRGIN, MERTON

*A quirky Victorian church barely concealing its medieval origins*

The first clue to St Mary Merton's age is that extreme rarity, a fifteenth-century timber north porch and an internal door with long Norman hinges culminating in C shapes like Saracen swords. The nave is Norman, the chancel thirteenth-century with a small hammerbeam roof lent splendour by coved ceiling boards tight between the beams. And there are Norman sections from 1125, its foundation year: a reincarnation of the church from the time of Edward the Confessor of which nothing remains. A good medieval doorway in a churchyard wall was a late addition, found in 1914 at the site of Augustinian Merton Priory which had stood on the banks of the River Wandle until its demolition in 1537. So behind its modern cladding of flint St Mary's is not the sweet, quirky nineteenth-century church for the suburb it inhabits that it at first seems. As it happens the suburb, Merton Park, is worth celebrating too, and in fact has been designated a conservation area.

The builder was the businessman John Innes (1829-1904), best known as the inventor of the branded compost produced by the John Innes Centre for plant science.

Within the church is one of those grandiose monuments that ease the passage to the hereafter. R. J. Wyatt, a nineteenth-century English sculptor who went to Rome to work for Canova and stayed for life, carved a Neo-classical memorial of a mourning woman for Elizabeth, widow of the circumnavigator of the Southern Seas, Captain James Cook, to commemorate her widely flung family but with only a glancing reference to her husband: despite the six children they had, she must scarcely have seen him.

And then there are the funeral hatchments of Horatio Nelson, artistically insignificant but with glancing interest historically. The only home he ever owned was Merton Place, where he lived with his mistress Emma Hamilton and Emma's husband, Sir William, in apparent amity. Soon after his death at the Battle of Trafalgar the house was sold to pay Emma's debts, and later pulled down. It had stood close to the site of the priory and the sheds built for the sixteenth-century dyers of calico who had arrived in the area as refugees from the continent. The sheds remained when William Morris came looking for a factory to call his own. Here he set up his whole enterprise, and from the factory at Merton Abbey, as the site was renamed, Morris & Co. supplied the memorial for John Innes: four stained-glass windows in the parish church south wall. But by the time the windows were inserted in

1907, Morris and his collaborator Burne-Jones were dead and the quality of Morris & Co.'s output was declining. Still, these mundane pattern-book biblical figures standing in pairs, Isaiah and David, St Mary with the Christ child and St John the Apostle, St Paul and St Stephen, Moses and Abraham, have the full bloom of Morris colour and knock the other Victorian windows in the church into a cocked hat.

CHURCH PATH, SW19 3HJ

## WHITEHALL, CHEAM

*A triumph of the ordinary with an extraordinary history*

The village of Cheam has bus services, its own railway station, a Costa, a Waitrose, a Majestic Wine, a William Hill, and a Pizza Express. It is so unlike the dear Cheam High Street of the cosy pre-First World War photographs by Francis Frith and barely distinguishable from a thousand other characterless urban high streets. But away from the High Street, Park Road is punctuated with old farm houses, cottages, the Olde Red Lion pub... memories of a rural past. There is more of the same in Malden Road, where seventeenth- and eighteenth-century houses and a Georgian rectory add to the mix.

Then there is one house dating from about 1500. This is Whitehall, a hall house just new enough to have been built with two storeys instead of with a house-high hall open to a hole in the roof for the smoke to escape. It's white (though that is only the least unlikely of several theories about how the house was named), weatherboarded, jettied, has a drunken

two-storey porch, a melange of stairs which met at the top of the house when the owner pushed a newel staircase up to the new loft conversion, a crown post roof and closely studded timbers, an indication that oak in the neighbourhood still grew like weeds. It is an archetype of the south-eastern domestic tradition accreted over 500 years, but with the charm laid on so thick that it can stand as a paradigm of the triumph of the ordinary.

In fact Sutton borough runs it as a museum with help from the volunteer Friends of Whitehall. Cheam School [prep], was active in 1645, when its first headmaster seems to have lived there. Prince Philip was educated there before it moved to Hampshire, and Prince Charles after the move. But the school may have started at Whitehall. A chamber in the roof is done up as a teacher's room, but in the manner of 1861 when, that year's census shows, three Cheam schoolmasters lodged here. The room above Whitehall's porch is dedicated to William Gilpin, another headmaster, from 1752-77, who fined pupils for misbehaviour instead of beating them, thus at a missed stroke enhancing school funds and ensuring his reputation for advanced views. His main celebrity, alas, depends more on his doctrine of the Picturesque (the category between the beautiful and Edmund Burke's downright sublime), satirised in Thomas Rowlandson's Dr Syntax prints (some are in the porch room), and in Jane Austen's *Northanger Abbey*, when Catherine accompanies a

Whitehall is a house that raises ordinariness to glory, half-timbered, weatherboarded, crooked floors, inglenook: time's intervention into art.

Gilpin-like character to a viewpoint above Bath where:

> *He talked of foregrounds, distances, and second distances – side-screens and perspectives – lights and shades; and Catherine was so hopeful a scholar that when they gained the top of Beechen Cliff, she voluntarily rejected the whole city of Bath as unworthy to make part of a landscape.*

What would Gilpin or Austen have made of Cheam today?

1 MALDEN ROAD, SM3 8QD

## ST DUNSTAN'S, CHEAM

*Lord Lumley, a coal magnate and his family entombed in former Surrey*

In the small parish of Cheam beyond the outer fringes of London in the 1860s, the church authority knocked down most of the old St Dunstan's and rebuilt it in the same churchyard, but a little to the north and a lot bigger. Of the old church, the precious survival was the chancel, retained as a memorial chapel and charnel house, mainly to the Lumley family. Tall, compressed, covered in monuments, it is evidently thirteenth century onwards and with a lovely, light fifteenth-century Perpendicular east window (renewed, says Pevsner) with stained-glass heraldic devices set in clear glass, a moulded plaster ceiling and hanging pendants of 1592, an ensemble that in its delicacy might almost have been a template for Walpole's Gothic Revival Strawberry Hill (see page 302). A frieze of fruit runs

Underneath lyeth Interr'd y.e body
of Sam.ll Pierson Esq.r who was An
Affectionate Husband, A Generous
Benefactor to his Relations and to the
poor of this Parish, A meere Freind,
Sociable Neighbour, & Indulgent Master
He dyed y.e 27.th of Aug.t 1719 in the
61.y year of his age

Here also lieth Interred the body
of M.rs Mary Elley, (mother of his
beloved wife M.rs Ann Peirson)
She dyed Feb. y.e 8.th 1697 Aged 80
years

Here is likewise Inter'd the Body of
M.rs Ann Peirson Relict of Sam.ll Pier-
son Esq.r she was a Person of great
Charity and Beneficence
who dyed Oct.r 22.nd 1726
Aged 82

Sacred to the Memory of
M.rs MARIA SANXAY
Wife of EDMUND SANXAY Esq.r ...
who departed this life February the ...
in the 54.th year of her age.

EDMUND ANTHONY ER...
of New street, Spring garden, Right...
Brother of M.r SANXAY
who died at this Place, October th...
aged 70 years.

EDMUND SANXAY Esq.r
who departed this life October th...
in the 75.th year of his age.

And Miss MARY SANXAY, young...
Daughter of M.r and M.rs SANXAY
above mentioned, who died January...
1788, in the 40.th year of her ...

ENRICO COM.TI ARVNDELIÆ FILIA ET COHÆRES IOH. BARONI DE ... CHARISSIMA CONIVNX, PRÆSTANS PIETATIS ... VIRTV...

around the tops of the walls, which otherwise are practically covered with memorials, though the light streaming in through the west window and suffusing the white Perpendicular ceiling turns this into a place of celebration of achievement as much as of mourning for lives cut off.

Of these achievers the two most notable are John, 1st Baron Lumley (1533-1609), a northern potentate from Lumley Castle in Co. Durham and the greatest coal mines magnate in the country, and his wife, Jane, Lady Lumley. Highly educated as well-born sixteenth-century women often were, she was the first translator of a play by Euripides into English (*Iphigenia at Aulis*), and politically important as the daughter of the powerful 19th Earl of Arundel, who had bought the fabled Nonsuch Palace from Queen Mary and completed the building interrupted by Henry VIII's death in 1547. At Mary's death Baron Lumley became involved with Arundel, the Duke of Norfolk and other powerful Catholic families in plots against Queen Elizabeth, but though he was interned for two years the queen could not afford to chance the consequences of arraigning any of the conspirators.

So Lumley managed to re-establish a working relationship with her and succeeded to the Nonsuch estates on Arundel's death in 1580. When he himself died he was buried in the chapel at dead of night, probably in a Catholic ritual. No effigy adorns his handsome alabaster memorial which fills the space between

The Tudor tomb of Lady Lumley and her three children in the family mausoleum in Cheam.

floor and ceiling. It has a long encomium with coats of arms on three sides flanked by two blackish-grey Corinthian columns supporting an entablature with elaborate strapwork and the gorgeously presented Lumley coat of arms adjoined with Arundel's. His wife's tomb chest has panels carved in relief of her three children, who all died young, in what has been suggested are wobbly perspectives of Nonsuch interiors. Her own relief, above the tomb chest, is obviously unfinished, oddly so, since she died years before her husband.

CHURCH ROAD, SM3 8QH

## STATUE OF ANNE BOLEYN, CARSHALTON

*A shriven Anne Boleyn for a corner where the future queen passed by*

Tucked into a corner of a 1960s building in Carshalton seems an unlikely place to find a statue of Anne Boleyn, but it turns out that it stands close to the source of a spring that magically rose when Boleyn's horse, passing by with its mistress to Carew Manor in Beddington Park, struck a stone with its hoof. That's about as likely a story as that, after it was erected in 1967, the statue won the Sir Otto Beit Medal for the best sculpture outside London anywhere in Britain or the Commonwealth. Yet a plaque mounted alongside the sculpture assures the world that this is the plain truth.

In fact it is a good wood carving by the sculptor Dennis Huntley (b. 1928), with an Eric Gill-like simplification of form,

but with a strong added element of almost Quakerish severity and sobriety. Huntley's Boleyn is not the temptress who bargained her virginity for marriage and a throne alongside her Henry. Perhaps Huntley sees her as the wronged wife, fitted up for execution on trumped-up charges. Perhaps she is, if not innocent, then shriven and prepared for death. Her long neck suggests this, head held high and close-wrapped in a simple headdress, eyes wide open. She wears a long blue gown with a sturdy girdle from which hangs a weighty letter B in gold. The architects of the block of brick and weatherboard housing, which does not disgrace the pretty village scene of church, ponds, good pubs, and cottages, presented the sculpture to the Borough of Sutton, and Lord Astor of Hever unveiled it. Huntley's Boleyn is not, however, the best sculpture in Britain and the Commonwealth. It may be the best sculpture in Carshalton.

CORNER OF CHURCH HILL AND HIGH STREET, CARSHALTON PONDS, SM5

## LITTLE HOLLAND HOUSE

*A craftsman who dreamed the dream and made it work*

John Ruskin's lectures to upwardly mobile Victorian audiences typically contained a mixture of bracing insults and inspirational advice. Some of these lectures were published as *The Crown of Wild Olive*; they were about industry, the relentless pursuit of wealth, the ruin of the countryside, and his preface started with a paean to the beauty of Carshalton and a lament that its beauty would soon be lost. 'Twenty years ago, there was no lovelier piece of lowland scenery in South

England,' he began, 'nor any more pathetic, in the world, by its expression of sweet human character and life, than that immediately bordering on the sources of the Wandle, and including the low moors of Addington, and the villages of Beddington and Carshalton, with all their pools and streams.'

The lectures were assembled in 1866, before Frank Dickinson (1874-1961) was born in Paddington, where he grew up in a succession of lodging houses. He left school at 13, trained as a draughtsman, learned at evening classes to be a potter and goldsmith, and then took an artisan's job at the Doulton ceramics works in Lambeth where he stayed for 20 years. He read Shelley, Morris, Tennyson and Carlyle, and then he discovered *The Crown of Wild Olive* and read the preface. He dropped everything, and in October 1902, having bought a plot on a beech-lined avenue among fields of lavender south of Carshalton, with two of his brothers and one hired brickie he started building a house for Florence, his wife-to-be, and himself.

It was to be a house 'solid looking and not showy' and he called it Little Holland House, the name of the home of his artist hero G. F. Watts. On their wedding night on 28 March 1904 he and Florence moved in to spend the honeymoon sanding window sills and staining floors, sleeping under a copy of Watts's painting *Hope*. It became open house, full of their own children and their friends and friends' children, a home fit for a craftsman and his family, a dream of Merrie England. When he died, Florence remained alone in the house until she moved into a nursing home in 1972. Sutton council bought house and contents lock, stock and kitchen sink, and in 1974 opened it as a museum. The paintings, the carved beams, the friezes, the beaten copper, the coal box, the high-backed chairs and the tables, the gateposts... practically everything is by Dickinson except for the Everyman's Library classics, the two-volume *Modern Painters* by Ruskin, and the Doulton pottery reliefs over the fireplaces.

Today the house is number 40 Beeches Avenue, SM5 3LW, one of a long avenue of homes for the sort of commuters Ruskin might have lectured to, a house distinguishable from the others by a slight quirkiness and a roof of greenish Cumbrian slate. As for Ruskin, he bought the Carshalton ponds to protect them from pollution. He succeeded in that alone because, unlike Dickinson's, his was an impossible dream.

40 BEECHES AVENUE, SM5 3LW

---

Frank Dickinson was an artisan at Doulton's pottery works but was hooked by Ruskin's works, bought this Carshalton house, and transformed it, starting with the gate and gateposts.

Overleaf: The George is a fragment of the kind of galleried tavern adapted for theatre. It is unique, though rebuilt in the eighteenth century, so doesn't reach back to Shakespeare and Ben Jonson.

THE PROPERTY OF THE
NATIONAL
TRUST

GALLERY BAR

ASK ABOUT OUR CURRENT
Wine
OFFER

PRIVATE

# South-East London

# South-East London

1. Sculpture by Frank Dobson
2. Royal Festival Hall
3. Sculpture by William Pye
4. Oxo Tower
5. St John's, Waterloo
6. Fountain by Naum Gabo, St Thomas's Hospital
7. Lambeth Palace
8. Garden Museum, Lambeth
9. Sculpture by Michael Sandle
10. Old Royal Doulton Building, Southbank House
11. Southwark Underground Station
12. Obelisk in St George's Circus
13. Imperial War Museum
14. Walworth Road
15. Statue in Trinity Church Square
16. Borough High Street
17. Winchester Palace
18. Austin Monument, Southwark Cathedral
19. Old Operating Theatre Museum and Herb Garret
20. Guy's Hospital
21. Hay's Wharf
22. More London
23. Butler's Wharf
24. St Mary Magdalen, Bermondsey
25. St Mary the Virgin, Rotherhithe
26. Brunel Museum and Thames Tunnel
27. Canada Water Library
28. St Paul's, Deptford
29. Laban Dance Centre
30. St Alfege, Greenwich
31. The Fan Museum
32. Statue of William IV, King William Walk
33. National Maritime Museum
34. Painted Hall, Old Royal Naval College
35. The Queen's House, Greenwich

## NEWHAM

*Thames*

Sculpture by Antony Gormley
Thames Barrier
Woolwich Arsenal DLR Station
Lesnes Abbey
St Luke's Church
Maryon Park
Charlton House
The Paragon

## GREENWICH

## BEXLEY

Ranger's House
Morden College
Sculpture by Keith Godwin
Severndroog Castle
Danson House
Red House
Boone's Chapel
St Saviour's, Eltham
Eltham Palace
Hall Place
Eltham Lodge

## LEWISHAM

Mottingham Lane

Camden Place
St Nicholas's, Chislehurst

*Thames*

## GREENWICH

34
33  35
30  32
28   29   31
Greenwich Park

St Mary's, Shortlands

Bethlem Royal Hospital

## BROMLEY

All Saints', Orpington

John the Baptist, West Wickham

St Mary the Virgin, Downe

## KENT

Down House

St Mark's, Biggin Hill

0   0.5   1   1.5   2   2.5   3 mi
0     1     2     3    4 km

# • SOUTH BANK, LAMBETH, SOUTHWARK, ROTHERHITHE •

## SCULPTURE BY FRANK DOBSON, SOUTH BANK

*A pride of London almost lost for ever in the scuttle from the Festival of Britain*

The Festival of Britain in 1951 was a wheeze of the Labour government to cheer people up in the middle of a bout of austerity that seemed worse than in wartime. 'A tonic to the nation' was their catchphrase, though the more enduring tonic was Aneurin Bevan's National Health Service. By a miracle, after three years of fumbling about wondering what to do and even where to do it, a sub-committee took a second look at the 27-acre bombed, marshy site on South Bank between Waterloo Bridge and County Hall. When George VI declared the festival open from the steps of St Paul's Cathedral on 3 May and the trumpeters of the Household Cavalry sounded a fanfare, the nation, or that large chunk of it that managed to make it to South Bank, couldn't stop smiling.

But there were those who hated it, including Winston Churchill and the dyspeptic Evelyn Waugh, and when the Conservatives returned to power in September as the festival closed, everything was ripped down and carted away except for the Royal Festival Hall. The sculptures that had been on display went back to various studios or else to decorate Harlow New Town. The murals were mostly destroyed though Ben Nicholson's went to the Tate. The wonderful Dome of Discovery and the elegant Skylon, the Sea and Ships Pavilion, the Lion and Unicorn Pavilion, the inventively designed wall to block out York Road, were all razed and nothing much has replaced them but the London Eye, a new building for the British Film Institute to replace the state-of-the-art cinemas that were demolished, a featureless stretch of grass called Jubilee Gardens, and the Shell Centre, London's most depressing building.

One of the sculptures removed was Frank Dobson's *London Pride*, cast from the clay model only in plaster because bronze was too expensive. The piece showed two figures side by side with a bowl between them, in which Dobson placed a pot of *Saxifraga urbium*, or London Pride. At the end of the festival, Dobson took the sculpture away to his studio and then to a wooden shed in Hampshire, where it languished until 1986 when the lease ran out on the property. Dobson's daughter rang the Arts Council for advice, the Council took a look, decided it was a masterpiece, and arranged for it to be cast in bronze and erected outside the National Theatre, where it puts to shame the weightless, fey statue of Sir Lawrence Olivier a few yards away. Dobson (1888–1963) was one of the pioneers of modern sculpture, adapting and sticking to a semi-abstract 'primitive' approach to the figure familiar at the time, particularly in the work of Epstein, Moore, Hepworth and John Skeaping. His most satifying nudes are in terracotta, perhaps because they recall

Pre-Columbian sculpture (the material helps); but the bronze *London Pride* is robustly monumental even though, as it is not currently displayed on a plinth of the height Dobson originally chose, the empty bowl is used as a bin by louts who would normally dispose of their litter on the ground.

OUTSIDE THE NATIONAL THEATRE, SOUTH BANK, SE1 9PX

## ROYAL FESTIVAL HALL

*Light and easy, the egg in a box*

In that summer of the Festival of Britain I joined the hordes descending from the northern tundra to check out what this Britain confined to a short stretch of Lambeth riverside might be. For a sixteen-year-old, what it was, was expensive. It is not easy to recall now how the patch of ground between Waterloo Bridge and Westminster Bridge appeared then, overlooked by the Skylon, that sublime upended giant cigar suspended in space, and crowded with pavilions like the Dome of Discovery (science), Homes and Gardens, Sea and Ships. The concert hall was different. With enhanced pocket money, I took my seat. A harpist arrived on stage, sat, gently plucked a string. Just her and me. And a few hundred others. I have forgotten who the conductor for that concert was, which the orchestra or what the programme, but that plangent harp-tuning note has lingered.

Herbert Morrison, lord president of the council (government high vizier), and Isaac Hayward, leader of London County Council, had determined that the hall was for the people, and that the council's architecture department should run the show. It was a typical invitation to mediocrity that turned out otherwise. The lead architect for the project, Robert Matthew (b. 1908), was the elder of a team that included his deputy, Leslie Martin. Peter Moro joined them and in turn assembled a group of youthful assistants. Contractors arrived, and worked at a blistering pace on a project with a timetable of less than two years, August 1949–May 1951, receiving working drawings piecemeal. Everything teetered on the edge of failure. The building was originally designed to have a steel core but steel was not to be had, so concrete was hurriedly substituted. Even the name of the hall was problematic. The group finally settled on Queen Elizabeth Hall, but a clerk accidentally omitted it in a letter to King George VI, who off-handedly suggested Royal Festival Hall. QEH was mothballed.

The basic concept, probably Matthews's, was later tagged 'egg in a box': that is, the hall was to be suspended above ground so that instead of an auditorium hemmed in by corridors, space would be opened up for the public. Matthews delegated work on the interiors to Moro and it was he who finessed the multiple-level spaces flowing into each other, the open staircases, the cafés, the wide views of the Thames. The hall drew visits from the big beasts of Modernism, hooked by the fabled youthfulness of the design team. Le Corbusier bestowed blessings. Frank Lloyd Wright, in his eighties, met Matthews and Martin, and chuckled, 'Why, you're just a couple of boys.'

Crusty Sir Thomas Beecham wouldn't be seen dead in the hall, but conducted there anyway. The festival came and went and wrecking crews took care of the temporary halls and pavilions. The Festival Hall grew into middle age, never a sensational piece of modern architecture, but loved for its light and easy spaces. A new art gallery was named for the old LCC leader Hayward and London acquired its first mayor, can-do Ken Livingstone, who invited in the multitudes. In this century Allies & Morrison has smartened up the Festival Hall, cleared away clutter and recovered the original lineaments. And the multitudes still come.

SOUTHBANK CENTRE, BELVEDERE ROAD, SE1 8XX

## SCULPTURE BY WILLIAM PYE, SOUTH BANK

*A sculpture that enraged Academicians but illuminates the South Bank*

Photographs in newspapers of 4 May 1972 show the dancer Nadia Nerina standing with a man slightly apart from a crowd of dignitaries gathered before a shiny steel abstract sculpture on the terrace outside the Queen Elizabeth Hall. One of them is Norman Reid, director of the Tate. Nerina was a star of the Royal Ballet, born Nadine Judd in Bloemfontein, a dancer whose allure conquered even Russian audiences when she appeared in 1960 as a guest with the Bolshoi and Kirov companies. She also bought art, often connected with ballet, sometimes not; and the photograph shows the unveiling of the sculpture that she has just presented to Londoners. The sculptor is William Pye, and the piece in shining stainless steel is called *Zemran*. The man with Nerina is probably her husband Charles Gordon, a merchant banker. He paid £3,000 to fund its making.

*Zemran* had been displayed in solitary splendour under the dome of Burlington House in *British Sculptors '72*, the winter show at the Royal Academy that enraged many of the Academicians and signalled a change of direction from the days of the dinosaurs. 'The RA has bowed the knee,' observed the critic from *Burlington Magazine*, trade journal of the cognoscenti, in its February issue. It added: '... some of the better items, like *Zemran*, would probably look better out of doors.' From the magazine's illustration, showing the wavy lines of the 17-foot tall sculpture uncomfortably constricted visually by the Greek Revival classicism of Robert Smirke's central hall, and comparing that to its careful positioning on the South Bank three months later, it is clear that the crystal ball consulted by the reviewer, the late Keith Roberts, was spot on.

As it happens, just as *British Sculptors '72* was a turning point for a fossilised Academy, *Zemran* was a new beginning for William Pye. He had grown up in a cottage by a stream in Surrey, and his early life seems to have been idyllic. His boyhood and adolescent sculpture often featured water, and *Zemran's* tentacles obliquely suggest its movement. After this he turned to making sculpture

It doesn't look like runnels and raindrops, but watching rain was the inspiration for William Pye to make this steel sculpture on a South Bank terrace.

involving water, including the famous wall of water for the architect Nicholas Grimshaw's British Pavilion at the 1992 Seville Expo. Pye pretty well gave up gallery shows after the 1972 exhibition and disappeared under the radar, quietly getting on with being successful. *Zemran* remains by the Thames, a token of the freshness of his vision, those tentacles a memory, maybe, of the fluttering ribbons carried over her head by Nerina in her lead role in *La Fille Mal Gardée*, floating, dancing; but then again, Pye emailed me to say:

> I got the name Zemran from a very old Times Atlas where it was shown as a hill fort in the Atlas Mountains. However, I can't find it in the Readers' Digest Atlas. The word has a resonance that I felt echoed the mood of the piece.

OUTSIDE THE QUEEN ELIZABETH HALL, SOUTHBANK CENTRE, BELVEDERE ROAD, SE1 8XX

## OXO TOWER

*A beefed up Oxo tower for the community*

The story begins with Professor Justus Freiherr von Liebig, a chemist born in 1803 in the Grand Duchy of Hesse, later president of the Bavarian Academy of Science. He was undoubtedly one of the great nineteenth-century scientists, among other things for discovering that nitrogen was an essential plant nutrient. As part of his daily laboratory lot he invented a form of beef extract, realised he was on to something, and founded the Liebig Extract of Meat Company. And so it remained until he died in 1899 and might have stayed so forever had not someone in the company with a snappier sense of marketing for the dawn of the twentieth century thought of calling the little beef extract cube by the internationally saleable palindrome Oxo.

At about the same time the post office built a power station on a site where once the royal barges had been stored. By the 1920s it was defunct and the Liebig company bought it to convert to a cold store. To this mildly Art Deco building the company architect, Albert Moore, added a tower on which Liebig Meat Extracts planned to display advertising. The authorities refused permission. The building went ahead, and on each of the four sides at the top of the tower was a ten-foot-tall artwork created by piercing holes through the wall, two on each side forming circles, one an X shape. OXO, yes, but apparently acceptable because it was solemnly judged decoration rather than advertising.

After the war the building fell into disuse; part of the general dilapidation of what became known as the Coin Street site, where a number of residents remained but which covered also the riverside and various disused lots. As at Covent Garden, commerce proposed wholesale redevelopment and, as at Covent Garden, the residents organised a protest. They formed an entity called Coin Street Community Builders, borrowed £1 million from the Greater London Council and the Greater London Community Board, turned derelict sites into car parks to raise revenue and organised the infrastructure for a flourishing new community. The redeveloped Coin

Street embraces Gabriel's Wharf market, groups of studios and galleries, new homes, and in 1996, at what was now known as Oxo Wharf, the architects Lifschutz Davidson Sandilands created on the eighth floor of the tower a bar and 500-seat restaurant and brasserie for Harvey Nichols. The restaurant was smooth and pricey, the brasserie busier than a motorway stopover with food just this side of heaven. Through a sheet-glass wall one of London's newly created views was visible over balcony and river; there was a suggestion of improvisation in the shiny blue louvred slats suspended from the ceiling, revealing the rough trade of bits and pieces of insulation, chicken wire, wooden laths. Not an Oxo cube in sight.

BARGEHOUSE STREET, SOUTH BANK, SE1 9PH

## ST JOHN'S, WATERLOO

*Ignoring the Luftwaffe: the priest and the photographer*

Against the IMAX cinema and Waterloo Station across the road, the clutter of street lights, street signs, bus shelters, and herds of red double-decker buses, St John the Evangelist stands its ground. It does so because of the broad and wide pedestrian concourse before it and by virtue of its own architecture: a big classical portico with six massive Doric columns and a three-storey tower crowned by an obelisk. It was erected with money voted by Parliament in 1818, one of four in Lambeth, built by Francis Bedford and consecrated in 1824, before Gothicism became the norm as National Health Service of the soul for the labouring classes.

It has a dry as a drawing board outline but is a handsome enough edifice and it would be a loss had it disappeared, which it almost did when it took a direct hit from a high-explosive bomb in December 1941. As it happened, in the year following, the summer of 1942, the celebrated Hungarian-born American war photographer Robert Capa was in town. The Battle of Britain had been won, Hitler had turned on Stalin, so Capa (1913–54), for once not in the front line, contented himself with putting together a photo-essay on how the people of Lambeth had survived the Blitz and in the course of it produced one of the most moving records of the human spirit defying destruction all around: a photograph of the parish priest of St John's at the high altar standing in the roofless church under the open sky preparing the Sacrament before two assistants and two choristers.

The east wall is horribly shrapnel-scarred, the glass blown from the window, and flags of the three services hang unfurled from poles fixed tipsily in the surviving fragments of the north and south galleries. Six tall candles burn on the altar before the shape of the reredos burned black on to the wall, the candle flames competing feebly with the unasked-for daylight. The simplicity and calm of this photograph make it a performance as masterly as Capa's photographs of the landings on Omaha Beach two years later were heroic.

After the war, the building was more or less faithfully restored in time to become the parish church for the Festival

of Britain in 1951. Two graceful memorials in the otherwise blank east-wall panels shown by Capa had vanished in the reconstruction, both hopelessly eroded. In 1998 the artist David Morris (1924–2007), who had emerged from wartime experience in the army as a pacifist, presented two emotionally charged murals to fill the gaps. Each is a view from Waterloo Bridge, one downriver towards the City, which possibly shows a modern Good Samaritan; the other upriver towards Westminster, containing a figure who might, the artist said, be either the Evangelist or the spiritual form of the visionary William Blake. Between these paintings another war-scarred artist, Hans Feibusch (1898–1998), a German Jewish refugee from Hitler, painted a Crucifixion to fill the space left by the shattered east window and beneath it a Nativity for the new reredos.

WATERLOO ROAD, SE1 8TY

## FOUNTAIN BY NAUM GABO, ST THOMAS'S HOSPITAL

*Naum Gabo's abiding preoccupation with defining space*

Short of parking a nuclear power station on the east bank of the Thames facing the Houses of Parliament, it is hard to think of a more uncongenial neighbour than the actual occupant, St Thomas's Hospital, a hotchpotch of white-tiled Modernism and redbrick Victorian, the ruin of a plan by the architects Yorke Rosenberg and Mardell that was never completed. The original St Thomas's was founded further along the river in Bermondsey in the twelfth century soon after the murder of the sainted Archbishop Thomas Becket for whom it is named; it fell victim to compulsory purchase in 1862 to make room for the railway viaduct between London Bridge station and Charing Cross. When the hospital moved to its new site in Lambeth it took with it from the old gateway Thomas Cartwright's statue of King Edward VI, seedcorn from which sprang the hospital's present wide-ranging collection of sculpture.

King Edward had given the hospital a new charter in 1551: he stands now, stiffly uncomfortable as any statue might beside a sensitively placed red 'No Smoking' sign next to the main entrance. He wears a tall hat, brimmed, with doublet and hose and a cloak hanging from shoulders to feet. In one hand he holds a sceptre, the charter in the other. Cartwright worked as a mason during Christopher Wren's rebuilding of the City, but on this evidence he was a less than wonderful sculptor. Grinling Gibbons was less than wonderful, too, when he stepped outside the wood carving that earned him enduring admiration, but he ran a workshop of statuaries capable of producing fine pieces like the statue of Sir Robert Clayton, a seventeenth-century lord mayor of London and president of St Thomas's, which is better served in its positioning before the remnant of an old arch by a remaining Victorian building on the riverfront.

Inside the hospital is a collection of

In 1928 the Russian émigré Naum Gabo made a sketch he called *Torsion*, but did nothing with it. Back in England in 1972, he turned his half-century-old idea into a sculpture and it was installed in the garden of St Thomas's Hospital.

statuary including another Edward VI, an elegant bronze by Peter Scheemakers. But the prize stands at the centre of the garden between the main entrance and Westminster Bridge Road, a fountain by the Russian emigré sculptor Naum Gabo (1890–1977). Gabo, a founder of Constructivism during the revolution of 1917, left Russia in 1922. By the time he moved to England, where he lived from 1935 to 1946 and had a huge influence, especially on Barbara Hepworth, he was insisting that his abstraction was not engineered, but based on living forms. In 1936 he made a little Perspex piece called *Torsion* based on a drawing of 1928: the transparency was his notion of a way to delimit space without constricting it. *Torsion* is now in the Tate; but in 1972 Gabo returned from America, still, in old age, turning over in his mind a notion conceived nearly half a century earlier, and directed the production of the big stainless-steel fountain based upon *Torsion*. In the fountain, the perspex awakens to life in the form of plumes of water sprayed across the surrounding pool as the fountain slowly revolves.

WESTMINSTER BRIDGE ROAD, SE1 7EH

## LAMBETH PALACE

*Heritage first, Utopia nowhere*

The entrance to Lambeth Palace is through the pedestrian door alongside the large carriage gate in Morton's Tower. See the gateway with its dual towers free from outside and be happy: it is the second best bit of the palace. The best bit (see below) is inside and for that you must lash out £10.

Cardinal Morton was still building the entrance tower when the 12-year-old Thomas More, pink-faced from school, came to take up employment with him. More was there to learn the arts of politics and diplomacy, stately manners and top-table wit, philosophy and theology and law. So Morton and Lambeth were deeply important in shaping More, yet the guide booklet to the palace contains nothing, not a word, about the future Lord Chancellor. Unlike Morton, of course, he never entered the Church but did make the mistake of becoming a Catholic martyr.

Later, when More wrote his satire *Utopia*, he recalled John Morton warmly as 'a person that one respected just as much for his wisdom and moral character as for his great eminence … polished and effective speaker… thorough knowledge of the law… remarkable intellect', and so on. All qualities for which More himself was famous worldwide. But the calmness within Lambeth Palace seems not like a place of retreat, more a safe place where the truth, the tourist truth, is heritage tailored for comfort. When we go to Lambeth Palace as paying visitors the history we see is the Morton gate, a nice piece of fifteenth-century brick architecture; a big quad with a row of charming medieval cottages that escaped the hammer of Edward Blore the bore, blandest of nineteenth-century architects, who built the big Bath stone south-facing range; close by, a gigantic fig tree said to have grown from an offering from Rome by Cardinal Pole, the last Catholic arch-

bishop before he died on the same day as his Catholic queen, Mary; and the entrance to the Great Hall, now the library. To the north is Archbishop's Park, nothing less than a paradise garden stretching almost to St Thomas's Hospital on the other side of the road. Also the best part of the palace, the crypt, harbouring the quiet of seven centuries: here the last archbishop, Rowan Williams, much loved by the palace staff, most liked to pray in private among the short, slender, thirteenth-century Purbeck marble columns that sprout an efflorescence of heavy-duty rib vaulting supporting the bomb-stopping chapel (rebuilt above after the war). There is the barest of crypt altars, apostle fashion rather than prince of the church, not quite hinting 'up yours, Rome'. After all, they're best of friends now.

LAMBETH PALACE ROAD, SE1 7JU

## GARDEN MUSEUM, LAMBETH

*The Tradescants, gardeners to the Rose and Lily Queen*

John and Rosemary Nicholson founded the Garden Museum in St Mary, formerly the parish church of Lambeth, in 1977, after the discovery in the churchyard of the tombstone of John Tradescant, royal gardener. Charles I first appointed Tradescant as gardener to his 'rose and lily queen', Henrietta Maria, at Oatlands Palace in Surrey, together with his son John Tradescant the Younger. Father and son travelled throughout Europe, in India and Africa, and to Muscovy, bringing back exotic plants for the royal couple and other clients of the order of the Cecils at Hatfield and George Villiers, Duke of Buckingham. As the eroded inscription on the sarcophagus reads (in part):

> *Those famous antiquarians, that had been*
> *Both gardeners to the Rose and Lily Queen,*
> *Transplanted now themselves, sleep here. And when*
> *Angels shall with their trumpet waken men,*
> *And fire shall purge the world, these hence shall rise,*
> *And change this garden for a Paradise.*

How this monument, richly carved with flourishing plants and crumbling civilisations, could have been lost in the first place is not entirely clear, but the former parish church of Lambeth was surplus stock and until the Nicholsons arrived on the scene it was under threat of demolition, so they are heroes for more than one reason.

The church is of rough Kentish ragstone and predominantly dates from 1370. It snuggles against the high crenellated garden wall of Lambeth Palace and the climbing plants of the churchyard threaten an invasion of the palace itself. Dow Jones (Biba Dow and Alun Jones, whose stock is measured in architecture, not Wall Street dollar indexes) completed St Mary's transformation to museum in 1998, wrapping the interior space in lightweight timber to create partitions for a shop, a café, and a lovely flexible temporary exhibitions space. A staircase leads to a permanent collection above the nave and aisles. There are good things to see, like an ancient host of alarmingly warlike

gardening implements, but the main bequest of the Tradescants, their cabinet of curiosities, its catalogue and other exotica, was transplanted after the younger Tradescant's death by Elias Ashmole to his new museum in Oxford. In Lambeth, the real joy is the garden; two really, one between the church and Lambeth Road, and, in the former churchyard, the seventeenth-century-style geometrical knot garden with plants of the period and a due sense of history that the Dowager Marchioness of Salisbury created in 1982; she was simultaneously working on the Hatfield House gardens where the elder Tradescant had been head gardener from 1610–15.

There is one other notable monument to another Lambeth resident and horticulturalist, of a sort: 'To the memory of William Bligh, Esquire, FRS, Vice-Admiral of the Blue, the celebrated navigator who first transplanted the bread-fruit tree from Otaheite [Tahiti] to the West Indies...' HMS *Bounty*? Harsh and tyrannical captain? Mutiny? Not a word. Instead, sweetly, the inscription continues: '[he] died beloved, respected, and lamented, on the 7th day of December, 1817, aged 64'. And yes, on top of the tomb is an urn, containing a bread-fruit.

LAMBETH PALACE ROAD, SE1 7LB

## SCULPTURE BY MICHAEL SANDLE, INTERNATIONAL MARITIME ORGANISATION

*A shipshape tribute*

Michael Sandle (b. 1936) and Mickey Mouse (b. 1928) go hand in hand. By far Sandle's best-known piece is the big

brass, bronze and wood *A Twentieth Century Memorial* (1971–8, Tate) with the skeletal Mickey like a fourth mouseman of the apocalypse, dealing death as he feeds a long belt of gleaming ammunition through a Sterling machine gun. Not too many chuckles from the engaging little rodent here. It began as Sandle's verdict on the war in Vietnam but widened into an overview, a spectacular expansion into monumental sculpture of the graphic edge and political beliefs that he developed further in the 1970s and early eighties when he was teaching in Germany. There he produced a dark sculptural critique of the apparatus of the Nazi regime, particularly *The End of the Third Reich*, with its scorched corpses of Hitler and Eva Braun side by side among abraded military debris and emptied petrol cans.

Sandle's *Seafarers' Memorial* on Albert Embankment hardly fits this picture; yet the darkness spills over. Given its date of 2001 its heroic realism might, but for its conviction, have seemed a gigantic anachronism. The International Maritime Organisation commissioned it for its headquarters building to commemorate all merchant seamen who died in war or peace. Seen from the street it looks like the bows of a cargo boat with a seaman standing high in the prow holding a coil of rope in his right hand as though the ship is about to dock. The second storey of the six-storey office block is canted out beyond the ground floor so that the memorial tucks in beneath and protrudes slightly beyond the façade. The smooth mass of the ship and the realism of the crewman (seamed face under a hard hat, with a corner of open jacket lifted by a gust of wind, radiophone stuck into one pocket), are a counterpart to Charles Sargeant Jagger's Royal Artillery war memorial at Hyde Park Corner (see page 211); hardly incidental, because Sandle admires Jagger and his seamless combination of realism, abtraction and classical references. Sandle regards the art of the past, from Greece to the Futurists, as a continuum that feeds and bleeds into today's art. His ship, which clearly cannot continue at full length into the maritime building, in fact reveals a hull cut away behind the bows to show structures suggesting heavy lifting gear within bows curved like the apse of a great church with massive buttress-like steel ribs. The *Seafarers' Memorial* is an allusive work, inviting inspection from across the Albert Embankment or from the entrance to Lambeth Palace, yet drawing viewers close, as great memorials ought to.

4 ALBERT EMBANKMENT, SE1 7SR

# OLD ROYAL DOULTON BUILDING, SOUTHBANK HOUSE

*A signature piece of pottery over the main entrance*

Once started, Henry Doulton couldn't get enough. He began work in 1835 for the firm his father had founded in Vauxhall Walk, manufacturing ceramic pipes for sewers. John Sparkes, the principal of

The ship in Michael Sandle's massive memorial to merchant seamen at the International Maritime Organisation's headquarters is finely calculated to fit the building's architecture, not just physically but in terms of its detail, down to the last incised panel.

Lambeth School of Art, asked Doulton to take on some of his students to produce art pottery, but received a cold reception. Sanitary ware was doing very nicely thank you. But Sparkes persisted and by 1867 Doulton was showing the first examples of art pottery at the Paris Fair. In 1878 he opened a new headquarters and factory on the corner of Black Prince Road and Lambeth High Street, the kind of elaborately decorated Victorian building that not very long ago most of us despised.

The little that remains of Henry Doulton's building is like a smaller St Pancras, without the railway but with added art. Carved decoration, coloured ceramic tiles, polychrome brickwork, turrets, oriels, pointed windows, round-headed windows, square-headed windows, circular windows, swags of flowers, clasped columns... even what appear to be vents on the roof for pouring boiling oil on to unwelcome visitors. And sculpture. The V&A rescued the friezes by Gilbert Bayes from the part of the building that was demolished. There remains the sculpted scene in the tympanum over the main entrance by George Tinworth, which encapsulates the story of the Henry Doulton years in a single frozen moment.

Tinworth (1843–1913) was the student Sparkes chiefly had in mind when he first approached Henry Doulton, and Tinworth stayed with Doulton, the firm, for the rest of his life. He didn't develop much as a sculptor. Why should he? The work was not of that sort. Even when Ruskin tried to persuade him to learn about proper Renaissance low-relief sculpture, Tinworth politely ignored him.

He probably regarded Ruskin's views on the elision between art and craft as an intellectual's mind games.

The scene over the Doulton headquarters entrance shows a group of six. At the centre is Henry Doulton, holding a large vase. To his right sits Arthur Bolton Barlow, one of the four Lambeth artists in the scene, indicating something on the base of the vase to Tinworth, who stands on the right, leaning forward. At the far left is Barlow's sister Hannah, decorating a pot, her cat beneath the stool. Between her and Doulton is the fourth artist, Frank A. Butler, highly original, younger than the others, deaf and dumb. In shallow relief in the background is a kiln man. Obviously by chance, this is part of the genre that includes Henri Fantin-Latour's famous (and contemporaneous) big canvas of Courbet in his studio with artworld celebrities and his model. Tinworth and his fellow Doulton artists earned a craftsman's fame, respected among their fellows. The boss it was who collected the knighthood.

BLACK PRINCE ROAD, SE1 7SJ

## SOUTHWARK UNDERGROUND STATION

*The new London Underground*

After the Second World War, when the Victoria line opened, plans were made for a Fleet line. This finally to come to fruition as the Jubilee line, which essentially

A precious detail of the crumbling old Royal Doulton building just off Lambert Embankment, when Henry Doulton was trying to persuade art schools to take fine art pottery seriously.

wrested a section of the Bakerloo line; and then in 1999 gained a new stretch to service the empire of capital at Canary Wharf. The new stations that now had to be added were commissioned from the high-tech masters Will Alsop at North Greenwich, Norman Foster at Canary Wharf itself, Ian Ritchie at Bermondsey. Michael Hopkins created a brand-new superstructure at Westminster around the established Circle and District lines; while at subterranean Canada Water an in-house London Underground architectural team created a glass and concrete drum above the surface in clear homage to Charles Holden, the great underground innovator, and his brick drum at Arnos Grove.

But the most exotic of all is Southwark tube station by Richard McCormack, clean, elegant and fantastic, with its signature flourish: the glowing blue glass wall by McCormack and Alexander Belschenko based, McCormack has said, on Karl Friedrich Schinkel's famous 19th century starlit stage setting for the Queen of the Night scene in Mozart's *The Magic Flute*. And, for all the fantasy, the work ethic of Holden's 1930s carries through into the new millennium in the classic house style sans serif letterface for signposting, tube maps, posters and all the paperwork bureaucracy is heir to. The calligrapher and typefounder Edward Johnston (1872–1944) created it for the underground in 1916, Holden tweaked it, and it still stands proud in the high-tech wonderland.

68–70 BLACKFRIARS ROAD, SE1 8JZ

## OBELISK IN ST GEORGE'S CIRCUS

### *A milestone of liberty*

The obelisk at the centre of St George's Circus was erected in 1771, the eleventh year of King George III's reign (see the inscription on the obelisk), as a milestone at the confluence of five major roads. In 1905 it was removed to a site opposite the Imperial War Museum in favour of an unimpressive clock tower. With the growth of motor traffic in the 1930s, the clock tower was demolished. A mere 60 years later, the obelisk returned to its rightful spot. May it never be removed. It performs two functions: in a circus that was once surrounded by fine eighteenth-century buildings but that now is distinctly unbeautiful, it is the finest structure in view. And as it is a milestone, the almost pedantic accuracy of the distances, awry when it stood outside the War Museum, has presumably been reasserted: 1 mile 40 foot from London Bridge, 1 mile 350 foot from Fleet Street, and 1 mile precisely from Palace Hall, Westminster.

As a milestone its height might be thought over-demonstrative, but it also serves as a monument to Brass Crosby, lord mayor of the City of London when it was erected. Earlier the same year he stood up against a House of Commons command that three printers should be arrested for breach of privilege in reporting Parliamentary debates. From the bench, Brass Crosby (sitting with the great libertarian John Wilkes and City MP Richard Oliver) delivered the ringing declaration that as lord mayor he was a guardian of the liberties of his fellow citizens, and no other power, not even the Commons, had the right to seize a citizen of London without authority from him or some other magistrate. For this he himself was committed to the Tower, but he was released at the end of the Parliamentary session and returned to Mansion House in a triumphant procession.

SOUTHWARK, SE1

## IMPERIAL WAR MUSEUM

### *War from the captive's viewpoint*

It's a children's paradise, 'boys' toys' as a female friend remarked. Friendly-looking Spitfires and Messerschmitts hang from the ceiling, denatured tanks from both wars stand on the floor, a captured V2 rocket points towards the sky; it has had a cladding panel removed so visitors can see the works, just like Damien Hirst's shark. This is the Imperial War Museum, a building well sited in what was once Bedlam, a madhouse (now, of course, Bethlem Hospital [see page 403], a place well acquainted with the knowledge that 'madness' is an illness).The paintings are upstairs, some by official war artists, some unofficial. Mostly, they are very much museum pieces. They meant so much in the making to Paul Nash and William Roberts, to name two of the better artists who were so affected by the sight of those potholed, shattered battlefields, but somehow the paintings don't work; they solicit shame and awe for the horror but the medium isn't right, too literal or else too remote. C. R. W. Nevinson said: 'This war will be a violent incentive to Futurism, for we believe

there is no beauty except in strife, no masterpiece without aggressiveness.' But the fact and impact of war knocked the guts out of Vorticism (a melange of Cubism and Futurism) and Nevinson turned to descriptive narrative. Before the war Jacob Epstein had made *Rock Drill* (now in Tate Britain), an armoured beetle-like humanoid with a drill, but war shocked him out of this. 'My subject is War, and the pity of War', wrote Wilfred Owen, and, apart from one great painting, Stanley Spencer's *Travoys arriving with Wounded at a Dressing-Station at Smol, Macedonia, September 1916*, it remained a subject described more viscerally by poets.

The First World War was typically experienced in slow motion, in the trenches. The Second World War did not lack poetry, but it wasn't concentrated in, as it were, conditions of hand-to-hand combat. Owen in the First anticipated his actual death with a poem imagining meeting a slain enemy in a 'profound dull tunnel' ('By his dead smile I knew we stood in Hell'). In the Second Keith Douglas fought and wrote on the move in a tank in the Western Desert and there, shortly to be killed himself, met his enemy dead by a gunpit with a photograph of his lover spilled from his wallet ('But she would weep to see today/ how on his skin the swart flies move'). Otherwise this mobile war was mostly best recorded by photographs and film.

Maybe the nearest Second World War equivalent to the static trench battles of the First was the Japanese prison camps of the death railway, and here the finest reporter of all was the graphic artist and cartoonist Ronald Searle (1920–2011). Even as the Japanese marched into Singapore, Searle, a 21-year-old sapper with the Royal Engineers, recently removed from a cushy billet packing cardboard boxes for the Co-op by day and studying at Cambridge School of Art in the evening, sat by the road sketching the conquerors. As a captive he was first confined to Changi POW camp, then laboured on the Burma railway as far as the Thai river and Siam. Constantly threatened by discovery, he continued making these remarkable sketches. He was close to death on several occasions; his fellow POW Russell Braddon (author of *The Naked Island*) later observed, 'We would only have known he was dead if he had stopped drawing.'

Far from stopping he recorded the daily round of horror as an ill and underfed prisoner and the terrible hardships and the deaths from cholera of his comrades, and he continued to draw his captors, from the relatively amiable to the smirkingly cruel (later he would bestow the goggle-eyed look of some of them on his St Trinian's girls). This is not the horror of Goya, nor does it have the pungency of a Daumier; instead it is an astonishingly objective record, turning the witty pen line of a lightweight newspaper cartoonist into an instrument tough and slender as bamboo, compiling in sweat and fear 'the graffiti of a condemned man', as he put it. We look at these drawings and shudder; but since the revolting images of Abu Ghraib, no longer with the comforting sense that it couldn't happen here.

LAMBETH ROAD, SE1 6HZ

## WALWORTH ROAD

*Where Charlie Chaplin grew up*

On the corner of East Street and the Walworth Road is a blue plaque to a local entertainer made good ('Charlie Chaplin 1889–1997, Walworth-born comic genius, voted by the people'). Half a century before Charlie was born, Walworth was considered a mild and beneficent rural setting, a place of market gardens and orchards. By 1889 it was a slum, but one that Chaplin's mother, abandoned by Charles Chaplin Senior, could not afford to live in, so she, with Charlie and his siblings, moved into a workhouse. Hard times has been the abiding story of the area and determined the priorities that still show on the face of Walworth Road. Pubs, chemists, a pizza joint, Indian, Chinese, Big Macs, electrical goods shops, vivid fascia boards jostling for attention.

At number 195 is Herbert Morrison House, once Southwark Labour Party headquarters, named for an old Labour hero, with a newer shop spatchcocked on to the front of the main building housing Kaim Todner Solicitors, 'available to respond and attend police stations at short notice'. Down the road, another lawyer's office, Anthony Gold, 'legal advice on Poly Implant Prothese (PIP) implants'. Advice for suckers born at more than one a day. A little closer to the Elephant at 157–169 is Walworth Health Centre, built in 1937 for Southwark borough council by its engineer, Percy Smart. It anticipated Nye Bevan's National Health Service by 11 years, a historic link embracing the 'cradle-to-grave' ethos which English Heritage gives as one of the faintly underwhelming reasons for listing the building grade II, like the adjacent town hall and Newington Library. The building is let today as offices, but it retains the plaque above the door with Plutarch's maxim, 'The health of the people is the highest law' (*Salus populi suprema est lex*).

The best possible reason for listing the health centre might have been (but wasn't) the sculptural group of a mother and three children high above the front entrance. It looks at first like a strong piece of realism by a sculptor who might be a convinced socialist, but it was executed by a firm as obscure as the borough engineer. It advertised itself as E. J. and A. T. Bradford, Architectural Sculptors, of Borough Road. It had a steady business mostly, it seems, in Westminster, carving capitals, decorative panels (heraldic devices and such like) and carved heads from fables. E. J. had retired 30 years earlier and although A. T. (Alfred Thomas) had been joined in the business by his son Ronald, a letterer, and his nephew Alfred Banks, a sculptor, the sculpture is probably by A. T. himself. Given the kind of work the firm did, this is a remarkable piece, modern only in that it is stripped of detail, with a classical dignity and fullness of form. It shows a mother, nude above the waist and carrying the rod of Asclepius signifying medicine – a serpent entwining a staff – and accompanied by her two daughters, one pubescent, one a child with a doll, and

The prevailing theory is that this statue is Alfred the Great, fourteenth century and taken from Westminster during work in 1835. The only certainty is that it has been in Trinity Church Square since then.

her young son, also naked and nursing a doll. It may be a single-parent family, no doubt as common then as now and during young Chaplin's workhouse days.
SOUTHWARK, SE17

## STATUE IN TRINITY CHURCH SQUARE

*The mystery of the misplaced king*

The following sprightly entry about the statue of a king in Trinity Church Square in Bermondsey comes from the website londoncabbie.net, wouldn't you know?

> *The 14th century statue of King Alfred in front of the church is the oldest statue depicting a person in London. It was nicked from Westminster Hall in 1822 and taken south of the river, like much else!*

That information is solid gold, up to a point. What the cabbie blogger doesn't say is that so much of the statue has been reconstructed with Coade stone, a form of stoneware invented by Eleanor Coade in the eighteenth century, that the identity of the king is pure guesswork, though commonly accepted, and that there are other theories about where the statue originates. But first, let's just use the evidence of our eyes.

It is a big gowned figure with a thick-haired, heavily bearded head and a large crown. The sceptre is missing from the right hand; both orb and hand are missing on the left. It is well carved, if raw, and stands before the gigantic Corinthian portico of the Georgian church built in the garden at the centre of the square of the same date (1823–32), splendid in daytime, dramatic when it is floodlit at night. If it

came from Westminster Hall when John Soane was reorganising things in 1825, it was removed from the group of 1395 originally outside the hall (others of them have been rearranged on the huge windowsills inside), not from the group in niches inside the hall commissioned by Richard II a little earlier, 1385–8, and which are smaller and more narrow in the shoulder. Other theories place the statue in the eighteenth century, coming from the demolished Carlton House, and in the nineteenth, from a Manchester statuary called James Bubb. Pevsner goes into a little detail about the Westminster statues and accepts the Westminster provenance (itself a theory as recent as the early twentieth century) for the Trinity Church Square statue, but quite casually. Many critics urge that the alleged King Alfred should be moved inside. They are probably right. It is not weathering well; but what a loss to street theatre that would be.

SOUTHWARK, SE1

## BOROUGH HIGH STREET

*A bridge, a cathedral, a high street,*
*a market, a railway*
*and a long memory of pubs*

Borough High Street is not handsome, but it is expressive. It has lived, and that shows on its face. Primarily on the east side, that is: the west was demolished in the 1820s for road widening and to follow the new line to the latest, maybe the seventh, London Bridge some yards west of the original Roman bridge and its successors. The road widening was invasive, but it paled beside the expansion and reach of London Bridge Station and the South Eastern Railway in 1862–3. The railway still invites trouble: already in the twenty-first century there has been a hoo-ha over its need for yet another viaduct over the street. The conservation area was duly disrupted, the conservation faction disgruntled, the railway's pressing need satisfied; yet for all the fuss, it hardly matched the earlier project, pithily summarised by the architectural historian John Summerson:

> *The South-Eastern swung out from London Bridge and, with the help of 17 bridges, 190 brick arches and an iron viaduct, with the destruction of a hospital, the removal of 8,000 bodies from a graveyard, and the construction of a new Thames bridge, got itself to Charing Cross.*

Borough High Street begins beside Southwark Cathedral and ends about half a mile south at the church of St George the Martyr, where it runs left, into Watling Street, the route to the Roman invasion port, Richborough, and right, into Stane Street, heading for Roman Chichester and, as Newington Causeway, to modern Portsmouth.

The pubs lie in the interstices between the hospital and the once-upon-a-time hospital: Guy's lies in the space between the junction of St Thomas (sic) Street and Borough High Street; St Thomas's (sic) Hospital itself pushed off to Lambeth after London Bridge Station shoved it so rudely out of the way. In John Stow's *Survey of London* (1598) the list of pubs sustained on Kentish hops (and maybe, just as today, decorated with hop bines ripped out of

hedgerows) runs like an incantation: 'many fair inns for the receipt of travellers, the Spur, Christopher, Bull, Queen's Head, Tabard, George, [White] Hart, King's Head etc'. The King's Head is still there, but it is a reconstruction. Southwark's own great fire in 1676 consumed the Tabard, which, as all the world knows, was the starting point for Chaucer's progress: 'It happened in that seson, on a day,/ In Southwerk at the Tabard as I lay / Ready to wenden on my pilgrymage...' (it took until 2003 before a blue plaque commemorating the Tabard was fixed to a wall in Talbot Place). The George Inn, a medieval hostelry, was rebuilt after the 1676 fire in the old style, a galleried rectangle like the many inns that doubled as theatres. What survives after the railway's ravages is only the southern galleried side, but it is some long gallery. The rest have gone or remain as a whisper in an alley nameplate.

Beer from Tudor times meant hops; hops were grown in Kent; and hops and beer defined the Borough, in warehouses, hop factors' offices on the narrow medieval burgate plots interspersed with the pubs, and the big gloriously gaudy nineteenth-century Hop Exchange on the corner of Southwark Street, like a Roman circus within and converted now to offices.
SOUTHWARK, SE1

## WINCHESTER PALACE

*A rose window among the ruins*

The Bishop of Winchester's palace on Bankside sat like an exotic bloom on a bed of dung. Through the centuries, until the time of Shakespeare, Londoners came to Bankside to take their pleasures and indulge their carnal desires. It's even possible that some still do, though they hardly run the same risks as when the bishop also ran the Clink, the prison that gave the world the generic slang for a lock-up. Here were the playhouses, cockpits, bearpits, alehouses and bawdy houses, and at the centre the bishop, licensing the brothels.

Wenceslaus Hollar, the seventeenth-century artist from Prague whose engravings of London before the Great Fire provide us with our best record, showed the palace, an accumulation of interlocked buildings beside the Thames, sitting within walled orchards. It served as a royalist prison in the Civil War, started to fall down in the years afterwards, and its remains then gradually became lost to view among new buildings. Today, the main courtyard is Winchester Square; everything else is gone, except for a stretch of the Great Hall's southern wall to the north of the square and the whole of the west wall with its three linked doorways, one to the buttery, one to the pantry and one to the kitchen. The floor has gone, so the undercroft is open to the sky. Nevertheless, among the great nineteenth-century warehouses, this astonishing remnant stands in clear view: the hall where Henry IV's half-brother, Cardinal Beaufort, Bishop of Winchester, held the reception in 1424 for the wedding of his niece, Joan Beaufort, to James I of Scotland; and, above the doorways, in the gable, a 13-foot rose window. Its survival seems a miracle. With glass, it must have been glorious; as a ruin it is impressive but stark. It is built on straight lines. Inside the

main roundel a big hexagon is just about discernible, and there is a small hexagon at its heart, with the rest of the stone frame built up of triangles – a rose with thorns.
CLINK STREET, SE1

## AUSTIN MONUMENT, SOUTHWARK CATHEDRAL

*A huge monument to a lawyer's wife that is a summer's delight*

Southwark Cathedral seems to be at the heart of working London, tucked below the approach to London Bridge, hemmed in by Borough Market, eateries, shops, pubs and old warehouses finding new tourist-related uses. The cathedral was originally the parish church of St Mary Overie, from at least the thirteenth century, until the Church of England upgraded it in 1905. In the early nineteenth century the nave was falling down, so the church authorities completed the job and rebuilt it, twice. Neither attempt was much good. The nineteenth and twentieth centuries have marked the building throughout with mechanically reproduced Early English details. And yet, because of its tombs and its neighbourhood friendliness, it is rewarding to visit.

There's a stone slab in the choir pavement recording that somewhere in the building is the forgotten grave of Shakespeare's younger brother Edmund, who, like William, worked at the Globe, and who died in 1607; and of Shakespeare's occasional collaborator the dramatist Henry Fletcher, died 1625; and Fletcher's own frequent collaborator, Philip Massinger, died 1640, though the *post mortem* slab is engraved 1638. Chaucer's friend, the Kentish poet John Gower, who lived his last years in Southwark, died in 1408 and his tomb chest and effigy survive in the north aisle, recently repainted, more or less, to the prescription of a sixteenth-century witness, John Stow: '... the hair of his [the effigy's] head, auburn... a habit of purple damask down to his feet; a collar of S.S., gold about his neck'.

Gold, too, is the angel poised above the living rock of Christ in the cathedral's prize possession, the huge monument of 1633 in the north transept by Nicholas Stone (c. 1586–1647) to Joyce Austin, the wife of a Southwark lawyer, William Austin. It's based on Jesus's parable of the sower ('as he sowed, some fell by the way side, and the birds of the air came and devoured it up. And some fell on stony ground... And other fell on good ground, did yield fruit that sprang up and increased'; Mark 4, 3–9). Above the angel is a golden sun; the rock is set within a niche with wheat and grass growing before it; to each side is a female reaper, sitting slumbering after labour, one with a tall rake, the other with a fork, sisters in high-waisted dresses, calf-length boots and big-brimmed straw hats: they are extraordinarily fresh, modern, naturalistic rustic creations, quite out of time, as though Stone had been relieved by the chance to step away from classical convention. They too were painted in about 1980: brown hair, yellow hats, green cummerbunds and dress hems, brown boots. Art historians have disapproved of the local colour as well as the gold, presumably on the perfectly

From when this operating theatre at Guy's was opened in 1822 the flow of blood drew a packed house of medical students.

good historical grounds that Stone, the son of a Devon quarryman and trained in the Netherlands, was among the first Englishmen to break away from polychrome Tudor sculpture (seen in glorious restored garishness throughout the cathedral). Regardless, Nicholas Stone's monument is a pastoral miracle.

LONDON BRIDGE, SE1 9DA

## OLD OPERATING THEATRE MUSEUM AND HERB GARRET

*Blood and guts above the former chapel of the old hospital*

It always seemed a reasonable assumption that an operating theatre was so called because, like a theatre of war, it was a place of bloodshed. The seventeenth-century church of St Thomas in St Thomas Street suggests a partly different answer. At the top of a narrow winding newel staircase in the attic is a highly functional operating theatre of 1822 with the rational calm, plainness and organisation of a Quaker meeting house. Around the operating table are steeply banked horseshoe-shaped rows with bars in front of them for an audience of medical students and apprentice apothecaries to lean on, standing room only. A theatre of operations was here more than a figure of speech. It is the kind of place that Hogarth had in mind in his engraving *The Reward of Cruelty*, showing a couple of surgeons disembowelling a corpse before a semi-attentive audience. And indeed blood was spilled in St

Thomas's: the space between the floor of the operating theatre and the ceiling of the church was stuffed with sawdust to stop blood dripping into the nave.

The operating theatre was handily placed in the herb garret, where the apothecary stored foxgloves, meadowsweet, marshmallow root, wormwood, sheeps' heads, stinking fish, poppies, conserve of roses and a hundred other things necessary for preparing and dispensing medicines.

The church then was at the south-western corner of St Thomas's Hospital and served as the college chapel. The hospital removed to Lambeth in the nineteenth century and the church itself has become the chapter house of Southwark Cathedral. The pretty redbrick tower stands out into the pavement of St Thomas Street. If the sick survived the journey up the spiral staircase, they were operated upon by surgeons in frock coats caked with muck and wielding unsterilised instruments, with the assistance of burly aides who held down the unanaesthetised patient. A contemporary print on the wall tells the full stomach-churning story. And yet at this point before the introduction of ether and chloroform (in 1847) and, in fact, from the time the church was built, the practice of medicine had improved beyond the state of the practice on 26 March 1658, when Samuel Pepys had an operation for the removal of a bladder stone (not at St Thomas's but 'at Mrs Turner's in Salisbury Court') and the event was so important that on the second anniversary, which was the first year of his diary, he noted that he had resolved 'while I live to keep it a festival... and for ever to have Mrs Turner and her company with me'. Amen to that.

9A ST THOMAS'S STREET, SE1 9RY

## GUY'S HOSPITAL

*The eighteenth-century hospital for the overspill from St Thomas's*

Thomas Guy, born in Southwark, the son of a lighterman, wharf owner and coal-dealer, embarked on bookselling at the age of 14 or 15 in Cheapside, and was by 1668 possessor of his own shop at the junction of Cornhill and Lombard Street, and a member of the Stationers' Company. He ratted on the company when, realising that it wasn't exploiting its right to print the King James Bible, he managed to obtain the licence to print it at Oxford University Press, and made his first small fortune. He became a governor of St Thomas's Hospital in 1704, made really big money manipulating South Sea Company stocks, and died at the age of about 80 leaving the huge sum of £300,000, which would have been even greater had he not spent £18,000 in his last great charitable act: building Guy's Hospital opposite St Thomas's.

Throughout his life and down the ages, accusations that he was a miser have pursued the unmarried Thomas Guy, some of them seemingly soundly based. Yet he founded almshouses in his mother's home town of Tamworth, gave money to schools and workhouses, and had given large sums to St Thomas's before founding Guy's. The building was completed in 1724, and Guy died just

before it opened to gather in the sick, the halt and the lame; the overspill from St Thomas's.

So it is this other Thomas Guy, the bringer of kindness and mercy, who is commemorated in the marble sculpture by John Bacon in the very pretty hospital chapel, created in 1779, presumably when the benefactor's remains were moved there from St Thomas's. It shows Guy taking the hand of a sick man and pointing towards the hospital engraved on the back of the niche. It is usually said to be Bacon's masterpiece, but despite its skill it has more than a hint of the sentimentality to follow in the next century. Not so Peter Scheemakers's splendid standing figure in bronze displayed on a stone plinth in the front courtyard of Guy's, open to St Thomas Street.

As it happens, the Antwerp-born Scheemakers was almost wiped out later in his career by the brilliance of the younger Roubiliac, a native of Lyon, both of them stars in the English firmament, but in this early work (1734) commissioned by Guy's great supporter and friend at St Thomas's, Dr Richard Mead, physician to George II, Scheemakers's naturalism translates perfectly into bronze. Guy stands, relaxed and unassuming, no wig, hair lightly brushed, waistcoat unbuttoned from the chest up, stockings wrinkled at knee and ankle, one hand holding his cloak clear of the ground, the other outstretched, welcoming, holding a document, perhaps the freehold of his new hospital, as grand today as it was yesterday despite the overshadowing presence of the twenty-first-century skyscraper the Shard pointing like a finger to heaven.

GREAT MAZE POND, SE1 9RT

## HAY'S WHARF

*Hay's Wharf, great location;*
*London Bridge City, pretentious idea*

Hay's Wharf is one of the best stretches of London river, and probably has been since the obscure Mr Alexander Hay bought the land in the mid-seventeenth century and filled it with shipping. Somewhere along its bewildering history of changing ownerships over recent years the PR people hung on it the designation of London Bridge City; but there is nothing to stop the rest of us sticking to Hay's Wharf, just as Hay's Wharf's headquarters building stuck steadfastly to the Thames, protected by a heritage listing. It lies on the south bank between London Bridge and Tower Bridge and contains one of the most significant twentieth-century buildings in the metropolis, H. S. Goodhart-Rendel's Hay's Wharf company headquarters.

Goodhart-Rendel was by no means a Modernist, but beneath the building-wide machine-shiny Art Deco capital letters spelling out Hay's Wharf in gold he created an electrifying early-Modern building. It is built of steel and glass and clad in Portland stone (unusual in its time in London) and it has no ground floor but stands on pillars (unprecedented in its time in London) to allow easy access from the Tooley Street front to the wharf. It would also be one of the most forgotten buildings in the city but for Frank

Dobson's relief sculptural decoration in gilded faience on the river façade, shining through the murk of a London winter's day like Monet's *Sunrise*.

Dobson (1888–1963), a little like John Skeaping (see page 402), began with the reputation of being one of the founders of Modern British sculpture, but by the time he had joined the fuddy-duddies of the 1951 Royal Academy he had become almost a figure of the past. His best work was founded on the female nude, robust broad-limbed mother-earth figures in masses wonderfully disposed and balanced (see, for instance, the two nudes of *London Pride* outside the Royal Festival Hall). The Hay's Wharf work sits within a black granite frame and surrounds and divides the three narrow, deep windows of the boardroom with two horizontal panels and four vertical. The horizontal panel across the top of the windows forms a frieze of three nudes denoting by some mysterious alchemy Commerce, Capital and Labour. Dobson's low relief pushes the figures towards abstraction; in fact, the male nudes are practically schematic, the female nude sensuously evocative of almost anything but capital.

Splendid as was the conversion of wharf into galleria (so called, presumably, because the glass tunnel vault closing in the old narrow dock was modelled on the famous Galleria Vittorio Emanuele II in Milan), it drove a wedge between the impoverished population of much of this part of Southwark and the river. The

Hay's Galleria, as the tarted-up shopping and eating space at the foot of London Bridge is known, was the tea trade's main wharf in the nineteenth century for cargo from the east.

worst of the fears locally were dispersed when the riverside walk between the bridges was opened up, but though the galleria is stuffed with shops and cafés, they are for London Bridge City kind of people. They have nothing to do with the locality, and the trumpery ship sculpture sitting on the filled-in dock between Balls Brothers and Café Rouge helps not at all.
TOOLEY STREET, SE1

## MORE LONDON

*Where the Thames is an accessory to glitz*

More London is spelled out all over the estate, the name etched on to granite blocks with nice restraint, so far as lettering a couple of feet high, give or take, can be thought restrained. Still, it's a welcome change from all those un-signposted main streets all over Everyman's London. More London, the signs here insist. Well, more or less. More for the high rollers.

But to start with Foster + Partners. Theirs is the spectacular site plan, and surely the Greater London Authority's City Hall is one of Norman Foster's finest single buildings, certainly externally, with the eight floors above the ground floor and basement expressed in a series of concentric circles marginally off centre so that each circle overhangs the one below, leaving the Thames-facing front with a pronounced and beautiful curve. The Thames is an important accessory to glitz: even the severe elevation of 6 More London, first on the left off Tooley Street, is expressed in an open grid of metal struts with a ripple suggesting water.

Yet not even City Hall is London's. It belongs with the whole project to an offshore investment company called More London. Mayor Boris Johnson's authority in his council's headquarters runs to signing the cheques to an invisible landlord. The name itself, More London, is a marketing man's evanescence that will evaporate with the morning mist. It hardly fits in with Bermondsey, from which its 13-acre chunk has been sliced, nor with Rotherhithe, Smithfield, Clerkenwell, Shadwell, Limehouse, Poplar – names that stand out from centuries of mapping London, from Matthew Paris in the thirteenth century to Phyllis Pearsall and her generations of *A to Z*s. The sculpture around the site is neatly placed and nicely judged, but Julian Opie's clever outline paintings of heads, the sort the ageing young tiger has been producing for decades and now appear ten foot high in Ernst & Young's smart lobby, are exactly right: art in the service of impossible riches.

The southern side of grotty Tooley Street, which I had thought impossible to love, remains; but the old buildings to the north have gone. Gone too the tavern where the publican and his wife took me in at two o'clock one morning in the nineties after a car crash and fed me milky tea and sympathy as we waited for the police sirens. All this joins the long-vanished wharves and stairs on the river front in some conservationists' heaven: Horsleydown Stairs, Pickled Herring Stairs; the charity school and the free grammar school.

What might seem simple PR is popular. Free films in the spiral outdoor arena, a children's theatre, M&S, Café Nero, general access to the public (courtesy of a private security force). But London's Living Room, as the GLA dubs a chamber at the top of City Hall, is not generally open to Londoners at all. Tell that to the democratic citizens of Berlin and hear them laugh: there the public climb the spiral ramp daily to the top of the Reichstag – Foster again – and, untrammelled by diktat, point their cameras at MPs debating in the depths below.

TOOLEY STREET, SE1 2DB

## BUTLER'S WHARF

*A dream of grotesque genius*
*by Eduardo Paolozzi*

The colossal bronze head by the Scottish artist Eduardo Paolozzi (1924–2005) lying on its side outside the Design Museum might easily be called *Portrait of Boris Karloff as Frankenstein's Monster*: the head is split vertically and horizontally, with wedges embossed with Italian words driven into the gaps, the back of the skull apparently sheared off and stuffed with junk machinery, the neck end embossed with big capital letters bringing together all the words in a quotation from Leonardo (in translation): 'Though human genius in its various inventions with its various instruments may answer the same end, it will never find an art more simple or more direct than nature because in her inventions nothing is lacking and nothing superfluous.' So now we know that this is one of Paolozzi's grown-up works, not his forties blueprint for Pop Art. The piece is

popularly known as *Invention*, because *invenzione* is the most prominent of the embossed words. Paolozzi's own title is *Newton After James Watt*, as if the great engineer had reduced the great scientist to a matter of constructed parts, a work of grotesque genius and a usurpation of nature; a monster for the age of computers. It is in any case a fine and disturbing piece of work, which arrived at the edge of the Thames because when Paolozzi taught Terence Conran on a design course at the Central School of Arts and Crafts, they became lifelong friends; after Conran cast his spell over Butler's Wharf, he commissioned Paolozzi to produce a sculpture. It was Conran, incidentally, who taught Paolozzi welding.

SHAD THAMES, SE1 2YD

## ST MARY MAGDALEN, BERMONDSEY

*A parish church that stands in for a vanished abbey*

Mammon's benison is being lavished upon Bermondsey, even as the poor of the area get poorer (or, in Mammonspeak, the economy is in recovery). The Bermondsey of the leather trade has been tipped into the skip of history, leaving only the old names and some of the buildings (Leathermarket, Leathermarket Street, Tanner Street, Morocco Street, and many abandoned or converted warehouses). Bermondsey Square has been rebuilt with faceless apartment blocks, though the Friday antiques market stays, in a back lot between buildings off Abbey Street among the coffee bars, Lebanese restaurants, delis, a boutique hotel (how big can a boutique be?) and Zandra Rhodes's fashion palace.

For abbey, read Bermondsey Abbey. The Tudor Reformation did for that and the nineteenth century dug and covered with tarmac what was left under Abbey Street. A fragment of the old gatehouse remained in three adjacent house façades in Grange Walk until it was swept up in the new London that builds for everyone but people and became a 'fantastic three-bedroom duplex penthouse apartment within this recently completed development including... sauna, terrace, balcony and stunning views of the city'. True, it did have only sentimental and atmospheric value.

No abbey then; instead, just north of the nave under Abbey Street is the parish church, St Mary Magdalen, originally for the lay workers at the abbey but after the Dissolution the parish church, neglected and in ruins by the seventeenth century when the barely known Charles Stanton rebuilt it in 1675–9. In 1830 the parish surveyor George Porter redid the west front and tower in a mode not skittish exactly but eccentric in the matter of emphasis, with the remains of the medieval west tower forming the base of a folly, clasped by two polygonal columns rising to crocketed pinnacles clear against the sky, but flanking the narrow top stage of the tower with its saddleback roof crowned by a faintly oriental-looking cupola; mock battlements like a dowager's ill-fitting teeth. The church reclines spaciously within its churchyard (a park since 1870) between Bermondsey Street and Tower Bridge Road. The crossing

ends outside the south aisle in a huge semi-elliptical gable containing a three-light pointed window, worth climbing to the grill and bar of the new hotel to view.

The interior, mostly Stanton, is charming, subtly illuminated by daylight from hidden lunettes in the clerestory, a beautifully set organ and organ gallery in the west, a prettily painted coffered barrel-vaulted ceiling in the chancel, flat ceiling in the aisles except where the *faux* crossing is enunciated merely by a barrel vault running at right angles across the aisles. The east window of 1883 hasn't received much attention but is festively composed and coloured, and shows Christ addressing a woman sinner washing his feet. For some, she is still identified with Mary Magdalen. Two doors down is a carved stone fascia of 1907 identifying the Time and Talents Settlement, founded to take girls off the street by introducing them to needlework and basket weaving. Poor Mary.

193 BERMONDSEY STREET, SE1 3UW

## ST MARY THE VIRGIN, ROTHERHITHE

*The church of the skipper who exported pilgrims to America*

Rotherhithe's connection with the Thames has been close to the point of drowning. If St Mary's church and churchyard sown with the bodies of generations of seafarers flooded frequently, so too the school and the tavern and other buildings at the centre of the old village, bound closely together by the winding lanes of stone setts: St Marychurch Street, Tunnel Road, Rotherhithe Street. Pepys knew Rotherhithe well (Redriffe he called it, by its older appellation), where he often visited a pub called the Halfway House, and in his diary entry for 5 January 1666 he blamed the floods on encroachments into the Thames of water 'running out of Cawse ways into the River at every wood wharfe, which was not heretofore when Westminster-hall and White-hall was built, and Redriffe church, which now are sometimes overflown with water.' History does not say whether St Mary's suffered as much as Westminster Hall upriver, in which, reported Walter Thornbury, the nineteenth-century London historian, 'wherries were rowed in the middle of the floor' in 1236, and in 1579 'fishes were left upon the floor of the hall by the subsiding stream'. (The hall was flooded even in 1928 and 1929 after the Embankment had been built.)

St Mary's as Pepys knew it was a medieval church, but rebuilding began in 1716. It wasn't finished until at least 1747, when Lancelot Dowbiggin, an architect from faraway Islington, completed the pretty redbrick west tower with its white stone facings, and a coronet of Corinthian columns surmounted by an octagonal spire and an elegant wind vane as streamlined as if the wind had shaped it. Somewhere along the line John James, a solid architect but not in the class of his close colleagues Wren and Hawksmoor, had something to do with the church, since he was paid the tidy sum of £45.

The best way of seeing the interior involves attending a service, for this church, like many, is a slave to its insur-

ance policy and stays locked up, though with the difference that the exterior south door is open and the body of the church can be viewed through a glass screen; like looking at paintings in reproduction, not good but better than nothing. There is a fine eighteenth-century reredos, though with nineteenth-century paintings which would be just as well viewed in reproduction. Lots of good memorials, of which the most significant, not erected until 1995, is to Christopher Jones, mariner and part owner of a small ship which he used between about 1611 and 1620 on the Aquitaine run, sailing out of Rotherhithe and importing clarets from Bordeaux. The boat, all 100 foot in length and 180 tons of it, was the *Mayflower*, and in 1620 Jones skippered her through the Atlantic winter gales with a crew of about 35 and a cargo of 102 Pilgrim Fathers, down to 100 when they arrived, men mostly from Nottinghamshire who had escaped persecution by moving en masse to Leyden but then decided to seek religious freedom in the English colonies of America. Jones returned to England in May the following year, died in March 1622, aged about 52, and was buried in a (lost) grave in St Mary's churchyard.

ST MARYCHURCH STREET, SE16 4JE

## BRUNEL MUSEUM AND THAMES TUNNEL

*Tunnelling under the Thames*

When passengers on the platforms of Wapping Station look south they are peering at the horseshoe arches supporting the two shafts of the first tunnel ever dug anywhere in the world under a navigable river; a Neo-classical hymn to invention. The concept was that of Marc Isambard Brunel, a French naval officer and inventive genius married to an Englishwoman, Sophia Kingdom. He invented a tunnelling shield, which is the lineal ancestor of the Greathead shield used for the London Underground and the modern development of machines tackling projects like the Channel Tunnel. His principal assistant was his son, Isambard Kingdom Brunel, an engineer whose fame would exceed even his father's and whose massive iron ship the *Great Eastern* was later built downriver in a Millwall shipyard.

Beginning in 1825 the construction became an epic tale. The tunnel flooded often, one man fell fatally down a shaft, an engineer died of river fever, seven miners drowned, men had to plug holes in the river bed with clay, Marc suffered a paralysing stroke and Isambard severe haemorrhages, capital ran out, the Duke of Wellington appealed to the patriotism of all Englishmen and the chairman of directors, William Smith, a character who would be at home in twenty-first-century governance, secretly sabotaged efforts to raise a government grant. *The Times*, with class-drenched hauteur, called it the Great Bore. In 1828 Marc bricked up the completed stretch of tunnel for seven years until the directors (by now Smithless) could raise the wind. As it happened, seven years later was when the Stockton and Darlington Railway laid down a marker: trains were to conquer the world. In 1843 the Brunel

tunnel reopened but continued to suffer indignity as a tourist attraction, a market place, and a whores' happy hunting ground. At last, in 1865, the East London Railway bought it to run trains via Wapping to Rotherhithe on what today is paradoxically called the London Overground. The family ill luck dogged Isambard Kingdom Brunel to the end. He was on his death bed in 1859 when he heard the news that seven crew members of the *Great Eastern* had died when a boiler exploded on its maiden voyage.

The Brunel engine room equipped with a steam-driven pump to draw off water was near the parish church and directly above the tunnel. It became just another crumbling building until restoration from the 1970s onwards brought it back to the dignity of solid functionality, brick-built with a timber-framed roof, the perfect place for a small Brunel Museum containing white portrait busts of the engineers standing against the scraped yellow brick walls and the charming trivia with which the public salutes its heroes: perspective peepshows, snuff boxes once sold to pedestrians by stall holders tucked in between the curving ribs of the tunnel, engraved commemorative glassware, decorated boxes, broadsheets, cartoons, even a watercolour daydream of 1835 by Marc Brunel himself, showing a section of river, high water with a skiff on the surface containing one passenger, his son, strata of gravel and clay, and finally

Many men died to build the first tunnel under the Thames, which was designed by the Brunels, father and son, in 1825. The museum is housed in the machine room used for drawing water off from the works.

toffs of the reign of William IV, shooting the breeze in the horseshoe vaults.
RAILWAY AVENUE, SE16 4LF

## CANADA WATER LIBRARY

*A daring library where once were ships, cargo and cranes*

While other local authorities were closing libraries, Southwark engaged the innovative architectural firm CZWG to build a new library at Canada Water, the last remnant of Surrey Docks. The library opened in the depths of economic recession in December 2011 and stands in a loose development of either too few buildings, and those bare and functional, or too many. It is a poor millionaire's Canary Wharf, but the library induced more disinterested intellectual effort and research on this one small site than can be seen on the whole Canary Wharf complex. It leans daringly outwards from its narrow base, schematically ship-like in profile, held there by unseen steel girders and anchoring not because Piers Gough (the G of CZWG) wanted to prove that whatever Frank Gehry could do for the Bilbao Guggenheim he too could do at Surrey Docks, but because the library site is tiny, squeezed between the transport hub of a Jubilee line station and bus terminal and the sheet of water where ocean-going tall ships once moored. So it made sense to let the main library, the 150-seat theatre and the offices expand in the spacious top floors, and put a café on the ground floor in what might simply have been the entrance hall. Food for thought.

The building is covered with ripple-effect bronzed aluminium, which picks up and interacts with the reflected ripples from the water. That was an end to the major expense. The library cost Southwark £14.1 million; in 2007 the HSBC building at Canary Wharf sold for £1.1 billion. So there is no marble cladding or anything else of the sort, just red-painted walls and hardwearing carpet in jolly colours. But there are laptops for the public to use; there is a library for adults containing anything from popular publications to erudite works of history and philosophy; another for teenagers, and a third for children. For any of Southwark's population with no quiet space to work in at home, the library provides it, and there are besides lecture rooms, meeting rooms, a book club, a poetry club and creative writing courses. The place is as stuffed with people reading and writing as the Bodleian.

The main interior physical feature is the wooden staircase clinging to the walls of a wooden O and spiralling up from the café to the main floor where the librarians' desk echoes the circular theme; conceptual design in action. The floor of the café is made of the same kind of wood, and there's more of it in the few rows of shelves cut into the wall of the stairwell so that café society can browse. In the ceiling above are lightwells, deep squares punched through the roof, the light they draw in from the sky supplemented by electric globes suspended from the ceiling. Purists who have seen Gehry's Bilbao Guggenheim may have reservations about the costs cut in Southwark, but this is a building that breathes out warmth and humanity.

21 SURREY QUAYS ROAD, SE16 7AR

## • DEPTFORD, LEWISHAM, GREENWICH, BLACKHEATH •

### BEN PIMLOTT BUILDING, GOLDSMITHS

*The 'scribble sculpture'*

When Will Alsop was sixteen his father died. Alsop (b. 1947) took himself out of school, went to work for an architect, studied for his A-levels at evening classes and did a foundation year at Northampton College of Art. It was an unconventional start to a maverick career, and in his design for Goldsmiths College's Ben Pimlott Building in New Cross he has paid his dues on that foundation year. The Pimlott Building is named for the political biographer who was warden of the college until his death in 2004, a few months before the building's opening. It contains Goldsmiths' art studios, and is a seven-column slab with a sheer glass curtain to the north. It is very purist Mies van der Rohe, aluminium with punched window spaces on the other three sides, though the glass wraps round to the west above the terrace. On the south front are abstract sculptures (or features, in the bloodless terminology of today), clipped on to the raised seams of the aluminium panels like gigantic brooches. But what the passer-by sees from New Cross Road (the A2) is the

gigantic scribble sculpture on the terrace like a loose skein of wool, two storeys high to range with the top of the building, a piece of freehand gestural art that enlivens the street scene like nothing else in London. For this piece Alsop has taken a lift on the bandwagon of his close friend Bruce McLean.

He has more interesting designs to his credit, like the fantastic Blizard Building for Queen Mary University of London and maybe Peckham Library, where much more goes on inside – Goldsmiths is basically a shell for flexible studio space – but nothing quite rivals it for instant impact, which, in a drab, traffic-heavy area of South London, is a very good deed. One critic has described the sculpture as gratuitous. Free-spirited, it is; gratuitous it isn't. The story is that Alsop starts all his buildings with a sketch in oils or charcoal, but that's about as far as the improvisation has gone here. A close look shows that the so-called scribble sculpture has been carefully perfected, possibly on a computer, for maximum clarity of linear form and its effect in space. It doesn't fill the terrace, as it appears to do from the street, but instead forms a nine-metre high open screen, leaving an uncluttered area as working and display space for other sculptors.

UNIVERSITY OF LONDON, SE14 6NW

## THE STEPHEN LAWRENCE CENTRE

*Black diamonds in Deptford*

The facts are simple and well known. On the evening of 22 April 1993, Stephen Lawrence, a black teenager with ambitions to become an architect, was waiting at a bus stop in Eltham. A group of white teenagers approached him. When they moved off, Lawrence was dead. It took many years of police blundering and obfuscation before two of the white gang were convicted of murder. The Stephen Lawrence Centre was an offshoot of Doreen Lawrence's fight for justice, for her son in particular and black kids in general, to show them the way to a professional life, particularly in architecture. Designing the centre became the occasion for the latest in a series of collaborations between the black architect David Adjaye (b. 1966) and his contemporary the black artist Chris Ofili (b. 1968).

Adjaye had chosen to finish his education at the Royal College of Art, because his ideal already was to think conceptually like an artist, not fall back on set architectural techniques. For him, the Adjaye-Ofili partnership was perfectly timed. It emerged in embryo in 1998 when Ofili, as a tribute to Doreen Lawrence, painted *No Woman No Cry* (borrowing the title from a song by Bob Marley). The following year Ofili showed Adjaye the dilapidated house he had acquired, and Adjaye transformed it for him into living quarters and studio, a pearl in a barnacled oyster shell. He followed this in 2002 with a dark, chapel-like walnut-clad space for Ofili's sequence of 13 paintings of monkeys, which Tate Modern bought as a complete art work and environment known as *The Upper Room*.

Quite early Adjaye began to move out into public buildings: the brilliant Ideas Stores for Tower Hamlets (re-thought

libraries), an arts centre in Shoreditch, a museum in the United States. Then came the Lawrence Centre. Adjaye had to work with a cramped site between the River Ravensbourne to the east and a busy route between the A20 Blackheath Road and Lewisham town centre to the west. He designed the building in two parts linked by a bridge: a trapezium (two parallel sides, two irregular), and a cantilevered irregular triangle. Of the three storeys, Ofili's spectacular seven-metre glass wall curtains the bottom two floors, a web of organic abstraction which opens out into a floral pattern.

Adjaye himself has never consciously aimed for beauty. Even the houses with which he began his career, combining old brick with dark concrete, from sludge brown to black, are ruggedly impressive, a throwback beyond mere Classicism. The Lawrence Centre is striking but functional, the interior finishes basic and the space divided into all the stuff necessary for preparing youngsters for a professional life: conference chambers, small interview rooms, film studios, lecture halls. The Adjaye-Ofili partnership has subsequently loosened and nobody talks of the two as they do of Gilbert and George or the brothers Jake and Dinos Chapman, but they will. Their work touches more lives.

39 BROOKMILL ROAD, SE8 4HU

## ST PAUL'S, DEPTFORD

*A sumptuous Baroque church in a tatty high street*

Tatty old Deptford High Street has more character than a hundred main roads in more favoured boroughs. With its vibrant market three days of the week and its small shops locally run, it is the nonchalant setting for St Paul's, a church whose grandeur would embellish Rome. For though its architect, Thomas Archer, was born in Warwickshire (1668/9), he had a Roman heart, and his work was decisively shaped by the experience of spending four years in Italy during which he looked closely at the Roman churches of the Baroque architect Borromini. That is especially clear from a glance at the shell of Archer's St John's Smith Square (it was bombed and refitted after the war as a concert hall). With St Paul's, Archer spurned the extremes of Borromini's Baroque, but not its theatre.

St Paul's is the parish church of south Deptford. St Nicholas, the parish church of north Deptford, is barely 200 yards away on the other side of Creek Road, an ancient foundation of which only a part of the tower survives from the original building. Inside is a small wood carving of St Ezekiel which some officers of the church believe to be by the then unknown Grinling Gibbons, who lived in a cottage at Sayes Court, the estate of the diarist John Evelyn. Christopher Marlowe was buried in an unmarked grave in the churchyard after his encounter in a drinking den with the knife-wielding Ingram Frizer. Today St Nicholas itself is buried with its history among gloomy blocks of flats covering what used to be Deptford Green, and it is St Paul's that basks in the curtain calls.

Thomas Archer was the son of an MP and former colonel in the Parliamentary army. On his return from a four-year

grand tour, Thomas became one of England's gentleman amateurs of architecture. He designed a few houses, added to a few more, but built only four churches. St Paul's was one of the churches approved by Commissioners in the last years of Queen Anne's reign to fill in gaps in and around London, wherever the population was soaring. It was consecrated finally in 1730 and is surely the best of the batch, and one of the finest anywhere in the country.

Archer solved the problem that had foxed the classical architects of Wren's generation and after: how to combine a spire to the west of the church above a classical pediment. We have become accustomed to James Gibbs's St Martin-in-the-Fields and its many successors, but strictly speaking they are abortions of Classicism. Archer's west end is a triumphant affirmation. He erected his spire, but gave it a capacious semi-circular base above a semi-circular portico crowned by a balustrade and with four giant Doric columns rising from a platform above a wide sweep of steps from the churchyard. Look at Wren's St Paul's from the Millennium Bridge and you have the likely immediate source for Archer's solution. Everything about the rustication, the keystones, the balustrade above the portico and to the stairs north, south and west, is crisp and authoritative. The interior, too, is a consummate triumph of early eighteenth-century decor: square-planned, flat-ceilinged, Corinthian order of columns and, going back a century, the Rome of Bernini and Borromini. Architectural writers tend to use for illustration the plan of Archer's church, not so much for purposes of information, I suspect, but for sheer pleasure in its beauty.

DEPTFORD HIGH STREET, SE8 3DP

## LABAN DANCE CENTRE

*Dance and painting,
works twinned in progress*

Deptford Creek is the tidal final stretch of the River Ravensbourne, which meanders from its source in Keston in the London suburbs to debouch into Greenwich Reach. At the mouth of the creek, just beyond the lifting bridge on Creek Road, Henry VIII had his biggest shipyard, still extant when Pepys used to ride, or sometimes walk, to Deptford to inspect progress and on a good day to fornicate with Mrs Bagwell, the wife of a ship's carpenter. Until the end of the twentieth century Deptford was a post-industrial cesspit filling the interstices between a medieval skeleton of country lanes. Now the view of the creek from the back of the glistening new Laban Dance Centre discloses the traces: the carcass of an abandoned boat rotting into the low-tide mud, builders' and car repairers' sheds on the far bank, a boatyard.

The Herzog & De Meuron Laban building of 2005, the Zurich architects' first work in London after Tate Modern, is a midsummer night's dream, a curving sheath of glass wrapped around a concrete core and itself cocooned fantastically in gauzy, lucent polycarbonate panels – semi-opaque, pink, mauve, turquoise, lime green – to obscure the view on to activities within, to moderate

the light and to conserve heat. Within the studios the dancers cast big wraith-like shadows on to the polycarbonate-backed glass as they move. The interior is more glass and broad acres of Liquorice All Sorts colours, magenta, lime green, turquoise, with eruptions of black-concrete partition walls and spiral staircases like the screws of gigantic propellers. It is architecture in the service of 12 studios, lecture rooms, conference rooms, a library, a café-bar, the 300-seat Bonnie Bird Theatre, and the ambition of the Hungarian wartime emigré Rudolf Laban to create an education in dance that would double as an education in life.

Jacques Herzog and Pierre de Meuron are always keen to work with artists, who are co-opted for their experience with colour, so in this case Michael Craig-Martin's involvement was as first among equals in making decisions about the colour schemes, a process that led logically to the mural covering the internal walls of the theatre on the mezzanine floor (a barely noticeable gradation from the ground-floor entrance lobby). It's a concatenation of items pulled from Craig-Martin's familiar lucky dip (see also page 386): a sandal, headphones, a bistro chair, a watch, a soda siphon, a ladder, a bucket; stuff out of tool boxes, kitchen drawers, a cupboard under the stairs, with no hierarchy of size, means to an end rather than the end, a meta-kit for Craig-Martin's transformations of the commonplace into a sublimely good-humoured near abstraction. It's only part coloured in and is named *Laban Wall Drawing*, suggesting a work in the process of becoming, which, after all, is a fit description too for the dance process.
CREEKSIDE, SE8 3DZ

## BOONE'S CHAPEL

*Alms and the man*

Lee High Road is a down-at-heel mess of shops and faintly squalid twentieth-century terraces of houses, a red route that it's good to get out of. Traffic usually crawls so that there is time to take in on the north side of the road one reminder of a civilised age: the enchanting Boone's Chapel, built in 1683, a small building still immensely pretty even though the brick has eroded in sympathy with the shabbiness all around. There is no record of an architect, but since it's so classy and in the direct tradition of Wren, Blackheath Historic Buildings Trust, which assumed the task of looking after the chapel after years of its being on the English Heritage at risk list, guesses at one of the Wren team: Robert Hooke. Why not? He is generally thought to have built the similarly pretty City church, St Benet (see page 28), and helped Wren with Flamsteed House by the Observatory in Greenwich Park. 'A little for pompe,' Wren remarked of this residence built for the royal astronomer, and a little of the pompe reserved for Boone's Chapel is in the detail: the emphatically cased front door, the round-headed windows either side and the bullseye window above (a bullseye window too in the middle of each of the other three sides), the big stone quoins articulating the corners of the chapel and gables on the four sides of the pointed roof, which sit on an entablature running right round the building to form four pediments with deep eaves. On top, there is a little white cupola.

Boone was Sir Christopher Boone, a member of the Merchant Taylors Company, who built the chapel to sit with four almshouses, which were later destroyed and replaced further along the road, leaving the chapel isolated at the southern edge of its little park. There was the usual price to pay by residents of the almshouses, who had to be able to recite the Lord's Prayer, the Creed, and the Ten Commandments within two months of arriving or face summary ejection. Recently, children have planted out a small physic garden in the park close to the chapel, to celebrate the founder's fondness for horticulture.

To the west of the chapel Brandram Road runs uphill to a group of roads lined by villas, classical, Gothic, Italian, late eighteenth and nineteenth century, commodious getting on for sumptuous. In a sense Boone's Chapel is their outrider, yet that is to understate its importance as one of only a pair of grade I-listed buildings in the whole of Lewisham (the other is the spectacular Baroque St Paul's Church, Deptford: see page 364). Perhaps because not enough of us know the Lord's Prayer, the Creed, and the Ten Commandments, the interior of Boone's Chapel has been converted into an architect's studio, but it opens to the public 30 days a year, including Open House weekend.

LEE HIGH ROAD, SE13 5PH

---

Down by Deptford Creek the Tate Modern architects Herzog and de Meuron built the magical Laban Dance Centre clad in translucent panels.

## ST ALFEGE, GREENWICH

*The key to Hawksmoor's career, the Roman ruins of Baalbek translated*

Since incendiary bombs rained on St Alfege in 1941, the best of what remains is the exterior. In a sense, that is as it should be, because St Alfege holds up the view at the end of the approach from the east along the processional route of Trafalgar Road, Romney Road, and Nelson Road, between Greenwich Park and the Queen's House to the south of the route and the old Royal Naval College to the north, with *Gipsy Moth* hard by in, so to speak, mothballs. Nicholas Hawksmoor (1662–1736) was the diffident pupil of Wren, clerk of works at the Naval College and author, perhaps, of some of its architecture; but he is the undisputed begetter of the new St Alfege, a church of ancient foundation built, it is supposed, on the site where a war party of Danes bludgeoned Alfege, Archbishop of Canterbury, to death in 1012. It was one of 50 commissioned by the government to be built or rebuilt in London and the environs in 1710, the first of a series of Commissioners' churches as London grew, just as St Alfege was Hawksmoor's first church.

It rounds out a wonderful piece of townscape with the swagger of *Gipsy Moth* riding a sea swell. Hawksmoor, too, is the key that unlocks the mystery of how Vanbrugh launched his career with the building of Castle Howard though he had not enough experience to win a place on a bog standard university architecture course, supposing there to have been such a thing: it was Hawksmoor's soaring talent and hard-won professional expertise that freed Vanbrugh's own imaginative genius.

Absent from Hawksmoor's St Alfege is the easy glory of Wren's Classicism. Instead, Hawksmoor throws up a great bulwark of stone carried on a deep plinth, echoed beneath the eaves by a Doric frieze mightily severed in the east by a Doric portico with its tall arch thrusting upwards into the pediment; the precedent was the Roman ruins of Baalbek in Lebanon, for views of which Hawksmoor the farmer's son had to rely on the etchings of travellers more privileged than he. In north and south walls are paired rows of windows separated by giant attached columns, the top windows tall and round-headed, the ones beneath with huge heavily articulated triple-faced keystones, there simply to make a statement. This is pure baroque, mass and void the declamatory story of this building, and the west tower makes the point: Hawksmoor's budget fell short and the Commissioners decided to make do by recasing the old tower and having it updated by John James. It's a nice tower, but for a City church, not this one.

A lot of carving by Grinling Gibbons was lost to the bombs, but there is one crucial survival inside, the coffered apse within the eastern portico with monochrome paintings on the pilasters by James Thornhill, the great artist of the Painted Hall a quarter of a mile away (see page 372).

GREENWICH CHURCH STREET, SE10 9BJ

The Fan Museum, *The Boy I Love is Up in the Gallery*: W. R. Sickert painted this fan (c. 1889) with a favourite theme set in the Old Bedford Theatre in Camden Town.

# THE FAN MUSEUM

*The record of a fast-vanishing way of life*

It is difficult to be a fan of fans in the twenty-first century, despite their history spanning 3,000 years and more. Wherever people grew too warm, at home or in crowded spaces they would deploy fans, and because they were usually women and often rich, fans became fashionable, made with great finesse and beautifully decorated. Velázquez's *Lady With a Fan* (1638–9) in the Wallace Collection is the portrait of someone rich, possibly a duchess; his canvas in the Scottish National Gallery, *An Old Woman Cooking Eggs* (1618), portrays a servant, and in the heat of the kitchen there isn't a fan in sight. In any case, air conditioning has made them virtually superfluous except as a symbol of an almost vanished way of life.

The Fan Museum claims to be the only one of its kind in the world. It is at 12 Crooms Hill, a street that climbs along the side of Greenwich Park up to Blackheath in an unbroken parade of seventeenth- and eighteenth-century houses, the great age of the fan. Number 12 was built in 1712. Yet of the more than 3,500 fans in the collection, the star exhibit, though far from the most beautiful, is a recently acquired folding fan decorated in gouache on vellum by Walter Richard Sickert (1860–1942). It was a reworking in about 1889 of a subject he had treated on canvas, showing the music-hall artiste Little Dot Hetherington in the Old Bedford Theatre in Camden Town, spotlit in a white dress and with face raised to the gods, arm

pointing above the heads of the audience in the front row of the stalls, and with another figure just discernible in the wings as she sings 'The Boy I Love is Up in the Gallery'. It is a bravura piece, almost Japanese in the autumnal delicacy of the colours agitated into flickering movement by the fan's ribs. Sickert made it as a present for a friend and fellow artist, Florence Pash, virtually forgotten but herself a good painter, who sat several times for Sickert.

Sickert's French contemporaries painted fans too, among them Gauguin, and a fan leaf with a landscape from his visit to Martinique is the other nineteenth-century jewel in the collection. Gauguin signed and dated it 1887 and it is closer to his brilliantly coloured but basically Impressionist Breton landscapes than to the sophisticated Primitivism he arrived at later in Tahiti. Several of the hard-pressed exhibitors at the first Impressionist exhibitions found fans easier to sell than canvases. But the true spirit of 12 Crooms Hill lies in the core collection, put together by the museum's founder, Hélène Alexander, of Chinese, Japanese and French fans. So perhaps it is perverse to draw attention to a silk fan painted in 1914 by an English-trained Australian, Thea Proctor, with a barefoot idyll of two stylish women and a child, the style a cross between Ballet Russe's Bakst and a more languid Watteau. Being in faraway Down Under meant even Gallipoli didn't shatter the mood of high society, and she made a career out of prime style for her rich compatriots.

12 CROOM'S HILL, SE10 8ER

## STATUE OF WILLIAM IV, KING WILLIAM WALK

*Roman grandeur for a dim king*

The Duke of Clarence went into the navy at 14, saw action by 16, progressed to being Admiral Nelson's best man but was a wrong-headed failure as a naval officer. Never very bright, he was prone to interfering in politics where he had no business to and was always broke. More than once his long-term paramour, the actress Dorothy Jordan, helped him out of an immediate cash crisis with earnings from her brilliant career. A contemporary broadside put it:

> *As Jordan's high and mighty squire*
> *Her playhouse profits deigns to skim*
> *Some folks audaciously enquire:*
> *If he keeps her or she keeps him.*

As time passed, it became increasingly likely that his childless elder brother, King George IV, would die before him and the duke would succeed as William IV. He did and was called the Sailor King, although he never went to sea again. In the line of duty he dismissed Mrs Jordan and married Princess Adelaide of Saxe-Meiningen. Dorothy had produced ten children by him but the new royal brood mare failed to give him an heir. His niece Victoria was next in line so the kerfuffle of his marriage was unnecessary. Nevertheless the unsuitable William IV turned out to be popular and lucky: all sorts of good things happened during his short reign (1830–7), from the 1832 Reform Act to more caring poor laws, abolition of slavery in the colonies and Catholic emancipation, enough for him to earn a 20-ton statue on a 25-foot-

tall plinth at the intersection of King William Street and Eastcheap. There it stood from 1844, seven years after his death, until, in the interests of traffic flow, it was re-erected in 1936 in a little public garden off King William Walk at the foot of Greenwich Park on a more modest plinth only 16 foot 6 inches tall.

The unluckiest man in these transactions was its sculptor Samuel Nixon about whom no personal details other than his dates of birth and death (1803–54) are known, and precious little about his work, the best of it a few fine, modest memorials in London churches. The king's statue was the most important commission of his life but he was paid a piffling £2,200 for it, which didn't even cover his expenses in chipping away doggedly at two blocks of Foggintor granite, the stuff they used to prevent the untimely departure of Dartmoor prison inmates. He protested, and his friends in the business protested too, to no avail. The City of London Corporation proved as adamantine as the granite.

Yet the statue Nixon produced is good if, understandably after all the ruined chisels, dull (the new 'unidealised naturalism' is the get-out phrase). Certainly it shows the positive quality of the king, most surprisingly, because it is not easy to evoke in this medium, his salty good humour. He wears the uniform of a Lord High Admiral (a ceremonial role only, the government of the day was careful to make clear), carries a leader's baton, and wears a long cloak, which allows a touch of Roman grandeur.

ENTRANCE TO GREENWICH PARK, KING WILLIAM WALK, SE10 9JH

## NATIONAL MARITIME MUSEUM

*Where they've bottled Nelson's Victory*

Yinka Shonibare's ship in a bottle looked as superfluous during its seven-month spell on the fourth plinth in Trafalgar Square as all the other works that have appeared there since 1998, by good artists and bad. All, that is, except for the wonderful Rachel Whitehead's strangely glowing resin inversion of the plinth it stood on. There is no reason why Shonibare's offering should have failed. The ship, after all, was Nelson's *Victory*, so the references to the man on top of the column, the name of the square, the battle that brought death and glory to a national hero, are quite explicit. What the bottled *Victory* needed was not all this crowding in of context, but distance and calm.

It has both in Greenwich, although there's still plenty of context in the National Maritime Museum, behind which the bottle stands ('see the uniform Admiral Nelson was wearing when he died' for instance). The bottle rests on a plinth no more than eight foot high; 'the biggest ship in a bottle in the world,' one newspaper asserted. In fact, it is getting on for 17 foot long and the neck is big enough for Shonibare's studio assistants to climb inside, so there were few of the usual problems to inserting the ship.

Old salts vouch for Shonibare's accuracy too; his ship's cargo, though, is not nostalgia but politics, lightly freighted but telling. He is Mr Multi-Culturalism in person, Yinka Shonibare, born 1962, Nigerian parents, education in Lagos and London, prolific producer

of art for shows all round the globe. His *Who's Who* entry doesn't mention the membership of 'the Most Excellent Order of the British Empire' (bestowed 2004) though, naturally, it does mention his membership of the democratic and easy-going Black's Club in Soho. He has in fact bolted MBE on to his name, Yinka Shonibare MBE, like that, without the courtly comma, so the Shonibare retrospective in Sydney, New York, and Washington DC, was called *Yinka Shonibare MBE*. His work is about empire and colonialism and trade and the mingling of cultures. So the sails of HMS *Victory* are made of the batik textile known as Dutch wax, the stuff African, or British African, women wear in the Tube or in the streets of Brixton. Brixton market is where Shonibare buys it to use in his work; but it is not African, it was always made in Indonesia for Dutch firms. Contradiction is the wind in Shonibare's sails.

PARK ROW, SE10 9NF

## PAINTED HALL, OLD ROYAL NAVAL COLLEGE

*Liberty and Tyranny on a ceiling*

Greenwich had been a medieval manor house and was converted into a palace by Henry VIII. James I's visionary commission for the Queen's House (see page 374) set in train the most momentous single architectural project in English history, interrupted by the Civil War and then taken up again with Charles II's decision to commission John Webb (favoured as son-in-law to Inigo Jones) to raze the brick Tudor buildings and design a new

Baroque palace. It turned into a half-century-long enterprise, beginning in 1662 with Webb's King Charles Block to the west of the site on the river front, and continued by Wren with assistance from Hawksmoor in 1698 with the eastern river front Queen Anne Block and the two blocks behind, King William to the west and Queen Mary, closer together but preserving the view from the river through to the Queen's House and Greenwich Park. Wren's great hall lies laterally across the northern end of King William. It was complete in 1705 and was ready for James Thornhill to begin painting the murals in 1708.

Thornhill (1675/6–1734) took second place in country-house commissions to Verrio and Laguerre, his contemporaries from Europe, but rightly believed his own talents superior and lobbied successfully for the commissions to decorate the dome of St Paul's Cathedral and the great hall at Greenwich. In time-honoured fashion, his subject, *Peace and Liberty Triumphing over Tyranny*, shows the monarchs William and Mary sitting in pavilioned glory in the heavens: while Apollo, shedding light, thunders above the scene in his chariot drawn by white horses, William III receives in his right hand an olive branch from Peace, a lightly clad young woman; simultaneously, with his left, he passes the cap of liberty to Europe, another semi-nude female, and places his right foot firmly on the head of Tyranny, represented by the fully clad but supine Louis XIV. On the ceiling above the high table in the upper hall Queen Anne and her consort survey the five continents; on the walls, the landings in England of William III and George I are depicted – the painter expeditiously updated the subjects as he laboured for 19 years.

To the murals Thornhill added painted cartouches in the hall's vestibule, which bear the names of donors to the building fund. The list includes the name 'John Evelyn Esqre' and records his gift of £1,000. Evelyn lived a mile or two upriver in Deptford (the John Evelyn pub in Evelyn Street marks the south-western boundary of his vanished estate); he had been treasurer of the project from the beginning, laid the first stone for this building in 1696, and nine years later notes in the journal by which he is remembered today: 'I went to Greenwich Hospital, where they now began to take in wounded and worn-out seamen, who are exceeding well provided for. The buildings now going on are very magnificent.' Rather too magnificent for the wounded and worn out, it soon became clear: the old seamen were dispatched pronto to dine in the undercroft, leaving the hall fit for tourists.

For his services in the cause of the higher sycophancy Thornhill was knighted, like Rubens before him for similar if much greater work in Whitehall. Naturally, there was a political agenda too. Catholic James II had been forced to abdicate in favour of William of Orange, but William was the son of Charles I's daughter Mary, so Stuart blood ran in his veins, and Mary, the daughter of James II, is by his side in the painting as well as in life, to assert the

Yinka Shonibare first showed his big bottled HMS *Victory* on the empty plinth in Trafalgar Square. Equally appropriate, it's now in full sail at the National Maritime Museum.

continuity interrupted by William's Protestant invasion from the Netherlands and Catholic James's flight from the throne.

As for the banished seamen, one remained in the hall. Thornhill chose John Worley, insubordinate and drunken at the age of 96 as he had been as a young sailor, to sit among the seasons in the William and Mary ceiling, anointed in dignity, white-bearded, representing Winter.

OLD ROYAL NAVAL COLLEGE, SE10 9NN

## THE QUEEN'S HOUSE, GREENWICH

*Pepys's apotheosis*

Inigo Jones built the Queen's House at Greenwich astride the old Dover Road on the divinely ordained spot where Sir Walter Raleigh laid down his cloak so that Queen Elizabeth would keep her feet dry as she crossed to Greenwich Palace. The road survives as a cobbled passageway beneath the house. The building, with its famous 40-foot cube-shaped hall is one of the most beautiful houses in Britain, and was the first fully classical one. James I commissioned it in 1616 for his queen, Anne of Denmark; she died in 1619 before the house was finished so Charles I's queen, Henrietta Maria, succeeded to it, though it wasn't completed until 1635. Never has a small house been so beautifully framed as this is by the old Royal Naval College, built as a palace for William and Mary. Today it is open to the public as part of the National Maritime Museum and contains a notable collection of paintings of the naval hierarchy of the seventeenth and eighteenth centuries by the great portrait painters of their day.

The welcoming curves of the double-sided staircase meet at a terrace to the north of the house. Immediately behind is the two-storey cube hall with single-storey service areas on either side, including the spectacularly twisting tulip staircase to the first floor. Here, to the east is the queen's drawing room, to the west her bedroom, each modules of the hall at 40 foot wide and 20 deep, with staircases and minor rooms behind. This front section of the house is joined to the rear part, a building of exactly the same size, by a bridge room, which was initially just that: a bridge beneath which ran the London to Dover road. The space beneath the bridge has been filled in, and the doors created to each side at the base of the house open on to the colonnaded walk that has replaced the old road. So the plan of the house is an H-shape.

By one of those strange quirks of history, the queen's dressing room is known today as the Pepys Room, thus signalling a triumph for genius and industry over social class. His diaries and his work in helping to turn the navy into a fully professional fighting force have made him more pertinent in this place than Henrietta Maria, and more famous than any of the 13 so-called Flagmen, the English admirals who fought with the Duke of York (later James II) in the Battle of Lowestoft in 1665 and are celebrated by a First Eleven of portraits by Peter Lely (1618–80) in this room, including Pepys's kinsman and

patron, Edward Montague, 1st Earl of Sandwich. (The other two in the series are in the Royal Collection.) On 18 April 1666 Pepys visited Lely's studio 'and there saw the heads, some finished and all begun, of the Flagmen in the late great fight with the Duke of Yorke against the Dutch. The Duke of York hath them done to hang in his chamber, and very finely they are done endeed.' Indeed. The 13 portraits are some of the best of Lely's work. The royal family retained the paintings after James's exile until George IV gave 11 of them to the old Royal Naval Hospital at Greenwich.

As Pepys's star rose throughout the 1660s, he commissioned John Hayls to paint portraits of himself (now in the National Portrait Gallery) and his wife Elizabeth (destroyed in the nineteenth century). But by 1689, when he was forced out of office, tarnished by his association with the papist James II, he had an ample fortune and could afford to commission portraits of himself and his former clerk and faithful friend, Will Hewer, from the much more fashionable and grand court artist, Sir Godfrey Kneller (1646–1723). Kneller's Pepys portrait, with the adjacent likeness of Hewer, now takes precedence in the Pepys Room over Lely's admirals. It is a half-length inside a painted oval and shows a handsome man running to plumpness, with a sensually curved mouth and a level gaze. There is a finely painted white stock at his throat and he wears a handsome wig of brown hair. It is every inch the portrait of a successful man.

ROMNEY ROAD, SE10 9NF

## RANGER'S HOUSE

*A Donatello in all except name*

Julius Wernher trained his eye choosing diamonds in the days when he operated out of a corrugated-tin shack in Johannesburg. By 1903 he had a town house in Mayfair as well as Luton Hoo, a country house in Hertfordshire, which he filled with a diverse collection of *objets d'art*, beautiful, curious, bizarre, and historic. After his death Luton Hoo became 'an exciting development in the leisure industry' (i.e. a hotel with an 18-hole golf course) and the collection is now in the fine late seventeenth-century (and later) Ranger's House on Blackheath outside the western wall of Greenwich Park.

No doubt Wernher bought one item of the collection, a tiny bronze plaque, no more than about 4 inches square, with a low-relief *Madonna and Child*, as a work by Donatello (Donato di Niccolò di Betto Bardi, *c.* 1386–1466), and no doubt at the time it was accepted as such. It is an outstanding work; a masterpiece, though probably only from the workshop of Donatello. Experts have narrowed down the Donatello oeuvre and the Wernher Donatello missed the cut (although, after the notorious mess they made of the complete Rembrandt output, the rest of us should have learned to view experts' strictures with some scepticism). It is almost identical to, except more 'finished' than, another little *Madonna and Child* on a plaque in the Schnütgen Museum in Cologne, accepted as by Donatello himself: in each the Madonna has a classical profile that does nothing to dilute the tenderness

# Blackheath Village and Heath

A few years ago I was a passenger in a small jet flying from Clermont-Ferrand and heading in the general direction of Marseille when I noticed the map-reading co-pilot turning the chart upside down. It was easy to understand without necessarily sympathising. Anyway, with or without his upside-down assistance, I and the man in the pilot's seat arrived at Marseille airport without further incident. Could it be that this event had its origins in the irritation the French felt when in 1884 an international conference in Washington, DC agreed to adopt as prime meridian the line that the British astronomer royal, George Airy, had defined in 1851? (In fact, the French stuck to a misconceived Paris meridian until 1911.) Airy's virtual line girdles the earth from the North Pole through the South Pole with prime meridian in Greenwich Park at 0° 00′ 00.00″ W, the first practical purpose being to satisfy tourists who needed a point where they could straddle the east and west hemispheres (the other purposes are mostly to do with navigation and timekeeping). The Greenwich meridian works well for shipping, and so it holds.

Greenwich Park is a northern appendage to Blackheath, a history-soaked common high above the Thames and the intervening stretch of Greenwich, separated from the park by the 12-foot-high brick wall built early in the seventeenth century at the command of James I. Blackheath is physically defined by its village to the south and its clusters of houses to east and west. The boundary to the north is the wall of Greenwich Park. Nothing much at all happened here before the eighteenth century. Strictly speaking, Blackheath was not a common (open to all) but a waste, and most of it belonged to the Earl of Dartmouth: so the first impressive houses off Blackheath Hill, the steep climb to Blackheath from Deptford, are in the clutch of little roads called Dartmouth Hill, Dartmouth Grove and Dartmouth Row. Theoretically, all this remains part of Lord Dartmouth's estate, but the 5th Earl waived his manorial rights in 1871 when the Metropolitan Board of Works took over the administration of Blackheath. The two outstanding buildings are the Paragon and the Ranger's House (see 375).

Across Blackheath (and through the meridian) runs Shooters Hill Road, now and for ever Watling Street, the Roman road from the Channel. This remained the high road to France and Spain, and to England's allies in the Netherlands; it remained the meeting point for the English court with visiting princesses and infantas appointed to marry into English royalty. It was an assembly area for Viking armies in tenth-century summers, crying havoc across Ethelred's kingdom, and this is where Wat Tyler gathered his force of Kentish rebels in the Peasants' Revolt of 1381, and Jack Cade in 1450 at the head of 'the filth and scum of Kent' (according to John Lydgate, a contemporary monk); the Cornish rebels of 1497 struck fear into London when they arrived here in force with Perkin Warbeck, their short-lived pretender to the throne of England. Today traffic crawls both ways along Watling Street, like tiny stink beetles seen from the charming Blackheath village which, based on a triangle of roads with All Saints church standing aside on the heath, has kept a lot of its original nineteenth-century cottage-sized buildings, even the street façade of the railway station. Every

fine summer evening paper kites take over the sky. Fairs visit on high days, and on holidays, circuses: British Zippos Circus (clowns, high-wire performers, strong men), the Chinese State Circus (elegant acrobats in the great tradition, jugglers, magicians, musicians). The 2012 Olympic marathon started here, and so does the annual London marathon, an idea borrowed from New York and made into the world's most successful such event. Here today, back tomorrow.

Where armies camped and rebels gathered on Blackheath, today fairs and circuses pitch tent and children play. All Saints is another newcomer, of 1858.

of her expression; her hair is indicated by schematic wavy horizontal lines, a rhythm picked up by the sweeping arc of her sleeve and the Christ child's clothes, and again more gently in the curve of her arm as she lays her hand on the child's. Though the plaque itself is tiny, the definition of the broad planes and the lucidity of the space in and around the two figures are monumental. The Cologne and Wernher plaques are equally beautiful, which is no surprise since 'workshop' usually implies the master's supervision. Which all goes to show that the cash value of an autograph work is often justified by nothing more than its aura as a piece of extreme rarity with a name attached.

CHESTERFIELD WALK, SE10 8QX

## THE PARAGON

*A local man's masterpiece*

The finest of all the houses on Blackheath had nothing to do with the landowners, the Earls of Dartmouth. It stands on part of the 250 detached acres of land bought in 1883 by John Cator, timber merchant and speculator. Cator bundled up the land into parcels for development and it fell to Michael Searles, a native of Greenwich, to build on the first and most visible of these offcuts, looking north across Blackheath. From the first it was called The Paragon; from the first it was fashionable, and would for a while be home and centre of operations to Eliza Frances Robertson, a notorious female swindler who was, it is thought, Thackeray's inspiration for one of the most engaging villains in English fiction, Becky Sharp in *Vanity Fair* – he was at least as avid a snipper of newspaper items as any writer of his day.

Searles's work and reputation is local. The son of a Greenwich surveyor, he grew up in the same trade but applied his drawing skills to the study of architecture. He had already built a Paragon off the New Kent Road, a full circle of houses since destroyed by the Victorians, who hated Georgian style much as my generation customarily despised everything Victorian. The Paragon is outstanding. It commands Blackheath, not because of its size – seven good yellow brick blocks – but because of its confident beauty, impeccably high Georgian of 1794. The sense of containment is deepened by the mansard roof on each block: two levels of roof, that is, the lower steeply pitched and tucked into the top of the building, the top level pitched shallowly. Between each pair of semis is a colonnade of unfluted columns (Tuscan Doric) with a front door within the colonnade for each of the houses on either side. At the rear, properly bowed elegant windows look out on the communal garden. In the 1950s another local man, Charles Bernard Brown, repaired war damage, converted each house into flats, and on each end of The Paragon added a little period lodge. You would never guess.

BLACKHEATH, SE3 0NX

## MORDEN COLLEGE

*Apartments 'for forty decay'd merchants'*

Morden College constitutes London's poshest almshouse, if the royal grace and

favour apartments at Hampton Court aren't counted, and is certainly the best-looking. It stands in 27 acres of well-kept gardens to the east of Blackheath and was founded in 1695 by Sir John Morden for some of his fellow merchants fallen on hard times. Morden, like his supplicants, was a Turkey merchant; that is, one who belonged to the Levant Company, which was chartered in 1581 and operated with privileges similar to those of the slightly later East India Company, though it never ran its own army. It sent out its ships to most of the Mediterranean seaboard.

Money was tight, so Morden was compelled to take in only 12 decay'd merchants although, as Daniel Defoe later reported, 'his first design, as I had it from his own mouth the year before he began to build, was to make apartments for forty decay'd merchants, to whom he resolv'd... to make their lives as comfortable as possible, and that, as they had liv'd like gentlemen, they might dye so.' Despite the straitened circumstances, there was the necessary chaplain and 'also dwellings for the cooks, buttlers, porter, the women and other servants, and reasonable salaries allow'd them'.

Though there are no documents to substantiate it, there is a strong case for supposing that Morden chose Christopher Wren to design the building. He and Wren were colleagues on the Greenwich Hospital Commission and the mason in charge of building Morden, Edward Strong, was involved in many Wren projects. And then the building itself, though not revolutionary like many of Wren's churches, is high quality not just in its totality but in close detail too.

The brick façade is an elaborate piece of north European baroque. The doorway stands between Tuscan columns supporting a pediment, and above that are the Morden arms in a pretty cartouche; above that again on the face of the big main pediment is a double niche containing good statues of Sir John and Dame Susan. There is an open cupola on the roof ridge. The chapel to go with the necessary chaplain lies across the quadrangle behind the façade on the axis of the building's entrance. It survives almost as it stood on the day in 1701 when the Bishop of Rochester consecrated it, a single chamber lined by pews, tunnel-vaulted ceiling, reredos of prayer boards that is a mixture of chaste restraint and exuberant elegance, and a fine tall pulpit with sounding board. The glass in the north and south walls is twentieth-century and dismal in a way one might have thought impossible after the example of Morris, Burne-Jones, Whall and others of the nineteenth- and early twentieth-century revival, but in the window above the reredos is a rich medley of Tudor and earlier stained glass.

It's a good place to die like a gentleman. The rest of us are not welcome to visit the college as a whole, but a polite approach can gain admission to the chapel.

19 SAINT GERMAN'S PLACE, SE3 0PW

## SCULPTURE BY KEITH GODWIN, BLACKHEATH PARK

*The architect who wrought peace out of planning hell*

Keith Godwin was a sculptor who specialised in commissions to sit with architecture, a man of many styles. For Hallgate, a development in Blackheath Park, he carved in black granite the figure of a wiry man lying in a rectangular opening built into a wall of the passage between and beneath a block of flats, leading to the gardens. He is in difficulties, chin forced on to his chest by the weight of the wall above him that he is apparently supporting, his wiry muscles taut with the strain. It's a caricature, really, and an amusing one; even more so when it becomes apparent that the architect of the development, Eric Lyons (1912–80), commissioned the sculpture, and that it is called *The Architect and Society*, and denotes a struggle like all the struggles Lyons always had with the local planning authority, with the local residents, with, as it proved, any other planning authority he ever met in his life. In this instance, as in others, he won his case at the last stage of the process, before the central government minister.

He was not the only forward-looking architect to suffer in this way, but his achievement is far enough in the past now for anyone to see how well it fits, how mild and English it is in a sense even though its lineage springs directly from the strand of Modernism developed principally by Walter Gropius at the Bauhaus. Lyons was 23 when he began work in the office of the London firm set up in 1934 by Maxwell Fry and the new émigré Gropius, who had fallen foul of the Nazis. As it turned out, Gropius passed through quite fast, having encountered official British attitudes to Modernism and decided to move on to America, but in the 12 months Lyons had with him before Gropius left, he came to love the German's work to 'this side idolatry'.

People and their housing and environment were always Lyons's chief concern, and after the war, when he formed Span with a friend from early days, the developer Geoffrey Townsend, joined later by the landscape architect Ivor Cunningham, his post-Gropius Modernism became naturalised, set in landscapes where shrubs and trees and grass played their part in separating cars from human beings. His earliest work is mainly in London, and in Blackheath he had the perfect setting for many of his projects, mostly in the grounds of big houses that had been demolished. Blackheath Park and Priory Park, close to Blackheath village, are perfect garden settlements in the context of surrounding houses up to two centuries old, and with a backdrop of an unusually extravagant Commissioners' church pointing an elegant finger heavenwards. Lyons adapted as he went on, from flat roofs to pitched slate roofs because, it is said, rain runs more easily off pitched roofs; from stucco to tile hanging and weatherboarding; big windows facing south, small windows north-facing; communal

Look hard to discern the man at the centre of Antony Gormley's *Quantum Cloud* at North Greenwich Pier.

gardens out front. And to render the message quite clear, some of the houses were painted a fetching shade of green. BLACKHEATH PARK, SE3 9SG

# • NORTH GREENWICH, CHARLTON, WOOLWICH •

## SCULPTURE BY ANTONY GORMLEY, NORTH GREENWICH PIER

*Man in the image of Gormley*

Everything on north Greenwich peninsula is within the gravitational pull of the O2 dome, even the gleaming coloured glass-slab office blocks, even Antony Gormley's *Quantum Cloud*, though at a height of 98 foot it's a taller sculpture, much taller, than *Angel of the North* (65 foot). The angel is the most famous piece of sculpture in Britain and as simple to comprehend as the Cerne Abbas hillside chalk carving, perhaps simpler; and so it must be since its daily 90,000 driver-viewers are flashing by at 70 m.p.h. on the A1.

*Quantum Cloud* is subtler. It has been in situ since 1999, standing on four caissons in the Thames dwarfing North Greenwich pier and the Thames Clippers moored there, its profile resembling the Swiss Re building (the Gherkin) in the City. It is viewed mostly by walkers on the Thames Path, who may take in the grand form but might need to pause to realise that the cluster of metal rods forming the ellipse gather in a thicker cloud at the centre of the piece into the shape of a gigantic man.

A man is almost always at the centre of Gormley's work: not just any old man, but a man based on Gormley himself. Each of Gormley's mutes stands alone, even when a group of them are more or less together, like the several on the beach and in the sea at Crosby on Merseyside or, from time to time, on rooftops in London, New York, Oxford or in the Austrian Alps (the Gateshead angel, being angelic, stands for a whole region and its history).

Critics have complained of boredom, and Gormley is irritated by what he regards as their metropolitan ennui; but they have a point. The Chinese terracotta army, which inspired Gormley to make one of his own, was funerary art, intended to be hidden through all eternity; Gormley in comparison is producing his figures for full-frontal exposure in a fast-moving worldwide culture with instant visual and verbal communication. He is in the condition of an old-time music hall comedian translated to television and drained by its insatiable demands for new material. An anonymous figure standing for universal man, even though based on one particular chap called Antony Gormley, suffers from the problem of all art not rooted in the particular. And, yes, it does become boring. Yet there are variants in the work he produces. The quantum of the title of the O2 work refers to the hundreds of small components of the sculpture making up the cloud with the man at its core in all his molecular splendour. Its building involved computer projection, chaos theory, digital scanning, and a team that knew about these things. More power to the computer's virtual elbow.

NORTH GREENWICH PIER, SE10

## THAMES BARRIER, WOOLWICH

*A visual treat and an essential defence*

In the Thames Barrier information centre you can see clips from old newsreels showing rowing boats acting as an impromptu taxi service in the streets of east and south-east London, and red double-decker buses (in black and white, of course) hub-deep in eddying flood water. The year was 1953 when floods devastated communities on both sides of the North Sea. Though by a fluke no Londoners drowned in them, 307 died in the eastern counties from Lincolnshire to Essex, and approximately 2,000 in Holland. Years of examination, consultation, feasibility studies later, the government twisted the arm of the Port of London Authority until it confessed that the port was obsolete. This freed up Woolwich as the site for a proposed barrier; the perfect situation because the chalk beneath the riverbed there is well suited to supporting foundations. In 1984 the Queen opened the new Thames Barrier. It is nothing like as big as the Oosterscheldekering (East Scheldt barrier) built to protect the province of Zeeland, where many had drowned in 1953, but it is much more beautiful.

Woolwich is terra incognita to many Londoners, though the Thames Barrier can be seen gleaming in the distant downriver reaches. Across the water in North Woolwich is the massive Tate & Lyle refinery, with jets taking off periodically from London City Airport behind it. South of the river Woolwich proper incor-

porates the lost past of Arsenal football club, which began life as the Woolwich Arsenal workers' team, and remains the home of fine parks, of Charlton House (see page 384), the wide open spaces of parade grounds and sports fields and martial eighteenth-century barrack blocks, mean streets, pubs closing down, breakers' yards, and depots for gigantic trucks and trailers that spill out across the streets, including the way into the Barrier information centre. But it's worth finding.

A neat capsule of a building, mostly glass, the information centre sits by the Thames Path with a terrace facing the couple of hundred yards upriver at the barrier with its steel-shell capsules like Sydney Opera House's, except that instead of being packed together like rugby forwards at a lineout, these are spread across the 572-yard stretch of river, leaving navigable spans between, two large, four smaller. If the tidal water threatens, the gates swivel closed, and do so monthly anyway for maintenance.

The genius who conceived all this was Charles Draper, but because he was an engineer he appears in none of the architectural reference books. There's not much on the internet either apart from the bare information that he died before the project was complete. The designers were Rendel, Palmer and Tritton, whose previous triumph was the post-war Howrah Bridge across the Hooghly at what was then Calcutta: an engineering and design triumph but maybe not, like the Thames Barrier, a national treasure.

INFORMATION CENTRE, 1 UNITY WAY, SE18 5NJ

## MARYON PARK

*The Antonioni factor*

As all cineastes know, the star of *Blow-Up*, Michelangelo Antonioni's English movie of 1966, is neither David Hemmings nor Vanessa Redgrave, but Maryon Park. Even though Maryon Park is an it, not a she, it spends more time on-screen than anyone but Hemmings. Antonioni was fascinated by its gloom and ancient air of menace, and filmed long and often silent passages of the steep wooded slopes leading up to a grassy plateau where the Hemmings character, based in part, it is said, on the celebrity photographer David Bailey, accidentally photographs what might have been a murder.

As it happens, the park is part of what was once an extensive forested area around the Woolwich Road and Shooter's Hill Road, known as the hanging woods; local people still call Maryon Park that even though it is, so far as is known, centuries since highwaymen and vagabonds were dragged off Shooter's Hill and strung up from trees in the woodland.

The council-bestowed name of the park comes from the Maryon Wilson family, who bought the Charlton Estate in 1767. In 1829 they enclosed the village green to add to their land. When they departed in 1923 they repaid the debt with interest. Maryon Park is one of a number of green spaces lying south and west of Woolwich Common, including the Maryon Wilson Park, Charlton Park (the gardens adjoining the house) and Hornfair Park. Somewhere in this mix is the football stadium built for Charlton Athletic, the Valley. Now these sedate parks (all but

one, that is) are interspersed with streets of nineteenth-century villas and twentieth-century tower blocks. In the background of several Maryon Park sequences in *Blow-Up* the most notorious of this housing, the ten-storey blocks of the Morris Walk Estate off Maryon Road, is shown as it was being erected, block by grim block. Today, the plan is to dynamite them.

Now, as then, Maryon Park, in defiance of the concrete monsters, holds visitors in an inexplicable state of suspended unease. Sure, there are perfectly park-like facilities like tennis courts, but even here in *Blow-Up* a group of noisy students dressed for a rag descend from a truck and play a spookily silent game of tennis without rackets and balls. Later in the movie, Hemmings spots on his contact sheet an unreadable but disturbing area in bushes flanking the grass and blows it up big to pin on the wall. There, over-enlarged, is the hazy shape of what might be a human body. Hemmings returns to the park and climbs to the plateau to check it out. I wouldn't have done. Not too many people go even in daylight, but Woolwich repays Antonioni's fascination with it. Every so often there's an open-air screening in the park of his English movie.

CHARLTON, SE7

## MEMORIAL TO SPENCER PERCEVAL, ST LUKE'S CHURCH

*Murder in the House, a prime minister's memorial*

Climbing up the hill from south of Woolwich Road close to the river as far as Shooter's Hill are streets of nineteenth-century villas and numberless twentieth-century tower blocks, many as numbingly grim as only industrially assembled rendered concrete can be. All this was once the single space of Charlton Park and one of the lost villages of London; here, at the intimate intersection of Church Lane with the Village (a short high street), are Charlton House, the parish church of St Luke, a row of nineteenth-century shops with gaudy modern fascias, a war memorial, a drinking fountain, and two good pubs, the porticoed Bugle Horn and the White Swan.

Charlton House and the parish church are umbilically linked. St Luke's, like the manor house, is early seventeenth-century, a lovely Kentish redbrick structure lifted from a pretty country scene, with a handsome west tower and a sweetly curving Dutch gable over the south door. A bomb destroyed what must have been a rare and wonderful treasure, the east window by the great portrait miniaturist Isaac Oliver, Shakespeare's almost exact contemporary, but there's a fine window in the north aisle filled with seventeenth-century heraldic glass. The church is full of tombs and memorials to lords of the manor and their families, the Newtons, the Wilsons, the Maryons and Maryon Wilsons, the Percevals. (Thomas Maryon Wilson, incidentally, as Lord of the Manor of Hampstead until his death in 1869, tried for 40 years to sell off chunks of the Heath for housing, and during that period himself despoiled areas of it until Parliament and residents thwarted him.)

Chief among these is Spencer Perceval,

Charlton House was an artistic backwater when it was built in 1607, but some backwater. Here it stands, not quite in full glory, behind its triumphal arch.

Britain's most unfortunate prime minister, born in Charlton House, assassinated in 1812 at the age of 49 in the lobby of the House of Commons by a disgruntled bankrupt. His portrait bust and epitaph are on the wall beside the chancel arch. The marble bust, by Francis Chantrey (1781–1841), though bog standard in showing the statesman wrapped in a toga, is a strikingly sensitive portrait of an astute prime minister, much loved, not least by his wife Jane, who insisted after his murder that he should be buried near at hand in St Luke's, not Westminster Abbey. The memorial inscription carries the due encomium but adds the private thought that the assassin's bullet 'severed ties more tender and delicate, those of conjugal and parental affection, and turned a home of peace and love into a house of mourning and desolation'. Even the judge at the trial of the assassin wept as he summed up.

CHARLTON CHURCH LANE, SE7 7AA

## CHARLTON HOUSE

*A great Jacobean house haunted by the memories of glory over four centuries*

Charlton House, high on a hill above Woolwich Reach, is the finest Jacobean mansion in London, still in its own park (now public). Nothing about it surpasses the first glorious view of the building, with its two pepperpot towers, one in each wing, the bay windows at each end of the façade, then simpler windows quietly flanking the exotic full-depth (three deep floors) fascia. Three wide steps rise to a paved terrace before the entrance. But then the fact that this is now a community centre becomes evident as Health and Safety rears its ugly head: iron railings up the centre of the flight of steps and an iron fence at the top linking them, so that the kiddies should not break their kiddy necks; and how they must hate it too. Otherwise, little but praise is due.

Since the last owners moved out in

1925, taking their possessions with them, only ghosts inhabit the house at night, the illustrious ghosts of the original owner, Sir Adam Newton, who built it in 1607; of James I's gifted elder son Henry, Prince of Wales, to whom Sir Adam was tutor; of a late seventeenth-century owner, John Perceval, 1st Earl of Egmont, who filled the house with paintings and sculpture and was ancestor to Spencer Perceval, born and brought up in Charlton House, buried in Charlton parish church, the only British prime minister to have been assassinated. Their memory drifts through the grand salon, the long gallery, the great dining room, and even tenuously in Prince Henry's bedroom now filled with institutional tubular steel chairs and tables. The chapel suffered the double indignity of being rebuilt in stock brick after wartime bombing, and then taking over as a rump library when the council closed the old Charlton public library in a twentieth-century wing by architect Norman Shaw.

The house is what's known as E-shaped, which isn't easy to see, though the brevity of the term is handy. Actually it's a central block, viewed lengthways from in front, with two wings at right angles across the end, protruding fore and aft. In 1607 St Peter's was functioning in its full Roman majesty; Andrea Palladio was dead and buried, but his villas and churches were scattered across the Veneto for all to admire, Versailles was only years off the unearthly extravagance of its royal palace. So architecturally speaking Britain was a backwater, but Charlton House was some backwater.

Officially, it is not open to the public, but the custodians are relaxed and point visitors towards a small exhibition of the house's history and then up the heavily carved grand staircase, the walls painted eau de nil and decorated with sprays of oak leaves in delicate moulded plaster. The greatest room, at the centre of the second floor, is the saloon with its original Jacobean plaster ceiling and a wonderful 1630s veined brown and black marble chimney-piece, quite likely by Nicholas Stone (*c*. 1587–1647). It is supported by figures of Vulcan, the Roman god of fire, and Venus, goddess of love and fertility, which seems to have worked for Spencer Perceval and his wife: they had a family of six boys and six girls. The hall runs back to front on the ground floor, but impressions of it are muted by modern usage. A good tour guide would be useful, but is unlikely in current circumstances, so keep your eyes open and go with a full working imagination.

CHARLTON ROAD, SE7 8RE

## MURALS BY MICHAEL CRAIG-MARTIN, WOOLWICH ARSENAL DLR STATION

*Street Life on the DLR*

Michael Craig-Martin's best-known work remains a glass of water that he exhibited in a Cork Street gallery standing on a shelf high on the wall in the otherwise empty space. He called it *An Oak Tree*. Now *that's* what I call conceptual art, although others have been known to call it a con. It is 40 years after the event now, and to Craig-Martin it remains an oak tree. Explanatory notes were available from the customary posh young woman at the reception desk, but later these were incorporated into the work as printed

notes behind a small sheet of glass screwed to the wall. Boiled down, Craig-Martin was saying that if Constable could call paint on canvas a landscape, he himself might call a glass of water an oak tree. It is his version of Duchamp's urinal, exhibited in 1917 as *Fountain*, but wittier.

Craig-Martin taught most of the Young British Artists at Goldsmiths, including Damien Hirst, Tracey Emin and Julian Opie. He has said that today most of them could buy or sell him, and, he adds, some have. Part of what he taught them was that painting no longer existed, and they took it from there. He himself makes a decent living; as it happens, from painting. Or, indeed, from painting transferred to another medium, like the ceramic murals at Woolwich Arsenal station on the Docklands Light Railway, the end of the line since the DLR was extended across the river in 2009. Not, however, the end of the line for Craig-Martin. For someone whose aim is to take style out of art they are immediately recognisable as his. Craig-Martin was working with a new building, perfect for testing his only mildly provocative view that decoration could be integrated in such a way that the building becomes part of the painting, or, in this case, ceramic decoration. It's called *Street Life*, and might as easily be *Street Cred*. The objects are all popular consumer items: a big trainer; a plastic watch, Swatch-style; a trombone with its bell sheltering under a green and purple umbrella, its slide following the line of the down escalator and a vermilion colour match for the railing on the staircase between the escalators; a tin coffee percolator; a carton of drink; a woman's openwork sandal, red inside, blue outside; a volleyball; a torch; a wall-deep mobile phone. All drained of expression, signifiers of modern life, the colours as bright and dumb as the bright blue ceramic tiles in which they are seated. Dumb is not the word for Craig-Martin himself. This art is as knowing and as rigorous as anything in England; certainly more so than the trick that, by a similar route, turned a glass of water into an obscure symbol for the process of art.

WOOLWICH NEW ROAD, SE18

## • PECKHAM, DULWICH, FOREST HILL, CRYSTAL PALACE •

### SCOTTISH POLITICAL MARTYRS MEMORIAL, NUNHEAD CEMETERY

*Where people find ruin even in death, but a column celebrates transported lovers of liberty*

O grave, where is thy victory? No need to ask: in Nunhead cemetery's 51 stately, gloomy acres. Mouldering tombstones tumble slowly together or lie shattered on the ground; unchecked brambles and tall sycamore and lime trees swallow the light; ivy closely embraces high obelisks and earthbound angels; the Anglican chapel on the hill has been reduced by yobs to a picturesque ruin. This is death's dominion. It was one of the seven cemeteries created

for London under an Act of Parliament of 1832 when the churchyards had filled up. It lies behind a wide entrance of iron gates and railings with Portland stone piers adorned with cast-iron brands, their flames pointed downwards. It holds none of the stars of Highgate, where the roll call includes Karl Marx, the pop painter Patrick Caulfield, George Eliot, Ralph Richardson and Christina Rossetti, nor has it Kensal Green's clutch of forgotten royals, together with William Thackeray, Terence Rattigan, and the Brunels, Mark Isambard and Isambard Kingdom. None of this but, my, it has atmosphere.

It sits on a hill behind a wide entrance surrounded by dismal, rundown streets and houses, with occasional glimmers of the nineteenth-century place of character it might briefly have been. The long paths winding through the vegetation yield veiled views of the City and the London Eye. The memorials themselves speak of a certain wealth; it takes money to buy this kind of grandeur, and those who spent it must have been the same people, tradesmen, entrepreneurs, merchants, who built the fine villas and three-storey houses further afield in Peckham and New Cross.

Yet the most splendid memorial is a seeming anomaly, a 30-foot tall obelisk that the Scottish radical MP Joseph Hume raised to honour the so-called Scottish Political Martyrs (although three of them were Englishmen). It was companion to an even more splendid obelisk commissioned by Hume, 90 foot high, and raised in the decayed cemetery on the spectacular heights of Calton Hill above Edinburgh. The leader of the martyrs was Thomas Muir, an Edinburgh lawyer and idealist successful in his practice despite his idealism. In 1793 he was arraigned at the High Court of Justiciary in Edinburgh, accused of sedition: distributing copies of Tom Paine's *Rights of Man* was a sample of the charges he faced and for which he was sentenced to 14 years' transportation to Australia. In a series of trials the other Scot, William Skirving, also received 14 years; so did one of the Englishmen, Joseph Gerrald. The other two, Thomas Fyshe Palmer and Maurice Margarot, received seven years each. They believed in votes for all and, foolishly, spoke up for their beliefs at an Edinburgh convention. Margarot made it back from Australia to England, Muir to France; the others died on the far side of the world.

LINDEN GROVE, SE15 3LP

## MURAL BY STAN PESKETT, GOOSE GREEN

*Blake's vision of angels recreated for a children's playground*

As a small boy in about 1765 Blake mightily displeased his parents when he returned home from a walk on Peckham Rye Common and told them that he had seen, as he wrote much later: 'A tree filled with angels, bright angelic wings bespangling every bough with stars.' Goose Green is not Peckham Rye, it is in East Dulwich, but the two open spaces must once have merged and are close enough for neither the artist Stan Peskett nor the Dulwich residents to worry about appropriating

William Blake's tree of angels rendered on a house in Goose Green near where Blake experienced his boyhood vision: this painted vision is by Stan Peskett.

William Blake for their own purposes. In 1993 the organisers invited Peskett to run a project involving children from ten local schools in painting a mural, beginning and ending in the week of the festival. Peskett chose the site, the gable end of a house at the eastern end of Goose Green, close to the border with Peckham Rye (where he was in digs), and the subject.

He had been part of the Hockney generation at the Royal College of Art, and Bryan Robertson, director of the Whitechapel Art Gallery, described his work as 'light, deft, and glancing'. This was in 1965 but soon afterwards Peskett had gone to ground, involving himself in interior installations and murals for commercial and private clients (Julie Christie for one), re-emerging in the early 1970s in a loft studio in New York. He retained that deft and glancing touch and also absorbed something of the influence of Blake, who had become a guru to the post Flower-Power generation (though his reputation in the Age of Enlightenment, his own time, was negligible). Jacob Brownowski had prepared the ground with an intense study of him in the 1940s; Joyce Cary's marvellous novel *The Horse's Mouth* (1944), which nobody now reads, had a bonkers visionary artist with Blake on his mind; and by 1971 Adrian Mitchell's play *Tyger* was a hit with the young at the National Theatre. In 1993, as Peskett prepared to work with local children and on a site just beyond a playground, Blake's *Songs of Innocence* came to mind:

> *Such, such were the joys*
> *When we all, girls and boys,*
> *In our youth time were seen*
> *On the Echoing Green.*

But the overriding theme of the mural is the tree of angels, which Peskett envisioned as a flaming blue growth licking at the top from one side of the mural to the other, full of angels' heads. It is not a direct imitation of Blake's flame-like line, and it doesn't frighten the horses, but it is a lovely conception set in an imaginary landscape with a river crossed by a bridge in the foreground and a church in the background, recognisably Charles Baily's broach-spired St John's, which stands on the opposite corner from the mural. In 2009 Peskett returned to repaint the mural and add across the garden wall a tiger in the river, but more Tigger than Blakean tyger.

GOOSE GREEN, SE22

## SCULPTURES BY CONRAD SHAWCROSS, DULWICH PARK

*A replacement for a stolen Hepworth*

A few days before Christmas 2011 thieves in the night stole Barbara Hepworth's bronze sculpture *Two Forms (Divided Circle)* from Dulwich Park. It had been insured for half a million pounds, like the Henry Moore sculpture that was stolen in Hertfordshire a year earlier: it's becoming the done thing in burgling circles. The Moore thieves were caught and imprisoned, having collected £46 between them for their efforts in enabling a scrap dealer to turn an artwork into scrap metal. The Hepworth thieves got away with it, and Southwark council blew the insurance money on commissioning a replacement, by means of a competition organised by the Contemporary Art Society.

The winner was the young sculptor Conrad Shawcross. The commission made it plain that the Hepworth replacement should not be of bronze and preferably not of metal at all. Shawcross ignored the second injunction and worked in pre-rusted cast-iron tubes stuffed with concrete, a medium unlikely to appeal to metal thieves. The piece is called *Three Perpetual Chords*, and in fact is composed of three separate sculptures, set many yards apart, describing a shallow arc in running and dog-walking territory on wide greensward near the tea pavilion at the north of the park (the Hepworth piece had been set close to trees, shrubbery and water). Shawcross named his individual pieces *The Octave*, *The Fifth* and *The Fourth*. Three for the price of one.

He welded lengths of pipe together to shape each of the sculptures into languid coils, one a simple double loop touching the ground at two points; another more complex and touching the ground at three points of an imaginary triangle; and the largest, above head-height, touching the grass at four points. Three sculptures, not at all reminiscent of the first 'tube sculpture', the menacing ancient classical-world carving of Laocoön and his sons caught in the coils of a sea serpent, but peaceful and at perfect pitch. In sculptural terms *Three Perpetual Chords* is (are) closer to Hepworth than to a random selection of current British abstract sculpture by, say, Rachel Whiteread, Anish Kapoor, or Tony Cragg, all older than Shawcross. But the Dulwich commission is untypical. His recent works have included a big robot based on

the Diana of Titian's *Diana and Actaeon* for the production of *Metamorphosis: Titian 2012* by the Royal Ballet at Covent Garden; and in 2014 a car factory welding robot whose software Shawcross reshaped to turn the machine from horny-handed son to elegant ballerina in a month's performances on the top floor of the Brewer Street car park. The robot was called *Ada* after Byron's daughter Ada Lovelace, a mathematician and inventor.

Shawcross's own parents are the writers William Shawcross and Marina Warner and his paternal grandfather was Hartley Shawcross, the prosecutor in the Nuremberg trials who delivered a pair of celebrated speeches in that forum attacking the evils of Nazism. So intellectual clout is part of the inheritance the Good Fairy bestowed upon Shawcross, and his reversion to a gentle form of Modernism for Dulwich is surely a conscious reaction to the loss of the Hepworth piece. The site, too, plays its part, and the title (*Three Perpetual Chords*) links the clunking fact of immovable cast iron and concrete to the music of his friends among a new generation of composers. Finally, the nature of the likely audience for this sculptural venture no doubt played its part. Burglars not welcome.

DULWICH PARK, SE21

## DULWICH PICTURE GALLERY

*Paintings fit for a king*

When John Soane's gallery opened in the village of Dulwich in 1813 it was the first public picture gallery in England. It remains, with the mausoleum for its founders, the Frenchman Noël Desenfans and the Swiss Francis Bourgeois, an architectural masterpiece only embellished by Rick Mather's fine extension of 1999. Its remarkable collection in an essentially local gallery with the intimate feel of a church coffee morning includes works by Rubens, Van Dyck, Veronese, magnificent Gainsborough portraits of the Linley family, and other great paintings from France, Holland, Spain, and England (from Claude to Cuyp, Murillo to Hogarth).

At the heart of the collection are paintings bought by the dealer Desenfans for the King of Poland. But in one of its regular cycles of history, Poland's neighbours dismembered the country, the king abdicated, and Desenfans and his business partner Bourgeois were stuck with a homeless royal collection. Desenfans died in 1807, and Bourgeois settled on Dulwich for no better reason than that the British Museum didn't want it and Dulwich College provided a captive audience educated by its own small gallery, originally designed to show the collection of Edward Alleyn, the actor and friend of Shakespeare who had founded the school in 1619.

Among the core collection in Soane's new gallery *The Triumph of David* by Nicholas Poussin (1594–1665) looms like an iceberg in the history of art, between Hellenic and Roman carved friezes of triumphs and bacchanals and nineteenth-century Classicism. The usually acknowledged authority on Poussin, Anthony Blunt, places the likely date for the completion of the *Triumph* as about

1635, when Poussin was moving away from the poetry of paintings like his *Rinaldo and Armida* (also at Dulwich): the *Triumph* is Titian (much admired by Poussin) with ice and lemon, his yellows sharply acid, his blues as cold as outer space, and the turban and blouse worn by a woman in the foreground are the white of an Alpine snowcap. All the colours are Titian's, in fact, the cinnamon, gold, russet, vermilion, absinthe green, but instead of the Venetian master's subtle broken touch, Poussin introduces porcelain-cool lucidity. He arranges his figures in little whirlpools before the podium of a great colonnaded building, a group of women on the left, reverend grave seigneurs to the right, and more groups upon the podium. David, preceded by blaring trumpet and horn (the horn itself describing a vortex), his hair a deeper red than his scant tunic, moves barefoot through a clear space carrying Goliath's head impaled on a pole; all these participants in the triumph are classical figures removed, as it were, from the face of the podium and given individual life and colour. It's a bold staging too: the only central figure is a seated woman in the foreground with her back to us; she forms part of a stabilising triangle with the mother in the white turban and blouse, her two children, and an old woman; and then the whole composition of figures is both triangle and vortex.

This Poussin is one of the great paintings of Western art in the gallery's holdings, to which might be added at random one of Antoine Watteau's most refined pre-Revolutionary idylls – no, more than an idyll, a very heaven – *Les Plaisirs du Bal* (1715–17), a scene of music-making and a dance on a terrace beneath a magnificent portico with, beyond, a landscape dreaming in a summer evening's light and sunk at one point into the deepest of woodland shade. John Constable described this painting in a letter to a friend in 1831 as 'this inscrutable and exquisite thing [which] would vulgarise even Rubens and Paul Veronese'. Then there is Rembrandt's painting of a girl leaning on a windowsill (1645), surely one of the most tender portraits ever executed. If showpiece oil sketches count, the *Head of an Old Man* by Annibale, the pick of the Carracci family, must be included too. And, not one of the greatest even in Van Dyck's output but strangely moving, the painting of Lady Digby on her deathbed in 1633, painted for the grieving husband she had repeatedly cheated on and treasured by him for the rest of his life.

GALLERY ROAD, SE21 7AD

## DULWICH ESTATE TOLLGATE

*The Checkpoint Charlie that stirred Parliament in the nineteenth century*

On 28 July 1896 Colonel Mellor, the member for Radcliffe, Lancashire, stood up in the House of Commons with a question:

> I beg to ask the President of the Local Government Board whether he is aware that there still exists on an important thoroughfare in London a turnpike where toll is claimed and paid at Dulwich; whether inquiry could be made to discover whether this gate has any legal right to exist; and whether, in such an event, it would be desirable to take steps for its abolition?

The president of the board, Mr Henry Chaplin, MP for Sleaford, told him that the tollgate belonged to Dulwich College estate and that College Road was private. 'I understand', he added, 'that the vestry of Camberwell, as the highway authority, asked the London County Council last year to include this gate in a Parliamentary bill for removal.'

Chaplin and his inquisitor Mellor are, of course, long gone. So are the Local Government Board, Camberwell vestry and the LCC; but the tollgate quietly survives its adversaries, cutting off the private half of College Road from the public half a few yards south of the south circular road, the A205, known here as Dulwich Common. The charity that owns Dulwich College still collects the toll on vans and cars passing through at £1 a time, though there remains an old board by the side of the road showing various rates, including twopence ha'penny 'For Sheep, Lambs, or Hogs per score in proportion (but not less than 1/2d) for any less number'.

Like Checkpoint Charlie on Friedrichstrasse but pretty, Dulwich's checkpoint sits in the middle of the road, white, weatherboarded, with Georgian Gothic windows and door, fish-scale slate roof and little pointed finial. The roof is not all that's fishy. Photographs taken in the very year of Colonel Mellor's Parliamentary question show the tollgate as just that, a gate. So either the tollbooth is a very acceptable modern fake, or it was lifted from one of the many other suburban London tollgate sites that no longer exist. We must rejoice that Alleyn's College of God's Gift, as the school was known from its foundation in 1619 until the harder-headed Victorian age, continues to benefit from the fruits of the tollbooth, equipped now with automatic barriers and CCTV just like its Berlin counterpart; though of course, like Colonel Mellor, that no longer exists, except as an *in situ* museum piece.

COLLEGE ROAD, SE21

## HORNIMAN MUSEUM

*A maverick architect's highest achievement*

It is not clear what prompted the tea merchant and philanthropist Frederick Horniman (1835–1936) to choose C. H. Townsend to build the museum he proposed to bestow on Forest Hill. Townsend was a maverick, Horniman a pragmatist who laid out his business principles crisply: '... we buy for cash,' he said, 'and we sell for cash... we shall never change.' But Horniman took to travelling the globe and putting together several collections of world culture. He was used to dealing in bulk – for a start, Horniman exported 5,000 chests of tea a week – and the sum of his collection amounted to hundreds of thousands of objects, from Benin bronzes to hedgehogs, Egyptian mummies, 8,000 musical instruments including a dulcimer and an electronic synthesiser, an aquarium and a butterfly collection.

Maybe it was Horniman's compulsive collecting, an exotic manifestation of the day job, that attracted him to the young architect. Charles Harrison Townsend, born in 1851, had pursued a sedate enough career in ecclesiastical work and house

design until he was 40, when he showed something edgier to his talent with the Bishopsgate Institute and its big arched entrance, the two turrets above powerfully compressing the façade between them, and its abstract friezes carved into the stone. In 1897 Townsend received commissions for both the Whitechapel Gallery and the Horniman Museum. They were ready in 1901.

The art gallery is a wonderful achievement, an idosyncratic building that fits into the street scene alongside the florid Passmore Edwards library (1891 – now an extension to the gallery – see page 438). The museum is in an altogether different setting, in fact on the hillside that was the location for Frederick Horniman's house (containing the collection that he displayed to the public for some years before the gallery was built). Horniman moved away and Townsend knocked the house down. A house on a hill? There must be a tower! A huge collection of ethnography and anthropology? Then build a barn (the 'barn' has a curved gable reflecting the curved roof over the gallery behind – not so far from the great train sheds of the period or from Norman Foster's curving glass structures of our own day). He chose Doulting stone, a soft brown limestone quarried only in the Mendips, so all the big corners too have been carved into curves, turrets are round-topped and, even though the flat surfaces have stone trees frozen and formalised into friezes, there remain unbroken expanses of beautiful soft brown oolite. There are other extensions now, including one by Townsend himself, and a wonderful conservatory from Horniman's bolthole in Croydon re-erected in the museum's gardens.

After 1901 Townsend was burned out, or else the cultural climate had changed. So it went as well for other architectural radicals like Arthur Mackmurdo and C. F. A. Voysey, dead stars who continued in orbit until the 1940s, and the one genius among them, Charles Rennie Mackintosh, who in effect gave up architecture before the First World War and died a couple of weeks earlier than Townsend, both of them in December 1928.

100 LONDON ROAD, SE23 3PQ

## RUINS OF CRYSTAL PALACE

*The ghosts of Victorian England*

Wide stone flights of stairs flanked by sphinxes lead nowhere... long classical arcades support terraces of nothing but expanses of municipal grass... a stone necropolis of shattered sculptures lies within a fenced-off compound. The ghosts haunting these ruins are Queen Victoria and Prince Albert and their priests and ministers plus the six million of their subjects who effectively invented day excursions on the railways to visit the mighty Great Exhibition of the Works of Industry of all Nations, opened by the Queen in Hyde Park on 1 May 1851. On that day *The Times* published William Makepeace Thackeray's homage, *A May Day Ode*:

This solitary Sikh soldier watches over the scattered ruins of Joseph Paxton's glorious Crystal Palace, a sum now amounting to less than his original blotting paper sketch.

*A palace as for a fairy prince,*
*A rare pavilion, such as man*
*Saw never since mankind began,*
*And built and glazed...*

In 1851 Britain's navy ruled the waves, its empire was the biggest the world had known, its foreign trade was four times greater than that of the United States. To celebrate high prosperity, but also to educate the population in applied art, the committee of the Society of Arts conceived the idea of a world exhibition. The best thing that came from it was the packaging: the stupendous glass hall conceived by the Duke of Devonshire's head gardener at Chatsworth, Joseph Paxton, who first sketched it on what is now the world's most famous piece of blotting paper.

Soon the dissenting voices of the new age aesthetes, the pre-Raphaelites, sponsors of art for art's sake, derided the achievements of the Great Exhibition. It is easy to see why. There were shoes and ships and sealing wax, furniture of awful aspect, elaborate wallpaper and domestic appliances, including a knife with eight blades, each richly engraved; there were railway carriages, steam ships, ingots of gold and iron, tapestries, cashmere from goats in Windsor Park, and a model of Robert Stephenson's bridge for the Menai Straits. Yet from the stands of other nations India's stood out, the jewel in the crown. And even among the other treasures from Hind, the Koh-i-Noor diamond dazzled spectators. It had been presented by Duleep Singh, a son of the Maharajah of Lahore, to Queen Victoria only 12 months earlier, after the East India Company annexed the Punjab to British India.

# Bandstands

Where there's muck there are brass bands, they say. It is true that in England Marx's proletariat everywhere loved its bands, and maybe still does: Black Dyke Band remains, after more than a century and a half, the most famous in the world, or certainly in the Anglophone nations that cultivate their own bands. France, too, has the tradition. Until Hector Berlioz (b. 1803) was 18 and went to Paris, the only orchestral music he had heard was from the local National Guard military band in his birthplace of La Côte-St-André on the nether alpine slopes. Anyone accustomed to being in Twickenham rugby stadium when France visits during the Six Nations championship knows that French brass bands are alive and brassily oompah-ing opposition to the raucously adopted Anglo chorus, 'Swing Low, Sweet Chariot'.

In Britain brass bands preceded the Industrial Revolution, but the slums that followed in industry's wake prompted the creation of public parks, and in the parks, a huge surge in the popularity of bandstands. In London the Royal Parks had a head start, and featured bandstands that were cousins to the gazebos in more stately gardens. Kensington Gardens has a replacement for its original bandstand of 1869, shipped off to Hyde Park in 1886 where it remains. The IRA bombed Regent's Park's bandstand in 1982 (seven soldiers died and 24 were wounded); its replacement is a charmingly tent-like structure. Greenwich Park's bandstand was erected in 1891 close to the Royal Observatory and Flamsteed House. The house, Wren said, was built 'somewhat for pomp'; the same could hardly be said for the bandstand a couple of centuries later, almost faery-like with the loveliest imaginable soaring finial even though in cast- and wrought-iron worked by the Coalbrookdale Company, the poetic heart of Ironbridge in Shropshire.

The Royal Parks don't have it all their own way, anyway not since the Heritage lottery fund's national parks programme in the closing years of the last century came to the rescue of a public park feature that had been decimated in the years after the Second World War by decay and neglect (the man who set up the programme, Dr Stewart Harding, described the sheer variety of bandstands 'like UFOs, Moorish temples, rustic cottages or Chinese pavilions'). Clapham Common has a bandstand dome like a magnified brass elephant bell from India in the days of the British Raj, but it was manufactured by the Sun Foundry in Glasgow, one firm among many in a prolific nineteenth-century bandstand industry there. Barra Park in Hayes (where Gurinder Chadha filmed some of her movie *Bend it Like Beckham*) has one with a touch of wiggly fantasy set off nicely by the neat row of semi-detached villas behind: it came from the West Midlands company Hill & Smith of Brierley Hill. Clissold Park bandstand in Stoke Newington is wooden and ridiculously rustic. The bandstand in the gardens of the Horniman Museum in Forest Hill teeters on the edge of a steep hill with a grand view over the city.

The pick of the bunch is surely in humble Myatt's Fields Park in Lambeth, on the 14.5 acre strawberry patch donated by William Minet and opened to the public in 1889. The park is unregimented like the best kind of private garden, a mixture of trees, lawn,

shrubs and freely blooming flowers. The bandstand has iron pillars and arches, a wooden rail with turned uprights, and a faintly pagoda-like slate roof with a wooden cupola on top. Oh, and brass bands perform regularly.

Kensington Gardens' elegant bandstand of 1931, which replaced the 1869 original, now next door in Hyde Park.

Finally the show was over, but the showplace was too good to lose and Crystal Palace rose again in Penge, in a park laid out by Paxton. The Queen opened it, as she had done in Hyde Park, and she knighted its creator, the gardener's lad who is remembered now as a great landscape gardener, a botanist, the man who imported the monkey puzzle tree and made the lily Victoria Amazonica flower at Chatsworth, though it had failed dismally at Kew. The greenhouse he built especially for the lily might have been the basis for the Crystal Palace's design. In Hyde Park the boast was that the Crystal Palace was four times as big as St Peter's, Rome; additions in Penge made it even bigger, and soon it gave its name to the area all around. From 1859 until the First World War a triennial Handel festival was held in the transept of the palace; there was also a separate vast concert hall, an exhibition palace and an open-air theatre. There was a winter garden and a terraced garden, sculpture from Hyde Park and sculpture newly made for Penge. Despite the involvement of Victoria and Prince Albert, this was a people's palace in all but name. The new railway station brought visitors en masse and developers came and built a whole new district.

But in 1936 Paxton's glass palace burned to the ground, leaving the grand ruins watched over from a terrace balustrade by the stone figure of a Sikh soldier. The British Empire dwindled and lingers only in the pink shading on old atlases. The Koh-i-Noor remains, the 'mountain of light', to remind the Queen of her great-grandmother, the Queen Empress.

CRYSTAL PALACE PARK, SE19

## • CROYDON, BROMLEY, WEST WICKHAM, DOWNE •

### AIRPORT HOUSE AND CROYDON AIRPORT VISITOR CENTRE

*England's first airport*

Two white buildings side by side on Purley Way in Croydon fleetingly summon the ghosts of the past for passing motorists. Airport House and the Aerodrome Hotel are the main Art Deco survivals of England's first airport, initiated in 1916 as one of a ring of aerodromes around London established to act as bases for fighter planes defending the capital against Zeppelins, and upgraded to an international airport in 1928. Winston Churchill nearly died untimely here when he crashed on these fields between Croydon and Wallington while learning to fly in 1919. Aviators attracted football crowds at this time: something like 100,000 people broke through cordons to try, apparently, to throw themselves under the wheels of Charles Lindbergh's *Spirit of St Louis* when he crashed at Le Bourget aerodrome in Paris after his non-stop solo transatlantic flight, Long Island to Paris, in 1927. Three years later a much more orderly crowd waited in Croydon as day turned to night for the return of Amy Johnson after her solo flight from Croydon to Australia, the first by a woman, under-

taken less than a year after her maiden flight and with sparse navigational skills. These were days of glory for private adventure in the air. They ended abruptly on 3 September 1939 when the man in the control tower took a call ordering him to clear civil aeroplanes out of the hangars to make way for the RAF.

The control tower is the block rising above what's now called Airport House, and is where air traffic control was devised. The original aerodrome was the first purpose-built air terminal in the world. During the First World War the airfield had a bog standard army guardhouse type of building with a large painted sign reading 'HM Customs/Douane', with beside it tall stilts supporting the control tower: a wooden hut beneath a sort of greenhouse for the staff. What's there now dates from 1927–8, uninspired Art Deco stolidly anchored to the ground despite the strong vertical ribs of the control tower aspiring skywards, surmounted by a cantilevered balcony defining the business end of the control tower, with oak-framed station-master clocks on each face and surmounted by a radio tower. There are more romantically imaginative Underground stations and cinemas than this. Anyway, by the time the Second World War ended Croydon was deemed too small and too hemmed in between Plough Lane in Wallington and Purley Way to take the new generations of airliners. The future was with Heathrow.

Croydon might well feel lucky to have escaped that fate and instead, since 2000, to have operated as a visitor centre, a modest term for a museum of air travel's pioneering years. The wooden ticket kiosks, currency exchange, and airline sales desks have gone, but under the glass dome of the booking hall is suspended a Gipsy Moth, not Amy Johnson's *Jason* (she crashed that in Melbourne), but the same type of light biplane as she flew to Karachi, Calcutta, Rangoon, Singapore, Java, and on to Port Darwin. The building is chock-a with photographs of the great days: of big Bristol-engined mail planes arriving and departing, of aircraft crossing Plough Lane to reach the runway area, of Douglas Fairbanks arriving before the war and Rita Hayworth after, Max Schmeling the German heavyweight champion, larger than life, visiting in 1936 before his encounters with Joe Louis, and a Czech refugee, four years later, slumped on a bench before being deported to the country from which he had fled seeking refuge. *Plus ça change.*

On a clear day, from the top floor of the control tower, I was told, you can see right over London to the Chilterns. Inside is a reconstruction of the instruments used for tracking the Imperial Airways liners on approach and departure. The visitor centre opens only on the first Sunday of each month but it's easy to find: a de Havilland DH-114 passenger plane from the 1950s is parked outside.

PURLEY WAY, CR0 0XZ

## CROYDON PALACE

*A Great Hall that has defied war, decay and part collapse*

The Archbishop's Palace, as it is still known for convenience in the heritage business, was the first stop in the stately progress from Lambeth to Canterbury: Croydon,

Otford, Wrotham, Maidstone, Charing and Canterbury, four of them ruins today. Only the Lambeth and Croydon Great Halls are extant, Croydon's having survived civil war and Cromwellian occupation, the destruction of some of its buildings, decay, partial collapse and, remarkably, well over a hundred (and continuing) years as a girls' school. Until 1780 Croydon served not just as a travellers' lodge on the stately archiepiscopal progress but as a summer palace, particularly after the Restoration, when Archbishops of Canterbury seemed not to care much either for Canterbury or its cathedral and opted to be absentee primates. By 1780, though, Croydon was becoming industrialised and the see of Canterbury sold the palace into an uncertain future.

An engraving of 1829 from a study by Nathaniel Whittock shows the beams of the Great Hall strung with lengths of calico and barrels, bundles of sticks, a handcart on the floor of what had become a calico bleaching and printing factory. In 1887 the Duke of Newcastle bought the crumbling Old Palace and presented it to the Sisters of the Cross, who with chisel, hammer, saw and adze in hand restored it themselves: some of the wall panelling in corridors and on staircases, rudely constructed from planks, is their work offered in humility to God and their new girls' school, soon to become the Old Palace of John Whitgift School. (Whitgift, Archbishop of Canterbury from 1583 until his death in 1604, was to Croydon what Hans Sloane was to Chelsea, a benefactor whose Whitgift Foundation has left its mark all over town, with the almshouses founded by the archbishop in 1596 in the town centre, schools and care homes.) In the roll-call of archbishops, Bourchier built the chapel in the fifteenth century; Charles I's ultra-royalist Laud introduced the altar rail and added pews with his coat of arms along the west wall to the fifteenth-century pews with poppy heads along the sides of the chapel; also in the fifteenth century Morton built the corridors and dining room that linked the chapel to the Great Hall; Herring added tiebeams in the mid-eighteenth century, to strengthen the already complex roof beams of the Great Hall.

The hall remains the glorious centre of this house, with its massive arch-braced roof springing from slender columns supported on angel corbels engraved with the arms of the archbishops. The east wall collapsed outwards in 1838, and though that was re-erected, the astonishingly solid and stone embellishment seen on this wall in Whittock's print was hauled from the debris and is embedded today rather lower down in the west wall: a sturdy block of stone finely carved with angels supporting a shield embossed with the arms of the ill-fated Henry VI above the shield of Archbishop Stafford, who gave the Great Hall its current shape in the mid-fifteenth century.

OLD PALACE ROAD, CR0 1AX

## ST MICHAEL AND ALL ANGELS

*Where the Renaissance golden section brings harmony to the Gothic*

In the post-war years Croydon had a crash course in becoming a metropolis, and it

looks like it. From the nineteenth century, when it was a pleasant Surrey market town notable for the sixteenth-century Archbishop Whitgift's palace and the almshouses he founded, it expanded as a staging post to Brighton, a dormitory for prosperous London businessmen, a big out-of-town shopping centre and the Heathrow of its day. The Blitz shattered this comfortable, well-provided-for community, and a sudden return to prosperity in the 1960s brought flyovers, underpasses and dual carriageways to hack the town into segments, each dominated by an upsurge of monstrous office blocks and unlovely shopping centres. Somewhere in the mess the palace survives as a school. The group of almshouses, which avoided demolition in the early twentieth century only because of the intervention of the House of Lords, still stand, crammed up against a big department store. But they have heritage status, so that's fine.

And then there is the church of St Michael and All Angels, with a bus station practically in its backyard.

St Michael's is plainchant in a cacophony of coarseness, the product of a Counter-Reformation, in effect, sparked by the churchman John Keble in his famous lecture of 1833 denouncing England's apostasy and leading to the Oxford Movement seeking a return to Roman practices. The consequent drift towards a new High Church Anglo-Catholicism coincided with Augustus Pugin's denunciation of decorative Gothic and advocacy of a return to the style of the thirteenth century. St Michael's in Croydon was part of the response to this, designed in 1876 when the architect, J. L. Pearson, was at the peak of his abilities. Pugin was a great decorative architect but Pearson had one important gift that Pugin lacked: a sublime ability to organise space in the service of his vision.

It's a big church and looks a bit French – in fact, as a young man Pearson had made a long visit to the continent, drawing all the way, and fallen in love with French ecclesiastical architecture. Internally, no screen obstructs the view along the nave and into the chancel, where it sweeps into a semi-circle of pointed arches revealing a round apse behind. The vertical counter thrust comes from slender vaulting shafts rising in a cluster from the piers, then climbing into the brick vault. In recent years an expert pointed out what no one had spotted before, that Pearson had usurped a Renaissance proportion (a stranger to medieval church builders) and applied it to bring harmony to his version of proportion.

The ambitious canopied pulpit, font and organ, all by the Gothicist J. F. Bodley, are very fine; less so, the hanging rood by Cecil Hare. But the awesome splendour of the church lies in its clarity and proportion. 'This is a place for real worship,' Pearson said. No one, believer or not, could disagree.

POPLAR WALK, CR0 1UA

## ST MARY'S, SHORTLANDS

*Skeaping's late Primitivism in an archetypal portrayal of a mother's love*

Shortlands was a slumbering pastoral parish until the second half of the nineteenth century. But it was too close for

peace of mind to the growing country town of Bromley, and in 1858 had acquired its own railway station. The manor house and its estate were bought up for housing and in 1868 Shortlands received a late Gothic Revival church dedicated to St Mary. Today the parish is a big dormitory covered in bricks, mortar and cars. St Mary's was one of five churches within the borough of Bromley to be Blitzed in a single night of bombing in 1941. Its replacement is distinguished by being undistinguished, a big brick purposeless-looking barn with a huge west window, good only because it provides relief from the relentless unimaginative deployment of brick everywhere else. But the new St Mary's holds one big surprise: outside, above the west window, is a deep-relief sculpture by John Skeaping (1901–80) of *The Flight into Egypt*, a commemoration of a panel on the same subject in the destroyed stained glass of the old east window.

Skeaping once seemed likely to become as influential as the first generation of Modern British sculptors, Epstein and Gill. He beat Barbara Hepworth to the 1924 Prix de Rome, but if she couldn't win the prize, she would have the prize-winner. Hepworth travelled to Italy in his wake, married him in 1925 in Florence, and during their early days together passed on her admiration for Henry Moore's work. By 1930 they had held joint sell-out shows at the famous galleries of Tooth's in Bruton Street and Alex Reid and Lefèvre in Glasgow. But by 1933 they had drifted apart. While Hepworth developed under the influence of her new husband Ben Nicholson into one of the greatest of modern sculptors, Skeaping meanwhile lost interest in the avant-garde and reverted to his original naturalism, becoming what's known in the trade as an *animalier*, the best around, turning his lifetime interest in animals into a living in what might politely be described as retro art.

But in 1949–50 Skeaping visited Mexico and lived with the Zapotec-speaking indigenous people of the Oaxaca Valley, learning their way of making pottery and refreshing his sense of the creative wells of sculpture. So a date in the 1950s for *The Flight into Egypt*, a modern work that would have been unexpected without the interlude in Oaxaca, becomes entirely explicable. He seems from 1950 onwards to have been able to slip effortlessly from money-making animal art to Modernism. It's difficult to know whether he was being cynical, but it seems likely that his initial rejection of modern art was a reaction to the end of his marriage and that Mexico took him back to source. It was one of the great wells of inspiration to twentieth-century artists.

*The Flight into Egypt* is just above ten foot high and four wide, and shows Mary sitting sideways on a small donkey. In the medieval way of setting out hieratic relationships through physical size, Mary here is physically bigger than the donkey. Skeaping carved the piece directly into white Dartmoor stone, satisfyingly stylised and very architectural. The forms are flattened, Mary's face broad but not as dramatically aboriginal as some of Epstein's work. The circular nimbus, the curving edge of her shawl thrown over her head and shoulders meeting the line

of the child's bonnet, her working woman's hand folded easily beneath him in gentle support, her bare feet showing below the full-length gown, the big spongy sedum-like plants beneath the travellers, the donkey's lugubrious face and corkscrew tail... all combine in a unified expression of a mother's love, more human than divine, perhaps; but then, that's what the story was all about.
KINGSWOOD ROAD, BR2 OHG

## BETHLEM ROYAL HOSPITAL

### *At the gates of Bedlam*

When the governors of the Bethlem lunatic asylum asked Caius Gabriel Cibber (1630–1700) to produce statues to crown the entrance gateposts, they got what they asked for: statues of a couple of lunatics, one called *Melancholy Madness*, the other *Raving Madness*. The asylum had been founded as the priory of St Mary of Bethlehem in Bishopsgate in the City of London in 1247, and through the centuries the name mutated, from Bethlehem to Bedlam to Bethlem. A document of 1329 refers to it as a hospital. Another of 1403 mentions that it has six insane patients. One of the then fashionable treatments was to chain lunatics to the wall and whip them; and still in 1680, when Bedlam reopened at Moorfields, Cibber's carvings showed *Raving Madness* as a howling, naked, manacled man.

Bethlem moved a third time, into the building that now commemorates global madness as the Imperial War Museum, and in 1930, with the recognition that patients were suffering treatable mental illness still relatively fresh, it fetched up in Beckenham. There in a little outbuilding is a small room that constitutes its own wonderful museum. You press a bell push, you are shown in, you sign in; the previous visitor was four days before me. One showcase has a nasty assembly of manacles and chains and leather 'restraints' that were utilised during the Age of Enlightenment and earlier, but the collection is mostly art, sombre paintings of children bereft of company and studies of compulsive handwashing by a couple of late twentieth-century manic depressives, and some preternaturally calm and routine portraiture by Richard Dadd, the nineteenth-century artist committed to Bethlem for slitting his father's throat in the belief that he was the devil incarnate. His most famous work, painted in Bethlem but now in Tate Britain, was *The Fairy Feller's Master Stroke*. Then there is a gaggle of bishops carousing in the foreground of a big apocalyptic nineteenth-century drawing by Jonathan Martin called *London Overthrown*. He was committed to Bethlem after trying to burn down York Minster. It was the bishops he was after.

Caius Gabriel Cibber was assuredly sane, although he might not have thought so himself when he embarked on carving his two sculptures of madness in hard, intransigent limestone. Yet they are his best work and wasted in this setting, however appropriate and necessary to their preservation. Cibber was born in Schleswig-Holstein in 1630; he arrived in England after touring Italy, and the two Madness carvings seem to be the godless progeny of Michelangelo's *Night and Day*

in the Medici chapel. *Raving Madness* and *Melancholy Madness* are pockmarked by exposure to London, and London's patina has added depth to them. The two men lie propped on their elbows, bald, vacant-eyed, their muscularity contorting to some internal imperative. They are deeply expressive and tell more of man's inhumanity to man than any other sculpture of the age.

The figure of *Melancholy* (1676) is closely similar to the final episode in Hogarth's *The Rake's Progress* (1733), in which Tom Rakewell is reduced to naked lunacy by his life of profligacy. Moorfields was only a few minutes' walk from Hogarth's manor; the alleys of St Bartholomew's, and the Cibber sculptures, were there for all to see on the gateposts of Bedlam. The debt Hogarth owed Cibber was repaid when Cibber's grandson Theophilus translated Hogarth's *Harlot's Progress* to the London stage.

MONKS ORCHARD ROAD, BR3 3BX

## ST JOHN THE BAPTIST, WEST WICKHAM

*A country church that has finally let papal bygones be bygones*

At West Wickham town and country meet, not in an embrace, but a stand-off. The old Kentish village is submerged under new building, its high street similar to any other in any sterile suburb in outer London. But up on a hill to the south, the fifteenth-century church dedicated to St John the Baptist is visible behind a sweet lych-gate and, half hidden by trees, the manor house, both built by a lawyer called Sir Henry Heydon. They stand side by side above the valley to the west where the ancient boundary was drawn between Kent and Surrey, and where every morning, wrote the poet Richard Church who was born in the neighbourhood, a mist lay across the bottom of the valley like a stream.

The mansion has been a hotel and is now a school. The church is what it always has been, a place of worship and for fighting ancient battles. Only in the 1970s, when it was thought incompatible with a Church of England ecumenicism reaching out to Rome, did the rector drop the practice of three and a half centuries of preaching a Guy Fawkes Day sermon denouncing the Pope and all his works. In 1991 another rector proposed moving the simple Tudor rood screen to open up chancel to nave. The townspeople in the north valley rose up in wrath but the rector had his way and today, as the curate put it to me (himself a native), hardly anyone in the congregation knows that the screen was ever anywhere else but separating chancel from north chapel.

In other words, this is a typical English parish church of the mildly odd class, with its crenellated west tower offset to the south, its north chapel heightened to take a vestry above and creating a double gable with the chancel, its eccentrically white-and-black-chequered southern extension for the organ to be installed in the nave without taking up existing pew space. The perpetrator of this and designer of the organ case was John Dando Seddon, the Arts and Crafts architect whose masterpiece is Holy

Set in gold and green: St John the Baptist, West Wickham.

Trinity, Sloane Street (see page 216), and who is buried in the churchyard, having lived in West Wickham for the three years before he died in 1891.

The interior of the church seems as fat as it is tall. The north chapel is a charnel house for dead lords of the manor, including John Lennard, the one who arrived in the Gunpowder Plot year of 1605 and left the stipend to pay for the annual sermon. When the family moved away in 1939 the vault was sealed until Judgement Day. In this chapel are three fine though abraded windows contemporary with the church and made by Flemish craftsmen. A word too in favour of the excellent Victorian window in the south wall by Charles Eamer Kempe, a man with a large practice, no artistic skills but great knowledge, who briefed his workshop to produce glass distinctively based on the northern European pre-Renaissance, with its rich colour and well-judged off-setting whites, and finely drawn figures.

LAYHAMS ROAD, BR4 9HJ

## ST MARY THE VIRGIN, DOWNE

*Downe to the sea in a ship, a window hailing the first non-stop round-the-world sailor*

The slate memorial plaque to Keith Coleborn in the flint-built, shingle-spired, early medieval and over-restored parish church of St Mary in the tiny village of Downe, is inscribed *Ars longa vita brevis* ('Art is long, life is short'), apt enough to him because he was an artist craftsman of the village ('and gentleman', the inscription insists). Still, it does scant justice to

the great span of 96 years his life traversed (1909–2005), even though that's not much in the face of eternity. There are two fine windows by Coleborn in the church, both associated with the Knox-Johnston family, inhabitants of the village, the most interesting one in the south wall of the sacristy, given in 1969 by David and Mary Knox-Johnston to honour their son. This is inscribed: 'In thanksgiving for the safe return of Captain Robin Knox-Johnston after making the solitary circumnavigation of the world, the first under sail without touching land.'

The brave merchant seaman set out from Falmouth to compete against fleet yachts and trimarans in a small, tubby ketch called *Suhaili*, teak-built for him in a Bombay boatyard. During the turbulent voyage his boat turned turtle, his radio was knocked out and he was out of touch in mountainous seas for about four months between Otago and the mid-Atlantic. Missing, in other words, and feared dead. At any rate, according to the village women in the church when I visited, his mother and father commissioned the window as a memorial but had to have the inscription hurriedly altered when *Suhaili* and their laughing Cap'n Robin turned up off Falmouth ten months after his departure, right as a Southern Seas rainstorm.

The window has alternating black and white quarries with beautifully etched signs of the zodiac for the ten months Knox-Johnston spent at sea, wedges of

The window in St Mary the Virgin, Downe celebrating Robin Knox-Johnston's feat of single-handedly circumnavigating the world, 'the first under sail without touching land' – in a teak-built ketch from Bombay.

white (for sails), and blues flowing from darkest aquamarine to paler turquoise engraved with waves. Its design is slightly 1950s, post-Festival of Britain, but its artistry lifts it clear of any period. Certainly it outshines the dominating east window Crucifixion by the Dublin artist Evie Hone (1894–1965), an untypically timid work in the sequence in which she seizes on the dark outlines of Georges Rouault's paintings inspired by medieval stained glass and conjures them into the black leading of her own modern stained glass.

St Mary's stands at the village crossroads opposite the Queen's Head, 'the little pot-house', as Charles Darwin called it, where he and his wife Emma stayed in 1842 when they were house hunting and, close to exhaustion, settled on Down House. Near the church's west porch a slate plaque beside a tomb records the six of the ten Darwin children who are buried there. Emma, too, is buried elsewhere in the churchyard. Darwin's memorial is the sundial on the tower; his tomb is in Westminster Abbey.

HIGH STREET, BR6 7US

## DOWN HOUSE

*Down and out in London and Bromley at Charles Darwin's home*

When Gwen Raverat published her memoir *Period Piece* in 1952, Downe, the adopted village of her grandfather, Charles Darwin, had been acquired by the British Association for the Advancement of Science. 'They have tried to keep the grounds just as they were; and even though Down is now called Downe, and

London has crawled much nearer, it still seems as quiet and remote in the garden as ever it was.'

Down has been written Downe, as it were, since the 1850s for the unlikely reason that otherwise the postman might confuse it with County Down. Today, although Downe has been subsumed into the London borough of Bromley, it still lies half lost in 'ancient wooded hills' at 'the extreme verge of the world' as another descendant, Darwin's great-great-granddaughter Ruth Padel puts it in *Darwin: A Life in Poems*, a clever trope to fit not just the geographical position of the village but also the villager who went beyond the edge of the known world in his scientific work. The greenhouse remains where Darwin experimented at Down House (the Darwins rejected the terminal 'e'). So too the mulberry tree in the garden outside the nursery window, just as Raverat showed it in one of the charming illustrations to her memoir (she was a Slade-trained artist), but the nursery has been translated into one of the Charles Darwin exhibition spaces established when English Heritage in turn took over the house, with large grants from the Wellcome Trust and the Heritage Lottery Fund to restore key rooms and the garden as closely as possible to the way it looked in Charles and Emma Darwin's time (he died in 1882 after 40 years in Down House, she in 1896).

The beautiful and lucid exhibition of Darwin's life and work and the new-tech-enabled staging of the man at work in his cabin aboard the *Beagle* fills the first-floor rooms. Downstairs are the study where he composed his works, among them of course *On the Origin of Species*; the Morris-influenced drawing room where Charles and Emma relaxed in the evenings playing backgammon, or Charles reclined on the chaise longue while Emma played Beethoven and Chopin on her Broadwood piano; the dining room which, since Wedgwood blood ran in Darwin's veins and his wife was a Wedgwood cousin, is laid with his mother's Wedgwood Water Lily dinner service; the billiard room, where Darwin would summon Parslow the butler and engage him in matches across the green baize; and in a corner of the house is the wooden slide that Darwin ordered from the local carpenter, with a ridge at the top to hook on to the stairs so that the children could play with precipitous pleasure. Such was the untypically noisy home otherwise typical of a well-to-do Victorian family, but in which, it just so happened, the father was a genius.

LUXTED ROAD, BR6 7JT

## ST MARK'S, BIGGIN HILL

*A church to replace the tin tabernacle*

There's a fading newspaper photograph of the Rev. Vivian Symons coming through a door carrying a large plank on his shoulder. For a moment it looks like one of the Stations of the Cross. As it happens, fate arranged for Symons to be born on a Christmas Day (1913) and to die on a Good Friday (1976). You get the drift. As he laboured with a pick knocking down a redundant late-Victorian church in North Peckham in London and transporting the stone and timber and a complete stone font in his own lorry along the Bromley road to Biggin Hill where he

set to building his own church, some of the more devout of his congregation might even have let their thoughts drift sacrilegiously (just a touch, with milk) towards notions of the second coming.

All that was known about Vivian Symons was that he had been a major in the Second World War but by 1951 was perpetual curate of St Mark's in Biggin Hill, a mean shack of corrugated iron, thrown up in the teeth of the advance of the pre-war surge of unplanned houses on the hills of West Kent. The Church in its eternal wisdom decreed that the tin tabernacle, as it was known, did not merit consecration, and Symons would remain perpetual curate instead of being inducted as vicar until he could find a respectable church building. So he built it himself. Then, shaping up like a perpetual vicar, engraved all the clear windows with scenes copied from a German Paupers' Bible, fudgy but decorative, carved the relief in the wooden altar frontal from the same source, fashioned the altar cross and, from donations of old silver, the holy vessels for Mass.

Of course, as behind all myths, there were helpers. Here, it was one in particular: Richard Gilbert Scott, a footnote in the biography of his father Giles Gilbert Scott, architect of Liverpool Cathedral, and still never credited for his own agile and inventive powers. His St Mark's is built beneath the big beamed roof of the demolished North Peckham church but takes the strain. There's a tall yellow-brick detached campanile, as severe as a control tower might have been at the RAF fighter station half a mile north, but with a big brick cross imposed over one of the bell openings. The addition of some kind of radio gear among the deftly organised concrete fretwork at the summit adds to the sense of aerial warfare. The church squats pyramid-like alongside. Its entrance rhymes with the tower, its glass doors dwarfed within a vertical glass screen stretching from the shallow plinth on which the church sits to the triangular point of the roof, the depth punctuated by three slender pipe-like concrete ribs. Pevsner describes St Mark's as 'Very free Neo-Gothic', which means that in 1959, when it was consecrated, it was not forgiven for its presumption in being Modernist too: another nail in the coffin of the reputation of the last of the great Scotts.

CHURCH ROAD, TN16 3LB

# • ELTHAM, BEXLEYHEATH, CHISLEHURST, ORPINGTON •

## SEVERNDROOG CASTLE

### *A folly built for love*

Severndroog Castle is not especially big, it is not beautiful, the name is plain wrong and it isn't a castle. But it is spectacular, up on Shooter's Hill (Roman Watling Street), in Castle Wood on Eltham Common, well above the road, a position high enough to be used as a beacon hill in the sixteenth century: today a wonderful shot in the arm to car-borne commuters

even though it is set among tall trees. It's there to commemorate the naval exploits of Sir William James, and especially his capture in 1755 of the castle of Savanadrug (Severndroog!) on a little island in the Arabian Sea just off the Malabar coast of India, part of the British East India Company's campaign to consolidate its business interests, including plunder, on the wonderfully rich subcontinent.

Sir William was a Company naval commander, patrolling the seas from Bombay to Cochin searching for pirates and other malefactors (Indians); the architect of the memorial was Richard Jupp, the Company surveyor, who as it happens had already built a house in Eltham for the James family. Sir William died in 1783 and his widow, Lady James, immediately commissioned the memorial, which was ready the year afterwards. Ready, not open exactly, with no more purpose as a building than Nelson's Column (though there has been a café on the ground floor and may be one again when the current restorations after years of neglect are completed). Of course, the conquest of Savanadrug does not quite match the glory of Trafalgar in the annals of imperial history. It is not recorded that bells pealed on 2 April 1995, the 240th anniversary of Savanadrug, not even in Eltham, but William James's attack was a decisive factor in the ending of Maratha power, leaving the young colonel Robert Clive just a few minor obstacles to clear, like the French army in India and the upstart Nawab of Bengal, Siraj ud-Daulah, in the quest to impose East India Company hegemony.

The Shooter's Hill monument fulfils all the requirements for a folly: no real purpose, a Gothic tower in variegated brick, pointy doors and windows with glazing bars in the eighteenth-century Gothic manner, three storeys with three corner turrets, hexagonal and battlemented. It is one of those romantic gestures, like the mourning Edward I's crosses on a funeral route over half of England in memory of his queen, Eleanor. Now, free India has changed the names of those former East India Company and Crown capitals, entrepots and cultural centres: Simla to Shimla, which is how Indians always pronounced it; Bombay to Mumbai, the imposition of the nationalist extremist Bal Thackeray; Calcutta to Kolkata, the seventeenth-century name of a settlement thereabouts; Madras to Chenai. Fine. It's their country. But Severndroog now: they can't take that away from us.

SHOOTERS HILL, SE18 3RT

## ELTHAM LODGE

*A house by a man about court*

The most influential house of its period lies behind tall, elegant, and forbiddingly closed iron gates, but anybody driving who pauses for a few seconds opposite the magic eye on a post will find that the gates glide open like a butler making a silken bow. Sadly, the butler is no more than virtual and the house, Eltham Lodge, is the nineteenth hole for the Royal Blackheath Golf Club.

The architect was Hugh May, a gentleman about court at the Restoration. He got in early as one of the party who escorted Charles II back from The Hague

to claim his throne in London. The housing market looked up after the coronation and he built houses for other gentlemen, though not many of them and of those few only three survive: the other two are Holme Lacy, Hertfordshire, and Cornbury House in Oxfordshire, but his work on these was added to by others. May built Eltham Lodge in 1664 for the banker Sir John Shaw while the memory of Jacob van Campen's Mauritshuis was still fresh from the visit to the Netherlands. The Mauritshuis stands with its feet in a small lake on a sort of plinth (a basement storey) and is only five bays wide, so it looks taller than Eltham, but what May's seven-bay building borrows from van Campen's in its brick façade is the frontispiece with its four giant white stone pilasters, the pediment with carved arms and swags of foliage in the triangular tympanum (in the Mauritshuis it's figure sculpture), the dentilled (tooth-like) cornice right round the building, its little square surfaces catching the light and bringing the illusion of movement to a still surface.

This innovation in England became known as the Wren style, though it preceded Wren, and Wren built virtually no houses. It's really Restoration style, but Wren was the burning brand; May suffered by comparison, viewed as a gentleman amateur. The penalty for the house being rescued and maintained beautifully by a golfing fraternity was that it lost a lot of the original internal decoration. There are no paintings in the hall, just a superfluity of boards bearing names of trophy winners in more profusion than the grateful dead on war memorials. The splendid staircase opens on to a vista of at least one portrait, but as an uninvited visitor I trespassed no further than the foot of the stairs so couldn't discern whether it was a genuine unholy relic or a job lot from a bazaar. The chap in the office (turn left inside the hall) seemed pretty relaxed, but then he had his back to me so I took a look at the lovely wall and ceiling plasterwork in white, set against dodgy flamingo pink paint, and departed.

I have the feeling that a polite request to visit might bring a positive response. If not, the virtual butler opens the gates on the way out too.

COURT ROAD, SE9 5AF

## ELTHAM PALACE

*Art Deco palace*

Everybody knows what Art Deco is but nobody has yet defined it very clearly. The dictionary gets no closer than 'the style of decorative art characteristic of the 1920s and 1930s'. It was there (still is where it's been saved) in cinemas and tube stations, hotels and bars, theatres and even street furniture. It featured in bent wood, Lalique glass, Susie Cooper ceramics, and a broadcasting HQ in Portland Place that looked like a Bakelite wireless set. It had circular mirrors and square chairs, kitsch table lamps dressed up as exotic dancers, low-relief sculptures like jolly Egyptian tombs; it came in flat bright primary colours and in bright South Seas flower patterning. It was vividly modern, but not Modernist. And when two socialites called Stephen and Virginia Courtauld, he a war hero and son of the founder of the textile business, she the Marchesa

Peirano, bought the crumbling great hall of the medieval royal palace of Eltham and stuck a squash court and orangery on one end and a house by the fashionable firm Seely and Paget on the other, they created the jazziest Art Deco home east of the Atlantic (that ocean that would be crossed by the Cunard liner *Queen Mary*, with its ostentatious luxury so like Eltham's, down to some quite fine details), and under Edward IV's hall with its great hammerbeam roof the Courtaulds threw the ritziest parties as well.

Stephen and Ginie, as she was known, built a circular entrance hall lined with Australian blackbean veneer inset with marquetry and lit from above through a circular glass-and-concrete domed roof. For the space below, Marion Dorn, aka Marion Dorn Kauffer, textile designer (for *RMS Queen Mary* among other top projects) produced a circular rug. Ginie liked the circular concept so much that she had a circular bedroom too, this time in maplewood, with a curved sliding door and an en suite bathroom with gold-plated taps; in an apse lined with gold mosaic, she placed a big bath with a golden lion's head spouting water.

Does this all sound inexpressibly vulgar? Curiously enough, it isn't. It is zestful, good-humoured and stylish, well this side of tackiness. It shows an almost naïve faith, certainly from the standpoint of the twenty-first century, in progress, perfectibility, science and technology. There are touching examples everywhere of the owners' faith in

Eltham Palace, the jazz-age home built by Stephen Courtauld and his wife, the Marchesa Peirano, in the purlieus of the ancient hall of a royal palace.

the new and the functional. In Ginie's boudoir there is built-in furniture with a huge couch, bookshelves, tables, and ledges for G and Ts, all locked in one immovable embrace against the wood-panelled wall; opposite, the wall is hung with leather cladding inscribed with a map of the district. Into the leather map a clock is inset, absolutely flush and correct to the second, because it and all the other clocks in the house worked on a pulse fed directly from the newly instituted National Grid. Siemens fitted up an internal Eltham Palace telephone exchange. The vacuum cleaners had pipes that siphoned dust through handsome bronze fixtures in the skirting boards down to the basement below. Sad to say, there are also coal- and log-lookalike electric heaters.

Towards the end of the war the Courtaulds realised that the brave new world would be a boring old world without servants. They moved out, leaving the building to pass ultimately (1995) to English Heritage, which has lovingly brought the house back to life. Stephen and Ginie moved to Southern Rhodesia where he founded what is now the Zimbabwe National Gallery and, no doubt, solved the servant problem.

COURT YARD, SE9 5QE

## ST SAVIOUR'S CHURCH, ELTHAM

*Unalloyed power in Expressionist colour and architecture*

The God of St Saviour has emerged from a thundercloud. He is an Expressionist

god, demanding awe. St Saviour's is the first avowedly Modern movement church in London, built in 1932–3, austere in dark brick: blue, grey, red and purple. It has a massive fortress-like tower over the chancel that looks as wide as it is high, and inside the church very tall, slender windows like lancets except that they are spectacularly deep, narrow rectangles, not pointed, which march up each side of the nave. Four more in the (liturgically) east wall are punctuated by emphatic brick ribs and filled with blue glass. The reredos picks up the rib motif in a succession of detached raw concrete ribs with a big statue of Christ by the short-lived sculptor Donald Hastings between them, tamely Modernist but impressive as part of the ensemble. It sits beneath a huge quasi-Byzantine cross in super-real fluorescent colours. The lady chapel makes a statement just as powerful but expressed quietly: a good altar to the east, harmonious proportions, and a dozen squares punched through the north wall and filled with punchily designed stained glass and heavy leading.

The architect, Nugent Cachemaille-Day (1896–1976), had trawled Germany and come back with a wife and an enduring passion for Expressionist architecture, though as much as anything the visual effect of St Saviour's chimes with a piece of secular art, the dramatic sets for Fritz Lang's sci-fi movie of 1927, *Metropolis*. St Saviour's wasn't Cachemaille-Day's first church; that was St Nicholas's in Burnage, Manchester (1931–2), but it is his earliest to have survived unscathed and it set the pace for the rest of his career: occasional secular buildings, but principally churches, several in other parts of London (which may explain why his estate at his death amounted to £216). It sits in a sea of sympathetically designed redbrick houses on the Middle Park estate, once part of Eltham Palace royal hunting grounds, and built in the 1930s to house Woolwich dockyards workers, but now displaying the marks of poverty. Locals call St Saviour's 'the prison', yet many still come to church and the women I met decorating it for a wedding with huge and wonderful sculptural arrangements of flowers love its unalloyed power.

MIDDLE PARK AVENUE, SE9 5JH

## MOTTINGHAM LANE

*W. G. Grace was here*

Mottingham Lane, in what was not so long ago deep suburbia, is a commuter rat run interspersed with a lot of ramps that don't deter the rats at all. They certainly wouldn't have worried William Gilbert Grace, the owner of one of the big old Victorian houses lining the avenue. The only driving he did was with a cricket bat. W. G., as he is known still to all the world, was born in Mangotsfield, Gloucestershire in 1848, a year of turmoil and revolution all over Europe, and died of a stroke aged 67 a year after the outbreak of the First World War. He was a gigantic man, a doctor who earned most of his money playing cricket as an amateur (don't ask). From 1865 until 1908 he played first-class cricket for 44 seasons and almost as many clubs, including All England (which, mildly

confusingly, was less than all of England), England (which was all England), and his beloved native county, Glos. He reaped nearly 100,000 runs, plundered more than 7,000 wickets, and stopped playing only because he had become too fat to field. He packed up and moved to Fairmount House in Mottingham Lane and placed his beer belly, his magnificent beard and the cudgel he called a bat at the disposal of the Eltham village team: full circle from his boyhood days in deepest south Gloucestershire, wreaking havoc for Mangotsfield. He played his last recorded match for Eltham on 25 July 1914 and hit a farewell knock of 60 – from long habit, not out. Ten days later, Britain was at war.

The blue plaque on Fairmount House (now an old folks' home, none of them still cricketers) is all that remains of him locally. In this short century Mottingham Lane has already become a mouthful of broken teeth. Eltham itself has only hints of the village it used to be, with its royal palace and Eltham Lodge, Severndroog Tower in the woods of Shooter's Hill (see pages 410 and 409), Well Hall housing estate designed in seven days at the end of the Great War and built in under a year, a garden village outdistancing in imaginative reach and warmth any of the post-Second World War bureaucratically ordered crass housing. Eltham High Street allows glimpses of its village past, especially a typical Kentish pub, the Greyhound. But in 1830 the church historian Stephen Glynne wrote that the parish church of St John the Baptist 'is a mean fabric, much patched and modernised; with scarce a trace of anything like good work'. It reads like a death sentence, and sure enough, a demolition crew later cleared the site for Arthur Blomfield's machine-tooled Early English rebuilding of 1870.

As for Eltham Cricket Club, it flourishes now in Foots Cray off the A20 beyond Sidcup where it turned to find a decent wicket. History is not slotted into the toolbar of the club's website so W. G. Grace has become an Orwellian non-person, though for the rest of the world he is forever the hero of the first hundred hundreds.

MOTTINGHAM LANE, SE9 4RT

## DANSON HOUSE

*A classical hymn to love inspirationally rescued by English Heritage*

Danson House is the seat of a love story underpinned by Caribbean wealth and founded on slavery. John Boyd, its first owner, was born in 1718 in the Leeward Islands, the son of a sugar planter with a thriving second trade in slaves. The younger Boyd bought the 304-acre Danson Hill in Kent, and in 1760 hired Robert Taylor, architect laureate to the newly rich, to build him a country villa. It stands in its park today, as crisply Neo-classical as the day he moved in.

The younger Boyd's first wife died in 1763; he remarried in 1766 as the house was nearing completion and dedicated the decoration of this new country villa to a celebration of love, marriage and the fecundity of nature. All this is concealed from the outside behind a broad flight of steps leading to the piano nobile, or main

floor, and a north-facing stone façade so rational, so measured, so, in a word, Palladian, that it seems to propose something quite different from the theme of love depicted in the principal rooms. In fact the hall, the first of the four, is Ionic and iconic, with scallop-shell motifs referring to Venus in a cool opening descant. The three remaining rooms open into each other: the dining room and library with its original bookcases and organ run the depth of the house on the east and west; in the south is the lovely octagonal salon looking out across the park. The principal decor of the dining room is a cycle of paintings by Charles Pavillon, an artist usually described as obscure since history has forgotten everything about him except that he was born in Aix in 1726, worked at Danson House in 1766, was proposed by Allan Ramsay as head of a drawing school in Edinburgh in 1768, and died in that post in 1772. His dining-room panels aren't much more than stage decor, trifles setting a mood of pastoral pleasure, invoking Bacchus, god of wine, and the story from Ovid of the love of the god of the seasons, Vertumnus, for the wood nymph Pomona. Between each narrative panel is an even narrower classical dec-oration of grape vines and, less classically, hop bines.

By 1995 the house was falling down; in fact, the roof of the salon had completely collapsed. So although it is quite astonishing that so many of the original fittings have survived, a great many more derive from inspired intervention by English Heritage. The chairs bought in for the dining room and salon were made for Napoleon's uncle, the Bishop of Paris; the painting originally hung above the salon fireplace, a classical landscape, now hangs in the Walters Art Museum in Baltimore, so the restorers commissioned a fine replica, with a bluer sky and brighter red setting sun than the original, no doubt to sit with the wallpaper whose blue was copied from the miraculously surviving blue of the lovely palmette frieze.

The restoration is a triumph, though for the original occupant the theme of love quickly turned to dust. Boyd was miserable in his second marriage.

DANSON PARK, DA6 8HL

## RED HOUSE

*Home and test bed for William Morris*

In his time William Morris (1834–1896) lived in Queen Square in Bloomsbury and Red Lion Square in Holborn, in Kelmscott Manor in Oxfordshire and Kelmscott House in Chiswick, but Red House was the only house he built. He commissioned it from his friend Philip Webb and, almost in spite of Webb's imaginative recreation of Gothic domestic design and faux suggestions of a vanished age of individual craftsmanship, its free-flowing internal spaces and easy domesticity became a paradigm for the Arts and Crafts movement and later for the Modern movement. In the career of a single avowed admirer, Frank Lloyd Wright, the Red House influence reached from late nineteenth-century homes to that monument of Modernism, the fabu-

As rural a scene as the architect, Philip Webb, could have hoped for the Red House (1859), this hugely influential home and studio for William Morris.

lous drum of the Guggenheim Museum in New York, with its garden creeping into the atrium.

Morris decorated the interior with Webb, wife Janey, and other friends and companions in arms against the industrialised nineteenth century, Edward Burne-Jones and Dante Gabriel Rosetti; Rossetti's wife Lizzie Siddal weighed in too. As his sultry red-headed muse and model, she inspired his curious *Dantis Amor*, now in Tate Britain but which in 1860 filled the square opening in the Morris-designed settle that remains, as then, in the drawing room.

'Have nothing in your houses that you do not know to be useful or believe to be beautiful,' Morris said, and of course that 'or' rather than 'and' lets in a lot of non-utilitarian stuff, paintings and painted and stained glass, and wall hangings and ceramics. Burne-Jones designed a couple of apprentice stained-glass panels for a downstairs corridor (surrounded by little panes painted by Webb with wild birds; and by Morris, with decoration derived from the plants in the Red House garden). To either side of Morris's settle are three small murals by Burne-Jones of an intended sequence of seven based on a medieval romance and depicting a wedding feast with a medieval Morris and Janey at the heart of the subject. Morris himself painted a scene (unfinished) on a settle on the landing grouping the friends who filled the house at weekends in response to their hosts' gargantuan hospitality, moving gently through a grove of orange trees in another romance inspired by medieval tapestry.

It all has a distinctly homemade feel to it, like amateur dramatics, but the experience of decorating Red House germinated the notion of founding the firm of ecclesiastical and domestic furnishers eventu-

ally known simply as Morris & Co., but which originally included as partners the Pre-Raphaelite painter Ford Madox Brown, Rossetti, and Burne-Jones. Morris & Co. went on to produce some of the finest stained glass of the nineteenth-century revival and underpinned Morris's theories about the close-knit integrity of craft and art.

Red House was his ideal, yet he and Janey moved out only five years later. The nineteenth century had caught up with him. He couldn't bear the burden of commuting to his business in Red Lion Square, where it had to be based to suit the other partners equally; it was a two-hour journey each way by horse and trap to Abbey Wood and a train journey from there. The house remains with the outward lineaments of a past idyll, and the garden roughly as Morris planned it, which was roughly. The stable and the coach house remain, but the lane outside is painted with double yellow lines, the Kentish countryside has been buried under London semis, and the journey to Abbey Wood railway station is over tarmaced streets.

RED HOUSE LANE, DA6 8JF

## HALL PLACE

*Only a building stripped of its last stick of furniture, but some building*

Hard by the serpentine exit road from the A2 on the eastern verge of Greater London is the Tudor façade of Hall Place, one of the first houses of England built on land seized from monastic establishments. In fact, when the new owner of the estate, Sir John Champeneis, built Hall Place in 1537 it was probably with stone hauled the four miles or so from the ruins of Lesnes Abbey (see page 419), which Cardinal Wolsey had suppressed a few years before Henry VIII took over the business of Dissolution wholesale.

From the west, Hall Place shows a three-sided courtyard formed by two wings projecting from the diaper-patterned, white stone and black flint Great Hall with its huge windows, the freshest fashion for country houses of the 1530s, which had no need any more to adopt the old defensive mode of an enclosed quadrangle. Still, it carried over from the middle ages the arrangement of hall, gallery, great chamber for the entertainment of guests, parlour, chapel and the huge kitchen necessary for feeding many mouths, for though this was not a great house like Charlton (see page 384), there were still numbers of retainers who looked after the family and ate in the hall.

A hundred years passed and the Tudor dispensation was over. In 1649 Robert Austen, a Tenterden merchant who kept his powder dry as the Civil War was fought, bought Hall Place and added a mellow redbrick extension punctuated with rows of crisp white-framed windows, those on the ground floor set into recessed brick arches. This almost precisely doubled the size of the house and added a whole range of smaller, cosier, more private rooms, amenities popular in Stuart times.

In the eighteenth century the Austens

Lesnes Abbey in a wooded glade but now close to *Clockwork Orange* territory: a place where corruption peaked when the abbot confessed his immorality to the Archbishop of Canterbury.

married into the Dashwood family, and in 1772 the property passed to the notorious rake Francis Dashwood, 15th Baron le Despencer, otherwise known as Hellfire Francis. He might have added colour to the history of Hall Place but instead he shrewdly leased it out to private tenants, a course in which the house continued until it became a school in the nineteenth century. In the Second World War it was a base for a US army detachment employed on intercepting enemy signals traffic and rerouting it to Bletchley Park for the wizards to decipher. So by the time Bexley council acquired Hall Place after the war the things by which the personality and taste of past owners could be judged had been dispersed to the last stick of furniture. What remains is only a building; but some building.

The most integral elements of the imaginative life of its inhabitants remains the decoration that could not be flogged off to distant parts, the gardens with the little River Cray wandering through, and the Tudor great chamber and long gallery with their stuccowork ceilings carved with a wondrous mermaid and other whimsical creatures and plants; a faerie world created by the sort of craftsmen from whom Shakespeare drew characters like Snug, Quince, Snout and Bottom.

BOURNE ROAD, DA5 1PQ

## LESNES ABBEY

*The problem abbey in a wooded landscape of surprising beauty*

Observed from the high ground to the south, Lesnes Abbey is nothing much more than an almost complete plan of a monastery drawn in stone. It delineates a nave of six bays, aisles, chancel and lady chapel, dormitory above an undercroft, and the chapter house. There is besides a

complete pointed doorway opening on to cloisters, chunky fragments of massive piers clasped by surrounding colonnettes and substantial stretches of wall, all this discovered or reconstructed during the two excavations in the early part of last century. To the north of Lesnes (once spelled and still pronounced Lessness) are the Erith marshes and the tower blocks of Thamesmead, the cosily named 1960s development instantly singled out by Stanley Kubrick as fit territory for the feral young thugs of his movie *Clockwork Orange*. These are hardly ruins on the scale of Fountains Abbey or Lanercost Priory. Yet the abbey on its smooth lawns contained by the mile and a half stretch to the south of ancient forest, Lesnes Abbey Woods, is a place of surprising beauty, still imparting a powerful sense of immanence.

Its dedication to St Thomas the Martyr is surprising. Its founder, Richard de Lucy, was the most powerful man in the kingdom after Henry II himself, but he had fallen out with Becket over the archbishop's quarrel with the king and had twice been excommunicated. The Augustinian Abbey of St Mary and St Thomas the Martyr at Lesnes, to give it the full name, had problems almost from the beginning. On founding the abbey in 1178 de Lucy gave up his career to become a canon in his own house and died there on 14 July of the year following, so while the de Lucy family remained patrons, money was always short. The Thames was much closer then and the abbey always had trouble paying for the upkeep of river walls and draining the marshes on ground prone to heavy flooding. In 1283 the Bishop of Rochester had to instruct Abbot Robert that nuns should not be allowed to sleep in the cloisters at night. Another raft of instructions insisted that women must be excluded yet in 1336 Abbot John confessed his own immorality to the Archbishop of Canterbury. Tales of corruption continued until 1525, when Cardinal Wolsey suppressed the abbey and seized the proceeds for his proposed new Oxford foundation, Cardinal College. Lesnes became a quarry for building stone, was overgrown, and for centuries disappeared entirely.

During excavation a broken mid-fourteenth-century effigy of a knight was discovered in a vault below the lady chapel. The shield bore an incised pike fish (luce), which identified the de Lucy family. It has been restored and is now in the Victoria and Albert Museum, which also contains the early thirteenth-century Lesnes missal. The mid-thirteenth-century ceramic jug found at Lesnes and now in the British Museum was made in Saintonge in western France with a beak-like spout and painted decoration of a bird and shields, Picasso-esque in its simplicity and beauty. In the woods are the abbey's fishponds, though nothing by way of supper swims in them now.

LESNES ABBEY WOOD, BEXLEY, DA17

## CAMDEN PLACE

*The last Emperor of France*

The last Emperor of France, Napoleon III, died in 1873 at Camden Place in Chislehurst, leased to him by its franco-

phile owner, Nathaniel Strode. The emperor had moved here in 1870 after being dethroned following the catastrophe of France's defeat at Sedan in the war against Prussia. In 1879, his son, the Prince Imperial, commissioned into the British army as a lieutenant, died from assegai wounds sustained on an ill-conceived scouting mission in Zululand and took with him hopes for a Third Empire. Afterwards, Chislehurst scraped the barrel for street names in honour of the imperial visitors: Prince Imperial Road, Imperial Way, Royal Parade, Empress Drive. Regardless, his wife, Empress Eugénie moved on to Hampshire in 1880, removed the royal cadavers from their mausoleum in St Mary's Catholic church, Chislehurst, and reinterred them in St Michael's Abbey, Farnborough. With the subsequent temporary shortfall in émigré emperors and their families to take on such houses (see also Orleans House, page 299), in 1894 Camden Place became Chislehurst Golf Club, which it has remained ever since.

Its fate might be thought dire, but the golfers have looked after it. Although rooms above the ground floor have been converted into studio flats and apartments and there are signs almost everywhere on the ground floor of sportsmen in occupation, some of what remains is wonderful if confusingly dislocated. The house is normally ascribed to remodelling by George Dance the Younger (1741–1825) of an earlier house, but no single room can be definitively attributed to him. *The Buildings of England* thinks Dance was responsible for the Adam-like ceiling in the lovely dining room, but the golf club's records apparently suggest that the author was actually James 'Athenian' Stuart, so nicknamed for the obvious reason in a man of his classical inclinations. He was the architect who designed the chapel in the Royal Hospital, Greenwich, and was the moving force in creating Spencer House in St James's (see pages 164 and 421).

There is an enfilade of good eighteenth-century rooms, one bow-fronted looking west with ornamental murals, the other oval with more murals, possibly Dutch, of romantic landscape; indeterminate period and inferior to the sort of thing Rex Whistler was doing in stately homes (and the Tate restaurant) in the twentieth century. The big success is the dining room, richly panelled, so-called boiseries with delicate raised gilded edgings breaking into sprightly decorative capriccios. These were part of a hunting lodge near Paris, the Château de Bercy, which Nathaniel Strode bought in order to strip the interiors. Bringing the panelling to Chislehurst was the equivalent for him to a hole in one.

CAMDEN PARK ROAD, BR7 5HJ

## ST NICHOLAS'S, CHISLEHURST

*Where a Shakespeare unbeliever looked for Marlowe and came away with dust*

Nowadays Chislehurst is the sentient man's Orpington: more visible history than its neighbour, better church, less built up. A huge acreage of woodland between Chislehurst and Orpington has survived as common land where around

the edges great men built their houses: William Camden, the Elizabethan historian, founder of the Camden chair of ancient history at Oxford and – quaint title but powerful in its day – Clarenceux King of Arms, lived his last years and died at the house he built in Chislehurst. Three hundred years later Napoleon III and the Empress Eugénie lived in exile in Camden Place (see page 420). A mile or so away Henry VIII's powerful subject, Sir Edmund Walsingham, lived at the family home of Scadbury; he is buried in the Walsingham tomb in the Scadbury Chapel of the parish church of St Nicholas, and alongside him his grandson Thomas, friend and patron of Christopher Marlowe. The penalty Thomas paid for this association came more than 300 years later when the Brooklyn press agent and Shakespeare unbeliever Calvin Hoffman applied successfully to open the tomb where, he was convinced, he would find Shakespeare's manuscript plays in Marlowe's hand. Well, the tomb was empty, but the tomb raider did expose a vein of credulity in the church authorities who allowed it.

St Nicholas's is built of flint and is not especially beautiful, although from the west it can be seen that the tower and tall spire are picturesquely offset against the north aisle instead of being centred on the nave. Basically the church is fifteenth-century Perpendicular and nineteenth century, the earlier the work of Alan Porter, the rector in 1446–82, funded by Thomas Walsingham, the later work the rebuilt tower and spire (after a fire), and the south aisle, in a passable imitation of Perpendicular. But the tombs and memorials are the draw here.

There's a memorial on the south-aisle wall to William Selwyn and his son George, especially finely carved by Francis Chantrey, with two seated women in classical Greek costume gazing inward and a man in the dress of the day (1823), standing, back to the tomb, but fixing his eyes on it intently over his shoulder: less like a traditional mourning group than characters in the elegiac tradition which produced so much art, the finest being Poussin's (twice), based on Virgil's phrase, *Et in Arcadia Ego* ('Even in Arcadia I [death] am present'). In the Scadbury Chapel is an efficient life-size recumbent figure of Lord Sydney (d. 1890) in garter robes, carved by the eminent Victorian Joseph Edgar Boehm and completed, though you would never know it, by Alfred Gilbert (of Eros fame). Inevitably though, it is the Walsingham tomb chest that grips, with its tightly wrought tracery of 1549, and two panels of gold with black lettering memorialising Edmund and his arts-loving grandson, somehow Victorian in its gold and black funereal solemnity, yet apparently of 1630. Life is short, gloom is forever.
THE GLEBE, BR7 5PX

## ALL SAINTS', ORPINGTON

*A Kentish war cemetery built with Canadian cash*

My father and my uncle Frank both came through the First World War and out at the other end, my father as a fusilier in the trenches, Frank in the Royal Flying Corps

and then in the Royal Air Force, as the corps became. Somewhat battered, my father made it to a good old age, but Frank died at home in the vicarage of the tiny village of Eryholme on the River Tees on 20 November 1918, nine days after the Armistice. He was 19. My grandfather buried him in a coffin draped with the Union Flag, and although Frank had died of pneumonia in the flu epidemic of that year, he was counted among the war dead and his grave in the little North Yorkshire churchyard is listed by the Commonwealth War Graves Commission. *Sic transit gloria mundi,* his gravestone is inscribed.

It felt to me like a singular story, but when I visited All Saints', Orpington, for quite a different reason, I discovered that it's a story repeated many times over, spectacularly so in Orpington. In an extension cemetery across a little lane to the north of the church and churchyard are buried 88 Canadian soldiers alongside 28 British and Irish soldiers and airmen, some victims of the Second World War, who were shipped from the front to the Ontario Hospital, Orpington, and died there. The total number of deaths was 182 out of more than 15,000 treated for war injuries. Ontario government money funded the building for Canadian war wounded shipped from the Western front, but in 1919 the hospital became Orpington's, and is now being phased out in favour of a big central hospital in Farnborough nearby. *Sic transit...*

The old country church itself is crushed by a dull suburb and a big feeble quasi-Gothic extension of 1947; but from the north the old Saxon and Norman foundation with its squat tower only as high as the pitched nave roof is charming, and its yew-shaded churchyard entirely pretty with a cluster of eroded eighteenth-century gravestones created by a single hand, a local stone carver with a sure feel for curly upper- and lower-case letters mixed with whole words in fine Roman capitals, and rustic reliefs of mourning figures, putti, urns, skulls and crossbones, with sheltering vegetation as big as banana leaves. 'Each in his narrow cell for ever laid, / The rude forefathers of the hamlet sleep.'

On the slope to the north of the old tombs the Canadians inhabit their graves lined up regimentally, the neat white crosses just so, all overlooked by a tall white stone cross carved: 'This cross of sacrifice is one in design and intention with those which have been set up in France and Belgium... where our dead of the Great War are laid to rest.'

BARK HART ROAD, BR6 0QD

Overleaf: Leamouth: historically an industrial city in itself.

*East London*

# East London

1. Brick Lane Jamme Masjid
2. Museum of Immigration and Diversity
3. Christ Church Spitalfields
4. Sculptures by Philip Lindsey Clark, Widegate Street
5. 56 and 58 Artillery Lane
6. The Eastern Dispensary
7. St George's German Lutheran Church
8. Whitechapel Gallery
9. Whitechapel Bell Foundry
10. King Edward VII Drinking Fountain
11. Whitechapel Overground Station
12. Wilton's Music Hall
13. Cable Street Mural
14. St John's Chapel, Tower of London
15. Sculpture by Wendy Taylor, St Katharine's Docks
16. Prospect of Whitby
17. King Edward VII Memorial Park
18. Albert Gardens
19. The Royal Foundation of St Katharine
20. St Dunstan and All Saints
21. St John on Bethnal Green
22. V&A Museum of Childhood
23. Mendoza plaque, Queen Mary University
24. Relief carvings by Eric Gill, Queen Mary University

ENFIELD

WALTHAM FOREST

St Andrew's, Ilford

St Mary's, Wanstead

Wanstead Flats

HACKNEY

Hackney Marsh

Sutton House

Hackney Empire

Geffrye Museum

Theatre Royal Stratford East

Victoria Park

St Margaret Barking

NEWHAM

TOWER HAMLETS

Ragged School Museum

St Matthias Old Church

Leamouth

Gates by Anthony Caro, Orchard Place

Blackwall Tunnel ventilation shafts

Wapping Wall and Wapping High Street

Canary Wharf

SOUTHWARK

GREENWICH

ESSEX

Hainault Forest
Country Park

The Green,
Havering-atte-Bower

*Havering Park*

Bower House

*rlop Waters*
*untry Park*

Gidea Park

DBRIDGE

HAVERING

Valence House

*Central Park*

Upminster Windmill

BARKING &
DAGENHAM

Dagenham Library

Eastbury
anor House

St Helen and St Giles,
Rainham

Rainham Hall

*Thames*

Rainham Marshes

*Lesnes Abbey Woods*

BEXLEY

0  0.5  1  1.5  2 mi
0  1  2  3 km

## • BRICK LANE, SPITALFIELDS, WHITECHAPEL, SHADWELL •

### BRICK LANE JAMME MASJID

*From Huguenot to Islam*

At street level it is called Banglatown, but the area of Spitalfields around Brick Lane has seen several changes in its prevailing character since 1685, when Louis XIV of France declared Protestantism illegal and drove the silk-weaving, Calvinist Huguenots abroad. Through later waves of Jewish, Irish and Bangladeshi settlement, Brick Lane became an early manifestation of Ellis Island, though without a Statue of Liberty. Now it has its own symbol, glowing blue at nightfall: the minaret alongside the Jamme Masjid Mosque on the corner of Brick Lane and Fournier Street, its 90-foot steel core embraced by eight segments of lacy patterning and crowned by a sliver of Islamic moon on a tall slender shaft. Since the building itself is listed and the minaret was erected by Tower Hamlets council with a pencil's space between it and the Jamme Masjid, the proper if unwieldy description, adopted by the architect, David Gallagher, and the special metal fabricators, m-tec, is 'minaret-like sculpture'. While it is true that most proper minarets have a gallery at the top from which the imam can issue the ululating call to prayer that is the common and compelling feature of many eastern cities, even without this the resemblance to the real thing is clear, and the fabulous surface decoration, computer-generated, follows a line from the ancient Masjid al-Quba in Medina through the pierced screens of the Taj Mahal to Brick Lane.

The best of the local street scene survives from the era of the Huguenots: the tall terraces of late seventeenth- and eighteenth-century houses and their chapel of 1743, now the prayer hall; even the brewery that would become Truman's. In 1815, Jews moved in, the chapel briefly became a centre for pushing Protestantism to the new arrivals, then a Methodist chapel, and after the late nineteenth century, when Eastern European pogroms brought Jews pouring in, the chapel turned synagogue. In 1976, with the influx of Bangladeshis following the chaotic and bloody secession from Pakistan, Islam claimed the chapel for its own.

As in the street scene of Brick Lane, where so much remains familiar though the English street names are echoed in Urdu, the structure of the mosque within and without remains European. The paintings in a classroom of the infants' Madrasa on the attic floor could be of anywhere, except that the legend on one of them reads 'Happy Eid' (the festive holiday marking the end of fasting during Ramadan). The walls are lined with matchboard, as they probably have been from the beginning, and the rooms everywhere above the ground floor, offices so far as I could see, one of them for the imam, are as plain as in any barely furnished bourgeois house. The differ-

The synagogue in David Rodinsky's house, unoccupied since he walked out in the 1960s: now the nascent Museum of Immigration.

ences are mostly on the ground floor, with the introduction of a big room for ablutions before prayer, and the adaptation of the chapel space into a prayer hall, with the big octagon in the centre of the ceiling piercing the space into the floor above; here the traffic of the faithful visiting to prostrate themselves in prayer is as natural and everyday as taking the air in Altab Ali Park over Whitechapel Road.
59 BRICK LANE, E1 6QL

## MUSEUM OF IMMIGRATION AND DIVERSITY

*House of dusty memories*

It's a museum of immigration surrounded by immigrants: ask them, and some may know where it is, some may only shrug. Few will ever have been inside, nor will their British, Spitalfields-born children. It is a grand dark Georgian terrace house, number 19 Princelet Street, among many that a couple of eighteenth-century entrepreneurs built in three parallel rows off Brick Street in 1719, the most prosperous period in Spitalfields history until now. Today millionaires are buying the reconditioned houses, part of the City's inexorable march east, but number 19 is falling down. I have phoned, emailed, passed by to take snaps, leaned on the door, knocked, turned the handle, but never made it in. Stephanie Wolff was more persistent, so I'm working from the photographs she took under tight supervision by number 19's dedicated carers from the Spitalfields Building Trust, a body strapped for cash but with an English Heritage grant promised.

So for now, the house survives on a diet of myth and dusty memory, a museum more perceptual than actual.

Maybe the star items are the pieces of luggage lying about, labelled, lids open. Not wanted on voyage. In 1870 a Polish Jewish prayer group built a little synagogue out over the back garden, with a gallery on three sides supported on slender twisted iron poles like those in Wilton's Music Hall (see page 443), an alcove to contain the ark, and wonderfully curly chandeliers. Only the decaying husk remains, no ark, the chandeliers still good but lamentably unpolished. All part of the museum now, even the cobwebs.

In an attic room close by a friendless young man lived with his mother and sister from 1932. When his mother died and his sister was institutionalised he remained in the room, a recluse. One day in the 1960s he went out, perhaps to buy food. He never returned. His name was Rodinsky, David Rodinsky. In 1980 the new guardians of number 19 forced open his door and found a room stuffed with the detritus of scholarship: newspapers, diaries, notebooks, maps (hand-drawn and doctored *A-Zs*). It appeared that Rodinsky, though he had been barely educated, spoke and wrote in live languages and dead ones: Yiddish, of course, Hebrew, Arabic, Sumerian, Greek, Russian, Japanese, Latin, maybe Hindi, and wrote commentaries on ancient texts of the biblical Near East. Years later, an English artist called Rachel Lichtenstein, while exploring the roots of her own part-Jewish identity, stumbled on 19 Princelet Street, pushed on the door, was shown the room and heard the legend of the missing man, a mystery that, as the writer Iain Sinclair later put it, 'lives in other men's tongues'.

Lichtenstein dedicated herself to discovering what had happened to him. Part shaman and part shamus, as a journalist said, she traced him to an East End hospital (where he had proved so clever they decided he must be mad and sent him to a psychiatric institution). He died in an Epsom mental home of pneumonia aged 44 on 4 March 1969, the year of Lichtenstein's birth, and was buried in the Jewish cemetery in Waltham Abbey. She wrote *Rodinsky's Room*, published in 1999, with every other chapter by Sinclair, and it remains a samizdat bestseller, always in print. Meanwhile, the house in Princelet Street leads a shadow life.

19 PRINCELET STREET, E1 6QH

## CHRIST CHURCH SPITALFIELDS

*Hawksmoor's shot in the arm for the Baroque*

Nicholas Hawksmoor's Christ Church commands attention from Bishopsgate in the City along the full length of Brushfield Street deep into Spitalfields. In London that kind of unobstructed view is a rarity. The front of the church is another rarity. It's a punchy and strongly defined arrangement in which Hawksmoor, champion of the baroque, firmly resists the incoming conventions propagated by Colen Campbell, architectural adviser to Lord Burlington, in his highly influential appreciation of all things Palladian, *Vitruvius Britannicus* (1715).

Hawksmoor's portico immediately emphasises the height of the building, with four columns paired, the pairing

stressed by an entablature over each; between the pairs is a deep, narrow, undecorated arch pushing upwards into the base of the tower and establishing an umbilical link. So it all looks tickety-boo and mathematically precise, but it is also powered by Hawksmoor's deep feeling for the slow dance of space and mass, each defining the other. The tower itself is as wide as the portico and picks up its theme with a tall, round-arched central window and four small blind windows, or niches, on either side. It supports a tall polygonal spire, plain enough compared to, say, his category-annihilating stepped steeple of St George's, Bloomsbury (see page 117).

We are lucky to be alive to see the beautifully restored interior after the wilful alterations of the nineteenth and the neglect of the twentieth century (principally, the almost ritual Victorian removal of galleries). In the west gallery there is an organ with a beautiful case of 1735 by Robert Bridge; above the reredos in the east, a Venetian window, borrowed shamelessly from the Palladians. The nave has five bays, which of course means six columns: of these the second and fifth on each side of the nave are clustered columns, thus defining, almost subliminally, the space captured within as a square; indeed, it leaves three squares, because it casts the west and east ends similarly, countering any possible hint of a long untamed Gothic nave.

There is no doubting Hawksmoor's genius, but some about his judgement. The Christ Church façade is so singular as to be taken by some as an aberration. The fact is that Hawksmoor comes in a line of English peculiarity that includes his poet, playwright and architect friend Vanbrugh and, of course, John Soane, born in 1753, 16 years after Hawksmoor's death. He himself never took the almost statutory visit for a budding architect to Italy, and though he had the luck to serve what amounted to an apprenticeship with Wren, Wren himself was self-trained, the architectural version of a literary autodidact. That said, if Hawksmoor and Vanbrugh, who worked together on Blenheim Palace, ever felt a deficiency in architectural training the power of their work denied it.

The jacket of the East London volume of the Buildings of England series pairs a photograph of Hawksmoor's St George-in-the-East on the front with one of Denys Lasdun's Keeling House, also in Tower Hamlets, on the back. Two brutalists together across the centuries: it's unlikely that it was a random selection.

COMMERCIAL STREET, E1 6LY

## SCULPTURES BY PHILIP LINDSEY CLARK, WIDEGATE STREET

*The bread of life in Widegate Street*

The sandwich bar at 12–13 Widegate Street continues, tenuously, the traditional business from 1710 of the matzo bakers, Levy Brothers. In 1926 Nordheim Model Bakery took over and hired George Val Myer to rebuild the premises. He produced the building that stands now, surprisingly modest for the architect who the following year was to design the grandiose BBC headquarters in Portland

Place. Part of the building contract specified a sculptor to decorate the façade. The choice fell on Philip Lindsey Clark (1889–1977), a Brixton-born sculptor who had made his living designing war memorials, the most famous of which, because of the controversy its commission aroused, was the Southwark memorial at the junction of Borough Road and Southwark Street (the poor of the borough were excluded from any part in the decision and protested vociferously).

Clark, who has been all but forgotten today, was a remarkable artist and man. In 1914 he joined the army and, as a temporary second lieutenant acting captain (a promotion rate indicative of the life-span of young officers), won the DSO. His citation reads in part: 'He personally led a charge against the advancing enemy and dispersed them, and later repelled another attack. He was wounded by a piece of shrapnel in the head, but though dazed continued to command his company for two days until relieved.' Yet his war memorials fail on a human level because, anxious to stress the heroism of his dead comrades, he showed them in action with faces strained into masks of war; an unreal realism, unlike the thoughtful quietism of the memorial figures by his fellow combatant (and hero), Charles Sargeant Jagger (see page 210). But by 1926 Clark was moving into his own quietism.

His four bakery workers are fired in faience ceramic and set into niches on the building's façade. They show a man with sleeves rolled up above the biceps half crouching as he carries a sack of flour; a baker bending over a work bench kneading dough; another two-handedly removing bread from the oven with a spade-like spatula; the fourth, a delivery man, leaning to one side as he hefts a tray of loaves on to his shoulder. The dignity of labour is an overused, even derided phrase, but these four figures do honour to it. The figures are in white lustre, the niches are blue: the colours suggest the Renaissance Della Robbia ceramic sculptures of Florence but are wholly contemporary, moving along with the mass media in their relation to working life caught on the trudge, yet with the full, tangible weight of sculpture. There is symbiosis too between firing in the kiln and baking in the oven, the bread of life, the artisanal sense of something handmade and watched over. Clark was to devote the rest of his career to religious sculpture before retiring to the West Country, a layman attached to the Cluniac order.

12–13 WIDEGATE STREET, E1 7HP

## 56 AND 58 ARTILLERY LANE

*The silk road to a beautiful building's salvation*

Artillery Lane is one of a congeries of little streets and alleys in Spitalfields, south of the axis running between Liverpool Street Station and Christ Church, Spitalfields: Gun Street, Artillery Passage, Fort Street, Bell Lane, Brick Lane, White's Row, Petticoat Lane (officially Middlesex Street), Tenter Ground. Even in bright

The Raven Row Gallery in Artillery Lane: renaissance of a silk merchant's house with its intact eighteenth-century shop front.

daylight, when the sun throws stark shadows across the narrowest lanes, this seems the perfect location for a *noir* movie: Jack the Ripper territory. It's hokum, of course. Brick Lane alone today is a different brew of exotica altogether, a place which, in the reality of Monica Ali's celebrated fiction of Islam and illicit love, is more real than the faceless Ripper's faded malefactions.

The best of Spitalfields's older houses are the pair at 56 and 58 Artillery Lane, which had ground-floor shops as recently as the 1990s. Taken together, the building is as fine a sight as any of its kind in London. In 1756 a French silk merchant called Nicholas Jourdain had this new style of unified shop and house front inserted into a very plain brick building of the 1690s. In the absence of proof opinion holds that Sir Robert Taylor (1714–88) built the new frontage; but floating around in the background is the older suggestion that the carpenter and writer Abraham Swan (active from about 1745) was responsible, and certainly some of his illustrations for his own books are close enough in style to suggest that this is likely. (Try, for instance, his best-selling *The carpenter's complete instruction in several hundred designs, consisting of domes, trussed roofs, and various cupolas: with the methods of securing them on the roofs for churches, chapels, houses, and other buildings: shewing the most approved manner of lighting stair-cases with various sorts of lanthorns in a new and elegant taste: explaining the manner of piecing beams, or plating, or any sort of bandage for timber spires for churches, &c., truss partitions, framing of flooring, trussing of beams, angle brackets, cornices, coving, form of groins, hips, &c.: to which is annexed, a great variety of timber bridges, of various dimensions.*)

The new frontages were modified during the Regency and are an intriguing and beautiful blend of classical cool and rococo frivolity. Roman Doric columns flank the windows. Above the double doors to the shop is a sumptuously proportioned and delineated cartouche. The entrance to 58 is the house door, single leaf but also with rococo decoration above, slightly smaller. The houses have merged but the original lineaments of each, still discernible, were two-up, two-down, with the addition of an extra two up on the third floor. Both properties retained deal (softwood) wainscoting throughout, decorated in places with garlands of flowers in *papier-mâché*, the medium of choice before plaster of Paris became workable, and a remarkable survival over a long period of neglect punctuated by a couple of fires.

The supermarket heir Alex Sainsbury providentially came across the premises in 2005 after they had been empty 12 years except for a couple of sisters, Rebecca and Hannah Levy, who had been living on the third floor since the 1930s. They died soon after Sainsbury's restoration project and plan to open the house as an art gallery had been completed in 2009. He called the gallery Raven Row, from the name of the lane until 1895 at this point where Artillery Passage meets Artillery Lane. It is non-commercial, free to enter, and has wonderfully original and unprejudiced

shows. The restoration, by 6a Architects, is a paradigm of the benefits modern architectural practice can bring to old buildings. They opened up the back of the house and added a couple of large galleries looking out over Frying Pan Alley. Patrick Baty, an eminent analyst of centuries-old paint who has worked in more places than most people see in a lifetime, from a bandstand in Bethnal Green to Buckingham Palace, chose several colours for the decoration after microscopic analysis of two centuries' worth of paint samples: all of them were white; several shades, that is, of eighteenth-century stone white in the galleries and the face of the building, with brighter nineteenth-century white in other areas.

The room above the front door of 58 has a special history. Its sumptuous panelling, carving and fireplace were ripped out and flogged off in 1925, and found their way to the Chicago Institute of Art. In the 1980s the Spitalfields Society tracked them down, organised repatriation and stored them all in an Essex barn before handing them over to Alex Sainsbury for reinstallation in glory. This room and Sainsbury's office are the only ones closed to the public except sometimes on Open House day in September, but perhaps Chicagoans might one day be given honorary citizenship of Spitalfields and allowed in any time. Their Art Institute behaved generously in agreeing to the repatriation, and the panelling and woodwork were safer there than they would have been in the house in 1972 when it suffered extensive fire damage.

RAVEN ROW, 56 ARTILLERY LANE, E1 7LS

## THE EASTERN DISPENSARY

*An East End forerunner of the National Health Service*

Among the mean streets of Spitalfields in the 1850s wandered an early specimen of homo sociologicus, Henry Mayhew, observing, conversing, talking, picking out samples and richly describing them, 'the pickpockets – the beggars – the prostitutes – the street-sellers – the street-performers – the cabmen – the coachmen – the watermen – the sailors and such like', many of them 'purely vagabond'. Even among those with a trade – printers, carpenters, tailors, costermongers, flower girls and so on – many were out of work. They survived on mutual assistance, whiprounds from those in work helping to feed those who were not. And then there were the institutions founded on charity by men such as Thomas Guy, organisations like the Salvation Army, founded by William Booth in 1865, and more local groupings which set up dispensaries for the sick in the poorest neighbourhoods.

The East End had by far the most dispensaries, about a dozen. One of these survives in Leman Street, abutting on the Lutheran Church around the corner in Alie Street (see page 436). A co-operative of doctors founded it for the ill and impoverished of the area, a kind of local prototype of Aneurin Bevan's National Health Service of a century and a half later. It is a large white-stuccoed seven-bay building of two deep storeys, not beautiful but with an air about it, the second-storey windows a busy mixture of pediments and segmental (curved) pediments, above the ground-floor windows' big keystones;

the central five bays pushed forward to create a sham block with two corners for dummy quoins to run top to bottom in noisy harmony with the quoins on the actual corners of the building. With its mock balcony for a pretend mayor above the front door, it could be the *municipio* of a small town in Campania. 'Eastern Dispensary' is splashed in letters a foot high above the entablature. One raised tablet is inscribed, 'Founded 1782', another, 'Erected 1859' and the legend 'Supported by Voluntary Contributions' runs almost the full width of the building.

In a manner of speaking, it still is supported by voluntary contributions: it survives spruced up as a gastro pub. The menus and drinks lists look enticing. The architecture picks up on the Italianate theme: a high ceiling supported by iron pillars above the public area, behind it the bar, above that a spacious balcony with elaborate railings. An awful colour scheme and decor, though. Some pub. Enough to make a costermonger queasy.
19A LEMAN STREET, E1 8EN

## ST. GEORGE'S GERMAN LUTHERAN CHURCH

*Deutsch Lutherisch, a Georgian meeting of Hanover and England*

In the first modest 1952 edition of the two volumes covering London in Nikolaus Pevsner's one-man, one-researcher enterprise *The Buildings of England*, he covered the German Lutheran Church in Stepney in a 25-word entry. The word 'German' is not one of the 25, although the stone tablet on the façade of the building is inscribed '*Deutsche Lutherische/ Gegr. [established] 1762 / St Georgs Kirche*'. Pevsner himself was Deutsch Lutherisch. St George's was

built to serve a growing and busy German mercantile community, though Pevsner describes it merely as: 'Sailors' chapel of 1762–3'. By 2005, in *London East*, the fifth of the new six-volume London survey (now accomplished with the help of two co-authors, three bylined contributors and a burgeoning team of researchers and assistants), the entry for St George's is an almost 440-word encomium for this 'remarkable, atmospheric survival'. There is room now for the word 'German', but might not Pevsner's omission have been at least partly an emotional need to suppress anything that might draw attention so soon after the war to his own origins? He had been in England only since 1933, when the Nazis had deprived him of his university lectureship, had been interned at Huyton as an enemy alien in 1940 and, after being naturalised in 1946, was remaking his reputation as an intellectual, a scholar of English culture.

The enthusiasm of his later collaborators on *The Buildings of England* for the Stepney Lutheran Church is hardly surprising. Anyone entering St George's for the first time must be astonished by the claustrophobic crowding in of galleries above and box pews down the middle of the church and on either side of the two aisles. They stop a couple of steps from the (liturgical) east wall against which are pressed the altar, the pulpit with its sounding board above it, and, flanking the sounding board, two elaborately decorative prayer boards, Exodus in German and gold on black. The whole

The German congregation of this flourishing Lutheran chapel (with a homage to Hanoverian George II on the wall) melted away fast in September 1939.

ensemble is beneath a glorious gilt-tinctured George III coat of arms as only the Georgians could make them, a happy symbiosis of Hanover and England. Each pew door is numbered, 1 to 70, room for six at a squeeze in the central pews, for eight easily in the square outer-aisle pews with bench seats on three sides.

It seems clear that the sudden departure of the German congregation meant that there was no post-war bonfire of the pews as happened in so many Anglican churches after separate chairs were found to be more flexible, just like modern Anglicanism. St George's, now in the care of the Historic Churches Trust, evidently looks much as it did to its eighteenth-century founders, and to Dietrich Bonhoeffer, the pastor and martyr to the Nazis, who often preached here in the 1930s.

55 ALIE STREET, E1 8EB

# WHITECHAPEL GALLERY WEATHERVANE

*As big a fool as any rides
the winds of East London*

Did Desiderius Erasmus of Rotterdam enter London through Aldgate? Quite likely, if he had disembarked in, say, Harwich, for Aldgate was the City's easternmost gate. Did he arrive facing over his horse's tail as it trotted Londonwards? Not very likely, except in the myth that has him facing backwards as he composed *Moriae Encomium* (*Panegyric on the Praise of Folly*, as it appeared in the first English language edition), his only surviving book, its title an affectionate (he claimed) pun on the name

of the friend he was arriving to stay with, Thomas More. The myth is sustained in the big copper weathervane atop the lead dome of the former Passmore Edwards Library in Whitechapel High Street, a strange anachronism in an area increasingly given over to edifices like the domineering office slab devoted to the Royal Bank of Scotland, though that too might be thought to be built in praise of folly. The library itself, which was splendidly known locally as the University of the Ghetto, has moved far down Whitechapel Road towards Mile End, where it is now the Idea Store, 'the borough's flagship library, learning and information service', in a fine new glass building by David Adjaye which the library itself (sorry, Idea Store), slightly cringingly, advertises as being next door to Sainsbury's.

The Passmore Edwards, named after its principal benefactor, has been married to the Whitechapel Gallery as an extension to what was once merely its neighbour. It is a romantic Queen Anne Revival building handily wrapped around one of the entrances to Aldgate East tube station. But it suffers by comparison with the art gallery, which is by Charles Harrison Townsend and is one of the finest Art Nouveau buildings anywhere (the Horniman Museum in Forest Hill, see page 393, and the Bishopsgate Institute are Townsend's designs too). Neither the gallery nor the former library has been structurally altered inside, but both have been refurbished to fit the purposes of a local art centre dedicated to catching art on the wing (it has no permanent collection).

The intention apparently had always been that the Passmore Edwards building (which was started in the early 1890s) should have a weathervane, but nothing happened until the idea germinated when the Vancouver artist Rodney Graham (b. 1949) had a show at the Whitechapel Gallery in 2002. Building work on the merger between gallery and former library began in 2003. Rodney is an artist immersed in comic extremes, in visual jokes, folly and glorious failure: he is impossible to categorise, but let's say his most likely inspiration is Dada. He happened also to be immersed in Erasmus and fascinated by bicycles to the point of learning a party trick of riding one back to front. So when the Whitechapel asked him to design the missing weathervane, he depicted himself as Erasmus riding back to front astride a bicycle while reading a copy of *In Praise of Folly*. Erasmus's text is narrated by the person of Folly. 'And indeed the whole Proceedings of the World are nothing but one continued Scene of Folly,' he writes, 'all the Actors being equally Fools and Mad-men'. So that wisest of wise men riding the winds above Whitechapel is, as Erasmus would have agreed, as big a fool as any.

77–82 WHITECHAPEL HIGH STREET, E1 7QX

## WHITECHAPEL BELL FOUNDRY

*Where they measure time, not in weeks, but in centuries*

In about 1122, Theophilus, probably a German, wrote the Latin treatise *De Diversis Artibus*, a practical guide to diverse arts. In the passage on hardening metal-

Hung out to dry: new bells in a small yard at the ancient Whitechapel Bell Foundry.

engraving tools, he recommended the urine of a goat tied up three days without food; alternatively, a red-headed boy's urine, tethering unspecified. None of this is current practice in the Whitechapel Road, though for making moulds the bell foundry does use a folkloric mixture of horse manure, goat's hair, red Mansfield sand, and clay. Pure functionality, the foundry firmly asserts. Otherwise, Theophilus's detailed instructions describe pretty accurately what still goes on when founding bells. The craftsmen run off a mixture of molten tin and copper from the furnace, ladle it into the mould, leave it to cool and, *Robertus avunculum tuum est* (Bob's your uncle), you have a bell. If it comes from Whitechapel, it will usually have the age-old master founder's symbol embossed on it, a trinity of bells. And these days it will be tuned using modern electronics.

Whitechapel Bell Foundry has been manufacturing church bells since 1570. It has cast Bow bells and the bells of St Martin in the Fields, St Lawrence Jewry, St Michael Cornhill and St Bride's among many others. Its trade is worldwide. It measures time in centuries, not weeks or months. When the Vicar of East Malling in Kent wrote to the Whitechapel Bell Foundry in 1956 asking for a quote for rehanging the bells, the reply started: 'Dear Sir, Thank you for your letter. We have not heard from you since 1885...' The foundry had made the tenor bell and four others for the church in 1695 and added a sixth, the treble, in 1831; 1885 was a rehang (timber bellframes tend to split before a millennium is out).

Change-ringing, difficult and eccentric enough to make it overwhelmingly an English pursuit (practised in 5,000 churches), keeps the foundry occupied fixing old bells and new frames, and producing cheery little handbells fills in any idle hours. It is not every day that someone comes along with an order for a monster like Big Ben. Whitechapel cast that in 1858. In 1752 it cast a bell for State House in Philadelphia, which in 1776 became known as the Liberty Bell; it cracked at the first use and inexperienced local bell ringers had to recast it. Two hundred years later Whitechapel sent the Bicentennial Bell as a present from the British. In 2001 came the 9/11 bell, which rang in the church of Trinity Wall Street on the first anniversary of the enormity; now, renamed the Bell of Hope and rehung in St Paul's, Trinity's associated eighteenth-century chapel, it rings in solidarity with victims of terrorism everywhere.

The foundry moved to 32 Whitechapel Road in 1738, added 34, then properties at the back, with steep narrow staircases, low doors and improvised spaces for the furnaces and tuning areas, but still cramped and archaic. Visitors enter through a little eighteenth-century shop front. A bell, of course, tinkles as the door opens and closes, just like an old grocer's. 32–34 WHITECHAPEL ROAD, E1 1DY

## KING EDWARD VII DRINKING FOUNTAIN, WHITECHAPEL ROAD

*An Angel of Peace that looks out over the Asian community*

The Angel of Peace in Whitechapel reaches just above the encompassing

stalls of the street market – now effectively a South Asian bazaar – over the road from the Royal London Hospital. The angel crowns a slender obelisk, not very tall and with graceful lines never intended to be hidden in this way. It is a drinking fountain of the second decade of the twentieth century dressed up as a memorial to the recently dead king, Edward VII, and sits in the ethnic Asian community today as naturally as the exotic and overweening Edwardian architecture of Mumbai, built on the high tide of the British Raj, suits the gateway to India. So William Silver Frith's wonderful memorial crowned by the Angel of Peace would sit as well in the streets of Kolkata or Karachi as it does in Whitechapel Road. It is also a glorious public celebration that goes, like its sculptor, as good as unnoticed in accounts of the art of the period, though it stands comparison with the work of the creator of *Eros*, Alfred Gilbert, a slightly younger contemporary (b. 1854) of Frith's (1850–1924), but infinitely more famous.

When Frith is mentioned, it is in the interstices of the records of some other sculptor who trained in his studio. His known output is small, and the reputation of what remains was presumably lost like Charles Sargeant Jagger's, the war memorial specialist, in the backwash of the style wars that erupted when Epstein's modernist *Rima* was unveiled in Hyde Park in 1925 and oceans of obloquy crashed about the sculptor's ears (see page 236). While Frith was a student at Lambeth College of Art, the brilliant French sculptor Jules Dalou (see page 50) arrived in London in 1871 and taught at Lambeth. Frith was immediately influenced, and not only Frith. Dalou guided a generation into forming a style on which the critic Edmund Gosse bestowed the name the New Sculpture: a comparison between Frith's Whitechapel memorial (or Gilbert's *Eros*) and the flaccid, chalky clapped-out Neo-classicism of the figure groups at the foot of the Albert Memorial in Kensington Gardens shows just how the Dalou effect lifted English sculpture out of a deep slumber.

The Hon. Charles Rothschild unveiled the drinking fountain on 15 March 1912. The Angel of Peace has wings ending in feathers like sword blades, her beautifully modelled figure draped in a long gown which kicks up at the feet as though she has just alighted. At the foot of the southern face of the obelisk is a bronze wreath encircling the head of the king. He is flanked on east and west faces by the Angels of Liberty and, above the fountain tap, Justice, with cupids playing at their feet. The market stalls make it nearly impossible to read the inscription on the north face, but for the record it says: 'In / grateful and loyal / memory of / Edward VII / Rex et Imperator / erected from / subscriptions raised by / Jewish inhabitants / of East London / 1911'.

OPPOSITE ROYAL LONDON HOSPITAL, WHITECHAPEL ROAD, E1 1BB

## MURALS BY DOUG PATTERSON, WHITECHAPEL OVERGROUND STATION

*The passing street scene*

To reach the London Overground from the Underground at Whitechapel station it is necessary to walk downstairs, but it is worth suspending disbelief and descending to look at Doug Patterson's murals on white enamel, even if you don't want to catch a train. Patterson (b. 1945) is an illustrator, as he himself says without demur, but that indicates the genre of artist and doesn't take the prefix 'mere'. He follows the documentary tradition of Paul Hogarth and Ronald Searle, and that made him a clear choice in 1997 to provide the decorations for what was then the East London Line but was subsumed into the Overground ten years later. For the murals Patterson simply noted with his quick nervous line the late twentieth-century residue of the East End archaeology of rich local street history, dating from when the Huguenot refugees escaped from France's religious tyranny in the seventeenth and eighteenth centuries, an ethnicity embedded in the history of the Huguenot chapel of 1745 in Brick Lane, which in the nineteenth century became a Wesleyan chapel, then a Methodist chapel, then a synagogue, and today is a mosque.

The Jews were still hanging on in the community at the end of the last century, but Bloom's kosher restaurant closed its doors for the last time in 1996, ceding Whitechapel to the insurgent balti houses; and now even the Jewish baker Grodzinski, started by the first Whitechapel Grodzinski from a barrow in Petticoat Lane Market in 1888, has folded its tents and departed, surviving in the widely disseminated recipe for its famous cheesecake and in one of Patterson's murals: with photographic immediacy, the swift, edgy scribble of, I guess, lithographic crayon, shows an Ashkenazi Jew in close-up behind tinted spectacles, a frown creasing his forehead as he looks into 'camera' and corkscrew ringlets of hair descending from beneath his skull cap. A woman in curlers pushes a buggy with a child ensconced, a dummy shoved into his mouth. Two more Ashkenazis in mid-distance approach Grodzinski's shop.

Another panel shows a vigilant shirt-sleeved bobby with a phone clipped to his pocket, head turning as a 106 red double-decker looms behind, big as a building. There's the Bombay Saree House with a woman (in a saree) behind the show window bent over a Singer sewing machine. It's all here: the London Hospital, a young man sporting a Mohican, a couple of women, each concealed in burka and hijab, pausing on the pavement in mid-shop to natter, a gaudy brick Edwardian building outshouted by the Poundbuster fascia on the ground floor, Tubby Isaacs's jellied eel stand, in Whitechapel since 1919 and was into its fourth generation of the Isaacs family proprietors when it closed in 2013. It's a vivid panoply of East End street life and one of the tokens of its success is that as (real) passengers walk by on the platform they momentarily merge with the enamel murals and become part of the passing scene.

277 WHITECHAPEL ROAD, E1 1BY

## WILTON'S MUSIC HALL

*Where the golden age of showbiz lives on*

Wilton's Music Hall is like some grand ancient ruin: the Golden Palace of Nero, let's say. It is a Victorian variant with peeling walls, hauntingly faded decoration, barrel-vaulted ceiling, and slender iron barley-sugar columns somehow propping up the horseshoe-shaped balcony. An apse at one end is decorated with Indian dancing girls inspired by Rajput miniature originals, each in a round-arched niche, one actually dancing, the others accompanying her, one on flute, the other plucking a *tanpura*, sublimely poised against a decaying blue background. A lot of this has resulted from an accumulation of film and television invasions for various projects. Not noble Roman then, but beguiling and... what the hell? This *is* showbiz.

At the other end of the auditorium is the stage, tall and arched, in the same conformation as when the hall opened in 1859. Wilton's is thought to be the only remaining music hall in the world in anything recognisably like its original form, or certainly of the golden age of the 1850–70s. John Wilton of Bath had it designed by a hands-on all-rounder, Jacob Maggs, as an extension behind a pub called the Prince of Denmark, also known as the Mahogany Bar, featuring an international cast of fighting-drunk sailors. The music hall lasted until 1880.

In 2011 the Heritage Lottery Fund board turned down Wilton's for a £2.5 million grant. Snobbery? Surely not? Lottery money is the people's money. Anyway, class barriers never existed here. Walter Sickert haunted the music halls for material just as his master Edgar Degas trawled the popular theatres of Paris. Wyndham Lewis took T. S. Eliot to the Stepney halls, slumming maybe, but Eliot was attuning his sharp ear to Cockney cadences ('Think of poor Albert,/ He's been in the army four years, he wants a good time,/ And if you don't give it him, there's others will, I said'). In fact, after years as a Methodist church, a mission, a rag warehouse and a film location up for grabs, Wilton's reopened in 1997 with Fiona Shaw's recital of Eliot's *The Wasteland*, which, though it does go in for some cod burlesque, does not quite match the sort of grand music hall programme of the early days: in one 1868 show there were arias, burlesque, comic songs, serio-comic songs, a ballad, 'the Graceful and Beautiful Lady Gymnast Lady Senyah' on the flying trapeze, and Les Soeurs Lucelles introducing the cancan.

The Lottery Board's rejection was the hall's second and it seemed hardly likely that Wilton's would still be standing more than another year or two. Today it is inconceivable that it could fall. The rejection prompted support from the public: the producers of Karel Reisz's movie *Isadora* (1969) used the theatre and at that early stage had bequeathed the original *papier-mâché* ornamentation of the balcony, beautifully restored; Guy Ritchie's movie, *Sherlock Holmes: A Game of Shadows* (2011) left behind the elaborately decorated 'Mahogany Bar' the company had created, a perfect match for the balcony decor; cash flowed in from arts foundations, City firms and private

individuals, from the box office selling tickets for a variety of events, even variety, and – at last and crucially – £1.85 million from the Lottery Fund.

1 GRACE'S ALLEY, E1 8JB

## CABLE STREET MURAL

*An East End epic celebrated
in an epic mural*

Cable Street was Oswald Mosley's nemesis. On 4 October 1936 he strutted from Royal Mint Street at the head of the British Union of Fascists, throwing Hitler salutes, arm bent at the elbow, palm outwards, and receiving the Nazi salute, arm fully extended, from his blackshirt followers. With the acquiescence of the Home Secretary, Sir John Simon, and the Metropolitan Police Commissioner, he intended leading his 5,000 blackshirts along Cable Street through the heart of a Jewish area of Stepney. He was stopped by, it is said, anywhere from 4,000 to 100,000 protesters; depending whom you believe. It was a humiliation from which Mosley's influence never recovered. By 1940 he and his wife Diana *née* Mitford were in prison as security risks.

Cable Street was near enough to the London docks to be flattened by wartime bombing, and what it has lost in rebuilding with tall blocks is the former hugger-mugger intimacy of the houses lining the street, close enough for housewives in upstairs windows to pour the odorous contents of their chamber pots over the fascist marchers. Among the surviving buildings is the Italianate Victorian St George's Town Hall – St George's is the part of Tower Hamlets in the neighbourhood of Hawksmoor's dominating church of St George-in-the-East, dedicated in 1729. On the side of this church is the epic mural depicting the so-called Battle of Cable Street: epic both in its proportions and its making.

In 1976 Dave Binnington began extensive research and interviews with survivors of the confrontation, but the viciousness of the loony right is always with us and he gave up in 1980, after two years spent on the scaffolding, when the mural was extensively vandalised. The 1970s brought together a loose coalition of art-school-trained painters dedicating their energies to working in public spaces, and now Paul Butler, Desmond Rochfort, and Ray Walker took over the mural. A public appeal and a grant from Tower Hamlets council raised £18,000 and, despite further vandalism, the trio completed the work in 1982 and treated it with a varnish that makes overpainting by vandals relatively easy to wipe away.

The scene covers the complete side elevation of the building, above a well-tended garden created between the Highway and Cable Street from the old churchyard of St George-in-the-East. It is a dizzying vortex of activity, composed as though the artist were caught up in the crush of police horses, battling East Enders, a Hitler lookalike stripped to his underwear, socks and suspenders being tossed in the air, a rude barricade of furniture, a door ripped from its hinges, and an

*The Mahogany Bar at Wilton's, the revived Victorian music hall where T. S. Eliot attuned his ear to Cockney speech rhythms.*

overturned lorry. A brawny arm in an upstairs window clutches an upturned chamber pot; workmen and shopkeepers fight the police, who are there to force a passage for the march. Clearly the painters have studied the crowded compositions of the revolutionary Mexican muralists Diego Rivera, José Clemente Orozco, and David Siqueiros, but the steely delineation of the grey police horse in the foreground and the violent motion suggest an influence closer to home: the Vorticists, the English Futurist movement cut short by the First World War.

236 CABLE STREET, E1 OBL

## • ST KATHARINE'S, WAPPING, LIMEHOUSE, STEPNEY •

### ST JOHN'S CHAPEL, TOWER OF LONDON

*The best Norman chapel in London*

The focus for visitors to the Tower of London is on the crown jewels in the Waterloo Barracks, whose barbaric splendour disconcertingly makes them seem as false as the made-over history in the rest of the Tower. See those, and then move on to the pretty little Tudor church, St Peter ad Vincula, a Chapel Royal, free-standing beside Tower Green and the approximate site of the execution block within the walls reserved for a privileged few, among them three queens: Anne Boleyn, accused by her husband of carnal crimes against his majestic person,

Catherine Howard (again for adultery), and the 16-year-old six-day queen Jane Grey, whose only crime was to be the pawn of powerful men plotting to avoid a return to popery. Newly added is Brian Catling's memorial sculpture at the site of the execution block, a wide transparent bowl with inscribed memorial verse.

Yet the true heart of the fortress is the original keep, the White Tower, built mostly of Kentish rag dressed with Caen stone (replaced over the centuries with Portland stone), which remains virtually intact, unlike the patched, rebuilt and evolving outer fortress. The interior of the White Tower provided working and living quarters for military staff and administrators, altered according to changing demand. What has not changed is the Chapel of St John, in the south-east corner. William the Conqueror commissioned the chapel in 1078, before Domesday, largely for his personal use. Gundulf, Bishop of Rochester, renowned as a master builder, was responsible for its creation. It was completed after the king's death in 1087 but before the century was out (Gundulf himself died in 1108). St John's is the elemental cave, an eternal truth. It is the earliest complete Norman building in London and the finest: small, yet massive-seeming in its proportions and simplicity, with no sculpture, ornament restricted to elementary abstract patterning on column capitals.

After the Reformation the chapel became a store for documents, but Anthony Salvin refurbished it in the 1860s and inserted random Flemish stained glass to plug the gaps left by the disappearance of the thirteenth-century glass installed by Henry III. Visitors reach it along a carefully plotted route through the towers and chambers of the Thames-facing walls before emerging into the inner ward in front of the White Tower. But here's a strange thing: there is little encouragement to pause at the chapel itself. You can join a Yeoman Warder's tour with the promise of entertaining tales of 'intrigue, imprisonment, execution, torture and much more', or 'find out whether the new king will be as powerful and respected as his father'. Which new king? Which father? The devil may be in the detail, but there's a vacuum without it. Stage flats set the scene in the different chambers for a sketchy medieval past: banqueting, resting, receiving petitioners. For the Chapel of St John there is no signposting at all until the visitor is a step or two away, and next to nobody stops. A passage is left clear at the rear of the chapel for the progress of visitors, and the rest is roped off (candles stand ready for the taper, a crucifix is in place on the altar).

No photographs, please. Hurry on through. History on the hoof. The crown jewels: as good as the Tudors on television.

TOWER HILL, EC3N 4AB

'They shall not pass,' a detail from the Cable Street mural celebrating the 1936 defeat by East End workers of Oswald Mosley's fascists.

## SCULPTURE BY WENDY TAYLOR, ST KATHARINE'S DOCKS

### *A timepiece that stands up to the bulk of Tower Bridge*

In June 1968 a review of the City of London Festival dwelt for a paragraph or two on the sculpture temporarily sited outside the south door of St Paul's Cathedral. 'The plastic sculpture looks amazingly good,' the reporter commented. 'Wendy Taylor's *Calthae*, red semi-spheres spaced between snapdragons and geraniums, comes off very well...' As it happens, that reviewer was me and though it was not the most penetrating critique Wendy Taylor has received in her career, it was certainly among the very earliest: she was 23, in her first year after graduating from the celebrated sculpture department of St Martin's School of Art and thus far without a solo show to her name.

Although solo shows were to come, they quickly became unimportant to her. She didn't want to produce gallery art, she wanted to make sculpture that scaled up against its environment, and her emergence coincided with a rush of public commissions for young sculptors. Placing her work became of central importance to her, and caused her much anguish when, on occasion, she was double-crossed by corporate clients who felt they knew better.

*Timepiece* on the riverside outside the Tower Hotel did not present that problem, though she created it out of a different anguish. In 1971 she had entered a competition sponsored by Peter Stuyvesant for six sculptures to be placed in different cities, but she did not make it to the shortlist. Taylor went ahead with her piece anyway, working in her studio in St Katharine's Docks. It so happened that the Lyons Group was building the Tower Hotel on the westernmost part of the old docks, heard about this young sculptor working nearby, and commissioned her to complete her project.

In some of the sculpture she had already displayed, including *Calthae*, the shadows the work threw were intended as part of the effect. In a sundial, shadow play is the heart of the enterprise, so Taylor was already in tune with the spirit of the commission when it fell into her lap; but she also wanted it to be clearly a work of art and a tribute to the docklands workers, so shackles, chains, a hugely enlarged washer and docks nail are the basis for the piece, magnificently sited against unmistakable outline of Tower Bridge.

Around Britain Wendy Taylor's works have become legion, but nowhere more so than along the Thames, from St Katharine's Docks to the Isle of Dogs. Most people who see her sculptures cannot put to them the name of the artist, and her reputation remains in the shadow of her hugely accomplished output.

ENTRANCE LOCK TO ST KATHARINE'S DOCKS, E1W 1LA

## WAPPING WALL AND WAPPING HIGH STREET

### *A waterfront pierced by stairs*

Wapping is an innovation, in terms of London's long history. When John Stow

penned his survey of the city in 1598 it was within living memory that Wapping had been a deserted strand whose only feature was that it was 'a place of execution for hanging of pirates and sea-rovers, at the low-water mark, and there to remain until three tides had overflowed them'. But now, Stow wrote, 'since the gallows being after removed farther off, a continual street or filthy straight passage, with alleys of small tenements, or cottages, [has been] built, inhabited by sailors' victuallers, along by river of Thames, almost to Ratcliff, a good mile from the Tower'. By the nineteenth century the spice warehouses had taken the place of the tenements. By the end of the twentieth century even the aroma of nutmeg in Wapping High Street had vanished, and the warehouses mostly returned to housing stock by conversion into flats.

With the exception of Shadwell basin, London Docks north of the street have vanished. Only the canals that linked them remain, crossed by the strong iron bridge joining Glamis Street to Wapping Wall. The entrance to the docks from the Thames is covered with a private garden for the stately eighteenth-century houses for dock officials on either side of Wapping Pier Head. Yet the little passages from the high street to the Thames remain, and the ancient stone steps down to tide level where the wherrymen once picked up passengers. There are Shadwell Dock Stairs, Pelican Stairs, New Crane Stairs, Wapping Dock Stairs, King Henry's Stairs, Wapping New Stairs and, westernmost, Wapping Old Stairs adjacent to a good pub, the Town of Ramsgate (one of only three pubs my nose sniffed out in the street where once there had been more than 40). Once upon a time the Town of Ramsgate was called the Red Cow, and it was here that Judge Jeffreys of 'Bloody Assizes' infamy, insufficiently disguised while waiting for a boat to follow King James II into exile, was taken by the mob and delivered to the Tower of London.

The Town of Ramsgate is a few feet east of Pier Head, almost opposite a green space that once was the churchyard of St John's, the parish church of Wapping with a Baroque steeple restored after blitzing, and the body of the church rebuilt as flats. The green is contained in the longbow curve of a high old dock wall. Wapping Old Stairs has the edge of fame over the other stairs because of the ballad by the popular English poet, Anon., which Thackeray declared 'one of the simplest and most exquisite ditties in our language':

> 'Your Molly has never been false,' she declares,
> 'Since last time we parted at Wapping Old Stairs.
> When I vowed I would ever continue the same,
> and gave you the 'bacco box marked with your name.
> When I passed a whole fortnight between decks with you,
> Did I ere give a kiss, Tom, to one of the crew?
> To be useful and kind with my Thomas I stayed, –
> For his trousers I washed, and his grog, too, I made.'

WAPPING HIGH STREET, E1W 2PN

## PROSPECT OF WHITBY

*Where only man is vile*

The best prospect of the Prospect of Whitby is from the river. Yet the view of yellow brick and bow windows from the street, say on the lifting bridge at the Shadwell basin entrance to the old London Docks, suggest a town pub. The interior, too, of brass and varnished wood, spells nineteenth-century urban tavern despite the old floor of big stone slabs and the old beams in the ceiling.

From a boat passing on the Thames, things look quite different: the building might be in Whitby itself. Although nothing earlier exists than some eighteenth-century wooden panelling on the first floor, the pub is thought to date from about 1520. The narrow sixteenth-century plot on which the white-painted river frontage stands and the shallow pitched slate-covered roof suggest a fisherman's inn. Modern bars and a terrace with a big willow tree extend eastwards and add to its random charm. The Pelican Stairs are alongside, one of the ancient accesses for pedestrians seeking the Thames wherries.

The name Prospect of Whitby may have been borrowed from a cargo vessel that habitually moored here – as with most pubs, actual history is buried in bar gossip twinned with wild surmise. Some of this (it was a haunt of Dickens/Pepys/Uncle Tom Cobley and all) can be instantly discounted. The miniature gallows suspended from a wooden post supporting the balcony over the river can be viewed as a nod to local history, for this shore, where 'every prospect pleases, and only man is vile', was certainly a

place of execution: see the speculative siting of the Captain Kidd pub in Wapping High Street, a modern conversion of part of an older warehouse in memory of an even older pirate and murderer, whose corpse swung in a cage thereabouts until the tide had covered it three times.

One of the Prospect's semi-regular drinkers was A. P. Herbert, MP, writer, poet, humourist and sailor, based among the artists at 12 Hammersmith Terrace with his small boat *Water Gipsy*, who before the Second World War found it 'pleasant to sit on the balcony in the dusk, watching the ships come round the Limehouse corner, and anchor off the dock, and hearing all their stories from a friendly waterman'. During the war, and as a veteran of Gallipoli in the 1914–18 episode, he and *Water Gipsy* joined the Royal Navy's patrol boat service and were ordered on the opening night of Hitler's big show, the Blitz of London, 7 September 1940, to deliver a load of cable to Woolwich, to enable burning barges to be towed out of the way. He sailed through Limehouse Reach and saw the river ahead transformed, he later wrote, into a lake from hell. In the middle of it was the little Prospect of Whitby, with gigantic warehouses blazing to either side. When he returned upriver the next morning the warehouses had burned to the ground, 'but the Prospect of Whitby stood there, white and perky, still'.

57 WAPPING WALL, E1W 3SH

The historic Wapping riverside pub, the Prospect of Whitby, and the Pelican Stairs to the river: one short passage among many leading to a wherryman's stop.

## KING EDWARD VII MEMORIAL PARK

*Where freebooters and explorers shared the river*

A few yards from the entrance to the Limehouse Link tunnel is the entrance from the Highway to a green space on the river at Shadwell with wild garden and lawns and trees, a bandstand and the rotunda that has served as an air shaft for the Rotherhithe Tunnel since 1904. Nothing at this gate tells visitors that this little park is, ostensibly anyway, a memorial to King Edward VII. Queen Mary, the consort of George V, came here with her husband to declare the park open in 1922 and to unveil a memorial relief portrait of her father-in-law. However it's the other memorial in the park that seizes the imagination: a rough block of stone with a panel recording the names of those great seamen who set off from the foreshore here in perilous barques to explore the Arctic sea passages, and a pretty inset ceramic panel showing three English ships in full sail and signed Carter Poole 1922 (Jesse Carter, founder; Poole, the town of the manufactory).

The sailors celebrated in the park include at least one, Sir Martin Frobisher, who flirted with danger by moonlighting as a privateer, but got away with it by successfully going legitimate. He tried to open the north-west passage to China, failed, but returned a hero and helped to defeat the Armada. Sir Hugh Willoughby, attempting to open a north-eastern passage to China and India, in 1553–4 anchored overwinter

near Murmansk and froze to death with his crew. Stephen Borough sailed with Willoughby's expedition but on a different ship, and he survived to travel to Russia and trade there many times. So did his younger brother William, who recovered from being thrown into irons by Francis Drake and succeeded his brother as commander of the royal ships in the Medway. He died ashore and is buried with his Stepney wife in in her parish church of St Dunstan's (see page 454).

At the time of writing, and after huge public protests, Thames Water was negotiating a compromise over their plans for a 'super sewer' at this point. With luck the park may be spared.

GLAMIS ROAD, E1W 3EQ

## ALBERT GARDENS

*Civilised urbanity in
a jawful of broken teeth*

In London alone there are many, many Alberts. There are a lot of Albert Roads, a number of streets, several mansions, a court, a gate, a bridge, a dock, an embankment, a crescent, a drive, a memorial and a hall, a square, a handful of terraces, but one of the least known of all these is Albert Gardens in Poplar, which used to be another Albert Square but was renamed to avoid, it is said, confusion.

The three terraces of houses hemming a garden with lawns and big plane trees behind railings are from the rump end of the Georgian era, completed in 1830, the year of the death of George IV. They are artisan Georgian, gentrified, and to our eyes they look stiff upper lip coming on

grand because they maintain the composure of this most civilised of English urban styles. The same could once have been said of Commercial Road, which defines the fourth side of Albert Gardens and was built in the first decade of the century and opened in 1810 as a link between the new West India Docks (1800–6) and East India Docks (1803–6). Much of the East End of London resembles a jawful of broken teeth, from bombing and from horrendous redevelopment in the 1970s, which ruined the composition of Arbour Square and its surrounding streets north of Commercial Road opposite Albert Gardens.

But Albert Green is complete and exemplifies the character of a whole area of the pre-war East End; the expense involved made it impossible to rebuild after the war, but such a loss tears the heart from a community. Close to the Commercial Road end of Albert Green's garden is an iron drinking fountain (not functioning) with a statue of an insouciant reaper (slightly girlish, but that's how it was in Arcadia), carrying a sickle, with a sheaf of corn sharing his plinth. It is better than the usual run of municipal sculpture and was cast in 1903 by the Fonderies d'Art du Val d'Orne in Paris. The sculptor is not known, except by the unstylishly cast initials D.F.F., which I have failed to track down.
COMMERCIAL ROAD, E1

Georgian East London was left broken by the blitz but Albert Gardens survived with its drinking fountain, including this figure of an Arcadian reaper.

# THE ROYAL FOUNDATION OF ST KATHARINE

*A peaceful retreat founded 900 years ago*

The Royal Foundation of St Katharine is a faint memory of a faint memory. Queen Matilda founded it in 1147 outside the City, in the green meadows by the river just east of the Tower of London. She intended it as a religious community and a resort for the poor. It remained that until 1825, when the City cast envious eyes on the site, and against protests, cleared out the religious community, levelled the site and built a dock retaining the name of St Katharine. The foundation – master, bedesmen and bedeswomen and all – decamped to the salubrious environs of Regent's Park to care for distressed gentlefolk there. So everyone was happy except for the dispossessed 3,000 souls of the area who, though they had lived in dismal streets and foul stews, now had nowhere and nothing.

In 1914 the foundation members decided to resume where they had left off nearly 90 years before, and to run an almshouse in Poplar. In 1948 it removed once more and built on the site of the bombed St James Ratcliff at Butcher Row, a short, wide stretch of road siphoning huge volumes of traffic between Commercial Road and the Highway and Limehouse link tunnel. Despite that it is a remarkably peaceful and remote-seeming retreat, and, as always in the past, still administered, quaintly, as a Royal Peculiar.

The new St Katharine rose around the Georgian house, which had been the vicarage of St James's and is now the master's house. The chapel of 1951, blandly

modern and reworked drearily in 2003–4, contains what little remains from the contents of the medieval chapel by the Tower; if the rest of the original foundation had treasures like this it must have been spectacular. In particular, the reredos, a new timber Arts and Crafty schematic Gothic setting, holds a possibly Italian, possibly fifteenth-century, marble relief sculpture of *The Adoration of the Magi*, a gorgeously carved panel closely similar in composition and narrative to the Washington National Gallery panel painting of 1470–5 by Benvenuto di Giovanni of Siena, with a procession of riders in the background emerging from the distant walled town of Bethlehem. Closer to home, a couple of seats at the east end and groups of stalls either side of the west door have excellent and varied fourteenth-century misericords, the best work available at the time since it was royally commissioned, and full of variety: heads of seers, bat-winged monsters, a centaur in fourteenth-century armour, an elaborately beautiful pelican stabbing her own chest to feed her young with her blood (symbol of the Eucharist), and exotic Sybil-like heads at the angle between the west-wall benches and the north and south walls.
2 BUTCHER ROW, E14 8DS

## ST DUNSTAN AND ALL SAINTS

*The saint's church in his own parish*

The twelfth-century monk William of Malmesbury filed this report on St Dunstan's powers: 'Once, when the church was locked, he entered by being gently put down on the ground by the help of ministering angels.' Which church he does not say, but a notice within the porch for us poor sinners visiting St Dunstan's, Stepney advises a pragmatic option: ring the bell if it's working or knock loudly if not.

As for the building of the church now known as St Dunstan's, the evidence is circumstantial, but real enough: in the course of assembling a curriculum vitae that would lead to canonisation, Dunstan was Bishop of London and Lord of the Manor of Stepney during the period of the Viking raid in 957–9 that destroyed the church building. So it seems likely that he would have been at least obliquely responsible for the rebuilding. Although the fabric is largely fifteenth-century (the chancel, is thirteenth-century and the last substantial work is the Victorian dumbing down of the exterior), a small pre-Conquest stone rood, 3 foot 3 inches by 2 foot 3 inches, set against the east wall behind the altar, dates from the time of Dunstan's birth, around the beginning of the tenth century. Dunstan must have seen it and, as an artist as well as a churchman, would have cherished the relief carving depicting the crucified Christ with St Mary and St John.

The rood has a crudely carved border of palmettes, a Byzantine decorative leaf form. Small Byzantine-influenced Carolingian ivory carvings from Aachen, say, or Cologne, were relatively common possessions of the English church. The Stepney rood is not as powerful or as competent as Byzantine art nor as the

Romanesque soon to be imported in the wake of the Conqueror's army, but, although eroded after centuries on an outside wall, it is human and affecting. Christ's arms hang limply from the cross, his head droops, and the flowing postures of the two saints indicate an openly expressed grief foreign to the art that came before and after.

The window above the rood replacing one destroyed in the war is another Crucifixion, a Christ of the Blitz. It shows in the lucid realism of Hugh Easton (1906–65) a muscular modern Jesus, apparently modelled on the rector of 1949, on a cross elevated hundreds of feet above the church tower with the smoked-brown ruins of his parish spread out beneath, a startling twentieth-century vision in a church full of intricate medieval corbels, delicately formed thirteenth- to fourteenth-century three-seat sedilia, and a fan-vaulted tomb chest to Sir Henry Colet, twice Lord Mayor of the City of London and father of John Colet, a rector of this church, founder of St Paul's School and friend of Erasmus and More. The splendid hanging wall monuments are devoted to merchants, clergy and, mostly, seamen: as the Church of the High Seas, St Dunstan's still hoists the Red Ensign above the tower each day.

STEPNEY HIGH STREET, E1 0NR

## • SHOREDITCH, BETHNAL GREEN, MILE END •

### GEFFRYE MUSEUM

*Fun heritage in Shoreditch*

Sir Robert Geffrye died on 26 February 1704 at the great age of 91 and garlanded with honours: past Master of the Ironmongers' Company, a sheriff of the City of London, alderman, knighted in 1673, Lord Mayor in 1685. Above all, his stairway to heaven was the money he left in his will for building 14 small almshouses for poor people 'of good character' over the age of 56. The result in the open fields and healthy air of Shoreditch beyond the northern boundaries of London was the sombre, dignified dark-brick building of three ranges enclosing a garden. This was the Geffrye almshouses, ready in 1723. A lead statue of Sir Robert himself stood in a niche above the front door. It was the work of the Nost workshops several years after the death in 1710 of the firm's founder, the Flemish-born, London-based sculptor John (van) Nost. By the beginning of the twentieth century the hubbub of the East End had caught up with the almshouses and the pensioners moved to a new home in Surrey. The statue went with them and has since moved on again to a newer Ironmongers' home in Hook, Hampshire.

In 1914 London County Council bought the Shoreditch almshouses and reopened them as the Geffrye Museum, with a replica of the Nost statue above the front door. In the course of the nineteenth century Shoreditch had become a centre of the furniture industry, so what better than to make the new Geffrye Museum a celebration of furniture. And since the

homes of the destitute and aged former inhabitants each consisted of a single room with a front door opening on to the garden, these were ideal for converting into a display of the living rooms of English families from the early seventeenth century to the end of the twentieth. Not the rooms of almshouse dwellers but mock-ups within 11 of them, showing how the middle classes lived: a good choice because the simplicity of working-class homes until relatively recently precluded the adoption of changing fashions, and the gentry and aristocracy had a more settled taste. It is always the aspiring middle classes whose taste changes with the prevailing wind.

The display begins with a room of the 1630s: oak-panelled hall and rush-mat-covered floor, refectory table, hard wooden stools and a hard wooden armchair for the head of the family. By 1695 the wainscoting has been painted an ivory white. Chairs have rush seats and backs, and the table is circular with folding leaves, maybe so that it can be pushed up against the wall, like the escritoire. This is the setting for a family at ease with the peace brought to England by William of Orange. By 1745 the curtains are draped from cornice to floor and everything is a tad more elegant. By 1790, the beginning of the Regency, taste is at its height and chairs are a work of art; there are white curtains, a carpeted floor. Possessions take over in the Victorian period, rooms are a hymn to ostentation. With the Edwardians, the plot is lost: a magpie selection of the cheap and nasty is displayed. None of the families in the centuries before this would have been rich, but this setting is fit for Mr Pooter,

waiting for the Ideal Home Show to be invented in 1908 and tell him what to like. Room displays for the rest of the century suggest how the mushrooming estates in vast new outer suburbs were enhanced by the inventions of central heating, radio, gramophones, manageable mortgages for the masses and loads of loot for young professional media types and financial adventurers. With vacuum cleaners and dishwashers, no one needed servants, or not the live-in kind.

The lived-in feel is what's missing throughout, perhaps inevitably. Precious few books anywhere, for instance, no family snaps, and though it's possible to believe in the 1965 wannabe who's left a copy of *Town* magazine neatly disposed on his shin-breaking coffee table, this is the stuff of fun heritage. And then there is the nineties loft conversion: a faux-Spartan display of pictures, kitchen off-centre dressed up like a cocktail bar with tall stools, the only part of the flat not focussed on the television set. The yuppie owner is out to lunch with a client. Don't blame the old Shoreditch furniture industry for any of this.

136 KINGSLAND ROAD, E2 8EA

## ST JOHN ON BETHNAL GREEN

*Blood, mascara and self-harm*

Bethnal Green is at the centre of what was once the most poverty-stricken of London villages as the destitute of Spitalfields began to spill outwards in the eighteenth

A middle-England sitting room of the 1930s in the Geffrye Museum: mediocre, except for the chairs and rug displaying the latest in textile design.

century and transform market gardens into slums. John Soane's church of St John on Bethnal Green (1826–8) shows the scars. It was ravaged, first by fire and then by architect, one William Mundy, who in restoring the fire damage in 1871 wilfully destroyed Soane's work in the nave. Curiously enough, though Mundy's massive iron hammerbeam roof is a travesty of Soane's original, it sits well alongside its tough neighbours, Bethnal Green Museum of Childhood (see page 458) and York Hall, the world's bloodiest boxing venue after Madison Square Gardens and Las Vegas.

In 2002 the vicar, the Rev. Alan Green, started the move towards the church's restoration by boating a party of his parishioners, many of them old, poor, and out of work, to the little upstream Thames island where the artist Chris Gollon has his studio. They liked what they saw and commissioned 14 canvases to replace the colourless plaster tablets of the *Stations of the Cross* along the walls of St John's. Gollon is, in that dreaded phrase, a self-taught artist, but because he obviously has a terrific eye and has acquired a confident and effective technique, he mostly benefits from his lack of conventional training. Art critics tend to detect the influences on him of the twentieth-century German Expressionists, Beckmann and Grosz; in Gollon's *Stations*, the jeering, distorted faces closing in on Jesus's agony from Matthias Grünewald's cast of medieval thugs in *The Mocking of Christ* comes most strongly to mind – hooligans down the ages. Gollon painted in acrylic, with brushes, fingers, palette knife, and the wooden end of the brush for scratching

through layers of paint to the dried layers beneath. Cinematic close-ups heighten the intensity, most noticeably in the episode of Christ being nailed to the cross, where blood and mascara pour freely down faces and one demented soul digs at his own eyes. Only the Crucifixion panel itself falls short, the drawing askew and unconvincing and the flat black background a failed attempt at dramatic contrast, even if St Matthew legitimises it ('darkness fell upon the earth').

Gollon painted only for his costs, but the parish constantly ran short of cash to fund the project. It gave out as Gollon was painting the scene of the women of Jerusalem, so Sara Maitland, author of the Somerset Maugham Prize-winning novel *Daughter of Jerusalem*, paid for it. She had once been the wife of an East End vicar. Gollon's models were volunteers: his wife and daughter, his son as Christ, a retired model as the Magdalene. Father Green stepped in as Nicodemus, who helps to take Christ down from the cross, and was, the vicar told a reporter, 'a bit iffy about committing himself completely to the cause. Seems about right for a parish priest in the Church of England'. There always has to be an exception.

200 CAMBRIDGE HEATH ROAD, E2 9PA

## V&A MUSEUM OF CHILDHOOD

*Not tonight, Josephine: rock gardens top this museum's bill*

If it is not the noisiest museum in the world, it must be close to it. This is the Bethnal Green Museum of Childhood.

Of childhood, note, not children's museum, though children are its main audience, with a few misty-eyed old men straggling on behind oblivious to the racket kicked up by the kids. More properly, this is a V&A museum. Its iron structure, exposed in the interior a bit like a railway station of the same period (1855-6), was shifted here from South Kensington, where it formed the core of the South Kensington Museum erected after the Great Exhibition of 1851. Henry Cole, the pioneering first director of the South Kensington Museum (which became the Victoria and Albert Museum), shipped it out to Bethnal Green in the late 1860s as a missionary outpost. It consists of three top-lit naves, the central one open from the fish-scale-patterned floor of tiles laid by women prisoners from Woking gaol, the other two with galleries carried on the same iron columns that support the roof too. At Bethnal Green the museum added a brick front, which made the resemblance to a railway shed complete, until during refurbishments in 2001-7 the architects Caruso St John, builders of the British Library, added a new entrance of patterned red quarzite and brown porphyry with a hall behind, to give it a touch of gravitas and twenty-first-century playfulness.

After a botched shot at exporting culture to the East End, it was not until 1974 that the V&A moved its childhood collection to Bethnal Green and renamed the museum, but it may be that the random portraits of children are a remnant of the old dream of exporting posh culture to the natives. One of the portraits is a high coloured and magnificently conserved canvas by James Northcote, the old man befriended by William Hazlitt and pumped by him for anecdotes of his previous friend, Joshua Reynolds.

Today the loudest sound, cries of 'Wow! Come and look at *this*!!!' leads, inevitably perhaps, to a working toy train model complete with railway station, a cable-suspension bridge, a small community of houses among grass and trees, and a red telephone box. Better by far than the average home-grown toy railway. Everything else is here too, from Paddington Bear to a Wurlitzer, 1920s swimming cossies to Jack-in-the-boxes (originated in the sixteenth century, the placard tells us), prams as big as limousines and a cradle that looks like something the Armada sent along. From Japan there is a child's kimono, orange and gold, of the faraway 1990s, from India a boy's tunic in pink and gold with a gold cap of great splendour, and from China model rock gardens populated by little people crossing Chinese bridges, living in open pagoda-style villas, taking their ease in garden terraces on mountain peaks. These are something special, and no wonder. They were a gift from the Emperor Chia Ch'ing intended for Napoleon's empress, Josephine, intercepted, it is said, by a British man o' war and delivered to the East India Company's India Museum before being passed on to the (future) V&A in 1880.

CAMBRIDGE HEATH ROAD, E2 9PA

Chinese puppets to enchant Bethnal Green's toughest kids visiting the V&A Museum of Childhood.

## MENDOZA PLAQUE, QUEEN MARY UNIVERSITY OF LONDON

*Boxing clever*

In July 1973, with a Parliamentary Act clearing the way, Queen Mary's College began to dig up the bodies in the Sephardic Jewish cemetery behind their building in Mile End Road (which was referred to after the work was completed as being 'newly landscaped'). St Mary's had always been pressed for land behind the college and now it was able to expand and provide a fine new library. The oldest graves went to a site in Essex near Brentwood, but some were lost altogether. It was not an entirely popular act with the Jewish community. One of those lost was the grave of Daniel Mendoza, the 5 foot 7 inch, 160-pound barefisted pugilist who spat in the face of anti-semitism by billing himself Mendoza the Jew, took on all-comers at all weights, developed the bad habit of beating muscular Christians and, thanks to his speed and elusiveness, became Champion of England. His life and death neatly encompassed all points of the Jewish East End: he was born in Aldgate, July 1764; baptised a week later in Bevis Marks, the Portuguese-Spanish synagogue to the north of the City; ran a pub, the Admiral Nelson, in Whitechapel Road; in his prosperous years as a fighter made his home in a good Georgian terraced house where there is a blue plaque to him, 3 Paradise Row, Bethnal Green; and, dust to dust, was buried at the Nuovo Sephardi cemetery, Mile End, after his death in 1836.

On 3 September 2008, the 172nd anniversary of Mendoza's death, a later much-loved champion, Henry Cooper, wielder of the Wagnerian "Enery's 'ammer', unveiled a new plaque commissioned by the Jewish East End Celebration Society for the outside wall of the library. It shows a scene of action: Mendoza in the ring, fists raised, the crowd driven wild by blood lust. The sculptor is Louise Soloway (b. 1962), a Londoner based in Hong Kong since the 1990s. Her sources seem to be the popular prints issued within days of his fights: the hieratic pose, fists held high, body erect, from work by the commercial engraver Henry Kingsbury in 1789 after Mendoza had beaten Richard Humphries over 65 rounds in the second of a series of three grudge matches (he had lost the first but took the series). James Gillray's own print included a crowd lusting for blood at the same fight, and Soloway seems to have looked at that before shaping her own crowd.

Shaping is the word. Soloway works in resin rather than carving in stone or casting in bronze because it can be modelled as fluently as the lines of a comic strip and coloured with pigment as bright as a Spitalfields Bangladeshi saree (the old Spitalfields Market was another of her subjects). For the Mendoza plaque she drops colour in favour of a memorial bronze effect, but maybe also in the spirit of a magazine editor choosing sepia to give a picture spread a sense of period – a sad, heroic period.

MILE END ROAD, E1 4NS

## RELIEF CARVINGS BY ERIC GILL, QUEEN MARY UNIVERSITY OF LONDON

*Music, dance, and joie de vivre*

The novelist and historian Walter Besant wrote in 1882: 'Two millions of people, or thereabouts, live in the East End of London. That seems a good-sized population for an utterly unknown town. They have no institutions of their own to speak of, no public buildings of any importance, no municipality, no gentry, no carriages, no soldiers, no picture-galleries, no theatres, no opera – they have nothing.' Four years later, even without gentry and carriages, a trust set up by the philanthropist John Barber Beaumont enabled the founding of a People's Palace in Mile End Road, an institution that combined education with pleasure. Fire destroyed it in 1931 so a New People's Palace arose further west alongside the almost as new Queen Mary College, named after George V's consort. It is a faintly Modernist building with seven relief carvings by Eric Gill on the Portland stone façade, two above the doorways (each with a languid figure representing Recreation), and five representing Drama, Music, Fellowship, Dance, and Sport.

Once Gill (1882–1940) gave up the attempt to rival Epstein as a sculptor in the round, he settled for what suited him best: he was a marvellously sinuous draughtsman, especially of the nude male or female where his linear skill bestows a sense of the sap rising, and he became a letter carver of alphabets united by grace and of fine relief sculpture. Often, though, he cut the reliefs too shallow for shadow to add life to the work. The two reclining figures above the doors of Queen Mary's show that, but the five panels in a row above are a real success. The figure of Drama, in profile, holding the masks of comedy and tragedy in full face between parted curtains, is a subtle reinterpretation of an ancient and, you would think, clapped out theme. Sport – two boxers – and Fellowship – chaps shaking hands – just about succeed on the basis of nothing much more than the nicely rounded outlines; but Music, a young woman plucking at a stringed instrument, and Dance are wonderful. Each wears a skirt with animating flounces, falling over the thighs of the seated girl and swirling around Dance's thighs as she rises to tiptoe on one foot and kicks the other in the air. There are illustrators who manage this joie de vivre, but no illustrators in stone other than Gill.

MILE END ROAD, E1 4NS

## RAGGED SCHOOL MUSEUM

*A celebration of the days of chalk and slates, metal pen nibs and china inkwells*

Dr Barnardo's Copperfield Road school was no more the first Ragged School than Barnardo himself was really a doctor. But it was the biggest and survives as the Ragged School Museum, the only remnant of the many once existing in London that happily adopted this wonderfully unflattering name, and which were funded by voluntary contributions: notably from philanthropists

like the phenomenally rich Angela Burdett-Coutts whose maternal grandfather had founded Coutts bank. (Nowadays Coutts quizzes potential clients about their 'circumstances' on two points: 1. wealth management for more than £1,000,000; 2. lending facility in excess of £1,000,000. Better perhaps stick with the Co-op?).

The best-known early exponent of this paraschooling, as we might now call it, was John Pounds (1766–1839), a Portsmouth shoemaker (for some reason shoemakers in that politically disturbed season seem always to have been auto-didacts, with an assured place in the history of welfare and radical politics). Pound realised a full belly had to come before a well-stocked mind, and tempted boys off the street into the classroom by offering them baked potatoes. Thomas Barnardo knew nothing of all this when he arrived in London from his native Dublin in 1886 to take a medical degree before going as a missionary medic to China. Instead, he found enough poverty among children in the London Hospital's neighbourhood in Whitechapel to narrow his aims from the Far East to the East End, abandoned his medical studies, awarded himself the title of doctor anyway, and set out on his lifetime's work in pastoral care.

The Copperfield Road premises had been built as a warehouse in 1873 on the edge of the Regent's Canal only four years before Barnardo acquired them and converted them into a depot, complete with a freight of children he found wandering the streets or sleeping on the roofs of Whitechapel and Mile End. To the workmanlike façade of three deep storeys he added a plain pediment. Today 'Ragged School Museum' is spelled out below this in capital letters several inches high.

Even when the school opened it was living on borrowed time. Seven years earlier, the 1870 Education Act had introduced free state schooling for all. Still, the Copperfield Road school survived for around three decades before closing in 1907, two years after Barnardo's death.

In the 1980s, after a second period as warehousing, a local movement won a reprieve for the building and set up the Ragged School Museum Trust. The museum opened in 1990, to act as a local history museum with a recreated schoolroom on the first floor: wooden desks with iron frames were displayed, but without books on them because the ragged pupils had none. Instead they were equipped with slates and chalk; older boys moved on to exercise books and wooden pens with metal nibs and ink in little china inkwells. Nobody much under the age of Richmal Crompton's scapegrace schoolboy William Brown can have used wooden pens and pen holders. But anyone can risk taking a lesson here (one Sunday a month) under a 'Victorian' teacher.

46–50 COPPERFIELD ROAD, E3 4RR

The finance-driven Canary Wharf as it has grown up this century around its first (and tallest) skyscraper, César Pelli's One Canada Square, completed in 1990.

# • CANARY WHARF, POPLAR, LEAMOUTH •

## CANARY WHARF

*An American Venice goes to the Dogs*

A plaque on the plinth of a statue on the Isle of Dogs reads: 'To perpetuate on this spot the memory of Robert Milligan... to whose genius, perseverance and guardian care the surrounding great work principally owes it's [sic] design...'

This does no honour to César Pelli's steel-clad skyscraper Canary Wharf Tower, nor to Cabot Square, Jubilee Square, or the gardens and artworks spread about this old docklands site. Milligan was a merchant and shipowner who died in 1809. He had been the driving force behind the West Indies Docks, Canary Wharf's prototype. His statue, by the great English sculptor of the day, Richard Westmacott, stands on West India Quay before the remnant of the export docks warehouses, now the London Museum of Docklands, and celebrates all his achievements – except for his profits from the slave trade.

An altogether more discreet monument with a crisply cut legend stands in a shady corner of Cabot Square. It is dedicated to Michael von Clemm (1935-97), the American who more or less invented the Eurodollar market, but not before, armed with an Oxford doctorate in anthropology, he had spent 14 months living with the Tanzanian Wachagga tribe. After that he turned to banking and spotted the potential of the London docklands site. From this spark of genius sprang the problematic triumph

of Canary Wharf, which survived going bust in its early days, followed by further tribulation with the world-shaking collapse of Lehman Brothers. If it looks like an American Venice that's because the master grid of streets, squares and measured stretches of water (the old docks) wrapped around Pelli's skyscraper is by the US firm Skidmore, Owings & Merrill. Then, of course, there are the acres of gleaming glass like a take on 'almost nothing', as Mies van der Rohe described his minimal Barcelona Pavilion, but far from almost nothing, the totality of Canary Wharf sings style, wealth and capital.

Then there's the art, all of a piece. That is, it's often hard to tell the art from the functional, Ron Arad's huge saucer, *Big Blue*, bluer than blue, making similar sense to Foster + Partners' transparent tube side entrance to the Jubilee Line station; Bruce McLean's railings at Wren Landing, scribbled metal shapes of hands and faces running along the railings with disc shapes suggesting a musical scale. Function? Art? A bit of both: or synergy, as architects like to say. At the heart of Pelli's One Canada Square (it can be seen fairly close up from outside the swipe card barriers) is William Turnbull's large bronze blade, which the title, *Blade of Venus*, suggests might be a prehistoric goddess figure, unproblematically art, older than anything rescued from the Thames, as ancient as Eve. When nothing else is left standing, the *Blade of Venus* will still be there.

CANARY WHARF, E14

## ST MATTHIAS OLD CHURCH

*The heart of the East India Company town*

Plumb centre, where the four ribs of a shallow vault meet in the ceiling of St Matthias, Poplar, is the coat of arms Queen Elizabeth I granted through her agents, the Garter, Clarenceux and Norroy Kings of Arms, to the East India Company on 31 December 1600. Within weeks John Company, as it became known colloquially, sent its first ships on the six-month voyage east from Torbay, set up wharves in Blackwall, and made Poplar the company town. Half a century on the company sponsored a church on its own land off Poplar High Street, for use by parishioners who found St Dunstan's, Stepney too distant. The church was called Poplar Chapel until the collapse of the East India Company in 1861; then William, one of the bizarre brothers Teulon, crazily wrapped it in a Victorian Gothic top dressing of Kentish rag, and the Church of England renamed it St Matthias. Beneath the ragstone mantle it is the only surviving chapel of the seventeenth-century Cromwellian Republic in England.

The churchyard is a public garden now, with scattered memorials to John Company sailors. The clean, simple Classicism has been faithfully restored and sympathetically adapted to the building's current use as a community centre. A gorgeous ceiling boss circled by a garland carries the company's arms: 'Azure, three ships of three masts, rigged and under full sail, the sails, pennants and ensigns Argent, each charged with a cross gules,' as Garter, Clarenceux and

Norroy Kings of Arms described it. A green thought in a green shade in the days of the East India Company's apple-green innocence. Each of its initial voyages in search of calico and silks, spices, China tea, and eventually opium, was proving to be a good investment for its subscribers in the Home Counties and the shires, but not yet spectacularly so. It reached its gaudy heights and sordid depths a century later under the dispensation of Robert Clive, 1st Baron Clive of Plassey as he was exalted after the last in a sequence of brilliant victories, against the odds, over French arms and Indian princes, that secured the continent for the most extraordinary and, some hold, rapacious commercial company in history.

John Company, stripped of its monopolies, went to the wall after the Indian 'Mutiny' of 1857, and with it the wharves and warehouses of Poplar and the headquarters in Leadenhall Street where Lloyds of London now stands. Poplar Chapel alone remains, nicely restored inside its disguise, shallow transepts making a cross of it, simple polished wooden pillars supporting the roof, giving daytime shelter and cheap food to the old and the jobless, and with its historic coat of arms, freshly coloured, a last survivor of glory on the ceiling above.
113 POPLAR HIGH STREET, E14 0AE

## BLACKWALL TUNNEL VENTILATION SHAFTS

*The lungs of the Blackwall Tunnel*

From South Kensington underground station to Seoul and Singapore, Paramatta and Lisbon, Terry Farrell (b. 1938) has projects worldwide. But when he was an employee of London County Council in the early 1960s he was already looking for inspiration across continents. In 1961 the council was building a second Blackwall Tunnel to add to the original one bored in the 1890s. Farrell was handed the job of designing the new tunnel's lungs, the ventilation shafts, two on either side of the Thames, of which the easiest to view are the pair on the north bank (the two on the south are wrapped now inside the O2 arena, the former Millennium Dome). His solution produced some of the first free-form architectural shapes in Britain, based on the use of reinforced concrete extensively pioneered in 1960 in the buildings of Brasilia, the new capital of Brazil, where the Cathedral, National Congress and National Library were built in a wonderful interplay of curved and straight forms. Consciously or not, too, Farrell's shafts look a bit like ship's funnels.

They drew also on the dawning awareness that in architecture, especially architecture for mass-habitation or mass-transit, the service aspects need not be hidden away. They are built of sprayed concrete, known as gunite, which had previously been used for patching up but is cheap and flexible, and anchored here by stressed cables fixed in reinforced concrete slabs. So the two shafts, a short, 40-foot one to expel fumes from the tunnel, and a tall, 90-foot one to draw in fresh air, curve almost sensuously above ground, in an evolving cityscape already displaying the work of succeeding generations, from the once-again fashionable

Balfron tower block by Ernö Goldfinger to the Robin Hood Gardens estate by Alison and Peter Smithson, and 10,000 new houses near the O2.

CORNER OF BLACKWALL WAY AND PAUL JULIUS CLOSE, E14

## LEAMOUTH

*Where the centuries blur into one*

Trinity Buoy Wharf stands at the tip of a small promontory at Leamouth, where the River Lea debouches into the Thames. It is at the end of Orchard Place, a lane bereft of trees. To the west lies the Isle of Dogs and the collision of high-tec buildings in the space where the old East India Docks once stood, drained for the manufacture of the concrete caissons for the D-Day Mulberry harbours. Close by is Nicholas Grimshaw's fabulous print hall for the *Financial Times*, glowingly new in 1988, suddenly old in 1995 when the *FT* disconcertingly decommissioned it for a share of the gigantic shed where the *Telegraph* papers are printed at West Ferry Wharf. Presses removed, the Grimshaw building has become East India Dock House, an internet data centre. By the Thames is Richard Rogers's suave Reuters Technical Services Centre, an impermeable black band standing on pilotis concealing computers within, a glazed band containing offices above, lifts and stairways on the outside of the building, with beside it a long shallow clear glass canteen, the whole thing flexible in a way Rogers could only dream of with the Pompidou Centre.

All this ends beyond the Leamouth roundabout, where there is the last surviving remnant of the docklands after Luftwaffe and docks closures had done their worst. The most immediate sign of life is Fat Boys Diner, built in New Jersey in 1941 and shipped here in 2002, a trailer that is going no further. Fat Boys dates back to the birth of boogie-woogie. Giant Pepsi bottle tops crown the trailer, flanking a cutout featuring a fat boy's face with pomaded hair surmounting a streamlined plaque with Fat Boys Diner spelled out in e-x-t-r-e-m-e fat and thin lettering. The trailer is upholstered outside and in with red and chrome and glass; food too is part of the decor, wrapped in bread, the Indian red of frankfurters, splashy chilli and tomato reds, the yellow paint of mustard; a series of Claes Oldenburg Pop Art set-pieces for real.

Opposite, also dating from 2002, are Container City 1 and 2, jazzy names for shipping containers piled up in ziggurats by the architects Nicholas Lacey & Partners, portholes and floor-to-ceiling windows punched into them, panels painted scarlet, maroon, yellow ochre and white, pot plants and garden furniture courtesy of the artists who inhabit the units. Behind Fat Boys is the glass and anti-rust red of the business end of a moored Trinity House lighthouse ship, a preview of a sort of Anish Kapoor's Olympic Park knitted metal. Here too is the old buoy shed (now an arts centre), alongside the only land-based lighthouse in London – short-arsed, brick-built – where Michael Faraday experimented to perfect lighthouses. Here too, in 1895, the labour force at the iron rolling mills and

foundries on both sides of Leamouth founded something else, a football team. As West Ham United it turned pro in 1900 and is bound for glory in Olympic Park. Nickname the Hammers... what else?
LEAMOUTH PENINSULA, E14

## GATES BY ANTHONY CARO, ORCHARD PLACE

*Steel gates that celebrate the vanished docks and the dance of the seven veils*

All that's left of the East India Dock basin apart from lengths of wall over a wide area is the entrance from the Thames and a stretch of water that was once the export dock. In this wasteland the now defunct London Docks Development Board set change afoot by commissioning Sir Anthony Caro to fashion entrance gates, which he delivered in 1996. It might seem odd that he should have called the big galvanised steel gates after one of the more provocative characters in the New Testament, Salome. She it was, says St Matthew (14:6–8), who, at the feast to celebrate Herod's birthday:

> *...danced before them and pleased Herod.*
> *Whereupon he promised with an oath to give her whatever she would ask.*
> *And she, being before instructed by her mother,*
> *said, Give me John the Baptist's head in a charger.*

The Bible only passingly hints at Herod's lust for his niece and does not mention at all the seven veils so essential to Oscar Wilde's tale, Pasolini's movie *The Gospel According to St Matthew*, Richard Strauss's opera and a hundred other modern entertainments, but it is the veils that Caro too had in mind.

The *Salome Gates* function as gates should, but he built them as sculpture. He says, on a plate screwed to an adjacent wall, that from a naval scrapyard in Portsmouth he picked up bits of a steel ladder, chains and shackles for fastenings and bolts, and combined them with seven galvanised steel plates. And when they're closed, he adds, they are like lock gates holding back water. That is true, but there seems to be much more to it. Caro continued to draw until his death in 2013 aged 89, in particular studies of the female nude, and though it had not struck me before, it seems certain that the *Salome Gates* are based on the sensuous volumes of hip, breast, shoulder and columnular throat (the head, like the Baptist's, is missing). These aren't the ideal nudes of the fashion pages, but working bodies. One of his late drawings is a Picasso-esque bull, rendered near-abstract so that its wide flank is like the flat sheet steel Caro worked with in his later pieces. And the whole gate assembly is a collage of regular elements (such as one near-perfect disc) and irregular gaps where the veil parts, with an elegant rippled-silk effect across a flat surface that might easily represent wind on the water. I should perhaps add that you must bring your imagination in full working order to this bleak spot.

ENTRANCE TO EAST INDIA DOCK BASIN, ORCHARD PLACE, E14

# The River Thames

The London river, as old boatmen still call the tideway, was once neither primarily about recreation nor stately ceremonial, except for very special events like the recently celebrated Diamond Jubilee. Instead, the Thames was the swelling waterway Joseph Conrad had in mind when he transmuted it into the Congo, 'a mighty big river... resembling an immense snake uncoiled', that still grips the guts of anyone of imagination negotiating it in a small craft, especially the downriver tidal waters. Never mind the sights from pretty little white castellated Trinity Hospital to the meridional vision of the old Royal Hospital with the Queen's House framed between its wings and a view of the Observatory on the hill: Wren, Webb, Hawksmoor, Vanbrugh and Inigo Jones in all their pomp. These are incidental moments in the unending saga of the Thames. Years after his seafaring days were over Conrad imagined a first Roman navigating the prow of his galley west into the estuary and negotiating his way through the unmarked sandbanks of the Margate roads between the featureless headlands; and then, turning to his own memories of service on tall ships, seeming hardly less ancient to us today than the Romans do, he wrote of how the 'wharves, landing-places, dock-gates, waterside stairs, follow each other continuously right up to London Bridge'.

Yes, even without the jungle of masts the river remains closer to Conrad than to Canaletto's glowing canvases of it, though the rusting hulk of an old Mersey ferry on the southern bank is more Beatles than *Heart of Darkness*. A boat heading downriver from Westminster or Charing Cross passes by channels leaking water into the river from old Surrey Docks, the inlets and tunnels siphoning ancient tributaries, old wharves, a lighthouse boat at the mouth of the Lea, the footings of industrial buildings in Poplar and Limehouse and, along Upper Pool, Wapping's riverside warehouses converted into apartments for bankers. The West and East Docks on the Isle of Dogs, the Pool of London, St Katharine Docks, London Docks, made the city in its day the greatest trading centre in the world. Royal Docks, Victoria (1855), Albert (1880) and George V (1921), seized the succession with 12 miles of quays between them, yet were already struggling for survival when Tilbury Docks opened to the vast new container ships. In the 1960s the Royal Docks closed. Now the area is an enterprise zone, with City Airport on one of the wharves.

On the marshy north shallows of the river at Beckton, Stanley Kubrick used the Victorian cast-iron pillars from the wharves of what was once the biggest gasworks in the world to stand in for war-torn Vietnam in his movie *Full Metal Jacket*, and further downriver Thamesmead, the bright hope of the 1960s, became in his *Clockwork Orange* a dystopian vision of a brutal new England. Just beyond, within sight of the Dartford Bridge at Erith, black stumps remain of a primeval forest from a time before England could be called England, and there are seamless modern buildings of mastodon beauty that eat Thames sludge and turn it into electric power. But the real story remaining on the marshes is at Dagenham, a one-industry town where Ford, which began rolling out Model 8s soon after opening in 1931, once employed 40,000 men and Sandie Shaw after the war. Now, with only diesel engines

and wind turbines manufactured, the labour force is 3,200.

For the journey upriver we must take an older, slower craft from Westminster Pier below the bridge. To reach Hampton Court Palace we pass through not just a different London, but a different England. The *Cockney Sparrow*, say, allegedly the oldest craft on the river but actually a newcomer from 1976, built on Eel Pie Island at Twickenham, chunters cheerfully upriver negotiating the locks of Teddington, where the tideway ends, and Richmond. At Richmond Lock the gates drop two hours after high tide to keep the water at a level, and rise as the tide recedes to keep the river high. And here the suzerainty of the Port of London Authority ceases, with a board warning severely: 'Rabies prevention / No animals from abroad permitted ashore... Penalties are severe.' This is the stretch where aristocracy and royalty liked to build: Chiswick House, Syon House, Queen Charlotte's House at Kew, Marble Hill House, Strawberry Hill, Ham House and Hampton Court Palace. On through mixed park and suburb to Hampton pier, opening on to the first courtyard of Hampton Court Palace, royal but inhabited mostly by ghosts, the first of them the spirit of Giovanni da Maiano, the early Renaissance master sculptor whose unexpected decorative terracotta portraits of the Emperors Nero and Tiberius, laurel-wreathed, gaze down from the towers flanking the palace frontispiece. What, Henry VIII's subjects may have wondered, was the king planning for himself and his hoped-for dynasty?

The downriver sweep, 'resembling a great snake uncoiled', of the Thames past Wapping, Limehouse and the Isle of Dogs (with Canary Wharf).

# • HACKNEY, STRATFORD, WANSTEAD, ILFORD •

## HACKNEY EMPIRE

*A piece of the British Empire that survives*

For a time a few years ago, punters checking the canopy space on the corner of Hackney Empire, normally used to publicise the current show, saw instead the message, 'Thank you Sir Alan'. As natives of Hackney knew, Sir Alan was one of their own, the local lad who fathered the Amstrad computer, was the wicked uncle of *The Apprentice* (BBC1) and Sugar daddy to Hackney Empire, which, following a much-needed refurbishment, was leaking cash alarmingly. Sugar handed over £3 million to help the rescue, and soon afterwards was made up from knight to lord: Baron Sugar of Clapton.

The Frank Matcham-designed Empire re-opened in 2004 and it was clear that the refurbishment was a triumph of showbiz with 'Hackney Empire' projected in terracotta capital letters 21 foot high, manufactured in Stoke, set two decks deep facing across the Town Hall Square, visible south along Mare Street as far as the Regent's Canal, and a landmark to passenger jets landing at City Airport in the docklands. The plan for this building-sized tabloid masthead was that of the architect of the refurbishment, Tim Ronalds, who envisaged a complete new south flank as sturdy as the extended fly tower, built half out of sight behind all the fancy stuff, but faced in terracotta like Matcham's dressing to the original brick façade of 1901 on Mare Street. The graphic designer Richard Hollis did the new lettering. He devised a dramatically compressed sans-serif typeface based on an old *Evening Standard* billboard he had scavenged years before, fitted like precision machinery and with the punch of a steam hammer. The M alone weighs three and a half tons. Beneath are six angled ridges of terracotta, which throw shadows as underscoring.

The Coliseum in St Martin's Lane (opened 1904), once a vaudeville house itself, now a lyric theatre housing the English National Opera, is often cited as Matcham's masterpiece. Maybe, but it is less outrageously inventive and exuberant than Hackney Empire, and exuberance is what Matcham is about, as well as the setting the celebrated East End singer and comedian Marie Lloyd needed. 'She was the philosopher of urban London's Saturday night,' as the obituary in the *Manchester Guardian* mourned when the performer died aged 52 in 1922, Hackney-born and, the *Guardian* added, 'there can be no doubt that Hackney is still written on her heart'.

Fred Karno's Comics (with Charlie Chaplin and Stan Laurel) appeared at the Empire; so too the Lancastrians George Formby and Gracie Fields, the abidingly scurrilous Max Miller, Fulham Football Club's Tommy Trinder, and an aspiring Tony Hancock.

In the corridors of the theatre there are decorative trophies embowered in flowering branches painted in doorway arches, and allegorical heads in the spandrels. The auditorium is packed with Rajput turrets, hints of Turkey, rococo

boxes, scarlet plush and lush gold trimmings, and in the foyer under coffered ceilings painted portraits of Handel and Mozart: an unlikely association? Yet as I write, the morning papers carry reviews of the Empire's esoteric production of *Ottone* by Handel. Never mind; next month brings a return to theatrical form with *Mother Goose*.

291 MARE STREET, E8 1EJ

## SUTTON HOUSE

*A country house for
Thomas Cromwell's man*

In the time of Henry VIII Homerton was a tiny hamlet in the parish of Hackney. The most substantial house in it was built throughout of brick, unusual enough for the house to be shown on maps as 'the bryk place'. Today it is the oldest domestic building in the East End, yet in a real sense its rich history is a discovery of the 1990s. So little was known about the bryk place when the National Trust took it on reluctantly in 1938 that they named it Sutton House; taking a punt on the proximity of Sutton Square and Sutton Place and guessing that Thomas Sutton, the founder of the Charterhouse, had lived here. He hadn't, though he was a neighbour. In the 1980s a group of interested Hackney residents persuaded the National Trust to drop plans to split the forlorn house into apartments and instead to invest in a restoration that had thoroughgoing historical research as a side effect.

So today we know that Ralph Sadleir, or Sadler, a *protégé* of the king's chief minister, Thomas Cromwell, built the house in 1535, soon after he had married and as he was gaining a toehold on a brilliant career in the royal service. He was already well-to-do, and grew in wealth and ruthlessness after surviving the fall of Cromwell; it was Sadleir, by now Sir Ralph, who disclosed the so-called Casket Letters, proving the involvement of Mary Queen of Scots in conspiring against Queen Elizabeth I, and Sadleir who recommended her execution.

The bryk place we know today is a superior Tudor manor house built around a pretty little courtyard. It retains the plain and beautiful ground-floor parlour with walls clad in linenfold panelling (since restoration some of the panels fold back on hinges to reveal the quaint first option of a painted simulacrum of linenfold). The oak-panelled Great Chamber on the first floor survives as well, with an elegant portrait of Sadleir's grandson, possibly by Hans Eworth, an artist favoured by James I, and the Tudor kitchen remains, a little embellished. In 1550 Sadleir moved to Standon, a big house in Hertfordshire to match his enhanced status, and sold the Homerton house, so although he would recognise it today, it is a record of the passing of time and styles (most obviously sash windows instead of mullioned) and of its later owners, a Middlesex JP, a London silk merchant, a succession of Huguenot families, Mrs Freeman's school for young ladies (education was an eighteenth-century growth industry in Hackney), a church institute, 1980s squatters and vandals. At one point the house was divided into two.

If Sutton House can never feel like a home again, it has the warmth of a place in daily use by the community, which took it to its heart and saved it in alliance with the National Trust. All it needs now is a more appropriate name. Something like Bryk Place.

2–4 HOMERTON HIGH STREET, E9 6JQ

## THEATRE ROYAL STRATFORD EAST

*Where Theatre Workshop fetched up after hard years on the road*

Every year on 11 February or thereabouts an In Memoriam notice would appear in the *Guardian*. 'A day to celebrate: the birthday of Gerry Raffles. Beloved One', it might say, or another time: 'Gerry Raffles, Manchester 1923 – Vienne 1975. Unforgettable Gerry. All my love. Joan'. Joan was Joan Littlewood, and Gerry was her lover who died suddenly and too young of diabetes and overwork when they were on holiday together in Provence. They were together in Manchester after WWII at the foundation of Theatre Workshop, and in that versatile company he was noted for ultra-versatility as actor, playwright, director, fixer, and the man you'd find under the Theatre Workshop truck when it broke down, which was often. In the early 1950s I saw the company's production of *Uranium 235* written by another big talent, Ewan MacColl, and followed it from Darlington training college to Stockton YMCA to Ferryhill colliery to Aycliffe remand home and back to Darlington Mechanics' Institute, then round again with *Henry IV*, its two parts knocked into one with Harry Corbett as king. It felt as it must have done to follow Shakespeare's company on the road.

The In Memoriam notices stopped after 2002, the year Littlewood herself died aged 88, but perhaps in the end these declarations of love buried in dusty newspaper files will prove a better tribute to Raffles than his other memorial, Gerry Raffles Square in Stratford, not Shakespeare's Stratford, but Stratford, London E15. Gerry Raffles's Stratford, yes, but what everyone locally and all taxi drivers remember now is not Gerry Raffles Square, but Theatre Square, which is the indeterminate neighbouring square signposted from the railway station. In 1953 Raffles was Theatre Workshop's manager when he first brought his company of tattered travellers to the Theatre Royal in Stratford for a two-week engagement. It smelled of disinfectant and cat piss, said Joan; but they liked having a permanent home, and stayed.

The paved square today has ground-level fountains, gushing but not drowning, before a Theatre Royal painted buff and red like a Wild West bar. Inside the surviving Victorian iron columns support circle and gods. J. G. Buckle built the theatre in 1884, and in 1902 the Grand Cham Frank Matcham had a hand in restoring the interior decor, plushly got out again in 1998 in red and gold, just the right side of vulgar (the other side, that is). I wandered around in this theatre of

*A door from a stone-flagged courtyard in Sutton House, 'the bryk place' as it was known during the Tudor dynasty when Homerton was a rural hamlet.*

dreams one morning, without asking but greeted by welcoming smiles from the current resident company and staff; which is exactly how Joan Littlewood and Gerry Raffles would have wanted it.
GERRY RAFFLES SQUARE, E15 1BN

## ST MARY'S, WANSTEAD

*Handsome remnants of Viscount Castlemain's great estate*

The pair of carved eighteenth-century stone gateposts at the entrance to Overton Drive are Wanstead's Ozymandias touch: 'Two vast and trunkless legs of stone/ Stand in the desert ... Nothing beside remains.' Beyond the pillars was one of the famous estates of the nobility in England, centred on Wanstead House with its central block of nine bays and two wings each of six. Now there is a golf club on the parkland, small sheets of water, a tennis club and the serried streets of a suburb.

Colen Campbell, Britain's most notable early eighteenth-century exponent of Neo-Palladianism, designed the house in 1715 for Sir Richard Child, later Viscount Castlemain and 1st Earl Tilney, the son of a newly rich East India Company merchant, Sir Josiah Child. The later heir to the fortune and the estate, Catherine Tylney-Long, sold the contents in 1822, could not find a buyer for the house and had it knocked down after making the mistake of marrying a feckless nephew of the Duke of Wellington, who, as feckless nephews will, went spectacularly broke at the gaming tables. Change the names, and it becomes the template for many once-great families fallen on hard times.

The classical Church of St Mary survived the avalanche. Thomas Hardwick designed it, the architect for whom the young J. M. W. Turner worked briefly until Hardwick pointedly told him he would make a better painter (nevertheless, Turner learned enough to build his own house: see page 293). Given the date 1789–90, St Mary's was old-fashioned from the day of its consecration, but acceptance came with age. It sits in its suburb, not unduly exciting, but serene as the only grade 1-listed building in Redbridge. Pediment, portico, window openings, the big blocks of Portland masonry, are all pretty well as sharp as the day they were carved, and there is a festive timber bell-cote with a clock on the square base. Every piece of furniture, every fitting, seems original, from the pulpit with its Chinese-looking hexagonal sounding board supported on slender carved palm trees, the columns with glorious Corinthian capitals (not, as it happens, carved, but modelled in clay and cast in Mrs Coade's patent artificial stone), the high oak pews in the nave to the deal pews in the north and south galleries (for domestics) and the bare benches in the west gallery.

This is clearly not a rich person's church. It doesn't match the charm of Petersham's St Peter's (see page 304), or the splendour of St Lawrence's where Handel played the organ in the park of another destroyed great house, Cannons

A crisply cut pediment and, above the rusticated clock tower, a wooden bell turret: by the architect Thomas Hardwick at St Mary's, Wanstead.

(see page 556), but it has gravity, a sense of propriety enhanced by a good sequence of monuments, from the obelisk opposite the stairs to the gallery, merely inscribed but handsome enough for that good, eventually English, sculptor Peter Scheemakers to have signed it, to the theatrical tribute by John Nost to the man who made a pile so that others might build this one: Sir Josiah Child.

OVERTON DRIVE, E11 2LW

## ST ANDREW'S, ILFORD

*A 1920s flapper with her head among the stars*

It was open season for builders and contractors on private parks and houses in Ilford and Wanstead. So in 1901 the owner of Cranbrook Park, a self-made builder and contractor called W. P. Griggs, demolished the old hall and set about using its drive as the spine of his big new housing estate. The Drive, as the old drive is now called, is a long street linking, roughly speaking, Ilford town centre with the A12 London to Colchester road. The huge redbrick church of St Andrew's was an afterthought. Griggs's son Albert commissioned Sir Herbert Baker to design it. At first sight St Andrew's looks like just another big brick inter-war church, but it is much more than that.

The sculptor Sir Charles Wheeler (1892–1974) joined Baker on the project. He too was a knight and Royal Academician from an era when the RA was stuffed with fuddy-duddies knighted and untitled. And in fact a lot of Wheeler's work is formulaic Modernism and sits unobtrusively on pompous modern buildings: he was Sir Herbert's frequent collaborator. Yet here is Peace, a pubescent female angel with arms outstretched, palms held upward, big hollow eyes in a lovely oval face, hair blowing out to either side, and dressed in a long shimmering skirt and top garment: anyone who can do all that in bronze is a master of his trade.

In the soaring nave, rounded apse, and, especially, in the aisle alcoves, the brickwork and carved wood is alive with pleasant detail, and in the alcoves especially the stained glass by Karl Parsons (1884–1934) in small single-light windows is something more. Parsons had been a pupil of Christopher Whall, the best of the Arts and Crafts stained-glass artists, and he has some of the same sweeping line and easy freshness as Whall plus a touch of Burne-Jones's elegance without the angst. Here is a very fine Saint Ruth, the Moabite who came out of her country to Bethlehem 'at the beginning of the barley harvest'; her hair cascades from beneath a green floppy hat, she wears a flowing green gown, her unshod feet stand among field poppies and in her arms she carries a sheaf of barley.

Perhaps not quite as good but instantly and powerfully appealing is the window in memory of a girl who died aged 14 in 1928. The girl in the window has a scarf thrown over her plaited auburn hair, a brilliant blue cloak worn over a blue dress with a violet sash, her head among the stars, her face entranced by the glory of God and her hands raised in amazement, her naked feet (so photographically accurate as to prompt the thought that they were in fact worked up from a photo)

above streaming clouds with big golden tears falling about them. Yes, it is frankly sentimental. She has the face of a 1920s flapper, perhaps one of those aspirational models on the cover of an early *Woman's Weekly*, so it might be thought that the work's contemporaneity would become dated. Not at all. Not great art either, but wonderful cinema.

THE DRIVE, IG1 3PE

## • BARKING, DAGENHAM, RAINHAM •

### ST MARGARET'S, BARKING

*The bounty of Barking recalled*

Barking had a fishing fleet from time immemorial – already by the fourteenth century its fishermen had been in trouble repeatedly with the authorities for using nets with too fine a mesh. Some things don't change. It grew up on the River Roden alongside Barking Abbey, which was the biggest nunnery in England, and the parish church, St Margaret's. By the nineteenth century it had become the biggest fleet in England. When the industry peaked in 1850 there were 220 or more smacks jostling together in Barking Creek, the Roden's inlet to the Thames, and at the town quay.

The abbey had been dissolved in 1539 and razed within two years. The fleet had virtually gone by the end of the nineteenth century and the biggest fleet owner resettled in Lowestoft. The church alone remains on the edge of the conservation area, which contains the stone outlines of the monastery, and at the entrance to the churchyard the fine old curfew tower, the only complete part of the monastery remaining; it is worth climbing the steps to see the ruined but moving twelfth-century rood.

Whatever abbey monuments have been lost, St Margaret's makes up for it. Its series overlaps the old monastery's with a fourteenth-century figure of Martin, the first vicar, incised in stone, in style still very like the incised figure of 700 years earlier on St Cuthbert's coffin in Durham. But the bulk of the monuments are Renaissance and later, the finest of them a memorial to John Bamber (d. 1753), a doctor who owned a large estate to the south of abbey and church, the bust quite conceivably by Roubiliac. The most fascinating is a grand memorial to Captain John Bennett, a part-time Royal Navy officer originally from Poole who died aged 70 in 1706. His son John died in 1716 and the monument was set up in 1717. The elder Bennett's commissioned spells were interspersed with activities that might have included fishing, a suggestion strengthened by the number of people named in his will who were active on Barking town quay.

His tomb in the churchyard includes a carving of the most famous ship on which he served, HMS *Lenox*, which took part in the conquest of Gibraltar in 1704. The extravagant monument to him in the lady chapel is carved in close detail with accoutrements of navigation and war and another ship, split between two panels bisected by a half-length figure of Bennett,

bewigged, insouciant, with one hand on his hip and the other clasping the hilt of a sword from which the blade has at some point been smashed. The ship, under full sail in a moderately choppy sea, is carved in faithful detail, and shows a two-deck fourth-rater of about 50 guns as sailed in the late seventeenth/early eighteenth centuries, which fits the description of four of the ships on which Bennett sailed. Whatever bounty he received, he paid out in good measure to the poor of both Poole and Barking.

NORTH STREET, IG11 8AS

## EASTBURY MANOR HOUSE

*A history of pride and vicissitude*

The River Thames was once the border of Eastbury Manor House's marshy back garden, a couple of miles from the house itself, and ancient maps show Ripple Road as the only highway in sight. Now the arterial A13 passes through a Dagenham industrial landscape from hell and carves Barking in two, and the once-rural Ripple Road is flanked on the initial stretch from the A13 by petrol stations, a Ford showroom, and a Kwik Fit service centre. Instead of the big estate that belonged to Barking Abbey until the Dissolution, Eastbury Manor stands on an island in a sea of pre-war council housing. It could have been worse: when Daniel Defoe saw it in 1722 it was still a great house, but 'antient, and now almost fallen down'.

Yet a sequence of owners and tenants just about kept it patched and standing, although one of its octagonal turrets containing the newel staircase with massive wedges of oak for treads was pulled down in the early nineteenth

century before it could fall down. At last, in 1918, the National Trust stepped in and the local authority, now the London Borough of Barking and Dagenham, took over the management. Maybe it should be sad to see Elizabethan Eastbury today hemmed in by the neat semis of an East London town, but instead it's touching to see it standing high among them flaunting multiple gables, tall chimneys and mullioned and transomed windows, Falstaff among the Merry Wives.

The structure is sound, the east garden within a high brick wall intimate and lovely, the rooms have been renovated and, innocent of furniture, exhibit their history of pride and vicissitude. Many families have lived here since Clement Sisley built Eastbury in 1566–72 (the first date proved by tree-ring analysis, the second by the date on a waterspout), but this is only implicitly the history of people; actually it is the chronicle of a Tudor house, timber-framed, English brick laid in neat English bond, and over the north portico moulded into a swanky, roughly Renaissance display of wealth. Throughout the house are big fireplaces with depressed arches, only one of them still with a decorated plaster surround, but the main act is the room above the Great Hall with its two large fragments of wall paintings, one showing a sylvan view through an open arcade, the other through arches separated by barley-sugar twisted columns letting on to a scene of fishing boats in a creek – not Barking Creek, but an imaginary Mediterranean scene, probably painted by peripatetic sixteenth-century Netherlandish artists. The house has its own views, from the remaining turret at the top of the newel staircase. They are not, however, remotely Mediterranean.
EASTBURY SQUARE, IG11 9SN

Magnificent Eastbury Manor House, built 1566–72, derelict in the nineteenth century, rescued in the twentieth, flaunts its splendour amidst a housing estate.

## VALENCE HOUSE

*The Dagenham idols, homages to a better life*

A steel cast of a Ford Capri, the 1960s Jack the Lad's affordable version of a Lotus or Aston Martin, stands outside Valence House, a static homage to wheels. Inside the house is a gnarled and fissured pinewood carving of a figure, under two foot in height, an aboriginal inhabitant of Essex made around 2459–2110 BC and found in 1922 buried alongside the bones of a deer in Dagenham Marshes at the point where the Ford Motor Company would later sink 22,000 concrete piles, to prevent the plant it built in 1931 from sinking.

Capri and carving… each embodies dreams of a better life. Ford designed the car at its Detroit headquarters to milk the European market. Its launch slogan was 'the car you always promised yourself'. The pitch worked; my, how it worked: 1,886,647 times over between 1968 and 1986. Most of the workers at the Ford plant lived on the vast Becontree Estate built by the London County Council of the 1930s and 1940s, and the Capri spelled aspirational lifestyle to their sons. Those workers who survived the cull of jobs (from 40,000 in 1953 down

to 4,000 at the turn of the century) still live there, and though the last Ford, a Fiesta, rolled off the Dagenham production line in 2002, the plant still builds engines. Because the town itself has the negative virtues of no discoverable centre and no major infrastructure, it has not suffered the calamitous collapse of big-city Detroit. Still, the inert steel Capri now stands for decline and fond memory, not for the future.

The Dagenham idol, as the prehistoric piece is known, is the real thing, assigned by radiocarbon dating to the earliest period of representational art in Europe. An initial glimpse of the carving in the centre of the first public room in Valence House delivers a visceral shock. It is a powerful late-Stone Age embodiment of human desire. It has only one eye and the hole in the pubic area was either for a phallus or to represent the female sexual organ (female is the current bet). The circumstances of the burial suggest a fertility offering.

It is on loan from Colchester Museum, where it went because at the time of its discovery Dagenham had no museum. Now it has Valence House, a fortunate survival of a timber-framed manor house with seventeenth-century fabric, but a site history dating from the thirteenth century, when Agnes de Valence, granddaughter of Isabella d'Angoulême (King John's queen), lived here as a widow. By the early 1920s Valence House had gone through several modifications before it became a comfortable middle-class home with a couple of panelled rooms and a magisterial staircase left over from its early days. After serving as offices for the old Dagenham urban district council, in 2010 it reopened as a beautifully thought through local history

museum. At the time of writing, the museum staff is negotiating for the idol to come home permanently. Dagenham has sweated for it.

BECONTREE AVENUE, RM8 3HT

## DAGENHAM LIBRARY

*A little bit of Ken Livingstone's paradise achieved*

When Ken Livingstone lost the mayoralty of London in 2008, his successor Boris Johnson had scarcely waved goodbye before he dumped Ken's favourite projects, Design for London with its associated 100 Public Spaces. The prototype public space was Trafalgar Square, transformed by Ken from pedestrian purgatory to paradise. Parliament Square was the obvious next candidate, but Boris knocked that on the head as well. The architect Richard Rogers walked out of Design for London because nothing was happening.

It had been slow going with Livingstone too. Developers might get planning permission for blocks of shops and expensive houses; in return, they must turn over a tithe to spend on affordable (i.e. subsidised) houses. It was a marriage made in toil and sweat, and it took forever to sort out, so by the time Livingstone left office only five of the target of 100 projects had been finished or more or less completed. One of the more or less was in Dagenham, a tiny village that had grown over a

Valence House, where the presiding genius is the Stone Age Dagenham idol, a fertility symbol found during the construction of Ford Motor's Dagenham factory.

century into an industrial town, first around a huge London overspill estate, Becontree, and than around the motor industry. Dagenham boasted a Football League team, the Daggers; it acquired culture: Valence House Museum (see page 479), the Dagenham Girl Pipers, and a hit comedy, *Made in Dagenham*, a movie about the strike of female machinists at Ford in 1968, with a title song performed by the former Ford clerk Sandie Shaw. But under the swiftness of a two-pronged twentieth-century assault (from Becontree and the Ford Motor Company), there was neither the time nor the will to plan a town centre. So 100 Public Spaces adopted it as a project, and the young group practice ArchitecturePLB produced shops, flats and a library built rather along the principle of the so-called five Idea Stores pioneered by Tower Hamlets.

ArchitecturePLB didn't attempt the jazziness of David Adjaye's Idea Stores. Dagenham Library, turning the corner of Dagenham Heathway and Elm Park Lane near the Central Line Tube station, shows from the opposite corner as a glass-fronted black wedge driven at an angle one deep storey above the pavement into a block of 86 private and affordable flats, with gay red, blue, yellow and green transparent balcony screens. Immediately within the wedge is a study centre with public computers and wide open spaces on split levels, containing a loan library with popular literature and serious reads (the Smiths, Ali and Zadie, for instance), an e-library, a toy library, a job shop (bright language in the Valley of Despond), and places to pay the Council Tax and sort out

community matters. Shops are at ground-floor level fronting a car park.

At the docks end of the scheme Dagenham and Barking Borough Council is trying to pull in business. So far, the main attraction is a pretty cycle path.

1 CHURCH ELM LANE, RM10 9QS

## RAINHAM HALL

*A sea captain's bid for landed glory*

The National Trust's note on Rainham Hall says the old lady is 'awaiting conservation'. Well, she looks pretty good on it; completely delightful in fact, although it seems almost (but not quite) as though the rooms haven't seen a paintbrush since the first coat was applied to the wood-panelled interiors in 1729, when the house was completed for Captain John Harle, a seaman from South Shields who bought Rainham Wharf and settled in the village. He died in 1742 but the house passed down through his family until 1887. A Colonel Mulliner restored the porch, built an attic fourth storey set back from the balustrade and now rented out as a flat, painted the front hall panelling in a marble effect, and in 1949 left the house to the Trust, without the traditional pot of gold for its upkeep. What's left of Rainham village since it became an industrial town of more than 12,000 inhabitants is centred on the melancholy group of the Norman church of St Helen and St Giles and Rainham Hall on Broadway (which is broad enough for a horse and cart to pass through) and a few scattered cottages and the old vicarage also in Broadway.

The hall lies behind fine wrought iron gates bearing Harle's monogram. People say that Jean Tijou was the iron worker responsible, the way it is said that any half decent bit of woodcarving is Grinling Gibbons's; but Tijou died in 1712, and only his influence lives on here. The house is brick, three storeys tall and elegant, five bays wide with an entablature beneath a balcony at the top. Among the stone urns in the garden are four that once stood on each top corner of the house. Quoins and the keystones above the white sash windows are white stone. The portico too is white, but it is carved of wood, a seductive piece, beautifully fashioned, with Corinthian capitals on fluted columns standing clear of the house and attached columns at the rear holding the broken pediment coffered beneath and freely carved with big flowers. The rooms make a different kind of statement. They are as small as a country cottage's though an aristocratically handsome arch leads through from the hall to the staircase. There is no furniture, there are no carpets, no pictures, no porcelain, nothing but the wood panelling, shuttered windows, tiled fireplaces, a good staircase with fine mahogany rails and twisted balusters just as the captain decreed. Preparatory analysis of paint samples show that grey was the underlying colour. No doubt when the National Trust can afford a few pots of paint they will return the interiors to their original condition. Catch it when you must: it is open only on Saturday afternoons during the season.

THE BROADWAY, RM13 9YN

## ST HELEN AND ST GILES, RAINHAM

*A pretty Norman church with mod cons*

It's a pretty church outside and in, especially in. An odd adjective, 'pretty', for the brutalist Norman take on Romanesque architecture, but in the church of St Helen and St Giles the proportions seem designed for a race of Lilliputians, from the tiny priest's door in the south wall with zigzag and nailhead decoration to the stocky square-section arcade piers, like a couple of rugby front rows standing at six foot something, rhyming with the bluntness of the west tower and carrying correspondingly low round arches springing from rudely scalloped capitals. Anywhere pews pass behind any pier, three parishioners have their view totally blocked. This being the twenty-first century, and with a growing and lively working-class congregation, it has proved possible to find the general nous and skills to set up a video screen at the ends of the north and south aisles, where latecomers can follow the action in the chancel.

Richard de Lucy founded the church in the 1170s, about the time that he founded Lesnes Abbey on the opposite bank of the Thames (see page 419), and Lesnes's abbots took over the patronage of the church at de Lucy's death, until the Reformation. Anything anomalous that accumulated in the centuries afterwards was cleared out by a thoughtful nineteenth-century vicar, who while he was at it judiciously added a handful of small Norman-style windows to the originals to allow in more light. The eighteenth century had already brought little clerestory windows shaped a bit like crossed cigars. What the light illuminates is charmingly uneven limewashed plaster barely disguising the rough walls of flint, chalk clunch, and Essex septaria, a seaside rock that really is rock. Small apertures in the walls, at least one of them a piscina designed for washing the sacred vessels of Communion, now display vases of white flowers; a bluntly functional Norman font caps a sixteenth-century stem; diagonal views through the arcade arches to the chancel arch modulate the space with a subtle intimacy.

At the foot of the stone steps to the abolished rood screen is the image of a ketch with a long, trailing anchor rope roughly carved into the stone wall. Myth ascribes this to a sailor on shore leave, or someone taking sanctuary in the church carving an object he knew well. Out of this farrago the likeliest thing is that the carver was local, and shipping passing by on the Thames would have been familiar to him. The work is dated at about 1500: in those days the Thames flowed where the railway is now, and St Helen's and St Giles, like Lesnes Abbey, stood at the river's edge. There too was Rainham's wharf and little port. From that era only the church still survives, and it is the oldest building in all Havering.

THE BROADWAY, RM13 9YN

## RAINHAM MARSHES

*Nature's hideaway on the marshy river's edge of London*

Through the drizzle and low cloud towards London distant tower blocks

look like prehistoric henges. Mastodons crawl along the long viaduct of the A13 and Eurostar glides silently by on another. Purfleet impinges close by to the east. The great arc of the Dartford crossing shows to the east too, a distant grey rainbow. There are the silent remains of a former army rifle range, once littered with burned-out cars. The vicar at Rainham parish church nearby says 'it's built up from here to Charing Cross, but people still say they're in the country'. Well, here on Rainham Marshes, it's easy to see why. Eight hundred and seventy acres of boggy land reinvented by the Royal Society for the Protection of Birds, with its wide horizons and lakes and runnels of leftover river inhabited by nothing but voles and moorhen, lapwings, widgeon, mute swans, the occasional kingfisher, marsh frogs, butterflies, bees and, on every path and wooden boardwalk through the morass, snails looking for a messy end under the boots of walkers and bird-watchers. Here and there are hides for the twitchers, especially the remarkable complex of three rusted shipping containers which, as the *Evening Standard* observed, carry the memory somewhere in their DNA of those burned-out cars; reinvented by the architect Peter Beard, the containers are a child's education centre clad inside with timber covered in kids' wildlife drawings, quite as wild as their models.

The main man-made attraction of this nature reserve, the creation of van Heyningen and Haward Architects, is what the handouts call an Environment and Education Centre but which to a lot of visitors is a shop and café as well. It is wonderful as a base for looking at the natural world outside, and good to look at from the outside in too, through the virtually all-glass walls to the entrance hall/café space. Beneath two big ventilation funnels that glow in the sunset the low-lying building is clad in elongated orange, ochre, white, grey and brown timber panels, horizontal and vertical: not exactly camouflage (though it does conceal the underlying concrete frame), but sitting nicely with the sedge, bramble, dog rose and seasonal wildflowers spreading over the surface of the marsh and serving another purpose also. When the centre closes for the night panels bunched beside the windows slide across to protect the exposed glass, for this building stands on stilts in its own dryish moat and has been designed to be vandal-proof, with defensive steel railings in the moat (not architect-approved) and draw-bridges at footpath level. There's an area out there beyond the Environment and Education Centre that has existed since most of London was marshland. So when anyone argues that the Isle of Grain, a few miles further downriver, is perfect for yet another London airport because 'there's nothing there', it means that there's nothing there that a politician would recognise as something.

RAINHAM MARSHES NATURE RESERVE, NEW TANK HILL ROAD, RM19 1SZ

## • HAVERING-ATTE-BOWER, GIDEA PARK, UPMINSTER •

### BOWER HOUSE

*The Mystery of Thornhill's stairway murals*

Until 1729 Henry Flitcroft, influential Comptroller of the King's Works at St James's, Whitehall and Westminster, by this time 32 years old, had not completed a building of his own. But John Baynes, serjeant-at-law (the highest level of counsel in his day), had already commissioned Flitcroft to build a country villa in Havering-atte-Bowe in Essex, and it was ready for him later in the year. James Thornhill was completing murals in the stairwell, but in his case the commission came at the end of his career. In 1722 he had been summarily deprived of the kudos of decorating Kensington Palace in favour of William Kent, through the influence with George I of Kent's patron Lord Burlington (the Charles Saatchi of his day and champion of Palladian Classicism, who had, coincidentally, also set Flitcroft on his path in architecture). Thornhill was entitled to believe that the huge success of his decoration of the Painted Hall at Greenwich would have guaranteed his continued pre-eminence. Instead, he was dumped into virtual retirement.

Edward Croft-Murray, a great authority on English art of the eighteenth century, has declared the Bower House murals cannot, on stylistic grounds, be Thornhill's. He didn't, however, argue the case against or propose an alternative and they are still widely accepted as Thornhill's. But if not his, then whose? It's possible that they could be by Francesco Sleter, a Venetian who had worked with Thornhill on another project (Moor Park, Hertfordshire, now a golf clubhouse) and whose work is similar. But Thornhill remains a strong contender, and in 1729 was certainly available; and maybe at a knock-down price. The decor draws on classical myth, one panel featuring Silenus, slobbish, drunken tutor to the wine god Bacchus; another shows a faux-peasant *Judgment of Paris*, and nearby is Vulcan leaning on his hammer with a shield nearby, presumably newly forged for Achilles. Perhaps, like the hero, Thornhill came out of retirement for one last sally.

The stairwell is small, and this may have influenced Thornhill's decision to abjure colour in favour of the equivalent to sepia in photography, grisaille, with the paintings displayed on horizontally channeled masonry, actually painted in trompe l'oeil, to fool the eye. The approach is relaxed, a little like Thornhill's spirited French contemporary, François Boucher, without the nudity, and could represent an old pro's late style. The landscape backgrounds are the idealised, unidentifiable Euroscape of the time, as light-hearted as the word rococo itself.

Flitcroft's house is strictly English Palladian, with Great Parlour and Hall front and back, and rooms to the south and north balancing the composition in perfect unity. Today the Amana Trust, a charity that promotes Christianity, occupies Bower House and the murals, lightly restored, are in good shape. But the portraits of the Baynes family and subsequent tenants and owners that hung in

the rest of the house were quite recently taken into care like neglected children by Essex Records Office, and there are no plans to return them at any point. They are nothing special but they belong here and the photographs of them are dismally inadequate replacements.

ORANGE TREE HILL, RM4 1PB

## THE GREEN, HAVERING-ATTE-BOWER

*The village green that resists the pull of London's gravity*

The gravitational pull of the redrawn boundaries in 1965 sucked the royal and ancient manor and liberty of Havering-atte-Bower into the great maw of London (note the Chaucerian preposition in the place name, so antique it lacks a reference in modern dictionaries). But while youngsters in Romford and Dagenham, Havering's new neighbours on the slopes below, kick a football around for recreation even in summer's heat, strong evidence that Havering-atte-Bower remains a real village lies in a field at Broxfield Road. 'Now in Maytime to the wicket/Out I march with bat and pad': here the village team contests division three of a mid-Essex cricket league in the congenial sunshine. A short step away at the south-eastern corner of the village green, the locals preserve the stocks and whipping post (refurbished in 1829 and again in 1966), perhaps in memory of condign punishment meted out to summer footballers.

Although Havering-atte-Bower lends the first word of its name to London's third-largest borough, encompassing Romford, Upminster, Hornchurch and, down on the mucky tidal shore of the Thames, Rainham (another village clinging to its ancient identity), it was an important royal manor from before the Conquest until 1828. Most of the legends that the past bequeaths to the village are, unlike history, bunk. But it holds its head up and, helped in its fib by the green belt policy, maintains that its address is Essex, not London. It likes to remind people that here on the village green once stood a royal palace, and a royal chapel where the nineteenth-century parish church of St John the Evangelist now stands. Around the green to south and west stretch woodland and farmland that are the remains of the royal hunting grounds of Hainault Forest and Havering Park.

Of the buildings in the village nothing remains from the Middle Ages, and along North Road such older dwellings as there are lie scattered between mid-twentieth-century bungalows. The green is the real thing, with eighteenth-century weatherboarded houses to the north and a hospice hidden by trees to the east. The tall, singular, white Round House (actually oval), built by the architect John Plaw in 1792, stands almost opposite the cricket ground; Henry Flitcroft's first commission, Bower House of 1729, remains off Orange Tree Hill, and Bower Farm Road has wonderful views. Where the road ends in a gravelled track and forecourt, a range of farmhouse, cottage, and several cattle sheds converted to stables speaks of solid nineteenth-century agricultural prosperity. Back at the heart of the village, Basil Champneys's St John the Evangelist of 1878/9, too, plays up and plays the

game. Champneys's masterpiece was the John Rylands Library, as much part of the soul of Manchester as the cathedral, Waterhouse's town hall and C. P. Scott's *Manchester Guardian*; St John's is a humbler, more playful Gothic, roof not quite catslide but sweeping down not far from the churchyard, its style Decorated, but rural Essex, Low Church in every sense and today proclaiming itself happy-clappy by denomination.

HAVERING-ATTE-BOWER, RM4

## GIDEA PARK

*Where the best architects of England competed to build every commuter's dream*

At the beginning of the twentieth century Ebenezer Howard's inspirational idea for planned garden cities was about to take shape in bricks and mortar, trees and water, in deepest Hertfordshire at Letchworth. Howard's philosophy of living intrigued others, who did not necessarily buy the fully developed package. One of them was Sir Herbert Raphael, MP for a Midlands constituency, Esssex county councillor and owner of Gidea Park near Romford – hobbies: shooting, fishing, motoring and golfing. Naturally, he owned the golf course flanking Gidea Park to the east; and on the western boundary Raphael Park. He saw possibilities in tweaking Howard's vision. He would build, not a garden city, but a smaller, cheaper garden suburb.

He set up a company to exploit the notion; in 1911 it promoted a house-building competition and 100 architects signed up. Between them, along an informal arrangement of winding roads, they built 140 dwellings at £500 a house and the cottages at £375 to constitute a homes exhibition. Great Eastern Railways built a station for Gidea Park (and Squirrel Heath to the south of the project, but that part of the name was soon dropped). Most of the best of the houses are at Reed Pond Walk, which is bent in a U-shape around a wild copse. They tend to be designed in an appealing English vernacular with beautiful brickwork and tiled roofs, some with a central chimney stack and some with sweeping roofs and low overhanging eaves, one by Cecil A. Sharp with a huge chimney stack holding the corner of the house. Clough Williams-Ellis, the architect of Portmeirion, the fantasy village on the Snowdonia coast, built at number 23 a startlingly attractive and unorthodox Regency villa in orange and grey brick and with tall dormer windows set into the orange pantiled roof. At 36 and 38 the Arts and Crafts specialist M. H. Baillie Scott set a couple of different but spiritually twinned houses side by side, with rendered surfaces, one pinkly pargeted with grapevines, a dream of rural England for the well-travelled.

In 1934 there followed a modern homes exhibition (meaning not Modernist, but more modern than the modern ones of 1911). It was not as successful as its predecessor but one house, 61 Heath Drive, actually is a modern classic. It was the first house of the 26-year-old Francis (Frank) Skinner, a Communist who, after studying at the Architectural Association, joined Tecton in 1932 just as the masterly Russian *émigré* Berthold Lubetkin was setting up the firm, having rejected Soviet

culture. Number 61 is L-shaped, flat-roofed, with sheer white walls and elegant slit windows; the main windows on the garden front are invisible from the street but look on to a neat terrace with a pond; a wide rectangular opening on the street front announces a roof terrace behind and theatrically frames a view from the street to trees in the middle distance. Tecton built the house for £900. It was an example that ought to have been widely followed after the war, but wasn't taken up. Red ideologue, Cold War, wrong climate.
GIDEA PARK, RM2

## UPMINSTER WINDMILL

*An ancient village at the end of the line*

Upminster is the end of the line. So is Richmond for that matter, at the other, western, end of the same District Line. Thirty-five stops separate them: mind the gap. Richmond is associated with royalty, watered by the Thames, blessed by great houses, parks, a pagoda, the finest collection of plants in the world, memories in old stone of a long-gone Tudor palace; Upminster is lassoed by the M25, caught up in the early twentieth-century surge of suburbia along the railway tracks into Essex. It could have been worse, but the Green Belt Planning Act of 1947 halted the tidal wave of bricks and mortar, so that Upminster remains within paddling distance of open country and will remain so as long as the short-termist uglyism rampant among politicians doesn't prevail.

So for now Hall Lane runs north-south out of open country south of the Southend arterial road to the crossroads where it meets St Mary's Lane at right

angles, all four and a half miles of it, meandering into Essex past Puddledock farm fishery and into West Horndon. Caught in the angles of Hall Lane and St Mary's Lane are the most significant reminders of a rich village history. East of Hall Lane stands one of the great medieval barns of England, built on Waltham Abbey land with trees felled between 1423 and 1440, thatched, aisled, and with a crown-post roof. Just south, the golf clubhouse was formerly the sixteenth-century Upminster Hall. The parish church, St Laurence's, at the crossroads with St Mary's Lane, has a nineteenth-century body with pre- and post-Renaissance memorials and vivid heraldic stained glass of 1630, with incidental bits and pieces of moths, butterflies and country fruits, berries and vegetables colourfully recorded. There remains a fine stocky thirteenth-century tower with stubby spire, leaded and rustically shingled. Along the lane there's a good plain dissenter's' chapel of 1800, and in the meadow opposite the windmill, two years newer. A local man called John Nokes built it for himself.

It stands on top of a hill, deep into suburbia. But viewed from a carefully chosen position in St Mary's Lane, against a background of cloudy sky and trees, it could be a Constable subject. Its great beauty derives from its purely utilitarian design which combines dignified and compact bulk with fine detail: the four great sails (soon to be put into working order once more with a Heritage Lottery grant) offset by the fan blades, exquisite as a geisha's fan, yet constructed of wooden planks. The mill wears its white weatherboarded four-storey smock above a single-storey brick base and beneath a boat, a mechanical invention that put nobody out of a job. A dozen pompous monuments would not be too many to sacrifice to save Upminster Mill.

THE MILL FIELD, ST. MARY'S LANE, RM14 2QL

The smock mill at Upminster, combining bulk with fine detail.

Overleaf: Italian Gothic, plate tracery windows, by the splendidly eccentric William Burges in Harrow School's polychromatic speech room (1877).

# North London

# North London

*HERTFORDSHIRE*

- Phoenix Cinema
- East Finchley Underground Station
- St Jude-on-the-Hill
- Highpo[int]
- Spaniards Inn
- Kenwood House
- *Hampstead Heath*
- Fenton House
- 2 Willow Road
- Keats House
- St John-at-Hampstead
- Freud Museum
- Grim's Dyke
- St Anselm's, Hatch End
- Hatch End Railway Station
- St Lawrence's, Whitchurch
- Avenue Hou[se]

**HARROW**

*c. 3 miles to the west*
← Harefield village
← St Mary's, Harefield

- Aeroville, Hendon
- St Mary's, Hendon

**BARNET**

- St Mary's, Harrow on the Hill
- Harrow School
- *Fryent Country Park*

**BRENT**

- St Mary's, Willesden
- Sudbury Town Underground Station
- BAPS Shri Swaminarayan Mandir

**EALING**

**HAMMERSMITH & FULHAM**

**KENSINGTON & CHELSEA**

| 0 | 0.5 | 1 | 1.5 | 2 | 2.5 | 3 mi |
| 0 | 1 | 2 | 3 | 4 km |

# Map of North London

**Counties and Boroughs:**
- ESSEX
- ENFIELD
- WALTHAM FOREST
- HARINGEY
- HACKNEY
- ISLINGTON
- CAMDEN
- CITY
- TOWER HAMLETS
- WESTMINSTER

**Parks and Green Spaces:**
- Trent Park
- Epping Forest
- Alexandra Park
- Finsbury Park
- Primrose Hill
- Regents Park
- Thames

**Points of Interest:**
- Forty Hall
- Royal Small Arms Factory
- St Andrew's, Enfield
- Friends Meeting House, Winchmore Hill
- Queen Elizabeth's Hunting Lodge
- Alexandra Palace
- Bruce Castle
- William Morris Gallery
- St Mary's, Walthamstow
- L. Manze
- Vestry House Museum
- Estorick Collection of Modern Italian Art
- Carlton Cinema
- Cecil Sharp House
- Mornington Crescent Underground Station
- Sir John Soane's grave
- Jewish Museum
- Penguin pool, London Zoo
- Carreras Cigarette Factory
- Ceramics by Gilbert Bayes
- King's Cross Station
- St Pancras New Church
- St Pancras International
- Rudolf Steiner House

# • REGENT'S PARK, KINGS CROSS, CAMDEN, ISLINGTON •

## RUDOLF STEINER HOUSE

*Where a dull high-street architect broke out into an Expressionist fever*

The first thing usually said about Rudolf Steiner House, the Anthroposophy Movement's London building, is that it is the only example of Expressionist architecture in London. Expressionism isn't a very helpful term in architecture, but the world headquarters built in Switzerland by Rudolf Steiner himself meets the Pevsner definition of 'creating a feeling of anguish or unease'. The curvy organic forms of Rudolf Steiner House fail that test; rather they arouse gentle surmise. If it is not the only building of its sort in the world, it absolutely is the only one in Park Road: anthropomorphic architecture – or Mickey Mouse Expressionism if you prefer, though that's a touch frisky for the subtly languid style. The façade of 1926 (additions in the thirties) is gently out of synch with the uprightness of its neighbours in Park Road, though even with its linked window bays marked by sapling-like outlines, the goggle eyes of the windows, the dip in a first-floor sill mischievously countering the low arch of a ground-floor window further along, there is absolutely no sense of 'anguish or unease', more of a gently rippling wave.

The time period allotted to Expressionism is usually given as roughly the first quarter of the twentieth century, which was also the time of niche religious spin-offs like Helena Blavatsky's Theosophical Society that ensnared certain artists of the period (though T. S. Eliot reacted to it satirically as something to look forward to in heaven, where 'Madame Blavatsky will instruct me/ In the Seven Sacred Trances'). Steiner himself was full of sonorous but windy observations such as that the working of conscience is 'God in man'. So it is a surprise to find that the architect of the Steiner building in London, Montague Wheeler (1874–1937), looks in his photograph like a trim, moustachioed former army officer; which was precisely the case, having interrupted his unexceptional practice as an architect to assume the rank of lieutenant-colonel commanding 3rd/4th Battalion of the Royal Berkshire Regiment up to the ripe old age of 42 in 1915–16. He already knew of Steiner's philosophy and that the great man, himself devoid of architectural training, had devised the Goetheanum, world headquarters of Anthroposophy, in the town of Dornach in Switzerland (it burned down in 1922 and was replaced by an even uglier version).

The big treats of Wheeler's Park Road mini-Goetheanum lie within, where a keyhole-like entrance opens on to a staircase that ascends through a grotto of curved piers and banisters and faintly dreamlike leaded windows. The globe-shaped lighting is threaded on to silver cable vertically through the narrow stairwell, an adaptation of an utterly rational Modernist approach to an Alice in Wonderland adventure. There are curves everywhere, intended to encourage the practice of eurythmic movement as advocated to Steiner's followers.

Wheeler died safely back in conventional practice after this loosening up exercise; David Austin added further embellishments in the eighties, and Nic Pople and Helen Springthorpe in 2008–9.
35 PARK ROAD, NW1 6XT

## PENGUIN POOL, LONDON ZOO

*Modernism that was a lesson to cosiness*

Berthold Lubetkin moved to London in 1931. He was 29, but at this tender age he founded the most famous of British pre-war architectural practices, Tecton. He had been a pupil in Moscow of, among others, Malevich and Tatlin, revolutionary artists before there had been a political revolution. Their work still looks startlingly modern and utterly different from the Fauvism, Cubism and Futurism of the West. In fact, when the leading Italian Futurist Marinetti visited Russia, proclaiming the new supremacy of the machine age, he received a frosty welcome. The Russians themselves had been motivated by the simplicity of peasant art and the icons of the feudal society that had prevailed in Russia until 1919. Their abstraction had more to do with the inspiration of Jewish shtetls and Orthodox Christian churches than with either the swords and ploughshares of Red Revolution or the example of individual geniuses like Picasso. As Lubetkin told students at the Royal College of Art in 1971:

> I am... often amused to hear the opinion that Tatlin started to experiment with three-dimensional montages and reliefs after he met Picasso in Paris. Unfortunately, I cannot accept such a comforting vision since Tatlin himself told me on several occasions... 'If it was not for the icons... I should have remained preoccupied with water drips, sponges, rags and watercolours.'

This lesson and the succeeding influence of Le Corbusier informed Lubetkin's practice in England, a Modernism that cut straight through the domestic cosiness that was our national lot in the 1920s and early 1930s. And how? He built the penguin pool at London Zoo and won an animal-loving nation's hearts.

Actually, Tecton had already designed some housing for human beings (see Gidea Park, page 487), when Lubetkin began to receive zoo commissions from the enlightened secretary of the Zoological Society of London, Julian Huxley: first came the gorilla house, then the penguin pool (1934) with its appealingly elegant, lucid and playful ramps of intermeshing concrete ellipses curving upwards from the water. This was the first big splash, not just for the penguins but for press and public too.

But the Zoological Society of London began to have their doubts early on. As the residents waddled up and down the ramps the society began to wonder whether their gait was exacerbated because the concrete made their feet ache. The zoo proposed a friendlier environment; but in one of the few recorded popular protests ever in favour of modern architecture, the public kicked up a stink. And so the pool stayed until in the 1980s the penguins moved out to a former duck pond while their home

was being refurbished. When it was time for them to move back, the penguins voted with their feet. No. QED, though Lubetkin's daughter Sasha said that since the last residents of the enclosure were burrowing penguins they were bound to find concrete intractable. So now the penguins have a beach and water and a closely integrated fans' club separated from them only by glass, and the Lubetkin pool serves as a not entirely convincing fountain, forlornly stripped of its real function.

REGENT'S PARK, NW1 4RY

## ST PANCRAS NEW CHURCH

*A church built when the fashion was all Greek*

The Acropolis of the Euston Road, the New Church of St Pancras, is an astonishing sight, out of time and out of clime with its four load-bearing statues, caryatids, looking out across the choking expanse of slowly moving traffic. It was derided by contemporaries and today the kiss of death is often bestowed upon it with the customary judgments of 'scholarly' and 'careful copy'. Certainly it is difficult in the interior to suppress a yawn at the sight of the big flat ceiling inlet with little square decorated panels; Robert Adam this is not. And yet the wholeheartedness of the concept carries the day. 'The fancy-dress fits like a glove,' as the architectural historian John Summerson wrote.

William Inwood won a competition in 1818 with his eldest son Henry, who was baptised in St Pancras Old Church, to build the new one deemed necessary because London was fast expanding and the suburb of Bloomsbury had by then extended as far as St Pancras. They immediately decided on Neo-Grecian for its style, and everything was determined by this decision. Henry set out for Athens to measure and sketch the buildings on the Acropolis. The obvious source for the caryatids was the Erechtheion. The Inwoods hired an academic sculptor, John Rossi, to complete the commission of his career. He modelled the draped female figures in terracotta on a core of iron to strengthen them for their load-bearing duties: they carry a massive entablature of Portland stone on their heads and slender necks and stand upon huge burial vaults with bronze doors. They have neither the aura nor the majesty of the Athens originals but go one better than the Erechtheion, which has caryatids only at a single corner of the building; St Pancras has them north and south. The Erechtheion was the source, too, for the six massive Ionic columns of the portico.

This was the apogee of Greek Neo-classical church building in England. Afterwards came the Neo-Catholic revival of the Church of England, the Tractarians, and with it the enthusiasm for all things Gothic. The Inwoods completed two or three smaller Neo-classical buildings in the neighbourhood, but St Pancras New Church marks the high point of their careers. William died in March 1843 and was buried behind

The four caryatids of St Pancras New Church, modelled in terracotta, stiffened with iron to ensure them against crumbling like biscuit.

# John Nash at Regent's Park

The Nash scheme of grand terraces in Regent's Park is Marie Antoinette's Petit Trianon transplanted. Let them eat cake? Majesté, this is where they do eat cake. And have it. The site was Marylebone Park, which a crown agency wished to improve and in consequence, naming the park for the Prince Regent, engaged the man who had already pleased HRH with his Hindoo design for Brighton Pavilion (Hindoo is to Hindus what Gothick is to Gothic). Like the Pavilion, Nash's Regent Park scheme is real, but in theatrical mode. Those triumphal arches bookending Chester Terrace, for instance, are merely elegant props through which glamorous visitors must manoeuvre their horse-drawn yellow phaetons. Yet it remains a testament like no other to urban planning despite Nash's attraction to the 'fatal facility of stucco' (the royal company he kept ensured his enduring unpopularity).

The place to start to grasp the full grandeur of the scheme is Carlton House (house gone, now Terrace only), where the prince lived. Nash started in 1813 to build a royal route from this point, along the new Regent Street and on into Regent's Park. The strategy was collapsing even before completion and Nash's Regent Street has largely gone except for its majestic sweep. But by 1826 all was complete, separating the plebs of Soho from the toffs of Mayfair, and not in anything like a great Parisian boulevard but rather the translation into grandeur of a country lane.

Regent's Park begins, really, with Park Crescent's equal white curving wings embracing a garden before it (and a Tube station) with the park north of Marylebone Road. Taking the eastern route out of Park Crescent into Regent's Park, the circular route skirts the perimeter. There's a hiccup immediately after Nash's Park Square East and the very pretty St Andrew's Terrace with the magnificent concrete statement of Denys Lasdun's Royal College of Surgeons (1964, some hiccup) followed by the lush Victoriana of Cambridge Gate. Then comes Nash's Chester Terrace, immensely long with huge Corinthian columns; behind it Chester Close and Chester Place, smaller, worth a look for the intimate planning, quite different from the next range, Cumberland Terrace, a roll of drums and a fanfare of trumpets, three figures silhouetted against the dawn sky on a huge pediment full of Wedgwood coloured sculpture surmounting a balustrade with great urns above ten Ionic bays in a stretch of more than 800 foot (James Thomson, 1826, to Nash's plan), enough to carry over the gap for the zoo and beyond to the last Nash terraces (actually the earliest, built between 1820 and 1823): Hanover Terrace, Sussex Terrace with its unusual but charming elongated octagonal domes and finials carried on bay windows, two smaller terraces, Clarence and Cornwall, both by the young Decimus Burton, with projections and recessions to add the interest of light and shadow. There are more little terraces and York Terrace, which Nash split down the middle when he discovered that the new Marylebone parish church was going to be built behind and would make the focal point of an approach to Marylebone Road. Another approach, Hanover Gate, is dramatised by a little lodge in the middle of the road, the single most charming building, a box with classical statues in recesses on the chamfered corners and a pointy lead hat sprouting unclassical chimneys.

A glimpse of the grand spread of John Nash's scheme of terraces on the encircling perimeter of Regent's Park.

those great bronze doors. Henry went on a voyage to Spain later that year in a ship that sank in a gale with all aboard lost. After the architects' deaths the Victorians installed tepid stained glass to dim the light and exorcise the ghosts of Greek Paganism.

EUSTON ROAD, NW1 2BA

## KING'S CROSS STATION

*Let there be light, a Cubitt solution for a fine railway terminus*

King's Cross station any Sunday through the 1950s: midnight, the double train sheds full of choking smoke, meths drinkers skulking in the shadows, a handful of civilians in the depressingly institutional waiting room, platform one filling with brutal and licentious soldiery, half drunk, fully fed up at the end of their 48-hour passes, subdued by the presence of white-belted and gaitered Military Police waiting for trouble, the A4 locomotive getting up steam for the journey north-east to the vicinity of Catterick Camp.

King's Cross Square 26 September 2013: Boris Johnson, Mayor of London, opens the new public space; true, it's a triangular sort of a square, but a wide expanse of it paved in broad bright stripes of York stone slabs, punctuated by new trees and granite benches and anointed by a Henry Moore bronze, one of his more lumpen pieces, but still, a Moore. All the 'temporary' buildings that had obscured the view for almost the whole lifetime of the railway station are now junked. Instead, we have a single Underground entrance hall, discreetly low so that for the first time in something like 150 years one of the great buildings of London is revealed in its lovely scrubbed-up yellow brick. It anticipates twentieth-century Modernism, avoiding the Victorian controversy over Greek Doric (the original Euston station) v. Gothic (next door at St Pancras: see page 501), eschewing ornament, expressing the unity of function and design with the two great arched windows, separated by the faintly Italianate station clock tower, reading straight through to the twin train sheds, one for departures, one for arrivals, beneath new glass letting light flood into the station. The square unites the separate entities of St Pancras and King's Cross into an exhilarating stretch of previously unachieved townscape.

It was the work of Lewis Cubitt, brother of Thomas and William – the three of them built most of Bloomsbury and Belgravia – and twin soul of W. H. Barlow, the engineer who would complete the train shed at St Pancras in 1868. The esteemed trade magazine of the day, *The Builder*, praised his King's Cross for 'the largeness of some of the features, the fitness of the structure for its purpose, and a characteristic expression of that purpose'. But towards the end of the last century, not only was the station decaying and under threat of demolition, the whole district was in decline. Network Rail took over the railway infrastructure in 2002 and was working on putting King's Cross into shape when Britain won the mandate to run the 2012 Olympics. Network Rail appointed the architect John McAslan to work on a radical expansion of the

station, a key transport hub for the games. He devised a huge semi-circular glass concourse as the new entrance to the west of the station (the old entrance is now for departures), with booking offices and a serpentine line of shops. The McAslan roof structure, engineered by Arup, is the big spectacle with its huge internal rib structure supporting the canopy, like a tree, as one critic wrote, with a trunk spreading its branches across a span of 170 foot.

Behind the station, Central St Martins school of art has taken over the old granary building. The King's Cross Filling Station is not quite what it says any more, but a chic bar. Gardens are growing immediately behind the station. Google continues its conquest of the world with a big new headquarters nearby.

EUSTON ROAD, NW1

## ST PANCRAS INTERNATIONAL AND RENAISSANCE LONDON HOTEL

*A terminus 'full of brass and assurance'*

The statue of Sir John Betjeman stands as if gazing admiringly at the awesome span and proportions of the Barlow train shed (1868) over St Pancras railway station. There can be no quarrel with that in itself, but William Henry Barlow was an engineer, and it was not for praising engineers that Betjeman received his immortality in bronze, but for opposing the demolition of George Gilbert Scott's brick frontispiece. Tellingly, in his book *London's Historic Railway Stations*, Betjeman granted the occasional nod to Barlow, but actually bestowed the praise for St Pancras's efficiency as a working station upon Scott and his hotel.

Scott's Midland Grand, as it was, that massive curving brick cliff covered with pinnacles and finials and spirelets and tall chimneys and ranked dormers as in any Gothic horror story of the sort so beloved of us Brits, looks fine in John O'Connor's contemporary painting executed from the heights of Pentonville Road, but close up, where the quality of the detailed decoration is important, it is quickly clear that it is heartlessly machine-tooled, quite what it ought not to be since Scott's aspiration was for believable medieval-looking craftsmanship. But here instead is everything that gave Victorian Gothic its bad name. Nor is this reaction knee-jerk post-Victorian – here are the comments of the architect Reginald Blomfield (b. 1856):

> *Now the modern workman has no tradition behind him. He may be an excellent, honest man; but historically his mind is a blank, and he has little or nothing in his surroundings to suggest any beautiful fancy... [in previous centuries] throughout his work there ran a certain organic feeling, an indefinable charm of organic life, which atoned for much barbarity of feeling and gave to the architectural sculpture of the Middle Ages a vitality and distinction that are invariably absent in modern reproductions.*

He was writing about the restoration of Manchester Cathedral, but that, beautifully put, is the major problem of

Victorian Gothic and applies even to the simple leaf forms in the cold capitals of the Midland Grand.

Yet Scott's interior is immense and outweighs the vulgarity of today's rich restoration of the guest areas and renaming as the St Pancras Renaissance London Hotel; the bigger the butler-serviced suite, the worse it is (matching the imperial vulgarity and ostentation of the original, 'full of brass and assurance', as Betjeman put it). Scott's famous hotel staircase, with lovely iron grille-work supporting the wooden banisters, twisting dynamically through several floors to a star-spangled rib vault, must have risen from the depths of this cold man's memories of childhood fairy tales and could be the best thing he ever did and the most fun he ever had.

Once the terminus for the Midlands, Derby and Sheffield especially, St Pancras re-opened in 2007 as the glamorous high-speed Eurostar terminal in which the glorious 240-foot span of the Barlow train shed and its 690-foot length come into their own. There on the big day was another sculpture, the 30-foot-high *The Meeting Place*, a Mills & Boon cover of a snogging couple rendered in bronze by Paul Day. As Antony Gormley put it, making a broader point about too much public sculpture, 'a very good example of the crap out there'. Curiously, as a late addition to the four sides of the plinth, Day added a small sculpted frieze of the passing show of Londoners and their railways, full of Hogarthian life and fun.

EUSTON ROAD, NW1 2AR

## SIR JOHN SOANE'S GRAVE, ST PANCRAS OLD CHURCH

*The gaiety of an architect's grave*

One of John Soane's most renowned works is the mausoleum he built in Dulwich, at the heart of the art gallery. The gallery holds Sir Francis Bourgeois's soul, residing in his remarkable collection of paintings; the mausoleum houses his mortal remains. Another of Soane's mausoleums is just about his least-known work, the much smaller but scarcely less remarkable edifice he built for his wife Elizabeth in the grounds of St Pancras Old Church. Actually, the church is known by this name to distinguish it from St Pancras New Church in Euston Road (see page 496), and is only as old as its pastiche Norman rebuilding in 1848; but an altar stone found at that time and now displayed in the church suggests an original very early foundation in the seventh century.

Both Elizabeth and their son John died some years before Soane himself, and they were entombed in vaults beneath this odd sarcophagus. Soane joined them in 1837, aged 83. 'Odd' is the word people commonly use to describe his austere architecture. Let's opt instead for 'idiosyncratic', which allows for his peculiar genius. So much of his work has been destroyed, notably at the Bank of England (see page 52). Fortunately, when the railway lines pushed out of St Pancras

*The staircase twisting through several floors to a star-spangled rib vault at St Pancras Renaissance London Hotel could be the most fun the architect G. G. Scott ever had.*

station in the 1860s and lopped off a chunk of the old churchyard, Soane's mausoleum remained safely within its protective circle of iron railings – as old, probably, as the big lime trees and London planes among which it stands. Incidentally, the young Thomas Hardy, then an apprentice architect, oversaw the arrangement of a decorative scrum of rescued gravestones through which a lone ash tree has grown. The ensemble survives.

Within a balustraded enclosure the mausoleum comprises a memorial stele contained in a temple-like structure with a shallow gabled roof supported on Ionic columns. This itself is contained under a canopied roof with a drum at the centre surrounded by a tail-eating snake (Ouroborus, the symbol of eternity) and a pineapple finial. Four more squared-off columns support the canopy and the capitals, with the Ionic form almost friskily incised into their surfaces, like nothing else so much as a classical motif lightly sketched by the cartoonist Osbert Lancaster, of Maudie Littlehampton fame. No other architect before the Postmodernists indulged himself as playfully as this, but Soane's counterpoint of gaiety and gravity leaves the levity of Postmodernists looking elephantine by comparison; though not Hardy, who wrote on behalf of the long-dead some time after the experience of working at St Pancras:

> *O passenger, pray list and catch*
> *Our sighs and piteous groans,*
> *Half stifled in this jumbled patch*
> *Of wrenched memorial stones!*

PANCRAS ROAD, NW1 1UL

## CERAMICS BY GILBERT BAYES, SOMERS TOWN

*A Renaissance ceramicist for modern London*

Gilbert Bayes is the twentieth century's Luca della Robbia, the fifteenth-century Florentine sculptor whose big-selling line was sweet polychrome-glazed terracotta plaques of the Madonna and Child, and whose reputation has survived without his ever pretending to be Donatello. Bayes (b. 1872) was firmly set as a follower of Alfred Gilbert and his mentor George Frampton, practitioners of the New Sculpture, frequently indistinguishable from Art Nouveau and Arts and Crafts. In the inter-war years he produced a huge quantity of ornamental sculpture of which his most ebullient work is the *Queen of Time* clock at Selfridges (see page 195). There was also the 120-foot-long artificial stone frieze *Drama through the Ages*, produced for what is now the Odeon on Shaftesbury Avenue, devised after a productive study of the unparalleled Ancient Assyrian reliefs in the British Museum. Most pertinently, Bayes made the ceramic frieze, now in the V&A, for the defunct Royal Doulton building near the Albert Embankment.

He benefited from the Doulton connection and during the 1930s made decorative ceramics for new housing in the notorious nineteenth-century slum of Somers Town. There's a glazed terracotta plaque of the *Madonna and Child* above the entrance to the St Mary's block of flats, which lies east of Eversholt Street, the road running up the side of

Euston Station, and straddles a space between Doric Way and Drummond Crescent. Bayes's Madonna is a fresh-faced, modern young lady; two cheeky *bambini* poke their heads out from beneath the skirts of her Renaissance gown, and her son stands confidently in her lap, as much infant Peter Pan as the infant Jesus, which neatly draws together the Frampton and Della Robbia threads.

Most of the surviving work is among the blocks further north off Chalton Street; these back on to the surrounding roads with grim defensiveness but show an altogether more charming face viewed from courtyards within. There is a complex of St Michael's, St George's, St Nicholas's, St Anthony's and St Francis's blocks. Here, St George pinions a pantomime dragon, and round about are scenes from Hans Andersen: the Swan Princess, the Soldier and the Princess from 'The Tinderbox', and the Little Mermaid. The jewel among these works is a clock fixed to a balcony. It has feather-tipped hands pointing to Roman numerals, an hour glass above, a copper bowl with Art Nouveau flames, and four little boys representing the seasons: Spring sniffing a tulip, Summer eating cherries, Autumn bearing a sickle and a sheaf of corn, and Winter, swaddled in blue, warming his hands at the bowl of flames. Watch out for ceramic finials of birds, beasts and ships to the washing poles; many of them were popular enough to vanish.

SOMERS TOWN, NW1

## CARRERAS CIGARETTE FACTORY

*Ancient Egypt embraces the jazz age*

The Jazz Age craze for all things Egyptian came at just the right time for Carreras cigarettes. The company opened its newly built headquarters and factory opposite Mornington Crescent in 1928 in the slipstream of Howard Carter's discovery of Tutankhamun's tomb in 1922. So the building was not just a factory, it was an exploitation of Egyptian pharaonic decorative motifs on the grand scale. And the two alert eight-and-a-half-foot black cats, ears pricked, guarding the main entrance are not giant pet pussies, even if they look like it, but representations of the feline goddess of protection, Bastet; a couple of their smaller but rather older sisters are on display in the Petrie Museum at University College London (see page 127). Carreras manufactured two of the biggest-selling brands of the first half of the twentieth century: Craven A and Black Cat, each with a cat on the packet. They were named after the nineteenth-century Lord Craven whose favourite tobacco mix, allegedly, came from Carreras. Naturally, the commercial meaning of the Carreras Building's cats was obvious to anyone who ever posed at a party with a sinful Craven A as an accessory.

The residents of Mornington Crescent probably said 'Player's, please' in their tobacconist's, not just because of the gaudy bulk of the factory plonked down before them but because the black cat took a large bite out of what had once

been an attractive public garden. The architect was Marcus Collins, a specialist in building synagogues, with his son Owen Collins and A. G. Porri. Porri had actually designed a Neo-classical monster for Carreras; Marcus saw the original designs and smartly produced alternative Egyptian-themed drawings, so Porri was written off, or down, as consultant, and the Collinses snatched the glory with their massive pillars (elongated versions of the ancient tomb of Akhenaten of Panehsy, seal bearer of Lower Egypt), colouring of maroon, mauve, green and sky blue against the white stucco ramped up several pitches higher than ever it was in Egyptian tombs, with the two big cat guardians and small cat heads studding the façade.

Craven A dropped out of the British market after the war and in 1959 Rothmans took over from Carreras and moved out to Essex. The cat factory became business premises and as, after around three millennia, Egypt had dropped out of fashion, the new owners stripped the building of all Egyptian attributes. In 1996 another management company took over the building and restored it beautifully (with replicas of the original cats). It might be an exaggeration to say that over time cigarettes, even Craven A, killed more soldiers of the two world wars than died in combat, but it's a nice irony that one of the businesses currently occupying the restored Carreras building is the British Heart Foundation.

GREATER LONDON HOUSE,
180 HAMPSTEAD ROAD, NW1 7AW

## MORNINGTON CRESCENT UNDERGROUND STATION

### A Yank in London

Mornington Crescent held a special attraction for artists in the late-Victorian and Edwardian period: its cheapness. Walter Sickert lived here and drew in other English Post-Impressionist artists who together formed the Camden Town Group. In 1910 Spencer Gore painted the emblematic view from his rooms looking out across the garden of the crescent directly at the gleaming ox-blood red tiles of Mornington Crescent Tube station. In 2009 this station reopened after closure for refurbishment since the early 1990s. It is the finest reminder we have of the period of the London Underground's emergence from prehistory, when a crooked financier from Philadelphia took over a large part of the city's internal railway system, electrified it, then bored, drilled and built whole new lines that would pass under the greatest metropolis in the world without choking its passengers with smoke.

This Yank in London was Charles Tyson Yerkes. He had bracketed a spell in jail between blowing one fortune and making another, the second made from revamping Chicago's transport system. He reputedly resorted there to crude bullying, up to and including blackmail, and departed amidst howls of execration from the Windy City's ungrateful population, with his eyes already fixed across the Atlantic. He arrived in London in 1900, gathered to his bosom a shrewd banker, a lawyer with special expertise in Parliamentary procedure, and a young almost unknown architect called Leslie Green (1875–1908).

Yerkes gave Green, only recently emerged from an apprenticeship with his father and a trip to Paris to examine the wonders of Art Nouveau, the job of creating a house style for the new Underground system. The architectural template Green devised was flexible enough to allow modification from station to station and to become the face of the Yerkes-owned, indispensable, amalgamated, astonishing new Underground Railway: the two-storey structures, the blood-red faience tile cladding over steel frames, the bold Arts and Crafts semi-circular windows, the green-tiled booking halls with discreet Paris Metro details at the ticket-office windows. Green began work in 1903 and by the time he died in 1908, cut off by tuberculosis, the project was well under way.

Mornington Crescent opened that year so it was the latest thing in railway design when Gore painted its portrait. The ox-blood red stations remain all over London: at Hampstead, where the Tube is dug so deep they probably send caged canaries down in the lifts in the early mornings to test for oxygen; Aldwych, now closed but refurbished for film crews and groups of visitors; Edgware Road, Tufnell Park, South Kensington, Holloway Road and others, still an indispensable part of the London scene. Yerkes died three years before Green and, true to form, left financial chaos behind. Yerkes's

---

The eight-foot black cats at the Carreras Cigarette Factory could be escapees from cigarette packets or images of the Egyptian goddess of protection. The building is Art Deco Egyptian.

baby, the Underground Electric Railways Company of London Ltd, sued him across the Atlantic and beyond the grave for $800,000. The first biography of Yerkes was published in 2008. Its title is *Robber Baron*; but, as he himself predicted, London did all right out of him.

EVERSHOLT STREET, NW1

## JEWISH MUSEUM

*The history of a people who made themselves indispensable*

Jewish economic utility was fundamental as far back as the Conquest: William I needed a big military establishment, the church needed to build extensively, and Jews could come up with the cash when usury was forbidden to Christians. Edward I deported them en masse in 1290 when their usefulness became secondary to their unpopularity, but since Oliver Cromwell readmitted them they have remained. Yet the 2001 census recorded only 266,740 British subjects professing Jewishness at a time when the Muslim population was 1.5 million (ten years later up to 2.7 million). However, the official questionnaire asked only about religious observance, and there are many non-professing Jews.

Either way, Jewish culture is rooted deeply in Britain, and the point is well made by the Jewish Museum in Camden, presided over by Epstein's bronze bust of Chaim Weizmann, whose Zionist aspirations led to the creation of the new Israel with Weizmann as its first president. The strongest secular seam in the museum is its collection of mementoes from a pre-Bengali East End when synagogues, food shops and restaurants, markets and Yiddish theatres, proliferated close enough to the docks to be easily recognisable when the passenger boats arrived from mainland Europe with their cargoes of Jewish refugees. The museum takes joy and disaster, the bedfellows of the race, and puts them together with the life of an Auschwitz survivor, Leon Greenman (whose mother and little brother Barney died in the Holocaust) as exemplars.

From the eighteenth and early nineteenth centuries come pretty pottery figures of Jewish pedlars and street entertainers, a Minton piece of a pedlar and a Rockingham china representation of a moneychanger. The Jewish boxing champion Daniel Mendoza, from 3 Paradise Row in Bethnal Green, appears as decoration on a jug by John Aynsley of Stoke-on-Trent, displayed in front of a sporting print by C. R. Ryley of Mendoza fighting Richard Humphreys in one of three contests of which he lost the first and won the other two. Mendoza the Jew, he billed himself in proud defiance (see page 460).

Inevitably religion is at the heart of the museum's holdings, in particular beautiful silver and gold holy vessels of observance. The most splendid single item is a seventeenth- or eighteenth-century synagogue ark, recovered from its use as a wardrobe in Chillingham Castle in Northumberland. The museum guesses that it is from that meeting place of Western and Eastern cultures, the Venetian ghetto, where an English milord most likely picked it up on his Grand Tour and brought it home. It is or was one of the first works of art in the museum when it

opened in 1932. The ark was devised to hold the Torah, the five Books of Moses, the scrolls contained in silver cases. It is made of walnut, gilded and marbled with decoration in carved relief. Above the doors a cartouche frames a Hebrew inscription that admonishes: 'Know before whom you stand'.

RAYMOND BURTON HOUSE, 129–131 ALBERT STREET, NW1 7NB

## MURAL BY IVON HITCHENS, CECIL SHARP HOUSE

*A mural to create a song and dance about*

Reclaimed after the Second World War by the deserving rich, the stuccoed squares, crescents and terraces of Camden Town, north of London Zoo, admirably conceal their gaudier past as the home of piano manufacturing as well as Alfred Doolittle's 'undeserving poor'. Modernist heroes like Serge Chermayeff and Ernö Goldfinger each built a house in the neighbourhood. They fit in, but H. M. Fletcher's Georgian-esque redbrick building of 1929 at the V-junction between Regent's Park Road and Gloucester Avenue, big and fudged, feels like an intruder. The *faux* pub sign outside tells pedestrians that this is Cecil Sharp House, headquarters of the English Folk Dance and Song Society, which Sharp pulled together from separate organisations. Yet, while the building itself is nothing special, it does contain an unparalleled collection of folk material in the Vaughan Williams Memorial Library, and in the Kennedy Hall a mural by Ivon Hitchens (1893–1979), celebrating folk song and dance, a notion which, given the nature of modern art, does not necessarily raise the spirits; yet this is among the best of all English twentieth-century paintings.

It runs the length of the hall. Hitchens himself said it was 20 foot high and 69 foot wide, though his entry in the *Oxford Dictionary of National Biography* puts it at 16 foot high and 82 foot wide. It is an extraordinarily fluid composition, pulsing rhythmically across the face of the canvas: a patch of blue with a flash of white suggesting a pool of water, leaf shapes against white, a leg, an arm appearing as though fleetingly, the head of a startled deer brushed in like a hieroglyph. So it is landscape-based but abstract, mostly in beautiful modulations of blue and green with warmer passages of earth colours, fluid and tactile with paints scrubbed on. The wonder is not that he kept control of it while painting it on six-foot widths of canvas strips to be fitted together on the wall at Cecil Sharp House; after all, he used the age-old technique of squaring off a working sketch and transferring the sized-up squares on to the actual canvas. No, the wonder is that Hitchens painted it as freshly as though it was one of his small Sussex canvases knocked out in the open air.

It's based on the tiny bit of woodland near Petworth where he and his wife made a home and where he worked for the last 40 years of his life. He was at his peak in the early 1950s when British painting was struggling with the breakthrough to abstraction, but he was never part of this. Where he reached was where he wanted to be, too abstract for the last three of a sequence of hopeless Tate

directors before Norman Reid; too rooted in landscape for the younger generation of artists wowed by post-war American art. But Hitchens is the real thing and, against expectation from a painter of small canvases, though gentler than Abstract Expressionism, this mural has everything. It is stupendously accomplished, something to create a song and dance about.

2 REGENT'S PARK ROAD, NW1 7AY

## CARLTON CINEMA, ESSEX ROAD

*Surfing the crest of an Egyptian wave*

I am the man on the Clapham omnibus, edging northwards through Islington, gloomily surveying the street scene as it becomes dingier by the yard, until a sudden flash of light and colour transforms it in close-up to a vision more of Luxor than of Essex Road. There on the left is a vision translated from the Egypt of the late 1300s BC. Translated, that is, into a 1930s picture palace called the Carlton, by the cinema architect George Coles (1884–1963).

Coles was Dalston-born, educated at Leyton and the Regent Street Poly, already 25 years old and just admitted to the Society of Architects when the government's Cinematograph Act took effect on 1 January 1910. The impetus the act gave to cinema building seized Coles's imagination and turned him into the first and best specialist in the field in Britain, with the unwanted battle honour of having had most of his work destroyed since. So Coles's name lives on only in the memories of cinema buffs and in his few surviving mostly Art Deco (never art house) cinemas, the most extraordinary of them the Carlton, covered in ceramic tiles of white, gold, azure, scarlet; stylised lotus patterning at the foot of the two swollen columns morphing into a ziz-zag frieze wrapped around the façade; the tall window embrasures golden. The whole edifice is a take on great temples like Karnak, but the gateway set between two columns replicating the Egyptian originals is lofted above the cinema's entrance canopy and set into the massive recess of the faux gateway to a mausoleum, all flanked by two big inclined towers.

It's pure kitsch, exoticism for exoticism's sake, but it caught the spirit of the hour. It was not a first-time craze: Napoleon's adventures along the Nile had seized the imagination of his contemporaries – there remains an inventive early nineteenth-century Egyptian dining room at Goodwood House, for instance – but it was fresh minted in 1922 when the spectacular Grauman's Egyptian Theatre opened in Hollywood and conquered the West, and Howard Carter performed the biggest archaeological coup of all in discovering Tutankhamun's tomb. Press and public were agog. For Coles, this was manna from heaven and he designed not one but two Egyptian-styled theatres (the other, at Upton Park, was bombed in the Second World War).

Well, the vision from the 38 bus is partly a momentary illusion. Splendid the old Carlton remains, but now even the sad fig leaf of bingo that was bestowed upon it after the post-Second World War slump in cinema's popularity has been torn

away. The side walls must always have been stark brick with a mess of boiler pipes, guttering and steel-framed windows visible, and after years of neglect the wraparound façade is muckily stained, the Mecca lettering on the canopy discordant. It's like Gloria Swanson playing the faded old silent star Norma Desmond in *Sunset Boulevard*. But it is listed and at the time of writing a church is negotiating for the lease.

161–9 ESSEX ROAD, N1 2SN

## ESTORICK COLLECTION OF MODERN ITALIAN ART

*The stillness at the heart of movement in the art of Gino Severini*

The spirit of Benito Mussolini taints the bombastic exhortations of the Futurists before the First World War, the exultation in war and speed, the glorying in machines, the denunciations of past cultures. And yet so much of what they prefigured came to pass: mass movement across the world, the slaughter of great wars, the triumph of art by diktat, the conquest of the world by capital, the new weightless architecture to go with lighter-than-air flying machines. But what of the art of the Futurist Manifesto, the art of a 'racing motor car, its frame adorned with great pipes, like snakes with explosive breath', 'the nocturnal vibrations of arsenals and workshops beneath their violent electric moons', and the aeroplane, 'the sound of whose propeller is like the flapping of flags and the applause of an enthusiastic crowd'? Some beautiful paintings and drawings of tautly organised abstract shapes, that's what. Some splendid visions of the Città Nuova by the architect Antonio Sant'Elia, who fell in the First World War before he could build a single thing. A fine quasi-Cubist sculpture by Umberto Boccione called *Development of a Bottle in Space* and a more nearly Futurist one called *Unique Forms of Continuity in Space*, which tries to fly but stays rooted. He too died in the war before he could take his inventions any further.

Eric Estorick (1913–93) became active as a collector when he came to England after the Second World War from his native Brooklyn to write a biography of Clement Attlee's Chancellor of the Exchequer, Stafford Cripps. He began to collect art and especially the work of the Futurists, which he discovered while on honeymoon with his wife Salome in Switzerland. In 1988 he converted his house into a gallery to display his collection. It is a villa of *c.* 1805 in Canonbury Square, a fine development largely designed by Henry Leroux, a Stoke Newington architect (the artists Duncan Grant and Vanessa Bell would later live in the square). Among the art collection is *Dancer (Ballerina + Sea)*, by Gino Severini (1883–1966), a wholly successful abstraction of the energy of a dancer's movements, like a sequence of photographs by Eadweard Muybridge of a woman in motion, but here gathered into a single image. Severini worked with oils, gouache, and black wash for different surface effects, and the brown tonality interrupted by thin patches of blue is the work of an artist with a real feeling for paint.

39A CANONBURY SQUARE, N1 2AN

# Railway Terminuses

The circle of railway terminuses on John Tallis's map of 1851 shows them to be the gateways to London, just as the named gates of Roman and medieval London define the City as it still is. The difference is that the Romans would have made a better job of the railway stations. From the beginning most of these have been a mess; but, some of them, loved for all that. From the west in a rough loop around Victorian London there are Paddington, Marylebone, Euston, St Pancras, King's Cross, Liverpool Street, Fenchurch Street, London Bridge, Cannon Street, Blackfriars, Charing Cross, Waterloo (twentieth-century) and Victoria.

The earliest was London Bridge. It opened in 1836, 11 years after the Stockton and Darlington Railway advertised the possibility of transporting large numbers of people between towns. The Liverpool and Manchester Railway cottoned on swiftly, and the US and France before Belgium, Russia and Germany in the 1830s. London Bridge had no international ambitions: its first target was Greenwich, three miles away. Blackfriars did, and boasted exotic destinations from Bromley and Bickley to Berlin to Baden Baden to Nice. Passengers hardly need to book for South London now: they can alight in Southwark because the rebuilt station magnificently carries its platforms right across the Thames.

London Bridge has begun to sort out 180 years of chaos, with different lines at first competing for space, the station itself growing piecemeal, an added Underground station that was difficult to find, a squeezed and disorderly concourse handling 50 million passengers a year. The outstanding feature, suggested by a lieutenant-colonel of the Royal Engineers, will remain: the massive and splendid brick viaduct on which the station stands.

London Bridge is the only pre-Victorian station in the capital. All the other nineteenth-century terminuses fall between Euston (1837, a month after the Queen's coronation) and Marylebone (1899). The uproar following British Rail's massacre of Euston in the 1970s stymied its plans to do the same to St Pancras and King's Cross. St Pancras, of course, had been spatchcocked together from two opposing conceptions, George Gilbert Scott's gross Gothic hotel and William Henry Barlow's utterly rational train shed. Next door, King's Cross was built by the engineer Lewis Cubitt, who specifically said that he sought 'fitness for purpose'. The Bauhaus meister Walter Gropius could hardly have put it more plainly. Joyless-sounding, bracing in fact. Paddington rivals St Pancras's Barlow shed, and outbids all others for its magnificent First World War memorial as well as for inspiring both Frith's documentary canvas *The Railway Station* (1862) and also Michael Bond's Paddington Bear.

Victoria has some of the chaos of London Bridge because it is basically two stations squashed together, both crummily refurbished. One is for Brighton and surrounds, one for Kent, so that two streams of disembarking passengers cut across each other heading en masse for the same Underground and the same buses. The Kent side also handled troop movements in both world wars and, between them, the Golden Arrow to Dover, connecting by boat with the Flèche d'Or at Calais; also the Pullman Orient Express that still runs on occasion to Venice and Istanbul from Platform 2 (don't ask at Blackfriars).

Liverpool Street serves East Anglia's wide

open spaces, plus, small to medium, Ely, Cambridge, Ipswich and Norwich. Its neighbour, Broad Street, was knocked down in 1986. Liverpool Street was refurbished and tied in with the spectacular business square, Broadgate, its own best features restored, like the iron arabesques adorning the train sheds, frankly modern restaurants and shops, two towers at the Bishopsgate entrance imitation-Victorian-imitation-Gothic – who would have thought to see the day?

At Waterloo, the outstanding feature is Nicholas Grimshaw's banana-bend train shed built for Eurostar (1993) and mothballed in 2007 when all Euro services were shifted to St Pancras. There were no contingency plans, so what's left is £120 million-worth of junk. Still, it looks terrific from the traffic island below.

Barlow's great train shed at St Pancras, completed in 1868, merges seamlessly with the elegant new Eurostar terminal (2007): master plan by Foster, lead architect Alistair Lansley.

## • HAMPSTEAD, HIGHGATE, HAMPSTEAD GARDEN SUBURB •

### FREUD MUSEUM

*The most famous couch in history*

One of the temporary exhibitions that the Freud Museum called *Objects in Mind* was a couple of vitrines of frisky 3D arrangements of cut-out watercolours by Robert Poulter, simulating Sigmund Freud's visit to the National Portrait Gallery in 1907. Freud kept notes of his visit, and the most surprising, included among Poulter's explanatory texts, was that the great man concluded that faces did not show people as they really were (Hitler's face might have changed his mind). Indeed, he thought Shakespeare didn't even look English: a view based on the gallery's prize portrait, of about 1610, and the only Shakespeare 'likeness', possibly taken from life, showing him wearing a piratical earring like a 1960s Hastings fisherman. Obviously Freud's views on physiognomy were no more insightful than the next man's; merely a Freudian blip.

It cannot, then, have mattered that he hid his own face when he sat behind his patients as they reclined on the world's most famous couch. In fact, he arranged it thus so that should he register emotion it would not be visible to them. Following his escape to London from Vienna with Martha, his wife, and their youngest daughter, Anna, in 1938, the couch, like his desk, his chair, his statuettes and objects from Ancient Egypt, Greece, Rome, Japan and China, and the hundreds

of books in the cases lining the walls, all arrived at 20 Maresfield Gardens from Berggasse 19 once Freud's dear friend and follower Princess Marie Bonaparte, great-grandniece of Napoleon, had paid the Nazi ransom on his behalf. The only patient who had not delved into his subconscious mind on this couch was Freud himself, though he certainly carried out a self-analysis starting in the early 1890s, which yielded both the first psychoanalytical case history and Freud's term 'psychoanalysis'.

When Freud sat at his desk in the study at Maresfield Gardens, he had an array of art objects facing him. He was, the small matter of genius apart, a perfectly ordinary rich Viennese bourgeois, which is as bourgeois as a bourgeois can be, and he had assembled his worldwide collection from Viennese dealers. None of the objects is very special though many are beautiful, these statuettes of Venus, of Artemis, of a falcon-headed figure, red- and black-figured Greek pottery, jars and bottles for scents and unguents, netsukes, reliquaries, a terracotta camel, an oil lamp, a ring. He welcomed them like old friends to his new Hampstead home, a wide nineteenth-century Queen Anne Revival house with a town garden at the back that he loved. As Freud might have conceded, the collection looks like an obsession. Dali visited him and the two men fenced verbally as Dali made a sketch. Later he sent the finished drawing but Freud's assistants hid it

The Nazi ransom on the father of consultation couches was paid for Freud by a great-grandniece of Napoleon, and is in his study in what is now the Freud Museum.

from him; they thought it foreshadowed death. Freud already knew all about that and only a year later, in September 1939, with his cancer and heart problems closing in on him, he called on his doctor to administer a last injection of morphine.

20 MARESFIELD GARDENS, NW3 5SX

## ST JOHN-AT-HAMPSTEAD

*Where luvvies come to rest in peace*

At the end of one of the finest streets in England, eighteenth-century Church Row in Hampstead, is St John-at-Hampstead, a hotchpotch from its inception (1745–7), starting with the tower at the east end because the ground slopes away at the west. A hotchpotch of ornament within too, of painting and sculpture. The best of all this are the early carved memorials, by the younger John Bacon and the elder Richard Westmacott, just as the acre or so of graveyard holds most of the interest. This is still essentially a country churchyard, typical, except that while Hampstead doubtless had its share of rude forefathers, in essence this is the last resting place of luvviedom: actors and artists, playwrights and novelists, comedians, and even politicians. Here lie Kay Kendall, delicious mid-century comedienne, fondly remembered for her booze-fuelled trumpet playing in *Genevieve*, the film that made her name, dead of leukaemia at 32; Hugh Gaitskell, 'the best prime minister we never had' and a womaniser to rival Lloyd George; Anton Walbrook, an Austrian player in Max Reinhardt's Berlin company who

fled to England and out of his versatility fashioned a career in English stage and cinema; Peter Cook, whose deathless stand-up comedy savaged the politicians and press of the Macmillan era and later; George du Maurier, the Victorian illustrator, novelist, and *Punch* cartoonist, who perpetrated in the caption to a cartoon of a bishop and a curate at the tea table the smelliest joke in the language:

> Right Reverend Host: 'I'm afraid you've got a bad egg, Mr. Jones!'
> The Curate: 'Oh no, My Lord, I assure you! Parts of it are excellent!'

This in turn produced the cliché about the curate's egg (good in parts) that surfaces to this day. Thank you and goodnight.

Many more of the great and good join this select few, but among them the one indisputable genius is John Constable (1776–1837), the greatest painter of skies there ever was – hundreds of cloudy skies painted from Hampstead Heath, dashed down on canvas, board, even planks of wood, some of them with drifting rain squalls that prompted his contemporary Henry Fuseli to remark before a Constable painting that he wished he had an umbrella with him.

Constable lies humbly at the bottom of the churchyard alongside his loved and lamented young wife Maria Bicknell, beneath a sober tomb. He had come to London to make a living and had a home and studio at 76 (now 35) Charlotte Street (now demolished), but Maria's health was so bad that he rented 6 (now 40) Well Walk in hilly Hampstead for her, then found that it was everything he needed too. As he wrote in a letter to his friend Bishop John Fisher, 'our little drawing

room commands a view unequalled in Europe – from Westminster Abbey to Gravesend. The dome of St Paul's in the air realises Michelangelo's idea on seeing that of the Pantheon – "I will build such a thing in the sky"'. He developed as deep an affinity with the views from the heath as for his native country of East Bergholt and Dedham, and it survived Maria's death of tuberculosis at the age of 41 in 1828, leaving Constable with their seven children.

CHURCH ROW, NW3 6UU

## FENTON HOUSE

*The happy accidents of
the Fenton House collections*

From the early 1960s the actor Peter Barkworth lived in Flask Walk; his stage and screen career was already flourishing when he moved in. When he died in 2006 he was worth more than £2.5 million, a disgrace to all resting actors. This he left to the National Trust together with his collection of British art, including a Constable cloud study (over Hampstead Heath?), but mainly paintings by the Camden Town Group: Harold Gilman, Robert Bevan, Spencer Gore, W. R. Sickert, and a view of Flask Walk by Charles Ginner, an obvious target for Barkworth. The trust placed them in Fenton House, a few minutes' climb from Barkworth's house to the top of Holly Hill, with two other imports, the fine Benton Fletcher collection of early keyboard instruments and a group of paintings by William Nicholson commissioned by his friend the early twentieth-century collector T. W. Bacon and now on loan from the Bacon family. It includes a simply sumptuous flower-piece in the rich tradition of Manet and Fantin-Latour.

The house itself is among Hampstead's best: William and Mary, five bays of brownish-red brick with redbrick-dressed windows and string courses, approached from the south through elaborate gates made under the influence of Jean Tijou and along a tree-lined drive. To the north of the house is a National Trust reconstruction of a seventeenth-century garden.

From 1686, the probable date of Fenton House's building, until 1952, when its last owner, Lady Binning, gave it to the National Trust, it had been home to lawyers, bankers, merchants, builders, sugar and tobacco importers and slave traders – James Fenton, the man whose name the house takes, was a Baltic merchant of London and Riga. Many of them were collectors or just accumulators in one way or another of furniture, porcelain, paintings, prints – there's an impression here from 1525 of an engraving by Dürer (d. 1528). This is the kind of stuff that moved in and out and left a silting of this and that while great treasures from the house washed up at the National Gallery, the V&A, and the Royal Museum of Scotland in Edinburgh. On the staircase is the fading memory of an ancient scandal: a copy of a Thomas Lawrence portrait of William

According to Constable, his Hampstead cottage's drawing room had the finest view in Europe. His tomb in the churchyard of St John-at-Hampstead is as sweetly rural as any town grave could be.

IV and his two sons by the actress Dorothy Jordan (of whom the publisher Rupert Hart-Davis was a descendant). A late, light Sickert illustrating the duet *Là ci darem la mano* ('There, we will hold hands') from *Don Giovanni* sings in tune with two showcases of Rococo Meissen statuettes not far in spirit from Watteau, and a late-Impressionist flowerpiece by the queen of the Scots domestic interior, Anne Redpath (1895–1965), sits close to the flowerpiece by Nicholson (1872–1949). It all hangs together quite casually, so there must be some divine guiding taste behind it.

HAMPSTEAD GROVE, NW3 6SP

## 2 WILLOW ROAD

*Goldfinger's utopian machine for living*

The architect Ernö Goldfinger once sued his near neighbour in Hampstead, Ian Fleming, over the publication of his seventh 007 thriller, which borrowed Goldfinger's name for its title and its villain, who was billed succinctly on the paperback cover as 'James Bond's most devilish adversary – an evil genius with a lust for gold'. A colleague of Goldfinger told him the only difference he could spot between the two was that one was called Ernö and the other Auric. Ernö settled for his costs and six copies of the book; and Fleming had to be talked out of renaming his character Goldprick.

In point of fact, Ernö Goldfinger was a utopian Marxist, comfortably reconciling this with marriage to a wife, Ursula Blackwell, who was a tinned soup heiress. After the war he built the glorious Trellick Tower as what's now known as affordable housing (see page 248). In 1937 he had built 1, 2 and 3 Willow Road, with windows running the width of the house, the structure concrete but brick-clad, subtly detailed, and inspired by his admiration for the continuity in design of Georgian terraces. He sold numbers 1 and 3; number 2 was for himself and his family. Ernö died in 1987, Ursula a little later, and the National Trust acquired this, its first Modernist house, in 1994 with a large part of the original furnishings and works of art still in place.

Goldfinger had made a wide circle of friends in the artistic community of Paris, where he went from Budapest to study in 1921 (here he met Ursula), and in Hampstead, home to Henry Moore, Ben Nicholson and Barbara Hepworth, and increasingly to artist refugees from the gathering clouds of war in Europe. Two framed photographs by Man Ray of Ursula are in the living room along with a portrait drawing of Goldfinger by the English Surrealist Eileen Agar; there are drawings by Amédée Ozenfant, the French founder with Le Corbusier of Purism, in the dining room, with paintings by Prunella Clough and Bridget Riley, a drawn version of Robert Delaunay's refracted prism paintings of the Eiffel Tower, a surrealist collage by Roland Penrose featuring the nude torso of his wife, Lee Miller, and a tiny sculpture by Henry Moore.

Some of the furniture Goldfinger made has aged and dated; other pieces are still wonderful, like the desk in his study with its drawers that swivel open instead

of pulling out. Walls fold back between rooms so that intimate spaces become a great party arena (and there were plenty of parties). The spiral staircase, top-lit and ultra-modern, is a take on the medieval practice of installing space-saving newel stairs. My personal benchmark for the beautiful ingenuity of Modernist domestic architecture is the Marseilles flats in Le Corbusier's Unité d'habitation, one of which I was lucky enough to be shown round by its owners. Corbusier was a genius not just in the framing of his buildings but in his use of space, even confined space, within. As Trellick Tower demonstrates, Goldfinger developed into a master of monumental architecture but not especially in his disposal of rooms or of close detail. So he isn't Corbusier, but 70 years after its conception, 2 Willow Road stands as a concrete example of a turning point in the cultural history of England.

2 WILLOW ROAD, NW3 1TH

## KEATS HOUSE

*The house where Keats spent his tortured final years*

In 1818 John Keats had been living with his younger brothers George and Tom in Well Street, Hampstead, but by the end of the year George had married and moved to America and Tom had died of tuberculosis. Already sickening of the TB that would kill him too, Keats moved into Wentworth Place in John Street (now Keats House and Keats Grove) at the invitation of his friend, Charles Brown. Keats Grove forks off Downshire Hill and runs down to the heath; near the bottom Wentworth Place was built in the winter of 1815–16 to look like a small but handsome Regency villa with a central front door and practically floor-to-ceiling windows set into blind arches: one on each side of the door; so as a semi-detached house each dwelling had a big front room with a lovely window overlooking a small garden. Keats moved in to live in one half of the house with Brown, and soon after, as fate would have it, Fanny Brawne and her mother moved in to the other half. Keats fell in love with Fanny, wrote some of his finest poetry with a passion to cheat death, but saw the spot on his bedsheet which he recognised at once as arterial blood and said to Brown, 'That drop of blood is my death-warrant; I must die.' In September 1820 Keats boarded the brig *Maria Crowther* for Naples, hoping to stave off the inevitable. From here he went on to Rome, where he ended his last letter, to Brown: 'I can scarcely bid you goodbye even in a letter. I always made an awkward bow.' He died on 23 February 1821 at the age of 25 in a lodging house in the Piazza di Spagna.

He was almost unknown except to readers of the Tory literary press, which disliked him for his association with the radical Leigh Hunt; the hacks roughed up Keats to get at Hunt through him. Otherwise Keats lived in obscurity and died in poverty. That does not make for a museum stuffed with possessions evoking the life of genius. We must accept the word of his biographer Andrew Motion that the house 'is a place with an exceptionally strong spirit'; but Jane

Campion, the director of the biopic *Bright Star*, couldn't sense it and chose to film elsewhere. The rest of us must settle for the recent refurbishment relying on analysis of ancient paint samples and the rest of the paraphernalia, and a few sticks of furniture 'of the period'.

From these years, Keats House displays a portrait by William Hilton, a friend of Peter de Wint, whose sister he married; a copy of the life mask of Keats taken by the poet's friend, the tormented painter B. R. Haydon; a number of documents in Keats's hand; and, an immense fillip, the letter bought in 2011 for £96,000 by the City of London to display in the house. In it Keats wrote to Fanny: 'I shall Kiss your name and mine where your Lips have been...'

Keats never after childhood lived in a place he could truly call home and he died too young to leave a mark, so although the house is worth looking at with sympathy heightened by imagination, the way to encourage that best is to read the poetry.

10 KEATS GROVE, NW3 2RR

## KENWOOD HOUSE

*A Robert Adam mansion restored, and a great art collection*

For a few weeks before Kenwood House reopened in 2013 after a majestic refurbishment, Jan Vermeer's *The Guitar Player* hung on loan in the National Gallery as part of the exhibition *Vermeer and Music*. In November, when the

Andrew Motion says Keats House has a strong spirit. But Keats had little to leave behind, so his life mask is the liveliest object there.

house threw open its doors to the public again, *The Guitar Player* was back in the music room of Kenwood's north wing. The difference was palpable. The National Gallery show was a thoughtful contribution to the burgeoning industry of the social history of art, of which the seventeenth-century Protestant Netherlands is rich in documentary evidence, and Vermeer was the big attraction, featured on the catalogue cover. The show contained five Vermeers among paintings by Gerard ter Borch and Hendrick ter Brugghen, Jan Steen, Gabriël Metsu, Carel Fabritius, Pieter de Hooch and so on, plus a few actual period instruments. In other words Vermeer, the outstanding genius of the exhibition, was reduced by the context to part of an argument that could well have been maintained without him. Returned to the country-house atmosphere of Kenwood, *The Guitar Player* becomes one of those few masterpieces in which Vermeer, supreme among other artists in this respect, suggests in the tilt of the young woman's head and her glowing skin, the string of pearls, the corkscrew spin of the curls framing her head, the suspension in space of her hand, a whole wide universe in the particularity of this scene of a woman playing, probably, to her lover.

The Vermeer hangs in the same room as a magnificent Rembrandt self-portrait beneath a Reynolds self-portrait in Rembrandtish browns, a conjunction which nicely points up William Hazlitt's observation, published in 1830, to the ancient James Northcote, who had been a pupil of Reynolds and was an admirer

of Titian and Van Dyck, that: 'I thought Reynolds more like Rembrandt than like either Titian or Vandyke: he enveloped objects in the same brilliant haze of a previous mental conception.'

The collection is the finest in any house in England apart from Harewood and the Wallace Collection in Hertford House, which is fully adapted to being a museum (see page 196). It sits in a Jacobean house remodelled for the jurist Lord Mansfield by Robert Adam as an exceptionally lovely Neo-classical mansion with a south portico rising the full three storeys: the difference now from pre-2013 is that English Heritage has restored the interior colour schemes to Adam's original pale blues, greens, pinks and whites, and the wonderful library has had the gilding removed to the memory hole of gaudy mistakes. A short walk away in the park is the eighteenth-century dairy with a big square creamery lined with marble sinks and, out of tune with the functionality of the building, a patterned stone floor with a small back marble fountain at the centre.

Lord Iveagh (Edward Cecil Guinness, founder of the brewery) assembled the collection of paintings in about 1890, including four Boucher pastorals in the green (ante) room, in the dining room gorgeous Gainsborough portraits of great ladies making Reynolds's competing works look a touch sickly, and elsewhere works by van Dyck, Hals, and a waterscape of Dordrecht by its favourite citizen, Aelbert Cuyp. Iveagh died in 1927, leaving the house, 112 acres of parkland and the art collection to the nation. So Guinness really is good for us.

HAMPSTEAD LANE, NW3 7JR

## SPANIARDS INN

*Drinking and driving*

The Spaniards Inn looks like the country pub it once was, although today it is a few miles from open countryside north of High Barnet. A country pub for townspeople perhaps and a town pub for country folk, it straddles the border of Hampstead and Barnet on a high ridge at the north of Hampstead Heath. It is eighteenth century (though originally built in 1585), whitewashed brick, three storeys tall, and bleak, except that it has a humanisingly rural weatherboarded extension to the north-eastish side.

A small eighteenth-century tollhouse stands opposite, also whitewashed brick and so close to the pub it feels as though you could stretch out from a window in the first-floor dining room and touch it. That is an illusion, but the pinch point the two buildings create has been contentious since before the tollhouse was decommissioned in 1888, when local authorities took over road maintenance. As late as 1966 in the House of Lords, the Second Baron Colwyn asked the government to remove 'the obstruction at the Spaniards Inn'. It interfered with the cars, you see. Lord Lindgren replied on behalf of the Government by passing the buck to the GLC, Barnet and Camden, and there the buck stops, allowing for changes in local government structure. Hampstead residents have made it clear that their tollhouse is an embellishment to the local scene, and what Hampstead residents have, they hold. They are right, no question, and so, despite the abolition of tolls, drivers still pay, but in the coinage of frustration.

Unlike the great nineteenth-century London pubs with their stained glass and closely engraved mirrors, snob screens and Victorian photographs, the Spaniards has maintained its rare eighteenth-century appearance, inside as well as out: wood-panelled rooms, high-backed bench seats, blackened brick fireplaces, matchboard-lined staircase, sash windows, cushions, a few books on windowsills. There has been repair and replacement but no extensive refurbishment as the rip-it-up-and-start-again school of interior design would have it. It does have pretensions to gastro-pub status: regardless of all that, the scotch egg is a revelation.

SPANIARDS ROAD, NW3 7JJ

## HOLLY VILLAGE

*The Lady Bountiful with a banker's fortune*

Baroness Burdett-Coutts, born Angela Burdett, was famous for her generosity to anybody who was poorer than she was, which was everybody. She distributed money liberally and she built for them, here a clock tower, there a market building or a tenement block. In Shepherd's Bush, on the advice of her friend Charles Dickens, she set up a home for 'fallen women' and she supported Ragged Schools with bountiful handouts (see page 461). At her own home, Holly Lodge, high up on West Hill in Highgate, she built a village at the foot of the slope where she could gaze at it from above as she took breakfast or tea. It was a tiny village admittedly, with just a handful of dwellings set out around a little green, and very pretty indeed, if you liked that kind of thing; people did and still do. She called it Holly Village and to make the point she caused holly trees and shrubs to be planted there, and on the pointed arch of the entrance to the village, despite her reputation for giving sums of money anonymously ('from a lady'), she saw that an inscription was carved in Gothick lettering reading: 'Holly Village erected by A. G. B. Coutts A.D. 1865'. And she saw that it was good.

For the purpose of the inscription, she compressed the Burdett part of her surname to an initial (her father, Sir Francis Burdett, was a radical politician). The prominently displayed Coutts part of her name derived from her maternal grandfather, the banker Thomas Coutts, and so did pretty well the whole of her fortune. She used her Coutts money to carry out Burdett aims, so far as private charity could ever stand in for social structure. Born the year before Waterloo, she bridged the whole of the Victorian era with her philanthropy and died in 1906, the year the new Liberal government began to introduce social reforms like the dole, national insurance, sick pay and free school meals, measures that remained unchallenged for around a further hundred years.

Holly Village was for her estate workers and she chose Henry Darbishire as her architect. He had worked on Peabody blocks of flats for the poor and the release from institutionalised bleakness into the Gothick extravagance of his new patron's taste must have driven him benignly off his rocker. At Holly Village the Peabody yellow brick is transformed by diapered

patterning, decoration inset and overlaid, windows and bell openings and tall arched doorways. There are towers with strangely etiolated pinnacles at the corners and roofs that might shelter vampires. The gatehouse has three tall gables, spires, pinnacles, a curious little oriel window over the archway. Disney could have done no better. To either side of the arch stands a good statue, like medieval saints beneath a Gothick canopy, one of Miss Coutts, as she was known, the other of her former governess and lifetime friend and doctor's wife, Hannah Brown. It is expensive, secluded, and as private as the graves in near-adjacent Highgate Cemetery.

HIGHGATE, N6

## HIGHGATE CEMETERY

*Death's dominion*

Highgate, among London cemeteries, is the queen of gloom. The original west cemetery, that is; the newer east adds a touch of celebrity and glum levity. Malcolm McLaren, punk entrepreneur and fashion designer, has a tomb like a black granite juke box inscribed with the advice of one of his schoolmasters: 'Better a spectacular failure than a benign success'. The pop artist Patrick Caulfield created for himself what looks like a blue slate tomb with a ziggurat upright carved with the pronouncement D-E-A-D. Not a syllable, not a letter, too many. Quite close to this gaiety is a corner devoted to celebrated lefties. There's Paul Foot, rabble-rousing journalist and author of *Red Shelley*, the book that reclaimed the poet from the aesthetes, beneath a stone carved with a Shelley stanza inspired by the Peterloo massacre: 'Rise like lions after slumber/ In unvanquishable number/ Shake your chains to earth like dew/ Which in sleep had fallen on you/ Ye are many – they are few!' Then the grey-beard historian of the ages of capital and of empire, Eric Hobsbawm, and the reddest of the reds, Karl Marx, his wife Jenny von Westphalen and their brilliant, ill-fated daughter Eleanor Marx Aveling in a tomb topped by Lawrence Bradshaw's ungainly bust of Marx unveiled in 1956, possibly as famous in one half of the world, though smaller, as the Mount Rushmore presidential portraits are in the other half.

The chapel is directly across Swain's Lane and acts as the reception area for visitors, who must join tours of the original west cemetery (landscaped in 1839) conducted by the friends organisation that rescued it from ruin and now applies a policy of 'managed woodland' rather than restoration. This is where Galsworthy set the scene in *The Forsyte Saga* of the gathering of the clan for the funeral of their aunt Ann Forsyte:

> *From that high and sacred field, where thousands of the upper middle class lay in their last sleep, the eyes of the Forsytes travelled down across the flocks of graves. There – spreading to the distance, lay London, with no sun over it... A hundred thousand spires and houses, blurred in the great grey web of property, lay there like prostrate worshippers before the grave of this, the oldest Forsyte of them all.*

Add the Shard and the picture is much the same now. That 'high and sacred field' is centred on a cedar of Lebanon, around 300 years old and formerly part of the garden of Ashurst House, home of a lord mayor of London (and now replaced by St Michael's Church). It became the inspiration for the Circle of Lebanon, designed by the architect and gin palace promoter Stephen Geary with James Bunstone Bunning and the landscape gardener David Ramsay, with the plan of the garden cemetery falling into place around the ancient cedar: the Colonnade; the Terrace Catacombs; the Egyptian Avenue with its romantic interpretation of the architecture of Ancient Egypt. Geary and Ramsay gave the place their ultimate imprimatur by being buried here.

SWAIN'S LANE, N6 6PJ

## LAUDERDALE HOUSE

*An earl with the king in his pocket*

Having played politics south and north of the border and fought and lost at Worcester in 1649 on the side of Charles I, the Scottish nobleman John Maitland, 2nd Earl and later 1st Duke of Lauderdale, languished as a prisoner for nine years until the Restoration, and then made up for lost time. First, he settled the business of his wife Anne's house on Highgate Hill, of which she had been dispossessed through legal chicanery when his fortunes were at rock bottom. It has ever since been known as Lauderdale House, though it had stood since 1580, having had several owners before Lauderdale and many since.

Maitland was brilliant and unscrupulous, an unbeatable combination. In very short order he had taken over as Secretary of State for Scotland, had defeated his enemies in King Charles II's Cabal and had the king in his pocket. Pepys reported in 1664 that 'he was never from the King's eare nor counsel', and his undisputed view was that Lauderdale 'is a most cunning fellow'. In July 1666 Pepys visited Lauderdale House on the king's business and was dubiously entertained in this small hill village in Middlesex by a servant playing Scotch tunes on a fiddle: 'the strangest ayre that ever I heard in my life... But strange to hear my Lord Lauderdale say himself, that he had rather hear a Catt mew then [sic] the best Musique in the world ... and that of all instruments, he hates the Lute most; and next to that, the Baggpipe'. The transformation from apparent Covenanter to apparent king's man was complete.

There are still signs of the original Tudor construction of the house, but an accumulation of alterations from the seventeenth century onwards, along with rebuilding after a fire that destroyed the upper floor and roof in 1963, have made it look as though you could don it like a comfortable old dressing gown (today the house has been adapted for community use). None of the alterations can be ascribed to Maitland, who left his wife for the widowed Countess of Dysart in 1669 and set up home in the grander Ham House (see page 306).

The Tory grandee Edward Pauncefort took the Highgate lease in 1705 and installed the loveliest feature remaining: the octagonal lantern set into the roof

at the top of the stairs. Fitfully throughout the century the house's appearance was changed from Tudor to classical despite the overriding problem that no classical structure ever had a jettied first floor – this was solved in 1763 by Matthew Knapp, who turned the space under the overhang into a loggia supported by classical columns. The twentieth century's masterstroke was to take three gardens, Lauderdale's, Fairseat's and that of a third house now demolished, and turn them into a single park named after its nineteenth-century donor, Lord Waterlow. Its hillsides are dotted with trees, its valleys with lakes, and in 1889 Waterlow donated all this and the house to the then London County Council with the graceful benediction, 'a garden for the gardenless'.

WATERLOW PARK, HIGHGATE HILL, N6 5HG

## HIGHPOINT

*The rout of the purists*

When Highpoint, the block of flats at North Hill in Highgate by Berthold Lubetkin and his firm Tecton, opened in 1934, Le Corbusier himself flew over from France to anoint it with praise. He called it 'a building of the first rank', and considered it a seed of the vertical garden city that would bring a halt to the endlessly sprawling suburbs of London. Lubetkin designed it for the copying machine magnate, Sigmund Gestetner, whose plan to build it as housing for his workforce attracted the idealist in the architect. It didn't turn out that way any more than it checked the spread of the suburbs, and the rich moved in. Same old story. But at least, as architecture critics say with a shrug each time it happens, the building remains well maintained.

Gestetner made enough money to decide he would like to build a Highpoint 2, partly to stave off unsuitable development next door. This time it would be avowedly for the rich. The purists put the boot in. It was a betrayal, they cried; not so much politically as artistically. As a matter of fact, even Highpoint 1 was not a formalist building, it had lots of curves and contrapuntal axes, especially internally. But at Highpoint 2 Lubetkin taunted the purists by placing two caryatids under the entrance canopies. They were clearly supporting nothing (thus abusing the Modernist credo, form equals function) since they were casts by the British Museum from the Erychtheion in Athens. Lubetkin airily remarked that he intended them as garden ornaments; though not so much airily, perhaps, as allusively. They did mediate the world outside the front entrance, but they also referred to the ancient tradition and values of architecture. The plan of Lubetkin's own penthouse flat in Highpoint 2 is like a still life by his friend Braque (also, with its rough pine fittings, reminiscent of a Russian dacha). He saw Functionalism as fashion, and time won the argument for him.

Try booking a place on a tour during Open House weekend each September. You will see the gardens and the interiors and, with luck, one of the flats, maybe one

Corbusier placed Highpoint 1 of 1934 in the first rank of modernism, but its architect Lubetkin followed up in 1938 with Highpoint 2 – and its pair of caryatids – to taunt the purists.

HIGH POINT

of those with all the rooms arranged in two layers alongside a double-height living room with 16-foot windows overlooking gardens. A Great Hall for the flat-living classes. And maybe someone could find out for me why each entrance has freestanding letters spelling out High Point, but the buildings have thereafter always been known as Highpoint.

NORTH HILL, HIGHGATE, N6 4BA

## ST JUDE-ON-THE-HILL

*St Jude, a London church by the builder of New Delhi*

In 1905, two years after Raymond Unwin and Barry Parker's plans for Letchworth, the first garden city in the world, had been accepted, the social reformer Henrietta Barnett and her husband Canon Samuel Barnett invited Unwin to design Hampstead Garden Suburb on land they had bought to the north of Hampstead Heath. These plans survived trial by bureaucracy and the Barnetts appointed Edwin Lutyens chief architect. He built two churches (Anglican and free), a school, a memorial hall and some houses in and around Central Square. There were by a mixture of general consensus and happenstance no shops, no pubs, no cinema, no public transport. Nothing. Many of the houses are a kind of elephantinely frisky adaptation of Norman Shaw's vernacular English style at Bedford Park (see page 526), and some are terraced and some semi-detached, but spaced out at eight to an acre. During business hours there is more life to be found at Golders Green crematorium, handily placed over the road.

For Lutyens, the Church of St Jude was the main attraction of the job. The principal external stylistic reference, including the steeple with its spire marked with chevrons, is Gothic: post-Ruskin, Henrietta Barnett was convinced that this was the one true architecture of Christianity. Yet inside Lutyens went deeper, for eclectic combinations of Byzantine arches and baroque piers, a circular dome at the crossing beneath the tower and domes and apses in the east chapels trying but just failing to recapture the great dark spaces of Westminster Cathedral (see page 187) that had captivated him; not to mention the very odd olde Englishe timber beams and crown posts in the aisles. Lutyens did not particularly want interior painting, but one Walter Starmer, a war artist and friend of the army chaplain, Basil Bourchier, the first vicar of St Jude, convinced the steering committee with his scheme of decorations. He spent the years 1919–30 painting – on the ceiling in the domes, on piers, a *Last Supper* in the eastern apse. Lutyens himself wrote, or said he wrote, to an applicant in New Delhi who wanted to decorate the Viceroy's House (now the Rashtrapati Bhavan): 'I thank you so much for your letter. The only remark I can make is what a pity it is you cannot design, draw, or observe.' He might justifiably have said the same to Starmer.

Further away from Central Square the style of houses grows freer and on the fringes it is not really possible to tell

garden suburb from plain ordinary suburb. The final irony is that The Bishop's Avenue, which borders the suburb on its eastern side, is notoriously known as Millionaires' Row, with houses costing tens of millions of pounds each. They are almost all hideously exhibitionist and most are empty, owned by sheikhs who have let them stand empty and rot away.

Barnett had intended her project to provide housing for all classes. Inevitably the middle class has moved in en bloc, though it's clear that not enough of them are at St Jude's dropping coins into the collection plate to keep this huge structure open. Luckily (and Lutyens himself put it down to luck) the acoustics are excellent and attract major recording firms to book sessions in the church. Just as well, because Jude is the patron saint of lost causes.

CENTRAL SQUARE, HAMPSTEAD GARDEN SUBURB, NW11 7AH

## • HENDON, FINCHLEY, MUSWELL HILL, TOTTENHAM •

### AEROVILLE, HENDON

*A tale of heroes tamed by bureaucrats*

Aeroville is a page torn out of an almost forgotten chapter of English history. It is a single square of what was intended to be a big area of houses for workers in the nascent aircraft industry in Hendon. The begetter of this cosily christened settlement was Claude Grahame-White (1879–1959), whose biography is best encapsulated in his self-portrait for *Who's Who*, in which he described himself as 'aviator and aeronautical engineer':

> Career: Owned one of the first petrol-driven cars in England; toured South Africa; established motor engineering business in Albemarle Street; became interested in aeronautics 1909, the first Englishman granted a certificate of proficiency as an aviator; started a school of aviation at Pau, 1909 — the first British flying school ... formed the Grahame-White Aviation Company, which became proprietors of the London Aerodrome, Hendon ...

What Grahame-White didn't mention is that his enthusiasm for aviation was kindled by Louis Blériot's cross-Channel flight on 21 July 1909 (the first in a heavier-than-air machine), and that he quickly left for France and worked for two months at Blériot's Paris factory. Then he set about making a small fortune from the lavish prize money available for winning big air races, especially in the USA where he also effected a perfect landing on Executive Avenue, Washington DC, to take his bow before President Taft.

The plane he used was a Farman III, which looked like a box kite (though with a 50-horsepower engine). Aircraft were still primitive when he opened Hendon aerodrome in 1910 and when he demonstrated the possibilities of aerial defence to a parliamentary committee a

year later; and in 1915, when he took part in an abortive raid on the German seaport of Cuxhaven, he and his plane were brought down into the sea not by anti-aircraft artillery but by rain. By this time the government had requisitioned Hendon aerodrome, and with it the workforce. Grahame-White never recovered possession. He may have died melancholy, but his entrepreneurial instinct ensured he lived rich.

He had planned Aeroville for the workers at the aerodrome and factory, and that went ahead with the friend he had chosen as architect, another daredevil airman, Herbert Matthews, who, when not aloft, led a peaceable life designing shops and houses. Aeroville is certainly peaceable, even slumber-inducing: a quasi-Georgian oddity, quite sweetly conceived as a square of 33 dwellings with ground-floor colonnades supporting maisonettes above and creating loggias on the ground floor. There is, above the main entrance, a big bow window that belonged originally to a refreshment room for residents, but has been converted into a flat. The complex is redbrick and has dark tile mansard roofs, tall chimneys and Georgian windows, though some of these have regrettably been replaced by PVC frames, and there are some ghastly front doors, too. The central square, initially a garden, has become a car park with residents' vehicles ranged in ranks like airmen on parade.

AEROVILLE, NW9 5JT

## ST MARY'S, HENDON

*The parish church, a cameo of medieval Middlesex*

The church is as broad and low as a home-made apple pie and has a stubby fifteenth-century ragstone tower not much taller. Take in the Greyhound pub and Church Farm just beyond that, and the whole ensemble on a bend in Church End looks like an archetypal village centre. And so it was for centuries. Nothing much of the original twelfth-century foundation survives although the font, foursquare like the church, is Norman with each side carved as an arcade of eight intersecting blind arches, basic Romanesque. Next door, the Greyhound looks authentically sixteenth- or seventeenth-century but the chimneystacks, each taller than another storey, speak the language of quasivernacular: the pub was in fact rebuilt in 1896, following on from Norman Shaw's clearing of the air after the foetid piety of so much Victorian Gothic, though of course not accomplished with Shaw's delicate precision. Beyond the pub, the farmhouse is a fine redbrick triple-gabled seventeenth-century building.

As a matter of fact, the rebuilt pub is older than most of the church, which consists of the old north aisle and nave (both basically thirteenth-century) with a new nave replacing the old south aisle, and a wide new south aisle as tall as the new nave. Additionally, the small south doorway is set into a capacious lobby projecting from the south façade. Inside, the immediate impression is of a light-filled basilica with a forest of arcade piers,

tall and elegant or short and stout; the vicar celebrating the Eucharist in the mid-distance appears miniaturised across the generous space. Each of the aisles and the new nave has a chapel at the eastern end (four in all). Notably, in the north aisle chapel, G. F. Bodley has set the small altar in an exotic reredos borrowing the whole of the wall and window. (The glass of 1897, not Bodley's, fits in decoratively but has the wan figures, all too usual at this time, of burgeoning suburbia and featured without exception in the rest of St Mary's.)

The architect was Temple Lushington Moore, who created mild Gothic additions in 1914–15 with no swagger but real feeling for the context. Small features from the old church appear here and there. An old figure of a scholar, the Chaucerian parson maybe, stands within a niche in the wall of the lobby, like St Simeon Stylites on a pillar, teaching 'The righte wey of jerusalem celestial'. Over his head is contained a delicate little remnant of what looks like thirteenth-century tracery. Did it belong with the figure or was it placed here to set it off? In either case, it's the sympathetic imagination at work.

The churchyard is of a piece with the rest of the scene. Plenty of interesting tombs: among them one for Stamford Raffles, who died in Hendon in 1826 having founded the still-flourishing and much-loved Raffles Hotel at the other side of the world, in Singapore; and another for Herbert Chapman, a journeyman footballer in the lower reaches who became a drab-suited manager and brought Arsenal from semi-obscurity to be the most illustrious football club in 1930s England.

CHURCH END, NW4 4JT

## AVENUE HOUSE

*Spike Milligan's special garden*

The bronze sculpture in the grounds of Avenue House ticks up another ledger entry for that large and growing genre in public art, man sitting on bench with an unoccupied space beside him for (... yes, you've guessed it). It happens that these grounds are a very beautiful garden and this kind of stuff has no business here, but we forgive it because it represents Milligan and we can bless the local sculptor, John Somerville, too because he's made the subject the real Spike. A cap is pulled down over the unruly mass of Milligan's hair and, as you move around the sculpture, it's clear that we are looking at a troubled man, as he himself said many times. Well, that's not why he's here; nor is it because BBC Radio's *The Goon Show* in which he featured in the 1950s was, to put it mildly, a wild success and made his colleagues crack up as well as the listeners. In a different sense, he cracked up too, with repeated nervous breakdowns and a ruined marriage. It was *The Goon Show* that did it, he said, and that's what made it so funny. People of a certain age can still be caught dropping into Milligan's Bluebottle voice and using Goons catchphrases. But his statue is here because he was co-founder and first president of the Finchley Society, whose remit is to 'protect, preserve and improve' buildings and amenities in Finchley and Friern Barnet. After his presidency he took over from John Betjeman as patron. He died at his home near Winchelsea in 2002. His headstone bears the epitaph, 'I told you I was ill'.

Milligan and Avenue House suit each other. The house is bonkers as well, particularly the garden face. We can employ the adjective 'eclectic' rather than eccentric for the architecture because it borrows traditional forms: Doric columns, passages of Venetian Gothic, a baroque doorway, a French chateau turret at one end, an Italianate tower in the angle of the house's basic L-shape, a Grimms' fairy-tale chimneypot, even a spot of English vernacular here and there. The Rev. Edward Cooper built it in 1859 and Henry ('Inky') Stephens, son of the patentee of Stephens Ink, bought it in 1874, added to it and brought in Robert Marnock as gardener. Marnock, a Scot, nevertheless worked in the eighteenth-century English landscape tradition of Capability Brown. But this was a century later than Brown and Marnock's garden was a mere ten acres set close to London, not the hundreds of rolling country acres typical of Brown's undertakings. Instead, Marnock changed the terms of engagement. The triumph of his strategy was to envelop the visitor immediately in groves of massive Scots pines, oak, and holly. There are sudden slopes, a pond, grassy open spaces intersected by paths, and a big walled garden at the centre together with small dwellings collectively known as the bothy (in Scots, a hut for farm labourers), now in semi-dereliction.

In 1900 Stephens bequeathed the house and gardens to the people of Finchley. In 2002 a charitable trust took a long lease on the house and garden from Barnet borough council and its plans include restoring the bothy, and not as a picturesque ruin (nor, at a guess, accommodation for farm labourers).

17 EAST END ROAD, N3 3QE

## SCULPTURE BY ERIC AUMONIER, EAST FINCHLEY UNDERGROUND STATION

*The archer who recalls the great hunting grounds of Epping Forest*

The old Great North Road through East Finchley and the homely streets of faded Victorian villas and terraces mark the western edge of the former Middlesex hunting grounds, part of the great medieval expanse of the Royal Forest of Middlesex, where Londoners were granted the right of the chase. It is that ancient memory that the sculpted archer on a parapet at East Finchley Underground station was designed to evoke, or so it is said. Naturally, in the land of the longbow, it discounts the crossbow arrow that settled the new hierarchy of the realm in 1066 and instead, for every red-blooded City-bound commuter, celebrates the feats of the bowmen of Crécy and Agincourt.

But for Charles Holden the prime purpose of the sculpture was to be a symbol of the speed of travel on the London Underground. Holden was the celebrated architect whose most Modernist statements were 1930s Tube stations like Arnos Grove, Southgate and Sudbury Town (see page 552); in 1939 he added East Finchley, which is most impressive at platform level with its glazed semi-circular stairwells.

Eric Aumonier, a fine but unsuccessful sculptor, turned to decoration. The archer at East Finchley Underground station is one of his best pieces.

What lifts it from the street is *The Archer*, by Eric Aumonier (1899–1974), high up on the station building. Holden appreciated sculpture, and had commissioned Epstein, Moore, Gill, Aumonier, along with a quiverful of also-rans, to place sculptures on the façade of the London Underground headquarters building of 1929. Aumonier ranks with those also-rans, unremembered even by those who daily see his archer, down on one knee, muscles and bow taut, gaze keenly fixed along the line of the railway track to the south, no less keen now that the Northern is widely known as the Misery Line.

The sculptor was born into a family of artists of Huguenot descent. He and his brother Whitworth Aumonier inherited their grandfather's firm and renamed it W. Aumonier & Sons. Unluckily, although the family firm provided the reportedly very good replicas of artefacts from the tomb of Tutankhamun for the British Empire Exhibition at Wembley in 1924/5, it became involved in a scandal when it had to fight off a breach of copyright writ issued on behalf of the illustrious discoverer of the tomb, Howard Carter. Carter eventually backed off, but, if the whiff of commerce went down badly in fine arts circles, commerce and a tawdry court case combined hardly helped Eric Aumonier's reputation.

And yet *The Archer* is a strong piece of work, a three-dimensional figure pretending to be flat, its decorative elements derived from the heavily stylised reliefs from Ancient Mesopotamia and Assyria in the British Museum elided with a Modernist apprehension of muscle and sinew as working parts of machinery. The figure is cased in moulded lead over beech on a steel armature. The bow, drawn back in a taut curve, is lead-

covered too but over ash wood. Although it seems on the point of release, there is no arrow. It is said that Aumonier completed his commission with an arrow placed at the southern terminal of the Northern line, Morden, but that within weeks it was stolen.

HIGH ROAD, N2

## PHOENIX CINEMA

*An art house that has stuck to its brief through thick and mostly thin*

A company called Premier Electric Theatres Ltd built the Picturedrome Cinema on East Finchley High Road in 1910, but before the grand opening night it had already gone bust. A publican from Farringdon Road rescued the cinema with another publican from East Sheen and a third man, also from Sheen, occupation unspecified, who moved in as the cinema manager. With its two turrets, Moorish-style onion domes and flimsy-looking fascia, the Picturedrome looked like a quirkily quasi-permanent version of the fairground bioscopes that had led cinema through the first decade of the century. It opened in May 1912 with a movie billed as 'The Ill-Fated *"Titanic"*... Captain Smith on the Bridge. The *Carpathia* nearing New York. Some of the heroes picked up at sea.'

*Titanic* went and came, and then for a few years Charlie Chaplin programmes remained a fixture as owners and managers changed, like the cinema's name. In 1924 the Picturedrome became the Coliseum. In 1938 the Middlesex authority looked at it and, citing safety regulations, issued orders to smarten up or shut up. It smartened up. In came the Gray's Inn Square architects Howes & Jackman to remodel the ageing flickhouse as a streamlined competitor to the modern Odeons and Ritzes. Howes & Jackman retained the 1910 barrel-vaulted ceiling but brought in Eugene Mollo and Michael Egan to reorientate and refurnish the interior; Egan (1907–2003) also modelled the masterly stucco panels that run along each side of the auditorium: Modernist semi-abstract decoration that makes even ventilation grilles exotic. Outside, the architects built a lean, minimalist, Jazz Age, cream-faced Art Deco façade with a vertical fin at one edge accentuated by three horizontal strips of glowing neon, and the cinema's name underscored by three more strips. Ah, yes, the name: that had changed again, to the Rex.

Another year, another crisis. In 1973 the Granada Group bought the Rex and destroyed the independence on which it had, just about, stayed afloat. It ran into a storm of local abuse along the lines of 'Granada wrecks the Rex', and two years later sold out to Contemporary Films, who renamed it the Phoenix. More crises, a fresh threat to knock the cinema down and build an office block, a sudden injection of funds from the old Greater London Council, a listing by English Heritage, and today the Phoenix is a community cinema run by a trust. The art-house programming remains its strength, augmented by big current features that help to swell the funds, still with the 1938 design but tweaked and freshened up in its centenary year, 2010,

with the introduction of a little cafe above the lobby and with a terrace behind the fascia billboard. Glory be, the trust has stuck with the same name and stuck it vertically down the fin, Phoenix, the symbol of rebirth from what were never quite ashes.

52 HIGH ROAD, N2 9PJ

## ALEXANDRA PALACE

*A colossus ignoring the writing on the wall*

There are panoramic views across London from Alexandra Palace on the northern heights and there is a park of 196 acres stretching down the slopes to suburban Muswell Hill, Hornsey and Wood Green. But then there's the palace building: a colossal, crumbling failure, its Victorian theatre with the wooden stage machinery swaddled in darkness and cobwebs. The great second-floor arches, like an open loggia framing the sky, ominously suggest a potential ruin, and the BBC studios tower on the south-east corner with its 215-foot mast is already practically that (though techno buffs have joined the BBC in wanting to preserve it as an important part of our island story, for reasons spelled out on a blue plaque at the foot of the tower reminding viewers that the world's first regular television service was inaugurated here by the BBC on 2 November 1936. It ran for a couple of hours). The mast is still working but in 1956 the BBC moved out, leaving behind a rump staff and memories of a different England.

Alexandra Palace was planned in 1858 to be a north London counterpart to Crystal Palace. John Johnson designed it as it finally appeared in 1875 after the first attempt built a couple of years before burned down almost immediately. It had a grand hall at the centre, and a concert hall that could hold 14,000 people and also contained one of the biggest organs in the world. There was a huge central glass dome and great gables north and south to this central section. Massively rusticated piers support the building above an undercroft. The 'Palace of the People' the planners called it when it opened at last after a couple of false starts, but maybe they forgot to tell the people, who never entirely embraced the idea of it as a great night out despite the way the South London public took to Crystal Palace, although they bestowed on it their own chummy name of Ally Pally. The companies running it followed one another lemming-like over the top and in 1901 the government took it over without much enthusiasm, least of all for promotion. Architecturally it struggles to justify its magnificent site. As construction, if not indestructible it's having a good shot at it: another fire in 1980 gutted large areas but it is still standing.

Were it all to fall down overnight, would anyone notice? Well, signs of life linger. There are rock concerts, Miss World and the 'World' Darts Championship (a couple of Dutchmen have occasionally intruded on this British fiefdom, but the Dutch all speak English anyway); there is a popular ice-rink needing renewal and there's a provisional Heritage Lottery grant of £19.4 million towards preservation. Haringey council had taken over in 1980 shortly before the fire and set

afoot a mini-renaissance with refurbishment to some parts including the Great Hall: today Alexandra Palace once again holds feasts as big as Belshazzar's, before Belshazzar saw the writing on the wall.
ALEXANDRA PALACE WAY, N22 7AY

## BRUCE CASTLE

*Aristocracy and education*

Bruce Castle was the name bestowed on this mansion because misty Scotch myth has it that the royal Bruce family once held this Tottenham manor. Actually, it is not altogether easy to envisage Robert Bruce resting up at his country estate in Tottenham after the battle of Bannockburn. It might have been fairer to name the mansion Coleraine Castle after Henry Hare, second Lord Coleraine, an Englishman with a Londonderry title, who rebuilt an old house in 1684 pretty well as we know it: two redbrick storeys and an attic storey; polygonal bays at each end; and a central entrance climbing two storeys, with two pilasters flanking the entrance, two by the window on the next floor, emphatic quoins crowding in, a wooden balustrade around the top and, surmounting all, a crazy tower conjured from a springtime dream, stuccoed, and with a big blue clock. That's not the end of it: above the clock is a further lookout balustrade (looking out over nothing more threatening, the mood suggests, than a village fair), and then a polygonal two-stage cupola (punctuated by yet another balustrade, purely decorative), with tall summer house windows; finally, a great streaming windvane. Blood-boltered Bruce be damned.

The third baron, Coleraine's son Henry, remodelled the rear of the house and installed the splendid Coleraine arms in the massive pediment: griffin supporters but ermine-spotted black and white, and on top a baron's coronet, all blazoned above what's now a people's park for runners, children, lovers, picnickers and pensioners.

The third baron's only offspring was an illegitimate daughter who inherited Bruce Castle and married James Townsend. He was a radical politician, supporter of the rascally but freedom-fighting John Wilkes. It was Townsend who rebuilt the east front in 1764 as the new main entrance, a well-mannered Georgian face soberly denying the extravagant architecture of the Henry Hares – which he tamed by removing romantic gables from the south façade, leaving it raw and the skyline deprived. In 1870 the north-west extension was added at right angles to the house as an extension for a new school set up by Rowland Hill. Hill's venture was an exercise in radical education, designed not to teach the young facts but teach them to think, and with a disciplinary approach based not on punishment but trial by pupil. It was a popular success but ultimately bored Hill, who gave it up and went to work, as all the world now knows, modernising the post office.

A seventeenth-century engraving

The entrance and tower of Bruce Castle in Tottenham, 'conjured from a springtime dream'.

shows the second baron's house freshly completed. The front lawn, more formal than it is today, is fenced in from the park, and the front wall lies, as now, along Lordship Lane, which was still developing from an ancient track linking the forest clearing of Wood Green with the Roman north-bound Ermine Street (roughly, the A10 and A1010). To the south-east of the house a few feet outside this palisade a free-standing embattled tower is shown, highly decorative and in perfect condition. It still stands today and is thought by some to be part of the pre-Coleraine house. However, there is no clear sign of its ever having been attached to anything, nor of having any obvious purpose but to display the lasting qualities of good brick.

LORDSHIP LANE, N17 8NU

## • WINCHMORE HILL, ENFIELD, CHINGFORD, WALTHAMSTOW •

### FRIENDS MEETING HOUSE, WINCHMORE HILL

*The quietness of a Quaker chapel*

The lady at the door gazes across at the faint November mist clinging to the burial ground and murmurs: 'Winter is much maligned, but on days like this it is beautiful.' She holds a book, the last of a batch of Bibles she has distributed around the benches, and is waiting to greet the first of this Sunday's Quakers and anybody else who cares to join them at the oldest Friends Meeting House in London, a replacement of 1790–1 for its ramshackle predecessor of 1688. The building is stock brick laid in neat courses of Flemish bond (long short long short, in a stately dance) with a shallow pitched grey-slated roof forming a gable in front doing duty as a simple pediment. The interior continues the motif of simplicity but with modest scruffiness. It is a single large room, a rectangular box really, boarded walls around five and a half foot high and above that what looks very like post-war plasterboard. Tall sash windows pierce the walls on two sides with another pair either side of the homely box-like porch. There's a simple circular wall clock by Clerke of 1 Royal Exchange, an enduring classroom and railway station pattern of the nineteenth or early twentieth century, and a fuchsia flourishes in a pot on a windowsill, nicely placed to catch the daylight. No altar, of course, and no pulpit. This is simpler even than the dissenters' chapels introduced by Oliver Cromwell: the most striking element of a Quaker meeting is silence. Silence speaks to them, of peace, of community and of communion (in the eternally everyday sense of the word).

The lady with the book is looking across at the green setting for the meeting house. She calls it a garden rather than a burial ground and it is in fact one of the finest in London: calm, dominated by a giant cedar, with gravestones laid flat into the ground and gradually, it seems, mouldering into the earth. Close to the entrance path are six or seven little round-

headed gravestones (typically Quaker, with minimal information): these are all for eighteenth- and early nineteenth-century members of the Hoare banking family. Here lies Samuel Hoare, close by his first wife Sarah who was only 25 when she died; he was one of the 12 founders of the Society for the Abolition of the Slave Trade, and he died aged 74 in 1825. Many Quakers chose to lie in unmarked graves, but the main cluster of stones is at a far edge of the garden beyond the cedar. Among them is a stone inscribed to Kathleen Rowntree, a member of one of the three great Quaker chocolate dynasties (Cadbury, Fry, Rowntree). A Rowntree approved my first loan on a house. He flinched when I remarked in all innocence that it was for the deposit. You're meant to have saved that yourself, he reproved me. But he granted it anyway. *Requiescat in pace.*

59 CHURCH HILL, LONDON N21 1LE

## ST ANDREW'S, ENFIELD

*The church of the power brokers*

The street name for Enfield's market place is simply The Town, and that seems just, for this is where the ancient character of the borough resides even though the market cross dates only from 1902, installed to celebrate Edward VII's Coronation. The square is filled with stalls, a big 'Tudor' pub of 1899 on one corner, a Flemish-style step-gabled Barclay's Bank on another and, filling the space to the north of the square, the genuinely ancient parish church of St Andrew. This enclave is a bubble of architectural interest preserved intact in the borough's stretching subtopia, but the town church is the star with its flint and rubble construction, some of it thirteenth-century (see the base of the big west tower), much of it fourteenth, with, beneath sixteenth-century clerestory windows, a wide nineteenth-century expanse of brick enclosing a new south aisle, a blunt summation announcing that this was the church of the local power brokers, gentlefolk who lived in Enfield but made their mark in London too.

One of them was Jocosa (Joyse or Joyce), Lady Tiptoft (d. 1446), a descendant of Edward I and distantly entangled in the ancestry of George Washington; she is celebrated in the chancel with a glorious carved and painted stone canopy over a tomb chest inlaid with a brass likeness. The men commemorated include Sir Thomas Lovell, loyal servant of the first two Tudor kings, owner of Elsyng House (see Forty Hall, page 540) and donor of the clerestory; Henry Middlemore, groom of the privy chamber to Queen Elizabeth; and Sir Nicholas Rainton, the builder of Forty Hall, a haberdasher dealing in ribbons, beads and pins, but with the armorial bearings of a warrior and a brash tomb in the north chapel of old-fashioned crudity and gaudiness. His and his wife's effigies recline wide-eyed but surprisingly at peace, she reading a good book, if not the good book, he contemplating eternity; but his death was greeted by riots that he provoked with his ongoing programme of enclosing common lands, an early form of green-belt enforcement.

On the north wall of the chancel is the

monument to Martha Palmer, the wife of Sir James Palmer, talented artist and friend of three kings whose miniature of the first of them, James I, is in the V&A. But here the glory is all to the sculptor responsible, Nicholas Stone, in whose variable output (given the load of work he undertook with his workshop) this imaginative little masterpiece ranks alongside his great monument to John Donne in St Paul's Cathedral (see page 31). The elongated figures of Faith and Charity, heads inclined, bodies swaying, define the vertical edges of the cartouche; Faith has a stack of books at her feet, Charity two sweetly carved children, and fruit tumbles profusely from the top of the panel. You would swear Stone had looked at William Blake's visionary watercolours before beginning to carve, but this was produced in 1617, two centuries before Blake. Stone was trained as a mason, but was touched by genius.

MARKET PLACE, EN1 3EG

## FORTY HALL

*A grand house and park that is greater than the sum of its bits and pieces*

The view from a second- or third-floor window in Forty Hall extends along an avenue of lime trees; to the north of the avenue once stood Elsyng Palace, owned by Thomas Lovell, who had backed Henry Bolingbroke against Richard III at the Battle of Bosworth, and was trusted and honoured as the Tudors began to found a dynasty. But all that was left of the house by the twentieth century were a few foundations, later covered over.

Whether or not it was already derelict when Sir Nicholas Rainton, member of the Worshipful Company of Haberdashers, acquired the land in 1629, he set about building Forty Hall on a hill above the site. It was ready in 1632, the year he became Lord Mayor of London. It is a revolutionary piece of Palladianism for that date in England. The general assumption a century later was that Inigo Jones was the architect, and you can see why. It took the shape a Jones house might have taken if we could assume he built small country houses of this sort, which we can't. Today the author is thought to be someone who knew Jones professionally, maybe Edward Carter, Clerk of the King's Works (a post once held by Geoffrey Chaucer).

A succession of owners changed things around, so it's difficult to follow the original layout but easy to enjoy the house as it stands now. The first two rooms are the best. Originally the north door opened into a screens passage, but in the eighteenth century that was turned into a little entrance hall with decor of Ionic columns, niches and wall panels, a couple of which each contain a female bust with abundant loosely tied hair, maybe Vesta the goddess of house and home. Behind the screen to the left of the entrance is the main hall where the screen has been revarnished a deep, glowing brown based on the analysis of seventeenth-century colour samples and looks wonderful with its closely carved pilasters, panels, and large shell motifs either side of the white-painted

The main block of the small arms factory in Enfield. Its first mass customers were both armies in the American Civil War, in which some 600,000 soldiers died.

door that is set into a white arched surround with a bold shell decoration in the tympanum. The decorated plaster ceiling is original too, like the ceiling in the drawing room to the north and the two first-floor rooms above, one of them dated 1629.

Enfield borough acquired Forty Hall in 1951 from the Parker-Bowles family (Andrew, who later surrendered his wife to the heir to the throne, spent his first 11 years here). Earlier, it had been stripped of furniture and pictures: a history of the house written in 1873 lists a long inventory of old masters which, even allowing ascriptions more hopeful than accurate, is a lot of canvas to go missing. Enfield turned Forty Hall into a museum but then realised that the house was an object of greater value than its contents. The restorers settled for schematic indications of what went where, but that gorgeous hall, two or three other rooms and the exotic gateway to the stables, show just what the moneyed non-aristocracy of the City could aspire to.

FORTY HILL, EN2 9HA

## ROYAL SMALL ARMS FACTORY

*Arms and the men*

The unsung story of how the American Civil War was won and lost lies in a marshy island at Enfield Lock formed by the spreading arms of the artificially created Lee Navigation and the River Lea (sic) itself. Here the Royal Small Arms Factory (RSAF), created by the government Ordnance Board in 1816 after disparate suppliers failed to fulfil the army's

needs during the Napoleonic Wars, put down a lot of hard core, built a factory, and began by simply rolling out the barrels. Locks and stocks followed in 1818. It was not enough. Crimean War arms production maintained the same tradition of hopelessness. So in 1854–6 the RSAF rebuilt, filled the island with an industrial plant and took on an American mass-production system. It was sweetly timed for the outbreak of hostilities between Rebs and Yankees in 1861. With fine lack of discrimination Enfield delivered not far short of a million rifles to the American market. No employee lives lost. In all 600,000 soldiers were slaughtered during the conflict, with a fair share of death-dealing attributable to other British concerns too, such as the Whitworth sniper rifle, designed and manufactured by the Manchester philanthropist Sir Joseph Whitworth.

The RSAF produced the Enfield .303 rifle for the Boer War, and carried on improving models of it practically to the end of National Service call-up in 1960, a tribute more to inertia than the weapon's continuing utility. In 1930 came the Bren light machine gun (*Br*nö/*En*field: it was produced under licence from a Czech model). It was the soldier's favourite for its accuracy over a distance (wartime sweats boasted a mile; the specs said 600 yards). In 1941, answering, in a fashion, the need for a submachine gun for close fighting, came the Sten (S for Maj. R.V. Shepherd, T for Harold Turpin, who is recorded in the name of the barge floating on the mill pond outside the surviving machine-shop building of the post-1856 expansion, and Enfield). They were cheap, eccentric, made a hell of a noise and frightened the soldier firing them more than they did the enemy. But there were lots of them.

On such was the greatness of Britain founded. Wars would keep the Royal Small Arms Factory prosperous until a mightier force, privatisation, struck it down in 1988. What's there now is yet another of England's redbrick estates with factory ruins interspersed: a miserable contrast to the plain but pretty row of two-storey workers' cottages along the riverbank opposite the factory's former machine shop with its clock tower above the front door, borrowed, it seems, from a little Italian market town. The machine shop has belfry openings above the clock and 11 round-headed windows to either side. It's built in yellow brick with pretty redbrick decoration – diaper patterning and the like – and there is a small museum in the old machine shop recording Enfield's role in worldwide warfare through displays of hardy but strangely innocuous-seeming weapons. And so they probably are compared to the hardware available now.

ISLAND CENTRE WAY, EN3 6GS

## QUEEN ELIZABETH'S HUNTING LODGE

*A wraith of the gaudy Tudors*

Queen Elizabeth's hunting lodge in the stretch of Epping Forest near Chingford was built by her father, Henry VIII. As a young monarch his appetite for hunting was huge, but as he grew older he preferred not to spend a whole day

chasing through thickets and streams to hunt down a single deer. Like his illustrious successor George V, with his reputed bag of 1,000 hand-reared pheasants in one day's shooting at Sandringham, Henry's taste, in sport if not altogether in political life, was for slaughter on the grand scale, and when he could no longer gallop at full tilt he had his parks arranged so that the wretched animals were guided through an arrangement of fencing and nets into full view of his open-sided hunting lodge and within range of his crossbow.

The hunting ground at Chingford was known as Fairmead and was the biggest and most important of four parks created from the confiscated lands of Waltham Abbey. Tree-ring analysis confirms documentary evidence that Chingford Great Standing, as the almost tower-like hunting lodge was known, was built in 1543 of timbers from trees felled the year before, massive enough to bear the weight of three floors packed with huntsmen and their guests, and maybe constructed with the king's bulk in mind. But by this time he was so gross, ulcerated and generally decrepit that it is unlikely he attempted to use it. This may be the reason the lodge became known as Queen Elizabeth's. Her excessively zealous courtiers compared her to the huntress goddess Diana, and she was very keen, though a dozen or so cadavers lined up on the grass before her after a little post-prandial shooting was quite sufficient, thank you. In any case, she too seems to have hunted elsewhere, but there is ample evidence of her orders for putting the Great Standing, by now falling apart, into good order and being converted into a residence much as we see it today, with walls in place of open sides and viewing stands exposed to the elements, and an outside chimney abutting on to the kitchen with its (extant) inglenook fireplace.

It is a fortunate survival, even though it is overshadowed by the huge, daft pre-Disney Tudoresque hotel next door, built in the late nineteenth century by Edmond Egan, an architect from nearby Loughton, and the view from the eminence on which the lodge stands, or from any one of its three floors, across a shallow valley to the dense forest, is much as it would have been for the Tudor nobility. When a hunting party was organised, the lodge's timbers were painted in bright, festive colours and the building hung with brilliant bunting. Today decommissioned, and, since the Epping Forest Act of 1878, owned by the City of London along with the 6,000 acres of what remains of the original vast primeval forest, its walls outside are washed in what is now considered to be best practice, all white, timbers included, like a wraith of the gaudy Tudor age.

RANGERS ROAD, E4 7QH

## WILLIAM MORRIS GALLERY

*Useful, beautiful...
not necessarily comfortable*

William Morris was born at Elm House in Walthamstow and the family moved to Water House in Forest Road, now the Morris Gallery, when he was 14. Walthamstow was changing from a village even while he lived there, the

population has gone through the six-figure mark and many of the humble cottages built for workmen when the railway was built during Morris's time are doing a turn as sex shops or cheap caffs; even an arts and crafts shop still selling Letraset, which almost takes it back to Morris's time. Across the road beside Water House is a Hindu temple gaily decked with images of avatars and attendants of the gods with the elephant-headed god of good fortune, Ganesh, centrally placed over the door.

Morris's own faith was rooted in the Middle Ages and the gallery even has an iron sword and helmet that he constructed beautifully as a prop for his models in the ridiculous enterprise of the Oxford Union murals, painted with his friends Burne-Jones and Rossetti when he and Burne-Jones were scarcely beyond the stage of ranting 'The Lady of Shalott', taking brass rubbings, and immersing themselves in the Arthurian legends, and Rossetti was probably simply susceptible to the attentive hero worship of the two young acolytes who had thrust themselves upon him. The original romantic dreaminess lay at the root of everything that was to follow: the socialism, the application of hand-crafted art to socialism, the research into stained glass, the hard-learned skills of tapestry weaving and stitching; and the reason too why his Holy Grail proved to be elusive. Only the rich could afford his kind of art.

This rich stained glass window in the William Morris Gallery, simply identified as 'Cymbal Player', probably from a design by Burne-Jones, was made at Merton Abbey in the 1880s.

It's here in Water House in abundance: Acanthus wallpaper, St James's wallpaper in different colourways, Larkspur, Peacock, a rug with a tree pattern and another with a paired birds pattern, his wonderful chintz Strawberry Thieves, and African Marigold and Wandle, both chintzes. Stained glass, from the lovable but coarse early attempts for private houses at subjects like the Labours of the Months (also produced as tiles), to the consummate sophistication of the later church glass. There is furniture, like the painted settle originally designed for his own use with his wife Janey at the Red House at Bexleyheath (see page 416) and then put into production when he set up in business; and a hefty tub-shaped chair also for his own use. 'If you want to be comfortable,' he would say, 'go to bed.'

LLOYD PARK, FOREST ROAD, E17 4PP

## L. MANZE

*Something special at a listed eel, pie and mash shop*

The Manze family arrived in London from Ravello, south of Naples, in 1878 with a mission to sell ice cream to the workers and the deserving poor. But, except on the prom at Margate or Southend, whoever heard of a London docker or brickie eating ice cream even if their kids craved it? So at the turn of the century Michele Manze set up shop on Tower Bridge Road, which has ever since sold eels, meat pies and mash, plated up all together, or just one option with mash. The unctuous parsley liquor from

the cooked eels copiously anoints all meals. By 1929 there were a dozen branches of M. Manze all over London. At this point a younger brother of Michele, Luigi, set up the thirteenth shop, L. Manze at 76 Walthamstow High Street, beatified since 2013 by an English Heritage listing.

At one end of the High Street is Walthamstow Central Library, jolly English Baroque revival of 1909 with hipped roofs and a cupola; at the other a faience-tiled, smug-looking commercial building of the early 1930s, originally one of the Burton's chain of tailors. Between library and the former Burton's is more than half a mile of brick nullity galvanised into life by a teeming street market and shop-fascia boards of a vividness and variety that give no quarter. In this souk of popular commerce, L. Manze is something special.

Behind its black Vitrolite fascia (a Pilkington-patented black glass somewhat like the material used for the former Fleet Street headquarters of the *Daily Express*), with the name picked out in gilt capital letters and an even brighter golden edging, is the finest remaining example of a working man's eatery. These were common until the 1950s, when there were more than 100 in London; today there are reckoned to be 30, much the same figure as in the pre-Manze days. The central door has a sash window to either side – so that the bottom half could serve as a hatch for takeaway sales – and the division of door and windows rhymes with the central aisle inside and the two rows of tables, each with two straight-backed benches side on to the aisle, their turned ends crowned by acorn finials. Customers order and collect meals from the servery at the front, most likely staffed by the current owner, Jacqueline Cooper, who retains an exotic ancient brass cash till for display rather than use. The rest of the decor mixes utility with display: white-tiled walls throughout enlivened by big mirrors and the kind of inset Classical Greek ornament popular equally in pubs and pie shops, egg and dart decoration in homely idiom. The floor is unidiomatic pink and grey terrazzo.

The Lea Valley runs through Walton Forest, but neither that river nor the Thames supplies the eels any more. They are the only things in these premises that aren't copper-bottomed Cockney. Manze's imports them from Singapore.

76 HIGH STREET, E17 7LD

## VESTRY HOUSE MUSEUM

*Vestry at the heart of an ancient village in town*

For the stranger, Walthamstow village is not straightforwardly accessible. One obvious-seeming approach, along St Mary Road, is entirely blocked at the town end. At the east end of the road, which is lined with good, modest Victorian terraced houses, the passage ahead is a footpath; a line of eighteenth-century cottages on the left, and then the path emerges into Church End and Walthamstow's big secret, the rightly touted Vestry House. This isn't all, however: strikingly the heart of the old

village on either side of Church Lane has remained more old villagey than most country villages.

On the left is the row of Squires almshouses in nicely weathered yellow brick, with a wide central gable toffed up as a pediment with double rows of slates imitating the moulding of a grown-up pediment. An oval stone plaque in the centre reads: 'Thefe Houfes are/ Erected and Endowed for Ever/ By Mrs Mary Squires Widow/ for the Ufe of/ Six Decayed Tradefmens Widows/ of this Parifh and no other/ Ano Domi 1795'. Ahead the grossly cemented parish church of St Mary (see below) stands to the north of Church Lane, in a graveyard devoted to mouldering tombstones and a large wildlife garden: all in all, a willful and somehow moving composition. On the pavement to the south of the church railing is a hexagonal Penfold postbox, a style of 1872–9. Across the road stands the Ancient House. This is a timber-framed domestic building, date firmly ascribed to the fifteenth century, which is what makes it especially ancient (most are sixteenth century). It has jettied wings, one of them with a fine pattern of curving timbers, the other weatherboarded with a late-Georgian sash window above and, in the shade of the overhang, a satisfyingly full bow window, presumably for a shop. Beside it is a neat little early nineteenth-century Georgian house with three bays and a Doric portico in the middle. To the north of the church, more almshouses with a large hall endowed 'for ever' by George Monoux, a sixteenth-century lord mayor of London.

Back to Vestry House, now a local history museum, and outside it the oddity of the village ensemble, the top of a gigantic shaft and capital of an Ionic column, as intriguing here as a beached whale. It is a remnant from the demolition in 1912 of Robert Smirke's classical general post office headquarters at St Martin-le-Grand, presented to the parish by a Walthamstow building contractor.

The vestry is a bit of an oddity itself, two buildings spatchcocked together. The parish built the original in 1730 as a workhouse and with its intimate little courtyard it must have seemed charming even then, though maybe not to the poverty-stricken parishioners banged up there, who were greeted by the plaque engraved, 'if any should not work, neither should he eat', a biblical injunction in sweet harmony with our own times. The comparatively unadorned extension followed a few years later. There were workshops and dormitories, and still existing is panelling predating the building and a staircase with urns on the balusters. It remained a workhouse until 1830, after which it was successively a police station and lock up (a cell is part of the museum exhibition), an armoury and a private house before Walthamstow council bought it in 1930.

Volunteers maintain the good formal gardens behind the house.

VESTRY ROAD, E17 9NH

## ST MARY'S, WALTHAMSTOW

*A fine memorial in a setting of grey*

If a church can be phlegmatic, St Mary's is it: big, grey and expressing nothing so

much as melancholy endurance. A report by the Royal Commission on the Historical Monuments of England could scarcely conceal its author's exasperation: 'The walls are entirely covered with Roman cement' is its opening sally ('Roman' is not Roman in this context; it is a concoction invented in the late eighteenth century); the west tower is 'either modern or covered with modern cement'; inside, restoration in the nineteenth century 'left little or no evidence in situ of the date of any portion'; the north chapel has 'no ancient features'; columns were 'cut down to an octagonal form in the 19th century'; the chancel 'has no ancient features'. I rest my case m'lud.

The defence might start by pointing out that the church deserves better than this sense of wounded dignity. It was bomb damaged and the lathering of cement was a hasty post-war fix. The visual evidence of antiquity may not be much, but it is known from records that St Mary the Virgin (the full name, rarely used) was dedicated in the twelfth century and was big by the thirteenth; and that underneath the building we see today there was once a Norman church. The best visual evidence for antiquity remains the brasses in the floor and the memorials on the wall, many of them imposing enough to indicate, like the later churchyard tombstones among the wild flowers and grasses, a wealthy community.

The pick of these memorials is on the north wall of the chancel: a husband and wife portrait of national interest commissioned by Sir Thomas Merry when his wife Mary died in 1633. Merry was an official of the royal household who suffered severely during the Commonwealth for having lent £2,000 to Charles I. Nicholas Stone, the sculptor, was an exceptional, sometimes great, sculptor and master mason in demand the length of England, from Northumberland to Kent. He had a large workshop and a stream of pupils working as assistants to him, but the superb Walthamstow piece is of such quality that he himself may well have carved it; as he records in his account book for the year: 'In 1633 I mad a tombe for Ser Tomas Meary & his lady & it standeth at Waltham Stow near by in Esex for the which I had £50'.

The setting of the portrait is splendidly set out: a big slab of alabaster with the portrait busts in alcoves in the middle surrounded by floral carving, reliefs of two sons and two daughters, and a laudatory poem attributed to the poet and playwright William Davenant (another royalist) who enjoyed being thought of as Shakespeare's illegitimate son. (Sadly, there is not much evidence of inherited genius in his encomium to Mary Merry: 'I have this hardy Pile inspir'd to mutter/ Playnts that would breake a widow'd heart to utter,/ The Type of conjugall obedience', and so on and on.) Inserted in a broken pediment at the top is a profuse rendering of the Merry coat of arms, the ultimate status symbol.

CHURCH HILL, E17 9RJ

# • WILLESDEN, NEASDEN, SUDBURY, HARROW •

## ST MARY'S, WILLESDEN

*The shrine of the only
Black Virgin in England*

If there were to be a competition for the best-known least-visited church in the world, St Mary's Willesden would be in with a chance. The unpopularity is because declining industry, unemployment, dismal town planning, worse building and overcrowding make Willesden an uninviting prospect. The fame derives from the cult of the Black Virgin the parish church has harboured from time immemorial – a phrase adopted when there is no way of pinning down a date within half a millennium, give or take, unless your name is Dan Brown. The church itself was first recorded in 938.

Today St Mary's holds the only Black Virgin in England (not counting a Roman Catholic version set up in the late nineteenth century that triggered Protestant riots; but that, as they say, is a different story). In its heyday, along with its miraculous healing powers, Willesden's was endowed with the power to pull in pilgrims, and by the turn of the sixteenth century their offerings were making St Mary's rich. But in 1538 Thomas Cromwell seized the image and condemned it to burn on a bonfire of the vanities in Chelsea. Then, in 1972, in the hope of reviving the Marian cult, the Bishop of Willesden supported the commissioning of a new carving of the Black Virgin from a little known sculptor called Catharini Stern.

Stern's Black Virgin is not a take on the Byzantine or later medieval archetype but is a modernist progression on the edgier pioneering of Epstein and Moore. The Madonna is life size, with the child standing in her lap larger than life size, his arms thrown wide. She sits erect on a stool (the throne) and is covered from head to foot in a long gown; and the rhythm set up by the drape of the gown below her knees, the tight crisscross of the swaddling, the horizontal emphasis of the Virgin's fingers grasping Jesus around the middle and Jesus's splayed fingers set up a parallel rhythm to the song of songs: 'I am black, but comely, O ye daughters of Jerusalem' (The Song of Solomon I: 5).

The church building itself has been isolated by useful (maybe) but destructive road engineering. In her novel, *NW*, set in Willesden, Zadie Smith casts the church as a paradisal moment in paradise lost: 'Out of time, out of place. A force field of serenity surrounds it.' She places it on a large roundabout as, presumably, a symbol of its isolation (actually, the roundabout is beside the church, small and beset by big Keep Left signs). 'Present church dates from around 1315 ... Cromwellian bullet holes in the door.' It's all there. The west door, which is modern, is held by great iron hinges beautifully wrought by a nineteenth- or twentieth-century blacksmith. The south door, the one with the Cromwellian bullet holes (repaired), is a medieval survival, rare in England, without fine hinges but with sturdy original wooden tracery on the outside. The font is Norman, fashioned from Purbeck marble. Water from the holy stream beneath the church is

dispensed from a glass flask with a little silver tap in the south aisle chapel where an old tomb has been adapted as a kind of small Easter sepulchre. This chapel is the shrine of the Black Virgin. Zadie Smith's central character, Leah, looks at the lime-wood carving and the child especially: '... his hands big with blessing, it says on the sign, but to Leah there seems no blessing in it ... the baby is cruciform; he is the shape of the thing that will destroy him.'

NEASDEN LANE, NW10 2TS

## BAPS SHRI SWAMINARAYAN MANDIR

*Enough carving for a lifetime at the biggest Hindu temple outside India*

BAPS Shri Swaminarayan Mandir is one of the biggest Hindu temples of its sort outside India, a collection of Himalayan peaks under a Neasden sky. It is dedicated principally to Krishna, the blue-skinned avatar of the great god Vishnu, though some adherents believe he stands apart from all others. And even if it isn't *the* biggest, it is surely the most beautiful; a *mandir* (temple) of marble and a *haveli* (the temple's cultural centre) of intricately carved Burmese teak all in one. It is not big as other centres of religion are big; say St Paul's Cathedral or Methodist Central Hall, Westminster, or even Wembley Stadium, not far away. In fact, the interior of the *mandir* itself, the holy of holies, is relatively small, but is so packed with detailed carving of pillars, of cornices, of screens – not to mention the miraculous dome that crowns the whole ensemble – that it seems enough for a lifetime; a thought prompted by an old man who, on retirement, moved from Croydon to Neasden to be close by and who can be

discovered there five days a week in the *mandir* helping visitors and two days worshipping on his own account.

The temple is new. The sect is a splinter group of a splinter group founded by Bhagwan Swaminarayan (1781–1830) to return to the purity of the original Vedic Sanskrit scriptures of 1500 BC, but Hinduism has had a long history of splinter groups. The leader of the sect, His Holiness Pramukh Swami Maharaj, inaugurated the temple in 1995. It is built of Bulgarian limestone (for its even consistency and lovely colour, at a guess) and Carrara marble, both shipped from Europe to India, carved by a team of craftsmen, packed in 26,300 separate numbered boxes, and shipped to Neasden to be assembled in under three years. From the viewpoint of an almost wholly different culture, it is hard to tell whether the Neasden temple relates to, say, the classic Hindu temples of 1,400 years ago the way Pugin's churches relate to Salisbury Cathedral, or whether Neasden is a direct continuation of the line. The craftsmen were there waiting, after all, to sculpt this astonishing edifice, but there is a sense, especially in the sculpted frieze of the gods that runs around the outside of the temple, that it does not have the magnificent intricacy of the best of holy India's, at the great ruined temple of the sun god in Konarak, say. On the other hand, the carving of the interior of the *mandir* is so profuse and intricate, figurative and abstract, as to overwhelm surmise about living and half-dead cultures.

The biggest Hindu temple outside the sub-continent, BAPS Shri Swaminarayan Mandir in Neasden, clad in Carrara marble carved in India.

I asked someone what BAPS stood for. It is the short form, he said, of Bochasanwasi Shri Akshar Purushottam Swaminarayan Sanstha. Ah. Roughly speaking, what would that mean in English? I asked. It is in English, he said.

So Google. It will yield something along the lines of the above.

105–19 BRENTFIELD ROAD, NW10 8LD

## SUDBURY TOWN UNDERGROUND STATION

*Through the bowels of the earth to the Queen of the Night*

It's the classic English double cube, but Sudbury Town Underground station (which, as it happens, is above ground) is a piece of Modernism as advanced as anything in the world in 1931 when it was built: concrete, brick, steel and glass in tall clerestory windows between entrance lintel and roof, the façade staring austerely down Station Way, two broad bands of brick either side of the building, one down the centre separating into two broad bands of glass, each pair in turn divided by a narrow pillar of brick. It is still modern, still almost raw in its spartan lack of ornament, a morning douche of puritanism for commuters emerging from behind their privet hedges at the start of the daily journey into London.

Charles Holden (1875–1960) built the station when this section of the District Line between Park Royal and South Harrow was handed over to the expanding Piccadilly Line, and it was

the first of a run of variations on a theme on the Northern and Piccadilly lines, culminating in 1935 with Arnos Grove's drum surmounting a rectangular box shape. The original Sudbury building, which replaced a shack in 1903 to coincide with the introduction of electrification, was part of a plan to push out beyond the suburbs. A poster of 1909 shows passengers in a train passing through open countryside; the message is: 'Right into the heart of the country. Book to Harrow, Sudbury or Perivale'. Sure enough, the bricks and mortar followed the train lines further into Surrey, Middlesex, Hertfordshire, and Essex, destroying in their progress the rural idyll shown on the Tube poster and creating in its place subtopia, in the disparaging word coined by the architectural critic Ian Nairn.

It is ironic, then, that Holden's Sudbury Town station should have been party to encouraging the mushroom growth of subtopia while itself introducing a clean Modernism, along with the stations at Sudbury Hill, Wood Green, Southgate, Ealing Common, Park Royal, Acton Town, and of course Arnos Grove. Holden's last Tube stations included Gants Hill (completed 1947). This is under the notoriously congested roundabout so there is no surface station building but a tunnel built after Holden had visited the Soviet Union to see the Moscow Metro. He was nothing if not open-minded: he designed the London Underground stations after visiting Germany and the Netherlands.

STATION APPROACH, HA0

## HARROW SCHOOL

*Churchill in heaven*

Harrow-on-the Hill, the old Harrow, basks in splendour high above new Harrow, a place of supermarkets, burger bars and convenience stores serving the surrounding Metroland; the name coined in 1915 by the publicity department of the new Metropolitan Railway for the line's hinterland, and used as a term of abuse or satire ever since. Harrow School practically *is* the old Harrow. Harrow School Outfitters commands the High Street from the easternmost corner, number 23, facing uphill towards the school. This was the shop that supplied the top hat, tails, silk waistcoat and striped trousers worn by the two Harrow boys captured leaning on canes outside Lord's during the 1937 Eton v Harrow match with three working-class lads hard by, not quite jeering, in Jimmy Sime's photograph that launched on the *News Chronicle* front page of 10 July and then travelled round the world, an image infamous or revealing according to the viewer's position in the class war. Shop and school survive, and today's blue trousers and sweaters, with jackets and straw hats added for formality, keep the show on the road.

The school is an early seventeenth-century foundation and a painting by the Flemish topographical artist Peter Tillemans (1684–1734) in the Old Speech Room Gallery shows that the hilltop was much prettier in its earlier years before

Part of the Harrow schoolroom wall carved with pupils' names. The quality of Byron's suggests he did not carve his own.

BYRON

S. BUSHBY 1886

W. YORK

Victorian intervention; but then, almost everything was, and almost everything at Harrow is Victorian. Even the Old Schools (one building) is more clunking C. R. Cockerell Tudor of around 1819 than actual Jacobean. Inside, an old seventeenth-century classroom survives with its big fireplace, narrow benches for the boys, and the headmaster's desk and seat under a hood built into the wall panelling. But the part of the Old Schools that is open daily to the public is the Old Speech Room Gallery, which has distinguished collections of Ancient Greek and Egyptian ceramics, a body of good English watercolours, and portrait busts of famous former pupils like Byron and Richard Brinsley Sheridan. Top of the class so far as Harrow is concerned is its undistinguished and bustless old pupil, Winston Churchill. The memento the school has of him is a painting: more interesting than any bust could have been.

Revisionists say that Churchill was not as bad at school as report has it. Oh, but he was; and he was packed off to Sandhurst. He was 40 before he started painting and became what is known as a good bad painter. He didn't look closely enough at his subject as he slapped it on to canvas, but closely enough, allied to his natural brio, to create a vital impression. In the school's collection is his painting of *A Distant View of Venice*: three fishing smacks, a lot of lagoon, Venice reflected prettily in the water, and some slapdash clouds – as clouds tend to be except under the brush of Constable. With nurturing, Churchill could have made a living as an artist. As it is, he promised to spend his first five million years in heaven learning to paint. Why bother with heaven? He had the Riviera.

5 HIGH STREET, HA1 3HP

## ST MARY'S, HARROW ON THE HILL

*Where mad, bad Lord Byron buried his little daughter and wrote a sad, bad poem*

Middlesex, the lost county, numbered among fictions like Barsetshire and Loamshire, is remembered in the survival of its county cricket XI and for its pretty churches. Of these, St Mary's, Harrow on the Hill, is not the prettiest but its silhouette on the hill's peak is the most romantic. It has a romantic history too, notably the mad, bad and dangerous to know Lord Byron burying his five-year-old daughter Clara Allegra there in 1822 in a grave that remained unmarked, and writing a melancholy poem based on his Harrow schooldays memories of lying gazing through the leaves of an elm in the churchyard: the elm has withered and so has the reputation of this navel-gazing verse. The Byron Society has placed a memorial stone near Allegra's grave carved with Byron's suggested epitaph, but adding the name of the child's mother, Claire Clairmont, which seems unaccountably to have slipped the poet's mind.

Anciently, St Mary was a peculiar of the Archbishop of Canterbury; that is, it was administered by Canterbury rather than a local diocese. The immediately post-Conquest Archbishop Lanfranc

Thirteenth-century Gothic at St Mary's, Harrow on the Hill; impeccable behaviour introduced by G. G. Scott, 1840s. Best feature: the tall octagonal spire.

began the rebuilding but died before it was finished and his successor Anselm consecrated it in 1094. There had been a dispute with the Bishop of London over who should do so. According to Anselm's biographer, the Canterbury monk Eadmer (*c.* 1060–*c.* 1126), adjudication went to Anselm, but an adherent of the bishop stole the holy oil at a crucial moment of the ceremony. Happily, the holy thief failed to make his getaway and the consecration went ahead. Today the oldest surviving Norman work is the big twelfth-century tower. This is misshapen by buttresses added when it was thought to be on the verge of sliding down the hill; and it is rendered, not attractively. But the tall, octagonal, lead-covered fifteenth-century spire redeems it. The body of the church – nave, chancel, transepts – is sturdily flint-built, from the thirteenth, fourteenth and fifteenth centuries with interventions by the nineteenth-century Gothicist George Gilbert Scott (who also built the Gothic Harrow School chapel a few paces down the hill).

There are memorials within the church to long-gone Harrow schoolmasters, since after the sixteenth-century foundation of the school the parish church doubled up as school chapel. The oldest of an abundant collection of small brasses is from 1370, a real titch but a beautifully detailed one of a knight called Edmund Flambard. The newest is a brass of 1592 of John Lyon, founder of the school, and his wife Joan. A wonderfully solemn Tudor memorial of painted alabaster in the north aisle shows a man and wife in black opposite each other, kneeling at prayer before desks; three sets of coats of arms that must have decorated a vanished canopy make a brave display set into the wall behind. But the church's finest ornament dates back to Norman times: the font. In 1800 it was thrown out and ignominiously made into a garden ornament. After nearly half a century it was reinstated, its glowing brown Purbeck marble carved in a simple geometric pattern, its sturdy stem decorated with spiralling diagonals.

CHURCH HILL, HA1 3HL

## • CANONS PARK, HARROW WEALD, HATCH END, HAREFIELD •

### ST LAWRENCE'S, WHITCHURCH

*The baroque remnant of a duke's beautiful dream*

Tread on Canons Park and you trample ancient dreams. Most anciently, the Priory of St Bartholomew the Great once stood here. Next, in 1713, came James Brydges, later Duke of Chandos, grown fabulously rich as paymaster-general to Marlborough's continental forces, and on Cannons Park (as the spelling was) he built a mansion almost as splendid as Blenheim itself; better, said Defoe, a palace 'so beautiful in its situation, so lofty, so majestick the appearance of it, that a pen can but ill describe it… no orna-

ment is wanting to make it the finest house in England.' But ignominy followed within a few years. The South Sea Bubble was only the biggest of the financial disasters that befell Brydges, and his palace was pulled down within three years of his death in 1744.

In the early twentieth century the London Underground arrived, with stations at Canons Park and, at the end of the line, Stanmore, and houses and schools on the park and along Whitchurch Lane south as far as Edgware Brook. All that is left of the duke's dream is the church John James rebuilt for him (apart from the medieval tower) in 1715, St Lawrence's, Whitchurch, buried among the 1930s semis that look so like the pretty houses depicted on London Underground posters of the time. Here in a mausoleum off the big single square chamber of the church is a massive monument to the duke for which 'Gibbons was paid', as Pevsner puts it cautiously, because Gibbons kept a stable of better sculptors in marble than he was himself; in fact the figure of a Roman-style Chandos is bland enough to have been carved by the boss. It is certainly overshadowed by its setting of witty trompe l'oeil painting of architectural details and sculpture in niches on all the interior surfaces of the mausoleum, by Francesco Sleter and Gaetano Brunetti, two of the team of painters Brydges had employed in the mansion painting walls, ceilings and glass (much of this decor now wonderfully re-employed in Worcestershire at St Michael and All Angels, Great Witley).

Of course, no one could match Gibbons for wood carving, and it may be that he made the wonderful pediment on Corinthian columns that frames the reredos in the aisleless church, though the ensemble does not have the full opulence of which he was capable. Sleter and Brunetti painted the figures in grisaille (half-tone, as newspaper picture desks referred to photographs in the days before colour) on the north wall. Louis Laguerre of Blenheim fame did the ceiling and Antonio Bellucci painted the *Nativity*, the *Deposition* and the respectable copy of Raphael's *Transfiguration*. As Chandos's composer in residence, Handel played on the organ set in the retrochoir (the current organ has recently been restored and given a new keyboard; Handel's is in a glass case in the mausoleum antechamber). Set in the latest instalment of Canon Park's dream, 1930s Metroland, this church is a wonderful and (dare one say?) entertaining survival, Baroque in the latitude of Edgware.

WHITCHURCH LANE, HA8 6QS

## GRIM'S DYKE

*Norman Shaw's exuberant Tudor pile*

Grim's Dyke, now a hotel, perfectly exemplifies the style of Norman Shaw's houses in the first flush of his career as an architect. Multi-gabled, jettied and double-jettied, half-timbered, brick-built, tile-hung, big stone-mullioned and transomed windows, an oriel, chimneys aspiring to deliver their smoke directly into the clouds. It's a Tudorbethan building; that is, high, wide and faked up, flushed red in daylight, at night under a full moon the perfect stage set. Shaw (1831–1912) was the great spoofer of nineteenth-century

architects. (The very word, spoof, was coined by his contemporary, the comedian and music-hall artist Arthur Roberts, as renowned in his day as Shaw was.) For Grim's Dyke he had the perfect client, the Royal Academician Frederick Goodall, a genre painter whose own highly popular spoofery, based on a couple of visits to Egypt, was paintings of such typical daily scenes as half-naked handmaidens in a landscape with pyramids recovering the baby Moses from the bulrushes for a half-naked daughter of Pharaoh. For his paintings of *fellahin* guarding their flocks beside the Nile he imported sheep from Egypt to the beautiful gardens of Grim's Dyke, though for the *fellahin*, sketches on Nile location had to suffice. Goodall embraced Shaw's notions about the propriety of adapting old English styles to domestic architecture and happily accompanied him on sketching tours of Sussex.

The domestic commissions following the sketching trips comprised the first work by Shaw after he had set up his own practice in the 1860s. Later, he became famous for Queen Anne derivations like his famous Swan House on Chelsea Embankment and the baroque New Scotland Yard, now replaced by Michael Hopkins's extension to Parliament, Portcullis House. The Old English, as this period became known, no doubt spawned its much frowned upon successor, the Tudorbethan estates that swamped middle England, but the sheer exuberance

The Grinling Gibbons team carved the Chandos memorial in the magnificent St Lawrence's, Whitchurch; Sleter and Brunetti, painters to the duke (Chandos), did the interiors.

of Shaw's Grim's Dyke, sitting on its hill at the end of a winding lane called Old Redding, was of a different order from his pasteboard imitators, and the apparent quirkiness of a wing placed at a diagonal to the rest of the house was actually the rational way of incorporating a north-lit studio (though Shaw adopted it for later houses purely for its quirkiness).

Yet Goodall grew tired of its inconvenient distance from his London haunts and moved out in 1882. In 1890 W. S. Gilbert, the librettist half of Gilbert and Sullivan, bought Grim's Dyke and instructed Ernest George and Harold Peto, famous London house designers, to make alterations. The most special of these is now the hotel dining room, a combination of nineteenth-century suavity with the proportions of a medieval hall; it has a fine barrel-vaulted ceiling and a spectacular alabaster fireplace imported for Gilbert from France.

He added to the amenities of the great garden by digging a small lake in which he swam daily. In 1911, after a splendid lunch at the Garrick, he returned home to teach two young women friends to swim. He disappeared beneath the surface, and when the gardener fished him out he was dead of a heart attack.

OLD REDDING, HA3 6SH

## HATCH END RAILWAY STATION

*A masterpiece of railway architecture*

Here, almost in full, is the English Heritage Grade II listing for Hatch End railway station:

*Entrance block of Hatch End Railway Station TQ 19 SW 1/8 16.2.82 II 2. 1911 by Gerald C. Horsley for London and North Western Railway. Symmetrically composed. Redbrick with stone dressings. Two arches to ground storey with central sashed window and large decorative crest over. Left-hand arch has doors with window over. Right-hand arch is fully glazed above stone plinth. Channeled pilaster quoins with dentil cornice. Tile roof surmounted by pedimented cupola with inset clock. Single-storey, irregular wings to right and left.*

The tile roof is actually slate, otherwise it is all present and correct. Except for the poetry. The description, necessarily perfunctory of course, is like Betjeman's verse rewritten for Bradshaw's railway timetables. For this may be the prettiest station in England. And there's even a railway line. Purists might gag at the notion of a Wren of the railways, but Hatch End is more expressively railway station than the Gothic monster in St Pancras. The conical roof with clock inset into a cupola and a weathervane on top insists 'country station', yet the panel between cornice and the window beneath bears a Modernist take on the School of Grinling Gibbons, with swags of fruit and a brave show of rose, thistle and shamrock; 1911 is writ large above the lush foliage, L&NWR elegantly lettered beneath; Wales presumably relegated as merely the terminus for the Holyhead-Dublin boat.

The architect, Gerald Callcott Horsley (1862–1917), built Hatch End as a replacement for the original station called Pinner, which had been erected in 1842 for the London and Birmingham Railway. He was a pupil of Norman Shaw (designer of the nearby Grim's Dyke house, see page 557), and with four fellow pupils and one other founded the Art Workers' Guild in opposition to the Royal Academy. The infamous five-plus-one wanted a society that accepted no division between high art, decorative art and the crafts: the full Ruskin/Morris Arts and Crafts bit. In the process, although the guild exists still, it alienated the academy as well as most architects, who saw themselves as belonging to a profession, and rich clients who wanted grand architecture, not the form-follows-function hovels proposed by the Arts and Crafts boys. So Horsley is really remembered today only for the tiny Hatch End station, which is on the new London Overground line from Euston to Watford, and on the same line, the good but less charming Harrow and Wealdstone station and Bushey, plus a Midlands church and a few houses.

In his *Who's Who* entry Horsley listed two hobbies: sketching and golf. His golf handicap is forgotten, but his use of the word sketching was modesty personified. He was the son of the watercolourist John Callcott Horsley, but in the mundane field of architectural draughtsmanship he excelled his father's art and supplemented his earnings by producing drawings for rival architects. The atmospheric rendering and the vibrant touch of the drawings are picked up in the white stone dressings of Hatch End station.

STATION APPROACH, HA5

## ST ANSELM'S, HATCH END

*The Piccalilli church of Hatch End*

The parish church of Hatch End, consecrated in 1895, might have been dedicated to St Crosse and St Blackwell, purveyors of baked beans to the multitude and Piccalilli to Her Majesty the Queen – Victoria, that is. The actual patron saint is Anselm, Archbishop of Canterbury in the reign of William Rufus, but it exists through the largesse of Thomas Blackwell, who gave farmland for the site of the church and added a cash donation. The chances are that his lifelong friend and business partner Edmond Crosse chipped in also, since the two acted as joint benefactors in many causes in their native village, Harrow Weald. They met in 1819 on the shop floor of the local food processing firm where they were apprenticed and which they later bought. They are united in death in the churchyard of All Saints, Harrow Weald, and, for all we know, throughout eternity on the labels of Crosse and Blackwell's 'store cupboard favourites'.

The parish could not raise enough cash to build the tower intended by the architect, F. E. Jones; a significant lack today, when the building is easily missed in the dense sprawl of suburbia. Its brick and flint exterior is pleasant if unremarkable, but within the church things are altogether more arresting; almost spectacular, but Arts and Crafts doesn't really do spectacular. Here, an open oak screen of filigree delicacy crowned by a crucified Christ with his mother and St John fills the low, wide roof space between nave and chancel. The artist, Charles Spooner (1862–1938), is relatively unknown; even at the time of the unveiling in 1902, the *Wealdstone Gazette* called him 'a Mr Charles Spooner'. Initially, a Church of England court banned the screen on the suspicion that it smacked of Roman Catholicism and encouraged 'superstitious practices and observances'. On appeal, common sense prevailed. It is not 'great art' – which is beside the point in the Arts and Crafts Movement. Here architectural context is everything, and the rood figures are sufficient unto the purpose.

The stained glass is a different matter. A Mr Louis Davis (1860–1941) made most of it in the second decade of the twentieth century. He had been a pupil and assistant of Christopher Whall, the artist who moved stained glass towards Modernism from its Victorian revival. Davis took from Whall the principle that even coloured windows must include enough clear glass to let light into the church. His figures are vivid, his colours light-washed: see the beardless young warrior Christ in the central light of three in the west window flanked by kneeling angels, a rippling band running through all three representing a fish-filled stream, the quartzes of clear glass between the leading worked like rough jewels. Michael Hill, a young soldier member of St Anselm, came home on leave with a piece of ruby glass from the shattered cathedral of Ypres. Davis set it in the Christ window, probably as the buckle clasping Christ's cloak. Hill returned to the Western Front and died there ten days before the consecration of the window.

WESTFIELD PARK, HA5 4JJ

## HAREFIELD VILLAGE

*A London village that treats triumph and disaster just the same*

Harefield is in London, but on a green hill far away, on the borders of Buckinghamshire and Hertfordshire, its High Street a remnant, seemingly untouched, from the Attlee years. At the southern end of it as I drive in someone is easing a pre-war Austin 10 on to a low loader; not yet, by the look of things, for its last journey to the knacker's yard. If you were to give it a nudge, Harefield would roll over and go back to sleep, stretched out below its big square village green. Parliament once proposed a railway line to the village, but somehow it got lost in the general slumbers and still only a few desultory buses venture this far. It is about 17 miles from Charing Cross, but deep in the green belt, hoping to stay that way, barely touched by time though with its share of trauma and triumph (rows over joining the twentieth century; pride over the significance of Harefield Hospital).

The western border of the village in the flood valley below runs alongside the River Colne, the Grand Union Canal and a chain of lakes, some of them half a mile wide. Yet industry has never taken hold: there is only a wind-driven corn mill and a paper mill dating from before history books coined the term Industrial Revolution. What's left is Black Jack's lock, still working, with an old mill hard by, now a bed and breakfast establishment, a group as pretty as a Constable painting. In the First World War the owners of Harefield Park on the hill above the Colne loaned the house to serve as a military hospital, mainly for Australian troops wounded in the disastrous Gallipoli invasion of 1915. Those who died lie in an Anzac cemetery by the parish churchyard. The hospital's glory now resides in its pioneering record in heart transplant: here in 1980 Magdi Yacoub performed Britain's first successful heart transplant and in 1983 its first heart and lung transplant.

Old mansions adapted to other uses stand sentinel, but the Countess of Derby almshouses on Church Hill is the oldest building in the village apart from St Mary's church. The countess's estate built it in 1637, after her death. It lies on three sides of a courtyard, the fourth open to the road. It is constructed of brick fashioned in the brickyards behind the High Street. It still houses four pensioners, each apartment marked by a soaring chimney emerging from a mighty stack. It is not just the oldest secular structure in Harefield but the prettiest, with the Derby arms carved in stone above the central entrance.

The countess was born Alice Spencer at Althorp, which makes her a distant cousin to Diana, Princess of Wales, at least in the creative convolutions of heraldry. She was a great patron of the arts, probably of Shakespeare, certainly of Edmund Spenser, another distant cousin, who bestowed on her the character of 'sweet Amaryllis' in his pastoral poem *Colin Clouts Come Home Again*. She died at Harefield Place and has a splendid tomb in St Mary's (see page 563).

HAREFIELD, WD3

## ST MARY'S, HAREFIELD

*The jolly mausoleum of the Newdigate-Newdegates*

The ancient parish church of St Mary's is lost in a deep hollow surrounded by fields, great trees, the big churchyard with its extension for Australian victims of the First World War Gallipoli landings who died of their wounds in Harefield Hospital, and, at nightfall, profound darkness. Yet the church's pastoral setting, its bulky brick tower hardly taller than the steep pitched roof of the nave, the patchwork of stone of every century from the twelfth to the nineteenth in the body of the building, speak of an unexceptional but very pretty country church; just the sort of place to find the rustic stone tablet raised on the outside north wall by the Ashby family to its faithful servant, the gamekeeper Robert Mossendew, who died in 1744 aged 60. Beneath a charming carving of the armed keeper following his pointer through a meadow, 12 lines of verse extol the man's virtues:

> *In frost and snow thro' Hail and rain*
> *He scour'd the woods and trudg'd the plain*
> *The steady pointer, Leads the way,*
> *Stands at the scent then springs the prey*
> *The timorous birds from stubble rise*
> *With pinions stretched divide the skys*
> *The scatter'd lead pursues the sight*
> *And death in Thunder stops their flight.*
> *His spaniel of true English kind*
> *Who's gratitude inflam'd his mind*
> *This servant in an honest way*
> *In all his actions copy'd Tray*

The interior of the church is a smoothly plastered barrel vault of the seventeenth century; the chancel ceiling too, but ribbed and decorated in a neo-Gothic style that bestows light and airiness on an interior crowded with brass memorials in the walls. There are stone floors and big pews bearing the fleur-de-lys of the Newdegates, one of the ancient families of the village. The glass roundels in the Breakspear chapel window are sixteenth-century Flemish, and the altar rails and extraordinary reredos against the east window, with angels kneeling either side of a double-arched frosted glass screen bearing the Ten Commandments, are Flemish too, but of the seventeenth century. To either side of the reredos are two massive tombs, one by Grinling Gibbons at his worst, white marble with a lumpen recumbent figure of Mary Newdegate (d. 1692), the design an echo of the other tomb by Anon., lovably clumsy, bearing the scarlet-swathed figure of Alice, Countess of Derby (d. 1637, see page 562), a power in the land by virtue of her marriage, recumbent beneath an elaborate canopy, and great in her own right from birth as a Spencer of Althorp.

But most of the things that count in this church are about Harefield's oldest families, the Breakspears, the Ashbys, but mostly the Newdegates. They emerged in Harefield in the fourteenth century, evolved into Newdigate, then, when a man called Charles Parker infiltrated the family, he combined all the options to become Charles Newdigate Parker Newdegate, though early twentieth-century successors settled modestly for Newdigate-Newdegate.

COUNTESS CLOSE, UB9 6DL

# INDEX

Abbey Street 357
Aberdeen, David du Rieu 123, 124
Acton Town Station 552
Adam, Robert 76, 93, 152, 302
    Adelphi Terrace 102
    Apsley House 209
    Kenwood House 521–2
    Osterley Park 268–9
    Syon House 289–90
Adam Street 102
Adams, Maurice 258
Adams-Acton, John 61
Adelphi Terrace 102, 103
Adjaye, David 363, 438
Aeroville, Hendon 529–30
Agar Street 97
Airy, George 376
Aitchison, Craigie 230
Aitchison, George 242, 246
Akhmatova, Anna 188
Albert Bridge 295
Albert Embankment 340–1
Albert Gardens, Commercial Road 452–3
Albert Hall 30
Albert Memorial 183
Aldgate 81–3
Aldgate East Underground Station 438
Aldwych Underground 507
Alexander, Hélène 370
Alexander Pope's Grotto 301–2
Alexandra Memorial 159–60
Alexandra Palace 535–6
Alfege, Archbishop of Canterbury 368
Alfred, King 294
All Hallows by the Tower 68–70
All Hallows, Lombard Street 296
All Hallows the Great 54
All Hallows, Twickenham 296–7
All Saints, Isleworth 290–1
All Saints, Margaret Street 132–4

All Saints', Orpington 422–3
All Souls, Kensal Green 250
All Souls, Langham Place 191–2
Allen, Joe 95–6
Allies and Morrison 332
Allingham, Helen 222
Alsop, Will 343, 362
Amigoni, Jacopo 37
Andreoni, Orazio 299
*Angel of Peace* 440–1
Angerstein, John Julius 158, 201
Annan, Dorothy 40–1
Anne, Queen 49, 287
    Statue of 180, 312–13
Anrep, Boris 140, 187–9
Anselm, Archbishop of Canterbury 556
Apothecaries, Society of 26–7, 220
Apothecaries' Hall 26–7
Appleby, Gabriel 50
Apsley House 208–10
Arad, Ron 464
Arbour Square 453
*Archer, The* 533
Archer, Thomas 364–5
*Ariel* 181, 192
Armstrong-Jones, Anthony 242
Arnoldi, Per 169
Arnos Grove Station 343, 532, 552
Arsenal Football Club 383
Artari, Guiseppe 300
Artillery Lane 432–5
Arts Council 47, 330
Arup 501
Asalache, Khadambi 279
Ashfield, Lord 234
Ashmole, Elias 340
Astor, William Waldorf 88–90
Athenaeum Club 148
Atkinson, Robert 9, 297
Augusta, Princess 93
Aumonier, Eric 9, 181, 182, 532–4
Austen, Robert 418

Austin, David 495
Austin Monument, Southwark Cathedral 350–1
Avenue House 531–2
Avis, Joseph 78
*Awakening* 223

Bacon, John 151, 352, 515
Bagutti, Pietro Martire 300
Bailey, David 383
Baker, Sir Herbert 53, 476
Bakerloo Line 101, 343
Balfron Tower 248, 466
Baltic Exchange 76
Bamber, John 477
Bandstands 396–7
Bank of England 52–3
Bankside 349
Banqueting House, Whitehall 72, 166–8
BAPS Shri Swaminarayan Mandir 550–1
Barber, Francis 13, 278
Barbican Centre 40–1
Bargehouse Street 335
Barker, Robert 140
Barkers building 240
Barking 477–9
Barkworth, Peter 517
Barlow, Arthur Bolton 343
Barlow, William Henry 500–1, 512
Barnardo, Thomas 462
Barnett, Henrietta 528–9
Barnsley, Ernest 255
Barry, Charles 136, 175
Bartholomew Close 37, 104
Basevi, George 190
Bates, Harry 216
Bath Road 257, 258, 272
Battersea 283–4
    Park 282–3
Battlebridge 43
Baty, Patrick 435

Bawden, Edward 106
Bayes, Gilbert 195–6, 342, 504–5
Bayliss, William 282
Baynes, John 485
Bazalgette, Joseph 118
BBC 192–3, 535
Beaufort, Lady Margaret 179
Beaumont, John Barber 461
Beaumont, Sir George 201
Beaverbrook, Lord 9, 194
Beck, Harry 101, 105, 234
Beckenham 403
Becket, Thomas 336
Becontree Estate 479
Beddington Park 323
Bedford, Dukes of 106, 120
Bedford, Francis 335
Bedford Park 256–9
Bedlam Hospital 63, 145, 344, 403
Beechey, William 55
Beehive Passage 74
Belgian Monument 99–100
Belgrave Square 190–1
Bell, Robert 244
Bellucci, Antonio 557
Belvedere Road 332
Ben Pimlott building 362–3
Benjamin Franklin House 104–5
Bennett, Captain John 477
Bennett, W. J. E. 189
Bentall's 312
Bentham, Jeremy 129
Bentham, Philip 29
Bentley, John Francis 187
Berkeley Street 202–3
Bermondsey 343, 347, 355, 357–8
Berwick Street 142
Besant, Walter 461
Bethlem Royal Hospital 403–4
Bethnal Green 457–9
Betjeman, John 97, 242, 273, 501, 531
    Statue of 501
Bevis, Leslie Cubitt 223
Bevis Marks 78–9

Bexleyheath 415–19
Bibendum Restaurant 226
Big Ben 440
Biggin Hill 408–9
Billingsgate 64–5, 68, 71
Binnington, Dave 445
Bird, Francis 291, 313
Bishop's Avenue 529
Bishopsgate 55–9, 63, 513
Bishopsgate Institute 438
Black Dyke Band 396
Black Friar, The 24–6
Black Prince Road 342
Black Virgin, Willesden 549
Blackburn, William 68
Blackfriars Lane 26, 27
Blackfriars Station 512
Blackheath 378–9
    Park 380–1
    Village and Heath 376–7
Blackwall Tunnel ventilation shafts 465–6
Blair, Tony 79
Blake, Admiral Robert 178
Blake, Peter 174
Blake, William 60–1, 155, 284, 388–90
Blakeman, Charles 16
Blee, Michael 290
Bligh, William 340
Blizard building 363
Blomfield, Arthur 415
Blomfield, Charles James 189, 251
Blomfield, Reginald 100, 501
Bloomsbury 94, 117, 120–3
Blount, Gilbert 286
Bluecoat Hospital Schools 244–5
Blundstone, E. V. (Ferdinand) 44
Blunt, Anthony 391
Bodley, G. F. 189, 531
Bodley, J. F. 401
Boehm, Joseph Edgar 422
Boleyn, Anne 88, 446
    Statue of 323–4
Bolingbroke, Henry 540

Boltons, The 230–1
Bonaparte, Napoleon 208–10
Bond Street 98
Bonnor, J. H. 258
Boone's Chapel 367
Boonham, Nigel 31
Borough, Stephen 452
Borough
    High Street 348–9
    Market 350
Boston Manor 267–8
Botero, Fernando 59
Boucher, François 268
Boudica 43, 294
Boudin, Stéphane 190
Bow Lane 45
Bower House 485–6
Bowling, Frank 279
Boyd, John 415
Bracken House 28–9
Bradford, Alfred Thomas 346
Bradford, E. J. 26
Bradford, Sarah 94
Brandram Road 367
Brealey, John 310
Brick Lane 428–9
Bridge, Robert 431
Bridges 294–5
Brilliant, Fredda 127
British Film Institute 330
British Medical Association 97, 98
British Union of Fascists 445
Brixton 278, 280–1
Broad Court 108
Broad Walk 204
Broadcasting House 192–3
Broadgate 56–8, 59
Broadway 182
Broadwick Street 142, 155
Bromley 401–3
Brompton Oratory 229–30
Brook Street 200–1
Brookmill Road 363
Brown, Charles Bernard 378
Brown, Ford Madox 418

Brown, George 144
Browne, Hablot K. ('Phiz') 115
Broxfield Road 486
Bruce Castle 536–8
Brunel, Isambard Kingdom 49, 359–61
Brunel, Marc Isambard 359–61
Brunel Museum 359–61
Brunetti, Gaetano 557
Brushfield Street 430
Brydges, James 556
Bryson, John Miller 18
Bubb, James 348
Buchel, Charles 116
Buckingham, Duke of 102–4, 137
Buckingham Palace 135, 163, 165–6
Buckle, J. G. 473
Bulldog Trust 88
Bull's Head Passage 74
Bunhill Fields 60–1
Bunning, James 30, 65
Bunyan, John 60
Burdett-Coutts, Angela 462, 523–4
Burges, William 229
Burke, Edmund 172
Burlington, Lord 168, 262–3, 301, 316, 430
Burlington Arcade 149
Burlington House 139, 332
Burne-Jones, Edward 216, 255, 320, 417
Burnham, Daniel 196
Burton, Decimus 207–8, 288, 498
Burton, Richard 285
Bury Street 155
Bushnell, John 33, 69
Butcher Row 453
Bute, Lord 93
Butler, Frank A. 343
Butler's Wharf 356–7
Butterfield, William 17, 50, 132–4
Byrd, William 162
Byron, Lord 554

Cable Street Mural 445–6
Cabot Square 463
Cachemaille-Day, Nugent 414
Cadogan Pier 66
Callcott, Frederick 24, 26
Calton Hill, Edinburgh 62, 388
Cambridge, Duke of 161
Camden 507, 508–10
Camden Place 420–2
Camden Town Group 517
Campbell, Colen 316–17, 430, 474
Canada Water 343
    Library 361–2
Canary Wharf 66, 343, 463–4
Cannon Street 29, 30
    Station 512
Cannons 147, 204
Canonbury Square 511
Canons Park 556
    Station 557
Canterbury, Archbishops of 107, 368, 400, 554, 556
Capa, Robert 335
Carew Manor 323
Carlton Cinema, Essex Road 510–11
Carlton House 348
Carlton House Terrace 191
Carlyle, Thomas 152
    House 221–2
Caro, Anthony 467
Carpenter, Andrew 147
Carpenters' Company 79
Carracci, A. 163
Carreras Cigarette Factory 505–6
Carshalton 323–5
Carter, Edward 540
Carter, Thomas 307
Carter Lane 30
Cartwright, Thomas 336
Caruso St John 459
Casanova, Giacomo 142
Casement, Sir William 250
Cass, Sir John 79–81
Casson, Hugh 228

Castlemain, Viscount 474–6
Catherine of Braganza 162
Cator, John 378
Cavendish Square 98, 125
Caxton, William 10
Cecil Sharp House 509–10
Central Avenue 74
Central St Martins School of Art 501
Chalton Street 505
Chambers, William 92–3, 288
Champeneis, John 418
Champney, Basil 486
Chandos, Duke of 556
Channon, Henry (Chips) 190–1
Chantrey, Francis 385, 422
Chapel of the Savoy 95
Chapel Royal, St James's Palace 160–1
Chaplin, Charlie 346
Charing Cross 123, 136, 142, 336
    Station 512
Charles Dickens Museum 115–16
Charles I 72, 77, 161, 162, 284, 303, 339, 548
    Portrait of 4, 165, 166, 307
    Statue of 33, 136–7
Charles II 54, 63, 66, 69, 137, 162, 272, 410, 525
    Statue of 33, 145–6, 218
Charlotte Street 516
Charlton 383–5
    Athletic 383
    House 385–6
Chase Manhattan 202–3
Cheam 320–3
Cheapside 352
Chelsea
    College of Arts 185–6
    Embankment 223–5, 559
    Old Church 222–3, 225
    Physic Garden 27, 220–1
    Royal Hospital 218
Chertsey Road 297
Chester Terrace 498

Chesterfield, Lord 14
Cheyne Row 221–2, 283
Child, Francis 269
Child, Sir Richard 474
Chinatown 144
Chingford 542–3
Chislehurst 420–2
Chiswick 36, 256–65
    House 262–3, 316
Christ Church, Spitalfields 430–1
Christ's Hospital 35, 36, 245
Church Row, Hampstead 515, 517
Churchill, Winston 29, 30, 127, 181,
    330, 398, 554
    Statue of 172
Cibber, Caius Gabriel 63, 145, 403
Cipriani, Giovanni Battista 290
City and South London Railway 49
City Hall 355
City Road 60–2
Clarence House 163–4
Clark, Kenneth 163
Clark, Philip Lindsay 431–2
Clattern Bridge, Kingston 312
Clayton, Rev. P. B. (Tubby) 42
Clayton, Sir Robert 336
Clayton and Bell 88, 187, 241
Clemm, Michael von 463
Cleopatra's Needle 99–100
Clerkenwell 17–20, 21
Cleyn, Francis 307
Clitherow, James 267
Coach and Horses, Soho 142
Coade, Eleanor 60
Cobb, Charlie 246
Cobbett, William 90
Cobden-Sanderson, Thomas 255
Cock Lane 36
Cocteau, Jean 140–1, 144
Coke, Thomas 139
Cole, George 306
Cole, Henry 459
Coleborn, Keith 405–7
Coleraine, Lord 536
Coleridge, Samuel Taylor 35, 36

Coles, George 510
Colet, Sir Henry 455
Coliseum 470
Collins, Marcus 506
Commercial Road 453
Comper, Ninian 134, 189, 207
Conder, Neville 228
Conduit Street 21
Congress House 123–5
Conner, Angela 156
Conran, Terence 155, 228
Constable, John 294, 516
Container City 466
Cook, Captain James 319
Cook, Peter 142
Cooper, Rev. Edward 532
Cooper, Henry 460
Copperfield Road 462
Coram, Thomas 15, 116
Corfiato, Hector 140
Cork Street 386
Cornbury House 411
Cornhill 48, 49
Coronation Stone 313, 314
County Hall 60, 330
Courtauld, Stephen 411–13
Courtauld, Virginia 411–13
Courtauld Gallery 93–4
Covent Garden 38, 95, 97, 105–9,
    112, 151
Cox, Richard 16
Craig-Martin, Michael 366, 386–7
Cranbrook Park 476
Craven Cottage 252–3
Craven Street 105
Craxton, John 156
Creechurch Street 77, 78
Creed, Martin 152
Creevey, Thomas 163
Cribb, Tom 71
Cripps, Stafford 31, 511
Criterion 97
Croft-Murray, Edward 485
Cromwell, Oliver 78, 137, 284, 293,
    508

    Statue of 176–7
Cromwell, Thomas 54, 55, 471–3,
    549
Cromwell Gardens 228–9
Crooms Hill 369–70
Crosby, Brass 344
Cross, Alfred 97
Croydon 400–1
    Airport 398–9
    Palace 399–400
Cruikshank, George 116
Crystal Palace 394–5, 398
Cubitt, Lewis 500
Cubitt, William 190, 512
Cullen, Gordon 23
Cumberland Terrace 498
Cundy, Thomas 189
Cunningham, Ivor 380
Curzon Mayfair 204–5
Cuyp, Aelbert 49

Dadd, Richard 403
Dagenham 468, 479–81, 486
    Idol 480
    Library 481–2
Dahl, Michael 139
*Daily Express* building 7, 9–10
*Daily Mail* 240
*Daily Worker* 248
Dalou, Aimé-Jules 50–2
Dance, George 48, 56, 62, 265, 421
Danson House 415–16
Danvers House 220
Darbishire, Henry 523–4
Darby, Thomas 50
Dartford Crossing 484
Dartmouth, Earl of 376
Darwin, Charles 407–8
Dashwood, Francis 419
Davidson, John 10
Davis, Louis 561
Day, Paul 503
Dean Street 18, 142, 146–7
Defoe, Daniel 60, 379, 478
Deighton, Leonard Cecil 106

Denny, Robyn 101-2
Deptford 363-4, 365-6
Derbyshire, Nick 59
Deripaska, Oleg 191
Desenfans, Noël 391
Design for London 481
Design Museum 355
Devereux Court 90
Devonshire Gates 203-4
Devonshire Terrace 115
Diana, Princess of Wales 161
Dick, William Reid 207
Dickens, Charles 115-16, 118-19, 189, 292, 523
Dickinson, Frank 325
Disraeli, Benjamin 79
District Line 488
Dixon, Joseph 284
Dixon Jones 93
Dobson, Frank 29, 193, 330-1, 353
Docklands, London Museum of 463
Docklands Light Railway 49, 386-7
Docks, London 453
Dr Johnson's House 13-14
Doggett's Coat and Badge Wager 66
Dome of Discovery 330, 331
Donald, Peter 202
Donatello 95, 375, 504
Donegan, Lonnie 232
Donne, John 31-2
Donoughue, Lord 315
Doolittle, Eliza 106, 107
Dorn, Marion 413
Doughty Street 115-16, 118
Doulton, Henry 341-3
Dow Jones 339
Dowbiggin, Lancelot 358
Down House 407-8
Downe 405-7
D'Oyly Carte, Richard 95
Draper, Charles 383
Drapers' Hall 54-5

Dreyfus, Alfred 52
Drogheda, Lord 156
Drury Lane 97
Duke of York Street 153
Duke of York, Roger Street, The 114-15
Dulwich
    Park 390-1
    Picture Gallery 254, 391-2
    Tollgate 392-3
Dunnett, James 248
Durham, Joseph 30
Durham House Street 102
Duveen, Lord 184
Dylan, Bob 232
Dyott Street 124

Eadweard Muybridge Gallery 313-14
Ealing 265-6
Ealing Common Station 552
Earls Court 231-3
East Finchley 534-5
    High Road 534
    Underground Station 9, 532-4
East India Company 90, 219, 250, 410, 464-5
East India Docks 453, 466, 467
East London Railway 361
Eastbury Manor House 478-9
Eastcastle Street 134-5
Eastcheap 371
Eastern Dispensary 435-6
Easton, Hugh 225, 455
Eaton, Herbert Francis 99
*Economist* building 156
Eden, F. C. 216
Edgware Road Underground Station 507
Edward I 78, 508
Edward III 54, 65, 104, 177
Edward VI 20
    Statue of 336, 338
Edward VII 96, 160, 451, 539
Edward VIII 114

Egan, Michael 534
Egremont, Lord 129
Ehrlich, Georg 30-1
El Vino's 107
Eldon Street 56
Eleanor of Provence 94, 137
*Election, The* 113
Electric Avenue, Brixton 280-1
Elgar, Edward 160
Eliot, T. S. 64
Elizabeth, the Queen Mother 163
Elizabeth I 4, 6, 16, 162, 293, 323, 471
Elizabeth II 27, 55, 94
Elliot, Walter 175
Eltham 413-15
    Lodge 410-11
    Palace 411-13
Ely Place 15, 16
Embankment 358
    Underground Station 101-2
Emery Walker's House 254-6
Emin, Tracy 117
Emmett, William 218
Enfield 539-42
    Lock 541
Engebrechtsz, Cornelius 178
English Folk Dance and Song Society 509
Epping Forest 542-3
Epstein, Jacob 31, 345, 508
    Congress House 124-5
    General Smuts 172-3
    London Underground 181-2
    Roper's Garden 223-5
    W. H. Hudson 236-7
    Zimbabwe House 97-8
Erasmus, Desiderius 437
*Eros* 35, 160
Erskine, John 91
Espinasse, François 226
Essex Road 510-11
Estorick Collection of Modern Italian Art 511
Etheldreda, Abbess of Ely 15

Eton 552
Euralille project 134
Eurostar 503
Euston Road 496, 500, 503
Euston Station 512
Evelyn, John 6, 68, 121, 373
Eversholt Street 508
Eworth, Hans 471
Exchange Square 59
Exeter Street 95-6
Exhibition Road 237-9

Faed, Thomas 203
Fairmount House 415
Fan Museum, The 369-70
Faraday, Michael 466
Farm Street Church 206
Farrell, Terry 465
Farringdon Road 18, 22, 40
Farynor, Thomas 63
Fehr, Henry 183
Feibusch, Hans 17, 336
Fenchurch Street Station 512
Fenton House 517-18
Ferguson, James 288
Festival Gardens 30-1
Festival of Britain 30, 123, 194, 330-1
Fetter Lane 15
Fifty Churches Act 49, 120
*Financial Times* 28, 29, 156, 466
Finchley 531-2
Fink, Peter 271
Finsbury Circus 58
Finsbury Health Centre 23-4
Firestone 270
Fish Street Hill 63, 64
Fisher, Geoffrey 296
Fitzrovia 134
Fitzroy Square 259
Flambard, Edmund 556
Flanagan, Barry 110-11
Flask Walk 517
Flaxman, John 112, 128-9, 172
Fleet, River 14

Fleet building 40
Fleet Street 6-13, 31, 33, 262
Fleming, Ian 518
Fleming Collection 202-3
Fletcher, Benton 517
Fletcher, Henry 350
Fletcher, H. M. 509
Flitcroft, Henry 485
Ford, Edward Onslow 216
Ford Motor Company 479
Foreign and Commonwealth Office 170-2
Forest Hill 393-4
Forest Road 543
Formili, C. T. G. 229
Forrest, Ebenezer 65
Fortunes of War 36
Forty Hall 540-1
Foster, Norman 169, 202, 343, 355, 464
Foundling Hospital 15, 201
Foundling Museum 116-17
Fox, Charles James 120-1
Fox, George 61
Frampton, Edward 178
Frampton, George 35, 100, 196
Francis Street 189
Franklin, Benjamin 104-5
Frayn, Michael 10, 30
Freud, Sigmund 514-15
Freud Museum 514-15
Friends Meeting House, Winchmore Hill 538-9
Frith, Francis 320
Frith, William Silver 441, 512
Frith Street 142, 146
Frobisher, Sir Martin 451
Frying Pan Alley 434
Fulham
  Football Ground 252-3
  Palace 251-2
  Road 226-8
Fuller-Clark, H. 24
Furnival's Inn 115

Gabo, Naum 23, 336-8
Gabriel's Wharf 335
Gaffin, Edward 192
Gainsborough, Thomas 158, 219, 287
Gallagher, David 428
Games, Abram 194
Gandhi, Mohandas 126-7
Gant's Hill Station 552
Garden Museum, Lambeth 339-40
Garrick, David 308
Garrick's Temple to Shakespeare 308-10
Garvin, J. L. 88
Gauguin 370
Gaulle, General de 297
Gay Hussar 144-5
Geffrye Museum 455-7
General Cemetery Company 250
Gentileschi, Artemesia 165-6
George, Bernard 240
George, Ernest 559
George I 91, 135, 239, 485
George II 353
  Statue of 147-8
George III 92, 104, 121, 130, 288
George IV 165, 207, 287
George V, portrait of 163
George VI 95, 98, 114, 163, 331
George Inn, The 349
Gerbier, Balthazar 103
Gerrard, Alfred 181
Gestetner, Sigmund 526
Gheeraerts, Marcus 130, 268
Gibbons, Grinling 138, 218, 297, 364, 557, 563
  All Hallows by the Tower 68-70
  Hampton Court Palace 310
  Kensington Palace 239
  St Alfege, Greenwich 368
  St James's, Piccadilly 154-5
Gibbs, Alexander 132
Gibbs, James 37, 90, 135-6, 139, 207, 299

Gibbs, Walter 153
Gibson, James 173
Gidea Park 487-8, 495
Gilbert, Alfred 35, 160, 422
Gilbert, W. S. 100-1, 146, 559
Gill, Eric 187, 188, 236
  Broadcasting House 192-3
  London Underground 181-2
  Queen Mary University of London 461
Gillray, James 52, 460
Gilpin, William 321
Giltspur Street 35-6
*Gin Lane* 108, 117, 120, 262
Globe Theatre 127
Gloucester, Duke of 219
Godwin, George 230
Godwin, Keith 380-1
Goldbourne Road 248
Golden Boy, Pye Corner 36
Golden Square 147-8
Goldfinger, Ernö 248, 466, 509, 518-19
Goldman Sachs 9, 11, 41
Goldsmith's College 362-3, 387
Gollon, Chris 457
*Good Samaritan, The* 38
Goodall, Frederick 559
Goodhart-Rendel, H. S. 352
Goose Green 388-90
Gordon, Charles 332
Gordon's Wine Bar 103-4
Gore, Spencer 507
Gormley, Anthony 381-2, 503
Gosse, Edmund 176
Gough, Hugh Roumieu 233
Gough, Piers 361
Gough Square 7, 13
Gould, James 56
Goupy, Joseph 140
Government Art Collection 129-30
Gowan, James 308
Gower, John 350
Gower Street 128-9
Goyen, Jan von 49

Grace, W. G. 414-15
Gracechurch Street 74
Graham, Rodney 438
Grahame, Kenneth 53
Grahame-White, Claude 529-30
Grange City Hotel 42
Gray's Inn Road 16
Great Exhibition 394, 459
Great Maze Pond 352
Great North Road 532
Great Plague 72
Great Russell Street 123-5
Great Turnstile 110
Great Western Railway War Memorial 247
Greater London House 506
Greathead, James 49
Greaves, Walter 221, 283
Greek Street 142, 144-5
Green, Leslie 235, 507
Green, The, Havering-atte-Bower 486-7
Green Park 203-4, 208
Greenwich 368-75, 378
Greenwich Hospital Commission 379
Grenville, George 104
Gresham, Sir Thomas 268
Grey, William 64
Grey Coat Hospital 244
Greyhound Tracks 315
Gribble, Herbert 229
Griggs, W. P. 476
Grim's Dyke 101, 557, 559
Grimshaw, Nicholas 334, 466, 513
Grocers' Company 26
Grodzinski's 442
Gropius, Walter 380
Grosvenor Chapel 198, 207
Grosvenor family 191
*Guardian* 146
Guild Church of St Benet 28
Guildford Street 116
Guildhall 30, 42, 48
Guinness, Edward Cecil 522

*Guitar Player, The* 521
Gundulf, Bishop of Rochester 447
Guy, Thomas 352-3
Guy's Hospital 348, 352-3
GWR War Memorial 247
Gwyn, Nell 110, 158

Haas, Elizabeth de 254-6
Habitat 155
Hackney Empire 470-1
Halfway House 358
Hall Lane 488
Hall Place 418-19
Hallgate 380
Hals, Frans 49, 196
Ham House 306-7, 525
Hamilton, Emma 319
Hamilton, Gawen 139
Hamilton, Ian 142
Hamley, William 131
Hamlyn, Paul 228
Hammersmith 253-4, 256
Hammond, H. G. 205
Hamp, Stanley Hinge 102
Hampstead 514-23
  Heath 528
  Underground Station 507
Hampstead Garden Suburb 528, 529
Hampton Court Palace 310-12, 316, 379
Handel House Museum 200-1
Handel, George Frederick 116, 117, 200-1
Hardman, John 206
Hardwick, Jimmy 96
Hardwick, Philip 190
Hardwick, Thomas 474
Hardy, Bert 10
Hardy, Thomas 504
Hare, Cecil 401
Hare, Henry 536
Harefield 562-3
Harle, Captain John 482
Harley, Robert 91

Harlow New Town 330
Harmondsworth Great Barn 272-3
Harmsworth, Alfred 6, 13
Harrington, Denis Edmund 114
Harrow 554-6
    Road 250
    School 552-4, 556
Harrow Weald 557, 559
Hart Street 70-1, 72-3
Hastings, Donald 414
Hastings, Jack 19-20
Hastings, Warren 172
Hatch End 561
    Railway Station 559-60
Hatton Garden 15-16
Havering-atte-Bower 485-7
Hawksmoor, Nicholas 15, 91, 445
    Christ Church, Spitalfields 430-1
    Royal Naval College 373
    St Alfege, Greenwich 368
    St George's, Bloomsbury 117, 120
    St Mary Woolnoth 49-50
Hayls, John 375
Haymarket Opera House 149
Hay's Wharf 29, 353-5
Hayward, Isaac 331, 332
Hayward, John 283
Hazelwood House 123
Hazlitt, William 142, 146-7
Heal's 129-30
Healy, Tim 96
Heathrow 272-3
Hendon 529-31
Hendrix, Jimi 201, 232
Heneage Lane 78
Henrietta Maria 137, 160, 162, 339, 374
Henry I 38
Henry II 447
Henry III 94
Henry VII 95, 292
    Tomb of 179-80

Henry VIII 27, 54, 178, 293, 372, 418, 471
    Hunting lodge 542
    Portrait of 138-9
Hepworth, Barbara 282, 402
    *Two Forms* 390-1
    *Winged Figure* 194-5
Her Majesty's Theatre 149
Herb Garret 351-2
Herbal Hill 18
Herbert, A. P. 451
Herbert Morrison House 346
Herland, Hugh 175
Hertford House 196
Herzog, Jacques 365-6
Hewer, Will 104, 375
Heydon, Sir Henry 404
Hicks, Nicola 282-3
High Barnet 522
High Holborn 123
Highgate 523-4, 525-8
    Cemetery 524-5
Highpoint 526-8
Hill, Rowland 536
Hill, William 66
Hiller, Wendy 107
Hilliard, Nicholas 307
Hills, Peter 244
Hindu temple, Neasden 550-1
Hitch, Nathaniel 24, 26
Hitchens, Ivon 509-10
Hoare, Samuel 539
Hoare Family 88
Hodgkin, Howard 106
Hogarth, William 65, 108, 168, 318
    Foundling Museum 116-17
    House 260-2
    Paintings 113, 158
    St Bartholomew's Hospital 36-8
    Tomb 259-60
Hoker, Sir William 288
Holbein 54, 138-9, 161, 223
Holborn 11, 15, 44, 110, 119
Holden, Charles 106, 234, 343, 532
    London Underground 181-2

Sudbury Town Underground Station 551-2
Zimbabwe House 97
Holland Park Road 242, 246-7
Hollar, Wenceslaus 349
Holles Street 194
Hollis, Richard 470
Holloway Road Underground Station 507
Holly Hill 517
Holly Village 523-4
Holy Trinity, Sloane Square 216
Home House 93
Homerton 471-3
Hone, Evie 407
Hone, Nathaniel 61
Honorable Artillery Company (HAC) 56
Hooke, Robert 28, 63, 78, 367
Hoop and Grapes, The, Aldgate 81-3
Hoover building, The 269-70
Hop Exchange 349
Hope, Beresford 132
Hope-Wallace, Phillis 107
Hopkins, Michael 29, 343, 559
Hopkinson, Stephan 284
Horne, Pip 135
Hornfair Park 383
Horniman Museum 393-4, 438
Horse Guards 164, 168-9
Horseferry Road 294
Horsley, Gerald Callcott 560
Houdon, Jean-Antoine 138
Houghton Hall 318
Household Cavalry 330
Houses of Parliament 174-5
Houshiary, Shirazeh 135-6
Howard, Catherine 447
Howard, Ebenezer 487
Howes & Jackman 534
Howley, Bishop 251
Hudson, W. H. 236-7
Hume, Joseph 388
Hunt, Leigh 519

Hunter, James 112
Hunterian Museum 112–13
Huntley, Dennis 323
Hutt, Alan 10
Huxley, Julian 495
Hyde Park 236–7, 394
Hyde Park Corner 44, 207–11

Idea Store 363, 438, 481
Ilford 466–7
Imperial War Graves
    Commission 203
Imperial War Museum 344–5, 403
Innes, John 319
International Maritime
    Organisation 340–1
Inwood, William 496
Isaac, Tubby 442
Island Centre Way 542
Isle of Dogs 64, 463
Isle of Grain 484
Isleworth 289–92
Islington 510–11
Ismaili Centre, The 228–9
Iveagh, Lord 522

Jacksons of Piccadilly 90
Jacob, Georges 198
Jagger, Charles Sargeant 44, 208
    GWR War Memorial 247
    Royal Artillery Memorial
        210–11
    Shackleton statue 237–9
James, John 198, 368, 557
James, Sir William 410
James I 26, 27, 33, 166, 349, 374,
    386, 471
James II 153, 375, 449
    Statue of 138
James Smith & Sons 121–3
Jamme Masjid Mosque 428–9
Jeffreys, Judge 449
Jennens, Charles 201
Jenson, Nicholas 255
Jervas, Charles 301

Jervoise, Richard 222
Jewel Tower, Old Palace Yard
    177–8
Jewish Museum 508–9
Jewry Street 79–81
Joe Allen 95–6
John, Augustus 163
John, King 5, 313
John Adam Street 102
John Cass School 81
John Company 464
Johnson, Amy 399
Johnson, Boris 355, 481, 500
Johnson, John 535
Johnson, Samuel 7, 13–14, 62, 278
Johnston, Edward 101, 234, 343
Johnston, James 299
Jones, Christopher 359
Jones, F. E. 561
Jones, Glyn 10
Jones, Horace 65, 71, 74
Jones, Inigo 28, 103, 106, 151, 160,
    540
    Banqueting House 166
    Queen's Chapel 161–3
    Queen's House 374–5
    St Paul's, Covent Garden
        106–7
Jons, Adrian 208
Jordan, Dorothy 370
Jordán, Esteban 22
Jourdain, Nicholas 434
Jubilee Gardens 330
Jubilee Line 234, 343, 361, 464
Judd, Nadine 332
Jupp, Richard 410

Kauffer, Edward McKnight 106,
    234
Keats, John 519–21
Keats House 519–21
Keble, John 401
Keble College 132
Kelmscott Chaucer 255
Kelmscott House 416

Kemeys-Tynte, Charles 318
Kempe, Charles Eamer 189, 405
Kendall, Henry 190
Kennington, Eric 282
Kensal Green Cemetery 250–1
Kensington 35
    High Street 240–1
    Palace 168, 239–40, 485
Kent, William 139, 164, 259, 485
    Chiswick House 262–3
    Devonshire House 204
    Horse Guards 168–9
    *Last Supper* 198–9
    Kensington Palace 239–40
Kenwood House 521–2
Kettle, Tilly 219
Kettner's 97
Kew 287–8
    Gardens 93, 288
Kidd, Captain 451
Kindersley, David and Lida 146–7,
    193
King Charles Street 170–2
King Edward Street 33, 34
King Edward VII Fountain 440–1
King Edward VII Memorial Park
    451–2
King Street 253
King William Street 48, 49
King William Walk 370–1
King's Cross Station 43, 500–1,
    512
King's Head 139
Kingsbury, Henry 460
Kingston 312–13
    Museum 313–14
Kipling, Rudyard 104
Kirby, Joshua 287
Kitaj, R. B. 106
Knapp, Matthew 526
Kneller, Godfrey 375
Knights Hospitaller 20, 21
Knights Templar 5
Knox-Johnston, Robin 407
Koenig, Fritz 191

Koolhaas, Rem 134-5
Krassa, Afroditi 205

L. Manze 545-6
Laban Dance Centre 365-6
Laguerre, Louis 557
Laking, Sir Guy Francis 21
Lamb, Charles 35-6
Lambert, George 38
Lambeth 335, 338-40, 344-5
    Palace 338-9
Lancaster, Duke of 94
Langham House Close 307-8, 308
Langham Place 191-2
Langtry, Lily 96
Lapidge, Edward 285
Lasdun, Denys 431, 498
Laud, William, Archbishop of
    Canterbury 107, 400
Lauderdale House 525-6
*Laughing Cavalier, The* 196
Lawe-Wittewronge, Sir Charles
    Bennett 183
Lawrence, Stephen 363-4
Lawrence, Thomas 114
Leadenhall 65, 74, 77, 116
    Market 71, 74
    Street 77-8, 465
Leamouth 466-7
Leathermarket Street 357
Ledward, Gilbert 223
Lee, Lawrence 45
Lee High Road 367
Leicester Place 140-2
Leicester Square 36, 140, 144, 259
Leighton, Frederick 242, 246-7
Leighton House Museum 242,
    246-7
Leitch, Archibald 253
Lely, Peter 306, 374
Leman Street 435
Lennard, John 405
Leroux, Henry 511
Lesnes Abbey 419-20, 483
Levant Company 379

Levy Brothers 431
Lewis, John 4, 194-5
Liberty Bell 440
Lichtenstein, Rachel 430
Liebig, Professor Justus Freiherr
    von 334
Lime Street 74, 76, 77
Limehouse 452-4
Limehouse Link 451
Lincoln, Abraham 172
Lincoln's Inn Fields 110-11, 112,
    113, 265
Lion and Unicorn Pavilion 330
Lipchitz, Jacques 56, 58-9
Little Holland House 324-5
Little Italy 17
Littlewood, Joan 473
Liverpool, Lord 201
Liverpool Street 56, 59
Liverpool Street Station 512, 513
Livingstone, Ken 332, 481
Lloyd George, David 172
Lloyds Bank 90
Lloyd's of London 74-6, 465
Locke, Thomas 27
Lombard Street 48, 49
London, Bishops of 117, 251
London Apprentice, The 291-2
London Bridge 36, 43, 63, 64, 66,
    294-5
    Station 348, 512
London City Airport 382
London County Council 331
London Docks 449, 450, 467, 468
London Eye 330
London Library 152
London Marathon 377
London Pride 330-1
London Rifle Brigade 56
London Transport Museum 105-6
London Underground 105, 234-5,
    343, 359, 557
    Head Office 124, 181-2
    Map 101, 105
London Wall 42

London Zoo 23, 495-6
Lordship Lane 538
Lorne, Francis 205
Lovat Lane 65
Lovell, Thomas 540
Lower Thames Street 64, 65, 68
Lubetkin, Berthold 487
    Finsbury Health Centre 23-4
    Highpoint 526-8
    Penguin Pool, London Zoo
        495-6
Lucy, Richard de 420, 483
Ludgate 6, 294
Lumley, Lord 321-3
Lutyens, Edwin 98, 99, 154, 528-9
Lyceum 112
Lyon, John 556
Lyons, Eric 307, 380
Lyric Theatre, Hammersmith
    253-4

Mackonochie, Fr Alexander 17
Maclise, Daniel 175
Maes, Nicholaes 49
Maggs, Jacob 443
Maiano, Giovanni da 310
Maiden Lane 97
Maids of Honour Row 293
Maitland, John 525
Maitland, Sara 457
Malet Street 127-8
Mall, The 163-4, 165-6
Manchester Square 196-8
Mandela, Nelson, statue of 172
Manning, Cardinal 189, 229
Manningham, John 4
Manresa Road 185
Mansfield, Isaac 120
Mansfield, Lord 175, 522
Mansion House 48-9
Mantegna, Andrea 310
Manzù, Giacomo 187
Marble Arch 208
Marble Hill House 316-17
Mare Street 470

Margaret Street 132
Marianne North Gallery 288
Marlborough House 159, 160
Marlborough Road 159–63
Marlowe, Christopher 364
Marnock, Robert 532
Marshalsea Prison 119
Martin, John 403
Martin, Leslie 331
Marx, Enid 106
Marx Memorial Library 19–20
Mary, Queen of Scots 471
Marylebone 115
   Road 498
   Station 512
Maryon Park 383–4
Mason, Red 109
Mason's Yard 152
Massinger, Philip 350
Matcham, Frank 153, 253, 470, 473
Mather, Rick 254
Matilda, Queen 108, 453
Matthew, Robert 331
Matthews, Herbert 530
Max Roach Park 278
May, Hugh 410
Mayes, Ian 146
Mayfair 93, 200, 206
Mayhew, Henry 435
Mazzuoli, Giuseppe 229
McAslan, John 500–1
McCormack, Richard 343
McGonagall, William 17
McLean, Bruce 464
McMorran, Donald 158
Mead, Dr Richard 117, 352
Meadows, Bernard 124
Meard, John 50
Meard Street 142
Mellor, Colonel 392
Melville Monument 62
Mendoza, Daniel 460, 508
Merchant Taylor's Company 367
Merry, Sir Thomas 548
Merton 318–20

Messel, Anne 242
Metropolitan Drinking Fountain
   Association 50
Metropolitan Railway 105
Meuron, Pierre de 366
Mewès and Davies 114, 152
Michelangelo 179, 201–2
Michelin House 226–8
Middle Temple Hall 4
Middleditch, Edward 156
Middlesex Guildhall 173
Middlesex Sessions House 18–19
Midland Bank, Piccadilly 154
Midland Grand 501
Mile End Road 460, 461
Mill, John Stuart 222
Millbank 182–5
Milligan, Robert 463
Milligan, Spike 531
Millionaire's Row 529
Milton, John 42, 61
Mitchell, William 205
Moholy-Nagy, László 106
Mollo, Eugene 534
Montagu, Mrs 139
Montague, Edward 374
Montigny, Jean 204
Monument 14, 28, 36, 49, 62–3
Moore, Albert 334
Moore, Henry 98, 181, 282, 500
   Chelsea College of Arts 185–6
   St Stephen Walbrook 47–8
Moore, Temple Lushington 531
Moore, William Richard 192
Moorgate 61
Morden, Sir John 379
Morden College 378–9
More, Thomas 15, 16, 338
More Chapel, Chelsea Old
   Church 222–3
More London 355–6
Moreton Street 186
Morgan, William de 258
Mornington Crescent 505
   Underground Station 507–8

Moro, Peter 331
Morris, David 336
Morris, May 255
Morris, Richard 271
Morris, William 216, 241, 258–9, 319
   Emery Walker's House 254–6
   Gallery 543–5
   Red House 416–18
Morrison, Herbert 331
Mortimer Street 18
Mortlake 285–7
Morton's Tower 338
Mosley, Oswald 445
Mottingham Lane 414–15
Mottley, John 26
Mount Street 206
Mozart, Wolfgang Amadeus 142
Muggeridge, Edward 313
Muir, Thomas 388
Mundy, William 457
Murdoch, Rupert 19
Museum of Childhood 458–9
Museum of Immigration and
   Diversity 429–30
Museum of London 21, 42, 103
Muswell Hill 535
Myer, George Val 431

Napoleon III 420, 422
Napper, John 161
Nash, John 149, 163, 165, 191–2
   Regent's Park terraces 498–9
Nash, Paul 106
National Army Museum 219
National Gallery 128, 136, 138, 158, 201
National Maritime Museum 371–2
National Police Memorial 169–70
National Portrait Gallery 138–40
National Theatre 228, 330–1
Neale, Thomas 108
Neasden 550–1
Neasden Temple *see* BAPS Shri
   Swaminarayan Mandir
Nelson, Horatio 48, 55, 319

Nelson's Column 136
Neuhoff, Baron von 146
New Adelphi 102–3
New Bond Street 199–200
New Bridge Street 24
New College 173
New Cross 362
New Fetter Lane 11
New Oxford Street 121, 123
New Scotland Yard 559
New Temple 5
New Zealand House 149
New Zealand War Memorial 210
Newcastle, Duke of 400
Newdegate, Mary 563
Newgate Prison 19
Newgate Street 33, 34, 35, 245
Newington Library 346
Newman, John Henry 189
*News of the World* 285
Newton, Sir Adam 386
Nicholas Lacey & Partners 466
Nicholson, Ben 330, 402
Nicholson, John 339
Nijmegen, Arnold van 199
Nine Elms 97, 107
Nixon, Samuel 371
Nokes, John 489
Nollekens, Joseph 18, 121
Nonsuch Palace 323
Norie and Wilson 116
North, Marianne 288
North Greenwich 343
    Pier 381–2
North Hill 526
Northcliffe, Lord 6, 13
Northcote, James 225, 459
Northolt 270–1
Northumberland House 289
Northumberland Street 102
Norwood, Douglas 264
Nost, John 147, 455
Notre Dame de France 140–1, 144
Nunhead Cemetery 387–8

Nunziato, Antonio Toto del 161
Nuttgens, Eddy 16

Obelisk, St George's Circus 344
*Observer* 88
O'Connell, Daniel 206
O'Connor, John 103
Octagon Room, Orleans House 299
Odeon, Elephant and Castle 248
Ofili, Chris 363
Old Bell, Fleet Street 10
Old Billingsgate Fish Market 64–5
Old Brompton Road 231–2
*Old Lady of Threadneedle Street* 52
Old Operating Theatre Museum 351–2
Old Palace of John Whitgift School 400
Old Palace Yard 177–8
Old Redding 559
Old Royal Doulton building 341–3
Old Royal Naval College 372–4
Old Sessions House 18–19
Old Street 18
Oliver, Isaac 31, 384
Oliver, Richard 344
Olivier, Edith 184
Olivier, Sir Lawrence 330
Opie, Julian 130, 355
Orange Tree Hill 486
Orchard Place Gates 467
Order of St John, Museum of 20–2
Orléans, Duke of 297
Orleans House Gallery 299–301
Orpington 422–3
Osterley Park 268–9
Oudry, Jean-Baptiste 198
*Our Lady of Westminster* 188–9
Overton Drive 474
Owen, Goronwy 270–1
Oxford and Cambridge Club 158–9

Oxford Street 18, 121, 142, 194–6
Oxo Tower 334–5

Paddington Station 211, 247, 512
Painted Hall, Old Royal Naval College 372–4
Palace of Westminster 174–5
Pall Mall 158–9
*Pall Mall Gazette* 88
Palmer, Sir James 540
Palmerston, Lord 159
Palumbo, Peter 47
Pancras Road 504
Panton Street 71
Paoletti, Roland 234
Paolozzi, Eduardo 101, 125–6, 356–7
Paragon, The 378
Park Road, Camden 494
Park Royal Station 552
Parker, Barry 528
Parker-Bowles, Andrew 541
Parliament Square 172–3, 174
Parsons, Karl 476
Passmore Edwards Library 438
Paternoster Square 33
Patterson, Doug 442
Pauncefort, Edward 526
Pavillon, Charles 416
Pavlenko, Sergei 55
Paxton, Joseph 394, 398
Peabody buildings 523
Pearson, Charles 234
Pearson, J. L. 88, 178, 401
Pearson, Lionel 211
Peckham 388–90
    Library 363
Pelican Stairs 450
Pellerin, Jean-Charles 131
Pelli, César 463–4
Pembroke Lodge 303–4
Penfold postbox 547
Penguin Pool, London Zoo 495–6
Penn, Sir William 68
Pennington, Robert 318

People's Palace 461
Pepys, Samuel 52, 63, 68, 69, 70–1, 72–3, 104, 110, 272, 352, 358, 374–5, 450, 525
Perceval, Spencer 384–5
Perivale 269–70
Perret, Auguste 248
Peskett, Stan 388–90
Peter of Savoy 94
*Peter Pan* 35
Petersham 304
Peto, Harold 559
Petrie Museum of Egyptian Archaeology 127–8
Petticoat Lane Market 442
Pettitt, Alfred 24
Petty, Sir William 52
Petworth House 68, 129
Pevsner, Nikolaus 7, 15, 53, 66, 152, 161, 269, 297, 348, 409, 436–7, 557
Philbeach Gardens 232–3
Philip II 22
Phillips, John 48
Phillips, Neil 231
Phillips, Thomas 130
'Phiz' 115
Phoenix Cinema 534–5
Phone boxes 107–8
Piano, Renzo 76
Piccadilly 35, 90, 97, 149
Piccadilly Line 551
Pick, Frank 105, 181–2
Pickled Herring Stairs 355
Picturedome Cinema 534
Pierce, Edward 108
Pilar Corrias Gallery 134–5
*Pilgrim's Progress* 60
Pimlico 186, 189–90
Piper, David 135
Piper, John 163
Pissarro, Camille 256–7
Pissarro, Lucien 256–7
Pissarro's House 256–7
Pitt, William 52

Pitzhanger Manor 265–7
Plaw, John 486
Pliny the Elder 120
Plough Lane 314
Plowden, Edmund 4
Plumbe, Rowland 22
Plunkett, Oliver 188
Police Memorial, National 169–70
Politkovskaya, Anna 10
Pollock's Toy Museum 131–2
Polo, Richard 96
Pompidou Centre 76
Poole, Henry 24, 26
Pope, Alexander 145, 301–2
Poplar 248, 452, 453, 464–5
Pople, Nic 495
Port of London Authority 382
Portcullis House 559
Porter, Charles 357
Portland Place 192–3
Portsmouth Road 312
Postman's Park 33–5
Pounds, John 462
Poussin, Nicholas 392
Precinct of the Savoy 94
Primrose Street 59
Prince Imperial Road 421
Prince of Denmark 443
Princelet Street 429
Princes Arcade 149
Prince's Street 48
Printer's Pie, The 11
Priory Church of St John 20–2
Priory Park 380
*Private Eye* 142
Prospect of Whitby 450–1
Prudential Assurance building 15, 44–5
Pudding Lane 36, 63, 66
Puddledock 489
Pugin, Augustus 175, 206
*Punch* 242
Punch Tavern 11–13
Purcell, Henry 161
Purley Way 398

Putney 251, 284–5
Pye, William 332–4
Pye Corner 36

Quaglino's 155
Quaker Gardens 61
Quality Chop House, The 22
Queen Alexandra Memorial 159–60
Queen Anne's Gate 180–1
Queen Elizabeth Hall 331, 332
Queen Elizabeth's Hunting Lodge 542–3
Queen Mary University of London 363, 460, 461
*Queen of Time, The* 196, 504
Queen Square 416
Queen Victoria Street 24, 28, 42, 45
Queen's Chapel, Marlborough Road, The 161–3
Queen's Chapel of the Savoy, The 94–5
Queen's House, Greenwich 372, 374–5
Queen's Yard 129–30
Quellin, Arnold 138

Rabinovitch, Samuel 181
Radnor House School 302
RAF Bomber Command 208
Raffles, Stamford 531
Raffles Square, Stratford 473
Ragged School Museum 461–2
Rahere 38, 39, 40
*Railway Station, The* 512
Rainham 483
  Hall 482
  Marshes 483–4
Rainton, Sir Nicholas 540
*Rake's Progress, The* 113
Raleigh, Sir Walter 178
Ramsay, Alan 117
Ranger's House 375, 378
Rangers Road 542–3

Raphael, Sir Herbert 487
Raphael Cartoons 165
Raphael Park 487
Raven Row 434
Raverat, Gwen 407–8
Rawlings, J. H. 153
Raymond Burton House 509
Reade, Lady Mary 267
Red House 416–18, 545
Red Lion, Duke of York Street, The 153
Red Lion Square 418
Red phone boxes 107–8
Redbridge 474
Redpath, Anne 203
Reed Pond Walk 487
Regent Street 142, 191, 241
Regent's Park 495–6, 498–500
  Road 509
Reid, Norman 332
Rennie, John 64
Reuters Technical Services Centre 466
Rex Whistler Restaurant 184–5
Reynolds, William Bainbridge 233
Reynolds-Stephens, William 35
Rhodes, Zandra 357
Rhodesia 98
Ribbentrop, Joachim von 190
Ricci, Sebastiano 218
Richard I, statue of 177
Richard II 348
Richard III 15, 540
Richardson, Sir Albert 29, 30, 154
Richmond 293, 303, 304, 307–8
  Palace 292–3
  Park 303–4
Ripple Road 478
Ritchie, Ian 343
Ritz Hotel 114, 152
Rivet, John 137
Roach, Max 278
Robert Adam Committee Room 76

Robert Street 102
Roberts, Keith 332
Robertson, Eliza Frances 378
Robinson, John 30
Robinson, Matthew 139
Rodinsky, David 430
Roger Street 114–15
Rogers, Richard 64–5, 142, 466, 481
  Lloyds of London 74–6
Rogers, Thomas 18
Roman London 42–3
Romanian Chapel 6
Romford 486, 487
Romilly Street 97
Romney 172
Ronalds, Tim 470
Roosevelt, Franklin 207
Roper's Garden 223–5
Ros, Robert de 5
Rosebery, Lord 176
Rosebery Avenue 17
Rossi, John 496
Rotherhithe 358–61
  Tunnel 451
Rothschild 135, 441
Roubiliac, Louis-François 79–81, 284, 309
Rousseau, Victor 100
Rowlandson, Thomas 321
Royal Academy of Arts 201–2
Royal Arcade 149
Royal Artillery Memorial 210–11, 247
Royal Automobile Club 158
Royal Ballet 332
Royal Collection 121
Royal College of Art 106
Royal College of Surgeons 112, 498
Royal Doulton 341–3, 504
Royal Exchange 36, 50–2
Royal Festival Hall 30, 123, 331–2
Royal Festival Street 353
Royal Foundation of St Katharine 453–4

Royal Hospital, Greenwich 421
Royal Hospital Road 218–21
Royal Mint 108
Royal Mint Street 445
Royal Opera Arcade 149
Royal Opera House 107, 108
Royal Small Arms Factory 541–2
Royal Society 28, 108
Royal Victorian Order 95
Rubens, Peter Paul 166–8
Rudolph Steiner House 494–5
Ruete, Hans Helmuth 191
Rufus, William 177
Ruisdael, Jacob 48
Rules 96–7
Ruskin, John 324–5, 342–3
Russell, Bertrand 304
Russell, Lord John 303
Russell Square 120, 121
Russian Orthodox Cathedral, Chiswick 263–5
Ruysdael, Salomon 48
Rysbrack, Michael 139, 172, 220, 300

Saarinen, Eero 207
Sacheverell, Dr 21
Sackler Galleries 202
Sadie, Stanley 201
Sadleir, Ralph 471
Saffron Hill 18, 119
Sainsbury, Alex 434–5
St Alban the Martyr, Holborn 16–17
St Alfege, Greenwich 368
St Andrew Holborn 14–15
St Andrew Undershaft 76–7
St Andrew's, Enfield 539–40
St Andrew's, Ilford 476–7
St Andrew's Terrace 498
St Anne's, Dean Street 146–7
St Anne's, Kew Green 287
St Anselm's, Hatch End 561
St Barnabas, Pimlico 189–90

St Bartholomew the Great, Priory Church of 38–40
St Bartholomew's Hospital 36–8
St Bartholomew's Lane 53
St Benet Gracechurch 297
St Benet, Guild Church of 28
St Botolph, Aldgate 56
St Botolph, Billingsgate 56
St Botolph without Aldersgate 34, 56
St Botolph without Bishopsgate 55–6
St Bride's, Fleet Street 10–11
St Clement Danes 31, 91
St Cuthbert's, Earls Court 232–3
St Dunstan and All Saints 454–5
St Dunstan-in-the-West 6
St Dunstan's, Cheam 321–3
St Dunstan's-in-the-East 33
St Etheldreda's Church 15–16
Saint-Gaudens, Augustus 172
St George-in-the-East 445
St George's, Bloomsbury 117, 120
St George's, Hanover Square 198–9
St George's Circus 344
St George's German Lutheran Church 436–7
St George's Town Hall 445
St Giles Cripplegate 42, 61
St Giles-in-the-Fields 108
St Helen and St Giles, Rainham 483
St Helen Bishopsgate 74, 77
St James the Less, Pimlico 186–7
St James's, Piccadilly 154–5
St James's Palace 160, 161, 164
St James's Park 169–70
St James's Place 164–5
St James's Square 151–2
St James's Street 156
St John, Henry 284
St John-at-Hampstead 515–17
St John on Bethnal Green 457–8
St John the Baptist, West Wickham 404–5
St John the Evangelist, Havering 486
St John's, Waterloo 335–6
St John's Ambulance 20
St John's Chapel, Tower of London 446–7
St Jude-on-the-Hill 528–9
St Katharine Cree 77–8
St Katharine's Docks 448
St Lawrence Jewry Fountain 29–30
St Lawrence's, Whitchurch 556–7
St Luke Old Street 15
St Luke's, Charlton 384–5
St Luke's, Chelsea 225–6
St Magnus the Martyr 63–4
St Margaret Lothbury 53–4
St Margaret Street 178
St Margaret's, Barking 477–8
St Margaret's, Westminster 178
St Mark's, Biggin Hill 408–9
St Martin-in-the-Fields 91, 135–6, 207
St Martin-le-Grand 34, 547
St Martin's Lane 37, 97, 470
St Martin's Place 140
St Mary, the Boltons 230–1
St Mary Abbots 241, 244
St Mary Aldermary 45–7
St Mary-at-Hill 65–6
St Mary Axe 56, 76
St Mary-le-Bow 45
St Mary-le-Strand 90–1
St Mary Magdalen, Bermondsey 357–8
St Mary Magdalen, Mortlake 285–7
St Mary Road 546
St Mary the Virgin, Downe 405–7
St Mary the Virgin, Merton 319–20
St Mary the Virgin, Rotherhithe 358–9
St Mary Woolnoth 49–50
St Marychurch Street 359
St Mary's, Battersea 283–4
St Mary's, Harefield 563
St Mary's, Harrow on the Hill 554–6
St Mary's, Hendon 530–1
St Mary's, Northolt 270–1
St Mary's, Putney 284–5
St Mary's, Shortlands 401–3
St Mary's, Walthamstow 547–8
St Mary's, Wanstead 474–6
St Mary's, Willesden 549–50
St Mary's Lane 489
St Matthew's, Brixton 280
St Matthias Old Church 464–5
St Michael and All Angels, Bedford Park 257–8
St Michael and All Angels, Croydon 400–1
St Nicholas, Deptford 364
St Nicholas's, Chislehurst 421–2
St Nicholas's, Chiswick 259–60
St Olave, Hart Street 69–71
St Pancras International and Renaissance Hotel 501–3
St Pancras New Church 496, 500
St Pancras Old Church 503–4
St Pancras Station 501, 512
St Paul's, Covent Garden 106–7
St Paul's, Deptford 364–5
St Paul's Cathedral 14, 30, 31–2, 60, 78, 302, 313, 330, 373
St Peter ad Vincula 446
St Peter's, Petersham 304–6
St Peter's Italian Church 17–18
St Saviour's Church, Eltham 413–14
St Stephen Walbrook 47–8, 53
St Stephen's Hall 175
St Swithin's Lane 135
St Thomas's Hospital 339, 348, 352
Fountain 336–8
St Thomas's Street 352
Salvin, Anthony 447
Sambourne, Edward Linley 241–2

Samuel, Harold 48
Sandle, Michael 340-1
Sandwich, Lord 72
Sandycombe Lodge 293, 296
Sassie, Victor 144-5
Saupique, Georges 140
Savage, James 225
Savoy Hill 94-5
Savoy Hotel 95
Scala Street 131
Scheemakers, Peter 165, 338, 352, 476
Schlamminger, Karl 229
Schomberg House 156, 158
Scoles, J. J. 206
Scott, Adrian Gilbert 17
Scott, Captain Robert Falcon 148-9
Scott, George Gilbert 30, 183, 241, 512
　Foreign Office 170-2
　St Margaret's, Westminster 178
　St Mary Abbots 241
　St Mary's, Harrow on the Hill 554-6
　St Pancras 501-3
Scott, Giles Gilbert 17, 30
　Houses of Parliament 175
　Red phone boxes 107-8
　Waterloo Bridge 294
Scott, Kathleen 6, 148-9
Scott, M. H. Baillie 487
Scott, Richard Gilbert 409
Scott, Ronnie 142
Scott, Samuel 65, 294
Scottish Political Martyrs Memorial 387-8
Sea and Ships Pavilion 330, 331
Searle, Ronald 345
Searles, Michael 378
Sedding, John Dando 216, 404
Seely & Paget 15, 413
Seething Lane 68, 69
Seilern, Count Antoine 94

Sekhmet 199-200
Selfridges 195-6
Selwyn, William 422
Serlio, Sebastiano 161
Serra, Richard 56-8
Seti I, Pharaoh 113
Seven Dials 108-10
Severndroog Castle 409-10
Seymour, Robert 115
Shackleton, Ernest 237-9
Shadwell Basin 449, 450
Shaftesbury Avenue 123, 142, 504
Shaftesbury Memorial *see* Eros
Shakespeare, Edmund 350
Shakespeare, William 4, 15
　Garrick's Temple to 308-10
Shard, The 352
Shaw, George Bernard 107, 228
Shaw, John 6, 411
Shaw, Norman 256, 257, 258, 557-9
Shawcross, Conrad 390-1
Shee, Martin Archer 159
Sheen Palace 292
Shell Centre 330
Shell Mex House 103
Shepherd, R. V. 542
Shepherd's Bush 523
Shoe Lane 9
Shonibare, Yinka 371-2
Shooters Hill 376, 383, 384, 409-10
Shoreditch 455-7
Sickert, Walter Richard 163, 369-70, 507
Siemens 413
Sign of the Sun 10
Silvertown 182
Sime, Jimmy 552
Sims, Ronald 285
Sir John Soane's Museum 113-14
Sisley, Alfred 312
Sisley, Clement 479
Skeaping, John 402
Skidmore, Owings & Merrill 59, 464

Skinner, Francis 487
Skirving, Thomas 388
Skylon 30, 194, 330, 331
Slaughter's 37
Sleter, Francesco 485, 557
Sloane, Hans 220
Sloane Square 216, 223
Smart, Percy 346
Smirke, Robert 159, 161, 190, 332, 547
Smirke, Sidney 95
Smith, Gervase 50
Smith, James Osborne 152
Smith, William 359
Smith, Zadie 549
Smithfield 36, 37, 38, 65, 71, 259
Smithson, Alison 156
Smuts, General Jan 172-3
Soane, Sir John 24, 112, 241, 296, 348, 457,
　Bank of England 53
　Dulwich Picture Gallery 391
　Grave of 503-4
　Museum 113-14
　Pitzhanger Manor 265-7
Society for Promoting Christian Knowledge (SPCK) 244
Society for the Abolition of the Slave Trade 539
Soho 142-3, 144
　Square 145-6
Soloway, Louise 460
Somers Town 504-5
Somerset, James 175
Somerset House 21, 92-3, 103, 290
Somerville, John 531
Sotheby's 199-200
South Audley Street 207
South Bank 194, 330-5
South Kensington
　Museum 459
　Underground Station 465, 507
Southbank House 341-3
Southampton, Lord 120, 121
Southgate Station 532, 552

Southside House 318-19
Southwark 344, 347-9, 432, 512
    Cathedral 348, 350-1, 361
    Underground Station 343
Soweto Memorial, Max Roach Park 278
Spaniards Inn 522-3
Spanish Civil War 19
Sparkes, John 341-2
*Spectator* 176
Spence, Basil 290
Spencer, Alice 562
Spencer, Gilly 96
Spencer, Sir Edward 267
Spencer, Stanley 345
Spencer House 164-5, 421
Spilsbury, Maria 62
Spitalfields 290, 428-36, 435, 457
Spooner, Charles 561
Springthorpe, Helen 495
Stafford Terrace 241-2
Stanford, Leland 314
Stanmore Station 557
Stanton, Charles 357-8
Starmer, Walter 528
Stationers' Company 352
Steiner, Rudolph 494-5
Stephen Lawrence Centre 363-4
Stephens, Henry ('Inky') 532
Stephens House *see* Avenue House
Stepney 454-5
Stern, Catharini 549
Stevenage Road 253
Stevenson, Elizabeth 105
Steyne, Lord 197
Stirling, James 183, 308
Stone, John 63
Stone, Nicholas 31, 77, 103, 350-1, 386, 540, 548
Stow, John 20, 26, 54, 55, 67, 108-9, 350, 448-9
    Memorial 76-7
Strachey, Lytton 183
Strand 11, 21, 90-8

Stratford East 473-4
Strawberry Hill 45, 302-3, 316
Streater, Robert 272
Street, G. E. 120, 186, 257
Street, Norman 256
Strode, Nathaniel 421
Strong, Edward 379
Stuart, James 164
Stubbs, George 112, 139
Sudbury Town Underground Station 532, 551-2
Sueur, Hubert le 137
Sugar, Alan 470
Summerson, John 91, 169
Supreme Court 173-4
Surrey Quays Road 362
*Survey of London, A* 26, 54, 77, 108, 348
Sussex Terrace 498
Sutton, Thomas 471
Sutton House 471-3
Swain's Lane 523, 525
Swakeleys House 271-2
Swaminarayan, Bhagwan 551
Swan, Abraham 434
Swan House 559
Sydney Street 225-6
Symonds, John Addington 288
Symons, Rev. Vivian 408
Syon House 289-90, 316

Tabard Inn, Bedford Park 258-9, 349
Tallis, John 512
Tallis, Thomas 66
Tata, Ratan 299
Tate, Henry 182
Tate & Lyle 68, 382
Tate Britain 110, 184-6, 308
    Sculptures outside 182-4
Tate Modern 108, 183
Taubman, A. Alfred 200
Tavistock Square 120, 126-7
Taylor, John 67
Taylor, Robert 415, 434

Taylor, Wendy 448
Tecton 23, 487, 495, 526
Telephone boxes 107-8
Templars 5
Temple Bar 6, 32-3
Temple Church 5
Temple Place 88
Teulon, William 464
Thackeray, William Makepeace 394
Thames, River 331, 468-9
    Barrier 382-3
    Tunnel 359-61
*The Meeting Place* 503
Theatre Royal Stratford East 473-4
Theobald's Park 31
Theobald's Road 18
Thomas, Brian 15
Thompson, Henry Yates 152
Thomson, James 498
Thornhill, James 37, 117, 168, 262, 368, 485
    Royal Naval College 373
Thornycroft, Hamo 176
Threadneedle Street 48
Throckmorton, Sir Nicholas 78
Throgmorton Avenue 55
Tijou, Jean 482
Tilleman, Peter 552
Timbrell, Benjamin 207
Tinworth, George 342
Tiptoft, Lady 539
Tom's Coffee House 90, 201
Tonks, Henry 184
Tooley Street 353-6
Torrigiano, Pietro 179
Tottenham 536-8
Tottenham Court Road 123
    Underground Station 125-6
Tower, Walter 190
Tower Bridge 74, 448
    Road 358, 546
Tower Hamlets 363
Tower Hill 42, 43
Tower of London 446-7

Town of Ramsgate, Wapping 449
Townsend, C. H. 393-4, 438
Townsend, Geoffrey 380
Townsend, James 536
Tradescant, John 339-40
Trafalgar Square 135-40, 481
Trajan, Emperor 42
Travers, Martin 64
Tree, Herbert Beerbohm 116
Tree, Ronald 180
Trellick Tower 248
Trinder, Tommy 253
Trinity Buoy Wharf 466
Trinity Church Square 347-8
Trinity House Lighthouse Ship 466
Trollope, Anthony 120
Troubadour, The 231-2
Truman's Brewery 428
Trumpeters' House 293
TUC Headquarters 123
Tudor, Mary 161
Tufnell Park Underground Station 507
Tunnel Road 358
Turnbull, William 464
Turner, J. M. W. 97, 283-4, 293-6
Turpin, Harold 542
Twickenham 292, 293, 296-303
Twinings, 216 Strand 90
Tyburn 108, 109, 188
Tyler, Watt 20
Tyson Yerkes, Charles 507

Underground, The 234-5 *see also* London Underground
Underground Electric Railways Company 105
University College London 127-9
Unwin, Raymond 528
Upminster Windmill 488-9
Upper Thames Street 54

V&A Museum of Childhood 458-9

Valence House 479-81
Van Dyck, Anthony 4, 165, 166, 307, 316
Vansittart, Sir Robert 228
Varah, Chad 47, 48
Vardy, John 164, 169
Vasarely, Victor 205
Vauxhall Pleasure Gardens 220, 318
Vauxhall Walk 341
Vavasour, Sir Thomas 306
Velde, William van de 307
Vergara, Juan Ruiz de 21
Vermeer, Jan 521
Vernet, Horace 163
Verrio, Antonio 307
Vertue, George 139
Vertue, William 33
Vestry House Museum 546-7
Victoria, Queen 90, 119, 161, 303, 394-5, 398
Victoria
    Coach Station 264
    Embankment 100-1
    Embankment Gardens 98-100
    Station 512
Victoria Line 343
*Victory* 371
Villiers Street 102, 103-4
Vine Street 18, 42
Vyner, Sir Robert 272

Wakefield Gardens 42
Walbrook 47-9
Waldorf Hotel 88
Wales, Charles, Prince of 163
Walker, Sir Emery 254
Wallace Collection 196-8
Wallis, Gilbert & Partners 269
Walpole, Horace 138, 139, 146, 168
    Garrick's Temple 310
    Strawberry Hill 45, 302-3
Walpole, Robert 130, 318
Walpole Park 267

Walsingham, Sir Edmund 422
Waltham Abbey 489, 543
Walthamstow 543-8
Walworth Health Centre 26, 346
Walworth Road 346-7
Wandsworth Road 279
Wanstead 474-6
Wapping 359, 448-9, 451
Warbeck, Perkin 376
Washington, George 138
Water House 543
*Water Seller of Seville, The* 210
Waterhouse, Alfred 15, 44
Waterloo
    Bridge 103, 294, 330, 331
    Gallery 209
    Place 148-9
    Road 335-6
    Station 335, 512, 513
Waterlow Park 526
Watermen's Hall 66-8, 67
Watling Street 45, 376
Watson, Raymond 278
Watts, George Frederic 34, 325
Waugh, Evelyn 9, 330
Webb, Aston 38, 39
Webb, Charlotte 109
Webb, John 372
Webb, Philip 255, 416
Well Hall Estate 415
Wellington, Duke of 207-10, 359
Wells, Henry 307
Welsh 19, 28, 271
Wembley Stadium 271
Wernher, Julius 375
Wesley, John 60, 61-2, 297
Wesley's Chapel and House 61-2
West, Nan 184
West Ham United 467
West Horndon 489
West India Docks 453, 463
West, Nicholas, Bishop of Ely 285
West Wickham 404-5
Westmacott, Richard 121, 463, 515

Westminster
  Abbey 61, 178, 179
  Bridge 60, 331, 338
  Cathedral 187–9
  Hall 175, 176–7
  Palace 174–5
  Underground Station 343
Westminster, Duke of 88, 190
Weston, Richard 137
Whall, Christopher 216, 476
Wharton, Lord 318
Wheatley, Francis 22
Wheatley, Henry 71
Wheeler, Montague 494
Wheeler, Sir Charles 476
Wheeler's Park Road 494
Whistler, James McNeill 65, 283
Whistler, Rex 184–5, 229
White Hart 11
White Tower 447
Whitechapel 81, 428, 440–1, 462
  Bell Foundry 438–40
  Gallery 437–8
  Overground Station 442
Whitefriars Monastery 7
Whitehall 137, 166–9
Whitehall, Cheam 320–1
Whitehead, Rachel 371
Whittington Avenue 74
Whittock, Nathaniel 400
Whitworth, Joseph 542
Widegate Street 431–2
Wilkes, John 19, 207, 344, 536
Wilkins, William 128, 136
Willesden 549–50
Willesden, Bishop of 549
William I 447, 508
William II 175
William III 64, 373, 374
  Statue of 151
William IV 163
  Portrait of 159

Statue of 370–1
William Morris Gallery 543–5
William of Malmesbury 454
Williams, Owen 9
Williams, Rowan 339
Williams-Ellis, Clough 487
Willoughby, Sir Hugh 451
Willow Road 518–19
Wilson, Harold 127
Wilton's Music Hall 443–5
Wimbledon 318
  Greyhound Stadium 314–15
Winchester College 273
Winchester Palace 349–50
Winchmore Hill 538–9
Windrush Square, Brixton 280
Windsor Castle 287
Wine Office Court 7
Winfield, Canon Flora 65
Wingate, Harold 205
*Winged Figure* 195
Woburn Square 94, 120
Wolsley, Cardinal 310, 420
Wood Green 535, 552
Woolwich 382–3
Woolwich Arsenal DLR Station 386–7
Wootton, John 139
Worde, Wynkyn de 10
*Worker of the Future Clearing Away the Chaos of Capitalism, The* 20
Worley, John 374
Worshipful Company of Armourers 54
Worshipful Company of Bowyers 56
Worshipful Company of Glovers 54
Worshipful Company of Haberdashers 540
Worshipful Company of Watermen and Lightermen 67

Wren, Christopher 28, 74, 91, 137, 147–8, 154, 272, 373
  All Hallows, Lombard Street 296
  Chelsea Royal Hospital 218
  Christ Church Greyfriars 34
  Hampton Court 310–11
  Kensington Palace 239–40
  Monument 62–3, 146
  St Andrew Holborn 14–15
  St Bride's 10
  St Magnus the Martyr 63–4
  St Margaret Lothbury 53–4
  St Mary Aldermary 45–7
  St Mary-at-Hill 66
  St Paul's Cathedral 31
  St Stephen Walbrook 47–8
Wren Landing 464
Wright, Andrew 161
Wright, Nathaniel 34
Wright, Sir Edmund 272
Wyatt, Benjamin 209
Wyatt, Matthew Digby 170
Wyatt, R. J. 319
Wyatville, Jeffry 287
Wykeham, William 273
Wyon, Allan 181

Ye Olde Cheshire Cheese 7
Yevele, Henry 175, 177
York, Duke of 114
York Hall 457
York House 102, 103, 104, 297–9
York Road 330
York Terrace 498
York Watergate 102–3
Young, Nicholas 27

Zimbabwe House 97–8
Zodiacal Clock, Bracken House 28–9
Zucchi, Antonio 269